MUSEUM FRICTIONS

DUKE
UNIVERSITY
PRESS
DURHAM
AND LONDON
2006

MUSEUM

Public Cultures/
Global Transformations

Edited by Ivan Karp,

Corinne A. Kratz,

Lynn Szwaja, and

Tomás Ybarra-Frausto,

with Gustavo Buntinx,

Barbara Kirshenblatt-Gimblett,

and Ciraj Rassool

FRICTIONS

2nd printing, 2007

© 2006 Duke University Press
"World Heritage and Cultural
Economics" © 2006 Barbara
Kirshenblatt-Gimblett.
All other rights reserved.
Printed in the United States of
America on acid-free paper ∞
Designed by Amy Ruth Buchanan
Typeset in Minion and Gill Sans by
Tseng Information Systems, Inc.
Library of Congress Cataloging-in-
Publication Data appear on the last
printed page of this book.

Duke University Press gratefully
acknowledges support for this
publication from the Rockefeller
Foundation.

IN MEMORY OF INGRID MUAN

CONTENTS

FOREWORD

This book results from a series of meetings on museums and globalizing processes convened over the last six years by the Rockefeller Foundation in New York, Buenos Aires, Cape Town, and Bellagio, Italy. It builds on two earlier conferences and volumes supported by the Rockefeller Foundation and the Smithsonian Institution over a decade ago, *Exhibiting Cultures* (1991) and *Museums and Communities* (1992).[1] These volumes reflected the concerns of the period, debating pluralism, the representation of minority and non-Western cultures, and the role of museums in civil society and in according or denying identity. The foundation's own programming, described briefly below, developed along similar lines in the 1980s and early 1990s.

The foundation's museums program, begun in 1989, sought to assert a more inclusive narrative of the United States in contemporary and traditional cultural production, supporting, among other projects, exhibitions of African American, Asian American, Latino, and Native American art both in mainstream museums such as the Whitney Museum of American Art and in culturally specific venues such as the Studio Museum in Harlem, the Wing Luke Museum in Seattle, and the Mexican Fine Arts Center in Chicago.[2] A persistent aim in funded exhibitions and scholarly research has been to question rigid and closed art history canons and museological practices, recognizing museums as arenas of discourse and negotiation useful in defining new forms of

public culture. A concerted effort has been made to establish archives, train a new generation of curators, and create new paradigms for the evaluation and interpretation of the multiple strands of cultural production that form contemporary art in North America. At the same time, the foundation has supported research and exhibitions on African, Asian, and Latin American culture and how artists and practitioners in those regions are responding to the cultural exigencies of multiple modernities. The frameworks and content of the museums program are also reflected in the foundation's humanities programming, which has for much of the last twenty years focused on race, gender, and ethnicity, on developing countries, and on transnational or diasporic issues and identities. Anthropologists, historians, and sociologists as well as art historians have provided context for the funded catalogues and exhibitions.

Much has happened in the world and in the world of museums since the publication of the two volumes that preceded this one. So in 2000 we began with Ivan Karp (our earlier collaborator), Corinne Kratz, and an international group of scholars and museum professionals to examine how international and global connections have become central today to the circumstances of museums and other display institutions. Museums and their staff have been international actors for some time, and other globalizing processes have deep historical roots. However, the present moment is one in which globalization and the changing nature of communication have created environments to which museums are adapting and opportunities museums are taking advantage of. Yet not all museums and certainly not all communities are positioned to benefit from these globalizing processes and new technologies. The processes of globalization are as likely to produce newly disadvantaged institutions and deepen the patterns of inequality between regions of the world as they are to provide occasions for attracting new publics and developing programs. The positive aspects of globalization — increased access to and innovative use of new technologies, the reemergence or preservation of voice and traditions, and the creation of "imagined communities" united across geographic boundaries — are in some cases offset by negative effects such as the global proliferation of mass media and concomitant loss of some traditional cultural transmission, clashes of value systems, and increasing inequality and poverty.

In recent years the foundation has sought to address in its cultural programming these two faces of globalization by supporting national and transnational networks of scholars, artists, and museum or heritage professionals as well as by funding more community research, training, and exhibition programs in eastern and southern Africa, Latin America, and Southeast Asia. This has involved strengthening a network of indigenous community museums in Mexico; supporting exhibitions and research that seek to understand

and define the "transnational imaginary" of migrant populations who continue to traverse cultural corridors between their homelands and the United States, and also to interrogate and theorize notions of cultural heritage (both tangible and intangible); and encouraging community cultural development projects that use oral history and dialogic exhibitions to probe histories of repression and conflict and to safeguard memory.

The five international meetings that Ivan Karp and Corinne Kratz have helped us organize have brought together colleagues from some of these funded projects, as well as a host of others from different kinds of cultural institutions, to specify how the cultural, economic, political, and social flows characteristic of globalization affect not only museum practices but also the societies within which museums operate. A number of tensions, or frictions, come to the fore as museums' international involvements and concerns have burgeoned in the last decade and as they position themselves within the interface between the local and the global. Some institutions are transforming themselves to reap the benefits of globalization or to build on significant political and social changes in their countries (e.g., in South Africa); others are being transformed in spite of themselves. The past decade has seen a proliferation of sites of memory in many countries, including national monuments, memorials, and "museums of conscience." Along with changing rhetorics within and about museums and the multiple roles that museums and related institutions are asked to perform nowadays (including display, collection, heritage management, social critique, and civic, historical, and cultural education) there are changing bases of financial, political, and constituent community support. Some museums attempting to survive the changing conditions may find that their very existence is under threat. Shrinking public budgets threaten museums everywhere, but especially in poor countries on the margins.

The set of discussions, with a long list of meeting participants, authors, and other advisors and consultants from many parts of the world, has been wide-ranging and provocative, and the Rockefeller Foundation's Creativity and Culture Program is grateful to all who gave their time, energy, and ideas to the project. These acknowledgments remind us of the thanks we owe to two early explorers and supporters of this field: Alberta Arthurs, former director of the foundation's then Arts and Humanities Division, and Steven D. Lavine, former associate director of Arts and Humanities, who also collaborated on and edited the two previous volumes with Ivan Karp. But especially we owe a profound debt of gratitude to the general editors and animators of this project, Ivan Karp and Corinne Kratz. Their broad knowledge and experience with the important roles museums play locally and globally in contemporary society have been sources of inspiration to us.

We have been committed to the critical development of museums as well as museum development per se because we believe that these institutions can and must be mobilized to help tilt the benefits of the world's globalizing processes toward those who are marginalized or excluded from these benefits. The volume makes clear how difficult this is but also demonstrates the transformative potential of these institutions in the public sphere, institutions that resonate with memory, history, pain, beauty, and resilience. Our hope is that this book, like its predecessors, will help to develop further both the theory and practice of museums as actors in global civil society.

Lynn A. Szwaja
Director of Theology
The Henry Luce Foundation
Former Deputy Director, Creativity and Culture Program
The Rockefeller Foundation

Tomás Ybarra-Frausto
Associate Director, Creativity and Culture Program
The Rockefeller Foundation

NOTES

1 Karp and Lavine, *Exhibiting Cultures*; Karp, Kreamer, and Lavine, *Museums and Communities*.
2 Developed initially by Alberta Arthurs and Steven D. Lavine as "Representing Cultures Through Museums" and more recently known as "Reinventing and Renewing Cultures Through Museums."

PREFACE

Museum Frictions: A Project History

IVAN KARP AND CORINNE A. KRATZ

useum Frictions is the product of a series of discussions that began six years ago and included a July 2002 conference at the Rockefeller Foundation's conference center in Bellagio, Italy. At the same time, it is part of a longer process, building on a project that began more than a decade earlier with two Rockefeller Foundation-supported conferences held in 1988 and 1990 at the Smithsonian Institution in Washington, D.C. Each of those conferences resulted in an edited volume: *Exhibiting Cultures: The Poetics and Politics of Museum Displays* and *Museums and Communities: The Politics of Public Culture*, both published by Smithsonian Institution Press. With *Museum Frictions*, this pair of books becomes a trilogy of volumes that seek to engage a wide range of scholars and museum professionals. Through their different foci, the books consider core issues in museum and heritage practice by examining how they play out in different kinds of museums and in related institutions through a collection of theoretically informed case studies that together present a valuable comparative collection.

A conversation with Lynn Szwaja and Tomás Ybarra-Frausto, officers in the Creativity and Culture Program at the Rockefeller Foundation, set the current project in motion early in summer 2000. We talked about the rich literature on museums that had burgeoned in the decade since the earlier conferences. Work had flourished on the history of museums, on particular types of museums and related places, on dilemmas and debates related to exhibitions, and

on connections among tourism, heritage, and museums. A few in-depth case studies had appeared, and greater attention had also been given to the diverse ways that visitors interpret and use exhibitions and to the dynamics among museums, communities, and publics.[1]

Looking back, we remarked that the essays in the first two books seemed to capture key questions and concerns at a particular moment in museum practice and in the developing field of museum and heritage studies, concerns that have been further taken up by that literature. The books also seemed to reflect a configuration of issues prominent in the United States of the time, though both volumes had a comparative breadth that included essays about other parts of the globe as well. We wondered what issues would have characterized the conferences had they been held ten years later, in the new millennium, and what themes would allow a similar overarching and comparative access to contemporary museum practice and the shifts that we sensed had taken place since the first two conferences. As we reflected on issues currently facing museums and museum and heritage professionals and on the most salient changes and continuities since the two earlier conferences and books, the four of us started to formulate a new project.

We recognized that international connections and global orientations had become increasingly central to the circumstances and practice of museums since 1990, in ways that sometimes seemed to differ from the international associations that have long been part of the museum world. At the same time, globalization had become the focus of an extensive body of writing during the 1990s, yet institutions of public culture such as museums were rarely part of that discussion.[2] Globalizing processes and museological practice thus presented an intersection with potential insights for both fields. We decided to examine this intersection and the workings and implications of this significant trend in museum practice through a conference and a book that would add to *Exhibiting Cultures* and *Museums and Communities* from our present vantage point. In developing an initial framework, we noted the importance of a critical concept of globalization, one that sees it in terms of a range of processes that entail and generate various kinds of frictions and contradictions.

An initial planning meeting in New York a few months later gathered colleagues experienced with museums and other cultural institutions to discuss the project and identify central issues affecting museums and heritage institutions over the previous decade. We circulated a preliminary statement outlining some of the circumstances and issues we hoped to address as well as responses written by all attending. The statements and the ensuing discussion raised questions, presented varied perspectives on issues through key examples

from specific museums and exhibitions, and provided invaluable input and advice that helped us rethink and reshape our plans. In the end, that meeting launched a project that would include three other workshops as well as a conference, concluding with this book. We knew our topic demanded consultation beyond the United States in order to determine what issues were most important in different regions and settings and to understand the different ways they were configured and defined. But we also knew we could not pretend to have a comprehensive sense of what was happening across the range of museum and heritage settings and around the world. We sought to include people from a wide array of situations but decided to concentrate particularly on Latin America and Africa, building on our own expertise and networks. We organized regional workshops in Buenos Aires and Cape Town the following year modeled on the one in New York, bringing together colleagues from the Caribbean and Latin America in the first and from the African continent in the second.

The shape of this volume and the paths that would lead to it were not fully envisioned when we began. Rather, we designed a process that would itself serve as a way to chart the varied contours of global connections and concerns in contemporary museums. The final conference and book became just one part of a larger coordinated project that would spawn other outcomes as well. The three workshops were meant to foster dialogue and exchange on these issues, to build networks regionally, and to help make cross-regional connections. Workshop participants wanted to know what colleagues in other workshops had to say, so we sent all who took part a compilation CD with the circulated statements, extensive notes from each workshop, and information on all participants. We also created a Web site where others could learn about the project.[3]

In July 2002, building on the workshops, we convened a four-day conference at the Rockefeller Foundation's conference center in Bellagio, Italy. Twenty colleagues came together from six continents to discuss contemporary museum, heritage, and exhibition practice in different parts of the world. Most essays in this volume were prepared for that conference.

We also planned for a postconference workshop intended to reach the next generation of museum and heritage professionals and scholars. This "next-generation" workshop took place in November 2002 at Emory University in Atlanta, Georgia. Participants from the Bellagio conference helped us identify junior staff to invite from museums and related institutions as well as advanced students doing relevant research. About two dozen people attended, including some Atlanta-based museum professionals and several visiting colleagues.

Participants read and discussed the Bellagio conference papers, relating them to their own work, experience, and research plans and providing feedback for authors. Their energy and excitement continued the discussion begun at the conference and expanded the networks and engagement that the larger project had been building.

Workshop participants in New York, Buenos Aires, and Cape Town had shown keen interest in the book that would result from the project, and as the volume preparation began we wanted to continue the dialogue and interchange that we had found so fruitful. We hoped the volume would serve as a resource and help frame conversations carried on in many places and projects, and we wanted to keep regional differences, issues, and perspectives in mind throughout the editorial process. To do so, we invited three colleagues from the workshops to become part of an extended editorial committee for this book. Gustavo Buntinx, Barbara Kirshenblatt-Gimblett, and Ciraj Rassool agreed to join the effort, and we met for three days immediately after the conference to start the editorial process. The full editorial committee convened again a year later to review final papers, finalize the volume's organization, and begin to write introductions for the book's sections.

The project began with the name "Museums and Global Public Spheres," but all agreed by the end of the conference that the notion of "global public spheres" lacked sufficient specificity and was not entirely useful or appropriate for articulating recent trends, circumstances, and issues in museum and heritage practice. While the sense of dialogue, exchange, and interaction associated with the notion of "public sphere" was important, that term's strong association with Jürgen Habermas was troublesome in part because of his emphasis on bourgeois European circumstances and bracketing of hierarchical differences.[4]

Instead of "global public spheres," we ultimately decided that intersections between the concepts of "globalizing processes" and "public cultures" seemed better to characterize the range of cases and changes outlined in the conference papers; they also more clearly recognized the varied articulations involved in globalizing and localizing. For us the concept of "public cultures," which we had used in the subtitle of the *Museums and Communities* volume, seemed to convey a better sense of the fields of activity that emerge out of diverse interests and orientations, fields that are less integrated than the public sphere and more heterogeneous in their politics and aims. These conclusions crystallized into the title *Museum Frictions: Public Cultures/Global Transformations* during the subsequent editorial meeting. Yet the debates that led to this reformulation continue to have a spectral presence in several essays in the book, with traces of

"global public spheres" providing their own kind of disjunctive friction against the recasting of the final title.

Given our focus, *Museum Frictions* includes a greater range and weighting of international cases and authors than the two earlier books produced around 1990. *Museum Frictions* seeks to develop frameworks for understanding how global opportunities and constraints affect the goals and practices of museums and heritage practitioners and organizations, and how well local needs are acknowledged and served in an increasingly diverse and contradictory global environment. It presents case studies that illustrate how relationships among museums, public cultures, and globalizing processes are being realized in exhibitions and in other museum and heritage programs. Throughout this project we have been particularly concerned with differences between people and institutions positioned at the apex of global systems and those at the margins, and we have sought to draw on examples that extend over the range of institutions. The results, we hope, will convey some sense of the intense and lively dialogue that animated all of the meetings we convened.

ACKNOWLEDGMENTS

The authors in this volume are but a fraction of those who took part in this project and helped support it in various ways. We would like to express our thanks to everyone who attended meetings in New York, Buenos Aires, Cape Town, and Bellagio for their generous and thoughtful participation and to several others who shared papers with us as we prepared the manuscript: Joseph Adandé, Norton Batkin, Ronaldo Bianchi, James Boon, Américo Castilla, Michael Cooke, Arlene Dávila, Ana Maria de Oliveria, Vishakha Desai, Charlotte Elias, Ticio Escobar, Kathy Halbreich, Carolyn Hamilton, Mauro Herlitzka, Maria José Herrera, David Koloane, Moussa Konaté, Richard Kurin, Susan T. Leval, Zayd Minty, Chon Noriega, Chika Okeke, Marcelo Pacheco, José Antonio Pérez Gollán, Jean-Aimé Rakotoarisoa, Mari Carmen Ramírez, Marion Pastor Roces, Doran Ross, Osvaldo Sánchez, Yonah Seleti, Patricia Tappatá de Valdez, John Kuo Wei Tchen, Storm van Rensburg, Stephen Weil, Connie Wolf, Victor Zamudio-Taylor, Vera L. Zolberg, Sharon Zukin, and the authors in this volume.

Those who attended the next-generation workshop in Atlanta offered astute responses to earlier drafts of these papers, for which we thank them: Natasha Becker, Amy Branch, Aimee Chang, Jeffrey Feldman, Cheryl Finley, Derek Hook, Qanita Lilla, Thanduxolo Lungile, Wayne Modest, Michele Gates Moresi, Huong Thi Thu Nguyen, Michael O'Hanlon, Jeffrey A. Ow, Andrea Silvia

Pegoraro, Veerle Poupeye, Yasmin Ramírez, Marina Roseman, Inez Stephney, Shelley Stevens, Jed Stevenson, Carol Thompson, Krista Thompson, Kirsten Wehner, Michelle Wilkinson, and Jonathan Yorba.

Lynn Szwaja and Tomás Ybarra-Frausto have been fellow travelers in this project from its inception, both intellectually and literally. Their partnership has made the entire enterprise a pleasure and an adventure. Editorial decisions and debates were much enlivened by the participation of Gustavo Buntinx, Barbara Kirshenblatt-Gimblett, and Ciraj Rassool on the extended editorial committee.

A multifaceted international project has complex logistics. Jennifer Adair not only handled all meeting and travel arrangements with grace and efficiency while she was at the Rockefeller Foundation but also contributed her bright curiosity and shared our enthusiasm. Staff at the Center for the Study of Public Scholarship took over after the conference, making arrangements for the next-generation workshop and guiding the manuscript through its lengthy preparation. Linnet Taylor at the Rockefeller Foundation also assisted in its final stages.

Through the Center for the Study of Public Scholarship, Emory University provided staff support for the project and a venue for the next-generation workshop. We particularly appreciate the steady and enthusiastic support for CSPS and its activities from Robert A. Paul, dean of Emory College. Ken Wissoker, Anitra Grisales, and other colleagues at Duke University Press have been attentive, efficient, and enthusiastic as this book came to fruition; it was a pleasure to work again with Sue Warga, our copyeditor. Support from the Rockefeller Foundation made this project possible, and the foundation's Bellagio Study and Conference Center provided an idyllic and congenial setting for the final conference and two editorial meetings.

NOTES

1 The following are just a sampling of the books that have appeared since 1990, listed in chronological order within each group. For works on the cultural analysis and history of museums, see Karp and Lavine, *Exhibiting Cultures*; Ames, *Cannibal Tours and Glass Boxes*; Coombes, *Reinventing Africa*; Findlen, *Possessing Nature*; McClellan, *Inventing the Louvre*; Sherman and Rogoff, *Museum Culture*; Bennett, *The Birth of the Museum*; Brigham, *Public Culture in the Early Republic*; Bal, *Double Exposure*; Simpson, *Making Representations*; MacDonald and Fyfe, *Theorizing Museums*; Barringer and Flynn, *Colonialism and the Object*; Holo, *Museums and Identity in Democratic Spain*; Maleuvre, *Museum Memories*; Crane, *Museums and Memory*; Legassick and Rassool, *Skeletons in the Cupboard*; McIntyre and Wehner, *Negotiating Histories*; Luke, *Museum Politics*; Kreps, *Liberating Culture*; and Bennett, *Pasts Beyond Memory*.

Several useful readers have compiled important journal articles on museum and heritage practice, including Pearce, *Interpreting Objects and Collections*; Greenberg, Ferguson, and Nairne, *Thinking About Exhibitions*; Preziosi and Farago, *Grasping the World*; and MacDonald, *A Companion to Museum Studies*.

Books that consider particular types of museums and related display spaces include Fjellman, *Vinyl Leaves*; Pointon, *Art Apart*; Duncan, *Civilizing Rituals*; Harvey, *Hybrids of Modernity*; and MacDonald, *The Politics of Display*.

See note 24 of this volume's introduction for works about dilemmas and debates related to exhibitions.

The following consider connections among tourism, heritage, and museums: Castañeda, *In the Museum of Mayan Culture*; Davis, *Spectacular Nature*; Handler and Gable, *The New History in an Old Museum*; Kirshenblatt-Gimblett, *Destination Culture*; Stanley, *Being Ourselves for You*; and McEachern, *Narratives of Nation*.

A number of in-depth case studies of particular exhibitions have appeared, including O'Hanlon, *Paradise*; Sandeen, *Picturing an Exhibition*; Gaspar de Alba, *Chicano Art Inside/Outside the Master's House*; Rassool and Proselandis, *Recalling Community in Cape Town*; MacDonald, *Behind the Scenes at the Science Museum*; and Kratz, *The Ones That Are Wanted*.

Other recent works focus particularly on how visitors interpret and use exhibitions, education and learning, museum design, and the dynamics among museums, communities, and publics: Karp, Kreamer, and Lavine, *Museums and Communities*; Falk and Dierking, *The Museum Experience*; Dean, *Museum Exhibition*; Roberts, *From Knowledge to Narrative*; and Hein, *Learning in the Museum*.

2 See, for instance, Featherstone, *Global Culture*; Robertson, *Globalization*; Ahmed and Donnan, *Islam, Globalization, and Postmodernity*; Featherstone, *Undoing Culture*; Sassen, *Losing Control?*; Clark, *Globalization and Fragmentation*; Bauman, *Globalization*; Jameson and Miyoshi, *The Cultures of Globalization*; Sassen, *Globalization and Its Discontents*; Meyer and Geschiere, *Globalization and Identity*; Tomlinson, *Globalization and Culture*; and Westbrook, *City of Gold*.

3 The project Web site is part of the Web site for the Center for the Study of Public Scholarship: http://www.csps.emory.edu.

4 Sound critiques and debate have led to various reformulations of the notion of "public sphere," but Habermas's theory typically remains the starting point. Nancy Fraser's useful summary of these critiques identifies several problems with the way Habermas defines "public sphere": (1) the public sphere is actually not separate from the state, as he seems to assume; (2) the notion must be pluralized, for there will always be multiple public spheres, sometimes intersecting and sometimes in contestatory relations; (3) Habermas's assumption of equal access to participation in a public sphere is wrong, as is the assumption that participation is defined as if among status equals, because hierarchy is bracketed (within museums, inequalities of access and status have been major issues in the past few decades); (4) unequal access and participation entail differential knowledge and skill in the communicative conventions involved in the public sphere (or more specifically here in museum practice) — shared communicative conventions cannot simply be assumed to exist already but would need to be

developed. In the end, Fraser finds the notion of "public sphere" to be important and necessary but in need of revision. Bruce Robbins concurs that "public sphere" is "a concept that must remain both unacceptable and necessary," surrounded by contradictions. See Habermas, *The Structural Transformation of the Public Sphere* and *The Structure of Communicative Action*; Fraser, "Rethinking the Public Sphere"; Robbins, "Introduction: The Public as Phantom."

INTRODUCTION

Museum Frictions:

Public Cultures/Global Transformations

CORINNE A. KRATZ AND IVAN KARP

M useums and other display and collecting institutions are surprisingly protean organizations. They have different and often multiple mandates and complex and contradictory goals. They experience conflicting demands made on them from a range of interested parties, including funders, audiences, government officials, professional communities, collectors, and peoples who are represented in the museum displays. In addition, there are other cultural and display institutions to which museums are inevitably connected and related. Wherever they are found and whatever their specific histories, museums are defined—and define themselves—in relation to other cultural, civic, and community organizations, whether they be art galleries, schools, fiestas, fairs, expositions, department stores, or theme parks. Over the years museums have also increasingly found themselves in fruitful and frustrating conversations and interactions with a variety of media, including cinema, television, video games, and other interactive forms.

Given the complexity of relations, pressures, and incentives, it is inevitable that museums have been described in myriad ways: as temples of civilization, sites for the creation of citizens, forums for debate, settings for cultural interchange and negotiation of values, engines of economic renewal and revenue generation, imposed colonialist enterprises, havens of elitist distinction and discrimination, and places of empowerment and recognition—although

different people might be empowered and recognized at different times and places, just as these other characterizations may be most appropriate for different periods, places, and institutions. In every case, however, the range of museum roles, definitions, and cross-institutional relations entails conjunctions of disparate constituencies, interests, goals, and perspectives. These conjunctions produce debates, tensions, collaborations, contests, and conflicts of many sorts, at many levels — *museum frictions* that have both positive and negative outcomes. International and globalizing processes have always been a prominent factor affecting museums, but increasingly they influence contemporary museum and heritage practice in ways that both generate new museum frictions and recast old ones. The essays in this book examine the ways these frictions play out as museum-generated social processes and globalizing processes intersect and interact.

In a 1997 essay, cultural historian James Clifford adapted the concept of contact zones to portray museums and heritage sites as lively, contentious intersections, "because it opened them up to contestation and collaborative activity. It helped make visible the different agendas — aesthetic, historical, and political — that diverse 'publics' bring to contexts of display."[1] The notion neatly captured and reiterated an emphasis on the museum as forum that emerged in museum practice and scholarly work alike during the mid- to late 1980s.[2] Yet a focus on the museum primarily as a zone or place can also imply a sense of boundedness that obscures the way these contests and debates arise from both within and outside the museum, shaped by museum contexts yet still also related to and often embedded in other contexts, institutions, and processes. While preparing this book, we developed the term "museum frictions" to shift attention toward the ongoing complex of social processes and transformations that are generated by and based in museums, museological processes that can be multi-sited and ramify far beyond museum settings. "Museum frictions" incorporates the idea of the museum as a varied and often changing set of practices, processes, and interactions. This sense of the museum as a social technology is a crucial addition to considering the museum as an institution of public culture and the different meanings and histories of the concept of the museum.[3] The importance of this shift became particularly clear in the discussions and meetings that led to this volume, as we explored the international and transnational connections and global considerations that have become increasingly central to the circumstances and practice of museums today, multiplying both potential conjunctions and potential frictions.[4]

Museum frictions might arise in any number of sites and relations, with parameters and dynamics particular to each context and case. While it may be futile to try to locate museum frictions in general, for all situations, the

intersections of public cultures and global transformations provide potential sites and sources where they are engendered and multiplied. Such intersections entail a number of different orientations and highlight the different mandates, roles, and responsibilities that museums often seek to fulfill. Many of the earliest national museums developed from princely or private collections and cabinets of curiosity, with collections expanded through colonial expansion, imperial plunder, scientific exchange, and aristocratic, elite, industrial, and state patronage. At once a sign and demonstration of national reach, status, and wealth, an institution dedicated to producing and presenting knowledge, and a means through which to constitute, educate, and impress its citizenry, such museums were addressed simultaneously to national publics and to other nations. These characteristics continue in today's national museums, whether museums of art, history, natural history, or ethnography, though in very different circumstances, with different ways of ordering knowledge and broader, more diverse understandings of publics and constituencies.

Other museums were founded and proliferated in major cities and far-flung colonies, staking their own claims to regional prominence, and providing similar kinds of experience and edification for those who did not or could not travel to the capitals or metropoles. Again, such museums faced in several directions at once, set in relation to local and regional institutions and matters and aligned in various ways with other national or metropolitan museums and concerns.[5] Documenting and collecting a range of cultural creativity and natural diversity, museum activities and claims were at once scholarly and educational, as well as bound up with ideas about the values and identities that constitute society and cultivated individuals. Institutions of knowledge, power, and exhortation, museums combined the effects of advocacy, outreach, and public relations with those of the university and the treasure house, creating potent modes of authority and legitimation. They presented exhibitions and narratives that claimed particular worldviews and ordered knowledge in ways that would enlighten visitors about them and simultaneously inculcate particular ways of seeing and being. Yet visitors could always produce counternarratives, whether through different knowledge bases, resistance, or sheer miscomprehension.

In these ways, museums became one of the institutions and practices associated with modernity, part of the checklist for being a nation, a means for disparate groups to present and claim their histories and values in the public sphere, and simultaneously an arena and means for constituting community identities. With the proliferation of museums across a wide range of settings and scales—including community museums, industrial and corporate museums, and thematic museums as well as the burgeoning heritage indus-

try—museums and heritage organizations have increasingly become sites and means for political contestation as well. At once facing inward to local constituencies and outward to wider audiences through relations to other museums and sites, these institutions provide ways to mobilize an internationalist—perhaps global—sense of local identities, histories, and concerns. They have become essential forms through which to make statements about history, identity, value, and place and to claim recognition. Reproduced, adapted, and transformed globally, museums are not just a place or institution but have become a portable social technology, a set of museological processes through which such statements and claims are represented, embodied, and debated. Whether they define their scope as national, regional, or community-based, museum spaces can become global theaters of real consequence.

Museums and the professionals who staff them have been international actors and part of various global orders for a long time. Yet the present global moment is one in which the changing nature of social relations and communication have produced circumstances to which museums and heritage organizations must adjust, exploring new possibilities and facing new challenges.[6] However, not all museums are positioned at the apex of the new global order. The consequences of globalizing processes might just as well produce newly disadvantaged institutions and exacerbate regional inequalities as provide opportunities for expanding constituencies and adding new content and programs. It is a commonplace observation that globalization has been characterized by the compression of time and space, with new forms of communication and transport enabling contact and social relations among people who had previously been culturally and spatially separated. But it is equally important to note that uneven patterns in globalizing processes and integration can also uncouple places and institutions from broader systems. "Globalization is uneven among countries and regions, among regions within countries and among categories within regions."[7]

Moreover, the term "global" can often obscure as many extralocal relationships as it illuminates. Many of the relationships and processes we examine in this volume are global only in the most general sense. They are often better described as "transnational," "international," "cross-regional," "intraregional," or even "bilateral." The overuse of "global" often conflates these differences and their implications. When the Guggenheim Museum describes itself as "global," for example, the use of the term conceals the fact that the museum limits its expansion of programming to relatively wealthy parts of the world and has no plans for whole continents that have their own museum traditions. As with so many processes that are described as "global," it is often vitally important to specify the type and kind of geographical and temporal

reach associated with the process, and particularly to note the direction of the flows that are called "global," whether we are speaking of economics or culture. As Anthony Shelton reminds us with a range of examples, "it would be wrong to speak only of a European led process of globalization," either historically or at present.[8] We accept that recent decades have seen increasing speed, growing intensity, and multiplication of directions of extranational flows, processes, and relationships that are called "global." But we also want to acknowledge that greater integration of the globe, either in cultural or economic terms, is not the necessary endpoint of globalization, which can produce uncoupling and isolation—the loss of opportunity—as much as it can produce new relationships and opportunities. A discussion of globalization does not require a triumphalist point of view. Such a viewpoint, in fact, obscures important components and effects of transnational and globalizing processes.

Within contemporary international relationships and global processes, circuits of transnational migration enable the configuration of new audiences and communities, thereby creating the possibility that the varieties of imagined communities that museums and heritage organizations address need to be rethought, particularly in light of changing institutions, policies, and practices. Yet, at the same time, they can also put some museums at risk of losing audiences and support. The contemporary focus on globalization should not mask the fact that many of these processes have deep historical roots and that some global connections and communications are centuries old. It is equally important to recognize that local institutions and conditions affect how broader processes are shaped and play out.

When we began this project we recognized that increasing international connections and global orientations were one of the major trends in museum and heritage practice in recent decades, yet their workings and implications were still relatively unexamined. Nor was much consideration given to how museums managed the often contradictory pushes and pulls that derived from globalizing processes and from the history of museums, which is sedimented in their organization, collections, and exhibitions. The sharp tension between past projects and achievements and new opportunities and constraints is one of the most significant features of the present museum and heritage scene, and few museums and heritage organizations have been able to manage these conflicts elegantly. We tend far too easily to forget that the goals of the past also can serve the needs of the present.

Hence we tried to examine the changing situation of museums but to keep in mind that we had reservations about the totalizing and triumphalist ways that globalization has often been portrayed. Much as we use the term "museum frictions" to foreground museum-based processes and transformations, we

found it essential to disaggregate globalization, to look at the range of global-izing processes collected under that term and consider both their interconnec-tions and their limits. The processes and relations that constitute globalization in a general sense are shaped on one hand by social, cultural, economic, and political flows created through systematic exchange and circulation and on the other hand by varied articulations between and across different sites, institu-tions, and levels of organization and integration. These flows and articulations are often in a conversation, if not a debate, with the past, so it was equally essential to keep in mind the history of museums. A central point of the essays in this volume is that global flows and articulations work in contradictory as well as complementary ways, both in relation to one another and in relation to museum pasts embedded in the goals and aspirations of many museums.[9]

The cultural flows and processes with which many museums are specifically concerned are not the only elements with which they must contend. There are also economic, social, and political flows and processes that are intercon-nected complexly among themselves as well as with those related to culture. None of these flows and processes necessarily follows the same patterns as the others. Museums exist at the intersections of all of these, but cultural flows are their special province. Forms of cultural production and exchange that exist increasingly outside of the spheres and frames of reference to which many mu-seums are dedicated, from local to national, provide subjects for museums and heritage organizations to examine and to help shape, even as they adjust to and engage with transforming circumstances.

It is important that they do so because culture, and its flows and processes, does not respect the political boundaries that so often define the terms "local," "national," "regional," and "global." As Simon During notes when attempting to define "global" in relation to popular culture, "culture is precisely that field in which differences and internal borders within the global system most per-sist."[10] At the same time global cultural flows can define terms of identity that operate outside of and often across conventional political borders, as the lit-erature on diasporas amply demonstrates. These observations suggest that the contrast commonly made between the global and the local is no more than a convenient shorthand often used to invoke—but not necessarily to consider critically—what is involved in the range of articulations through which global-izing and localizing processes and cultural flows take shape. This (increasingly sterile) shorthand bears the risk of flattening complex processes and articula-tions into a conflating binary division, which evades the task of examining the new and unexpected geographical and temporal units and identities that are emerging.[11]

In addition to looking across a range of sites and structural levels of inte-

gration and disjunction, it is equally important to understand the conditions under which these processes take place and to ask what they mean for differently situated actors and institutions. It is also important to recognize relations and connections that are not nationally based. We need to think about how museums articulate with units of different geographical and temporal scales, and how different scales themselves affect developments in public cultures. Apart from identifying the varied and systematic connections and disconnections that characterize contemporary subnational, international, transnational, and global structures and processes, one must also be alert to more ephemeral, conjunctural, quirky, and contradictory aspects that arise and shape them. These orientations in turn illuminate the ways that public cultures are produced through museums, heritage resources, and related institutions of public culture and ongoing global transformations in associated domains of knowledge and practice.

A number of tensions emerge and are highlighted as museums remodel themselves and negotiate among various projects and definitions that may be derived from different spheres of involvement and identity. These range across spaces that could be described as local to global but encompass and link many different spaces in between, each of which might be seen as a form of "local" in relationship to a more encompassing space. These tensions and definitions take different shapes and are managed in diverse ways by different types of museums, as well as being handled in different ways in different parts of the world. Some museums attempting to survive changing conditions may find that their very existence is under threat. At the same time, new museums and display settings and new collaborations have also been emerging in the past two decades.

Some ethnic and community-based museums in the United States, for example, are torn between competing tasks: developing programs for audiences with forms of self-consciousness derived from transnational migrations and diasporas, yet also following missions defined and associated with their history as museums fundamentally grounded in local and national concerns. Nor should we forget that these missions were developed in communities whose composition has often changed in fundamental ways and that the museums are sometimes facing different challenges and constraints in today's financial landscapes. The Centro Cultural de la Raza in San Diego, California, provides one such instance. Founded by Chicano artists in the late 1960s and now a nationally prominent art center, the Centro has been the subject of a heated campaign and a four-year boycott by some of its founders, mounted in protest of a new director and board members appointed in 1999 in an effort to rescue a debt-laden organization. The Centro's new leadership made changes in

programming and decision making as part of what the protestors regard as a depoliticization and mainstreaming that run contrary to the center's roots and original mission. The Centro presents its goal as "becoming the best Chicano cultural arts center in the United States. It's a goal that they readily admit requires certain things that would tend to rub a grassroots arts community the wrong way: corporate grants and sponsorship; alliances with local government; appeal to a wider, more conservative audience."[12]

In New York City, a parallel debate has raged around El Museo del Barrio, founded by Puerto Rican activists and artists, also in the late 1960s, to be a community museum and center in East Harlem. The neighborhood is now more diverse, with large numbers of Dominican, Mexican, and other Latin American residents, and has been undergoing gentrification. In the mid- to late 1990s, new board members at El Museo recast its mission and activities to put more emphasis on Latin American art, seeking to reach wider audiences—changes reflected in a 2002 blockbuster exhibit on Mexican art and a 2004 exhibition on Latin American art done in collaboration with the Museum of Modern Art. These changes have met with protests by a group called Nuestro Museo Action Committee, which, like the San Diego group, sees the transformations as inimical to the integrity and spirit of the institution as they have known it.[13] The key point to recognize, in these examples and more generally, is that the processes and imperatives to which museums and heritage organizations must adapt—including increasing community diversity and articulation with the international order, on one hand, and service to long-standing components of local communities, on the other—do not happen sequentially. These are simultaneous, ongoing, and conflicting. Thus, El Museo has to contend not only with transnational connections and globalization (it has always had to do that) but also with competing social and cultural flows. In this case a Puerto Rican diaspora competes within the museum with the incentives and constraints produced by the increasing density of cultural, economic, and political relations with Latin America. These conflicts have been dramatically acted out on the stage of the museum itself.

Museums often strive simultaneously to be community-based, national, regional, and global in various ways, and must also negotiate those projects and definitions with other competitor/colleague institutions. Some museums are now modeling themselves after global corporations, and display events now exhibit emergent identities shaped by perceptions of non-national and sometimes global processes. The 2000 World Exposition in Hannover, Germany, for example, did not have a United States pavilion, but "American" companies such as Coca-Cola exhibited there not as American but as global corporations.[14] Museums, communities, national councils, and transnational bodies

such as UNESCO are all grappling with categories, policies, and practices related to tangible, intangible, and world heritage as well as intellectual property rights. At the same time, community museums are seeking to define the communities they serve in ways that acknowledge that community boundaries change according to how they are identified, which of their historical experiences and cultural forms are being addressed in programming, and how they articulate with other communities. What effects do these tensions have on museums and the ways they define and serve visitors and communities? What do these issues look like from peripheries, from centers, and from dispersed diasporic vantage points?

Some new forms of display have been emerging that are derived from world's fairs, but taken in new directions in places ranging from Walt Disney World to cultural theme parks in Latin America, Africa, and Southeast Asia.[15] New media have also presented ways for museums able to access them to expand their reach and range of activities, as well as possibilities for virtual exhibitions and forms of cultural production and social interaction that bypass museums altogether. How do these new directions exemplify changing forms of the social imaginary as it is constructed in what, following Tony Bennett, we call the public cultural and historical sphere?[16] How are social identities constructed and for whom in these display forms? These are some of the many issues and questions raised as globalizing and museum-based processes interconnect, producing a set of conjunctions that we wanted to explore as we began the project that became *Museum Frictions*.

THE MOMENT

This volume's focus on transnational and globalizing processes in museum and heritage spheres both reflects and partakes in the kinds of shifts we noted when we began the project in 2000 (see the preface). Looking back at that time to 1990, we saw a museum and heritage landscape that was being remapped and had been marked by a number of salient processes and events. But the moment in which we find ourselves today is not the same as the one during which we began. Over the course of this project, some highly significant political events and cultural shifts occurred that began reverberating through museum and heritage sectors almost at once. Natural disasters such as the 2004 tsunami in the Pacific region and Hurricane Katrina along the Gulf Coast of the United States in 2005 brought devastation and misery on enormous scales, as well as worldwide responses. They have had significant effects on museums and heritage in these regions and will surely become topics of museum-based expressions as well. The attacks of September 11, 2001, in the United States and sub-

sequent wars waged by the United States and others in Afghanistan and Iraq have changed global relations, regional and national cultures, and the patterns, meanings, and textures of life in many communities throughout the world.

They also spawned powerful exhibitions such as "Here Is New York: A Democracy of Photographs,"[17] triggered knotty politics and debates about a memorial at ground zero (the former site of the World Trade Center towers), and created conditions for the looting of the Iraqi museum in Baghdad, the destruction of archaeological heritage, and the closing of the Kabul zoo — now seen as "a microcosm for the rebuilding of Afghanistan" as it is reconstructed with aid from transnational organizations and international donors from Australia, the United Kingdom, the United States, and other countries.[18] Tougher customs and immigration restrictions now make it more difficult for some people and cultural institutions to work collaboratively and for exhibitions to travel internationally, just as some topics and interpretations in art, exhibitions, and programs have come under greater scrutiny, at times seeming to touch new taboos.[19] This is the case particularly, but not only, in the United States. Yet at other times, both in the United States and elsewhere in the world, the daily workings and projects of museums and heritage institutions seem little affected by these recent geopolitical and cultural shifts, and other events and concerns may be more consequential to their local and regional circumstances and relations. This provides a cogent reminder that global processes unfold unevenly and differentially, ever shaped by specific settings and concerns.

There may have been some surprising turns, but developments taking place during the course of our project still built on processes in train when we began, significant events and trends that have been reconfiguring museum and heritage practice and institutions in various ways over the past fifteen years. There had already been tremendous growth in the numbers both of museum and heritage organizations and of visitors, a general trend that was continuing.[20] The period after 1990 saw the opening of a plethora of community, ethnic, and thematic museums around the world as well as a number of large, new national museums, including Robben Island Museum in South Africa (1997), Te Papa Tongarewa in New Zealand (1998), the National Museum of Australia (2001), the National Museum of the American Indian in Washington, D.C. (2004), and plans for a new National Museum of China (expected to open in 2007). In these settings, museums were still defined as spaces for advertising national wealth and achievement, but in some of them the nature of the nation and its relationship to its society were contested and even challenged. Once again the outward-looking aspect had to contend with dynamics internal to the society itself, whether this meant splitting the director's authority between Maori and

Pakeha (non-Maori New Zealanders) at Te Papa Tongarewa or contesting the role of different and competing liberation organizations in interpretations at Robben Island Museum in South Africa.

In these new museums, nation and citizenship were defined in relation to plural societies in ways that contrasted with such definitions in national museums founded a century or more earlier, in very different times. Many smaller organizations also drew on and grew from pluralist and multicultural emphases, casting their appeals and displays around local histories and cultures, minority populations, and special themes. Older, established museums also sought to reconfigure some of their displays, collections policies, and relations with visitors and communities within a continuing cultural and political context that recognized that the social order is composed of diverse elements and groups, some of whose presence had not been acknowledged in the museum sphere. Museums and heritage sites were also perceived as a means of claiming or appropriating a role in broader public spheres and of legitimating identity, history, and presence, a perception that shaped this change and growth.[21] Representation and legitimation could matter within social groups as much as, and sometimes more than, they did in wider arenas. Communities sought the legitimacy conferred by museums for themselves, not necessarily to display themselves to others.

Exhibitions were central manifestations of and forums for these processes and debates, with a significant, perhaps increasing number presenting topics related to particular cultural identities, histories, diasporas, and hybridities and involving consultative engagements with the communities depicted and/or those living in a museum's own vicinity. The range of topics and community engagements was also one face of efforts to increase visitor numbers, an effort simultaneously intended to help provide secure fiscal foundations. Blockbuster exhibitions with similar audience and revenue goals sought to be crowd pleasers with tried-and-true topics: treasures rarely seen or associated with the lives of the rich and famous, sweeping historical surveys, or broad, generic themes that assembled objects without historical connections to illustrate universalist or humanistic connections. In the United States this resulted in exhibitions of varying quality and success on dinosaurs, mummies, and Impressionist art; "Matisse" (1992), "Vermeer" (1995–96), "Rings: Five Passions in World Art" (1996), "Picasso" (1996), "Star Wars" (1997), "Egyptian Art in the Age of the Pyramids" (1999–2000), "Leonardo da Vinci, Master Draftsman" (2003), "Matisse/Picasso" (2003), and Wonders, an international series of exhibitions produced in Memphis, Tennessee, that included "Ramesses the Great" (1987), "Catherine the Great" (1991), "Splendors of the Ottoman Sultans" (1992), "The Etruscans" (1992), "Napoleon" (1993), "Czars: 400 Years of

Imperial Grandeur" (2002), and "Masters of Florence: Glory and Genius at the Court of the Medici" (2004).

Blockbusters flourished particularly in the United States and in larger museums, continuing a trend that began in the late 1970s (when "Treasures of Tutankhamun" toured), but blockbusters have also taken root in Australia, the United Kingdom, and elsewhere and frequently involve international cooperation in mounting the exhibition and international venues on exhibition tours.[22] "Matisse/Picasso" showed in New York, Paris, and London, for example, but international blockbuster tours rarely, if ever, reach so-called less developed countries, which from the organizers' viewpoint lack both the funds that such exhibitions require and a sufficiently elaborate infrastructure to support them.

A parallel development has seen dramatic blockbuster-like reinstallations of permanent collections completed or under way in a number of major museums, including the Louvre (with seven galleries reopened in 1999), the Metropolitan Museum of Art (with reinstallations opened in 2000 and 2004 and an ambitious project of further reinstallations called "21st Century Met" launched in 2004), and the National Museums of Kenya (ongoing). New exhibition halls on African cultures alone opened at the Field Museum (1993), the Smithsonian's National Museum of Natural History (1999), and the British Museum (2001). Also related to the spirit of the blockbuster, in contemporary art the last fifteen years have seen a burgeoning series of biennial exhibitions hosted around the world, along with other large-scale exhibitions such as Documenta in Germany. These have brought issues of globalism and globalization to the forefront of curatorial practice and artistic display in that field, also raising questions about exhibitionary form and postcoloniality.[23]

The 1990s also saw museums and exhibitions taking center stage in the public sphere with waves of public controversies centered on exhibitions, shaping public cultures and the ways that cultural politics played out in many settings. In the United States, there were vociferous public debates about "The West as America" (1991), the exhibition of the *Enola Gay* in "The Last Act" (1994–95), "Back of the Big House" (1994; see Ruffins's essay in this volume), "Sensation" (1999), *Our Lady*, an artwork depicting the Virgin of Guadalupe in the "Cyber Arte" exhibition at the Museum of International Folk Art (2001), "Mirroring Evil" (2002), and many others, raising issues about the interpretation and representation of history, race, religion, and identity; whose perspectives should be represented; what financial relations lie behind exhibitions; and the role of museums and exhibitions in public culture more generally. Similar questions were in contention in Canada over "Into the Heart of Africa" (1989–90), in South Africa over "Miscast" (1996), in Germany over "The War of Extermina-

tion: Crimes of the Wehrmacht 1941–44" (1995–97), in Australia over "Body Art" and "Sensation" (again) (both 2000), in England over "Trading Places: The East India Company and Asia" (2002), and in India over removal of artwork by Surendran Nair from the National Gallery of Modern Art in New Delhi (2000), to name just a few. In each case, the particular sparks that set off controversies and the framing of issues were particular to the context and situation, but taken together these debates point to a prominent role for museums, exhibitions, and heritage sites as forums where such contests take place and where public cultures take shape. They also highlight the sometimes conflicting demands and expectations that communities place on them, and the ways that controversies in one part of the world might replicate and combine patterns and strategies used elsewhere. It is also important to note that controversies have rarely arisen around exhibitions in some countries, and to consider some of the reasons why.[24] In the end museum controversies are not wholly predictable, as we argued in *Museums and Communities*, but always are shaped and set off by the very same relations with civil society and communities that museums rely on. However, a significant difference that has emerged in the years since the publication of *Museums and Communities* has been the development of media and communication technologies that have enabled widely dispersed communities to organize and lobby museums.

The 2001 controversy over the Virgin of Guadalupe image by artist Alma Lopez relied on the Internet to help galvanize a far-flung network of conservative activists, just as the curator of the "Cyber Arte" exhibition herself used the Internet extensively in organizing the show.[25] New media have gained far greater prominence in the museum and heritage sector in the past fifteen years, incorporated in many ways. Increasingly powerful Web-based design and digital imaging capabilities have combined with growing popular usage of electronic media in many parts of the world to spur the range and extent of their use. They have become an increasingly common part of exhibition design and changed the ways that contextual information and explanation are provided for visitors. Many museums, cultural centers, and heritage organizations have launched digital projects as part of their collections management, making information about their collections more widely accessible, and Web promotion has become an integral part of marketing plans and outreach. The growing integration of new media into museum and heritage practice has resulted in a certain democratization of access, with collections and exhibitions available in virtual form in homes, schools, and elsewhere, and it has provided the basis for cooperative ventures among institutions. Yet it simultaneously creates new barriers defined by digital divides both within and among countries. Only wealthy

institutions can afford the initial investment and extensive upkeep such endeavors often require, for instance, and only some people in some parts of the world can readily access them.

Over the past fifteen years, virtually all museums and heritage institutions, new and old alike, have grappled with financial issues and with continuing debates about how to combine and balance education and entertainment in exhibitions and programs. These concerns come together quite pointedly as institutions seek to tap burgeoning tourism industries. Indeed, the museum and heritage sector has been undergoing significant restructuring that brings business concerns and greater emphasis on visitor volume clearly to the fore. This has repercussions for management structures, staff organization, exhibitions, marketing, community relations, and far more. As Derina McLaughlin put it, "The new museology has resulted in the convergence of museums, the heritage industry, tourism, profit-making and pleasure-giving."[26] This is not a new process in museums. Neil Harris documented the competing relationship between museums and department stores in the United States in the 1930s, and Corinne Kratz and Ivan Karp have examined the authorizing role that museums play as part of Walt Disney World (see also Hall's essay in this volume).[27]

As business models, branding, and bottom line issues gained greater prominence, some specialized and small organizations have been forced to close, ranging from the Musée de Terra Amata in France (1996) to the Daventry Museum in England and the Graves Museum, the Heartland Orthodox Christian Museum, and Chicago's Terra Museum of American Art in the United States (all 2004). Some were casualties of fiscal and management problems, but others closed to make way for real estate development or due to lack of interest and support.[28] While museum and heritage professionals and institutions everywhere grappled with funding shifts, the specific mix of funding and sources of support available and the nature of those shifts varied considerably across the globe and across institutions — the full range of sources might include governmental bodies, foundations, private donors, corporate funders, public-private partnerships, and income-generating enterprises such as entry fees, shops, restaurants, and IMAX theaters.

These differences, as they related to place and institution, were a recurrent topic in the preliminary workshop we organized in Buenos Aires. Participants particularly noted weak (or nonexistent) traditions of philanthropic support in a number of countries and saw a trend in Latin American museums toward privatization, a change they characterized as moving from a European model of support to an American one.[29] Speaking of the Museo del Barro in Paraguay, Ticio Escobar commented that the museum receives a lot of international support, but since it is not supported by the state, it is constantly struggling to

identify funders and to support itself. During our next-generation workshop, which followed the conference for the volume, Veerle Poupeye asked a more general question: what difference does it make when museums are highly dependent on external funding and international support and revenue? This can also be extended: how do financial relations work with and against the possible range of relations among museums and communities, and with and against models of museums as places that can mobilize and galvanize as well as educate and entertain? This is a substantial question, one that addresses the effects and influences of international funders and organizations, which have had major influences on "third-world" museums especially. The Scandinavian countries have been major actors in this field, and the ecomuseum model that is so important in Scandinavia has been influential elsewhere in Europe and in places such as Vietnam and South Africa.[30] The International Council on Museums (ICOM), International Centre for Study of the Preservation and Restoration of Cultural Property (ICCROM), Swedish International Development Cooperation Agency (SIDA), and Swedish-African Museum Programme (SAMP) have been among the most important sustaining organizations for African museums, yet no one has considered the effects, both positive and negative, of these organizations on the work of museums and the orientation of museum professionals in different parts of the world.[31]

These organizational shifts and economic concerns were at times an integral part of simultaneous developments that saw new cross-national and global linkages within the museum and heritage sphere. The Guggenheim Museum's international expansion after 1990 presents one such paradigm, now self-described as "a worldwide network of museums and cultural partnerships" with branches in New York (opened 1939), Venice (1951), Bilbao (1997; see Fraser, this volume), Berlin (1997), Las Vegas (opened September 2001, closed January 2003; see Hall, this volume), and plans discussed at various times for Taiwan, Brazil, Singapore, Hong Kong, and Guadalajara.[32] Also established were a number of innovative collaborations and networks linking institutions in different parts of the world for a range of purposes. A few examples that have sought to unite far-flung museums around common issues and to foster information sharing and research on collections include the International Coalition of Historic Site Museums of Conscience; the Relational Museum project, based at the Pitt Rivers Museum in Oxford, England; and the Indigenous Collections and Knowledge Archives Research Network, launched in Australia in 2003.

The International Coalition of Historic Site Museums of Conscience, begun in 1999, joins together museums that present and interpret "a wide variety of historic issues, events and people . . . to assist the public in drawing connections between the history of [these] site[s] and its contemporary implica-

tions." The coalition currently includes museums in Bangladesh, South Africa, Senegal, Argentina, England, the United States, Russia, and the Czech Republic. The Pitt Rivers Museum's Relational Museum project (2002–2005) examines the history of its collection and of relations with communities in different parts of the world from which objects came, and establishes collaborative links with related institutions in the United Kingdom and Europe. A related project, the Indigenous Collections and Knowledge Archives Research Network (known as IDIG for short) seeks to broaden the purview of such collaboration to include the "full range of Indigenous collections and knowledge archives, covering ethnographic, anthropological, historical, linguistic and fine art collections; and sound, film, photographic and print materials." Beginning with the Australia-Pacific region, IDIG hopes to expand its linkages to institutions and colleagues in Europe, the United States, and elsewhere.[33] In addition to such formal institutional linkages, the past fifteen years saw a wide array of short-term international collaborations on specific exhibitions and projects and the international circulation of museum professionals. Many of the new national museums, for instance, relied on consultants and design companies from around the globe (see Morphy, this volume).

International cooperation and exchange among museums is not new, of course, particularly in matters related to collections. International coordinating bodies have also been in existence for decades, such as the two major nongovernmental bodies that advise UNESCO on museum and heritage issues and policy—the International Council of Museums (ICOM), created in 1946, and the International Council on Monuments and Sites (ICOMOS), founded in 1965 and having over a hundred national committees today.[34] But the extent and current range of such initiatives and integration, their particular forms, and the degree to which they are publicly presented as distinctive and forward-looking are important components of a configuration that has been taking shape in the museum and heritage sector in the past fifteen years or so. And with tourism as a continuing frontier of growth and rapidly expanding heritage sectors, attention to heritage policies and politics by transnational organizations such as UNESCO has also heightened and expanded in recent decades, along with contests and frictions over legal issues related to cultural and intellectual property rights (see Kirshenblatt-Gimblett, "World Heritage and Cultural Economics" in this volume).[35]

This section has sketched in broad outline many developments and shifts that seemed to define the global museum and heritage landscape as our project began and developed. Some are more centrally connected with globalizing processes than others, while others are more strongly influenced and mediated through local and national concerns. Yet the interrelations and articula-

tions among these various processes and shifts have together helped shape the ways that museum and heritage practitioners and organizations are being re-imagined in a context of emphatic international and global connections. The essays collected in this book evoke more particular inflections of these processes and examine cases that show how they play out in specific settings and circumstances.

THE BOOK

Museum Frictions offers a series of accounts and analyses of contemporary museum and heritage practice. Together the essays present not a panorama but a prismatic view — one in which perspectives are located in a diverse range of positions, places, and institutions and at different organizational levels, from macro to mezzo to micro. This is only appropriate, as museological processes involve an array of actors, perspectives, and interests, and globalizing processes themselves affect different sectors, institutions, and localities differently. Such perspectival shifts are essential to convey the variability and complexity of intersections among museological and globalizing processes, and the frictions they provoke. Though wide-ranging, *Museum Frictions* is not intended to be comprehensive or encyclopedic, and it carries traces of the project and contingencies through which it was produced, resulting in both concentrations and lacunae that were not entirely intentional. These patterns have to do with geographical representation and with the kinds of institutions and aspects of museum and heritage practice that are considered.

While the workshops and conference that led to this book emphasized Latin America and Africa regionally, *Museum Frictions* includes cases, examples, and authors based in every continent of the world but Antarctica. A single book can sample such a vast area only very selectively, but including clusters of two or three related papers provides a way to glimpse different facets of museum and heritage practice in the same country and to consider museological processes from different vantages within linked locations. At the risk of neglecting other important examples, then, we included three papers that focus on South Africa (Witz, Rassool, Bunn), two that consider Australian exhibitions (Morphy, Myers), and two in which museum displays on the history of slavery are central (Ruffins, Kreamer). These papers were initially chosen for the analytical insights each provides and the cases each describes. Yet in addition, the different concerns they raise and the resulting clusters illustrate specific issues from a number of points of entry, ranging from how museums confront transformation in a single society to the transnational nature of problems of representation, intercultural translation, and the production of different

values. They may be read to show far-reaching connections that can be diagnostic of globalizing museological processes and the entanglements, contradictions, and opportunities that arise as these are localized across a range of sites, scales, and articulations—identifying particular frictions involved with Australian exhibitions located in Canberra and New York, with slavery displays in the United States and Ghana, and with international bodies, finance, and tourism providing parameters for heritage institutions in South Africa (and elsewhere).

The three South African essays appear in different sections of the book, in conversation there with other essays on the basis of common themes and concerns. However, they can also be profitably read together to gain an understanding of the complex currents and dynamics of South African public cultures during a remarkable and consequential period of transformation, still ongoing, that stretches from 1990, the year Nelson Mandela was released from prison, through the country's first democratic elections in 1994 and the recent celebrations and stocktakings occasioned in 2004 by their ten-year anniversary. Museums and heritage resources have been vital in shaping, interpreting, and contributing to transformations in public culture in South Africa over the past fifteen years, caught up in intricate interplays between forceful national (and regional) imperatives, local interests, and globalizing processes.

The papers here provide a taste of these dynamics as well as a sketch of the history and array of settings involved, including established national museums, thriving and struggling community museums, national heritage policies, a landscape full of memorials, transfrontier parks, and places such as the Gold Reef City theme park and casino in Johannesburg (mentioned in Hall's essay in the first section). Just as these geographically related essays can be read together across sections, so too intriguing connections (and frictions) might also arise from other juxtapositions across sections (e.g., Fraser and Morphy on the creative and subversive potentials of performance in museum settings; Bunn and Kirshenblatt-Gimblett on the politics of tangible and intangible heritage). Because they treat nations with colonial histories as settler societies, the South African and Australian essays also provide a cluster of papers with potential comparative interest. It would be well worth developing analyses that consider contemporary globalizing processes in museum and heritage domains in relation to continuing sedimentations from earlier globalizing processes such as different colonial systems and empires. Gustavo Buntinx's notion of marginal occidentality, developed in his paper on Peru in this volume, would have broader relevance in such a study as well.

The cases and examples in *Museum Frictions* include national museums and a wide array of community museums, historic sites, heritage landscapes,

and theme parks. Major metropolitan and urban museums are included, but they are only one kind of setting considered; smaller institutions have a more prominent place, which is appropriate in a volume that seeks to have something of a global reach. The institutional and geographic range of the essays here has the effect of decentering the metropolitan and European/North American foci that often seem to dominate writing about museums. The two earlier books in this series, *Exhibiting Cultures* and *Museums and Communities*, had a similar institutional range and included essays about Japan, Zimbabwe, India, and elsewhere, but they had a preponderance of North American and European examples. Including a broad comparative range of examples can make salient concerns that are distinctive to different settings, the varied dimensions of common issues, and the complex interactions and frictions involved as global and museum-based processes intersect.

Two important aspects of museum and heritage practice are addressed here only in passing, despite discussion of them at the workshops and conference and efforts both to include essays in which they are central and to encourage authors to consider them. Museum education programs create interfaces with a range of visitors and constituencies, who interpret museum exhibitions, projects, and the institutions themselves. Fred Myers's paper in this volume shows how productive a careful consideration of museum programs—in his case a public symposium—can be. Yet, oddly, such programs receive little sustained attention in the literature of the new museology. Similarly, the diverse expectations and experiences of those who visit museum and heritage venues —visitors and audiences—are not as much in evidence as we wanted them to be. More analytical emphasis is devoted to production than to consumption and the kinds of interpretive movement that take place as people connect their own experience and concerns with exhibitions, collections, memorials, and so forth.[36]

Again, this is a limitation that our book seems to share with other literature on museum and heritage practice. After tracing different phases in the history of visitor studies in the United States, Neil Harris concluded in 1990 that "[t]he museum visit may well be . . . a continually revised set of transactions between exhibitor and visitor, with constant renegotiations of meaning and value. . . . But the impact or the intensity of [museum experience] . . . remains, perversely enough, mysterious."[37] With the turn to reception studies in media and literature, visitor experience has been receiving more careful examination in recent years.[38] In workshop and conference discussions, we underlined the importance of taking account of differences and variations among visitors, how they understand museums, exhibitions, and heritage resources, and what they do with them. With the increasing emphasis on raising visitor num-

bers, questions were also brought up about what constitutes a critical mass, how much is enough, and who is most concerned with attendance figures and visitor studies.[39]

Museum Frictions is divided into three sections: "Exhibitionary Complexes," "Tactical Museologies," and "Remapping the Museum." In each section short pieces that we call "Documents" are interspersed with full-length essays. The Documents offer striking examples from current worlds of museum and heritage practice and interesting cases from other parts of the globe, as well as a change of pace within the book. They illuminate issues raised in the longer essays from a different angle, and often elaborate papers with which they are juxtaposed or sharpen the frictions to which they point. Documents might be short excerpts from other works or statements drawn from actual situations; they might reproduce news articles or be brief pieces written specifically for this volume.

Each section begins with an introduction and is also described briefly below, but four crosscutting themes and concerns are also worth noting. First, all three sections are informed by a concern with the ways that museum and heritage institutions are defined and how their premises, principles, and workings relate to one another and to other institutions of public culture. While this is particularly foregrounded in the title of the first section, "Exhibitionary Complexes," authors throughout the book embed their descriptions and analyses within broader relations of cultural production. This is critical to understanding the pervasive and varied effects of globalizing processes and how different topics, places, and people articulate across public cultures.

The prismatic view mentioned earlier extends throughout the book as well. This is not simply an artifact of reading different essays together but also characteristic of individual essays in each section. The involvement of more than one perspective is part and parcel of museum frictions, and many authors here move across different sites and scales and among different vantages as they consider their material. Furthermore, essays throughout the volume seek to historicize the cases and situations under discussion, an integral part of the emphasis here on social, cultural, and political *processes*, both museological and global. Yet this is not just a matter of filling in facts of historical context, for the cross perspectives produce intriguing critical and ironic historiographies, as found in Ingrid Muan's "musings" from Phnom Penh, Andrea Fraser on the Guggenheim Bilbao, David Bunn's paper on Kruger National Park, Gustavo Buntinx on Peru's museum void, Fath Ruffins on museumizing the history of slavery, and others.

The collection of authors itself constitutes the final feature we want to note. Our workshop and conference discussions identified a telling shift since the

two earlier books were produced: that notions of community and community museum have become ever more complicated. This can be seen particularly in the essays of the "Tactical Museologies" section, but it is also evident in the ways that the volume's authors participate in a number of activities often taken to be separate. A substantial number of authors combine the roles of scholar, practitioner, and activist in various ways and blur assumed divisions among the museum, the academy, and engaged social action. Such combinations are more common among authors here than in the earlier volumes, and this may be partly due to the fact that a substantial number of the essays were written by scholar/activists in so-called third-world countries. Hence a number of essays are—or could have been—written in the first person, about projects and institutions with which the authors have been significantly involved. As a result, the essays often have a reflexive and self-critically engaged stance. Striking a balance between critical assessment and testimonial chronicle is both difficult and complex and produces its own tensions and frictions in the writing itself. But accounts that proceed, in part, from interventions and mediations made by the authors themselves—as practitioner-scholar-activists—in transacting meanings and value into different public spheres may also be keenly sensitive to the different locations involved in the production of knowledge and to different modes of knowledge.

A few examples can illustrate such conjunctions and overlapping engagements. Artist Andrea Fraser melds tough political economic analysis and sociological theory with evocative public performance in her work, represented here in the form of a museum tour commentary. As anthropologists, Howard Morphy and Fred Myers have both worked in Australia with Indigenous communities over several decades as advocates in mediating and facilitating translations of artworks, cultural landscapes, audiences, and meanings in the world of the museum and the art market. Leslie Witz is a university-based historian with research interests in public history who has curated several exhibitions in recent years and participated in antiapartheid activities in South Africa before 1990. Fath Davis Ruffins, as a researcher and scholar at the Smithsonian Institution, has been at the forefront of debates about the museumization of African American history since the early 1980s and most recently has prepared research and exhibition plans for the creation of the National Underground Railroad Freedom Center in Cincinnati. Finally, Ingrid Muan's work with the Reyum Institute of Arts and Culture in Phnom Penh brings together her background in art history, gallery exhibitions, and the wrenching memories and silences in Cambodian public culture. Similar conjunctions of public scholarship, museum and heritage practice, and social and academic engagement could be described for other authors as well.

These features and concerns thread through the entire book, along with analyses that consider how both structural/institutional dynamics and social actors and agencies shape and take shape through museological processes and museum frictions. Museological processes are characteristic of, but not necessarily unique to, museum and heritage settings. When found outside such contexts, they seem simultaneously to evoke museums and to decenter them. Yet values, memories, identities, and histories are produced in ways that range across these sites through various forms of cultural display, collection practices, and the very creation of museums and related settings and institutions.[40] With the entanglement of museum and heritage practice in globalizing currents, the reach and compass of museum-based processes may also alter, just as the notion and shape of the museum itself transform in different settings and institutional configurations. In workshop and conference discussions during this project, these phenomena generated a persistent conundrum having to do with how the "local" relates to different scales—global, regional, national, and transnational—in museum and heritage practice.[41]

Transported and taken up in places around the globe, the museum is at once transformed in these diverse settings and simultaneously transforming of local understandings through its transnational notions of professional practice and heritage values, its status as an indicator of national or regional identities, and so forth. Yet professional and public cultural debates outside Europe and North America often raise questions about the existence of appropriate "museum cultures" and articulate an urgent quest for museums and exhibits in a "local idiom," whether this yearning is expressed by museum professionals in Jamaica or elsewhere in the Caribbean, in South Africa, in Indonesia, or in the goal of having "a museum for all Australia." This impulse seems to have several sources, including (1) a genuine concern to address local audiences and constituencies in appropriate and understandable ways, (2) nationalist understandings of distinctive identities, defined vis-à-vis other nations, and (3) insatiable global markets for identity and authenticity, for tourist dollars are often a concern as well. The tension inherent in defining the local in part through transnational and global notions and values and the dialectic this sets in motion are at the heart of this conundrum.

But what does this mean? What would a "Caribbean" or "South African" idiom or an "Australian museum" look like? How would one recognize it? Does it have to do with topics or themes addressed? Are there signs of national culture or indigeneity in a formal or design sense? Would it be related to differences in social practice, organizational plan, or the particular economic circumstances in which it operates? Most likely the answer would be all of the above, in various ways, but this is something to be articulated more specifi-

cally. In talking about this at the next-generation workshop, Veerle Poupeye (who has worked in Caribbean museum settings for over a decade) observed that the "local idiom" question raises other issues. If one looks to local display styles (e.g., street art displays) to create a local idiom, one must ask whose idiom is adopted, since there will be more than one. Similarly, popular cultural styles can change quickly. If one is selected for development, it may in the end enshrine a nostalgic or dated idiom.[42] A local idiom has to do with aesthetics, with synesthesia, and with structures of feeling, and can be vexingly elusive and hard to define. This is but one example of the issues and debates that arise as museological processes and globalizing processes intersect. Essays in the book's three sections discuss many more.

The first section, "Exhibitionary Complexes," takes as its starting point Tony Bennett's concept of the exhibitionary complex, a notion that informs essays throughout the book in various ways. While Bennett formulated the concept in relation to a particular time and place, it has become the basis of a more general framework that examines the museum within an array of related cultural institutions and as a means of governmentality through which values and notions of citizenship and publics are inculcated, imposed, and portrayed through exhibition design and behavioral habits as well as exhibition topics and themes. Essays in this section seek to reexamine and update the concept for a time that is roughly a century after the period in relation to which Bennett first developed it, with different sorts of globalizing processes at work, and for locales beyond his original European and North American focus.[43] What this implies first of all is that the concept has to be pluralized. We are speaking here of a variety of complexes that have to be specified and mapped. Relationships between museums and other forms of leisure and entertainment are profoundly altered by changes in and the emergence of forms of governance, by technologies, by social, political, and cultural tasks undertaken by display institutions, and by options and constraints that emerge out of the changing global environment. These broader processes open up some of the terms that were originally considered by Bennett, notably how the constitution of subjects operates in changing exhibitionary complexes and how citizenship is addressed when the appeal to and concern with audience either changes internally in a nation or is addressed beyond the nation. What happens when forms of community draw on and imagine themselves to be part of a non-national public culture?

Authors in this section try out a variety of alternative terms that emphasize different aspects of these processes, including shifts in the relations among cultural institutions, exhibition technologies, the nature of visitor expectations, and ideas about audiences and publics. Apart from "exhibition-

ary complex," then, Martin Hall proposes "experiential complex," Barbara Kirshenblatt-Gimblett talks about an "expositionary complex" in the section's introduction, and Tony Bennett examines what he calls "dialogism" as a paradigm in contemporary museum practice, related in part to various concerns with multiculturalism.[44] It is also fruitful to think about how analytical perspectives are shaped by the priority that the notion of "exhibitionary complex" seems to place on exhibitions, which are only one aspect of museum and heritage work. Other authors offer careful explorations of workings within a particular exhibitionary complex, whether the Guggenheim Bilbao, as in Andrea Fraser's essay, or Leslie Witz's discussion of a range of postapartheid South African museums. The section's two Documents spotlight issues, representations, and rhetorics in play in the heritage boom as well as in monuments, museums, and art that address the historical meaning of nuclear nationalism in the United States, with pieces on the "U.S. Department of Retro" from the farcical New York–based newspaper *The Onion* and on commemorations at the Trinity Test Site in New Mexico.

The second section, "Tactical Museologies," considers the relationships between museums and different actors as they adapt to and use complex environments of the sort discussed in the first section. Working from multiple vantage points, essays in this section provide different ways of thinking about museum and heritage practice. They treat the museum as an institution whose value lies in the way it can be made to serve different constituencies, a task that entails reflection and theorizing. The museum is seen as a specific kind of framing that can be mobilized for good or ill, not something to be given a fixed definition. Exhibitions and the museum are treated as a technology of space, time, and representation. While museums often provide a place apart or a time-out, these essays show how they are also clearly connected to contests beyond their own spaces, a means of engagement and tactical maneuver. They may be engaged in tactics vis-à-vis the metropole, class-based inequalities, public culture representations, or other kinds of contests. The notion of tactical museology instantly grounds issues — whose tactics, vis-à-vis what issues? Essays in this section show these different facets and the range of issues that come together in sometimes contradictory or ironic ways. In doing so, the casts of people involved and the variety of their positions and relations come particularly to the fore. The essays likewise show how different senses of community are produced in a variety of ways.

Each essay in this section presents a case study that draws on and, to greater or lesser degree, alters the definition of the museum — or at least pushes it in directions that are not easily read from the standard history of European or American museums (as in the Cambodian and South African cases discussed

by Ingrid Muan and Ciraj Rassool). In each case global processes and international linkages become resources on which local institutions and actors draw (in Cuauhtémoc Camarena and Teresa Morales's essay on Mexican museums, among others) or which they resist (as Gustavo Buntinx describes in Lima). Other examples could be added in which these transformations and reformulations are signaled by debates about the very name to be used, with different terms suggesting different associations, charters, and positions within communities — whether it be museum, gallery, cultural center, project, or "keeping place" (as in some Australian instances). One of the most important conclusions that can be drawn from this section, and that the essays demonstrate, is that the relationship between museums and, for example, communities cannot be read simply from the changing nature of global relations as they encompass the local. Historical and contextual aspects remain fundamental to understanding how museums operate and their tactical significance and potential.

There is a tactical sense in all museums and institutions, but this set of essays deals particularly with cases of new museums, often smaller museums, that have a self-conscious sense of shaping and reshaping themselves and that often work from marginal positions in relation to the government, other state institutions, and the metropole. They show what a fundamental place of theoretical articulation that can be. Yet they also manifest profoundly vulnerable moments and the tensions of institutionalization and professionalization — a certain security and continuity are needed to sustain a critical stance in public forms. The Documents in this section represent museums from both ends of the scale: the "Declaration on the Importance and Value of Universal Museums" issued in December 2002 and signed by eighteen directors of European and North American art museums, the statement "Art Museums and the International Exchange of Cultural Artifacts" issued by the Association of Art Museum Directors around the same time, and "Some Words from the Director" of Museo Salinas, a museum founded in 1996 in the bathroom of artist Vicente Razo in Mexico City. All are instances of tactical museologies. The first is a thinly veiled intervention in international debates about repatriation, the second addresses the smuggling and looting of art and heritage from a similarly authoritative stance, and the third contains a bold commentary on Mexican government at the time and on the potential of museums themselves. When we selected these Documents, we wondered whether Razo's statement might be the start of a counterdeclaration on nonuniversal museums.

In the third section, "Remapping the Museum," essays examine how the concept and practice of the museum are affected by extramuseum contexts, and also the converse: how other contexts, interests, and normative institutions are affected by the museum and museological practice. Global processes

are once again an organizing but not determining factor. In this section essays consider the meaning of placing objects or people in a museum space, or how spaces external to museums draw their legitimacy from museums. These processes are complicated by factors that include law and regulations related to heritage and the definition of objects, or how the history of ideas associated with one museum or heritage form becomes a means to realize institutional and community goals in another context. Each case shows how these actions and contexts are complex, are not necessarily contiguous, and cross conventional definitions of institutions and place, as likely to reinforce institutional definitions as to challenge them.

These papers are also very much about differences of power and authority and how these are mediated across institutional locations, for the zones of engagement central to these essays stretch beyond the museum. The translations, disjunctures, and displacements this entails are simultaneously processes of value creation that operate across contexts. David Bunn's discussion of the contradictory and many-layered meanings of landscape management in South Africa finds a counterpart in the recent repatriation of lions from Baghdad to South Africa reported in one of the Documents here. The Junkanoo Museum, described in the section's other Document, poses interesting questions of revaluation and collection practice. Based on an annual festival in the Bahamas, the museum intercedes to collect, display, and thereby revalue abandoned costumes, only to destroy them a year later. Fred Myers's paper notes that he felt himself displaced in a New York museum symposium with Aboriginal Australian artists. Part of his discomfort might have arisen from being enmeshed in the very kinds of mediation and transformation associated with the metacultural operations of reproducing and explaining intangible heritage, as discussed by Kirshenblatt-Gimblett in the first section. These issues are prominent as well in essays by Howard Morphy on performance as a mode of cross-cultural engagement and exhibition, Christine Kreamer on exhibitions in Ghana's Cape Coast Castle Museum, and Fath Davis Ruffins on exhibitions about slavery in the United States. As they tack among different perspectives, the essays in this section also incorporate a range of historical scales and dimensions.

Taken together, the essays in *Museum Frictions* convey a multifaceted sense of museum and heritage practice and institutions today and their complex engagements and roles in the production of public cultures. They offer serious consideration of an array of issues that emerge when museum-based processes and globalizing processes come together. By examining carefully located cases in settings and circumstances around the globe, the essays show how such conjunctions have become increasingly central to the practice of museums of vari-

ous kinds and to related cultural institutions. Global transformations involve institutional articulations across a range of scales along with flows of knowledge, people, capital, objects, and more. It is important to recognize, however, that such transformations, articulations, and flows reconfigure the museum and heritage landscape in ways that are uneven. New possibilities and synergies that may emerge are inevitably accompanied by tensions and contradictions, neglect, and failure. The challenge is to recognize and embrace museum frictions with all their potential and their risk, and to find ways to work with them so as not simply to survive but to flourish.

NOTES

1 This quote is from Coles, "Interview with James Clifford." The 1997 essay is in Clifford's book *Routes: Travel and Translations in the Late Twentieth Century*. He takes the notion of "contact zones" from Mary Louise Pratt's book *Imperial Eyes*, while she in turn borrowed and adapted the concept from linguistics and the study of pidgin and creole languages.

2 See Cameron's influential essay "The Museum: A Temple or the Forum" and the development of this idea into the concept of exhibits as "contested terrains" in Karp and Lavine, "Museums and Multiculturalism."

3 In this sense these essays develop the themes of the previous volume in the series, *Museums and Communities: The Politics of Public Culture*, which tended to focus primarily on social processes in museums but recognized that members of museum audiences and museum professionals alike brought complex, multifaceted, and often conflicting identities to the museum setting.

4 While our manuscript was in final preparation, a new book appeared that uses the metaphorical image of friction to consider global interconnections among business interests, environmental action groups, and empowerment projects in Indonesia during the late 1980s and 1990s and the role that universals play in these interactions. See Tsing, *Friction*. Though Tsing's case study focuses on a domain other than museums, heritage sites, and related cultural organizations, many of her assumptions and ways of approaching global interconnections are in harmony with those in this volume.

5 Compare Bennett's discussion of past-present alignments and realignments, using a notion drawn from Patrick Wright, in "Out of Which Past?" 147–48.

6 Nederveen Pieterse talks about recent developments as one of a series of periods of "accelerated globalization," where what have been more gradual and ongoing processes in global communication, technology, and political relations seem to intensify through a series of changes and developments. See Pieterse's "Multiculturalism and Museums," 131.

7 Pieterse, "Globalization North and South," 129.

8 Shelton, "Museums in an Age of Cultural Hybridity," 233–34.

9 Appadurai's formulation for looking at disjunctures and relations among cultural flows in terms of a series of "scapes" has been influential. He identifies five dimensions

of global cultural flows: ethnoscapes, mediascapes, technoscapes, financescapes, and ideoscapes. Originally published in 1990, his article "Disjuncture and Difference in the Global Cultural Economy" has been republished several times. and collected in his own book *Modernity at Large*. More recently, Appadurai has characterized globalization simply as "a cover term for a world of disjunctive flows." See "Grassroots Globalization," 6. Based on an Indonesian case study, Tsing's description in *Friction* of global connections introduces essential qualifications to this formulation, emphasizing the frictions, transience, instability, and conjunctural qualities that are often central in the social and cultural processes involved.

10 During, "Popular Culture on a Global Scale," 825.

11 Nederveen Pieterse notes that different modes of articulation with specific historical and geographical circumstances affect the character of multiple modernities and capitalisms, but the point can readily be extended beyond these parameters. "Globalization North and South," 134.

12 Davis, "A Question of Ownership." Tomás Ybarra-Frausto drew our attention to debates about San Diego's Centro Cultural de la Raza and the Save Our Centro Coalition. In addition to the summary in the Davis article, see http://www.centroraza.com/about .htm and http://www.calacapress.com/centrowatch/about.html (accessed July 25, 2004).

13 On El Museo del Barrio, see Morales, "Spanish Harlem on His Mind" and Dávila, "Latinizing Culture." Yasmin Ramirez also talked about the debates concerning El Museo del Barrio at the next-generation workshop that we organized in November 2002 (see the preface to this volume).

14 This global reach and identity is also presented in exhibitions at the World of Coca-Cola in the corporation's home city of Atlanta, Georgia.

15 See, for example, Stanley, *Being Ourselves for You*; Volkman, "Visions and Revisions"; and Witz, Rassool, and Minkley, "The Boer War, Museums and Ratanga Junction."

16 Bennett, "Out of Which Past?"

17 This powerful exhibition began as a grassroots effort in a storefront in the SoHo neighborhood of New York City, near ground zero, eventually gathering over five thousand images from professional and amateur photographers. All were displayed simply hung from wires, without captions or attribution. The exhibition eventually traveled to Switzerland, Ireland, England, Japan, France, eleven other venues in the United States, and four in Germany. A nonprofit organization with the same name was also established, selling the prints for $25 each to raise funds for the Children's Aid Society WTC Relief Fund. The project created an ongoing Web site and later developed a video and oral history project called "Voices of 9.11." The exhibition is now available in book form as well: George et al., *Here Is New York*. See also http://hereisnewyork.org (accessed August 1, 2004).

18 See http://www.aza.org/Publications/2004/04/April04KabulZoo.pdf (accessed March 26, 2006). The plight of the Kabul Zoo and its animals was publicized in 2001–2002 particularly through stories about Marjan, an aged lion that had been a gift from Germany in 1979. See also the Document on repatriating lions from Baghdad included in the "Remapping the Museum" section of this book; BBC, "Lion of Kabul Roars

His Last," January 26, 2002, http://news.bbc.co.uk/2/hi/south_asia/1783910.stm; National Geographic News, "Conditions Improving at Kabul Zoo," June 10, 2002, http://news.nationalgeographic.com/news/2002/06/0610_020610_kabulzoo.html; and http://www.nczoo.com/News/20050908154106238 (all sites accessed August 1, 2004 and March 26, 2006).

19 A few examples of how the political climate in the United States has affected exhibitions and artists in many communities: the longtime director of the Southeast Museum of Photography at Daytona Beach Community College quit in December 2001 after being told to cancel an exhibition on Afghanistan; an annual prize given by California's Redwood Art Association was withdrawn in December 2003 because of the artwork's depiction of George W. Bush; and early in 2004 a painting by Los Angeles artist Victoria Delgadillo, part of a tapestry called "Eye-Speak" at the Los Angeles airport's international terminal, became the center of debate for its depiction of nudity and the twin towers collapsing on 9/11. See Stewart and Brownfield, "DBCC Museum Director Claims Censorship," and other articles and commentary that followed, available in the *Daytona Beach News-Journal*'s online archives; Ridgeway, "Bush-League Censorship"; Victoria Delgadillo, "Censorship at LAX," http://www.latinola .com/story.php?story=1578; and Oldham, "Art Work Spurs Flap." Other examples are noted in Max Blumenthal, "Political Art Is Dangerous Again" (http://maxblumenthal .blogspot.com/2004/06/political-art-is-dangerous-again.html) and in the project "9–11 New Adventures in Censorship (New Meanings for Old Work)," announced on the Web site of the Artists Network of Refuse and Resist, http://www.artistsnetwork.org/ news3/news145.html (accessed August 1, 2004).

20 For some figures on this rate of growth, see Kirshenblatt-Gimblett, "Museums, World Heritage and Cultural Economics," 4, and Kreps, *Liberating Culture*, 20–22.

21 *Museums and Communities* and *Exhibiting Cultures* dealt specifically with such concerns; these shifts and their implications have continued to develop in the 1990s and into the new millennium.

22 For instance, "Egyptian Art in the Age of the Pyramids" was organized by the Royal Ontario Museum (Toronto), the Metropolitan Museum of Art (New York), and the Réunion des Musées Nationaux (Paris). Blockbusters shown in Australia include "Gold and Civilisation" (2001; the first in the new National Museum's blockbuster program), "Chinese Dinosaurs" (2002), "Caravaggio" (2004), "The Edwardians: Secrets and Desires" (2004), and "The Impressionists: Masterpieces from the Musée d'Orsay" (2004), while the United Kingdom has had "Titian" (2002), "Armada" (2003), and more.

23 See Griffin, "Global Tendencies" for an interesting roundtable discussion on global exhibitions in contemporary art.

24 A series of such controversies were examined in a workshop called "Cultural Battlefields: The Changing Shape of Controversy in Exhibition and Performance," organized by the Center for the Study of Public Scholarship at Emory University in March 2002. Several recent books examine particular exhibition controversies and related issues in the politics of representation, though most attention so far has been paid to controversies in the United States (even in relation to the "Sensation" exhibition,

which generated conflicts in a number of countries). See Harwit, *An Exhibit Denied*; Henderson and Kaeppler, *Exhibiting Dilemmas*; MacDonald, *The Politics of Display*; Dubin, *Displays of Power*; Butler, *Contested Representations*; Rothfield, *Unsettling "Sensation"*; Kratz, *The Ones That Are Wanted*; and Luke, *Museum Politics*.

25 Ice, "Invoking Community."

26 McLaughlin is an exhibition coordinator and manager in Australia. See Derina McLaughlin, "Is the Development and Touring of the Blockbuster Exhibition in Australian Museums and Science Centres a Long-term Strategy?" (1998). This is a shorter version of a paper presented at the National Museum Australia Conference in September 1997, and can be found at http://www.astenetwork.net/issues/blockbuster_phenomenon.html (accessed August 1, 2004).

27 Neil Harris, "Museums, Merchandising and Public Taste: The Struggle for Influence"; Corinne Kratz and Ivan Karp, "Wonder and Worth."

28 These issues were the focus of a workshop called "High Expectations, but Low Funding: How Do Poor Museums Meet Their Targets?" organized in Lusaka and Livingstone, Zambia, in 2002 by the National Museums Board of Zambia and one of ICOM's international committees. A private folk art museum in Shanghai, for instance, was closed to make way for a road and development, while the Seagram Museum in Waterloo, Canada, was closed in 1997 to make way for a multiplex movie theater. The Latin American Art Museum (LAAM) in Florida "closed its doors on June 30, 2004 because of lack of support and building problems." The Terra Museum of American Art closed in October 2004 after "failure to draw crowds even after effectively eliminating its admission charge a few years" earlier. Even the Guggenheim had to retrench after its rapid expansion. See a description and papers from the Zambian workshop at http://museumsnett.no/icme/icme2002/; Xinhua News Agency, "First Shanghai Private Art Museum Closed," http://www.china.org.cn/english/culture/69823.htm (accessed August 1, 2004); Nunn and Jalsevac, "Museum Closed, Converted into Cineplex"; the LAAM Web site, www.latinartmuseum.org; Bernstein, "A Museum in Chicago Is Closing Its Doors"; and Kimmelman, "An Era Ends for the Guggenheim."

29 These points were made by Marcelo Pacheco, Maria José Herrera, and Charlotte Elias, among others.

30 For instance, a new ecomuseum was launched in Vietnam in 2003 at the UNESCO World Heritage Site of Ha Long Bay with Norwegian support.

31 ICCROM's work in Africa has included the Prevention in Museums in Africa program (PREMA), 1996–2000, and its current Africa 2009 program, started in 1998 and focused on the conservation of immovable cultural heritage in sub-Saharan Africa. The West African Museums Programme, started in 1982, also serves as an intermediary in securing small grants from SIDA and the Ford Foundation for museums and cultural organizations in the region, in addition to organizing conferences and training programs.

32 See http://www.guggenheim.org (accessed August 11, 2004) and Vogel, "Despite Criticisms."

33 See http://www.sitesofconscience.org; http://www.prm.ox.ac.uk/RelationalMuseum .html; and http://www.idig.org.au/about.htm (accessed August 11, 2004).

34 More recently ICOM has also supported such regional bodies as AFRICOM (International Council of African Museums), which grew out of a series of meetings organized by ICOM in 1991. UNESCO also declared an International Decade for Cultural Development from 1988 to 1997, a proclamation that went along with efforts to foster and emphasize connections between cultural heritage preservation and development. See Kreps, *Liberating Culture*, 118–20.

35 However, Shelton cautions that "if essentializing discourses have largely retreated from ethnographic exhibitions, they have re-grouped in a dangerous, new exhibition genre which treats culture as heritage, and objects as the embodiment of the cultural genius and identity of a distinct group or peoples. . . . [H]eritage detemporalizes and homogenizes history, permitting globalization to naturalize itself as a permanent condition." "Museums in an Age of Cultural Hybridity," 245.

36 See Kratz, *The Ones That Are Wanted* for further discussion of visitors' interpretive processes, and Kennedy, "With Irreverence and an iPod" on the creation of unofficial audio guides to exhibitions.

37 Harris, "Polling for Opinions," 53.

38 In addition to Kratz, *The Ones That Are Wanted*, see Pekarik, Doering, and Karns, "Exploring Satisfying Experiences in Museums." Lisa Roberts recounts the history of visitor studies from a museum educator's perspective, noting shifts in focus from visitor demographics to evaluation of exhibition components. She advocates incorporating methods of narrative research and analysis into studies of museum visitors. See Roberts, *From Knowledge to Narrative*.

39 Jonathan Yorba was particularly helpful in framing the latter questions during the next-generation workshop.

40 Kratz analyzes such cross-media, cross-contextual processes in relation to the production and perpetuation of stereotypes in *The Ones That Are Wanted*.

41 The following discussion of local idioms draws on Kratz, "Rhetorics of Value." Christina Kreps also describes examples of indigenous practices that parallel museological practice. She considers museums "a site of cultural hybridization where local approaches to the interpretation and representation of cultural materials are mixed with those of a wider, international museum culture" and the disjunctions this entails. Kreps, *Liberating Culture*, 16.

42 In addition to Poupeye's astute observations, Wayne Modest was persistent in pursuing these questions in the lively discussion at the next-generation workshop. Kirsten Wehner broadened the issues by noting that questions about local idiom are not limited to museums but also come up in relation to national broadcasting in a number of countries (e.g., in regulations governing the percentage of "local content"—difficult though that may be to define—that must be broadcast in media in Australia, Malaysia, Yap, France, Canada, South Africa, Kenya, and elsewhere).

43 Bennett, "The Exhibitionary Complex."

44 See also Shelton, "Museums in an Age of Cultural Hybridity" and Nederveen Pieterse, "Multiculturalism and Museums."

PART I

Exhibitionary Complexes

Exhibitionary Complexes

BARBARA KIRSHENBLATT-GIMBLETT

The term "exhibitionary complex" signals a nervous preoccupation with exhibition as a practice. In his 1988 formulation of the concept, Tony Bennett characterized the exhibitionary complex as a set of civic institutions whose goal was to encourage "new forms of civic self-fashioning on the part of newly enfranchised democratic citizenries."[1] Taking shape in the nineteenth century, the exhibitionary complex included not only museums but also libraries, schools, and other places where popular schooling took place, such as galleries, arcades, department stores, and international expositions. In his contribution to this volume, Bennett has refined the concept to account for new modes of citizenship in the contemporary context of official policies of multiculturalism. Public museums, as we know them from their history in the United Kingdom and Australia, have become " 'differencing machines' committed to the promotion of cross-cultural understanding, especially across divisions that have been racialized." Funded by the state and guided by official cultural policy, no matter how enlightened, public museums are by their nature governmental. For this reason, Bennett proposes that museums, while they are public spaces, should be distinguished from public spheres so as to better understand their intermediary role in public culture.

Reflecting on a wide range of museums, heritage sites, and themed attractions in Spain, South Africa, the United States, Japan, and the United Kingdom,

the essays in this section attempt to historicize contemporary museum prac-
tices and the exhibitionary complexes associated with them in light of glob-
alization, understood as a complex and far-flung system of integrated flows
of people, goods, technologies, knowledge, and capital. The global produces
the local, either as the outtakes of globalization—the places left out or left be-
hind—or as a value-added space within a global economy of heritage tour-
ism. Global processes always manifest themselves locally, and museums are
no exception. The webs of relations that characterize globalization and instru-
ments for expanding them differ qualitatively and quantitatively from earlier
colonial empires, with which they also share many features. Whereas Bennett
cautions that the impact of globalization has been exaggerated, Martin Hall
sees an epochal shift so profound as to require not an updating of the exhi-
bitionary complex but the formulation of something quite different, what he
calls in his essay the "experiential complex."[2] These two essays offer alterna-
tive models for thinking about the sites discussed in this section and elsewhere
in this volume. The historical question they pose is whether Hall's experien-
tial complex follows Bennett's exhibitionary complex or whether the two are
historically contemporaneous, their differences arising from the types of ex-
hibitions upon which they are based. The locus classicus of the exhibition-
ary complex is the nineteenth-century public museum. The locus classicus
of the themed attraction is the international exposition or world's fair. Both
arose in all their fullness at the same time, during the second half of the nine-
teenth century, and their paths of development are intertwined, though each
has a much longer history.[3] Indeed, American anthropologist Franz Boas, who
worked on behalf of the American Museum of Natural History at the World
Columbian Exhibition in Chicago (1893), distinguished between the "exposi-
tion method" of commercial exhibits and the "museum method," which was
systematic, scientific, and educational. Both methods were represented at the
Chicago World's Fair.[4]

To capture their contemporaneity, we might offer as a complement to the
exhibitionary complex, which Bennett identifies primarily with civic institu-
tions, the "expositionary complex," in keeping with Boas's distinction between
the museum method and the exposition method. This is not to suggest that
museums are a pure example of the former and world's fairs a pure example of
the latter. On the contrary, the value of Hall's contribution is in developing a
question posed previously by Corinne Kratz and Ivan Karp as to why themed
amusements such as Disney's Animal Kingdom and Epcot (the latter itself a
permanent world's fair) incorporate museums and actual things, "authentic
objects," into simulated environments, why they become more exhibitionary,
while museums such as the open-air Beamish in the north of England, with

their thematic treatments and rides, become more expositionary.[5] Whether the sites that Hall discusses are significantly different from their world's fair predecessors—whether they represent an epochal shift of the expositionary complex itself or whether the expositionary is overtaking the exhibitionary in museums—remains an open question.[6]

In her essay Andrea Fraser asks, "Have new museums such as the Guggenheim Bilbao finally succeeded in replacing the pedantic discipline of a nineteenth-century ordering of things with the fluid freedoms of unprogrammed flows?" Or has this kind of museum, with its spectacular "wow" space, become a corporate entertainment complex?[7] Instead of recycling a dead industrial economy as heritage by making it into an exhibition of itself, the city purchased a Guggenheim franchise and became a McGuggenheim outpost along with Venice, Berlin, and Las Vegas—and Johannesburg and Rio de Janeiro, should their dreams come true. Now on the map of world cities and part of the grand tour of our own time, Guggenheim Bilbao remaps not only the museum but also its political economy. What Fraser describes is a capital-intensive monument to neoliberal ideals in the economic wasteland of a deindustrialized city.[8] Rather than functioning as a differencing machine, this museum first injects the Guggenheim formula into a local situation and then imports the tourists, who make up the vast majority of visitors. The differences produced and even exaggerated in the local setting by these processes are economic, but not part of the museum's exhibition. What is called the "Bilbao effect" has proven difficult to replicate.

To better understand the relationship of the complexes that are the subject of this section—note the anxiety that one sense of the term "complex" indexes—follow Fraser's tour of a tour of the Guggenheim Bilbao. At the heart of this tour is the walk. In the absence of the encoded floor plan of the classical public museum, an audio guide directs the visitor through the arterial space of the building. To move through the floor plan of older public museums is to walk a particular plot, whether evolutionary, revolutionary, or something else. To change the plot, you must change the walk.[9] Above all, what Fraser's account captures is the importance of mode of locomotion in defining museums and in distinguishing them from themed attractions and theater and cinema. In museums we walk and the exhibits are stationary. In theaters, we are stationary and what we watch moves. In theme parks, we ride and the exhibits move. Themed attractions share locomotion of visitors with museums and the creation of illusions with theater and cinema. All of them tell a story.

While all of them engage the senses, they do so in distinctive ways. How they do so is central not only to Bennett's notion of the role of the exhibitionary complex in training the senses but also to Fraser's critique of how the art

museum institutionalizes a particular aesthetic discipline and Hall's description of the multisensory aspect of themed environments. Using a wide variety of techniques and genres, themed attractions feature experiences ranging from the spills and thrills of extreme rides and motion-simulation attractions to immersive themed environments that are structured around a story. These environments combine theatrical sets and lighting, a sound track, haptic effects (temperature, moisture, texture), proprioceptive effects (disorientations of the body's orientation in space), smell (the latest technology to be developed for this purpose is the "smellitzer," a machine that adds the appropriate aroma to each part of the attraction as the visitor moves through it), emotional triggers to set mood, and special effects derived from cinema. Like fiction in other media, they depend on what designers call the sixth sense, the imagination or suspension of disbelief, which allows the visitor to fill in the gaps. Creating strategic gaps is a form of "brain scripting," a term for how commercials create gaps that structure how consumers will fill them. Central to this process are "cliché icons."[10]

What is it about these complexes — exhibitionary, expositionary, experiential — that provokes anxiety? Fraser points to the aesthetic discipline of the Guggenheim Bilbao, a Trojan horse of neoliberalism. Hall focuses on the undisciplined commercialism of Disney's Animal Kingdom, which harbors precisely the outmoded ideas that the South African Museum, discussed by Leslie Witz in his essay, tries so hard to identify. All these authors foreground the importance of the critical and tactical museologies that are addressed elsewhere in this volume, as does Kirshenblatt-Gimblett, who looks at heritage as a mode of cultural production that is essentially museological in character. They do this by taking up, first, the normative museum practices associated with the exhibitionary complex and, second, the consensual aspects of the expositionary complex. Many of the sites they discuss are in large measure strategic in the sense that they command the resources and the space from which to plan and manage large operations and to exercise control over the stories they tell, the experiences they provide, and above all the people who enter their precincts. Motivated by civic ideals, profit, or both, these sites provoke anxiety over issues of control, whether in the forming of citizens or consumers, and over the instruments for exercising control — the disciplinary regime of the museum, the totalizing nature of imagineering, the manipulations of scripting, the intractable appeal of clichés, and a more general engineering of consensus.[11] Joseph Masco's Document in this section echoes all these anxieties and ambiguities and raises still others, looking at the Trinity Test Site and museums, monuments, and anniversary commemorations related to the history of U.S. nuclear involvement. Nothing could be further from the public sphere as a space of rea-

soned debate and oppositional perspectives operating outside of the control of the state (and the market).

The issue for Witz is the role of museums in creating new pasts for new kinds of citizenry in a postcolonial and postapartheid African society with a settler history. How are older museums such as the South African Museum (the oldest in South Africa) reforming themselves to this end, and what new forms are museums taking? Consistent with a larger trend, particularly as encouraged by UNESCO, the World Bank, and NGOs, museums and heritage more generally are seen in South Africa as important to peace (strengthening civil society and civic culture, understood in terms of cultural identity, reconciliation, and nation-building) and prosperity (economic development, primarily through tourism), though in practice these competing goals may not be compatible. So deeply embedded was the old South Africa in every aspect of museums — architecture, institutional structure, collections, exhibitions, narratives, staff, and visitors — that the revamping of them and the exhibitionary complex that guided them is important as a process in its own right.

South Africa's museums, as Witz shows, are struggling against received images, whether produced in South Africa, such as the Gold Reef City casino's themed evocation of early-twentieth-century Johannesburg, or elsewhere, such as Disney's Animal Kingdom, with its Primeval Whirl (a "prehysterical spinning roller coaster for a wacky run"), Affection Section (a petting yard), and South African–themed lodges.[12] Under pressure to serve as agents of social transformation as well as economic development in postapartheid South Africa, museums find themselves torn between conflicting imperatives (the state and the market) and constituencies (South Africans and foreign tourists). Tourism — itself a museum of outmoded but marketable tropes (an attractive colonial past, a modern nation with European roots, pristine wilderness, picturesque and diverse natives, and now also triumphal portrayals of the antiapartheid struggle) — is at odds with the new narratives and images that many museums are attempting to offer.[13]

While museums offer a sanctuary for objects removed from the everyday world, much that is considered heritage is sited in that world — whether as material heritage (buildings, monuments), natural heritage (landscapes, wilderness), or intangible heritage (knowledge and practices of living communities). The dilemma for intangible heritage, which is the focus of Kirshenblatt-Gimblett's essay, is how to reconcile a valorization of customary practices with a program of social transformation. Bennett's essay here, in revising the exhibitionary complex, identifies changes in museums that are consistent with their role in "shaping and transforming people through their own self-activity" in ways that encourage the "individualizing and innovative self" over the

"custom-bound self." The success of such transformations creates the crisis to which heritage is a response. Kirshenblatt-Gimblett suggests that heritage is a mode of cultural production that creates something new, namely, a new relationship to what comes to be designated as heritage. That new relationship arises from the conversion of habitus (unconscious culture) into heritage (self-conscious selection of valued practices). The result is a transvaluation that "preserves" custom without preserving the "custom-bound self." This is why heritage figures so prominently in official cultural policy and why it undergirds the differencing machine that Bennett suggests museums have become. The satirical American newspaper *The Onion* captures this dynamic in its "U.S. Department of Retro" article, reproduced as a Document at the end of this section.

How opposing subject positions make a difference—how they shape the differencing practices that are intended to overcome the very racial divisions that museums have historically reified—is evident from Witz's account of two museums in and near Cape Town. One is a large museum with a long history and state support (the South African Museum). The other is a small, new museum, formed independently and with very limited resources (Lwandle Migrant Labour Museum). In some ways, the South African Museum recognizes its complicity in a repudiated history and has been taking some necessary steps to reform itself in the postapartheid era. In the case of its ethnographic exhibits, it is engaging in a museology that includes elements of self-critique and self-indictment, even as it simultaneously takes part in efforts to inscribe indigenous pasts as part of a new postapartheid triumphalism. A full-blown mode of self-indicting museology has been particularly important in Germany, but the South African situation introduces different inflections to this kind of perspective.[14]

The Lwandle Migrant Labour Museum presents a stark contrast to the South African Museum, but its exhibitionary perspective is not the same vindicating mode of museology sometimes associated with museums of the aggrieved, such as the Holocaust and slavery museums discussed elsewhere in this volume. The challenge for museums of the aggrieved is to set the record straight, convey the fullness of a people's historical experience and understanding, deal with the degradation and dehumanization to which they were subjected (but without perpetuating the shame and psychic damage), ensure that their museums do not become monuments to their oppressors, and express their own dignity, resistance, resilience, and hope for the future. While the Lwandle Museum presents displays that address key components of the apartheid economic system, its primary concerns have been to forge community relations in Lwandle, a dormitory town that resulted from labor migration to the area,

and to establish a firm economic foundation for the museum through tourism. These orientations complicate any simple characterization of the museum's stance as that of the aggrieved, and its humble, dispersed museological practice bears only slight resemblance to a "vindicating" mode of museology. More like the micromuseums discussed elsewhere in this volume, the Lwandle Migrant Labour Museum is small, local, and resourceful in a situation of extreme economic hardship. The contrasts between these two South African museums and between the South African museums and museums discussed elsewhere in this volume that deal with difficult, polarized histories show how different subject positions are also molded by the particular social, historical, and political circumstances of the institutions. The contrasts that Masco's Document draws between the physical monument and display at Trinity Test Site in New Mexico and Patrick Nagatani's photographic vision of the place offer a striking illustration of this point as well.

Working against received images is one of the key issues facing South Africa's museums today. Witz presents one particularly contentious case, that of the "bushman diorama," the most popular exhibit at the South African Museum. In light of Hall's discussion of simulations in and out of the museum, it is worth noting that embedding artifacts in simulated environments is standard practice in the history of dioramas, and that this diorama — a simulation, if you will — carries with it the power of an aura, which is what makes it so dangerous. It has become an artifact in its own right, an artifact of the museum, which makes the museum doubly responsible for it. Every attempt to deal with this problematic display and ones like it elsewhere in the gallery — whether to cover it up, explain and apologize for it, or add warning labels — produces friction and foregrounds the museum itself, its operations, history, and mistakes, in a series of reflexive moves that make the museum, its practices, and its mediations visible. We can see here a critical shift from an informing museology (the exhibit as a neutral vehicle for the transmission of information) to a performing museology (the museum itself is on display).[15] In so doing, the South African Museum, by attempting to confront "the ideological burden of [its] own history" as a response to "the imperative for transformation," generates controversy and public debate. In this way the South African Museum animates multiple public spheres and does so perhaps more dramatically than through any exhibition within its own walls — especially since the museum cannot control the outmoded ideas that outside tour guides continue to present to the tour groups they take through the museum.

Given Bennett's call for museums to "break with the discursive and sensory ordering of the exhibitionary complex in order to open up new possibilities for negotiating relations of cultures-in-difference," what is the role of original

objects, the sina qua non of the great public museums that inspired his origi-
nal formulation of the exhibitionary complex? Some museums break with this
past by refusing, on principle, to form collections or exhibit original objects,
as is the case with Beth Hatefutsoth/Museum of the Diaspora in Tel Aviv. This
museum was conceived by Jeshajahu Weinberg, the person largely responsible
for conceptualizing the United States Holocaust Memorial Museum in Wash-
ington, D.C., where the evidentiary value of what is shown, like the status of
a notarized copy in a court of law, is more important than the original object.
Such museums are unabashedly expositionary in their approach to installa-
tion, while holding to a strong sense of civic and moral mission. They put the
very definition of a museum into question. While the International Council of
Museums defines the museum as "a non-profit making, permanent institution
in the service of society and of its development, and open to the public, which
acquires, conserves, researches, communicates and exhibits, for purposes of
study, education and enjoyment, material evidence of people and their en-
vironment," it also states that "in addition to institutions designated as 'mu-
seums' the following qualify as museums for the purposes of this definition,"
among them exhibition galleries and cultural centers.[16]

Since neither museums nor exhibitions require original objects, what is the
role of objects in the various complexes discussed in this section? Given the
fascination with creating simulations and the ability to do so in high fidelity,
Hall asks why actual things and even whole museums are being inserted into
simulated environments, and he proposes that actual objects anchor illusions
and give them authority. It has also been argued that copies add value to the
original.[17] In the words of anthropologist Clifford Geertz, "It is the copying
that originates."[18] Or, as André Malraux said in 1947, "The history of art is the
history of what can be photographed."[19] Malraux proposed a *musée imaginaire*
made up entirely of black-and-white photographs of works of art from all peri-
ods and places, without distinction. What was lost in reproduction was offset
by portability, accessibility, and juxtapositions, consistent with the idea that
new information and complexity are functions of unpredictability. Malraux
had met Walter Benjamin and read his work but took the opposite approach
to photographs of art, which he valued because they generated new visual and
social practices. Many projects today are using digital technologies to realize
and extend Malraux's vision, whether by compiling collection databases and
making the images and information widely accessible through the Internet,
creating virtual museums and exhibitions, or, as discussed in Hall's essay, inte-
grating digital media and actual objects within the physical gallery.[20]

If globalization is characterized by, among other things, the technologies

it uses to organize far-reaching networks and flows, what are the implications of these technologies for the future of the museum and for the various complexes discussed here? Long before digital media, museums exhibited copies and continue to do so today, as could be seen at the Museum of Pictorial Reproductions (Museo de Reproducciones Pictóricas, MRP) in Lima, which Buntinx discusses in the "Tactical Museologies" section of this volume. The Victoria and Albert Museum has preserved two spectacular "cast courts," which are filled with the kinds of collections of copies of great works of art and architecture that used to be the mainstay of nineteenth-century art museums. Since it was not possible for every art museum to acquire masterpieces — and certainly not a complete collection of the most important works — it was considered better to have copies of first-rate works than originals of second-rate ones. Not far from the cast courts are the newly installed British galleries, which display original objects together with digital images that reveal details and facets of the objects not otherwise visible or legible. The issue here is not whether the object authenticates the copy or might even be supplanted by a simulation of itself. Rather, digital media are deployed in the gallery to intensify the visitor's engagement with original objects by holding the visitor's attention and directing it to significant detail.

Under what circumstances does the substance of the object matter? The conception of intangible heritage guiding UNESCO's preservation program is directed to supporting practitioners and the transmission of what they know so that what is preserved is the ability to continue to make and do things in ways that continue to be meaningful and valued. As Kirshenblatt-Gimblett notes, more than a millennium before UNESCO, the Ise Jingu, a sacred shrine in Japan, began a tradition of tearing down and rebuilding the temple at regular intervals, adhering to precise protocols for tools, materials, and construction methods, as a way of ensuring the continuity not of the substance of the temple but of the knowledge, values, and social relations required to build it. The sense of museum as a repository of objects is both very old and very resistant to change. The contrast between the museum as container and the museum as activity is itself exhibited in the debates over different definitions of museums, the object, heritage, and display. Museums, especially, often strive to hold to the classic definition of their purpose as a repository of objects at the same time as they experiment with new technologies of display, and also borrow from other exhibition settings. As I have argued, this tension is inherent in the history of museums and display forms, but the tension and the way it is exhibited are shaped by the changing historical contours of exhibition itself. The essays in this section of the volume document and seek to interpret the tension and

anxiety over institutional definitions of self and appeals to publics that become ever more difficult to define and attract under conditions of globalization.

NOTES

1 See Bennett in this volume.

2 Hall bases the idea of "experiential complex" on Pine and Gilmore, *The Experience Economy.*

3 See Grau, "The History of Telepresence."

4 Boas, "Ethnology at the Exposition." World's fairs and public museums are historically intertwined, as are their exhibition practices. Museums such as the Smithsonian have been active players in world's fairs. They created exhibitions expressly for them and formed collections for those exhibitions that later became part of the museum's permanent collection. In addition, buildings created for world's fairs sometimes became permanent museums after the fair closed, as with the Field Museum of Natural History in Chicago.

5 Kratz and Karp, "Wonder and Worth."

6 To properly historicize the relationship between public museums and commercial amusements of the kind that Hall discusses, consider Altick's *The Shows of London*, which ends its account in 1851, the year the Crystal Palace opened in London, hosting the first world's fair. Altick suggests that until the mid-nineteenth century, instruction and amusement were not as compartmentalized as they became with the rise of the public museum, with its public support and educational mission, and of world's fairs and their offshoots (theme parks, amusement parks), which were unabashedly dedicated to popular entertainment and profit. Indeed, the exhibitions or shows he considers were largely in the hands of commercial showmen. This development of more differentiated display settings is the historical ground upon which Bennett first developed the concept of the exhibitionary complex. At Te Papa Tongarewa, the new national museum of New Zealand that opened in 1998, instruction and amusement are again closely and prominently entwined in an unabashed bid to reach the widest possible audience with attractions such as Time Warp, featuring motion-simulation rides and a virtual bungy jump, among others.

7 This kind of museum is consistent with a theatrical approach to exhibitions, which marks new relationships between information and experience, display and mis-en-scène, things and stories, thinking and feeling, hard mastery and soft mastery, identity and identification, visitor and customer. I discuss this approach and what it represents more fully in Kirshenblatt-Gimblett, "The Museum as Catalyst."

8 Honigsbaum, "McGuggenheim?"

9 Fraser does this in a number of her performance pieces. See, for example, the video of her performance "Museum Highlights: A Gallery Talk." The text of the performance is reproduced in *October* (1991) 57:103–22.

10 Christian Mikunda, *The Art of Business Entertainment*, cited in Naverson, "Theme Attraction Design, Part Three." http://www.themedattraction.com/sixth.htm (accessed September 28, 2004).

11 The term "Imagineering" was invented by the Walt Disney Corporation to describe the elaborate design process and aesthetic of utopian realism involved in creating the total environments of Disney theme parks. The Disney designers are called "Imagineers." See Kratz and Karp; "Islands of 'Authenticity.' "

12 See http://disneyworld.disney.go.com/waltdisneyworld/parksandmore/attractions/attractionindex?id=AKPrimevalWhirlAtt (accessed September 28, 2004).

13 Rassool and Witz, " 'South Africa: A World in One Country.' "

14 One of the most consequential examples is the exhibition "The War of Extermination: Crimes of the Wehrmacht 1941–44," which opened in Munich in 1995 and toured until 1999, drawing nearly a million visitors.

15 Compare Johannes Fabian's discussion of moving from informative to performative ethnography in chapter 1 of his *Power and Performance*.

16 "Development of the Museum Definition According to ICOM Statutes (1946–2001)," at http://icom.museum/hist_def_eng.html (accessed April 20, 2006).

17 MacCannell, *The Tourist*.

18 Geertz, "Epilogue."

19 Malraux, *Le Musée imaginaire*.

20 On the history of the virtual museum as an idea and practice that antedates digital technology, see Huhtamo, "On the Origins of the Virtual Museum."

Exhibition, Difference,

and the Logic of Culture

TONY BENNETT

A good deal of contemporary museum theory
and practice has concerned itself with the
ways in which museum environments — and
the social and symbolic exchanges that take
place within them — might be refashioned so as to transform museums into
"differencing machines" committed to the promotion of cross-cultural under-
standing, especially across divisions that have been racialized. The question
I want to pose here is whether this aspiration involves a series of collateral
changes that, taken together, add up to a more general change in how muse-
ums operate and their situation within the cultural field. To put the point more
rhetorically, does the conception of the museum as a "differencing machine"
aspire to new forms of dialogism that place earlier notions of exhibition into
question? I want also to review, and qualify, the concept of the "exhibitionary
complex" by arguing the need to view the operations of this complex in the
broader perspective of what, for the purposes of my argument here, I shall call
the "logic of culture."

Before I come to either of these questions, however, I want to worry away
a little at what is involved in pursuing these concerns in a context defined
by a conjunction of "public cultures" and "global transformations" and the
ways in which these evoke the concepts of globalization and the public sphere
(or spheres) even while distancing themselves from such concepts. The con-
sequences for how we engage with the changing role of museums can vary

significantly depending on how each of these terms is interpreted and how the relations between them are viewed. And each has the potential to significantly misdirect inquiry.

MUSEUMS, GLOBALIZATION, AND PUBLIC SPHERES

Take the concept of globalization. While this need not imply the notion of a qualitative shift from one historical situation to another, it all too often does, functioning side by side with accounts (of the network society, for example) suggesting that societies are now different in qualitative ways from what they once were. As a shorthand description, of course, the term usefully highlights relations between what are, by any standards, important contemporary phenomena: changing patterns in the international flows of capital, people, ideas, and information, on the one hand, and changing spheres of influence of national governments and transnational economic, social, political, and cultural actors, on the other. It's just that, when looked at closely, these changes are usually not so new, not so closely interrelated, and not so general and comprehensive as theories of globalization often suggest. Capital flows remain largely locked up in regionally defined trading blocs.[1] An emerging international digital divide effectively stems the international flow of ideas and information. Some parts of the world are affected by significantly increased rates of immigration, while some are not.[2] And the relations between national sovereignty and new regional forms of government are typically more consequential in contemporary political negotiations than a generalized polarization between the roles of national governments and transnational corporations would suggest.

The same is true if we look at the relations between museums and globalization. In some respects, museums now seem self-evidently to be parts of more globalized flows of information, people, and ideas. They reach out not only beyond their own walls but also beyond national boundaries through new practices of Web curation, and their audiences, at least in the case of major metropolitan institutions, tend to be increasingly cosmopolitan, reflecting the growth of cultural tourism. It remains the case, however, that public museums are largely, and probably entirely, the administrative creations of national, municipal, or local governments or private organizations. Insofar as globalization concerns questions of governance, its implications for museums have so far been relatively muted: international protocols remain little more than that, with their interpretation and implementation remaining largely the preserve of national jurisdictions — witness the British Museum's continuing determination to hold on to the Elgin Marbles. More to the point, perhaps,

there are a number of ways in which museums are now arguably *less* global-
ized than their nineteenth-century counterparts. The representational ambit of
contemporary museums, for example, is characterized by a postmodern mod-
esty when compared with the totalizing frameworks of representation charac-
terizing nineteenth-century museums in their aspiration to render metonymi-
cally present the global histories of all things and peoples. And if we consider
nineteenth-century museums in their relations to international exhibitions, it
is clear that there are few contemporary exhibition phenomena that can match
the size and international mix of the audiences those exhibitions recruited in
their heyday.[3] It is also true that the networks that existed for the international
traffic in people as exhibits — in "living ethnography" displays as well as the
traffic in dead "primitives" — no longer operate.

It is thus not true that only recently have museums become parts of global
networks organizing flows of things, people, and expertise. This has been an
important aspect of their constitution and functioning from the second half
of the nineteenth century. Recognizing this, however, does involve a signifi-
cant qualification of the suggestion I made in 1988 that the formation of the
modern public museum should be considered as part of the development of
a broader "exhibitionary complex" — a somewhat clumsy neologism for a net-
work of institutions in which earlier practices of exhibition were significantly
overhauled in being adapted to the development of new forms of civic self-
fashioning on the part of newly enfranchised democratic citizenries. While this
argument took account of the totalizing exhibitionary frameworks that re-
sulted from the increasing influence of evolutionary thought over the practices
of museums and exhibitions, resulting in a regime of representation that aimed
to encompass "all things and all peoples in their interactions through time,"
it did not adequately recognize the respects in which museums and exhibi-
tions were themselves actively implicated in the organization of new interna-
tional networks, promoting new transnational forms of cultural exchange and
perception.[4] Carol Breckenridge's formulations are more incisive here. Muse-
ums and international exhibitions functioned to create what Breckenridge calls
a Victorian ecumene — that is, a transnational imagined community encom-
passing "Great Britain, the United States, and India (along with other places)
in a discursive space that was global, while nurturing nation-states that were
culturally highly specific."[5] But the specificity of this nation-culture relation-
ship, Breckenridge argues, derived its logic from the transnational cultural
flows characterizing the Victorian ecumene, particularly in their othering of
the colonized, just as those flows led to "the creation of a global class united by
their relation to newly invented rituals, newly constructed metropoles, newly
naturalised objects."[6] Peter Hoffenberg's analysis of the role that international

exhibitions played in forging connections between metropolitan and colonial elites in Britain, India, and Australia, thereby organizing "both national and imperial public cultures," points in the same direction.[7]

A longer historical perspective, then, should invite a skeptical response to the proposition that museums are now parts of global networks of information and cultural flows in ways that have no precedents. To understand what is new about the ways in which museums organize and operate within global networks means looking at quite specific matters concerning, for example, the technical means of organizing those networks (the Internet contrasted with earlier networks centered on rail and navigation, telegraphy, and telecommunications), the forms of expertise they interconnect, and the new styles of cosmopolitanism they effect, rather than any generalized preglobalization/postglobalization contrast.

The concept of the public sphere needs to be approached with equal caution. This is not because of any general difficulties with the concept, or because I doubt that globalized (or at least significantly international) public spheres exist: the Open Democracy Web site (www.opendemocracy.net) is a good example, fulfilling in an international arena a function analogous to the one that Habermas in *The Structural Transformation of the Public Sphere* ascribed to the bourgeois literary public sphere. It is rather the relations of museums to such public spheres that I have in mind here. For while few difficulties are occasioned by defining museums as a part of public culture, conveying the sense that museums are public both in the sense of being outside the private sphere of the home and—usually—in the sense of their dependence (whether direct or indirect) on public funding, this is, if the theoretical lineage of the concept is to be respected, quite different from defining museums as public spheres. This is not to deny that museums may connect to such public spheres, join in their debates, and—as they most certainly are—be affected by those debates. They are not, however, themselves public spheres in the sense defined by Habermas: a set of institutions within which, through reasoned debate, a set of opinions is formed and brought to bear critically on the exercise of state authority. It is true, of course, that in Europe, where in the late eighteenth and early nineteenth centuries museums often formed adjuncts to local literary, philosophical, and scientific societies, museums *were* (sometimes) significant components of the bourgeois public sphere, articulating principles of reasoning and forms of public discourse and social relations that stood in opposition to absolutist regimes as well as to aristocratic or courtly patronage.[8] And some aspects of the subsequent European development of museums might just, at a stretch, be illuminated by drawing on Habermas's account of the structural transformation of the public sphere as a process through which the institutions

of the public sphere lost their oppositional aspect as they were either commercialized or integrated into the state. But if this is to stretch a point, it also neglects the more important consideration that the network of public museums developed in the course of the nineteenth century more typically consisted of institutions moving in a quite different direction: collections that, having earlier symbolically buttressed royal or aristocratic power, were translated into public institutions with a newly defined civic mandate.[9]

This is, I think, why the case of the Louvre remains so significantly emblematic in defining a new space and form of publicness that was, above all else, governmental and civic.[10] It was a space in which the collections that had been assembled through the varied histories of earlier collecting practices were fashioned for the new purpose of helping to shape the civic attributes (of belief, identity, comportment, and civility) needed by the members of democratic polities. This was a new form of publicness, providing a rendezvous for institutions moving in different directions, a space where both collections that had earlier formed a part of the bourgeois public sphere and royal collections that had represented the forms of publicness of the absolutist state, magnifying the person and power of the monarch, were brought together in new networks. As such, it was a space that redefined the social articulations of its constituent parts as these new public museums — whatever their origins or earlier histories — were put to work as civic technologies directed toward the population at large. Viewed from a broader, less Eurocentric perspective, moreover, it is clear that many of the contexts to which museums were "exported" in the history of colonialism were ones in which neither absolutist nor public sphere conceptions of publicness — or the coordinates supplied by the relations between state and civil society that made these intelligible — had much relevance.[11]

So far as the history of their formation is concerned, then, it makes little sense to refer to museums as parts of public spheres if by this term we mean a set of institutions standing outside the state and functioning as a means of criticizing it. To the contrary, since the mid-nineteenth century their publicness has been largely a civic and governmental one. This is not to say that museums have not been shaped by their relations with public spheres; to the contrary, this is a significant aspect of their recent refashioning in response, for example, to feminist and Indigenous critiques. However, the nature and significance of such relations are more likely to come clearly into view if museums are distinguished from, rather than equated with, such public spheres. Such transactions constitute only one aspect of museums' publicness as this has been, and continues to be, shaped by their interactions with other civic and governmental institutions whose development has been coeval with their own — libraries, adult education, and, above all, mass schooling — and shaped

by broader governmental articulations of the relations of culture and citizenship. If this intermediary role of museums in public culture is to be properly understood, however, then some attention needs to be given to what it means to define their activities as cultural.

THE LOGIC OF CULTURE: MUSEUMS AS "PEOPLE MOVERS"

Let me broach this question by means of a concrete example—evoked by two contrastive scenes—to highlight the key point I want to get at here, which concerns the transformational capacity of museums. Scene one concerns the exhibition of *bakemono* (monsters) in the *misemono* (sideshows) at Ryōgoku Bridge in Edo, circa 1865, three years before the Meiji Restoration. Gerald Figal evokes this scene as follows:

> A whale washed ashore and advertised as a monster sunfish, a hideously ugly "demon girl," a scale-covered reptile child, the fur-covered "Bear Boy," the hermaphroditic "testicle girl," giants, dwarfs, strong men (and women), the famous "mist-descending flower-blossoming man" who gulped air and expelled it in "modulated flatulent arias," and the teenager who could pop out his eyeballs and hang weights from his optic nerve, all attest to a libidinal economy in which a fascination with the strange and supernatural conditioned and sustained the production, consumption, and circulation of sundry monsters as commodities in "the evening glow of Edo."[12]

Scene two focuses on the same area, but today, when under the impact of successive waves of modernization the *misemono* and *bakemono* have all but disappeared, their place taken, at first, by Western forms of popular entertainment —variety theater and later the cinema—and now by the nearby Edo-Tokyo Museum, where the *bakemono* and *misemono* survive, but only as history in the museum's various exhibits of the popular festivals and book trade of the late Edo period. It is a scene in which both *bakemono* and *misemono* give way to the museum and the claims it makes for itself as "an instrument of civilisation" and "a conduit for transmitting knowledge"—a thoroughly modern museum that, breaking with earlier traditions of museums as "mere treasure repositories," aims to "evoke an emotional response" in visitors, to "inspire them to develop their own ideas" and so to involve them in a process of "cultural development."[13]

In these respects, both the claims and the practice of the Edo-Tokyo Museum—Japan's first museum of urban history—perfectly embody the logic of the Western history museum insofar as this has operated as a means of displacing popular customs and traditions standing in the way of moderniza-

tion by transforming them into historical representations of themselves. This partly reflects the influence on Japanese practices of collection and exhibition of those knowledges — history, art history, archaeology, geology — whose development, as what Jan Golinski tellingly calls "visible knowledges," has been caught up with that of the exhibitionary complex, both shaped from the start by complex international networks of exchange and interaction. The ways of exhibiting history in evidence at the museum are thus the outcomes of a much longer process of cultural interaction through which the notion of a past clearly distinct from the present was introduced into Japanese thought, and through which it became possible to read the urban past of a city such as Tokyo as symptomatic of a national past that, in turn, is accorded its place within the longer "universal" histories of "progress" or "civilization" and, indeed, those of natural and geological history.[14] If the museum's main story is that of a tale of two cities, Edo and Tokyo, connected and yet separated by the rift of modernization initiated in the Meiji period, it is also concerned to place both cities in the longer and shared histories of the region's archaeological record and its distinctive geological characteristics.

There is, however, a more general mechanism at work here, one that, subtending the specific uses to which a range of visual knowledges are put within the Edo-Tokyo Museum, draws on the broader logic of culture understood as a historically distinctive, and complexly articulated, set of means for shaping and transforming people through their own self-activity. William Ray helps to identify the distinctive characteristics of this logic of culture when he notes that the same term, "culture," is used both to designate "the shared traditions, values, and relationships, the *unconscious* cognitive and social reflexes which members of a community share and collectively embody" and to refer to "the *self-conscious* intellectual and artistic efforts of individuals to express, enrich and distinguish themselves, as well as the works such efforts produce and the institutions that foster them."[15] The key to understanding culture as a mechanism of person formation, Ray argues, lies not in opting for one or the other of these seemingly opposing uses but in attending to the movement — the processes of working on and transforming the self — that arises from the tension between them. Culture, in simultaneously articulating a sense of sameness and difference, inscribes our identities in the tension it produces between inherited and shared customs and traditions, on the one hand, and the restless striving for new and distinguishing forms of individuality, on the other: "it tells us to think of ourselves as being who we are because of what we have in common with all the other members of our society or community, but it also says we develop a distinctive particular identity by virtue of our efforts to know and fashion ourselves as individuals."[16]

Culture is thus, on this view, a mechanism that at its heart takes issue with habit: tradition, custom, habitual usage, superstition (the role assigned to *bakemono* in Japanese programs of modernization). These are the "adversary to be overcome before we can realise our full humanity."[17] Culture initiates a process of critique through which the individual extricates him- or herself from unthinking immersion in inherited traditions in order to initiate a process of self-development that will result in new codes of behavior, but ones that—in being freely chosen rather than externally imposed, and in meeting the requirements both of reason and of individual autonomy and expression—distinguish those who have thus culturally re-formed themselves from those who remain unthinkingly under the sway of habit. Because the question of habit has always been at issue in the museum in one way or another, this logic of culture has played a significant role in the organization of Western exhibition practices from the nineteenth century through to the present.

This is most evident in the art museum, which—throughout the history of modernism and into that of postmodernism—has persistently pitched itself against the numbing of attention associated with habitual forms of perception. Jonathan Crary underlines the significance of the issues at stake here in noting the apprehensions that were generated in the late nineteenth century around the new distracted and automatic forms of attention associated with industrial production and the development of new forms of popular visual entertainment. The fear was that, owing to the association of the habitual with instinctual procedures rather than rational ones, modes of perception that had become routinized "no longer related to an *interiorisation* of the subject, to an intensification of a sense of selfhood."[18] They were therefore inimical to the production of those forms of tension and division within the self that are required for the machinery of culture to take hold and be put to work within a dialectic of self-development in which individuals renovate and distinguish themselves from the common mass by disentangling their selves from the weight of unconscious inherited reflex and traditional forms of thought, perception, and behavior. It is not surprising, then, that the modern art museum, as an instrument of culture, has been committed to a program of perpetual perceptual innovation, seeking to prevent vision from falling into "bad habits" by critiquing not only the distraction of attention associated with popular visual entertainments—today the television and computer screens are the prime targets in this respect—but also the flagging forms of perception associated with earlier artistic movements that, while once innovative and able to provoke new forms of perceptual self-reflexiveness, have since atrophied into routine conventions. The modern art museum, looked at in this light as an instrument for "perpetual perceptual revolution," thus functions to keep the senses in the

state of chastened attentiveness that the logic of culture requires to produce a dynamic of self-formation that is sustained by a dynamic of sensory life.

Yet it is also clear that neither the ability nor the inclination to keep up with this "perpetual perceptual revolution" is evenly distributed throughout all classes. To the contrary, these are characteristics mainly of those members of the middle and professional classes who have acquired a sufficient degree of what Pierre Bourdieu calls "cultural capital" — that is, a knowledge of the rules of art and the workings of art institutions — and the ability to translate that capital into the distinctive forms of perceptual athleticism that the program of the art museum requires.[19] In this respect too, however, the art museum embodies the logic of culture. For in serving as a mechanism of self-development, Ray argues, culture has simultaneously served as a social sorting mechanism through which individuals "*sort themselves* into groups" by virtue of the cultural activities they choose and the degree to which these enable them to break with habit and thus to become self-reforming.[20] There is, however, a deceptive aspect to this mechanism to the degree that the groups into which individuals seem to sort themselves are usually those to which they already belong by virtue of their class and educational backgrounds and the social trajectories to which these give rise.

However, if the exhibition practices of Western art museums have functioned as mechanisms of social triage — that is, of sorting people into different groups and arranging these hierarchically — they have also always operated along racialized as well as class lines. This is evident in the checkered history of the evaluation of "primitive art," which, prior to its integration into the dynamics of Western modernism as a source of aesthetic innovation, was considered art's antithesis: traditional, collective, and formulaic, standing alongside the tools, weapons, decorations, and culinary implements of "primitive peoples" as evidence of societies that had never broken with the force of inherited custom to initiate the restless dynamic of self-formation characterizing the logic of Western culture.[21] The place accorded "Asian" art and material culture within colonial frameworks of interpretation was a more intermediate one. Interpreted as evidence of once innovative and dynamic civilizations that had allegedly subsequently ossified under the weight of "Asian despotisms" of one kind or another, they were seen as nurturing slavish habits and custom-bound behavior as the price of an obedient population.[22] The effect, however, was broadly similar. Whether it was a question of the static civilization of "the primitive" or the "arrested development" of Asian societies, museums invoked and exhibited others — and their art and artifacts — as signs of societies where the logic of culture, and the independent, critical, and individualizing orientation it required, either had failed to operate or had gone into decline.

Museums did so, moreover, precisely as a means of putting the logic of culture into effect by and for Western publics by producing, in the representation of a series of custom-bound others, the counterfoils against which processes of self-differentiation and self-development might be developed. Viewed in class terms, the division between the custom-bound self and the individualizing and innovative self, which the logic of culture generates as the site of its own operations, has served largely to organize a distinction between the middle and working classes. This has mainly been the work of the art museum. There has also been a gendered aspect to these processes. If, as I am suggesting, the art museum can be understood as a "people mover," then this has been true more of its relations to men than to women. Indeed, the art museum's ability to mobilize male identities has often depended on its simultaneously fixing women in unchanging positions. I refer here to the complex history of the relations between the art museum and aesthetic modernism.[23] If the linear time of modernism was a racialized time that organized different peoples and civilizations into different stages along the so-called unidirectional and forward-moving time of modernity, it was also — and still is — a gendered time in which the linear, largely male, and public time of modernity is contrasted to the private, cyclical, repetitive, and habitual time of everyday life that has classically been represented by women.[24]

Yet at the same time, in other kinds of museum — archaeological and anthropological, for example — the logic of culture has operated across racialized divisions, producing a Western or white self that, when looked at closely, might splinter into differentiated class capacities but which, when viewed in the aggregate, was defined in terms of a capacity for an inner dynamic of self-development that was identified as such only by being distinguished from the flat, fixed, or frozen personas that the primitive and "Asiatic types" represented. Much the same purpose was served by the development of folk museums, which, while romanticizing the inherited customs and folkways of the parents and grandparents of modern urban populations, simultaneously transformed those customs and folkways into immobilized remnants of redundant pasts that served as a counterfoil to the forward thrust of the modern. Mark Sandberg quotes the account of a journalist who, recounting a visit to the Copenhagen Folk Museum in 1885, conveys this effect precisely as his glance moves between the museum displays and the railway yard outside:

> And if during your wandering past all of the old treasures, stopping in front of this or that rare showpiece — a tooled mug, a majestic four-post bed, or a precious, nicely-inlaid wardrobe — if you have for a moment been envious of the people back then who enjoyed and lived surrounded by such magnificence,

then just look out the window in front of you. Over under the train station's open hall a train is about to depart. The bell rings, the locomotive whistles, the steam billows up beneath the ceiling's iron beams and flushes out the pigeons nesting up there. In great arcs they circle around in the sunlight that gilds their wings. But the train is already far away, the last wagon is now passing the last telegraph pole you can see. Reconsider and tell me then, if you want to trade. I didn't.[25]

However, the balance that is struck here between custom and innovation, between the old and the new, is less sharp than what is produced by the cutting edge of new artistic practices in the art museum. The same is true, typically, of history museums: the relations these organize between past and present are, with the exception of ruptural moments (the French Revolution, the Meiji Restoration), more likely to be smooth and continuous, splitting the self between past and present in a manner calculated to generate a regular tempo of self-modernization, as opposed to the more staccato pattern of self-modernization associated with the modernist art museum. The Edo-Tokyo Museum is a good example of the tempo of the history museum in this regard, installing a qualitative division between the time of the Edo period and that of the post-Meiji period, the former as a realm of superseded (but still valued) custom and tradition—including the *bakemono* and *misemono*—and the latter, once the break of 1868 has been passed, as a realm of constant change and innovation in which the Japanese citizen is depicted as, and thereby enjoined to become, incessantly self-modernizing. And it is, of course, in relation to this realm that the museum locates and defines itself as an "instrument of civilization." The museum, if you like, tells the story it needs to tell about the past in order to place itself as both an outcome of and a means of continuing the ongoing dynamics of self-transformation that the logic of culture promotes.

All of this is to say that museums are best understood as distinctive cultural machineries that, through the tensions that they generate within the self, have operated as a means for balancing the tensions of modernity. They generate and regulate both how, and how far, we are detached from the past and pointed toward the future. But, depending on the type of museum concerned, they do this in different ways, producing different tempos of change. These differences of tempo are important and are often related to the different publics that different types of museum address. History museums, for example, have functioned more effectively as mass "people movers" than have art museums, which, in tune with the socially restricted publics they have attracted, have functioned more effectively in installing new dynamics of self-development among those professional and managerial elites who usually have been impli-

cated most quickly in processes of economic modernization. In either case, though, museums have proven themselves to be highly productive machineries in their capacity to transform modes of thought, perception, and behavior— in short, ways of life.

The question I now want to put, to return to my starting point, concerns the directions in which these significant engines of social transformation are now pointed, or should point, in their contemporary conception as "differencing machines" operating in the midst of societies marked by new and increasingly salient forms of cultural diversity. As a corollary of this, the further question arises as to what, if any, consequences these developments have had for the organization and functioning of the exhibitionary complex. I shall, in exploring these questions, develop three arguments. The first will be to suggest that it is the modes of thought, behavior, and perception shaped by the associations between museums and modernity sketched above that now constitute the field of inherited custom and tradition—or bad habits, if you will—that museum practice must engage with if it is still to act in conformity with the transformative logic of culture. The second will outline the respects in which the development of such an orientation for contemporary museum practices has involved a commitment to dialogic and multisensory forms of visitor engagement that have challenged the authoritarian and ocular-centric forms of didacticism that characterized the earlier organization of the exhibitionary complex.[26] My third contention will be that many of the contradictions that currently beset museums as they wrestle to define their place in public cultures that are in the midst of global transformations arise from the different twists they give, and sometimes are obliged to give, to the logic of culture in the context of social divisions that are, always, simultaneously racialized, classed, and gendered.

TRANSFORMING THE EXHIBITIONARY COMPLEX: MUSEUMS, CULTURE, AND DIFFERENCE

It will be helpful, as a first footing, to cast doubt on a further aspect of the thesis of globalization. If, as I have suggested, it is a mistake to see globalization (in the qualified sense I have proposed) as an entirely new phenomenon, so it would also be a mistake to see it as an uninterrupted process that has characterized the development of capitalism from the voyages of discovery to the present. This is especially important in relation to museums owing to the degree to which their relatively short history has coincided with one of the most extended periods of downturn in the internationalization of the flows of goods, people, capital, and culture. I refer to the 1914–18 and 1939–45 wars,

and the years between them. These witnessed significant and often drastic de-
clines in rates of international population migration, trade, culture, and capital
flows. And this entailed a parallel, and considerable, decline in the interna-
tional networks within which museums operated. The 1914–18 war brought
about a significant reduction in the international activities of European muse-
ums while also splintering the professional networks that had begun to form
in the Anglophone world around the Museums Association and its various off-
shoots.[27] The international traffic in artifacts and exhibits declined; museums,
especially in Germany, became much more strongly ethnicized in their con-
cerns, often breaking with earlier transnational principles of classification and
display as a consequence.[28] In addition, international exhibitions often became
more markedly national or colonial events — in Britain, for example, giving
way to specifically imperial exhibitions.

If we turn now to the post-1945 period and ask how the relations between
museums and global processes in this time have differed most evidently from
those that characterized the pre-1914 period, four issues are worth noting. The
first is not just that patterns of international population mobility have reached
and exceeded their pre-1914 levels but that they have done so in different con-
ditions in the sense that movements of people have taken place within a his-
torical context of decolonization as opposed to the period of colonial expan-
sion that characterized the late nineteenth century. Second, this has also meant
that these movements of people have taken place in the context of, and have
given rise to, campaigns for the recognition of equal political, civic, and cul-
tural rights for those who move between countries. Third, these campaigns
have been accompanied by a pluralization of public spheres — Indigenous and
diasporic — with, in some cases, the identification and assertion of differenti-
ated rights rather than solely universal ones, as in earlier conceptions of the
public sphere.[29] And fourth, the international networks that museums now
form a part of are much more pluricentric, in part because of the emergence
of North America as a rival hub to Europe, and in part because the dynam-
ics of postcolonization have resulted in a broader network with more clearly
independent national museum systems.

The most significant consequence of these changes from the perspective of
my concerns here is that, as Anthony Shelton elegantly summarized it, muse-
ums — particularly those with an ethnographic focus — are now subject to radi-
cal interrogation "by members of the disjunctive populations they once tried
to represent," as their audiences are "increasingly made up of peoples they once
considered as part of their object."[30] This is the basis of what is now the most
evident challenge to the ways in which, in the earlier formation of the exhi-
bitionary complex, museums translated the logic of culture into hierarchical

organizations of the relations between peoples, cultures, and knowledges in functioning as "people movers" within the temporal dynamics of modernity. Difference was, of course, always on show within the evolutionary frameworks governing late-nineteenth- and early-twentieth-century museums and exhibitions. But this was difference within a highly normative framework in which a whole series of others—cast in the role of representing outmoded or degenerate habits, customs, and traditions—defined that from which modern man (who is always not-quite-modern) must distinguish himself in order to remain at the forefront of modernity's advance. The challenge now is to reinvent the museum as an institution that can orchestrate new relations and perceptions of difference that both break free from the hierarchically organized forms of stigmatic othering that characterized the exhibitionary complex and provide more socially invigorating and, from a civic perspective, more beneficial interfaces between different cultures. There are, however, sharp differences of opinion about how this challenge might best be met. It will prove productive to consider these less with a view to seeing how they might be resolved in favor of one perspective against others than for the light they throw on the current predicament of museums as they seek to negotiate the tensions arising from the contradictory relations between international public spheres and their position within what remain nationally or locally defined arenas of civic governance.

One strategy, and it is the predominant one, stems from the conception of museums as the kind of "differencing machine" proposed by official policies of multiculturalism. The emphasis here is on developing the museum as a facilitator of cross-cultural exchange with a view to taking the sting out of the politics of difference within the wider society. According respect and recognition to previously marginalized or repressed histories and cultures, opening up the museum space to the representatives of different communities by providing them with opportunities for authoring their own stories, connecting exhibitions to programs of intercultural performance, repatriating objects collected through earlier colonial histories where the retention of those objects in museums generates ongoing cultural offense: these are now significant aspects of contemporary museum practice. That said, their legacy is perhaps most publicly evident—and most publicly debated—where new national museums have been formed in so-called settler societies with strongly developed official commitments to multiculturalism or, in the case of New Zealand, biculturalism: the Canadian Museum of Civilisation, Te Papa Tongarewa, and the new National Museum of Australia are good examples.[31] These provide compelling evidence of the respects in which museums articulate the logic of culture to nationalist frameworks, seeking to move the imagined community of the na-

tion from outmoded forms of identification and perception to new ones and, in the process, articulating relations of similarity and difference in new ways.

Take the National Museum of Australia: opened in 2001 to mark the first centenary of Australia's establishment as a federation, its governing themes are land, nation, and people. The relations between these intersect with the museum's commitment to act as a "people mover" on a number of fronts simultaneously: articulating a postcolonial agenda by placing the story of British colonization in the context of longer and ongoing histories of movement and settlement; questioning narratives of settlement by according equal—if not greater—weight to Aboriginal perspectives on the process of colonization as one of invasion and conquest through a frontier history characterized by ongoing racist massacres; lending credence to Aboriginal claims to prior Aboriginal ownership of the land by foregrounding the role of scientific archaeology in establishing the antiquity of Aboriginal culture and civilization; and challenging the centrality of Anglo-Celtic contributions to the Australian story by emphasizing the contributions made by successive periods of non-Anglo migrants. These, in brief summary, are some of the more obvious ways in which the museum spoke to and into some of the major Australian public political debates of the period (the most significant being that over the report on the "stolen generation" of Aborigines who had been forcibly removed from their families and that over the developing refugee crisis) in ways that often stood in marked contrast to the position of the Howard government.[32] This provoked a good deal of controversy. The museum's depictions of the colonial frontier were alleged by the conservative historian Keith Windschuttle to credit accounts of the numbers massacred passed down within Aboriginal oral tradition, even when these might lack documentary confirmation.[33] This, in turn, occasioned a significant public debate regarding the position and responsibilities of museums in mediating the relations between the authority of memory and that of documented history. Indeed, this debate formed a part of the background against which, very shortly after the museum opened, the Howard government set up a panel to review the National Museum's exhibitions and public programs. Although largely right of center in its composition, the panel produced a report in July 2003 that exonerated the museum of any systematic bias while at the same time criticizing it for a lack of balance in certain areas.[34] These included its exhibition of the colonial frontier, a judgment that echoed the tenor if not the detail of Windschuttle's criticisms that these paid insufficient attention to the need for both documentary evidence and the exhibition of objects with a clearly authenticated relation to the events in question.

Political reactions of this kind make it clear that museums seeking to im-

plement official multicultural policies can be perceived as "going too far" or can rapidly fall out of step with changing policy agendas. Both aspects were true of the National Museum of Australia. While a good deal of the museum's philosophy was developed during the period of the Hawke/Keating Labor governments, when official support for the agendas of multiculturalism and for a reconciliation of white and Aboriginal Australia was high, the realization of this philosophy occurred under the Howard administration, noted for its hostility to both of these principles—so much so that "multiculturalism" came to be known as "the *m* word" owing to Howard's evident reluctance to ever actually say it. Out of step with its political masters, the National Museum was also, some of its critics have argued, out of step with public opinion in failing to register how many Anglo-Celtic Australians felt challenged by Australia's cultural pluralization. Nor is it only conservatives who took this position. Intellectuals on the left have also suggested that by failing to take sufficient account of the deep cultural purchase of many of the traditional nationalist sentiments that, in its reforming zeal, it took issue with, the museum, while attempting to shift identities and perceptions in one direction, may for some have had the opposite effect of congealing habitual identifications and perceptions. The essence of the charge here is that the museum, as a "people mover" acting under the auspices of the state, has not been able to strike the right balance in putting the logic of culture to work in managing a transition to a new articulation of relations of similarity and difference within the framework of a national imaginary. It is thus notable that perhaps the most significant refrain in the report of the panel appointed to review the museum was the need for a strong and coherent narrative governed by the themes of discovery, exploration, and development to replace the stress it had initially placed on "interpretative pluralism."

From a second perspective, however, the very participation of museums in attempts to manage relations of cultural diversity in these ways is a problem in and of itself, owing to the ethnocentric assumptions and forms of control that it entails. Ghassan Hage's concept of "zoological multiculturalism" is a useful summary of this line of argument. For Hage, the multicultural museum is too often "a *collection* of otherness" in which diversity is displayed as a national possession.[35] Its roots, he argues, lie within the earlier history of the colonial ethnographic showcase in view of the relationship of possession and control that this established in constituting other cultures as the objects of an organizing and controlling ethnographic gaze. The main change, as he sees it, is one of context:

For, if the exhibition of the "exotic natives" was the product of the power relation between the coloniser and the colonised *in the colonies* as it came to exist

in the colonial era, the multicultural exhibition is the product of the power re-
lation between the post-colonial powers and the post-colonised as it developed
in the metropolis following the migratory processes that characterised the post-
colonial era.[36]

The issues to which these objections point concern the disposition of the semi-
otic frames within which relations of difference are organized and depicted.
The principal shortcoming of zoological multiculturalism in this respect is that
it echoes what Hage sees as the chief weakness of multiculturalism as social
and cultural policy. Just as the latter constructs and organizes cultural diversity
from a position of whiteness that remains the assumed governing center from
which diversity has to be managed, so zoological multiculturalism results in
museum displays that are governed from and by a position of whiteness that
constructs diversity as a national possession, a sign of its own tolerance and
virtue. Hage again:

> While White multiculturalism requires a number of cultures, White culture is
> not merely one among those cultures — it is precisely the culture which pro-
> vides the collection with the spirit that moves it and gives it coherence: "peaceful
> coexistence."
>
> Here again, however, for exhibitionary purposes this time, left to themselves
> "ethnic" cultures are imagined as unable to coexist. It is only the White effort
> to inject "peaceful coexistence" into them which allows them to do so. Like all
> elements of a collection, "ethnics" have to forget those "unexhibitable" parts
> of their history and become living fetishes deriving their significance from the
> White organising principle that controls and positions them within the Austra-
> lian social space.[37]

It is in response to difficulties of this kind, and the need to go beyond diver-
sity as a possession to its conception as an ongoing process of intercultural
dialogue, that Anthony Shelton, drawing on his experience of rearranging the
exhibitions at London's Horniman Museum while its director, advocates the
virtues of hybridity and dialogism as regulative principles for museum prac-
tices. The advantage of these principles, Shelton contends, is in the means they
offer for engaging with difference without either reifying it into separate ethni-
cized enclaves (with all of the dangers this entails) or orchestrating the relations
between cultures-in-difference from a governing discursive position that, in
spite of its open-minded tolerance, thereby remains resolutely monological.
Far from anchoring objects in a fixed relation to specific cultures, the per-
spective of hybridity focuses on their role in mediating the relations between
different cultures, belonging to none exclusively, but operating always in mo-

tion in the context of complex histories of transactional exchange. Similarly, viewed in its Bakhtinian lineage, the perspective of dialogism stresses the need to dismantle the position of a controlling center of and for discourse, paying attention instead to the multiaccentuality of meaning that arises out of the dia- logic to-and-fro, the discursive give-and-take, that characterizes processes of cross-cultural exchange.[38]

The implications of these principles, when translated into exhibition prac- tices, favor the production of decentered displays in which objects and texts — rather than being "spoken" from a clearly enunciated controlling position — are assembled so as to speak to one another, and to the spectator, in ways that allow a range of inferences to be drawn. The resulting principle of "ca- cophony," as Nélia Dias describes it, involves a number of breaks with earlier museum practices: it questions the virtue and validity of the traditional ethno- graphic practices of observation and description by denying the availability of a position of discursive neutrality on which such practices depended; it stresses flux, fluidity, and indeterminacy — the restlessness and permanent im- permanence of things, meanings, and people in movement; and it stresses the dialogic virtues of speaking and hearing in relations of discursive reciprocity over the more fixed organization of attention associated with the museum's traditional form of directed ocular-centrism.[39] It is in the light of this last con- sideration that we can appreciate the major revival of interest in the museum's various precursors — cabinets of curiosities, *Kunstkammern, Wunderkammern*, et cetera — for the evidence they provide of a different, and less disciplinary, ordering of vision in which the eye, rather than being fixed before the scene of the exhibition in order to register its (singular) lessons, was, in seeking to deci- pher the puzzling relations such collections posed, pulled into the polyphonic forms of "chattering" that characterized the relations between their objects.[40]

Here, then, are new practices that, precisely in their reinvention of older ones, constitute a departure from the privileging and regimentation of vision associated with the exhibitionary complex. It would be wrong, though, to see this as entirely new. There is, Dias reminds us, a longer history connecting attempts to detach museums from hierarchical arrangements between differ- ent cultures to the reorganization of practices of looking. The case she has in mind is Franz Boas's introduction of the human life group into the American Museum of Natural History and its role, by no means unproblematic, in pro- moting the view that different cultures should be exhibited and represented on their own terms rather than — as had been the implication of the typologi- cal method, which Boas aimed to supplant — being ranked in evolutionary se- quence from the perspective of a single, Eurocentric set of values and optical vantage point.[41] This shift, related to the emerging influence of habitat displays

for illustrating the variability of species and their relations to their environments, was part of a more general development leading from a morphological conception of the basic grammar of natural history and ethnological museum displays to an ecological one. It also reflected new ways of framing the scene of exhibition that were more closely aligned with the scopic pleasures of cinema and, perhaps more importantly, new ways of involving the viewer in that scene. Dias, contrasting the life group with the more directed and distanced forms of seeing associated with typological displays, argued that the life group both invited and promoted a more participative look—she likens its mechanisms to those of the coup d'oeil—that involved the viewer in an associative practice of knowledge and memory, constructing an image of a culture through the associations she or he establishes between its component parts:

> Whilst the typological arrays allowed the viewer to recognise what he or she already knew before (in this case, linear evolution), life groups . . . facilitated the viewer's process of cognition, and enabled the viewer to establish his or her own correlations. In a certain way in the life group, the viewer was invited to occupy the anthropologist's place, in order to see what he or she had seen in the field.[42]

Of course, this still privileges a particular point of view, an ethnographic gaze that constructs other cultures as its object. Be this as it may, it makes the point that transformations of the exhibitionary complex that have aimed at developing a relativizing and pluralizing civic task for museums have usually entailed the development of new forms of vision and perception.

MUSEUMS, CULTURE, AND CONTRADICTION

The arguments briefly reviewed above stand out as among the most innovative aspects of contemporary museum theory and practice. And the case seems a compelling one: these are the kinds of exhibition practices that are needed to break with the discursive and sensory ordering of the exhibitionary complex in order to open up new possibilities for negotiating relations of cultures-in-difference. One can also see the ways in which they meet arguments coming from the literature on "contact zones," which has stressed the role of museums as mediators in complex histories of cultural exchange.[43] But (there is always a "but") such practices are also in some respects worrying when the role museums play, when viewed in the light of the logic of culture, is considered in terms of their relations to the dynamics of social class. I want to draw on Ghassan Hage again here for the illumination he throws on how a commitment to the value of cultural diversity can function as part of a cosmopolitan forma-

tion that—aided considerably by museums and art galleries—binds together international intellectual and cultural elites in shared practices and values, but often at the expense of widening divisions between those elites and other classes within national polities. In Hage's words:

> The cosmopolite is an essentially "mega-urban" figure: one detached from strong affiliations and roots and consequently open to all forms of otherness. . . . Just as important as his or her urban nature, the cosmopolite is a *class* figure *and* a White person, capable of appreciating and consuming "high-quality" commodities and cultures, including "ethnic" culture.[44]

Hage's point here is that the forms of cultural capital that are required if one is to become adept in the practices of "cosmo-multiculturalism" are far from being evenly distributed throughout the social body; rather, they are restricted to educated elites. If this is so in relation to those forms of multiculturalism that retain a central, implicitly white, coordinating discursive position, the same is true—only considerably more so—of the kinds of cultural capital that are called for in order to engage with dialogic and hybrid representations of cultures-in-difference. It is, I think, clear that the influence of such conceptions owes a good deal to their currency within the practices of modern art museums and art spaces, where they function as parts of strategies for the renovation of perception through the defamiliarization of habituated modes of seeing. Yet the publics for such institutions are notoriously more socially restricted than for other kinds of museum.

There is, then, to the extent that these tendencies constitute an aestheticization of museum practices more generally, a risk that in the very process of fostering greater and more open cross-cultural dialogue among cosmopolitan elites, museums may do little to address racialized forms of social conflict arising from the relations between sections of the white working and lower middle classes, whose only experience of globalization is deindustrialization and unemployment, and the migrant communities who live in close proximity, usually in contexts where the housing stock, social services, and public amenities are under tremendous pressure. The more museums prioritize their role in relation to what might from one perspective be viewed as global public spheres, or from another as international tourist networks, the greater the risk that they might forget their civic obligations in relation to the spheres of local and national governance.

That these are not idle concerns is evident from recent events. The support for Jean-Marie Le Pen in France, the rise of Hansonism in Australia and more recently the refugee crisis there, the race riots in the north of England in the summer of 2001—these are all symptoms of a deep malaise in the body

politic of contemporary societies. It is also arguable that this malaise is wors-
ened by a deepening sense on the part of white working-class constituencies
of being less a party to, than an object of critique within, those discourses —
evident in the official languages of law and administration as well as in the
major institutions of public culture (schools, colleges and universities, public
service broadcasting, libraries, and museums) — which promote an acceptance
of cultures-in-difference. Where this results in a discursive environment that
mobilizes and legitimizes ongoing hostility toward racialized minorities, the
risk is equally real that the latter will also opt for ways of maintaining and
developing their own specific cultures and values that rest more on separatist
values than on dialogic ones. Nor is it difficult to see here how, against its better
history, the community museum movement might, in providing hard-pressed
cultures with minimal sustenance, serve to reinforce the divisions between dif-
ferentiated communities as rigidly distinct enclaves.

It is, Pierre Bourdieu argues, an effect of the "scholastic illusion" that intel-
lectuals, scarred by a separation from the world that is the other side of their
relative freedom and autonomy, believe that changes in behavior come about
as a result of prior changes in consciousness wrought by the critical work
of intellectuals. In its contemporary form, Bourdieu contends, this illusion,
which is rooted most strongly in the abstraction of the humanities academy
from the "realities of the social world," produces a tendency toward an "un-
realistic radicality."[45] I draw on Bourdieu here because there is, finally, another
perspective from which we might look at the relations between museums, pub-
lic cultures, and global processes: that concerning the much greater traffic that
takes place between museums and the humanities disciplines in what is now
a more extensively internationalized university sector. There is little doubt
that this has been productive and invigorating, generating the effervescence
of the "new museology" that has been so crucial to the critical reexamination
of earlier legacies that has been required for the development of new museum
practices. At the same time, however, there is the risk that an "unrealistic radi-
cality" might also be translated into the practices of museums at the price of a
decline in their ability to connect with the ways in which socially majoritarian
behaviors and values are routinely reshaped and transformed. No program of
social change, Bourdieu argues, can neglect "the extraordinary inertia which
results from the inscription of social structures in bodies," meaning that be-
havior cannot be altered simply at the level of a change or raising of conscious-
ness but must involve "a thoroughgoing process of countertraining, involving
repeated exercises."[46]

Transforming the exhibitionary complex similarly entails a recognition that
museums function as civic technologies in which the virtues of citizenship are

acquired, and changed, in the context of civic rituals in which habitual modes of thought and perception are transformed not through sudden acts of intellectual conversion but precisely by acquiring new habits through repeated exercises. If they are to provide such exercises in a new civics, museums need to take account of the different ways in which they can intelligibly relate to sharply diverging constituencies and publics in the context of complex intersections of class and racialized social divisions. And this means, among other things, taking account of the complex and contradictory ways in which their capacity to act as "people movers" is shaped by the ways in which they activate the logic of culture in the context of such intersecting social divisions.

NOTES

The research for this paper was finalized under the auspices of the ESRC Centre for Research on Socio-cultural Change. I am grateful to the ESRC for its support.

1 Hirst and Thompson, *Globalisation in Question.*

2 Held et al., *Global Transformations.*

3 Greenhalgh, *Ephemeral Vistas.*

4 Bennett, "The Exhibitionary Complex," 92.

5 Breckenridge, "The Aesthetics and Politics of Colonial Collecting," 196.

6 Ibid., 214.

7 Hoffenberg, *An Empire on Display*, 63.

8 Pomian, *Collectors and Curiosities*; Golinski, *Science as Public Culture.*

9 I have argued elsewhere why I think it is difficult to sustain this view. See Bennett, "Intellectuals, Culture, Policy."

10 Duncan and Wallach, "The Universal Survey Museum"; McClellan, *Inventing the Louvre.*

11 Prakash, "The Colonial Genealogy of Society"; Prosler, "Museums and Globalization."

12 Figal, *Civilisation and Monsters*, 22.

13 Tadao et al., "Edo-Tokyo as an Instrument of Civilisation," 165.

14 Tanaka, *Japan's Orient.*

15 Ray, *The Logic of Culture*, 3.

16 Ibid., 3.

17 Ibid., 16. I should stress, though, that I do not press this interpretation of culture as one that must displace all others — the term is far too much of a semantic shifter for such prescription to be intelligible. The aspect of Ray's discussion that I most value is that it sets up a tension between culture as a historically specific mechanism for the shaping of identities, on the one hand, and, on the other, everyday customs, values, and traditions, which others often view as a part of the extended definition of culture but which here constitute the ground on which culture works. If this gap is closed down, analysis is unable to engage with the operations of this mechanism. That said, Ray's account of the ways in which this mechanism works is a little too abstract and

generally stated. The result is an overunified account of culture as always working through the same operations rather than, more convincingly, a more ad hoc assembly of different machineries for the shaping of identities and conducts.

18 Crary, *Suspensions of Perception*, 79.

19 Bourdieu, *Distinction*.

20 Ray, *The Logic of Culture*, 91.

21 Clifford, "On Collecting Art and Culture," 224. This is an effect of the operation of what James Clifford calls the art-culture system.

22 Pagani, "Chinese Material Culture"; Prakash, "The Colonial Genealogy of Society."

23 Pollock, *Differencing the Canon*.

24 Felski, "The Invention of Everyday Life."

25 Sandberg, "Material Mobility," 8.

26 Bennett, "Pedagogic Objects, Clean Eyes and Popular Instruction."

27 Lewis, in *For Instruction and Recreation*, provides the best account of the early history of the Museums Association, which from its establishment in the 1880s was the only international Anglophone museum network prior to the establishment, from the 1890s on, of separate ones in the United States, Australia, and Canada. Kavanagh, in *Museums and the First World War*, gives some sense of the declining influence of international networks on the activities of museums in the 1914–45 period.

28 This was most evident in the implications of Nazi *Kunstpolitik* for the practices of German art museums. See Petropoulos, *The Faustian Bargain*.

29 Kymlicka's *Politics in the Vernacular* has been especially important in distinguishing the principles on which Indigenous and multicultural claims to difference rest.

30 Shelton, "Museums in an Age of Cultural Hybridity," 222.

31 McIntyre and Wehner, *Negotiating Histories*.

32 I draw here on the BBC television program *The Museum of Conflicted Histories*—which, with Claire Lasko of Diverse Productions, I made for the Open University course Sociology and Society. The program includes interviews with the museum's director, Dawn Casey, and three curators—including Mike Smith, who was responsible for the exhibits relating to the environment, and Margo Neale, who was responsible for the Gallery of Aboriginal Australia. There are also interviews with Keith Windschuttle, with Australian academics Bain Attwood, Ghassan Hage, and Tim Rowse, and with members of the Aboriginal Tent Embassy in Canberra.

33 Windschuttle's criticisms of the National Museum of Australia are informed by his more general criticisms of what he sees as widespread historical fabrication by historians who have interpreted the colonial frontier as one characterized by widespread racial massacres. See Windschuttle, *The Fabrication of Aboriginal History*.

34 Commonwealth of Australia, *Review of the National Museum of Australia*.

35 Hage, *White Nation*, 158.

36 Ibid., 160.

37 Ibid., 161.

38 Bakhtin, *The Dialogic Imagination*.

39 Dias, "Looking at Objects," 173.

40 Bredekamp, *The Lure of Antiquity*; Daston and Park, *Wonders and the Orders of Na-*

ture; Durrans, "Talking in Museums"; Pomian, *Collectors and Curiosities*; Stafford, *Artful Science*.

41 George Stocking Jr. notes how Boas's critic John Wesley Powell, representing evolutionary anthropology at the Smithsonian Institution, was able to accuse Boas of essentializing differences by ignoring the interchanges between different tribal units. See Stocking, "The Space of Cultural Representation," 171–72.

42 Dias, "Looking at Objects," 173.

43 Clifford, *Routes*; Thomas, *Entangled Objects*.

44 Hage, *White Nation*, 201.

45 Bourdieu, *Pascalian Meditations*, 41.

46 Ibid., 172.

The Reappearance of the Authentic

MARTIN HALL

Disneyland is presented as imaginary in order to make us believe that the rest is real, when in fact all of Los Angeles and the America surrounding it are no longer real, but of the order of the hyperreal and of simulation. It is no longer a question of false representation of reality (ideology), but of concealing the fact that the real is no longer real, and thus of saving the reality principle.

—Jean Baudrillard

The authenticity of a thing is the essence of all that is transmissible from its beginning, ranging from its substantive duration to its testimony to the history which it has experienced. Since the historical testimony rests on the authenticity, the former, too, is jeopardized by reproduction when substantive duration ceases to matter. And what is really jeopardized when the historical testimony is affected is the authority of the object.

—Walter Benjamin

Is the world a simulation? Do the themed experiences of Disneyland, San Francisco's Metreon, Kinepolis in Brussels, Japan's burgeoning theme parks, or South Africa's Lost City stand for a hyperreality that is now everything, or are the lives of the majority of people rarely touched by such extravaganzas?[1] Are material objects—"things," "artifacts"—still essential to

grounding our sense of identity? And what are the consequences of questions such as these for museums in the global public spheres of the contemporary world?

The playfulness of themed experiences is matched by a more sober engagement with the material world. For all the appeal of simulated environments, material things matter, and are more than "tourist gazes" that can be collected as photographs.[2] For a group of Tlingit elders meeting with curators in the Portland Museum of Art, the masks, headdresses, and other artifacts from the collections were the occasion for storytelling, establishing a "contact zone" critical to the performance of identity.[3] For onetime residents of District Six in Cape Town, whose homes were destroyed in the apartheid removals of the 1960s, the bric-a-brac of everyday life is reconstituted as precious memorabilia, the skeleton of memories.[4] For many in India, the violence of history continues into the future, as complex issues of identity, privilege, and politics are realized through claims and counterclaims over the foundation stones of temple and mosque at Ayodhya. In the Balkans, genocide and the destruction of cultural property have been intertwined, an ethnic cleansing of both people and the materiality of their identity. There seems to be a connection between the marking of ethnicity through material culture and genocide — elision of people with the artifacts that define them seems to make the killing easier, to aid the transformation of ordinary people into their neighbors' killers.

This essay explores the paradox in juxtapositions such as these — of material objects in a world that seems at the same time destined to simulation. How can the claims for hyperreality be reconciled with the urgency with which many people grasp the material culture of their identity, or the ferocity with which they attack the cultural property of others? What does it mean when the simulation implodes, when the celluloid crinkles and catches fire and the specifics of time, place, and object are reasserted as primary?

My argument starts with a small example, seemingly trivial. In their study of the World Showcase at Walt Disney World's Epcot, Cory Kratz and Ivan Karp find an unexpected aesthetic in the five museums that form part of the theme park. These presentations of the culture of Japan, China, Mexico, Morocco, and Norway are surprisingly conventional. In a setting that foregrounds futuristic extravaganza and which uses the most advanced techniques of automation and simulation to amaze visitors and transport them to a fantasy world, the museum displays rely on conventional dioramas, presentation themes, and boutique lighting that draws attention to the inherent qualities of the object itself, often on loan from leading public museums.[5]

Visiting Disney World's latest theme park ten years later, I found the same approach in displays at the Animal Kingdom Lodge — the same apparent in-

consistency of a conventional museum inside a high temple of simulation. African artworks are displayed in the lobby and other public areas on freestanding plinths, with uncluttered Perspex cases and boutique lighting, and minimal, traditionalist labels such as "Initiation mask, Pende People, Democratic Republic of Congo," "Feathered hat, Cameroon" and "Male and female couple, Lobi people, Ivory Coast." The centerpiece is a giant Ijele headdress with an interpretative display that recounts its making and use in standard ethnographic style: "The Igbo people of Nigeria enact their traditions and beliefs through the arts of dance and music. Masks are central to their celebration of history, spirit being and scenes of daily village life. The grandest of these 'masquerades' is Ijele, a giant structure that incarnates the spirits of Igbo ancestors."

In contrast with this celebration of authenticity—of the originality of the work of art—Animal Kingdom Lodge is pure simulation, Disney at its best. As Cypher and Higgs have shown in their detailed analysis of Wilderness Lodge (the work of the same architect), the effect is created by distilling the detail from a set of exemplars into a simulacrum—an edifice that combines the best of its sources while disclaiming to be a copy of any particular original.[6] Thus Animal Kingdom Lodge is inspired by the detailed study of a set of East Africa's best safari lodges as well as other sources, such as the "Shaka Zulu" footprint for the massive semicircular kraal of guest rooms. The lodge's architecture impresses through scale, with a massive four-story lobby, scaled-up carvings, and a dark interior highlighted by pools of light, flickering illumination from the fire pits, and the suggestion of distant storms. Carefully placed speakers provide faint African rhythms, singing, and the sounds of cicadas, evoking the savanna. This theme is equipped with ethics by means of a prevalent association with conservation and the mission to save the planet. Guests are asked to "assist the animal care staff in maintaining the health and safety of the animals" so that the lodge is "a safe and magical place for everyone and every creature."

As a simulacrum, Animal Kingdom Lodge aspires to be better than the originals that inspired it. The guest is treated as an intelligent participant in the simulation. This is not an elaborate trick of false consciousness—a pretense of transportation to the Serengeti—any more than the film *Titanic* seeks to convince the movie audience that they are "really" about to sink into the icy waters of the Atlantic. Disney environments such as Animal Kingdom Lodge are better than the big screen and several notches up from Imax; they are a wraparound simulation that plays on all the senses at once, an invitation to join in a sophisticated game.

Consequently, the resort to the conventional museum display and ethno-

graphic focus on the inherent qualities of the object is counterintuitive. Disney's imagineers are quintessential semioticians who would, we would expect, identify firmly with Tony Bennett's summary of the destiny of material things as "rhetorical objects," signifiers with no inherent meaning.[7] Indeed, the Walt Disney Company is the apotheosis of the mechanical reproduction of the work of art that Walter Benjamin, writing in 1936, saw as the end of the "authority of the object."[8]

There is, then, something here that needs to be explained. An appropriate point at which to start is the question of "artifactual autonomy." Barbara Kirshenblatt-Gimblett has presented this as a surgical matter. "The artfulness of the ethnographic object," she writes, "is an art of excision, of detachment, an art of the excerpt. Where does the object begin, and where does it end? . . . [S]hall we exhibit the cup with the saucer; the tea, the cream and sugar, the spoon, the napkin and placemat, the table and chair; the rug? Where do we make the cut?"[9] Her observation can just as well be applied to any object in a display, ethnographic or otherwise, and can be turned on its head to ask whether the object can be excised completely, leaving only its representation — perhaps a photograph of cup and saucer that evokes, as a minimum, the same responses as if the original place setting were behind the Perspex. This takes us into the realm of semiotics and the relationship between signifier and signified — questions for later in this essay. Here, I want to explore Bennett's assertion that the artifact has no autonomy in itself but is rather part of a representational machine, the "exhibitionary complex." It is important to do justice to Bennett's position here. The key passage is as follows:

No matter how strong the illusion to the contrary, the museum visitor is never in a relation of direct, unmediated contact with the "reality of the artefact" and, hence, with the "real stuff" of the past. Indeed, this illusion, this fetishism of the past, is itself an effect of discourse. For the seeming concreteness of the museum artefact derives from its verisimilitude, that is, from the familiarity which results from its being placed in an interpretative context in which it is conformed to a tradition and thus made to resonate with representations of the past which enjoy a broader social circulation. As educative institutions, museums function largely as repositories of the already known. They are places for telling, and telling again, the stories of our time, ones which have become a doxa through their endless repetition. If the meaning of the museum artefact seems to go without saying, this is only because it has already been said so many times. A truly double-dealing rascal, the museum artefact seems capable of lending such self-evident truths its own material testimony only because it is already imprinted with the sedimented weight of those truths from the outset.[10]

For Bennett, the "birth of the museum" can be best understood through an extension of Foucault's concepts of power and order, as used to understand regimes of discipline and punishment and the construction of penal institutions. Where the prison sought order by removing punishment from the carnivalesque, unruly public space and substituting a clinical regime hidden within the institution's walls, the museum contributed to social regulation by promoting a public morality of education and improvement. In this, the museum was one of the essential projects of modernism, closely bound up in the nineteenth-century momentum of industrialization and the rise of the bourgeoisie.

More generally, this exhibitionary complex supported, and was supported by, other aspects of nineteenth-century public life — events and spectacles such as the Highland Games (with royal patronage from 1852), the Royal Tournament (from 1888), and the Promenade Concerts (from 1895). "Participating at least once in these leisure events came to be an important part of the emergent sense of Britishness in the late nineteenth century, a sense increasingly derived from people's leisure activities."[11] Leisure in general, and holidays in particular, were promoted as beneficial to health and progress, and the technology of roads and railways underpinned the rise of mass tourism, seaside resorts, holiday camps, and eventually the theme parks and heritage industry that are the context for museums today.[12]

While there was, of course, variation in the form and content of museums, Bennett has shown how, through the later nineteenth and early twentieth centuries, there was an interlinked set of overarching concepts and assumptions that shaped museum themes, the organization of their displays, and (where this was possible) their architecture. This was the idea of the progress of humanity toward its pinnacle in European civilization, given evidence by means of the "exhibitionary disciplines" of history, art history, archaeology, geology, biology, and anthropology. Museums organized their displays, where they could, as a linear path through these exhibits, building up a story of global coherence and purpose: "the superimposition of the 'backtelling' structure of evolutionary narratives on to the spatial arrangements of the museum allowed the museum — in its canonical late-nineteenth-century form — to move the visitor forward through an artifactual environment in which the objects displayed and the order of their relations to one another allowed them to serve as props for a performance in which a progressive, civilizing relationship to the self might be formed and worked upon."[13] This, then, was more than an attempt to impose a dominant ideology through subterfuge. The exhibitionary complex worked to construct an idea of the self as the subject of knowledge — the story of humanity's progression — while also identifying the visitor as the object of

the exercise, exhorting the reform of manners through decency of dress, language, and behavior in the public domain. As with Foucault's prison, this could involve the design of the panopticon, "a technology of vision which served not to atomize and disperse the crowd but to regulate it, and to do so by rendering it visible to itself, by making the crowd itself the ultimate spectacle."[14]

In seeking to civilize the new industrial proletariat, nineteenth-century museum curators turned more to the sequence of displays and the information provided for the visitor. In contrast to the curiosity cabinets and private collections of earlier years, museums turned decisively away from evoking surprise and wonder at the object itself—whether three-legged chicken or priceless gemstone—and toward more sober and didactic information. Sir William Flower, curator of London's Natural History Museum, wrote in 1898:[15]

> First, as I said before, you must have your curator. He must carefully consider the object of the museum, the class and capacities of the persons for whose instruction it is founded, and the space available to carry out this object. He will then divide the subject to be illustrated into groups, and consider their relative proportions, according to which he will plan out the space. Large labels will next be prepared for the principal headings, as the chapters of a book, and smaller ones for the various subdivisions. Certain propositions to be illustrated, either in the structure, classification, geographical distribution, geological position, habits, or evolution of the subjects to be dealt with, will be laid down and reduced to definite and concise language. Lastly will come the illustrative specimens, each of which as procured and prepared will fall into its appropriate place.[16]

For Sir William Flower, then, there was no "artifactual autonomy." In the exhibitionary complex the message is everything, the object an illustration of an interpretation of the world.

In some respects, Flower's credo seems as germane to our world as to his, and he reads today as a plausible imagineer. Indeed, the design and realization of Disney World followed the same track as the rearrangement of the Natural History Museum in 1884: Walt Disney's careful consideration of the purpose of his new complex and his evaluation of the space available in central Florida, his division of the overall theme into "kingdoms" and the determination of the propositions that each would address, and finally the design of the installations, each falling "into its appropriate place."[17]

This, though, would be to miss the main point of the exhibitionary complex—the economic and social context that the new museums served, and in which they flourished. Bennett shows how the nineteenth-century museum was a product of bourgeois anxiety about the proclivities of the working class.

By proclamation museums were inclusive. In the sententious prose of one com-
mentator on the opening of a new gallery at the Victoria and Albert Museum
in 1858: "The anxious wife will no longer have to visit the different taprooms
to drag her poor besotted husband home. She will seek for him at the near-
est museum, where she will have to exercise all the persuasion of her affection
to tear him away from the rapt contemplation of a Raphael."[18] But in prac-
tice, museums served as an instrument for differentiating populations: "in spite
of its formally addressing an undifferentiated public, the practices of the mu-
seum served to drive a wedge between the publics it attracted and that recalci-
trant portion of the population whose manners remained those of the tavern
and the fair."[19] Through proscribing forms of behavior associated with raucous
public assembly, they filtered the respectable working class from the riffraff.
"Viewed in this light, the museum might be seen as issuing its visitors with both
a prompt and an opportunity to civilize themselves and in so doing, by treat-
ing the exhibits as props for a social performance aimed at ascending through
the ranks, to help keep progress on path."[20]

The issue, then, is not that the nineteenth-century emphasis on thematic
displays is preternaturally postmodern, but rather is whether or not the eco-
nomic and social conditions that generated the exhibitionary complex apply
today. They clearly do not. Rather than responding to the circumstances of
rapid industrialization, public institutions today are shaped by deindustrial-
ization, new ethnic identities, the rise of service economies, and the widespread
loss of credibility in the idea of unitary progress in the face of manifest social
inequities. The key to understanding the authority of the artifact — whether in
an archive in Sarajevo or a theme park in California — is not in stretching the
exhibitionary complex beyond the historical context for which it was formu-
lated. Rather, it is in looking at the economic and social determinants of the
"museum effect" today.

In his now-classic interpretation of the postmodern as advanced capitalism,
Jameson argues that "culture" has become a "second nature," "a prodigious ex-
hilaration with the new order of things," the celebration of commodification
as a process.[21] This can be seen as originating in the coincidence of informa-
tion technology, the crisis of the nation-state, and the rise of new international
movements such as environmentalism and feminism, together prompting new,
transnational forms of organization.[22] This "network society" has an economy
with the capacity to work as an integrated unit in real time and on a global
scale, resulting in new patterns of capital flows and increasing division between
the world at large and the triangle of wealth and power that is North America,
the European Union, and the Asian Pacific region. This has resulted in a new

cultural code, "a multifaceted, virtual culture, as in the visual experiences cre-
ated by computers in cyberspace by rearranging reality." Rather than a fan-
tasy, this is a force that "informs, and enforces, powerful economic decisions
at every moment in the life of the network."[23]

Information and media are, of course, central to this network society.
The convergence of digitization of telecommunications, broadband transmis-
sion, and a marked increase in computer performance has allowed interactive,
computer-based, and flexible systems of communication. At the same time, the
widening disparity between centers of wealth and zones of poverty promotes
the widespread migration of people, with information elites who service global
service economies, and large numbers of generic laborers who fill low-paid
positions in the new service sectors and support their families at home through
remittance economies. This is prompting new forms of ethnicity, as diasporic
communities identify with homelands to which they rarely return and may
never have known. Arjun Appadurai has shown how media and migration are
interconnected in the constitution of subjectivities. Electronic media

> transform the field of mass mediation because they offer new resources and new
> disciplines for the construction of imagined selves and imagined worlds. . . .
> Through such effects as the telescoping of news into audio-video bytes, through
> the tension between the public spaces of cinema and the more exclusive spaces
> of video watching, through the immediacy of their absorption into public dis-
> course, and through their tendency to be associated with glamour, cosmopoli-
> tanism, and the new, electronic media (whether associated with the news, poli-
> tics, family life, or spectacular entertainment) tend to interrogate, subvert, and
> transform other contextual literacies.[24]

Whatever the continuities with earlier years, then, the last quarter of the twen-
tieth century saw significant changes in the nature of social and economic life:
information technology and transnational economic and social institutions; a
widening gulf between a developed core and subordinate economies; global
diasporas and new ethnic identities, no longer entirely tied to specified geo-
graphical regions; and, in developed economies, deindustrialization and the
rise of dominant service economies. Pine and Gilmore have proposed that
these changes have enabled a new economic form — an "experience economy"
that has, by extension of their argument, particular implications both for mu-
seums and for other "cultural sites." Their premise is that experiences can be
decoupled from services and understood as a form of economic output in their
own right. Experiences are offered "whenever a company intentionally uses
services as the stage and goods as props to engage an individual. While com-

modities are fungible, goods tangible, and services intangible, experiences are memorable."[25] Consequently, the experience economy depends not merely on entertaining customers but also on engaging them.

For Pine and Gilmore, an experience can be envisaged as having four "realms": entertainment, education, escape, and aestheticism. Education requires the active participation of the individual. Escapism requires immersion in the experience (in contrast to the passive observation of entertainment). The aesthetic requires quality of place: "the sweet spot for any compelling experience — incorporating entertainment, educational, escapist, and esthetic elements into otherwise generic space — is similarly a mnemonic place, a tool aiding in the creation of memories, distinct from the normally uneventful world of goods and services. Its very design invites you to enter, and to return again and again. Its space is layered with amenities — props — that correspond with how the space is used and rid of any features that do not follow this function."[26] Consequently, the key danger in the experience economy is the "commoditization trap" — the disillusionment of customers because things stay the same. In sharp contrast with service economies, the drive in the experience economy is toward customization, creating the impression that every experience is unique and has been developed for the individual alone. Ideally, service providers become "transformation elicitors" who "must determine exactly the right set of life-transforming experiences required to guide aspirants in achieving their goals."[27] Such simulated experiences are, of course, available only to those who can afford them, and the world that Pine and Gilmore foresee is the world of the elite of the network society. Indeed, the roots of such El Dorados are in the 1980s, in the nexus of developments that are now seen as formative of the network society. Early projects, such as the rejuvenation of Baltimore's and Boston's harbor areas, brought together public and private partnerships to establish festival marketplaces, clusters of specialty shops sharing historic and architectural themes and an emphasis on entertainment and eating. Profitability required "special activity generators" such as sports stadiums, casinos, convention centers, and entertainment complexes, providing the platform for the large-scale expansion of "themed entertainment" in the 1990s. Today, there is a clear pattern of urban regeneration that is to be found in cities across the world, bringing together in one place the primary consumer activities of shopping, dining, entertainment, education, and culture. By the end of the decade, almost every major multinational entertainment company had established a development team to evaluate and initiate "urban entertainment destination" projects, fueling a new urban economy with clear defining features: scripted themes, aggressive branding, twenty-four-hour opera-

1. New York City's Forty-second Street has become the type site for urban entertainment destinations, combining movies, theater, brand-name marketing, and dining in a neon extravaganza. Photo by Martin Hall, 2001.

tion, modularity (an increasingly standard set of components mixed in varying ways), isolation from surrounding neighborhoods, and a dependence on the spectacular (see figure 1).[28]

"Postmodern consumers" are attracted to such "urban destinations" by the technology of simulated experiences, which owe little to nostalgia and more to the appreciation of the technology behind the simulation and to the opportunities for accumulating cultural capital. "It is no accident that the profit core of themed restaurants and attractions is not from food, drink or the rides, but is generated instead from its logo-imprinted souvenir merchandise—acting as a passport stamp which confirms that the tourist has come and gone."[29] At the same time the experience economy is generating a demand for global travel that matches the allure of the urban themed zone with that of exotic destinations. Urry has termed this the "spectatorial gaze"—the valorizing of unique sites that can be collected through participation in international tourism.[30] In this form of the experience economy, towns, regions, and (potentially) whole countries can become "destination museums," offering immersion in a world other than one's own: "what is most ordinary in the context of the destination becomes a source of fascination for the visitor—cows being milked on a farm,

the subway in Mexico City during the rush hour, outdoor barbers in Nairobi, the etiquette of bathing in Japan. Once it is a sight to be seen, the life world becomes a museum in itself."[31]

Here, there is a close and mutually reinforcing connection between destination museums and photography, which is a means of "taming the object of the gaze" and facilitating the tourist in "collecting" experiences.[32] Photography gives form to the travel itinerary, providing a reason to take a particular route, stop, and then move on again. Through framing images, the tourist/photographer becomes a semiotician, recognizing that a shot with a thatched-roof cottage and roses represents the essence of England, or that a bare-breasted woman with a string of colorful beads stands for the essence of Africa. And photography completes the hermeneutic circle of tourism, in which the desire to travel and consume the experience of the exotic is initiated by travel brochures, magazines, travel documentaries, and the movies, and then recalled through photo albums, home movies, or digital images shared with family and friends via the Internet.[33]

Rather than providing a unifying morality in the way that the intertwined principles of progress, civilization, and Christian values gave common purpose to museum directors in the late nineteenth century, today's moralities are less certain. Pine and Gilmore recognize this, ascribing "transformation elicitors" a status that seems somewhere between therapist and priest, and with an obligation to "determine exactly the right set of life-transforming experiences required to guide aspirants in achieving their goals."[34] They believe that the experience industry will adopt, as a matter of course, a set of ethics akin to the fiduciary responsibility of the financial services industry. But it seems more likely that moralities themselves will be available for consumer choice. Current destination museums include Auschwitz-Birkenau, Changi Jail in Singapore, Nazi occupation sites in the Channel Islands, Dachau, extinct coal mines, Northern Ireland, northern Cyprus under Turkish "occupation," Pearl Harbor, Sarajevo's "massacre trail," and Vietnam.[35] Lennon and Foley's "dark tourism" includes concentration camps in Poland and Germany, the sixth-floor room in Dallas from which John F. Kennedy was shot, the site of the Oklahoma City bombing, and the place where Diana, Princess of Wales, was killed.[36] Given that pornography and travel arrangements are two of the most successful commercial uses of the Internet, it is likely that destination museums will cater to any predilection, whether this be for a sex tour in Thailand or medieval cathedrals in France.

What are the implications of such diverse destination projects for the nature of the museum — for the future of the authentic, the ethnographic object, or the work of art? In one sense, this is a tautology — the experience economy

has no terms of limitation, and the museum of the present and future can be whatever its creators wish it to be, or whatever its visitor-participants make of it. This, though, does not help in isolating the key changes that make today's "museum effect" essentially different from museum visiting a century ago.

My proposition is this. Bennett has shown how the nineteenth-century museum sought to reform the manners of its working-class visitors both through the metanarrative of progress toward civilization and through their physical participation in the bourgeois rituals of dress, language, and habits. In this, the exhibitionary complex seeks to change the individual's worldview and behavior through institutions of order and control. In contrast, I suggest, museums in the experience economy start not with institutions but with the individual, offering to those who can afford to participate the fantasy of a customized world, the opportunity to be who they want to be through the technologies of simulation. This is Foucault's penal institution inverted, the camera inside the prison walls, reality television and snuff movies.

As an interim — and tentative — device, this can be called the "experiential complex." I will draw out some of the ways in which museums "work" in the experiential complex through two rather different examples. But keep in mind the crux of the issue — the paradox of the reappearance of the authentic work of art in the stratosphere of simulation. It is my contention that the signal distinction between the exhibitionary complex and the experiential complex is the eclipse of the authentic artifact in the heyday of the classical museum, and its unexpected reappearance in the age of digital simulation.

The first example is a pair of museums in the northeast of England that are widely considered to be good examples of the contemporary approach to museum display and the needs of the visitor. Beamish, the North of England Open Air Museum, is a civic project administered by a consortium of city, county, and district councils. Established in 1970, it has the purpose of "studying, collecting, preserving, interpreting and exhibiting buildings, machinery, objects and information illustrating the development of industry and agriculture and way of life in the North of England."[37] In this, it has been singularly successful, winning a string of awards that includes both British Museum of the Year and European Museum of the Year and attracting large numbers of visitors to both its installations and its staged events. Set in the grounds of a onetime country house, Beamish comprises a model farm, a colliery and pit houses, and the main street of a market town — places that are imaginary, but which are assembled from "authentic" buildings and machinery from various parts of the northeast. They are linked by a period tramway and circular road that carries visitors, if they wish, in carriages.

Tony Bennett has shown how Beamish works to sentimentalize "the peo-

ple." Thus in the introduction to the museum, a "geological narrative" of plentiful mineral resources coincides with a cultural narrative of a tenacious regional spirit, a people tough enough to take advantage of the opportunities offered in coal mining. This story is framed by the "neutral" accent of a "BBC voice," preparing the visitor to see the people of the northeast "only through the cracked looking glass of the dominant culture."[38] From this introduction, the visitor moves to the installations themselves—the pit houses, the bandstand in the reconstructed market town, or other parts of the complex. Bennett notes that these features are marked not just by what they include but by what they exclude: labor and trade union movements, or the activities of women in suffrage and feminist campaigns. Beamish organizes a concept of the northeast by bringing together buildings and artifacts from a range of different places and periods, recontextualizing them as an integrated system with a harmonized set of relationships between town and country, agriculture and industry and different social classes. "The consequence is that the story of industrial development in the North East, rather than being told as one of ruptures, conflicts and transformations, emerges as a process that is essentially continuous with the deeper and longer history of a countryside in which the power of the bourgeoisie has become naturalized."[39]

Beamish, then, is more sentiment than history, part of Britain's massive heritage industry with its emphasis on the combination of entertainment and education. As such, the museum is a roller coaster, ever gaining momentum. Beamish is a place "where the past comes to life," providing "entertainment and education for visitors of all ages and interests"; "there's always something happening at this 'living' Museum—sweet making in the Sweet Factory, horses at work in The Town, lessons in the Village School, 'clippy' mat making in the pit cottages—and many other activities."[40] Events for 2002, for example, included the history of Meccano, May festivities ("a recreation of the colourful and traditional May Festivities in the Colliery Village, with a May Queen, Maypole dancing competition and Morris Dancers"), a national traction engine rally, Morgan and Rover car rallies, demonstrations of the traditional craft of north country quilting and patchwork, a school sports day ("children, in period costume, compete in customary events including potato, skipping and three-legged races"), world championship quoits matches, a National Archaeology Weekend hosted by the Council for British Archaeology ("calligraphy, baking, candle making, bee skep making and traditional pole lathing"), a recreation of a Napoleonic recruiting muster "re-enacted by the 68th Regiment of the Light Infantry in full battle dress," a lace-making weekend, a plowing match, a prize leek show and harvest festival, and the commemoration of Empire Day, with the town "decorated with patriotic flags and colourful bunting."

Although Beamish is marketed nationally and internationally, the majority of its visitors come from the region that it represents in its installations, displays, and staged events. For most people who go there, this is a familiar countryside, a short drive from Newcastle, Gateshead, Sunderland, or Darlington, and easily reached from the motorway. As Bennett notes, the contrast between Beamish's sanitized history and the ravages of industrialization in the nearby urban sprawl is evident to anyone. Few will believe that life in a colliery town was maypole dancing, three-legged races, quoits, and patriotic flags. So why has Beamish continued to be so popular with those for whom the realities of history are evident?

Here the explanatory power of the exhibitionary complex fails. Beamish is clearly not about reforming the manners of the northeast's industrial proletariat or about persuading them to embrace a metanarrative of progress and civilization. Empire Day at Beamish is more an ironic remembrance of the naiveté of a long-gone patriotism than a rallying call to British nationalism. Bennett suggests that Beamish offers tranquility and reconciliation with the past — following Foucault, a "place of tranquillized sleep."[41] But this seems too easy, suggesting a simple false consciousness that is incongruent with the active participation of the museum's visitors in the ceremonies of heritage and the energetic reinvention of century-old sports, crafts, and pastimes.

I would suggest, rather, that Beamish's success is due to a double move that makes it an exemplar of the experiential complex. First, the museum is a "destination" that meets the requirements of themed urban regeneration, offering entertainment, advanced simulation, and valued mementos in a secure and controlled environment. Beamish is to the Newcastle-Gateshead conurbation as Faneuil Hall Market is to Boston and South Street Seaport is to Manhattan. As Hannigan has pointed out, such reconstructions are not expected to persuade their visitors that they are "real."[42] Part of the pleasure lies in the awareness of the artifice — an admiration for the skill of the animator in creating the simulation. Beamish gives pleasure through the skill and enterprise of its curators in bringing together fifteen or more traction engines in a parade of steam and gleaming brass, or through the attention to detail in reenacting a muster of the light infantry. In this respect, heritage is not history, and doesn't pretend to be.

Second, Beamish is self-reflexive — the subject matter of its fantasy is the past of the majority of its participants. It is self-exoticizing — through its installations, the past is indeed another country. As Barbara Kirshenblatt-Gimblett has pointed out, this characteristic of heritage results in the alienation of the representation of the past from the community in which it is located, and foreclosure on history.[43] Thus Tyneside's industrial past — the coal mines and

pit houses and the working-class culture of the nineteenth and early twenti-
eth centuries—is framed and packaged as photo opportunities and memo-
rable cameos. Such remembrances become part of family histories—the ways
in which visitors' parents and grandparents lived. Indeed, one of the char-
acteristics of Beamish in the 1980s and 1990s (although presumably less so
today) was multigenerational visits in which retired participants in the north-
east's decimated industrial economy reminisced about the past to children
and grandchildren, using Beamish's buildings and displays as props for their
stories.

Looked at in wide context, this foreclosure of the past is part of the trans-
lation of the northeast from an industrial economy to the service industries
characteristic of late capitalism in developed economies. The core of Beamish's
visitors is the new middle class of the region, employed in the postindustrial
enterprises that are seen as the key to the economic revival of the area. The mu-
seum is one of a number of public facilities that represent the new Tyneside: the
Metro Centre, promoted as one of the largest retail centers in Europe and in-
corporating the now-standard entertainment complex; Newcastle's gentrified
city center and pedestrianized shopping area; opera and the Royal Shakespeare
Company's annual season in the city; the promotion of Newcastle's club life
as the best in the country; the rejuvenation of properties along the banks of
the Tyne; and Antony Gormley's extraordinary sculpture, *Angel of the North*,
spreading its wings over the road into Tyneside from the south.

A second museum well demonstrates this claim to the future and stands
as an instructive counterpoint to Beamish. Life Interactive World, close to the
center of Newcastle, is part of a cluster of high-tech buildings that form Times
Square, the centerpiece of which is the restored Market Keeper's House, built
in 1842 (figure 2). Life Interactive World is one of Britain's new science centers,
seventeen of which have been promoted by the Millennium Commission by
means of national lottery revenues and matching funds.[44]

This is a single-theme, interactive exhibit with linked concepts that fall into
three parts. A first group of eleven exhibits—the "River of Life"—takes the
visitor backward in time to the origins of life in single-cell organisms. In trac-
ing back the path of evolution, the visitor is invited to "leave 21st century North
East England behind you as you capture your image to morph yourself into
your ancestors." Successive interactive displays go first to the hominoids of the
African grasslands seven million years ago, then through successively archaic
life-forms until the visitor "scuttles back to the world of the dinosaurs" and
becomes "a tiny shrew-like creature coming out to feed in the relative safety
of the night." Eventually, 520 million years before the present, the visitor is in-
vited to become a "strange sea creature, a relative of worm-like *Pikaia*, maybe

2. Life Interactive World in Newcastle's Times Square brings the futuristic museum of the biology of life to the historic core of an industrial city in rejuvenation. Photo by Martin Hall, 2001.

the first animal with a backbone." The concluding message of this part of the museum is "that's life—flexible, adaptable, co-operative, productive."

With life having been deconstructed into its most basic biological form, the middle part of the itinerary presents the story of DNA and, through a cluster of interactive displays, explains how the cell is the basis of all organisms. This introduces the third part of the center, which constructs the individual as "life's amazing journey." This series of displays starts with sexual reproduction, the "tunnel of love": "have we put our animal origins behind us when choosing a mate? Like gibbons, we pair off as a couple, like puffins, the woman invests as least as much in her looks as the man . . . like peacocks, men are show-offs." The theme continues with the development of the human embryo, ethical questions about genetic modification, and the way in which the human brain works. The visit ends with "life is a roller coaster," which includes a video arcade and a "crazy motion ride"; these have little to do with the overall theme but certainly reward children (and their adult relatives) for having persisted through the educative displays.

Life Interactive World and Times Square Newcastle provide a vision of the knowledge economy, "the first time anywhere in the world where entertainment, research medicine, life science business, education and ethics have come together on one site to share the unfolding knowledge of the Secret of Life."[45] Where Beamish offers closure on the past—a way of converting Tyneside's industrial economy into nostalgia and participatory entertainment— Life Interactive World uses the museum effect to signal what the northeast as-

pires to become. And, as befits the experiential complex, Life Interactive World draws the individual out from the mass of life, first working back through time to a point of origin, and then substituting genotype for phenotype, constructing the unique identity of the individual from the moment of conception through to the unique complexity of the individual brain. In contrast to the message of the nineteenth-century museum, where the visitor was invited to conform to the manners and outlook of class, Life Interactive World tells its visitors that each is unique, with the prospect of an unbounded future.

Both Beamish and Life Interactive World are simulated environments with strong themes that organize the concepts to which these museums are dedicated. But, in different ways, both depend on material objects for their authority. Life Interactive World deals with DNA and genetic material—the stuff of science that cannot easily be seen, though it is everywhere. It stakes its claim to authority on Times Square, its roots in Newcastle's history, and the authenticity of the restored Market Keeper's House. This is buttressed by the explicit association with the University of Newcastle and the edifice of the academy. Beamish works by taking the ordinary and making it extraordinary. Nondescript buildings, not worth a second glance in the normal flow of urban regeneration, are taken apart brick by brick, cleaned up, and reassembled. Ordinary objects, the stuff of flea markets and dusty attics, are acquired, accessioned, conserved, and displayed. In this process, material objects are relocated from the profane world to the sacred site of the museum, which is itself reaffirmed as a special place by accolades and awards, which are listed on Beamish's Web site and serve as claims to authority. This, again, is the paradox of the authority of the object in a time of digital simulation.

Museums and theme parks are sometimes considered to be different classes of phenomena. But it is a short conceptual journey from Life Interactive World to Epcot's science and technology installations, or from Beamish's themed entertainment to Disney World's attractions. Indeed, Disney's Animal Kingdom is the direct descendant of the nineteenth-century zoological garden, where, for example, the 1836 arrival of four giraffes attended by Nubian and Maltese keepers attracted a crowd of more than 260,000 and where in 1850 Obaysch, the first hippopotamus in Britain, prompted a "hippo craze" in London and the wildly popular "Hippopotamus Polka."[46] Disney's Animal Kingdom is an altogether more serious enterprise, a place to learn about the lives and needs of animals, about the principles of conservation and the danger to the planet: "you can learn so much about animals and the natural world at Disney's Animal Kingdom that a visit should be worth three hours of college credit."[47] Today's theme parks are the direct descendants of the international and world's fairs of the last century, which thrived alongside museums

and curiosity cabinets. Like Beamish, Life Interactive World, and many other themed entertainment destinations, Disney's Animal Kingdom has a spatial design that directs the visitor ("guest" in Disney's world) through a sequence of installations. The concept is of four "lands" that lead off from a central hub, marked by the Tree of Life, a 145-foot modified steel rig with a 430-seat theater in its "roots." Africa—the largest of the "lands"—is reached by a bridge across the Discovery River. On the far side, and past massive, carved gates, is the East African town of Harambe, where "Swahili streetscapes, thatched roofs, and world bazaars transport you to a foreign land. . . . The stage is set for an exuberant African street party with authentic artisans and storytellers sharing their rich African heritage."[48] Harambe, in turn, is the point of departure for Africa's two major attractions, Pangani Forest Exploration Trail and Kilimanjaro Safaris.

As with Beamish's northeast England and the Animal Kingdom Lodge, Harambe is a composite simulation. Tom Sze, a member of its design team, sees it as "true to form as to the textures and essence of an East African coastal town. We created an old town, and it tells a history of that place. It's subtle, but if you sit back and look at it, you will understand the town's story."[49] Most buildings are discreetly dated, covering the full span of colonial settlement in Africa and ranging from Harambe Fort (built in 1426) to Mrubwa House (1781; now the home of the Mombassa Marketplace) and a signpost dated 1961. Although not explicitly recognized in any guest information or promotional material, time seems to have stopped in Harambe not long after independence from British colonial rule. The contemporary occupants, just out of sight of their guests milling about in the dusty street, are Africans presiding over the weathered buildings and relics of long years of occupation, shortly after the colonial authorities have departed.

Harambe gives the impression of honest, well-meaning people making do with scarce resources and the legacy of history—an African equivalent of the gritty Geordie miners who lived in Beamish's pit houses. This serves to reinforce the ethic of Disney's Africa as a whole—the invitation to join a crusade to save the animals of this part of the planet. Thus the Pangani Forest Exploration Trail is imagined as a training school and sanctuary, a "joint effort by the citizens of Harambe and international conservation groups," under the direction of "Dr. K. Kulunda." Here, in one of the switches in time and place that are unexceptional in simulated environments, the guest is in West or Central Africa and the featured animal is the gorilla. "Cultural representatives" add to the information provided by display boards and other, quite traditional museum devices. Here, the assumption is that real people from Africa are experts on animal life: one of the cultural representatives, Thembi from Germiston, in

the urban heartland of South Africa, states authoritatively that hippos can stay under water for five minutes without breathing. At the exit to the attraction, there is a message from Dr. Kulunda:

> To our esteemed visitors, thank you for joining us here today in the beautiful Pangani Forest. The staff and students hope that you have found here a renewed appreciation for all the animals of our wild Africa. It is only through our concerted efforts and commitment that we can hope to save these precious animals for future generations. Asante sana — thank you.

Having toured the conservation center and appreciated its animals and the work of its staff, the guest now shares a moral domain with the postcolonial citizens of Harambe and the international conservation organizations that are determined to save Africa's wildlife.

Dr. Kulunda's counterpoint at the second major attraction in Disney's Africa is a game warden named Wilson Matua, who circles overhead in a light aircraft, speaking over the radio to the safari guides and directing them — and the guests in their care — in a chase after an elephant-poaching gang. Kilimanjaro Safaris take place in the Harambe Wildlife Reserve, which we are asked to imagine was established in the 1970s. Introductory displays provide information about the animals, and the warden — a local citizen of Harambe — asks for help in combating poachers, whose destruction of the wildlife is illustrated by video. The safari, in open-sided Land Rovers that rattle over dirt roads and splash through streams, offers photo opportunities of a variety of antelopes, birds, hippos, rhinos, giraffes, and elephants, whose enclosures are carefully disguised to give the impression that they are roaming free in an east African savanna. As with Harambe town, the relics of colonialism are evident — an "old African bridge" and the track of the East African Railway. The guest, indignant at violations of nature, is invited to repudiate the consumerism of the theme park itself in favor of a nobler cause.

There can be no better accolade to Disney's art of verisimilitude than Jane Goodall's endorsement: "I think when one gets away from the music, the singing and the Disney part of it, the exhibits are wonderful. The animal caregivers are just fantastic. I think the people who come here for the Disney glitz and then get led out to look at the animals — well, maybe they will start to think about conservation in a new way. It may open their eyes to the world around them."[50] In other words, the animals are reality — authenticity — in a fake world that has lost a sense of priority. In achieving the status of a respected zoological museum or conservation organization, Disney has beaten itself at its own game.

Disney's Animal Kingdom contrives, as does Beamish, to transport the visi-

tor away from the present: "though the Serengeti is halfway around the world, visitors walking along the paths of Animal Kingdom undergo a remarkable transformation. Ambient noises slowly change from the chatter of parents and children to the quiet of a rocky grotto, where the only sounds are running water and whispers inspired by the slow, lumbering gait of an anteater."[51] But — again — the contrivance does not rely on the visitor believing that this is some- how "reality." Disney makes it clear that this is all theater, presented by a "cast" that includes the animals. The visitor leaves Africa from Harambe Station on the Eastern Star Railway, traveling "backstage" past the animal houses. The conductor — "Crystal, all the way from South Africa" — tells the passengers that the animals return each night and receive the "best care possible." The animals are actors too, joining the dedicated staff and empathetic guest in a common moral crusade to save the planet from humanity's own depredations.

Beamish, Life Interactive World, and Disney's Animal Kingdom, then, offer themed entertainment with differing underlying moralities. Beamish is fore- closure on an industrial economy that is now over and which is best framed and contained as nostalgia. Life Interactive World is the possibility of the future, the power of the individual mind to achieve the unimaginable in the knowl- edge economy. Disney Animal Kingdom is the obligation of the world citizen to unite with like-minded people to save the planet from destruction. All three offer their participants ways of seeing themselves as individuals within the world. Rather than seeking to reform visitors' manners, to encourage them to conform, these museums condone choices that have already been made, posi- tions that have already been attained. Visitors to installations such as these are already part of privileged elites, and participation in themed entertainments helps them feel better about themselves.

What of "artifactual autonomy" in this experiential complex? While the object has little inherent authority in the museum as conceived and realized by Sir William Flower and his generation, the value ascribed to authentic items in contexts as diverse as the Animal Kingdom Lodge and the maelstrom of con- tested identities in the Balkans suggests that there is, so to speak, more than meets the eye in the meaning of things in the network society.

This problem was first framed almost seventy years ago by Walter Benjamin in his essay "The Work of Art in the Age of Mechanical Reproduction." Ben- jamin was fascinated by the consequences of reproduction and, particularly, by the implications of photography. He saw the years around 1900 as millennial in their consequences for art — a time when advances in technology allowed all forms of art to be reproduced and therefore made widely available. As a con- sequence, art was increasingly available to all, rather than being restricted to a small group of connoisseurs who had access to private collections, galleries,

and select performances. This phenomenon directed Benjamin's attention to the status of the original, to its particular qualities.

In a way, Benjamin was concerned with the obverse of the issue that I am concerned with here. Writing in 1936, Benjamin was acutely conscious of the gathering momentum of mass, popular culture and of the contradiction between the desirability of democratic access to artistic production, on one hand, and the consequences of commodification for works of art, on the other. At the beginning of the next millennium, the easy availability of near-perfect copies of artworks is taken for granted, and major genres of artistic production are enabled and inspired by this mass market. The question now is: why the stubborn saliency of original objects at a time when the mass reproduction of copies seems unexceptionable?

Benjamin's argument hinged on the proposition that an original work of art has an "aura." This is founded in its uniqueness, "its presence in time and space, its unique existence at the place where it happens to be," and is reinforced by the trace of its history, by "the changes which it may have suffered in physical condition over the years," and changes in ownership that constitute its history. Together, position in time and space and the patina of "trace" constitute authenticity, and authenticity is beyond reproducibility: "the authenticity of a thing is the essence of all that is transmissible from its beginning, ranging from its substantive duration to its testimony to the history which it has experienced." Consequently, the "authority of the object" is jeopardized by reproduction — "that which withers in the age of mechanical reproduction is the aura of the work of art."[52]

Benjamin was interested in photography, and particularly film, because this was a newly emerged mass art form that could be reproduced without recourse to an original. Here, his argument was that the "aura" of film-as-art was externalized as the cult of the movie star, who became a sort of vulgar, auratic "original." This anticipates Eco, Baudrillard, and other postmodern theorists of hyperreality and the simulacrum. Here, and particularly in the voluminous field of Disney criticism, it is often assumed that hyperreality renders originality obsolete, that themed entertainment and simulation catch the participant up in a world in which signifier and signified can be decoupled through artifice. Thus Michael Sorkin on Disneyland:

> Television and Disneyland operate similarly, by means of extraction, reduction, and recombination, to create an entirely new, anti-geographical space. On TV, the endlessly bizarre juxtapositions of the daily broadcast schedule continuously erode traditional strategies of coherence. The quintessential experience of television, that continuous program-hopping zap from the remote control,

creates path after unique path through the infinity of televised space. Likewise Disneyland, with its channel-turning mingle of history and fantasy, reality and simulation, invents a way of encountering the physical world that increasingly characterizes daily life. The highly regulated, completely synthetic vision provides a simplified, sanitized experience that stands for the more undisciplined complexities of the city.[53]

In a different register, Roberto, the central character in Umberto Eco's novel *The Island of the Day Before*, is stranded on a ship that has been wrecked on one side of the date line, a short distance from an island that is always in the past. Roberto is destined always to look back in time, to a past represented by an elusive orange dove, "bright as the sun," "wings covered with silver and feathers with glints of gold," a "rare beauty — which, if it was now awaiting him, had always been awaiting him since the day before." Roberto resolves the paradox by casting himself adrift on the date line: "If he were to let himself float, his eyes staring at the sky, he would never again see the sun move: he would drift along that border that separates today from the day before, outside time, in an eternal noon."[54]

There is, though, a catch in this formulation. For if we are indeed caught up in a self-referential spiral of hyperreality in which simulations refer only to one another, creating an "infinity of televised space," or a virtual date line along which time can be conquered, then how can any economic value be generated? Why, if all is simulation, is the Walt Disney Company a successful multinational company that converts its fantasies to brand-name products that sell at a high premium? A closer look at Baudrillard's formulation of the simulacrum shows that things are more complicated than they may seem, directing attention back to the distinctive qualities of authenticity and originality.

In his 1981 essay "Simulacra and Simulations," Baudrillard distinguishes different "orders" of simulation: the "play of illusions and phantasms"; an "ideological" order, or false representation; and a "third-order simulation," that of the hyperreal, the condition in which there is no original for the simulation. "Disneyland is presented as imaginary in order to make us believe that the rest is real, when in fact all of Los Angeles and the America surrounding it are no longer real, but of the order of the hyperreal and of simulation. It is no longer a question of false representation of reality (ideology), but of concealing the fact that the real is no longer real, and thus of saving the reality principle." Such "third-order simulation" becomes self-referential. Thus, in Baudrillard's example, criminal actions such as armed robberies become "inscribed in advance in the decoding and orchestration rituals of the media, anticipated in their mode of presentation and possible consequences."

This position has served as a foundation for a subsequent tradition of interpretation. However, Baudrillard goes on to argue that third-order simulation does not make actions inoffensive, without material consequence. It is rather that the simulated world is placed beyond the traditional legitimation of power by ideology (what Althusser would have called the "state apparatus"). Baudrillard argues that this threatens the very basis of social control. In a situation where there is "a referential order which can only dominate referentials" and where there is no constraint over "that indefinite recurrence of simulation, about that weightless nebula no longer obeying the law of gravitation of the real," power will itself break apart and become "a simulation of power." Baudrillard argues that in this situation, the only recourse is to attempt to reinsert "realness" into the simulation: "the only weapon of power, its only strategy against this defection, is to reinject realness and referentiality everywhere, in order to convince us of the reality of the social, of the gravity of the economy and the finalities of production."[55]

In other words, Baudillard is mapping out, in his concept of third-order simulation, a vortex in which late capitalism is spinning out of control. Rather than establishing a mandate for a virtual world, whether utopian or dystopian, in which simulation is freed from the constraints of reality, Baudrillard is describing circumstances in which simulation generates an ever-increasing need for the anchors of reality. This is the "hysteria" of material production and overproduction. His essay implies a matching economic thesis, not spelled out, in which the traditional view that economies are driven by production is inverted and the emphasis is placed on consumption as the primary determinant. In this, his thesis anticipates a major direction in contemporary economic theory and, of course, the concept of the "experience economy." Rather than being divorced from the real world, simulation is intimately connected to economic value through the circulation of commodities.

This, I want to suggest, is the key to the importance of authentic works of African art in the lobby of the Animal Kingdom Lodge, to the reinvention of conventional museum displays in the midst of Epcot's futuristic technology, and to the significance of cultural treasure for ethnic identities that seem largely created through virtual media. Caught up in Baudrillard's vortex, where third-order simulation generates the mass production of commodities, which in turn fuel the consumer-led demand for ever-innovative simulation, how can the entrepreneurs of the experience economy anchor their themed environments in ways that will make them memorable, valued, and worth paying a premium for? One solution is to put the aura back on the work of art, to reverse, for a very specific set of objects, the trend that Benjamin identified in his investigation of authenticity and reproduction.

Arjun Appadurai has provided a useful set of conceptual tools for showing how the aura of an object can be established. Appadurai explores the conditions under which things ("economic objects") circulate in different regimes of value. He shows how objects have social lives—life histories—during which they move in or out of "commodity situations," defined as circumstances in which an object's "exchangeability (past, present, or future) for some other thing is its socially relevant feature."[56] In some situations, objects can be "enclaved," or removed from circulation as commodities (Appadurai gives as an example royal monopolies over categories of things, serving to establish rank). Such restrictions "have clear implications for framing and facilitating political, social, and commercial exchanges of a more mundane sort."[57] Objects may also be "diverted," often in the service of entrepreneurial interests. Here, the best examples are in the domain of fashion, domestic display, and collecting. In these cases, "value . . . is accelerated or enhanced by placing objects and things in unlikely contexts"—"an aesthetics of decontextualization." "Such diversion is not only an instrument of decommoditization of the object, but also of the (potential) intensification of commoditization by the enhancement of value attendant upon its diversion."[58]

Practices such as enclaving and diversion, then, interrupt the circulation of an object as a commodity, either raising its value because of its scarcity or else removing it from circulation completely, making it—literally—invaluable. This can perhaps be described as "neo-sumptuary" regulation of value, in that it mimics aspects of premodern economies in which rare and valued objects, whether liveried coachmen and parasols in seventeenth-century Dutch Indonesia or the consumption of marzipan in the doge's Venice, were subjected to regulation in law to protect their role as marks of status.

We can now understand why the impresarios of simulation—the curators of an open-air museum in the north of England or the imagineers of a Florida theme park—are drawn to the authentic, whether period artifact, a work of art, a rare ethnographic specimen, or a building restored or transported to a destination museum. The authentic object—diverted from circulation as a commodity, enclaved—serves to anchor the simulacrum, arresting the endless process of production and consumption that drives down the value of experiences, undermining the foundations of the experience economy. In Pine and Gilmore's terms, enclaving selected objects is a tactic that counters the "commoditization trap," the disillusion of customers who find that much the same experience is available elsewhere, diminishing the value of the "spectatorial gaze."[59]

This resolves the paradox with which this essay began. Simulation depends on "reinjecting realness"—on the close connection between hyperreality and

the "hysteria" of commodity production and marketing. The "museum effect" is achieved by withdrawing selected artifacts out of circulation as commodities, thus creating a destination with added value. Similarly, in a world in which identities are claimed and disputed by communities who may be far removed from the homelands with which they identify, cultural property may be endlessly reproduced through digital and other media. To retain value, the simulacra of identity need to be anchored by cultural treasures. There is, then, no contradiction between the experience economy and the materiality of the object, and the experiential complex is marked by the return of the aura of the work of art in an age of digital simulation.

With hindsight, Benjamin's contrast between the original work of art and mass reproduction seems overdrawn. Rather than continued severe restrictions on access to private collections, the second half of the twentieth century saw major collections enter the public sphere through museums and art galleries that were increasingly open to all. As Bennett has pointed out, one of the tensions in the Foucauldian terms of the exhibitionary complex was between the wish to segregate the socially acceptable working class from the riotous mass, and the ideology of inclusion that museums and galleries needed to promote if they were to gain acceptability as institutions of social reform. This tension has steadily pried open the museum's doors, and major public art collections are now generally seen as a sine qua non of the city.

In other cases, though, the requirements of the experiential complex are prompting a sort of reverse engineering of authenticity. Rather than appropriating original works of art, reproductions need to be invested with aura through evidence of their rarity and the "trace" of history — much as Benjamin identified the invention of the aura of the film star as the key to adding value to a movie. Here, the Walt Disney Company has led in the development of expertise. Established as a movie company, Disney pioneered "nature drama," shaping perceptions of "wilderness" through techniques of visual extension and compression: the close-up sequences of animal "families" in their "homes," allowing the viewer an intimacy with the animal world that could not be matched "in real life," or the fast-run sequences of a flower opening or a butterfly emerging from the chrysalis that compress many hours into a few moments. As a result, the audience is led to presume that "the footage closely records the real thing out there in mountain, meadow, prairie and pond . . . we cannot help being disappointed by the real thing."[60] John Hench, a close associate of Walt Disney and for many years one of the company's senior imagineers, saw this as a "recaptured" reality: "We've taken and purified the statement so that it says what it was intended to."[61] In ways such as these, objects can be designed

to convey a sense of presence, of fabricated originality. The effect can be further enhanced through additional techniques long in the museum repertoire, including lighting, the implication of value when an object is behind glass, and widening the distance between the work of art and the viewer. Benjamin observed that in the creation of popular culture, "every day the urge grows stronger to get hold of an object at very close range by way of its likeness, its reproduction."[62] Enclaving an object reverses this direction, and consequently implies greater value.

Benjamin saw the most important mark of authenticity as "trace" — the patina of an object's history and the genealogy of its ownership. In the language of Disney, this is the "back story," a key aspect of all themed entertainment. Because anyone can invent a back story, this is particularly important to an object's value as a neo-sumptuary marker. In the case of Epcot, back story was provided by the simple device of loaning objects from national and public museum collections.[63] Similarly, cultural representatives are "on loan" from their countries, and their authentic biographies provide "trace" for the installations they introduce and interpret. Thembi, who was the cultural representative on duty with the hippos in the Pangani Forest in October 2001, was a university student from the industrial hinterland of Johannesburg who had not been familiar with the ways of animals before she arrived in Florida for a vacation job. But she and the dozens of other young Africans deployed in Disney Animal Kingdom contribute a cachet of "authenticity" to the theme park.

The dependence of an enclaved object on an authentic history gives particular saliency to ethnographic material. Ethnographic collections are a vast pool of potential "new originals" that can appeal both to exoticism and to the politics of identity fueled by the diasporas of the network society. In the words of Charles Davis, art consultant for the Animal Kingdom Lodge, "we want people to have just as much a learning and visual experience inside the resort as they do outside looking from their balcony. We want them to be so excited that they will want to wander through the resort and read and learn. The idea is to show that Africa is a vast continent full of gifted and culturally diverse people."[64] The centerpiece of the Lodge's ethnographic exhibits is the Igbo Ijele mask. Here, the designers have broken with the minimalist labeling of the rest of the collection and have mounted a discursive interpretation of the mask's history and manufacture, using the familiar text-and-photograph combinations of the ethnographic museum. This serves to claim the particular value of this work of art: "The Ijele, the largest and one of the most respected masks of sub-Saharan Africa, usually appears every 10 to 25 years among the Igbo people of Nigeria for celebrations and important events. This rarity is regarded as an attribute of

greatness." The caption on the Animal Lodge's specimen claims it is "the only Ijele known to exist outside of Africa" (although this is incorrect).[65]

The Ijele mask, along with the other neo-authentic objects on display through the Animal Kingdom Lodge, convey value by association with the simulated environment that is the theme park's signature: lighting and sound effects, scaled-up kraal theme, fabrics, décor, and staff costumes. Similarly, the collections of authentic bric-a-brac in the parlors of Beamish's pit houses, in the schoolroom, or in the windows of the shops in the market town transmit value to the simulated north-of-England environment that isn't anywhere in particular and is therefore everywhere. This reverses the tradition of the exhibitionary complex. Museums in the style of the nineteenth century privilege context, using techniques of arrangement, classification, and explanation to convey ideas.[66] In contrast, the experiential complex makes use of metonymy— the meaning that arises from the contiguous association of things. Value rubs off in the foyer of the Animal Kingdom Lodge. Because the Igbo Ijele mask and displayed objects such as the Pende initiation mask and the feathered hat from Cameroon are evidently authentic, the faux-leopard-skin sofas around the giant television set looping an excerpt from *The Lion King* seem more special. This is why the lodge's ethnographic collections are so understated in the promotional literature for Disney Animal Kingdom, why Kratz and Karp found Epcot's five museums curiously underadvertised. Anticipation is reserved for the simulated world—the primary business of the theme park. Enclaved objects are there to be discovered, adding their value through association, and anchoring the simulacra around them.

The age of digital simulation, then, is witnessing the recovery of the authority of the object as part of a neo-sumptuary system that connects cultural and financial capital in what Castells has called the "space of flows" of the network society. This leads to some strange mixing of registers, with the trivia of destination entertainment rubbing shoulders with the deadly seriousness of ethnic identity politics, and long-established ways of exhibiting cultural capital juxtaposed with the razzmatazz of new destination museums.

Such a mixing of registers can be experienced in a visit to Guggenheim Las Vegas at the Venetian (available in cyberspace at www.guggenheimlasvegas .org) (figure 3).[67] An introductory video claims the high ground of culture. Careful research, the visitor is told, has revealed that the same sort of people visit both Las Vegas and the Guggenheim in New York, obliging its curators to bring their collection of authentic masterworks to Nevada for the benefit of the people. But one cannot help but think that the real winner is the Venetian. Rather than decry the casino's Renaissance fantasies as the ultimate in

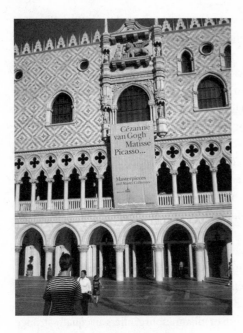

3. The Guggenheim Foundation opened its museum in Las Vegas in late 2001 in expectation that visitors to a newly family-oriented Vegas would step out from the casinos to enjoy interludes of high culture. Photo by Martin Hall, 2001.

kitsch, the Guggenheim's guidebook is obliged to describe the themed entertainment of its newfound partner as "new cultural territory" and "an extraordinary western venue." So does the imprimatur of New York high culture mark the coming of age of Vegas entertainment architecture.

The Venetian is themed entertainment at its most extravagant. The design incorporates elements of the doge's palace and St. Mark's Square, with richly decorated ceilings in the forecourt and in the hotel lobby, Venetian-style arcades leading to the casino area, and gondola rides for guests. In the words of the resort guide: "You are invited to relish the ageless history, inspiring architecture and ambiance of Venice. You are invited to stroll through the magnificent, arched hallways and streets that have inspired artists, poets and romantics for centuries. The Venetian is perhaps the most extraordinary tribute to the beauty and romance of Venice." The Guggenheim's gallery is in the lobby, and comprises an oversize container constructed from rust-colored industrial steel. The collection is protected by burly guards with ill-fitting jackets who seem more like nightclub bouncers than conventional museum attendants. On admission, they warn against eating, smoking, drinking, taking notes or writing, touching anything, and "any photography whatsoever." Inside are four rooms. The 2001 inaugural exhibition was titled "Masterpieces and Master Collectors: Impressionist and Early Modern Paintings from the Hermitage and

Guggenheim Museums" and comprised forty-four works by Cézanne, Pissarro, Gauguin, Matisse, Picasso, and others. The paintings are hung conventionally, with minimal labeling and no concession to establishing context.

The Guggenheim at Las Vegas illustrates the meeting of the exhibitionary and entertainment complexes. At one scale, the resulting confusion of codes is unbridgeable. Despite the Guggenheim's attempt to achieve an ironic distance from Mammon by housing its treasures in a rusty box, the juxtaposition is absurd, and becomes comic though the behavior of the attendants, who are a parody of the warders in a Foucauldian institution. But at another scale, the partnership demonstrates the power of metonymy in establishing cultural capital in the competitive world of themed entertainment. As Vegas seeks to attract middle-class visitors and families to its world, each resort needs to differentiate itself from the others. In a town where anything, it seems, can be simulated, there is a special cachet in being able to display items that cannot be bought at any price. By their mere contiguity, the Guggenheim's Gauguins and Picassos add value to the Renaissance décor of the lobby, the gondoliers punting visitors on the canal, and the slots and gaming tables down the hall.

The Gold Reef resort, to the south of Johannesburg, offers an equally strange juxtaposition between the museum conceived and realized in conventional style and the new extravagance of the urban destination (figure 4). This complex comprises three major elements: Gold Reef City, a theme park that has been operating for over a decade, the Gold Reef Casino, and the Apartheid Museum, the last two opened in 2001. Together, they give a comprehensively mixed message, with the theme park and casino presenting early-twentieth-century Johannesburg as a place of wild fun, with little trace of conflict, and the Apartheid Museum presenting the chilling brutality of segregation and cruelty, showing how this same city was a place of misery and death. The Apartheid Museum's key theme is that legislated segregation came into being as a response to massive black migration to the city, while the casino's organizing idea is that the center of Johannesburg has always been a free and easy space for all. The casino's reconstructed town square is now inhabited by black citizens playing the five-cent slots in hope of a fortune, and the controlling financial interests are held by Abe and Solly Krok, who made their money by selling skin-lightening creams to black housemaids until their products were banned as toxic, and who were inspired to build the Apartheid Museum by the Holocaust Memorial Museum in Washington.

Instances such as these suggest that we are in a time of transition. For Walter Benjamin and others, the early 1900s seemed a welter of confusion, when new art forms such as film were fueling a mass culture that broke out of the frame

4. Gold Reef City celebrates an imagined Johannesburg in its early years—
a city of adventure and possibility for all. The Apartheid Museum, across
the parking lot, provides the counterpoint of exploitation, segregation,
and discrimination. Photo by Martin Hall, 2001.

of conventional art. Today, mechanical reproduction has reached an apogee
in simulation, and the search for originality has resulted in premier examples
of high art being displayed in a reconstruction of a Venetian palace set in a
Nevada desert, and the relics of a brutal system of racial segregation on the
grounds of a casino that denies the reality of this same history. Such confu-
sion draws a continuing line from Las Vegas to Bosnia and a raid on a Croatian
artist's studio in the Sarajevo neighborhood of Grbavica:

> Serbian soldiers broke into his studio looking to steal money and equipment.
> They were incensed to discover an Islamic levha—a calligraphic inscription
> from the Koran—which the painter had mounted as a wall hanging. They took
> it down and, cursing, butchered it. According to witnesses, they then took all
> the artist's paintings, drawings and sketches, lined them up against the front
> wall of the house and executed them with machine-gun fire until they were in
> shreds.[68]

NOTES

The first epigraph to this chapter is taken from Baudrillard's "Simulacra and Simulations," in his *Selected Writings*. The second epigraph is from Benjamin's "The Work of Art in the Age of Mechanical Reproduction," in his *Illuminations*.

1 Featherstone, *Undoing Culture*.
2 Urry, *The Tourist Gaze*.
3 Clifford, *Routes*.
4 Rassool and Prosalendis, *Recalling Community in Cape Town*.
5 Kratz and Karp, "Islands of 'Authenticity.' "
6 Cypher and Higgs, "Colonizing the Imagination."
7 Bennett, *Birth of the Museum*, 146–47.
8 Benjamin, *Illuminations*.
9 Kirshenblatt-Gimblett, *Destination Culture*, 18.
10 Bennett, *Birth of the Museum*, 146–47.
11 Urry, *The Tourist Gaze*, 25.
12 Urry, *The Tourist Gaze*.
13 Bennett, *Birth of the Museum*, 186.
14 Ibid., 68.
15 At the time, the museum and its collections were still legally a department of the British Museum and formally known as the British Museum (Natural History). It was only in 1963 that the Natural History Museum became an independent entity, and its name was not officially changed until the Museums and Galleries Act of 1992.
16 Sir William Flower, as quoted in Bennett, *Birth of the Museum*, 42.
17 Foglesong, *Married to the Mouse*.
18 Quoted in Bennett, *Birth of the Museum*, 32.
19 Bennett, *Birth of the Museum*, 99.
20 Ibid., 47.
21 Jameson, *Postmodernism*.
22 Castells, *The Power of Identity*; Hardt and Negri, *Empire*.
23 Castells, *The Rise of the Network Society*, 199.
24 Appadurai, *Modernity at Large*, 3.
25 Pine and Gilmore, *The Experience Economy*, 11–12.
26 Ibid., 43.
27 Ibid., 176.
28 Hannigan, *Fantasy City*.
29 Ibid., 69.
30 Urry, *The Tourist Gaze*.
31 Kirshenblatt-Gimblett, *Destination Culture*, 132.
32 Urry, *The Tourist Gaze*, 127.
33 Urry, *The Tourist Gaze*.
34 Pine and Gilmore, *The Experience Economy*, 176.
35 Urry, *The Tourist Gaze*.
36 Lennon and Foley, *Dark Tourism*.

37 http://www.beamish.org.uk/about.html (accessed September 28, 2005).
38 Bennett, *Birth of the Museum*, 111.
39 Ibid., 114.
40 http://www.beamish.org.uk/visitor-info.htm (accessed September 28. 2005).
41 Foucault, *The Archaeology of Knowledge*, 14.
42 Hannigan, *Fantasy City*.
43 Kirshenblatt-Gimblett, *Destination Culture*.
44 Pickrell, "Science Centers Blossom."
45 Life Interactive World, *Take a Look at Life*.
46 Blunt, *The Ark in the Park*.
47 Kramer, "Inside Disney's Animal Kingdom."
48 Disney's Animal Kingdom Park.
49 Tom Sze, as quoted in Kubin, "Disney, Dinos and Company."
50 Jane Goodall, as quoted in Kubin, "Disney, Dinos and Company."
51 Kubin, "Disney, Dinos and Company."
52 Benjamin, *Illuminations*, 215.
53 Sorkin, "See You in Disneyland," 208.
54 Eco, *The Island of the Day Before*, 279, 500.
55 Baudrillard, *Selected Writings*, 182.
56 Appadurai, "Commodities and the Politics of Value," 13.
57 Ibid., 24.
58 Ibid., 28.
59 Pine and Gilmore, *The Experience Economy*; Urry, *The Tourist Gaze*.
60 King, "The Audience in the Wilderness," 66.
61 Findlay, *Magic Lands*.
62 Benjamin, *Illuminations*, 217.
63 Kratz and Karp, "Islands of 'Authenticity.' "
64 Charles Davis, as quoted in Edith E. Stull, "Disney's Animal Kingdom Lodge—the Spirit of Africa," http://florida.allinfo-about.com/features/orlando/wdw/akl/akl_kids.html (accessed September 28, 2005).
65 Stull, "Disney's Animal Kingdom Lodge." The Horniman Museum also has an Ijele mask in its collection.
66 Bennett, *Birth of the Museum*; Kirshenblatt-Gimblett, *Destination Culture*.
67 http://www.guggenheimlasvegas.org (accessed August 15, 2006).
68 Lovrenovic, "The Hatred of Memory."

5:29:45 AM

JOSEPH MASCO

July 16, 2005 — 5:29:45 AM — thousands of tourists assemble in the early morning hours at a remote desert location in the southwestern United States to bear witness to the sixtieth anniversary of the first atomic explosion. Located in the middle of the White Sands Missile Range (an active U.S. military test range located in central New Mexico), the Trinity Test Site is open to the public only two days a year and for special anniversaries. Getting to this open-air museum and historical monument (which gained National Historical Landmark status in 1975) requires a difficult journey: visitors commit to a minimum two-hour drive from Albuquerque, and must negotiate military checkpoints, gates, and miles of barren, two-lane desert road to arrive at the birthplace of the atomic age. Once there, international tourists mix with past and present U.S. nuclear workers and military personnel, anti-nuclear activists, military history buffs, and the increasingly large number of Americans fascinated by the historic sites of the atomic age.

But what of the bomb actually remains at this desert test site? And what is capable of drawing such an international and politically diverse audience to this remote piece of New Mexican desert minutes before sunrise on this specific July morning? Visitors expecting to encounter the great modernist accomplishment of the twentieth century — the start of a new "age" of military science, international relations, and everyday fear — instead discover a large patch of desert surrounded by a chain link fence. There are no buildings at the point of

1. Photographic display at the Trinity Test Site (White Sands Missile Range, New Mexico, 2005). Photo by Joseph Masco.

detonation, only a simple historical marker, the metal casings of the bombs that destroyed Hiroshima and Nagasaki (devices code-named "Little Boy" and "Fat Man" by Manhattan Project scientists), and a photographic display.

Both a museum and monument to itself, the site is a near-total simulation: the closest visitors get to the first atomic explosion is by viewing a long line of historical photographs strung on the chain-link fence, which document some of the personnel and equipment involved in the test, as well as a time-lapse sequence of the detonation. The display ends with a photograph of the historical marker (figure 1) whose caption reads: "The Obelisk sits exactly at ground zero. It is made of Lava Rocks." The stupefying banality of this exhibit is enhanced by the fact that the obelisk actually sits some fifty yards behind the viewer and is the core object of public attention at the Trinity Test Site, providing the preferred snapshot souvenir for most visitors. The culminating image in the historical display thus introduces the viewer to the space that he or she actually inhabits—conveying nothing of the sublime power of the nuclear age. For those interested in acknowledging the wonder or terror of the first nuclear explosion—a scientific accomplishment that revolutionized nearly every institution of American life, turned the surface of the earth into an experimental test range (involving radioactive fallout), produced a new kind of state (the

global nuclear superpower), as well as new kinds of world war (both cold and apocalyptic)—the bomb remains invisible in its site of origin. Visitors are presented instead with a hall of mirrors, a simulation that evacuates the nationalist fervor, the technoscientific accomplishment, and the terror of the first nuclear explosion through the deployment of neither first-hand experience nor expert knowledge nor realistic ambiguity but instead blindingly obvious factoids.

The Trinity Test Site is part of an evolving series of monuments and museums commemorating nuclear nationalism in the United States. Since many of these projects were concealed by U.S. national secrecy practices for decades, the new Cold War museums and atomic monuments often represent not a commemoration of known history but rather the first public inscription of it. These new military museums and monuments strive to document the historical evolution of the nuclear security state on its own terms; consequently, they are also deeply embedded within the current U.S. national security project known as the "war on terror." Thus, while officially positioned as "neutral" histories of World War II and the Cold War, atomic history sites are nonetheless highly politicized spaces, ideologically charged in how they engage the past, present, and future. In summer of 2005, for example, the Bradbury Science Museum at Los Alamos National Laboratory pulled "Little Boy," the bomb that destroyed Hiroshima, from display, citing new security concerns. Thus, despite years of public display in New Mexico, the first bomb used in atomic warfare became, at age sixty, once again a national security secret in Los Alamos, one of potential use to "terrorists." Concurrently, the National Atomic Museum in Albuquerque (which houses the largest public collection of U.S. nuclear weapons casings in the world) staged a "blast from the past" fundraiser on July 15, in which participants were given secret identities for the evening, presented with a 1940s-era fashion show and a panel of Manhattan Project personnel, before taking an early morning bus to the Trinity Test Site for the sixtieth anniversary. A coalition of anti-nuclear activist groups responded to this effort to romanticize the bomb by flying a survivor of the atomic bombing of Hiroshima in from Japan to attend the event. Crashing the fundraiser with an alternative narrative of the nuclear age, activists also installed a "sidewalk museum" in front of the building. Presenting images of damaged bodies and buildings from Hiroshima and Nagasaki, activists challenged not only the National Atomic Museum's effort to approach the bomb as light hearted popular culture, but also the continued U.S. investment in nuclear weapons in the twenty-first century.

Thus, despite official efforts to ideologically contain the Trinity Test within New Mexican museums and memorials, public discourse around the sixtieth anniversary of the bomb proliferated. Nuclear activists—both pro and con—mixed with tourists (Japanese, German, American) in the summer of 2005 dem-

2. "Trinity Site, Jornada del Muerto, New Mexico," 1989. Photo by Patrick Nagatani, from his larger *Nuclear Enchantment* project. Image courtesy of the artist.

onstrating that the bomb is not yet located in a stable narrative of the past or present. Indeed, the nuclear public sphere in New Mexico revealed the nuclear explosions in the summer of 1945—on July 16 in New Mexico, and three weeks later on August 6 in Hiroshima and August 9 in Nagasaki—to be fundamentally linked events, explosions that make the U.S. the only country in the world to have engaged in nuclear warfare. The more subtle transformation of the U.S. into a society that largely organized itself around the bomb in the second half of the twentieth century remains a more difficult and elusive narrative, one more easily encountered today in works of art than in official history.

Patrick Nagatani's vision of the test site, for example, "Trinity Site, Jornada del Muerto, New Mexico" (figure 2), engages the nuclear revolution from a rather different vantage point than that offered by the official history sites. Part of a larger photographic work, *Nuclear Enchantment*, this work directly challenges the silences, contradictions, and public romance with the bomb in New Mexico, a state that is almost entirely supported by U.S. nuclear weapons research and tourism. Nagatani's beautiful photographic montages present philosophical statements on race, class, nationalism, childhood, militarism, and the processes of social normalization in a nuclear age. Nagatani recovers lost histo-

ries, not only of nuclear tests, accidents, and espionage in New Mexico, but also of the complicated racial context of the bomb, which connects the indigenous populations (both Native American and Nuevomexicano) in New Mexico to the Japanese through forms of nuclear victimization. His "Trinity Site, Jornada del Muerto, New Mexico" returns us to the Trinity Site but through the eyes of tourists who appear to be literally startled by the viewer. Under the wing of the Enola Gay (poised to drop another Little Boy bomb?), the startled Japanese (or are they Japanese-American?) expressions raise immediate questions about the normalization of the bomb and the economy of otherness that supports the U.S. nuclear arsenal. What, after all, is being commemorated by their tourist snapshots of the "Obelisk . . . made of Lava Rocks" at the Trinity Site—a scientific accomplishment, a new military superweapon, the end of World War II, the destruction of Japan, the start of the Cold War, or merely some unarticulated collective pleasure in atomic kitsch?

The explosion at 5:29:45 AM on July 16, 1945 inaugurated a continuing revolution in global affairs. However, the Trinity Site, the precise spot of the detonation in the New Mexican desert, though promising visitors unmediated access to the bomb, actually denies entry into the event or its historical meaning. For that, one must turn to a more imaginative register, one that makes a claim not on the physically real, but on the complexity of the nuclear revolution itself. As comparative modes of display, the physical site of the first atomic explosion pales in comparison to the photographic fantasy, as Nagatani's ambiguous challenge to the present articulates the vital need for critical public engagement—a sorting out of memory, history, and ideology—in an increasingly nuclear age.

Transforming Museums on

Postapartheid Tourist Routes

LESLIE WITZ

The demise of apartheid in South Africa in the 1990s and the advent of universal adult franchise were heralded both locally and internationally as marking the beginning of a new democratic nation. A government headed by the African National Congress (ANC) assumed power in 1994 and proclaimed its commitment to a national state where public institutions would be much more accessible, employ a wider and more representative staff, respond to broad societal needs, and restore justice. The elected government called upon the populace, most of whom had been racially excluded from these institutions under apartheid, to bury the past and participate as citizens in the newly constituted nation. Yet in looking forward to the commonality of a postapartheid nation, the idea of forging a collective past that would be aligned with the present and the anticipated "never-ending" future was promoted by the government.[1] Presented as a national inheritance and labeled as heritage, this past was to be utilized as "a powerful agent for cultural identity, reconciliation and nation-building."[2]

Museums as sites for the visual management of the past have become important signifiers in the unfolding of this discourse of a newly rediscovered heritage. Whereas museums in apartheid South Africa were spaces where black people were represented only in "ethnographic collections and exhibits," in postapartheid South Africa they have presented the possibility of changes in the domain of visualizing a new, more inclusive society.[3] By drawing upon

notions of the museum as a domain of public education and citizenship, museums could potentially help "form a new public and inscribe it in new relations of sight and vision."[4] In the government's white paper on arts and culture, state-funded museums were encouraged "to redirect their outputs to new activities which reflect the overall goals of the Government." Key features that would guide this policy included the need to correct historical racial and gender imbalances and to facilitate "the emergence of a shared cultural identity constituted by diversity."[5]

Since 1994 there have been a range of government-sponsored and independent initiatives to construct and reconstruct museums in South Africa. In pursuing its policies the national government committed substantial resources to establishing new national museums built around a narrative of repression and resistance, leading inexorably to a reconciled, multicultural South Africa: the Nelson Mandela National Museum in Mthatha, Qunu, and Mvezo; the Robben Island Museum in Cape Town; and Freedom Park in Pretoria. Some local government authorities gave museums under their control a complete overhaul, reconstituting them as institutions that collected, documented, and exhibited social histories of their locality: "representing the lives of ordinary people, particularly those of the black majority in South Africa."[6] Most notable among these were the Kwa Muhle branch of the Durban Local History Museum and MuseumAfrica in Johannesburg. The political changes also provided the space for the emergence of independent museums with very limited financial support from the government. Some of these are well resourced, forming parts of larger commercial operations or relying upon wealthy benefactors. The Apartheid Museum attached to the Gold Reef City casino in Johannesburg, the Gold Museum that the mining company AngloGold set up in Cape Town, and the reconstituted South African Jewish Museum are all examples of these.[7] Another group of independent museums, based upon a sense of spatial and/or political affiliation, were established as community spaces where histories forgotten and repressed during the days of colonialism and apartheid would be remembered, recovered, collected, and exhibited. These museums, such as the District Six, South End, and Lwandle Migrant Labour Museum, do not necessarily conform to the national narratives, and they rely heavily upon short-term grants from local and international funding agencies.[8] Finally, in order to promote change, the central government facilitated the amalgamation of older museums in the north and south of the country into national flagships, along the lines of the Smithsonian Institution in the United States. This new arrangement was intended as a precursor to changes in their employment, exhibition, and collection policies. Before the new flagships were in place, the president, Nelson Mandela, had launched a scathing attack on these older national mu-

seums. Officially opening the site of his incarceration for eighteen years, Robben Island, as the first national museum of the new South Africa, he accused older museums of continuing to present "the kind of heritage that glorified mainly white and colonial history." When they did display black history, he maintained, it "was largely fixed in the grip of racist and other stereotypes." He called upon museums "to ensure that our institutions reflect history in a way that respects the heritage of all our citizens."[9]

These appeals and initiatives to alter museum practices have occurred at a time when South Africa is not only attempting to locate itself as a new polity but also endeavoring to place itself in an international economic system where strategies for growth are prioritized. In such a framework the objectives are defined as increasing productivity, marketing effectively, and sustaining long-term growth in order to create jobs and alleviate poverty. Translated into the domain of arts, culture, and heritage, the mission of the Department of Arts and Culture is defined almost entirely as "developing the economic potential in the cultural industries."[10] For government-funded museums the implications are twofold. On one hand, they are instructed by the department to ensure "effective and efficient use of limited resources," undergo a "systematic process of restructuring and rationalization," and subject themselves to "performance measures."[11] On the other hand, their primary role, according to the department, is to position and market themselves so that they become "part of a strategy of branding the Country as a sought-after tourism destination."[12] Museums in South Africa, and not only state-funded ones, are increasingly being required to become commercial operations with international tourism as their core function.[13]

In a postcolonial society such as South Africa, where the demands for societal transformation are high on the agenda, the situating of museums primarily as sites of international tourism has major implications for how new museums develop and older ones are reconstituted. The increasing numbers of tourists worldwide in the late twentieth century have had a marked effect on the ways that pasts are represented in museums and other heritage sites. Writers have emphasized how the need to present neatly commodified, packaged products for the expanding tourist market has resulted in simplified, unthreatening, sanitized, superficial histories being presented as heritage.[14] The problem with these analyses is that they assume an almost undifferentiated, unthinking tourist audience. Moreover, some of the most popular displays for tourists are extensively researched, present complex histories, and explicitly seek to present a tainted past.[15] Nonetheless, tourism, *as an industry*, does rely upon sets of images of societies that appear as complete, isolated, and closed.[16] These bounded societies are marked as different in order to make them desir-

able destinations.[17] In promoting tourist activity as voyages of discovery and exploration to these enclosed places of difference, the industry draws upon and sustains the image of the colonial enterprise that indeed often paved the way for the opening up of "primitive" and "exotic" destinations. As Kirshenblatt-Gimblett has pointed out, international tourism continues to provide a "safe haven" for "marketing a troubled history that glorifies colonial adventure and a repudiated anthropology of primitivism."[18] The promotion of South Africa as a place of exploration, where one encounters wildlife and ethnic indigeneity in comfortable, secure surrounds, the fabled "World in One Country," draws precisely upon these metaphors of exploration and uncritically celebrates the development of colonial modernity.[19] Museums in postapartheid South Africa thus appear to be faced with a set of conflicting demands. They are being urged to brand themselves so as to be incorporated into a tourist package that invokes the colonial journey and at the same time are being required to discard colonial histories and reflect new national pasts in their policies, exhibitions, and collections.

This essay deals with how museums resolve this dilemma. How do the older museums, for instance, deal with their stereotypical displays of African culture and ethnicity when these are what the tourist industry appears to promote and the government's transformation agenda explicitly discourages? And how do newer museums, striving to establish themselves as community spaces, respond to constant demands on them from the tourist industry to present a romanticized vision that reflects a supposedly authentic African experience? This essay examines these questions by looking at the changing histories that are being presented at two museums: the oldest museum in the country, the South African Museum in the center of Cape Town, and one of the newest museums, the Lwandle Migrant Labour Museum, situated some thirty miles from Cape Town in a township that was constructed during the days of apartheid to house black male migrant workers who were deemed by the authorities to be temporary sojourners in the city. The essay starts off by taking a brief look at how South Africa was presented in the image-making circuits of international tourism and the correspondence of these images with the changing meanings of national heritage.

SOUTH AFRICA, HERITAGE, AND INTERNATIONAL TOURISM

Southern Africa was a relative latecomer on international tourist routes, only beginning to emerge as a destination in the 1890s. It was presented in tour guidebooks as a place of colonial settlement, the "White Man's country," offering to the imagined tourist arriving by steamship from Europe "the most ex-

tensive and oldest example in Africa" of "European settlement on a permanent, considerable and progressive scale."[20] The visitor to South Africa was invited to marvel at and share in the European colonial enterprise in Africa. Sunshine, scenic landscapes, and an array of buildings that were considered to give historic substance to the civilizing claims were highlighted as the main attractions. For many a visitor to South Africa the focus was Victoria Falls (in present-day Zimbabwe and Zambia), where one's visit was always framed by the journey of the nineteenth-century missionary-cum-explorer David Livingstone. The view "from Livingstone Island," according to the guidebook, was the most moving, as this was "the spot from which Livingstone first saw the falls."[21] For the visitor South Africa thus afforded not only the opportunity to observe the claims of Europe as the bearers of civilization to Africa but also the chance to follow in the tracks and partake of its assertions of discovery.

Yet the country's climate, scenery, and traces of Europe were not enough to attract the tourist. In a world where more and more places were becoming destinations, South Africa had to market itself as distinctive. This was done by representing South Africa not only as a place with a lengthy European tradition but also as one where it was still possible to see "the native" in large numbers and in an "unspoilt" world of the "little thatched huts" of the "native kraal." Inhabitants of these huts were represented to potential tourists as essentially "undisciplined," "likeable," "impulsive," "immature," "childlike," "illogical," "carefree," and "unchanging."[22] Even if the scenes were largely inaccessible to most tourists — visiting "primitive" communities involved an arduous journey by train and on horseback — they were a key ingredient in marketing South Africa as a destination of difference.[23] Alongside the scenery, climate, and European modernity, the "native" enabled South African tourism marketing bodies to assert that the country was "so situated as to reflect in miniature the whole . . . of mankind."[24]

These early intonations of South Africa designed as a "World in One Country" were concretized with the opening of game parks in the late 1920s. The Sabi Reserve was converted into a large game reserve with a road network for tourist vehicles and renamed Kruger National Park. Not only did this add wildlife onto the South African tourist package but also it positioned the "natives," whom the government at the time was placing in rural reserves with very limited land, as part of the country's natural attractions. The establishment of Kruger Park was described in early guidebooks as the conversion of a "tract of truly 'Darkest Africa,'" consisting mainly of "native tracks," into a game reserve offering tourists the modern facilities and infrastructure to view the wildlife.[25] The "natives," whose tracks had been eliminated for the tourist traffic, were cast as objects of observation, who could be "conveniently seen" on

a Cook's tour in the "native territory," "combined with scenic attractions."[26] By 1947, when the South African Tourism Board (SATOUR) was established, the country was being made known to tourists abroad through its wildlife, primitive tribalism, and modern society.[27]

As the racial structuring of South African society became much more formalized beginning in the 1950s, with the institutionalization of apartheid, these features of the tourist package were reinforced. Not only was more land set aside for game parks, making wildlife more viewable, but also their boundaries became much more clearly demarcated with fences, and many of the "native" inhabitants were forcibly relocated into reserves.[28] These "native" reserves were fundamental to the extension and maintenance of white rule under apartheid. Exercising racial control over the majority of the South African population involved splitting "the majority into compartmentalized minorities." To make these "ethnic minorities" into "believable" and durable entities, they had to be constructed in terms of selected and featured aspects of "historical and cultural experience" and spatially located in the designated reserves, which were renamed "homelands."[29] Encountering and viewing these "natives" was integral to the marketing of South Africa to international tourists, with the "primitive tribes" recast as "Bantu nations speaking different languages."[30]

Alongside these ever-expanding wildlife options and an elaborate recasting of "primitive" peoples as ethnic nations, apartheid South Africa marketed itself to tourists as a modern nation with European roots. Apartheid itself was represented as a modern policy, which visitors were encouraged to take full advantage of. The tourist facilities were proclaimed as the most advanced, and favorable comparisons were always drawn with offerings in Europe and North America. The South African heritage that was on offer to tourists portrayed a colonial past and extended this into a common European ancestry for people who racially designated themselves as white and were in the process of becoming classified as such under the Population Registration Act of 1950. This European heritage was constructed as the coming together of the races, in which races were presented as Afrikaans- and English-speaking white settlers.[31] The three components to this heritage were an increased prominence given to an Afrikaner national past; the promotion of an English ancestry, with the British not as imperial conquerors but as settlers who contributed to the nation; and the advancement of a much more generalized South African past derived from European "traditions."[32] Colonial buildings were designated as national monuments and restored so as to depict a romanticized European past of high culture. The modern apartheid South Africa, marketed to potential tourists, presented a past of European "traditions" together with the provision

of superior amenities to view its distinctive offerings in the game and "native" reserves (reconstituted as homelands).

But there was one major problem with this package of tourist offerings: to go to the "picturesque Bantu-lands where customs and tribal rites are still practiced according to ancient traditions" was still immensely difficult. First, roads and accommodations in the "native territories" were not adequately developed. Second, tourists who wished to "go off the main roads" had to obtain a permit from the secretary for Bantu administration and development. Those who did not adhere to this regulation were warned that they would be "severely penalized." But most significantly, many tourists were coming to the conclusion that in the "native territories," the "natives" were not native enough. In the Valley of a Thousand Hills, the "House of Zulu," tourists were disappointed to find that "this delightful fragment of the Zulu past" was "marred" by "an occasional roof or wall of corrugated iron among the round, thatched huts comprising the kraals of that reeling landscape."[33]

To overcome these problems from the late 1960s a series of cultural villages were set up as independent operations, often on white-owned farms. The "first authentic Zulu village," KwaBhekithunga, was set up on a farm between Eshowe and Empangeni. Similar Zulu villages—Thandanani Craft Village, Simunye Cultural Village, Phezulu Safari Park, Dumazulu—and an array of villages devoted to other ethnic groups followed it. In these villages, culture and history were brought together in a timeless zone as a kaleidoscope of frozen ethnic stereotypes that had their genealogy in colonial encounters, the creation of administrative tribal units, and displays in imperial exhibitions across Europe in the nineteenth and early twentieth centuries. Visitors were allowed to witness distinctive tribal ceremonies and to participate en masse in daily programs of secret, ancient rituals. Yet, for all these ethnic characterizations, there was a common imagery of music and dance that, without exception, the villages offered as the highlight of the tourist encounter, blending the boundaries of ethnicity into an African essence of rhythmic movement. The cultural village fulfills the need to present safe and comfortable "native authenticity" to tourists seeking to travel to the "World in One Country."[34]

The political changes in the early 1990s did not alter the key marketing features of the South African tourist package. As the South African polity and social fabric were being re-formed, the image of a "World in One Country" was consolidated. The modernity of a new recoded South Africa, with an ordered environment of safety and comforts, afforded even greater opportunities to gaze upon the "ancient rituals" and traditions of "Olde" Africa, replete with the wonders of its wildlife, natural beauty, and a "culture as fascinating as it

is diverse."[35] It is this last aspect that postapartheid South Africa holds up as its primary marker of difference. This is encapsulated in the marketing slogan "Explore South Africa: Culture," which was coined by SATOUR in 1996. These explorations are primarily offered to tourists in the cultural villages, which flourished in postapartheid South Africa, and through the emergence of tours to the townships, the dormitory locations on the margins of cities that were established at the beginning of the twentieth century to accommodate and control African laborers from rural areas. In the tourist brochures, a visit to a township is described as a movement across the (colonial) frontier to "the other side of the colour line," enabling the postapartheid adventurer to enter areas "previously inaccessible to whites."[36] The tourist theming of South African society thus continues to reside in the age of exploration and discovery. South Africa is mapped for international tourists as a sequence of routes from tribe to tribe in rural and urban settings.[37]

More and more international tourists undertake these "voyages of exploration" to postapartheid South Africa. The number of overseas tourist arrivals has increased dramatically since the mid-1980s. From a low of 297,060 in 1986, the number of visitors rocketed to 6.4 million in 2002, making it "the fastest-growing tourist destination in the world." This "torrent of tourists" has been attributed to the relative cheapness of a vacation there because of a fall in the value of South Africa's currency, the quality and diversity of tourism products, "positive global perceptions of peaceful political transition," and, after September 11, 2001, changing perceptions "about what constituted a safe destination." Almost half of these visitors come from the United Kingdom, Germany, and the United States; on average, they stay approximately sixteen nights in the country and spend R1,000 per day. All these tourists enabled the industry to provide employment for 574,000 people and to contribute 5 percent of the country's GDP (gross domestic product) in 2000.[38]

This sign of growth enables and sustains a discourse of tourism as providing the engine for economic transformation, which must take place alongside the political change. The statistics are reeled off relentlessly: tourism is the world's largest earner of foreign currency; tourism brings an estimated 20 billion rand (US$3 billion) into South Africa's economy; for every eight tourists who visit South Africa, one permanent job is created. Mohamed Vali Moosa, the minister of tourism and environmental affairs, in urging South Africans to develop a culture of welcoming tourists, claimed that "tourism follows manufacturing and mining in its contribution to our country's GDP and could quickly overtake mining if we continue to grow tourism both domestically and internationally. It is also the sector identified by the World Economic Forum as capable of rapid job creation."[39] Tourists have clearly become, in the novel-

ist J. M. Coetzee's words, the primary crop to be cultivated in postapartheid South Africa.[40]

It is little wonder, then, that the South African government's Department of Arts and Culture urges museums to see their primary task as developing products for the international tourist market. The museums themselves are also keen to reap this crop of tourists, especially at a time when they face severe financial constraints. The government allocates very little to national and provincial museums — in 2001–2002 the national government's allocation was R110,132,000 (approximately US$18 million) — and much less to community museums, where entrance fees are kept to a minimum in order not to dissuade prospective visitors, and where finding sources of local and foreign funding is increasingly difficult.[41] Statistics indicating that museums and art galleries are visited by 36 percent of tourists to South Africa must therefore be very good news, potentially providing a lucrative source of income.[42] But what happens to the requirements for museums to alter their static, stereotypical displays when their primary objective is located more and more in developing products for a tourism industry where such images abound and are perpetuated?

THE SOUTH AFRICAN MUSEUM

When President Nelson Mandela, on Heritage Day 1997, criticized South African museums for depicting African people as "lesser human beings, in natural history museums usually reserved for the depiction of animals," it was immediately assumed by the press and most observers that the museum he had in mind was the South African Museum (SAM), in the center of Cape Town.[43] A guidebook produced by the South African Museums Association in 1969 described this museum as being "chiefly concerned with natural history" — "palaeontology, entomology, ornithology and marine biology" — but it also had "important archaeological and ethnological departments" that included "the Bushman groups [that] are world renowned!"[44] The title of Walter Rose's biography of James Drury, the museum's modeler, caster, and taxidermist — *Bushman, Whale and Dinosaur* — characterizes for many the main ingredients of the SAM.

The same guidebook asserts that the "only cultural history display" in the SAM is the one showing the development of the printing industry. All the other "cultural historical material," it claims, was shifted to the South African Cultural History Museum in 1966. These included "extensive Egyptian and Roman archaeological collections, Greek vases and terracotta figures, . . . Chinese and Japanese objects, . . . Indian and Tibetan weapons, . . . South African postage

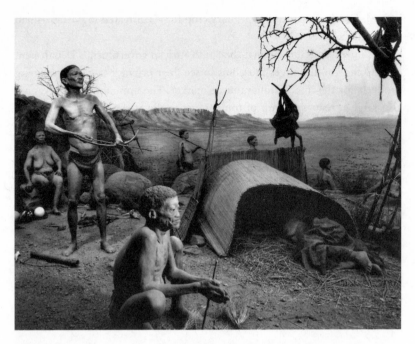

1. The "bushman diorama" ca. 1985, depicting a hunter-gatherer camp in the Karoo in the nineteenth century. Photo by Patricia Davison. © Iziko Museums of Cape Town.

stamps and . . . the coins of many countries used at the Cape."[45] The local indigenous peoples and their artifacts, though, were categorized as ethnology, not cultural history, and were collected and displayed in the museum that was primarily concerned with natural history.

For most visitors to the SAM, on organized tours and on their own initiative, the ethnological wing is the section they first encounter.[46] The wing has three components. In the archaeological section, iron age and stone age finds are displayed, with a substantial proportion of this gallery being devoted to rock art and some of the more recent interpretations that emphasize its symbolic nature. The visitor then moves into a gallery that, up until April 2001, displayed the diorama scene of a hunter-gatherer camp in the nineteenth century—more widely known as the bushman diorama (figure 1). This diorama, which opened in 1960, displayed painted plaster figures in an invented cultural world of Khoisan hunter-gatherers based on a nineteenth-century painting by Samuel Daniell. The figures on display were derived from a body-casting project that the museum had undertaken in the early twentieth century, in which casts were made of farm workers and prisoners in the northern Cape, who were taken to represent a racial type of "bushmen." This body-casting

project, the way that the figures on display came to represent "generic physical types," and their setting in a museum devoted largely to natural history had made the diorama a center of controversy for many years.[47] Teachers and tour guides would constantly use the display to emphasize racialized physical features, pointing to skin color, hair type, body shape, and genital forms.[48]

Unless visitors want to retrace their footsteps and return to the foyer of the museum, they are led into the African cultures gallery, where there are a series of ethnic displays: the Zulu, the Swazi, the Southern Nguni (Xhosa), a Nama camp, Khoisan hunter-gatherers, dancers in the Central Kalahari, the South Sotho, the Tswana, the Lobedu. Found in these displays are either casts or sculpted models taken to represent each ethnic group. In the glass cases, alongside the models, are a series of objects signifying ethnic meaning, including clay pots, snuff boxes, and blanket pins, and notices telling about the importance of beer, clothing, and narcotic substances. Unlike with the bushman diorama, these are not reconstructions of invented scenes (the Nama camp is an exception), but the models or casts together with the artifacts are used to explain aspects of ethnic culture such as initiation rituals, beadwork, hunting, dancing, and music. Most of the displays emphasize that "the dark-skinned people"—this is how the people in the gallery are referred to on a notice that is now virtually hidden away—live in rural areas and are located in timeless places as "tribes" or "groups."[49] Taken in its entirety, the gallery creates the impression "of traditional ways of life situated in the ethnographic present with no account taken of historical context or the dynamics of change."[50] Upon departure from the ethnology wing the visitor encounters displays of marine life, including seals and penguins, before moving into the central hall of the museum, the whale well.

Since the African cultures gallery was completed in the 1970s it has remained largely unaltered. This is in spite of a range of negative criticisms that academics, political activists, museum workers, students, and some visitors have leveled against the displays. These include the assertion made by Mandela about African people being displayed alongside animals, whereas white people are represented in the cultural history museum. Additional critical issues raised are the use of classificatory categories that largely coincide with apartheid's ethnically based classifications, the production of the exhibits by casting living people, and the role of "white ethnologists" in constructing and presenting the lives and cultures of indigenous peoples.[51] Although staff at the museum assert that "these issues and criticism have been taken seriously," the SAM tended to hold back on the construction of new displays until a new museum structure was instituted by the postapartheid government.[52]

But there were some small signs of change in the late 1980s and early 1990s.

The first was a series of dilemma labels placed in the African cultures gallery in 1993, asking viewers to consider whether the displays and the earlier labels perpetuated ethnic and racialized stereotypes of African people as undeveloped and unchanging. In addition, photographs of African people in modern urban environments were placed on the glass in front of the displays. It is difficult to tell whether this strategy destabilized the viewing of these displays. According to the deputy director of the museum at the time, some visitors found these photographs very confusing, while others felt "it successfully focused attention on critical issues surrounding the interpretation of cultural difference."[53] Rankin and Hamilton observed that the "overlays served not so much to disaggregate the ethnic identities as to qualify previous notions of cultural stasis by acknowledging urbanization and other changes."[54]

Probably the most significant, and certainly most visible, changes that have occurred in the ethnology wing have been around the bushman diorama. In many ways the diorama was not merely an icon of the SAM but of museum displays throughout the country. In the late 1980s, the museum placed alongside the diorama an exhibit that showed how the diorama had been produced. Using a model that illustrated the process of casting, photographs from the actual casting project, and a model from a cast dressed in the early-twentieth-century attire of a farm laborer (not as a nineteenth-century gatherer-hunter), the exhibit was intended to alert viewers to the constructed nature of the diorama. A series of newspaper cuttings reflected some of the debate over the representation of indigenous people in general and the controversy about the diorama in particular. This exhibition, which engaged some of the key contextual issues around the diorama, seemed to have had a minimal impact on visitors to the museum, however. Most spent a large amount of time viewing and commenting on the reconstructed scene of the bushman diorama and then passed by the display about its production (which consisted mainly of photographs and text) to move on to the African cultures gallery.

The exhibition that constituted the most serious points of engagement with perceived ideas of culture contained in the bushman diorama was "Miscast: Negotiating Khoisan History and Material Culture," which opened in 1996. This temporary exhibition, though, took place in the South African National Gallery, some five hundred yards away from the SAM. This institution collects and displays art, but since the 1990s it had systematically sought to "assess, and challenge definitions, categories and standards."[55] "Miscast," which attempted to counterpose atrocities against "Khoisan" people by the gun and the museum with "bushman" self-representations, spoke to the controversial bushman diorama at the SAM. The central exhibitionary space contained an installation of unpainted resin casts of farm workers and prisoners. James Drury had origi-

nally made these casts in the same casting project used to produce the painted plaster figures in the bushman diorama in the SAM. In addition, there were boxes on shelves depicting the collections kept in the vaults of the museum, display cases containing a variety of instruments used in the science of physical anthropology to measure and classify people in racially frozen categories, and a monument to colonial conquest. Under a quotation from the work of the anthropologist Greg Denning, "There is no escape from the politics of our knowledge," were a series of cases displaying musical instruments, apparel, and other artifacts of Khoisan peoples. Most of these cases bore the names of characters from a bushman narrative that had been constructed through the philological and linguistic work of the scholars Wilhelm Bleek and Lucy Lloyd at the end of the nineteenth century. Lucy Lloyd was accorded a special place in the exhibition, with a large portrait photograph of her in a prominent position on the main wall. She appeared as the voice of humanity whose work sought "to preserve the memories of cultures and traditions which were fatally threatened."[56]

There is no doubt that "Miscast" generated a great deal of controversy and debate, and it attracted large crowds to the National Gallery.[57] Much of the debate centered on whether the curator, in attempting to show the politics and violence involved in representations of indigenous peoples, had in fact reproduced these images.[58] A key aspect of the exhibition, though, was its attempt to construct a metaphorical bridge between the SAM and the National Gallery in order to challenge classificatory systems and move away from notions of essentialized, timeless traditions that pervade the displays in the ethnology wing of the SAM. Two features of the exhibition made this bridge very difficult to construct. First, institutional politics meant that explicit connections were not made between the exhibition in the National Gallery and the various stereotypical displays of African culture in the SAM. The SAM made very little attempt to notify visitors to the bushman diorama about the presence of "Miscast." The National Gallery, in turn, directed visitors to "Miscast" to a collection of Kuru artworks on display at the SAM, seemingly as just another bushman exhibit. Indeed, the National Gallery was insistent that "Miscast" be given the subtitle "Exhibiting Khoisan History" instead of the curator's choice of subtitle, "Exhibiting Bushman History," which would have been more consistent with the exhibition's concern with "the colonial apprehension of different groups of people."[59] Second, the exhibition itself was caught between these two contending intellectual projects: recovery of Khoisan agency and attempting to understand processes of bushman construction. The exhibition's attempt to challenge racial and ethnic categories in a spectacular manner was somewhat thwarted by the search for an authentic bushman voice, as reflected

in the Bleek/Lloyd archive and presented as containing material about Khoisan peoples that "is not seen from the perspective of Europeans."[60] The uncritical celebration of Bleek and Lloyd did not allow any space for their work to be contested and questioned as to how it may have, at times, relied upon essentialized categories and classifications similar to those that found their way into collections and displays at the SAM.[61]

In 1999 the SAM, the South African Cultural History Museum, the National Gallery, the William Fehr Collection, and the Michaelis Collection were all brought together under the Southern Flagship Institution and given a corporate image as Iziko Museums of Cape Town. Existing classifications were abolished and in their places three broad categories of collections were established: South African social history, art, and natural history. Once the institutional changes had been made, it was clear that the bushman diorama, as an icon of South African museum exhibitions, would be a major item on the transformation agenda: should it be moved into the building where cultural history was displayed, be redesigned, remain the same, or be closed down? In what was an almost unilateral move, the chief executive officer of Iziko Museums of Cape Town, Jack Lohman, decided on April 3, 2001, to "archive" the diorama because it was, in his words, "offensive to black people."[62] The museum boarded up what all surveys pointed to as its most popular exhibit (figure 2).[63]

The closure of the diorama spurred even more public debate in the media about its future. Some welcomed the closure of what they saw as a dehumanizing exhibit, while others felt that it was an affront to board up a display devoted to what was claimed as indigenous culture. It was most notable that a great deal of the negative comment about the closure came from the tourist industry that had included the SAM, and the diorama in particular, as major stops on their itineraries. City tours of Cape Town invariably take in a trip up Table Mountain, a visit to the Castle of Good Hope (where the Dutch East India Company headquarters were located), the Company Gardens, and the South African Museum. Once the announcement had been made that the diorama would be closed, tour operators were up in arms, claiming the "diorama as the 'number one draw card' for international tourists." With the closure of the diorama in April 2001 many tour companies decided not to take their guests to the SAM and the number of visitors fell markedly.[64] While the drop in visitors, and particularly tourists, was a major concern of the museum, the "vigorous" debates and discussions that emerged were welcomed as "an affirmation of the role museums can play in civil society."[65]

The closure of the diorama has not meant that the depictions and narratives of outside tour guides have altered substantially. Guides who still take groups to the SAM bypass the closed diorama, which they refer to as having

2. Visiting the "archived" diorama in January 2002. Photo by Wendelin Schnippenkoetter.

being shut down for reasons of political correctness, on their route from the archaeology section into the African cultures gallery, where they repeat almost the same stereotypes that were previously elaborated upon in the presence of the bushman diorama. The narratives that they present place a great emphasis on the physical characteristics. "This is what they [bushmen] look like," a guide explains to a group of tourists as they stand in front of the Nharo dancers display. The guides point to their supposed steatopygic condition, which is explained in terms of "the need to carry children" and by the comment that "they store fat in their buttocks for survival." The label on the display refers to the significance of music and dancing to inhabitants of the Kalahari and how it "enabled healers to enter a state of trance, during which they were able to draw on powers derived from the spirit world," but this is completely ignored. Giving the tourists a brief history lesson, one guide claims that when Jan van Riebeeck, the Dutch East India Company commander, arrived in the Cape in 1652 to establish a revictualing station, "there were no Africans in South Africa other than the Bushmen and Hottentots." She also maintains that "many Africans . . . still prefer to live in grass huts, even when the State provides them with brick-and-mortar accommodation." In the surrounds of the African cultures gallery a comparative visual rendition of physical types becomes possible.

The bushmen are referred to as being "smaller and lighter than the Bantu," having a "different physical structure of a hollowed back which pushes the stomach forward." "Their noses and lips," the guide tells the tourists, are "similar to the Bantu." He then draws comparisons with other racial types. "There is physically no difference between the Hottentots and the Bushmen," he elucidates, "but Hottentots were more well developed. The Bushman are tough but are not physically strong." Other displays in the gallery are referred to in the same physical terms. At the reconstruction of a late-nineteenth-century Nama herder's house in Namaqualand, the guide tells the tourists that "Namas living in Namibia are about 80 percent pure." The gallery also provides a mechanism to talk about South Africa in tribal terms, and guides use the opportunity to say that South African has nine tribes. How the guides arrive at this number is unclear: perhaps it is because there are eleven official languages and two of these are Afrikaans and English, or, even more likely, it may refer back to the ethnic groups identified under apartheid.[66]

It would be incorrect to assume that all tour guides present a similar narrative in the SAM. There are some exceptions, and these seem to be among companies that offer alternative types of tours, especially into the townships on the periphery of the city. When guides from these companies are in the SAM there is a tendency to present a discussion that talks about the symbolism and the making of the exhibits. There is an extensive discussion on the process of making body casts, the reasons for the closure of the diorama, and the results of this action. One guide, for instance, put forward the view that the closure was not achieving much, as there was still a museum "down the road" that dealt mainly with South African culture in European terms (even though there was now an umbrella structure of museums in Cape Town). He also said that the shutting of the diorama while keeping the African cultures gallery in place has meant that the same stereotypes are being perpetuated. "Bushman! Look!" continues to be the main refrain of visitors to the African cultures gallery.[67]

For Iziko Museums of Cape Town, there are clear difficulties in dealing with outside tour operators and, at the same time, transforming the museums' collections and displays. Not only is the ethnological wing of the South African Museum a major attraction, but also it provides the visual cues for the tour guides to explain South Africa. Iziko does not want to antagonize any operators who bring their visitors to the museum.[68] But it also does not have sufficient resources to employ staff to conduct the tours themselves. While there are strong political pressures from the government to transform, the imperatives of the museums to brand themselves and develop products for international tourists that accord with the slogan "Explore South Africa: Culture" gives strength to

conservative elements within Iziko who want to maintain existing institutional arrangements, classificatory divisions, collections, and exhibitions.

LWANDLE MIGRANT LABOUR MUSEUM

For tourists who want to go beyond the city and what Luvuyo Dondolo has referred to as the "white heritage trail," there is the option of making a trip into the townships.[69] Although there are many township tours available, there are very few museums in townships and only one in a township in the Western Cape. The Lwandle Migrant Labour Museum (figure 3) is situated some thirty miles outside Cape Town, alongside the motorway that leads past the airport and the winelands. The museum serves as a reminder of a system of migrant labor, single-sex hostels, and the control of black workers through the infamous pass book—an identity document that controlled access to employment and residence in urban areas.

Given the origins of Lwandle, it is highly appropriate that such a museum be located in the township. Lwandle was established in 1958, with hostel-type accommodation for workers who mainly serviced the nearby fruit and canning industry. These hostels were intended for single men. In terms of apartheid, the African family was to be bound to a rural environment, where they were

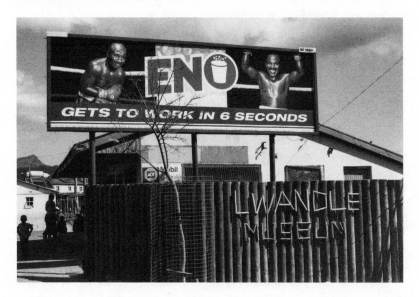

3. Entrance to the Lwandle Migrant Labour Museum complex, September 2003. Photo by Joanne Parsons.

to be identified in ethnic or tribal categories, and the laborer was seen as a temporary sojourner in the city. This meant not only that wages were kept low on the basis that the worker in town was supposedly merely supplementing his family's income but also that a minimal amount of money was spent on providing housing and services in urban areas. Hostels provided very basic accommodation, with four to six men occupying a small confined space, with an entire block sharing rudimentary ablution facilities. In the 1980s, as the control of the flow of people from rural areas was eased, these hostels became even more overcrowded.

In the 1990s, as part of the Reconstruction and Development Programme, the new ANC-led government decided to upgrade the hostels and turn them into family accommodation. The "Hostels to Homes" project provided the catalyst for the development of the Lwandle museum. Charmian Plummer, a resident from Somerset West who had done considerable volunteer work in Lwandle over the years, felt that at least one hostel should be preserved in order to sustain a memory of how the system of apartheid had operated. She joined together with Bongani Mgijima, a young resident of Lwandle and a graduate of the Postgraduate Diploma Programme in Museum and Heritage Studies,[70] to establish a museum on the basis of a preserved hostel. When the opportunity arose of also being able to occupy an old community hall, their plans expanded, and on May 1, 2000, the Lwandle Migrant Labour Museum officially opened with its exhibition "Memorising Migrancy."

The most striking and overwhelming image in the museum was that of an enlarged version of the pass book, the identity document through which the lives of Africans in urban areas were controlled, with a sign above indicating segregated beach facilities for people racially designated as white (figure 4). (Lwandle is near the town of Strand, the name of which, translated from Afrikaans, means "the sea." *Lwandle* is the Xhosa word for "sea.") This enlarged book gazed upon a set of wheelbarrows containing artifacts that were used by the residents of hostels. These barrows are an installation work by Cape Town artist Gavin Young. Finally, on a set of panels surrounding the barrows were photographs from the University of the Western Cape–Robben Island Museum Mayibuye Archive containing images of migrant labor, from poverty in the rural areas to influx control and resistance. In 2001, the Project on Public Pasts, a government-funded research project based at the History Department of the University of the Western Cape, became involved in reconceptualizing the museum's displays and constructed, together with the museum's staff, a new exhibition. "Unayo Na Imephu? (Do You Have a Map?)" aimed to "lay bare the initial motivation behind this apartheid-engineered settlement" and show

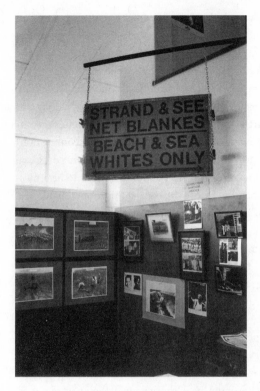

4. Exhibits at the Lwandle Migrant
Labour Museum, September 2003.
Photo by Joanne Parsons.

how "many of the maps of Lwandle were actually instruments to control mi-
grant workers who arrived in the Helderberg in the late 1950s and early 1960s."
According to the museum's curator, Bongani Mgijima, the photographs, maps,
and accounts were "selected, designed and displayed to tell what has been iden-
tified as crucial in the changing life and landscape of Lwandle." The hope was
that the exhibition would "encourage debate and discussion about the con-
tinual process of reliving and remapping Lwandle" and draw in members of the
community, whose individual stories would contribute to developing displays
and building collections.[71]

The Lwandle museum has, from its very inception, struggled with notions
of community. Given that the migrant labor system was based upon a delib-
erate use of ethnic categories, the museum rejects apartheid notions of com-
munity, which are based upon racial and/or ethnic identities. Instead it seeks
to establish the spatial configuration of Lwandle and all its residents as its im-
mediate community. But for these residents the notion of a museum in the
township is a very new one. Nearly all museums in South Africa are located

in or near the central urban areas. In Lwandle, the function of a museum as a place of collection is hardly acknowledged, as the artifacts it seeks to collect are seen to be of little interest beyond immediate personal use. There is the question of why it is necessary to have a museum when the most pressing requirements are for housing, employment, and health and educational facilities. Associated with this is the questioning of the need to preserve old buildings as a reminder of the days of apartheid when new and substantially better accommodation is needed. This was expressed by a notice that appeared on the door of Hostel 33 the day the museum officially opened: "We the residents of Room 33 deside to write this notice desagree with you about this room to be a messeum. Firstly give us accommodation before you can get this room. Thank you. From room 33." Finally, many residents of Lwandle often think of museums as places where schoolchildren are sometimes taken to view "stuffed animals . . . or to encounter the 'Bushmen.' "[72] Lwandle residents tend to see the museum as something for tourists, not for themselves.

Indeed, from the planning stages, which began in 1998–99, the Lwandle Migrant Labour Museum was keen to attract a community of international tourists. One of its first funding applications was sent to the Western Cape Tourism Board, expressing the hope that the museum would become "an extremely popular tourist venue." Reservations that the museum might have had about using racial and/or ethnic categories were cast aside as the museum presented itself as seeking to depict "the life of the local Xhosa people, their past and their present culture," providing a "WHOLE African experience for a tourist . . . an opportunity to see glimpses of the past, a comparison with the present, dancing, singing, arts and crafts and a taste of Xhosa cuisine and Fashion." Placed in an extremely vulnerable position, with little or no possibility of funding on the immediate horizon, the museum, in order to establish itself, found that it "had to dance to the tune of tourism."[73]

One way the Lwandle Migrant Labour Museum has endeavored to become a destination is to place itself on a township tour route (figure 5). Township tours are based on the premise of making the "real city" visible.[74] One tour company has produced an information booklet for tour guides about "another side of Cape Town: a side that we prefer not to show the tourist." Whereas tourism training has generally been limited to snippets of knowledge about the "most beautiful city in the world," the information booklet provides guides with a foundation that will enable them to show tourists "a reality we have to face." Although the author asserts that "squatter camps" are "not a very good way of introducing Cape Town to tourists and visitors," the booklet aims to assist guides "in answering questions from tourists . . . about the black townships and squatter camps of our city."[75]

5. A township tour of Lwandle in September 2003, conducted by the museum manager, Vusi Buthelezi. Photo by Joanne Parsons.

There is no doubt that these township tour companies and their guides are presenting, through their routes and destinations, parts of the city that stretch beyond the usual scenic sites and historical trails. But in the stories that are presented, the sites that are visited, and the people who are called upon, the townships almost retain an aura of being hidden places, where there is a "maze of dwellings, customs and traditions" and "it is peremptory to go with a guide." The routes along which one is guided take one into an almost essentialized Africa, where key stops are the craft shop, the "witch doctor's store," and a "shack where a few elderly men sit on the floor [and] conversate and drink Mqombotie."[76] This discourse replicates a tourist imaging of South Africa as a place of primitiveness and wildlife in a modern setting, the "World in One Country." There is much to be said for the assertion that the township tours are extensions of the rural "cultural village" in urban surrounds.[77] In this world of tradition the township tour remains an encounter where the West meets Africa through "music, dancing, mysticism, hospitality, joy, laughter, hope . . . beauty . . . and friendliness of the people."[78]

There is very little place for museums as destinations on these tours. Tourists are sometimes taken to museums, but generally such institutions are not located in the townships. In addition, museums usually provide a historical explanation (context) before making the journey across the imagined frontier between the city and the township. The township is being offered as a

6. Arts and crafts for sale at the
Lwandle Migrant Labour Museum.
Photo by Joanne Parsons.

place of difference. Museums do not fit into this pattern, being cast as places of
"Europeanness" instead of an essentialized "Africanness" of almost ahistorical
traditions.[79]

Thus, when the Lwandle museum, for instance, endeavors to offer a "safe
guided walk" through the "whole township" with an excursion through "an
original historic hostel," it finds that it has to represent itself as an African
place. The walk is presented as an opportunity to "learn more about the mi-
grant labour system (1958–1994)."[80] But this legacy of repression under apart-
heid is placed within an internationalized tourist representation of traditional
Africa as a place of essentialized ethnic rhythms, tastes, and crafts. The result
is that the intention to portray the political and economic history of migrancy
"slips almost magically" into tourist expectations of "authentic Africa," where
migrant histories might be exoticized to fit in with the tourist expectations
long conditioned by histories of travel.[81] As with other township tours, the
tavern, the homes, and the crèche become destinations on the walk. On its pro-
motional material the museum includes images of "traditional dress," claims
that it is a site of "cultural activities," and offers, among other items, "bead-
work and other locally produced souvenirs" (see figure 6).[82] Despite these
marketing efforts, the museum has not been able to insert itself as a desti-
nation for township tourism in the Western Cape. This may be a result of
its distance from central Cape Town, but perhaps it is also because the mu-

seum does not conform entirely to images of what constitutes an "African place."

CONCLUSION

Histories of the development of public museums and mass tourism are inextricably bound together. It is no coincidence that among the first package tours undertaken by the Thomas Cook organization in the mid-nineteenth century were trips to the Great Exhibition in London, an exhibition that set in place the key discursive practices of the modern museum. Perhaps most important was the notion of the exhibition creating a public citizenry, enabling the public to identify a sense of national belonging through the displays.[83] Moreover, when modern public museums developed, they served as what Kirshenblatt-Gimblett has called "surrogates of travel," enabling the visitor to gaze upon the world via the exhibits on show.[84] This remains a major function of museums, and perhaps even more so as museums have become bound into the world of international travel, becoming destinations in themselves.

The two museums discussed in this essay form part of the international tourist packaging of South Africa by a range of tourist networks and agencies "overtly driven by commerce and the state."[85] There are often disjunctures between how these museums project themselves to their more localized communities—what Lippard calls their covertly ideological function—and their positioning within the marketing apparatuses of international tourism.[86] In the portals of the SAM, the knowledge conveyed through outside guided tours of the African cultures wing is at odds with both the museum's stated aims of "promoting greater understanding and appreciation of natural history and anthropology for the enrichment of southern Africa's heritage to the benefit of all" and, more broadly, Iziko's mission to "empower and inspire all people to celebrate and respect our diverse heritage."[87] On township tour routes, where there is a "lot of lifestyle" on show and the emphasis is on "rhythm and vibrancy," museums hardly feature.[88] Instead, township tours in cities are now explicitly presenting themselves in precisely the same terms as cultural villages, offering tourists an opportunity to "meet people from different cultures and have a uniquely African evening experience without having to travel too far off to tourism villages."[89] When museums are on township routes, such as in the case of Lwandle, where the demands are for places of difference, there are huge pressures for the museums to locate themselves as exotic, ethnic destinations. Yet it is precisely through ethnic mobilization that places such as Lwandle came to exist as an African location: an "apartheid-engineered settlement" designed to "control migrant workers who arrived in the Helderberg in the late

1950s and early 1960s" through attempting to ensure that the urban African male laborer remained bound to an ethnically based rural environment.[90] Although the Lwandle museum recognizes the demands of tourism, one of its intentions is to show how the process of ethnicization was at the core of the system of migrant labor, and the museum itself does not want to display bounded ethnicities.

In resourcing community and tourism, postapartheid museums, both new and old, are therefore having to constantly mediate the pasts they collect, present, and represent. This mediation takes place in the global circuits of international tourism, its economy of images, and the insistent marketing of postapartheid South Africa as a place of ethnic difference. But in South Africa ethnic difference was the basis of apartheid and its self-representations. For older museums, such as the SAM, which claim to be "responding to the imperative for transformation" by confronting "the ideological burden of their own history," and newer ones, such as the Lwandle Migrant Labour Museum, which aims to give a version of South African history that talks to and about community, the struggle is to ensure that they do not alienate their local communities and, at the same time, to become part of a tourist economy where the official marketing agency describes the country's heritage as one of "European influences" and "African tribes."[91] The almost daily call by politicians and the business community for South Africans to embrace this "culture of tourism" is fertile ground for collections and displays of culture defined by ethnic, bounded, timeless identities to grow or take root in the museums of the new nation.[92] This is reinforced by another global movement of the late twentieth century (and not dealt with in this essay): that of assertions and claims by groups of people to land and cultural rights as first or indigenous peoples.

But perhaps the divergence between the representational demands of local communities and the branding imperatives of international tourism is not so great. Indeed, the bushman diorama is still open, albeit as a photograph, to illustrate the lifestyle of Khoisan hunter-gatherer communities. It forms part of a new display in the SAM that opened in the late 1990s on systems of indigenous knowledge.

NOTES

This essay is based upon research conducted for a National Research Foundation–funded project based in the History Department at the University of the Western Cape: the Project on Public Pasts. The financial support of the National Research Foundation toward this research is hereby acknowledged. Opinions expressed in this essay and conclusions arrived at are those of the author and are not necessarily to be

attributed to the foundation. I also wish to thank my colleagues Ciraj Rassool and Gary Minkley, who have worked together with me closely over the years in this research on public history. In this essay I draw a great deal upon their individual contributions as well as our collaborative work.

1 Bennett, *The Birth of the Museum*, 148.
2 Arts and Culture Task Group, *Report of the Arts and Culture Task Group*, 55.
3 Hudson and Nicholls, *The Directory of Museums*, cited in Davison, "Museums and the Reshaping of Memory," 149.
4 Bennett, *The Birth of the Museum*, 73.
5 Department of Arts, Culture, Science and Technology, "White Paper on Arts, Culture and Heritage."
6 Hamilton, "Against the Museum as Chameleon," 185.
7 Hall, "The Reappearance of the Authentic," this volume.
8 Rassool, "Community Museums, Memory Politics, and Social Transformation," this volume.
9 Rantao, "Museums Must Rewrite History."
10 Department of Arts, Culture, Science and Technology, *Annual Report 2001/2002*, 29.
11 Department of Arts, Culture, Science and Technology, "White Paper on Arts, Culture and Heritage."
12 Department of Arts, Culture, Science and Technology, *Annual Report 2001/2002*, 9.
13 Rassool, "Community Museums, Memory Politics, and Social Transformation."
14 Walsh, *The Representation of the Past*, 139; Lowenthal, *The Heritage Crusade*.
15 Urry, "Gazing on History," 214.
16 MacCannell, *The Tourist*, 176.
17 Kirshenblatt-Gimblett, *Destination Culture*, 152.
18 Ibid., 136.
19 Rassool and Witz, " 'South Africa: A World in One Country.' "
20 Moubray, *In South Central Africa*, 24; South African Railways and Harbours, *Travel in South Africa*, xi–xiii.
21 South African Railways and Harbours, *Travel in South Africa*, 80.
22 Ibid., 194.
23 Ibid., 196.
24 Ibid., xix.
25 Stevenson-Hamilton, *The Kruger National Park*, 23.
26 Thomas Cook & Son, *Cook's Tour of South Africa*, 11.
27 Rassool and Witz, " 'South Africa: A World in One Country.' "
28 Bunn, "The Museum Outdoors."
29 Mamdani, *Citizen and Subject*, 96.
30 CVR Tourist Guide, *The CVR Tourist Guide to South Africa*, 15, 36, 207.
31 Witz, *Apartheid's Festival*.
32 Bunn, "The Museum Outdoors"; Witz, *Apartheid's Festival*.
33 Conolly, *The Tourist in South Africa*, 9; Norval, *The Tourist Industry*, 181–82; Automobile Association of South Africa, *Road Atlas and Touring Guide of Southern Africa*, 41; Spencer, *Beautiful South Africa*, 101, 103–4.

34 Rassool and Witz, " 'South Africa: A World in One Country' "; Witz, Rassool, and Minkley, "Repackaging the Past."

35 Connex Travel, *South Africa*.

36 Grassroute Tours, *Grassroute Tours Invites You*; Chapman, "Township Tours—Exploitation or Opportunity."

37 Witz, Rassool, and Minkley, "Repackaging the Past."

38 South African Press Association, "Tourists Flock to SA After Sept. 11." The statistics on visitor numbers are a little misleading because they do not distinguish how many of these were tourists. Jackson and Cloete, "Lessons from www Tourism Initiatives in South Africa"; KwaZulu-Natal Tourism Authority, "Some Useful Tourism Statistics" (http://www.kzn.org.za/kzn/investors/59.xml; accessed May 7, 2002). and "South Africa: The Foreign Tourist Picture" (http://www.kzn.org.za/kzn/investors/63.html; accessed May 7, 2002); South African Development Community, "Trade, Industry and Investment and Review 2001"; Naidu, "Moosa Ecstatic over Torrent of Tourists."

39 Jackson and Cloete, "Lessons from www Tourism Initiatives in South Africa."

40 Coetzee, "The African Experience," 24.

41 Van Graan and Ballantyne, *The South African Handbook on Arts and Culture*, 74.

42 KwaZulu-Natal Tourism Authority, "Some Useful Tourism Statistics."

43 Rantao, "Museums Must Rewrite History, Says Mandela."

44 Fransen, *Guide to the Museums of Southern Africa*, 21.

45 Ibid., 21–24.

46 The description of the ethnological wing is based upon visits to the SAM in 2002. This was before the opening, on December 6, 2003, of a substantial new exhibition, "The Power of Rock Art."

47 Davison, "Typecast," 7.

48 Skotnes, "The Politics of Bushman Representations," 254.

49 There are some cases of what may be termed "nonethnic displays" in this gallery, but they are minimal and tend to fit in with stereotypes of Africans as craftspeople.

50 Cluver and Davison, "The South African Museum and the Challenges of Change," 280.

51 Ibid., 280–81.

52 Ibid., 281.

53 Davison, "Typecast," 153.

54 Rankin and Hamilton, "Revision; Reaction; Re-vision," 5.

55 Martin, "Bringing the Past into the Present."

56 Skotnes, "Introduction," 23. There were two other halls in the exhibition that are not discussed here. The first contained a series of photographs by Paul Weinberg on contemporary Khoisan communities. The second was an educational center where resources from various collections were on view that allowed further examination of how bushmen were represented and represented their own lives.

57 Hall, "Earth and Stone."

58 Abrahams, "Miscast"; Kozain, "Miscast"; Davison, "Typecast"; Robins, "Silence in my Father's House."

59 Skotnes, "The Politics of Bushman Representations," 263.

60 Ibid., 263.

61 Bank, "Evolution and Racial Theory."

62 Interview with Jack Lohman, South African Broadcasting Corporation, Oct. 4, 2000, cited in Davison, "Typecast," 8.

63 Davison, "Typecast," 4.

64 Ibid., 8, 18; Rassool, "Ethnographic Elaborations and Indigenous Contestations," 6.

65 Davison, "Typecast," 18.

66 These observations and quotations are from time spent by the author in the African cultures gallery of the museum in January 2002, observing tour guides and their groups, and also from a visit by students of the UWC/UCT/RIM Postgraduate Diploma in Museum and Heritage Studies in September 2001. See letter from Andrew Lamprecht to Dr. Patricia Davison, deputy director, South African Museum, Sept. 6, 2001 (copy provided by Lamprecht to the author).

67 Observations and discussion with tour guide, Richard Engel, Legends Tours, South African Museum, Jan. 9, 2002.

68 Letter from Andrew Lamprecht to Dr. Patricia Davison.

69 Dondolo, "The Construction of Public History and Tourist Destinations in Cape Town's Township," 38.

70 The Postgraduate Diploma Programme in Museum and Heritage Studies is a collaborative program of the University of the Western Cape, Robben Island Museum, and the University of Cape Town.

71 "Exhibit Maps the History of Lwandle."

72 Mgijima and Buthelezi, "Mapping Museum-Community Relations in Lwandle," 11.

73 Ibid., 8.

74 Cape Rainbow Tours, *See the Cape with Colour*; Grassroute Tours, *Grassroute Tours Invites You.*

75 Johannes, *The History of the Black Townships and Squatter Camps of Cape Town*, i.

76 "Life in Transit in Makeshift Housing: Khayelitsha," 7. In the Xhosa language, *umqombothi* is the name of a traditional beer brewed from maize.

77 Witz, Rassool, and Minkley, "Repackaging the Past."

78 "Life in Transit in Makeshift Housing," 7.

79 Witz, "Museums on Cape Town's Township Tours."

80 Lwandle Migrant Labour Museum, *Lwandle Migrant Labour Museum and Arts and Crafts Centre.*

81 Mgijima and Buthelezi, "Mapping Museum-Community Relations in Lwandle," 8.

82 Lwandle Migrant Labour Museum, *Lwandle Migrant Labour Museum and Arts and Crafts Centre.*

83 Bennett, *The Birth of the Museum*, chapters 2 and 3.

84 Kirshenblatt-Gimblett, *Destination Culture*, 132.

85 Lippard, *On the Beaten Track*, 78.

86 Ibid.

87 South African Museum, "Mission Statement," http://www.museums.org.za/sam/gen/mission.htm (accessed May 11, 2002); Iziko Museums of Cape Town, "Our Mission," http://www.museums.org.za/iziko/miss.htm (accessed May 11, 2002).

88 Coburn, "Township Tours," 34; Marais, "Flavours of Soweto," 73.

89 iAfrica.com, "Best Party of the Eastern Cape," April 19, 2001. http://travel.iafrica.com/activities/township/262572.htm (accessed May 11, 2002).

90 "Exhibit Maps the History of Lwandle."

91 Davison, "Typecast," 8; "Welcome to South Africa: A World in One Country," http://www.satour.org/TenReasons.html (accessed May 11, 2002).

92 Mokaba, *Tourism*.

Isn't This a Wonderful Place?

(A Tour of a Tour of the Guggenheim Bilbao)

ANDREA FRASER

If you haven't already done so, walk away from the desk where you picked up this guide and out into the great, high space of the atrium. Isn't this a wonderful place? It's uplifting. It's like a gothic cathedral. You can feel your soul rise up with the building around you. This is the heart of the museum, and it works like a heart, pumping the visitor around the different galleries. If you look up, you can see walkways, elevators, and stairways leading up and around the walls of the atrium between the galleries. These are the arteries. The separate galleries all lie off this central space, and to go from one to another, you must come back here.

In the great museums of previous ages, rooms linked from one to another and you must visit them all, one after another. Sometimes it can feel as if there's no escape. But here there is an escape: this space to which you can return after every gallery, to refresh the spirit before your next encounter with the demands of contemporary art. This building recognizes that modern art is demanding, complicated, bewildering, and the museum tries to make you feel at home, so you can relax and absorb what you see more easily.

As you look around you'll see that every surface in this space curves. Only the floor is straight. These curves are gentle, but in their huge scale powerfully sensual. You'll see people going up to the walls and stroking them. You might feel the desire to do so yourself. These curving surfaces have a direct appeal that has nothing to do with age or class or education. They give the building its warmth, its welcoming feel. And in this way the atrium tries to

I. Andrea Fraser, *Little Frank and His Carp* (still), DVD, 2001. Courtesy of Friedrich Petzel Gallery.

make you feel at home and prepares you for the purpose of the building: the art it contains.

Let's take a closer look at one of the stone-clad pillars in this space. If you stand with your back to the entrance, there's one to your right, holding up a large stone box that actually contains a tiny gallery. Go right up to it. This pillar is clad in panels of limestone. Run your hand over them. Squint along the surface. Feel how smooth it is.

Paradoxically, these sensual curves have been created by computer technology. Because of the way the surface of the pillar curves, each of these panels is slightly different. No two are quite the same. And this is true for all the curved walls of the building. If these panels had been produced by conventional means, this would still be a building site and the cost of the building would be astronomical. But these panels were cut and shaped by robots working to a computer program developed for aircraft design. To a computer, the mathematical problems involved in fitting together this vast jigsaw are simple. This process is very new and it should have a revolutionary effect on the way architects work, because it will allow them to embody more freely the productions of their imaginations, as well as allowing them to build more cheaply, and to a better quality.

Now turn to your right and look at the glass tower that contains two of the elevators. The glass surface of this tower also curves, and again the curves are produced by panels fitted together. But here they overlap, like the scales of a fish. This is no idle metaphor. The architect who designed this building, Frank Gehry, has always found inspiration in fish. He dates this obsession from the days when he used to go with his grandmother to the market to buy a live carp, which he would then take home and keep in the bathtub until it was time to cook it. Here little Frank would play with the carp and here the magic of its sinuous, scaly form somehow entered his bloodstream.

If you look to your left now, beyond the pillar under the stone box that we looked at a moment ago, you'll see the entrance to a large space. This is the largest gallery in the museum and, believe it or not, it's known as the Fish Gallery, because the long curving shape of this part of the building is derived, once again, from the shape of the fish. Let's go in there now. Press your pause button until you are in the gallery.

You are standing in a room of 3,200 square meters. It's 150 meters long and between 12 and 25 meters high. Contemporary art is big. In fact, some of it is enormous, and this gallery was designed to accommodate the huge pieces that artists have begun to create.

(Official audio guide, Guggenheim Bilbao Museoa)[1]

Yes, "in the great museums of previous ages, rooms linked from one to another and you must visit them all, one after another. Sometimes it can feel as if there's no escape."

But "here there is an escape," an escape from order: the order of one after another; the order of a rational, linear progression of rooms, objects, exhibits; the order of regulated movement; the order of looking; the order to look — to look at all and only look. Here, we are invited to feel. We are invited to touch.

Here there's an escape from the rules of behavior that have always told us not to touch. We are made aware of our desire to touch, so direct, that we share with those around us, that transcends age and class and education.

Here we can escape from our social selves, from social determination.

Here we can escape from identity in a place of endless differentiation. We can escape from our place of origin. We can feel at home away from home.

Here we can escape the boundaries of our discrete bodies. We become formless matter, fluid, pumped through the building's heart, its arteries, its corporeal passages; passages formed in masturbatory memories (what else are we to suppose little Frank was doing in the bathtub with that fish?); fantasies of sensual curves, sinuous forms, and powerful scales; fantasies of overcoming

the weakness and smallness of little individualities with the magic of tower-
ing cybernetic members. Contemporary art is "big." "In fact, some of it is
enormous."

Here we can even escape the forces of gravity. We feel our souls rise, limbs
like airplane wings.

Here, like architects and artists, we can be free to embody the productions
of our imaginations.

And that is the museum's revolutionary effect.

**In the great museums of previous ages, rooms linked from one to another
and you must visit them all, one after another. Sometimes it can feel as if
there's no escape.**

Douglas Crimp is often credited with introducing Foucauldian theory to the
study of museums. In his 1980 essay "On the Museum's Ruins," he famously
writes:

> Foucault has analyzed the modern institutions of confinement—the asylum,
> the clinic and the prison—and their respective discursive formations—mad-
> ness, illness and criminality. There is another institution of confinement ripe for
> analysis in Foucault's terms—the museum—and another discipline—art his-
> tory.[2]

Tony Bennett took up the challenge with his 1988 essay "The Exhibitionary
Complex." Nevertheless, he opens the essay by misreading Crimp's proposal:
"It seems to imply," he writes, "that works of art had previously wandered
through the streets of Europe."[3] It's a wonderful image, but one that unfortu-
nately has nothing to do with Crimp's argument, which is concerned above all
with the way technologies of reproduction may undermine the ordered dis-
course of the museum. A much more literal application of Foucault's work on
carceral institutions can in fact be found in my "Museum Highlights: A Gallery
Talk." The script of a 1989 performance in the form of a museum tour, "Mu-
seum Highlights" juxtaposes the museum to another institution of confine-
ment—the poorhouse—and develops the hypothesis that museums emerged
in the context of the formation of urban public spheres as systems of goads and
deterrences to particular forms of social behavior and cultural identification.

What Bennett is primarily concerned with, in any case, are not exhibits but
the publics constituted by exhibitions—publics that one *could* say, according
to Bennett's own arguments, had indeed wandered the streets as unruly crowds
before being constituted as orderly audiences by and for orderly displays orga-
nized for their edification. Bennett goes on to distinguish carceral institutions
from the nineteenth-century museums and exhibitions, panoramas, and ar-

cades that he dubs "the exhibitionary complex." Following Foucault, Bennett is concerned with institutions above all as technologies of order and discipline, "instruments of the moral and cultural regulation of the working classes."[4] However, whereas institutions of confinement developed technologies of surveillance that rendered the populace visible to the forces of order, institutions of exhibition served rather "to render the forces and principles of order visible to the populace." As such, they constituted "a set of cultural technologies concerned to organize a voluntarily self-regulating citizenry."

> Through the provision of object lessons in power—the power to command and arrange things and bodies for public display—they sought to allow the people, and *en masse* rather than individually, to know rather than be known, to become the subjects rather than the objects of knowledge. Yet, ideally, they sought also to allow the people to know and thence to regulate themselves; to become, in seeing themselves from the side of power, both the subjects and the objects of knowledge, knowing power and what power knows, and knowing themselves as (ideally) known by power, interiorizing its gaze as a principle of self-surveillance and, hence, self-regulation.[5]

I wonder if the anonymous author of the Guggenheim Bilbao's introductory audio tour ever read "On the Museum's Ruins" or "The Exhibitionary Complex." I suppose it's irrelevant. Reflections on the function and purpose, meaning and effects of museums and their architecture—which can now be found in the fields of art, art history, architecture, anthropology, sociology, history, and cultural studies and which have developed into their own discipline of museum studies—are also informing, directly and indirectly, developments within the field of museums themselves. In contemporary art museums in particular it's safe to assume that most of the educators preparing didactic materials, curators preparing exhibitions, directors setting policy and planning expansions, and architects developing new physical structures are at least aware of the existence of a critical discourse on museums. So it's not surprising to hear an echo of this critical discourse in the halls of new art museums themselves—even or especially within a set of negative representations: that is, as what new art museums do not want to be. Prisons. Carceral institutions. Institutions of confinement, of discipline, surveillance, order, regulation. Factories of edification and of taste.

But here there is an escape.

Of course, the museum's audio guide isn't telling us anything that hasn't already been proclaimed in the reams of writing generated on Frank Gehry's Guggenheim Bilbao, a building that seems on its way to becoming one of the

most written-about structures in the history of architecture. "Exultant erup-
tion," "frozen explosion," "stormy volumes," "floral splendor," "titanium ten-
tacles," "Tower of Babel," "a Basque bomb," "Lourdes for a crippled culture,"
and "the reincarnation of Marilyn Monroe" are among the metaphors com-
piled in one critic's survey of the literature.

The building has been described as a "world of sand castles and fairy tales,"
a euphoric world of "radical heterogeneity," "a place of contested borders" like
the Basque region itself. It finds beauty and meaning in "social fragmentation"
and "diversity," proving that "many languages can not only coexist but also
babble around within a broad and vibrant vista of the world."

It's a statement "on behalf of irregularity."

It "lives in the spirit of risk and experimentation."

It's "a sanctuary of free association. It's a bird, it's a plane, it's Superman.
It's a ship, an artichoke, the miracle of the rose."

Its "free-flowing and undulating surfaces" are the very " 'images' of archi-
tectural freedom" and a monument to art "understood as an excessive, impos-
sible, even farcical dream of freedom."

"If there is an order to this architecture, it is not one that can be predicted
from one or two visual slices of its precisely calculated free-form geometry.
But the building's spirit of freedom is hard to miss."[6]

Yes, the spirit of freedom.

**This space to which you can return after every gallery, to refresh the spirit
before your next encounter with the demands of contemporary art. This
building recognizes that modern art is demanding, complicated, bewilder-
ing, and the museum tries to make you feel at home, so you can relax and
absorb what you see more easily.**

Have new museums such as the Guggenheim Bilbao finally succeeded in re-
placing the pedantic discipline of a nineteenth-century ordering of things with
the fluid freedoms of unprogrammed flows? Is the "Bilbao Effect" indeed a
realization of the "myth of the next reality" in heterotopic spaces of radi-
cal heterogeneity? Or is the "Bilbao Extravaganza" just another symptom of
the spectacularization of museums and their transformation from public edu-
cational institutions into corporate entertainment complexes—a process in
which the Guggenheim has been counted as leading the avant-garde?

However, the audio guide reminds us explicitly that art museums are not
all fun and games. Modern and contemporary art, at least, is still "demanding,
complicated, bewildering." Art remains a challenge to be met, a bitter pill after
which one needs to "refresh the spirit" with a draught of soaring space. The

2. Andrea Fraser, *Little Frank and His Carp* (still), DVD, 2001. Courtesy of Friedrich Petzel Gallery.

architecture recognizes this. The architecture knows. The architecture under-stands. It not only sees (and speaks) but also listens to its visitors. And in the wisdom of its understanding it works not to reinforce art's impositions but to provide a respite from art's disturbing effects. Like in a dentist's chair, we're given a shot of Novocain before a root canal. *Now, you just relax. I'll try to spare you pain. But the operation must be performed.*

Another kind of discipline still seems to be at work here, but it's one that the "architecture," at least, would explicitly disown. It's a discipline deployed not *by* the institution of the museum but *within* the museum, it seems, by the institution of art itself. Or can we say by the art museum as an institutionalized form of art?

A program of movement is in fact laid out for us. We can go from one gal-lery to another as we please, but we must always come back "here." No, it's not a linear movement through a succession of rooms. It's more of a spiral up through space. The grand staircases of beaux arts museums elevated us for civilization. To enter the Guggenheim Bilbao, however, we must first descend, pouring into the museum lobby through funnel-shaped front steps. It is only from there that we are to ascend. From the atrium to the galleries to the atrium to the galleries to the atrium, we are to wind our way from uplift to bewilder-

ment to sensual communion to confronting demand and on to magical release in a dialectic of aesthetic transformation that promises to sublate us into fluid and finally perhaps even into air.

Yes, here there is an escape.

As you look around you'll see that every surface in this space curves. Only the floor is straight. These curves are gentle, but in their huge scale powerfully sensual. You'll see people going up to the walls and stroking them. You might feel the desire to do so yourself.

One may be able to speak of technologies of discipline common to an entire range of "exhibitionary" institutions—from panoramas and dioramas to expos, fairs, and the ever-growing family of museums. However, in order to understand the functions, meanings, and effects of art museums as a particular class of exhibitionary institutions, it's necessary to consider the very particular form of discipline they impose.

This may well be what Crimp had in mind when he called for a Foucauldian analysis of the art museum. When he returns to Foucault in his essay it's not with reference to the prison or the asylum. Rather, it's to a reflection on the work of Manet, in which Foucault found an acknowledgment of "a new and substantial relationship of painting to itself, as a manifestation of the existence of museums and the particular reality and interdependence that paintings acquire in museums."[7]

What began to make modern art so "demanding" in the nineteenth century may have been less the physical closure of museum spaces than the emergence of a kind of discursive closure that, in the words of Pierre Bourdieu, "categorically demand[ed] a purely aesthetic disposition which earlier art demanded only conditionally." And it is precisely this demand that was "objectified in the art museum: there the aesthetic disposition becomes an institution."[8] There, we can add, the aesthetic disposition also becomes a social discipline as the dialectic of aesthetic transformation is inserted into a specifically moral economy of freedom and renunciation, sacrifice and self-realization.

The aesthetic discipline institutionalized in the museum has been exemplified by the asceticism, silence, and stillness associated with art museums until so very recently. It is a discipline practiced in the renunciation of what so much aesthetic philosophy has described as the direct, immediate, obvious, easy gratification of the senses; a discipline performed in the bracketing off of corporeal wants and material needs, of economic interests and social prejudices; a discipline realized in the neutralization of "ordinary urgencies" and "practical ends" that has been considered the prerequisite of taste, of aesthetic pleasure, of contemplation and reflection, even of critical distance and reflex-

ivity—the prerequisite, that is, of all there is to be gained from a trip to the museum for an encounter with works of art.

Art museums were built and their contents collected and ordered to accomplish this aesthetic neutralization. The social world, with its noise and movement, urgencies and ends, was banished by the silence and stillness of windowless rooms. The uses of objects and representations were neutralized by their withdrawal from everyday life and by the juxtaposition of forms "originally subordinated to quite different or even incompatible functions."[9] And above all, perhaps, the economic value of things as commodities was neutralized by their permanent withdrawal from private consumption and material exchange into the public collections of public institutions.

These curving surfaces have a direct appeal that has nothing to do with age or class or education.

In Bourdieu's analysis, however, the aesthetic neutralization institutionalized in the art museum is anything but neutral. Aesthetic principles exist, rather, as the "universalization of the dispositions associated with a particular social and economic condition."[10] The aesthetic disposition "is one dimension of a total relation to the world and to others, a life-style, in which the effects of particular conditions of existence are expressed in a 'misrecognizable' form." Like the philanthropic acts of donation through which so many objects find their way into museum collections and on which so many museums themselves depend, the aesthetic and its institutions are both the product and the manifestation of a distance from economic necessity: of economic power that is "first and foremost a power to keep economic necessity at arm's length." The world of artistic freedom institutionalized in the museum is a world "snatched, by economic power, from that necessity." As such, it is engendered as "the paradoxical product of a negative economic conditioning."

In other words, according to Bourdieu, the aesthetic and its institutions presuppose "a distance from the world . . . which is the basis of the bourgeois experience of the world."[11] It is an experience of the world, one might say (at the risk of suggesting too direct a correspondence), common to the patrons of art museums, the previous owners of much of their collections, and, in the American tradition, their founders and trustees.

The particular symbolic power of the aesthetic lies in the almost complete circularity of its essentialism: another kind of institutional closure, perhaps; another kind of prison. As Bourdieu demonstrates over and over again in *Distinction* (1984), a disposition to aesthetic experience is a clear product of social and economic conditions, such as "age and class and education." However, it exists as a manifestation of those conditions precisely to the extent that it

3. Andrea Fraser, *Little Frank and His Carp* (still), DVD, 2001. Courtesy of Friedrich Petzel Gallery.

denies and distances them in its affirmation of the "direct appeal" of surface, shape, color, and form. And it is this very distancing that defines the experience it produces. The aesthetic is thus the perfect product of a determination that frees us precisely through a negation of the (negative) determinations of freedom of which it is the "paradoxical product."

Like all essentializing ideologies, the aesthetic accomplishes its seduction by way of a cruel ruse: the promise that the pleasures and satisfactions, advantages and capacities—in a word, freedoms—provided for by particular social and economic conditions can be achieved by an individual effort of the mind and willful disciplining of the body. If museum visitors were to be "liberated from the 'struggle imposed by material needs,' " as a Philadelphia Museum of Art pamphlet promised in 1922, it was not by way of the satisfaction of those needs, but by way of their distancing and displacement, mastering and renunciation: a liberation to be achieved by way of submission, not to the omnipotence of a surveilling gaze of power so much as to the omnipotence of the neutralizing gaze of the aesthete institutionalized in the art museums.[12]

They give the building its warmth, its welcoming feel. And in this way the atrium tries to make you feel at home and prepares you for the purpose of the building: the art it contains.

But museums aren't like that anymore. They're neither ascetic nor silent nor still, but warm and welcoming and open to the street and full of everyday life. And they're not only for the well-educated middle and upper classes, but teeming with the most diverse people with the most diverse interests and reasons for being there. "The museum is really free space. People do what they want to do," from "sleeping there, to looking at art, to having a meal . . . to picking each other up."[13]

Aestheticism may still be represented in a modernist corner of the collection, but you'll also find pop art and maybe even pop culture—like fashion, movies, and motorcycles—as well as contemporary art in all its diversity: not only painting, but performance, photography, digital media, big slabs of rusty steel, and monumental puppies made of flowers.

Most important of all, museums no longer leave their visitors at the mercy of such demanding, complicated, and bewildering art. Having learned from such groundbreaking studies as *The Love of Art*, museums now offer a wide range of educational programs and materials to help guide visitors without backgrounds in art through their experience at the museum.[14]

Like this introductory audio tour.

Now . . .

Let's take a closer look at one of the stone-clad pillars in this space. If you stand with your back to the entrance, there's one to your right, holding up a large stone box that actually contains a tiny gallery. Go right up to it. This pillar is clad in panels of limestone. Run your hand over them. Squint along the surface. Feel how smooth it is.

Like so many other visitors, I obediently run my hand over the limestone panels. Yes, I do feel how smooth it is. I press my body against the column. I lift up my dress and start to rub up against its "sensual curves." No one moves to stop me: not the security guards—men in uniforms with guns—patrolling from the walkway-arteries, nor the gallery attendants—women in gray skirts, elegant red jackets, and colorfully printed silk scarves carefully tied so that the word "security" is visible between lapels. After all, I'm only following the suggestion of the official audio guide. Then someone takes out a camera to snap a photo. The offending apparatus is immediately surrounded by a swarm of women in red.

Freedom, it seems, still has its limits.

The threat of ETA attacks explains the presence of an X-ray machine at the coat check counter and guards with guns on the catwalks. The plaza in front of the museum is named after a policeman killed there by ETA militants whom he discovered planting a bomb in flowers destined for the opening ceremonies.

4. Andrea Fraser, *Little Frank and His Carp* (still), DVD, 2001. Courtesy of Friedrich Petzel Gallery.

The main job of the guards and gallery attendants, however, appears to be preventing people from videotaping and photographing the art and architecture. Visitors are encouraged to caress the walls, but they're strictly prohibited from photographing them. The museum is aggressive in enforcing its copyright to the image of the building and has threatened unauthorized reproductions with legal proceedings. When a local artist who runs a pasta shop started selling dry macaroni in the shape of Gehry's building, the response from museum lawyers was swift and unequivocal: cease production of the noodle or prepare to be sued.[15]

Such image control is evident in other ways in the museum's interior. Like the impeccably dressed gallery attendants and information staff whose appearance and behavior are closely regulated by guidelines laid out in an employee handbook, the museum is spotless. The white walls are reportedly touched up daily. The glass always sparkles. The floor also looks clean enough to caress. Together, the security, corporate hospitality culture, and shine make the lobby feel like a cross between a business hotel and an airport—all that's lacking are trolleys with piles of luggage. It wouldn't be a surprising sight in a museum that prides itself on the fact that 85 to 90 percent of its visitors are from outside the region.

Paradoxically, these sensual curves have been created by computer technology.

If the discipline imposed by the art museum has always in some sense been an order of freedom, what the Guggenheim Bilbao represents may not be the transgression of the order and discipline of the art museum so much as the imposition of another kind of freedom: the paradoxical product, perhaps, of a new set of social and economic conditions.

The Guggenheim Bilbao Museoa has now become the inevitable example of the success of museum-driven urban revitalization plans. Supported by the governing conservative Basque Nationalist Party, or PNV, and publicly financed to the tune of $150 million by various levels of government of the Autonomous Community of the Basque Country, the Guggenheim Bilbao is the product less of cultural policy than of economic policy.[16] As is well known, the social, economic, and environmental devastation of Bilbao had reached catastrophic proportions by the mid-1990s. With the collapse of mining, steel, and shipbuilding industries, the metropolitan area had lost 20 percent of its population and 47 percent of its industrial jobs in the two preceding decades.[17] Its birthrate fell by almost half, to 7.4 per thousand. It contained an estimated 465 hectares of industrial ruins, up to 50 percent of the total industrial land in some municipalities. Entire valleys were devastated by pollution, with hills dotted by toxic ponds of flooded open-pit mines and a river reduced to a bubbling ribbon of orange sludge. Last but not least, it was the metropolitan center of a region home to a militant separatist movement that had claimed over eight hundred lives since the 1960s.[18]

The Guggenheim Bilbao Museoa became the centerpiece of a plan to turn Bilbao around: to rescue its image, revive its economy, and transform it, if not into a global city, at least into an internationally competitive city in the areas of culture and advanced services.

The scope of the Basque government's ambitions is evident in the "Revitalization Plan for Metropolitan Bilbao" outlined by Bilbao Metropoli-30, a public-private partnership group created to promote redevelopment.[19] The Guggenheim Bilbao is listed alongside a series of other initiatives, such as the revitalization of the stock exchange, the redevelopment of the port, a new urban train system designed by Sir Norman Foster, a new airport by Santiago Calatrava, the new Euskalduna Palace Concert and Conference Hall by Federico Soriano and Dolores Palacios, the European Software Institute, and the Technology Park of the Basque Country. Other projects include a new central train station by James Stirling, and Abandoibarra, a 30-hectare riverfront area next to the museum redesigned by Cesar Pelli to include

space for advanced services, high-income housing, shopping, leisure, and culture.[20]

"Cultural centrality" is one of the "eight critical issues" identified by the plan that "will allow Metropolitan Bilbao to compete successfully in the European system of cities." "Cultural centrality" means that metropolitan Bilbao's "competitive advantage in the face of other cities in its sphere will be set by its new position as cultural center of international dimension" — that is, as "an obliged point of reference in cultural circuits and industries which are developing at an international scale."[21] "Cultural centrality" is linked to the expansion of tourism, the city's ability to attract congresses and fairs, and, perhaps above all, the creation of an environment favorable for the development of advanced services.

By the time the Guggenheim Bilbao Museoa opened on the banks of the Nervión River in 1997, metropolitan Bilbao seemed on its way to accomplishing the economic restructuring envisioned by these strategic revitalization plans. According to a study of 1996 indicators by Rodriguez, Guenaga, and Martinez, service employment had already made up for many of the industrial jobs lost between 1975 and 1996, increasing its share of the economy from 41.7 percent to 65.2 percent while manufacturing dropped from 45.5 percent to 26.9 percent.[22] However, services, and particularly advanced service employment, were strongly concentrated in Bilbao and in historically affluent communities on the right bank of the Nervión River. In the historically working-class communities and industrial zones of the left bank, unemployment and poverty rates continued to rise. Economic restructuring in metropolitan Bilbao appeared not only to be reproducing and exacerbating "earlier patterns of differentiation between the left and the right bank areas of the river" but also producing "new forms of social and spatial exclusion; demographic decline, rising unemployment and increasing poverty levels." According to the study's analysis, high unemployment rates "are only the most visible effect of a more profound dynamic associated with increasing deregulation and flexibilisation of the labour market" running parallel to the expansion of services: "the precarisation of employment conditions, evidenced by the proliferation of weakened forms of the labour relation (part-time, temporary and intermittent contracts, etc.), is of even greater importance."[23]

Because of the way the surface of the pillar curves, each of these panels is slightly different. No two are quite the same. And this is true for all the curved walls of the building.

"What is the impact of the ascendance of finance and producer services on the broader social and economic structure of major cities?" Saskia Sassen

opens one of the final chapters of *Cities in a World Economy* with this question.[24] The tertiarization of the economy of metropolitan Bilbao seems to show every sign of following the pattern of increased social polarization analyzed by urbanists such as Sassen. When manufacturing was the leading sector of urban economies, it facilitated unionization and other forms of worker empowerment.[25] It was based on household consumption, so wage levels mattered. Now, "components of the work process that even 10 years ago took place on the shop floor . . . have been replaced by a combination of machine/service worker or worker/engineer," typically through computerization. Work that was once "standardized mass production is today increasingly characterized by customization, flexible specialization, networks of subcontractors, and informationalization." Economic regimes "centered on mass production and mass consumption" reduced "systematic tendencies toward inequality." So, Sassen adds, "did the cultural forms accompanying these processes."[26]

And the cultural forms accompanying the new production processes?

Art museums have long been considered institutions founded in opposition to mass popular culture. In the United States, cheap manufactured goods, jazz, burlesque, and pulp fiction are among the emerging forms of popular culture named in the early documents of the Philadelphia Museum of Art. Against such cultural evils, philanthropists and reformers sought to impose, through museums, their own distinctive and exclusive cultural forms as exclusively legitimate public culture. Do current trends toward the popularization of art museums represent the collapse of this project? Many observers think so, and even offer some of the immensely well attended exhibitions presented by the Guggenheim as examples—exhibitions such as "The Art of the Motorcycle," "Armani," and a retrospective of the work of Norman Rockwell. What such exhibitions may represent, however, particularly in the context of museums such as the Guggenheim that aggressively pursue mass media publicity campaigns, is not the popularization of the museum but rather its opposite: a new subjection of cultural goods produced for mass distribution and consumption to the distinctive and exclusive modes of appropriation that are what finally distinguish high from low, elite from popular culture.

Within ever more popular art museums, cultural goods are subjected to a chiastic symbolic process. On one hand, "popular" culture is articulated within the distinctive and socially and functionally neutralizing systems of perception, appreciation, and classification that define aesthetic appropriation. On the other hand (and at the same time), these exclusive and exclusionary modes of appropriation are inserted into popular cultural networks as the art museum itself becomes an ever more "popular" institution. And because the symbolic neutralization performed by art museums is inseparable from the economic

neutralization that defines their publicity, this distinctive system is severed from the social conditions of its production and realization. The result is not the democratization of the museum but the mass marketing of rarefied tastes that articulate an economic condition in a fundamentally misrecognized symbolic form.[27]

The unique, customized, and individualized objects and environment that the Guggenheim both architecturally represents and contains can be seen as the perfect products of the leading production processes of a new economic regime. At the same time, it may be that the mass marketing of unique, distinctive, and rarefied tastes by ever more popular museums contributes to consumer demand for ever more individualized products and services, demand that in turn may contribute to the expansion of the production processes — and labor relations — required to satisfy them.

If these panels had been produced by conventional means, this would still be a building site and the cost of the building would be astronomical. But these panels were cut and shaped by robots working to a computer program developed for aircraft design. To a computer, the mathematical problems involved in fitting together this vast jigsaw are simple.

So if, as Bennett writes of late-nineteenth-century world's fairs, museums always served "less as vehicles for the technical education of the working classes than as instruments for their stupification before the reified products of their own labor," the Guggenheim Bilbao may exist rather as a monument to the obsolescence of that labor.[28] It is the product of computers and robots, obsession and magic, fantasy and imagination, facility and freedom. It's the product of a world in which the human labor of production does not exist.

Construction of the Guggenheim Bilbao Museoa began in 1993 on the Nervión River a few kilometers upstream from where the Euskalduna shipyards once stood. The shipyards were closed in the late 1980s amid violent protests that left one demonstrator dead. The Euskalduna Palace Conference Center and Concert Hall that now stands in its place was designed to look like a grounded ship. Between the Euskalduna Palace and the museum extends the 30-hectare Abandoibarra development area.

Widespread opposition to the museum in its planning stages seems to have given way to an acceptance of its positive effect on the image of the city and its contribution to urban regeneration. Although interpretations of the numbers differ, the museum reportedly generated economic activity that added 0.47 percent to the gross regional product in its first year of operation, contributing to the maintenance of 3,800 jobs, mostly through tourism. Even with these numbers declining, the public investment in the museum would have been

repaid within three years by increased tax revenues.[29] Bilbao and the Basque country increasingly appear in the international media in connection with topics other than terrorism. While inflows of foreign capital don't seem to have increased significantly, the crucial role of the museum and related redevelopment projects in transforming Bilbao is not only a matter of direct investment. As suggested by Rodriguez and colleagues, bringing together culture, leisure, shopping, advanced services, and high-income housing in the very center of the city "provides the basis for a new model of collective identification based on the lifestyles and aims of emerging power groups and urban elite."[30]

For most Bilbao residents, it's difficult to imagine that the museum's displays serve as object lessons in civic order, as Bennett suggests of nineteenth-century museums. Residents hardly go inside (only 10–15 percent of visitors are local). The museum itself, with its chaos of curves and surfaces, may rather serve as a lesson in the *disordering* of their lives by a new economic regime. The promises of that regime, however, may remain for others to enjoy. The museum as a workplace itself provides evidence of the kind of jobs the new economy can be expected to bring. The information staff consists of sub-minimum-wage interns supplied by the degree program in tourism at Deusto University, across the Nervión River. Tours are given by freelancers, often also students. Gallery attendants and security guards are subcontracted. Art preparators are hired on a show-by-show basis, with no benefits or provisions for workplace accidents. These are hardly the kind of jobs that would provide residents with the material basis to pursue the new freedoms the museum represents. Instead, they impose other kinds of "freedoms": the freedom of freelancing, the freedom of temporary work and flexible hours, the "freedom" of insecurity. But they are precisely the kinds of flexible, part-time, and art-related jobs traditionally favored by artists who want time to "embody more freely the productions of their imaginations."

This process is very new and it should have a revolutionary effect on the way architects work, because it will allow them to embody more freely the productions of their imaginations as well as allowing them to build more cheaply, and to a better quality.

Hal Foster concludes his 2001 essay "Master Builder" by asking of Gehry's architecture and then of himself: "So what is this vision of freedom and expression" proclaimed by so many Gehry fans? "Is it perverse of me to find it perverse, even oppressive?" He answers:

> [It] is oppressive because, as Freud argued long ago, the artist is the only social figure allowed to be freely expressive in the first place, the only one exempted

from many of the instinctual renunciations that the rest of us undergo as a matter of course. Hence his expression implied our unfree inhibition, which is also to say that his freedom is mostly a franchise.[31]

According to Freud, however, the instinctual satisfactions available to artists come at the price of turning away from reality, making art what Bourdieu might have called a profession of social fantasy.[32] The attractiveness to artists of flexible positions and individualized relations that are "vague and ill-defined, uncertainly located in social space" is that "they leave aspirations considerable room for manoeuvre."[33] And while the "privilege" of freedom — and instability — was once reserved for artists and intellectuals, it is now being extended to a whole range of service occupations, and beyond. So it is no longer only into our own fantasies (and those of our patrons) that we artists project our uncertain futures. Those fantasies already may have merged with what Bourdieu called neoliberalism's "utopia of unlimited exploitation": a system of structural instability not only of employment, but in the "representation of social identity and its legitimate aspirations."[34] And through the increasingly popular publicity generated by institutions such as the Guggenheim, artists (and some architects) have become the poster children for the joys of insecurity, flexibility, deferred economic rewards, social alienation, cultural uprooting, and geographical displacement, as if it's all just one big, sexy lifestyle choice.

In the context of neoliberal economic regimes, the art museum is emerging as a privileged site for valorizing the precarization of work. Through representations of art and artists, architecture and architects, flexibility, spontaneity, customized products, individualized relations of production, and even insecurity itself are represented as positive values, sources of creativity, dynamism, and growth. The products of disempowerment are transformed into promises of freedom and previously unimagined pleasure.

Now turn to your right and look at the glass tower that contains two of the elevators. The glass surface of this tower also curves, and again the curves are produced by panels fitted together. But here they overlap, like the scales of a fish.

Why have modern and contemporary art museums become a favorite tool of urban regeneration and redevelopment schemes? How is it possible that cultural forms even museums themselves admit are "difficult, demanding, bewildering," cultural forms widely identified with obscurantism, elitism, and exclusivity, cultural forms ridiculed in the media and periodically subjected to censorship, vandalism, and protest — how is it that such culture could possibly be placed at the center of multimillion-dollar development schemes whose

logic depends on attracting massive numbers of visitors and worldwide media recognition?

The question has been taken up, but the answers offered only seem to beg it once again.[35] Is it just that a contemporary art museum offers a particular conjunction of attributes, like a product profile that suits a particular audience profile, sought-after market, or target economic sector?

One could rest the argument on a roster of substantive attributes that might tally up to a balance of the art museum's contradictions. Such a list may be informative. Taking another look at the text of our introductory audio tour, we can put "freedom" at the very top of the list. Then would come "open," like the space of the atrium and the plan of the museum, and "flexible," like the uses to which the building's materials have been put and the flow of our movement through it. That flow could be called "dynamic, moving, self-transforming." It allows us to experience the "future" of museums, of culture, of production in all its "novelty." It allows for "growth": the growth of the institution and its architecture to enormously powerful scales; our growth as "individuals"; the growth of "individualism" itself, perhaps, in the unique forms and objects and spaces of the museum in all its "diversity" and "democratic" populism.

This is no idle metaphor. The architect who designed this building, Frank Gehry, has always found inspiration in fish.

My list is actually borrowed. All the terms in quotation marks are derived from an "ideological schema" of the rhetoric of neoliberalism set out by Pierre Bourdieu and Loïc Wacquant. Each appears in a series of oppositions:

state	market
constraint	freedom
closed	open
rigid	flexible
immobile, fossilized	dynamic, moving, self-transforming
past, outdated	future, novelty
stasis	growth
group, lobby, holism, collectivism	individual, individualism
uniformity, artificiality	diversity, authenticity
autocratic ("totalitarian")	democratic[36]

The only term I left out was the first, "market," a term to which all the others in the right-hand column are directly or indirectly made to refer. I would add one final opposition to the set: local and global.

The fantasies of freedom packaged by the Guggenheim Bilbao can certainly be read as symbolic manifestations of the freedom from national, civic, and

communitarian order, cultural tradition and social determination, and political and economic regulation that are the foundation of neoliberal programs. They are freedoms increasingly realized by the global mobility of capital, production, and the transnational elites among whom cultural producers can be counted in growing numbers. And they are also freedoms increasingly sought and enjoyed not only by artists and the individual and corporate patrons of museums but also by the corporate entities many major museums themselves have become.

A more revealing exercise may be to consider the terms in the left-hand column as describing what museums have been considered — and no longer want — to be: instruments of the "state"; institutions of confinement and "constraint"; architecturally and discursively "closed" structures following "rigid" organizational and conceptual models that are as "immobile" and "fossilized" as their "outdated" displays of the "past." Et cetera.

No, we're dealing not with idle metaphor here but with extremely active homologies: homologies that accomplish their work of structuration by linking apparently distant or even opposed spheres through parallel sets of oppositions — oppositions that may themselves serve as the motor for the very "dynamism" they affirm.

He dates this obsession from the days when he used to go with his grandmother to market to buy a live carp, which he would then take home and keep in the bathtub until it was time to cook it. Here little Frank would play with the carp and here the magic of its sinuous, scaly form somehow entered his bloodstream.

Like Frank Gehry, our "master builder" and "Greatest Living Artist" (as Foster facetiously calls him), contemporary art museums are transforming the old (culture, cities, economies) into the new — even as they transform themselves.

Folksy memories of Grandma's quaint preindustrial consumption practices unfurl into towering cybernetic members. Obsessions, far from being pathologies, are realized on monumental scales. Idle metaphors spring into activity. They are put to work like robots, like computers, performing their magic of production without need for human labor.

If the Guggenheim Bilbao represents an institutionalized form of art, it isn't because Gehry has been considered an artist and his building a sculpture. Nor is it in the sense, as Foster and others have suggested, that the museum has "trumped" contemporary art, corralling it and swallowing it whole, appropriating and incorporating its transgressions.[37] The Guggenheim Bilbao is neither more nor less an institutionalized form of art than the "great museums of pre-

vious ages." Rather, it's a different dimension of art that has become institution here; a different fraction, if you will, of the artistic field, whose products of imagination and freedom correspond to a different, ascendant, fraction within the field of power.

If you look to your left now, beyond the pillar under the stone box that we looked at a moment ago, you'll see the entrance to a large space. This is the largest gallery in the museum and, believe it or not, it's known as the Fish Gallery, because the long curving shape of this part of the building is derived, once again, from the shape of the fish. Let's go in there now. Press your pause button until you are in the gallery.

Peter Lewis, the president of the Solomon R. Guggenheim Foundation, the parent corporation of the Guggenheim Bilbao, has described its director, Thomas Krens, and himself as "change agents." "To accept the status quo is early death. Change is valuable for its own sake, whether or not it turns out to be an improvement."[38]

From an institutional aestheticism that reached its peak with modernism and museums of modern art, we have now moved on to what can be called institutional trangressivism: the museological manifestation of the avant-garde traditions whose legacies now dominate the field of contemporary art. Art for art's sake has been discredited in the field of art as in museums and, as Peter Lewis would have it, it has been replaced with change for the sake of change.

Interestingly, unlike most museum directors, Thomas Krens does not have a doctorate in art history. Rather, he has two master's degrees: one in studio art and one in business.[39] His appropriation of for-profit business models, aggressive globalizing through an international network of branch museums, ties to corporations, deals with foreign governments, and exhibitions featuring luxury consumer products have all inspired much critical writing. Under Krens's directorship, the Solomon R. Guggenheim Foundation has even been described as a rogue institution and compared to rogue corporations such as Enron.[40] Despite often hostile appraisal, however, the Solomon R. Guggenheim Foundation has nevertheless become the leading model within the highly competitive market that the field of art museums has become. And the compelling force of that model has rested, above all, on the success of the Guggenheim Bilbao.[41]

You are standing in a room of 3,200 square meters. It's 150 meters long and between 12 and 25 meters high. Contemporary art is big. In fact, some of it is enormous, and this gallery was designed to accommodate the huge pieces that artists have begun to create.

Thomas Krens has said, "[G]rowth is almost a law. . . . Either you grow and you change or you die."[42]

As Foster has suggested, the gargantuan scales that one finds in contemporary art museums as well as in the contemporary art inside it are mechanisms of the spectacularization of art and its institutions.[43] They exist as two points in a self-justifying and self-perpetuating logic of expansion in which they serve, in turn, as symbolic manifestations. Big art demands big spaces. Big spaces demand big art. Big, spectacular art and architecture draw big audiences. Big, general audiences, with less specific taste for the specific traditions of modern and contemporary art and architecture, are drawn by big, spectacular art and architecture. Museums need big spaces to accommodate big art and big shows and the big audiences they draw. They need big shows and big art to draw big audiences to raise big money to build big spaces and organize big shows with big art to draw big audiences. . . .

The growth in the physical dimensions of museums such as the Guggenheim Bilbao is, however, only the most visible symptom of museum expansionism. It can also be seen as a manifestation of institutional ambitions and the strategies employed to realize them. It may be no accident that two of the most enormous museum spaces in Europe, the Guggenheim Bilbao's Fish Gallery and the Tate Modern's Turbine Hall, were developed by institutions pursuing expansion through the development of branch museums: the Tate within Britain and the Guggenheim globally.

The Guggenheim Bilbao is now only one of a growing number of Guggenheim branches in a family of franchise museums that spreads from St. Petersburg to Berlin, Las Vegas to Venice, and soon to Rio de Janeiro. The Guggenheim Foundation's growing international network of branches has also made it the leading model of globalization for museums, demonstrating that a global museum has potential for global sponsorship that single-location museums could never hope to secure.[44] That potential includes attracting sponsorship from public and private local interests in a wider range of localities as well as being more attractive to globalized corporate interests looking to reach more markets with their contributions.

As in so many other fields, one of the primary effects of globalization on the field of museums has been to transform it into a highly competitive market. Museums could once be relatively secure in local support, whether public or private, individual or corporate. Nations supported their patrimony. Cultural philanthropy, historically tied to urban reform movements, tended to be local, even for corporations, and driven, at least symbolically, by civic pride. Certainly museums played roles in the competitive struggles of nations and cities and their regional elites, and these struggles had economic and political

as well as social and cultural stakes. Generally, however, the forms of competition that existed between museums themselves were of a highly sublimated kind: struggles defined by the criteria of the cultural fields to which museums themselves belonged — such as conservation and research in art, history, ethnography, science, et cetera.

In the past decades, however, the spread of the American model of private support through Thatcherism in Britain to neoliberalism on the European continent and beyond has made museums increasingly dependent on private sponsorship. At the same time, these new private funders themselves, particularly corporations but also foundations and increasingly mobile elites, have undergone a process of globalization that makes them less interested in local institutions. Finally, enormous growth in the number of museums has created more competition at every level. The combination of these three factors may have effectively restructured the field of museums itself. Competition between museums may always have existed, but it now appears that the *survival* of many museums depends on their ability to compete, locally, nationally, and globally, for sponsorship and also for audiences.

Walk over to the left-hand side of the gallery and look up at the ceiling. You'll see a lighting gantry.

Oh, this tour is starting to seem interminable. Do we really need to know about the gantries? I turn off my headset and head back to the atrium. I want to give the walls another good grope.

NOTES

1 Much of the research informing this essay was conducted in the context of the development of an artist project with Consonni, Bilbao and with the assistance of the staff of that organization, Franck Larcade, María Mur, and Aranxta Pérez. Additional research was assisted by Yasmine Nessah. The introductory audio-tour of the Guggenheim Bilbao also served as the basis for the videotape "Little Frank and His Carp," video stills from which are reproduced with this essay. "Little Frank and His Carp" was produced by Consonni.

2 Crimp, "On the Museum's Ruins (1980)," 45.

3 Bennett, "The Exhibitionary Complex," 59.

4 Ibid., 73.

5 Ibid., 63.

6 The sources of these descriptions of Gehry's Guggenheim include Muschamp, "The Miracle in Bilbao"; Ockman, "Applause and Effect"; and Vidler, "Aformal Affinities."

7 Foucault as quoted in Crimp, "On the Museum's Ruins (1980)," 47.

8 Bourdieu, *Distinction*, 30.

9 Ibid., 30.

10 Ibid., 493.

11 Ibid., 54–55, 44.

12 The pamphlet is quoted in my 1989 performance "Museum Highlights." The text of this performance was published under the same name in 1991, with the pamphlet quoted on page 121.

13 In the words of the Museum of Modern Art's chief curator of architecture Terence Riley. In Foster et al., "The MOMA Expansion," 21–22.

14 Bourdieu and Darbel with Schnapper, *The Love of Art.*

15 Letter from Uría & Menéndez, Abogados, to Fausto Grossi, Bilbao, July 4, 2000, made available by the artist as part of his art project. That Fausto Grossi gets slapped for a noodle while I'm able to exhibit a video shot in the museum with hidden cameras with impunity—even at a conference organized by the Guggenheim itself ("Museum as Medium," Mexico City, April 2002)—is a perfect example of how corporatized museums and a celebritized art world are colluding to bring about the particularization of universal principles such as freedom of expression, which increasingly appears rather as a form of privilege. For an extended discussion of this issue, see my "A 'Sensation' Chronicle."

16 Bradley, "The Deal of the Century," 48–55, 105–6. That the Guggenheim Bilbao was the product of economic and not cultural policy is one answer to the riddle of why a nationalist party in power in one of the more nationalist regions of the world would spend $150 million on a museum more or less guaranteed to include no "national" culture. Another answer is that the museum can also be considered the product of a foreign policy. Through the museum project the PNV pursued a kind of anti-Madrid globalism, bypassing the national cultural policy apparatus to establish a relationship with an international organization, the Solomon R. Guggenheim Foundation. It seems that the PNV understands the global public sphere quite well: it is defined not by nation-states but by cosmopolitan financial and cultural centers for which national boundaries may be increasingly irrelevant, particularly in the context of a unified Europe. Considering the Guggenheim Bilbao as the product of a neoliberal nationalism on the part of the PNV would be an interesting topic for another paper.

17 Bilbao had a population of 433,000 in 1981. In 2001, that figure had fallen to 350,000. See http://en.wikipedia.org/wiki/Bilbao and http://www.demographia.com/db-intl cityloss.htm (accessed September 28, 2005).

18 Zulaika, *Crónica de una seducción*; Rodriguez, Guenaga, and Martinez, "Bilbao: Case Study 2"; Kurlansky, *The Basque History of the World.*

19 Metropoli-30's plan is largely based on Anderson Consulting's *Strategic Plan for the Revitalization of Metropolitan Bilbao*, commissioned by the city of Bilbao in 1989.

20 Bilbao Metropoli-30, "Revitalization Plan for Metropolitan Bilbao"; Rodriguez, Guenaga, and Martinez, "Bilbao: Case Study 2."

21 Bilbao Metropoli-30, "Revitalization Plan for Metropolitan Bilbao."

22 Rodriguez, Guenaga, and Martinez, "Bilbao: Case Study 2."

23 Ibid.

24 Sassen, *Cities in a World Economy*, 117.

25 Here it would be important to note that in addition to their well-known history of militant nationalist separatism, the Basque country and Bilbao in particular also have a long history of militant trade unionism and socialist politics. Bilbao was home to one of the earliest chapters of the First International, the first Socialist Party chapter in Spain, the first general strike on the Iberian peninsula, and "La Pasionaria," Dolores Ibárruri. In the first half of the 1970s, the Basque country was also the home to over 35 percent of all labor conflicts in Spain (Zirakzadeh, *A Rebellious People*, 54–55, 65). While the old Basque financial and industrial capital behind the PNV might have mourned the passing of Bilbao's industrial might, it's unlikely that they shed any tears for the collapse of its unions. However, to be fair to the PNV, it was the Socialists in Madrid who settled on a policy of "liberalizing" Bilbao's heavy industry, which had been subsidized for decades by the Franco regime. This policy played some role in expanding the ranks of radical left and nationalist political parties with disillusioned socialists—including many Franco-era immigrants from other parts of Spain and their descendents. See Zirakzadeh, *A Rebellious People*; Hooper, *The New Spaniards*.

26 Sassen, *Cities in a World Economy*, 118–19.

27 For a more extensive discussion of these issues, see my "A 'Sensation' Chronicle."

28 Bennett, "The Exhibitionary Complex," 81.

29 Rodriguez, Guenaga, and Martinez, "Bilbao: Case Study 2."

30 Ibid.

31 Foster, "Master Builder," 40–41.

32 Freud, "Formulations Regarding the Two Principles in Mental Functioning (1911)," 21–28.

33 Bourdieu, *Distinction*, 155.

34 It may be in this sense that the vision of freedom Gehry represents does indeed correspond to " 'the cultural logic' of advanced capitalism," as Foster suggests. Foster, "Master Builder"; Bourdieu, "Utopia of Endless Exploitation," 3; Bourdieu, *Distinction*, 156.

35 Baniotopoulou, "Art for Whose Sake?"

36 Bourdieu and Wacquant, "NewLiberalSpeak," 2–5.

37 Foster et al., "The MOMA Expansion," 3–30.

38 Filler, "The Museum Game," 100.

39 Ibid.

40 Saltz, "Downward Spiral," 65.

41 It's now clear enough that the Guggenheim's expansion strategy is primarily a financial strategy. When it struck a deal with the Basque government, it was in dire financial straits. The Guggenheim's primary assets were its collection and its image. But how does a museum generate income from collections, if entrance receipts are not enough? The Guggenheim had already tried deaccessioning some works, amid much controversy. Instead of selling some works from its collection, the museum hit on the idea of renting them—to itself. Branch museums financed by foreign governments and corporations but directed entirely by management in New York would pay the Guggenheim for the privilege of presenting its exhibitions and collections. The mu-

seum could thus capitalize not only on its collections, but also on the value added by its expertise and the ever-increasing brand power of its global image. Thus, the Guggenheim's expansion strategy allowed it, like so many corporations of the 1990s, to draw new investment that would cover debt from existing operations.

42 Filler, "The Museum Game," 104.

43 Foster et al., "The MOMA Expansion: A Conversation with Terence Riley," 3–30; Foster, "Master Builder," 27–42.

44 Guggenheim curator Lisa Dennison calls "the concept of global sponsorship" one of the "big secrets" of Krens's success. Corporations "want to support a museum that has many bases in as many places as possible. And ideally that means you're touching more markets" (quoted in Filler, "The Museum Game," 105).

World Heritage and Cultural Economics

BARBARA KIRSHENBLATT-GIMBLETT

This essay works toward a notion of the global public sphere through an analysis of UNESCO's efforts to define and protect world heritage. I will argue that world heritage is a vehicle for envisioning and constituting a global polity within the conceptual space of a global cultural commons. Central to my argument is the notion that heritage is created through metacultural operations that extend museological values and methods (collection, documentation, preservation, presentation, evaluation, and interpretation) to living persons, their knowledge, practices, artifacts, social worlds, and life spaces. While heritage professionals use concepts, standards, and regulations to bring cultural phenomena and practitioners into the heritage sphere, where they become metacultural artifacts, whether Living National Treasures or Masterpieces of Oral and Intangible Heritage of Humanity, the performers, ritual specialists, and artisans whose "cultural assets" become heritage through this process experience a new relationship to those assets, a metacultural relationship to what was once just habitus. Once habitus becomes heritage, to whom does it belong? How does heritage come to belong to all of humanity?

The essay addresses these questions with special reference to intangible heritage, the most recent category of world heritage formulated by UNESCO. After briefly presenting the history of UNESCO's efforts to define intangible heritage,

I examine two cases—UNESCO's list of Masterpieces of Oral and Intangible Heritage of Humanity and several Silk Roads projects—in order to demonstrate how valorization, regulation, and instrumentalization alter the relationship of cultural assets to those who are identified with them, as well as to others. More specifically, such instrumentalizations produce a paradoxical asymmetry between the diversity of those who produce cultural assets in the first place and the humanity to which those assets come to belong as world heritage.

To better understand this asymmetry, I explore the difference between cultural diversity and cultural relativity and, following from this distinction, the difference between celebrating diversity and tolerating difference. I argue that diversity works centrifugally by generating cultural assets that can be universalized as world heritage, a process that expands the beneficiaries to encompass all of humanity—your culture becomes everyone's heritage—consistent with Maxim Gorki's dictum, "Being most characteristic shall enable one to be universal."[1] In contrast, relativity works centripetally by invoking tolerance of difference to protect, insulate, and strengthen the capacities within individuals and communities to resist efforts to suppress their cultural practices, particularly in situations of religious and cultural conflict—a live-and-let-live approach.

Thus, in July 2003, UNESCO announced the simultaneous emergency inscription on the World Heritage List and List of World Heritage in Danger of two sites—Ashur (Qal'at Sherqat) in Iraq and the Bamiyan Valley in Afghanistan, where ruins of the monumental Buddhas destroyed by the Taliban in March 2001 are located—and explained that "[t]he [Bamiyan Valley] site symbolizes the hope of the international community that extreme acts of intolerance, such as the deliberate destruction of the Buddhas, are never repeated again."[2] The limits of relativity—and tolerance—were captured on a January 17, 2000, banner protesting the flying of the Confederate flag over the South Carolina statehouse; the banner declared, "Your heritage is my slavery."[3]

The tension between diversity and relativity—and their relationship to universal human rights—informs my analysis of the role of world heritage in defining a global cultural commons and global public sphere, consistent with UNESCO's twin goals of peace and prosperity. However, without prosperity there can be no peace, and culture may well be part of the problem—to mention only the violence arising from ethnic and religious conflicts and the economic consequences of culturally sanctioned resistance to educating women. World heritage offers a way to make culture part of the solution: first, through the metacultural operations that alter the relationship of all parties to the cultural assets in question; second, by modeling peaceful coexistence based, at the very least, on tolerance of difference and, at best, on bequeathing the fruits of

cultural diversity to humanity; and third, by making world heritage an engine of economic development by adding value to cultural assets that are not otherwise economically sustainable locally or globally and are therefore in danger of disappearing.

Tourism is the largest industry or source of foreign currency in many developing countries. Paradoxically, it is underdevelopment, transvalued as a heritage, that becomes the basis for economic development through tourism. A strong tourist economy is a barometer of political stability, and violence is anathema to tourism everywhere, to mention only Kenya, whose largest industry and source of foreign earnings is tourism; Israel, whose economy, though more diversified, still relies on tourism; and New York City after the 2001 attacks on the World Trade Center. Indeed, the events and aftermath of September 11 have shaken the tourism industry worldwide.[4]

With the World Bank now factoring culture into economic development and treating culture itself as an opportunity for investment, there have emerged economic theories of valuation for calculating the monetary value of culture, understood as a public good. However, while culture is an externality in economic theories of markets (the idea that markets operate according to their own logic and can be accounted for without reference to culture), economics is not an externality in theories of culture.[5] The economic basis for habitus and habitat is integral to what they are and different from the economic basis for protecting them as heritage (which is also to constitute them as heritage).

The essay concludes with a discussion of cultural economics that proceeds from the idea that world heritage as a phenomenon arises from the very processes of globalization that were supposed to homogenize world culture. Promoters of world heritage offer it as an antidote to the homogenizing effects of economic globalization, but world heritage is actually made possible by globalization, in both political and economic terms, the most important form of which is cultural tourism. World heritage, like world's fairs and museums, are part of a world system, within which the world is to be convened, a world image projected, and a world economy activated.[6] The degree to which these processes generate one or more global public spheres — spaces of relatively autonomous critical debate — remains to be seen.[7]

INTANGIBLE HERITAGE

Since World War II, UNESCO has supported a series of world heritage initiatives, starting with tangible heritage, both immovable and movable, and expanding to natural heritage and most recently to intangible heritage.[8] Al-

though there are three separate heritage lists, there is increasing awareness of the arbitrariness of the categories and their interrelatedness. *Tangible heritage* is defined as "a monument, group of buildings or site of historical, aesthetic, archaeological, scientific, ethnological or anthropological value" and includes such treasures as Angkor Vat, a vast temple complex surrounding the village of Siem Reap in Cambodia; Robben Island in Cape Town, where Nelson Mandela was incarcerated for most of the twenty-six years of his imprisonment; Teotihuacán, the ancient pyramid city outside of Mexico City; and the Wieliczka Salt Mine, not far from Cracow, which has been in operation since the thirteenth century.

Natural heritage is defined as "outstanding physical, biological, and geological features; habitats of threatened plants or animal species and areas of value on scientific or aesthetic grounds or from the point of view of conservation" and includes such sites as the Red Sea, Mount Kenya National Park, the Grand Canyon, and most recently Brazil's Central Amazon Conservation Complex.[9] Natural heritage initially referred to places with special characteristics, beauty, or some other value, but untouched by human presence, but most places on the natural heritage list — and in the world — have been shaped or affected in some way by people, an understanding that has changed the way UNESCO thinks about natural heritage. At the same time, natural heritage, conceptualized in terms of ecology, environment, and a systemic approach to a living entity, provides a model for thinking about intangible heritage as a totality, rather than as an inventory, and for calculating the intangible value of a living system, be it natural or cultural.

Over several decades of trying to define *intangible heritage*, previously and sometimes still called folklore, there has been an important shift in the concept to include not only the masterpieces but also the masters. The earlier folklore model supported scholars and institutions to document and preserve a record of disappearing traditions. The most recent model aims to sustain a living, if endangered, tradition by supporting the conditions necessary for cultural reproduction. This means according value to the "carriers" and "transmitters" of traditions, as well as to their habitus and habitat. Whereas intangible heritage is culture, like tangible heritage, it is also alive, like natural heritage. The task, then, is to sustain the whole system as a living entity and not just to collect "intangible artifacts."

UNESCO's efforts to establish an instrument for the protection of what it now calls intangible heritage date from 1952, when UNESCO adopted the Universal Copyright Convention. The initial focus on legal concepts, such as intellectual property, copyright, trademark, and patent, as the basis for protecting

what was then called folklore, failed. Folklore by definition is not the unique creation of an individual; it exists in versions and variants rather than in a single, original, and authoritative form. It is generally created in performance and transmitted orally, by custom or example, rather than in tangible form (writing, notating, drawing, photographs, recordings).[10]

During the eighties, legal issues were distinguished from preservation measures, and in 1989 the UNESCO General Conference adopted the "Recommendation on the Safeguarding of Traditional Culture and Folklore."[11] Dated May 16, 2001, the "Report on the Preliminary Study on the Advisability of Regulating Internationally, Through a New Standard-Setting Instrument, the Protection of Traditional Culture and Folklore" significantly shifted the terms of the 1989 document. First, rather than emphasize the role of professional folklorists and folklore institutions in documenting and preserving the records of endangered traditions, it focused on sustaining the traditions themselves by supporting the practitioners. This entailed a shift from artifacts (tales, songs, customs) to people (performers, artisans, healers), their knowledge, and skills. Inspired by approaches to natural heritage as living systems and by the Japanese concept of "Living National Treasure," which was given legal status in 1950, the 2001 document recognized the importance of enlarging the scope of intangible heritage and the measures to protect it. The continuity of intangible heritage would require attention not just to artifacts but above all to persons, as well as to their entire habitus and habitat, understood as their life space and social world.

Accordingly, UNESCO defined intangible heritage as:

All forms of traditional and popular or folk culture, i.e. collective works originating in a given community and based on tradition. These creations are transmitted orally or by gesture, and are modified over a period of time through a process of collective recreation. They include oral traditions, customs, languages, music, dance, rituals, festivities, traditional medicine and pharmacopoeia, the culinary arts and all kinds of special skills connected with the material aspects of culture, such as tools and the habitat.[12]

And at the March 2001 meeting in Turin, the definition further specified:

Peoples' learned processes along with the knowledge, skills and creativity that inform and are developed by them, the products they create and the resources, spaces and other aspects of social and natural context necessary to their sustainability; these processes provide living communities with a sense of continuity with previous generations and are important to cultural identity, as well as to the safeguarding of cultural diversity and creativity of humanity.[13]

This holistic and conceptual approach to the definition of intangible heritage is accompanied by a definition in the form of an inventory, a legacy of earlier efforts at defining oral tradition and folklore:

> The totality of tradition-based creations of a cultural community, expressed by a group or individuals and recognized as reflecting the expectations of a community in so far as they reflect its cultural and social identity; its standards and values are transmitted orally, by imitation or by other means. Its forms are, among others, language, literature, music, dance, games, mythology, rituals, customs, handicrafts, architecture and other arts.[14]

Elsewhere in the *Implementation Guide*, terms such as "traditional," "popular," and "folk" situate oral and intangible heritage within an implicit cultural hierarchy made explicit in the explanation of "What for, and for whom?": "For many populations (especially minority groups and indigenous populations), the intangible heritage is the vital source of an identity that is deeply rooted in history."[15]

Neologisms such as "First Peoples" (rather than "Third World") and "*les arts premiers*" (rather than "primitive art") similarly preserve the notion of cultural hierarchy while effecting a terminological reshuffling of the order. This can be seen with special clarity in the reorganization of museums and collections in Paris, including dissolution of the Musée national des Arts Africains et Océaniens and Musée national des Arts et Traditions Populaires; redistribution of the collection of the Musée de l'Homme; and creation of two new museums — the Musée du quai Branly in Paris, dedicated to the "arts and civilizations of Africa, Asia, Oceania, and the Americas," and the Musée des civilisations de l'Europe et de la Méditerranée, in Marseilles.[16] Starting in April 2000, highlights of the African, Oceanian, and American collections destined for the Musée du quai Branly, which opened in 2006, were showcased for the first time in the Louvre's Pavillon des Sessions, which has become the museum's Salles des Arts Premiers.[17] The presence of these works at the Louvre is taken as a long awaited answer to the question posed in 1920 by the art critic Félix Fénéon, "*Iront-ils au Louvre?*"[18]

These developments at the national level are consistent with UNESCO's efforts to mobilize state actors "to take the necessary measures for the safeguarding of the intangible cultural heritage present in its territory."[19] UNESCO's role is to provide leadership and guidance, to create international agreement and cooperation by convening national representatives and experts, and to lend its moral authority to the consensus they build in the course of an elaborate and extended process of deliberation, compromise, and reporting. This process produces agreements, recommendations, resolutions, and provisions.

The resulting covenants, conventions, and proclamations invoke rights and obligations, formulate guidelines, propose normative and multilateral instruments, and call for the establishment of committees. The committees are to provide guidance, make recommendations, advocate for increased resources, and examine requests for inscription on lists, inclusion in proposals, and international assistance. Recommendations are to be implemented at both national and international levels. State parties are to define and identify the cultural assets in their territory by creating inventories. They are to formulate heritage policy and create bodies to carry out that policy. They are expected to establish institutions to support documentation of cultural assets and research into how best to safeguard them, as well as to train professionals to manage heritage. They are supposed to promote awareness, dialogue, and respect through such valorizing devices as the list.[20]

THE LIST

On May 18, 2001, after decades of debate over terminology, definition, goals, and safeguarding measures for what had previously been designated "traditional culture and folklore" — and before the "Report on the Preliminary Study on the Advisability of Regulating Internationally, Through a New Standard-Setting Instrument, the Protection of Traditional Culture and Folklore" was presented to the UNESCO Executive Board — UNESCO finally announced the first nineteen Masterpieces of Oral and Intangible Heritage of Humanity.[21] What is the nature of such lists, and why, when all is said and done, is a list the most tangible outcome of decades of UNESCO meetings, formulations, reports, and recommendations? Some of those involved in the process of developing the intangible heritage initiative had hoped for cultural rather than metacultural outcomes. They wanted to focus on actions that would directly support local cultural reproduction, rather than on creating metacultural artifacts such as the list.

James Early, director of cultural heritage policy for the Smithsonian's Center for Folklife and Cultural Heritage, and Peter Seitel, project co-coordinator for the UNESCO/Smithsonian World Conference, reported their disappointment that "UNESCO's institutional will became focused on adopting the Masterpieces program as UNESCO's sole project in a new convention on ICH [Intangible Cultural Heritage]" that would make the convention a tool for "national governments to proclaim the richness of their cultural heritage," rather than focus on the culture bearers themselves.[22] The "Call for Action" in the proceedings of the 1999 Smithsonian-UNESCO meeting "Safeguarding Traditional Cultures" specified a wide range of actions that could be taken with and on

behalf of culture bearers.[23] While acknowledging the importance of valorizing cultural assets, the "Call for Action" did not stop there. Nor did it specifically recommend the creation of a list of the Masterpieces of Oral and Intangible Heritage of Humanity.

Not only is each word in this phrase highly charged, but the phrase itself also suggests that heritage exists, as such, prior to—rather than as a consequence of—UNESCO's definitions, listings, and safeguarding measures. I have argued elsewhere that heritage is a mode of cultural production that gives the endangered or outmoded a second life as an exhibition of itself.[24] Indeed, one of UNESCO's criteria for designation as a masterpiece of intangible heritage is the vitality of the phenomenon in question: if it is truly vital, it does not need safeguarding; if it is almost dead, safeguarding will not help.

Accordingly, the first nineteen Masterpieces of Oral and Intangible Heritage of Humanity proclaimed were:

> The Garifuna language, dance and music, Belize (nominated with the support of Honduras and Nicaragua)
> The oral heritage of Gelede, Benin (supported by Nigeria and Togo)
> The Oruro carnival, Bolivia
> Kunqu opera, China
> The Gbofe of Afounkaha: the music of the transverse trumpets of the Tagbana community, Côte d'Ivoire
> The cultural space of the Brotherhood of the Holy Spirit of the Congos of Villa Mella, Dominican Republic
> The oral heritage and cultural manifestations of the Zápara people, Ecuador and Peru
> Georgian polyphonic singing, Georgia
> The cultural space of Sosso-Bala in Niagassola, Guinea
> Kuttiyattam Sanskrit theater, India
> Opera dei Pupi, Sicilian puppet theater, Italy
> Nôgaku theater, Japan
> Cross crafting and its symbolism in Lithuania (supported by Latvia)
> The cultural space of Djamaa el-Fna Square, Morocco
> Hudhud chants of the Ifugao, Philippines
> Royal ancestral rite and ritual music in Jongmyo shrine, Republic of Korea
> The cultural space and oral culture of the Semeiskie, Russian Federation
> The mystery play of Elche, Spain
> The cultural space of the Boysun district, Uzbekistan

Consistent with the stated criteria, this list recognizes communities and cultural manifestations not represented on the tangible heritage list, including the

1. The Royal ancestral rite and ritual music in Jongmyo Shrine in the Republic of Korea was among the first nineteen Masterpieces of Oral and Intangible Heritage of Humanity declared by UNESCO in 2001. Photo courtesy of UNESCO, © Korean Cultural Properties Administration.

orature, performance, language, and ways of life of indigenous peoples and minorities.[25] Responses to UNESCO's first proclamation of Masterpieces of the Oral and Intangible Heritage of Humanity have been mixed. In an article entitled "Immaterial Civilization" in the *Atlantic Monthly*, Cullen Murphy, noting the campaign of Alfonso Pecoraro Scanio to have pizza declared a masterpiece, found the UNESCO list underwhelming: "These are indisputably worthy endeavors. But the overall impression is of program listings for public television at 3:00 a.m." Murphy proceeded to offer candidates of his own for the 2003 list. They included the white lie, the weekend, and the passive voice, among others.[26] Such ironic statements index the process by which life becomes heritage and the contemporaneous (those in the present who are valued for their pastness) becomes contemporary (those of the present who relate to their past as heritage).[27]

While the white lie, the weekend, and the passive voice would not pass the test of being endangered masterpieces, such commentaries are a reminder that a case could be (but has not been) made for the intangible heritage of any community, since no community is without embodied knowledge transmitted orally, gesturally, or by example. By making a special place for those left out of the other two world heritage programs, UNESCO has created an intangible heritage program that is also exclusive in its own way (and not entirely consis-

tent with its stated goals). Thus, the Bolshoi Ballet and Metropolitan Opera do not and are not likely to make the list, but Japanese Nôgaku theater, not a minority or indigenous cultural form, does. All three involve formal training, use scripts, are the products of literate cultures, and transmit embodied knowledge from one performer to another. Moreover, Japan is well represented on the other world heritage lists and the Japanese government has been protecting Nôgaku as an Intangible National Property since 1957. By admitting cultural forms associated with royal courts and state-sponsored temples, as long as they are not European, the intangible heritage list preserves the division between the West and the rest and produces a phantom list of intangible heritage, a list of that which is not indigenous, not minority, and not non-Western, though no less intangible.[28]

World heritage lists arise from operations that convert selected aspects of localized descent heritage into a translocal consent heritage — the heritage of humanity.[29] While the candidates for recognition as Masterpieces of Oral and Intangible Heritage of Humanity are defined as traditions — that is, by mode of transmission (orally, by gesture, or by example) — world heritage as a phenomenon is not. As a totality — as the heritage of humanity — it is subject to interventions that are alien to what defines the constituent masterpieces in the first place. World heritage is first and foremost a list. Everything on the list, whatever its previous context, is now placed in a relationship with other masterpieces. The list is the context for everything on it.[30]

The list is also the most visible, least costly, and most conventional way to "do something" — something symbolic — about neglected communities and traditions. Symbolic gestures such as the list confer value on what is listed, consistent with the principle that you cannot protect what you do not value. UNESCO places considerable faith — too much faith, according to some participants in the process — in the power of valorization to effect revitalization.[31]

The Convention for the Safeguarding of Intangible Heritage, which the UNESCO General Conference adopted in October 2003, was ratified and entered into force on April 20, 2006. Responding to objections to the three lists of masterpieces, which were issued over a six-year period (2001, 2003, 2005), this convention does away with any future lists of masterpieces and established two new lists: the Representative List of the Intangible Cultural Heritage of Humanity and the List of Intangible Cultural Heritage in Need of Urgent Safeguarding. How these lists, which are no less problematic than the lists of masterpieces, will fare remains to be seen. This convention also envisions the establishment of a fund to support efforts to safeguard heritage. Signatories to the convention and others are expected to contribute to the fund.

In addition to maintaining the list, UNESCO also selects and supports pro-
posals for various programs and projects, "taking into account the special
needs of developing countries."[32] Such projects include documentation, both
the preservation of archives and the recording of oral traditions; the cre-
ation of research institutes and organization of scientific expeditions; con-
ferences, publications, and audiovisual productions; educational programs;
cultural tourism, including the development of museums and exhibitions,
restoration of sites, and creation of tourist routes; and artistic activities such
as festivals and films.

The festival is the showcase par excellence for the presentation of intangible
heritage, and the 2002 Smithsonian Folklife Festival, which was dedicated to
the Silk Road, is a prime example of putting policy into practice.[33] The follow-
ing account of the 2002 Folklife Festival, which presented a living museum of
intangible heritage from countries along the Silk Road and was coordinated
with UNESCO's Silk Roads project, explores what is created—as opposed to
safeguarded—when culture becomes heritage. Of special interest is how the
process of safeguarding, which includes defining, identifying, documenting,
and presenting particular cultural traditions and their practitioners, produces
something metacultural. What is produced includes not only an altered rela-
tionship of practitioners to their art but also distinctive artifacts such as the
list, the route, and the folklife festival itself. I explore how such metacultural
artifacts give form to the idea of an imagined global cultural commons and
with what intended and unintended consequences.

THE SILK ROAD

While lists have a long history within UNESCO's heritage efforts, the organizing
of heritage efforts around a route or road is a more recent development dating
from 1988, when UNESCO proclaimed the World Decade for Cultural Devel-
opment and established two ten-year projects, Iron Roads in Africa and the
Silk Roads. UNESCO inaugurated the Slave Route project in 1993 and shortly
thereafter the Routes of al-Andalus and Routes of Faith. In 1997, when UNESCO
created a new project dedicated to East-West intercultural dialogue in Central
Asia, it extended the Silk Roads project. In November 1998, the year 2001 was
declared the United Nations Year of Dialogue Among Civilizations. Despite
resistance from some quarters to this declaration, the various routes programs
have since been subsumed under this heading.

Taking historical roads and routes as an organizing principle, UNESCO
found a way to use travel and trade as positive historical reference points for
globalization and models of cultural dialogue and exchange:

Throughout history, peoples have exchanged cultural experience, ideas, values and goods through art, trade and migrations. Human history is the tale of such journeys. As we cross into the twenty-first century, we too have embarked on a journey whose destination holds out the promise of justice, well-being, and a peaceful existence for all. These encounters, in which individual travelers or communities have conveyed their ideas and customs across whole continents and oceans, are celebrated in a series of UNESCO projects.[34]

By 1997, the message of the Silk Roads had crystallized: "common heritage and plural identity."[35] Unlike lists, what routes and roads, along with networks and webs, offer is a strategy for linking subnational phenomena to transnational ones in the face of intractable intranational and international conflicts.

UNESCO's Silk Roads project is one of three major initiatives on this subject, the other two being the Silk Road Project, Inc., produced by Yo-Yo Ma, since 1998, and "The Silk Road: Connecting Cultures, Creating Trust," the theme of the 2002 Smithsonian Folklife Festival on the National Mall in Washington, D.C., in collaboration with Yo-Yo Ma.[36] Given the role of the Smithsonian's Center for Folklife and Cultural Heritage in helping UNESCO formulate a workable concept of intangible heritage and the center's leadership in the field of public folklore in the United States, an analysis of what the center actually does in practice—how it conceptualizes and deals with "intangible heritage"—provides a counterpoint to UNESCO policy documents and conference proceedings, as well as insights into specifically American approaches to "public folklore," a professional enterprise that has developed over the last four decades.[37]

For the first time in its thirty-six-year history, the Smithsonian Folklife Festival was organized around one theme in 2002, the Silk Road, rather than featuring one country, one state, and a thematic area, as it normally does.[38] Conceived as "a living exhibition of the music, crafts, culinary and narrative traditions involved in the historic cultural interchange between the 'East' and the 'West,'" the Smithsonian Folklife Festival celebrated "the living traditions of historic Silk Road lands" by doing what it always does. However, the Silk Road map created for the festival told another story. A dotted line marked out paths connecting cities from Nara, Japan, to Venice, Italy. Countries were barely discernable, so pale were their borders and indistinct their names. "Linking diverse people and societies," the dotted line slipped over today's national borders as if they were not there. Getting visas for 370 artists and presenters from twenty-four countries was a different story. Due to quarantine regulations, for instance, it was not possible to bring camels from Kazakhstan, so two-hump camels from a reservation in Texas were trained to respond to orders in Kazakh.[39]

Consistent with the operation of world heritage as a globalizing enter-
prise, the Smithsonian's Silk Road, a dotted line across a virtually borderless
map, linked sub- and transnational cultural expressions to a supranational and
transhistorical phenomenon, a trade route. Like the UNESCO conception of
the Silk Road, value was accorded to ideas of movement (rather than territo-
rial rootedness), networks (rather than borders), and trade (rather than rule).
The traveler was the hero in this scenario, whether merchant, pilgrim, soldier,
nomad, archaeologist, or geographer. The market — in this case, trade in lux-
ury goods — became a model of free exchange and of connection, interdepen-
dence, and, at the heart of it all, trust in regions today from Japan to France,
some of which, such as Afghanistan and Iraq, have been devastated by war and
poverty, notwithstanding comments about a new Silk Road based on oil and
"modest victories of democracy and capitalism."[40]

The 2002 festival was also the largest in the center's history, with 1.3 mil-
lion visitors over a ten-day period, despite the closing of the Smithsonian stop
on the Metro on July 4 for security reasons. Silk Roads projects, planned long
before September 11, had to be rethought in light of the attacks and their after-
math, which inevitably became a subtext for them. Not by chance was the
Smithsonian's Silk Road program subtitled "Connecting Cultures, Creating
Trust." The theme was timely.

How, then, did the Smithsonian Folklife Festival map the Silk Road onto
the National Mall and what was the message? This virtual Silk Road took the
form of a long corridor, with geographical sections down the north side and
crafts down the south side (see figure 2). The north side was laid out in six sec-
tions: Nara Gate, Xi'an Tower, Samarkand Square, Nomads (Inner Eurasia),
Istanbul Crossroads, and Venice Plaza. Each section included tents for perfor-
mances, examples of traditional architecture, and, in all but the Nomads sec-
tion, culturally appropriate food concessions. A lavishly decorated Pakistani
cargo truck appeared in the Nomads section. These kinds of trucks pick up
goods in Karachi, a port city, and take them along parts of what were the his-
toric silk routes. While these drivers are not nomads in the strict sense of the
word, the truck's appearance in the Nomads section is linked to the theme of
travel (see figure 3).

The south side was organized thematically by craft (paper, ceramics, cloth,
and other crafts) and function (Family Oasis, press, first aid, and lost and
found). Each craft area included craftspeople from various places along the Silk
Road. Visitors were encouraged to "note connections between Chinese blue-
and-white porcelain and its Middle Eastern, Japanese, European, and New
World derivatives," for example.[41] Interpretive text panels traced the histori-

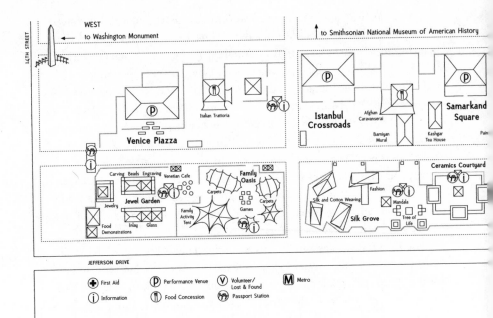

2. Diagram of the Silk Road at the 2002 Smithsonian Folklife Festival in Washington, D.C. Courtesy of the Center for Folklife and Cultural Heritage, Smithsonian Institution.

cal path of silk or paper along the Silk Road, as a context for the various craft demonstrations and displays.

In this way, the layout conveyed two ideas—the route itself and cultural exchange—that proved difficult to align with the physical space of the festival. A walk down the north side took the visitor from one identifiable location to another along a virtual Silk Road. A walk down the south side took the visitor from one craft to another, an experience akin to walking through a bazaar in which particular crafts from different places are concentrated in distinct areas. Visitors zigzagging across the corridor that separated the two sides quickly discovered the limitations of a scenographic treatment based on the principle of geographic location. Since each craft display was dedicated to a single medium and included practitioners from many places, a particular craft could be located anywhere along the southern side. But, once placed, that craft bore no particular relationship to the location immediately across the corridor—the Paper Garden was opposite the Xi'an Tower, the Ceramics Courtyard was opposite Samarkand Square, the Jewel Garden was opposite the Venice Piazza. Scenographic leitmotifs intended to orient the visitor to ordered locations along the Silk Route and festival corridor tended to thematize the craft areas geographically, but the cultural heterogeneity of each craft display

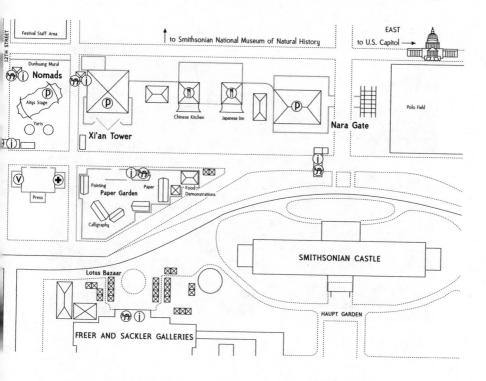

resisted a unified scenographic treatment. The entire Silk Road was virtually present in each craft tent.

Characterizing the Smithsonian Folklife Festival, Lawrence M. Small, secretary of the Smithsonian, said, "It's a party that scholarship gives."[42] Consistent with the expectations of a national museum, the Smithsonian's Center for Folklife and Cultural Heritage maintained high standards of scholarship in preparing for the festival, selecting participants, and developing interpretive strategies and materials. Scholars who had dedicated the better part of their careers to the study of cultural expressions featured at the festival curated in their areas of expertise and were on hand during the festival itself. The craftspeople and performers were among the most respected in their fields. Text panels for each geographical section offered authoritative information on such topics as geography/history, commerce, connections between the global and the local, the treasure house, sacred spaces, travelers, shamanism, and Silk Road stories.[43] Each craft area included text panels that traced the history and discussed the motifs and techniques of the crafts demonstrated. Astonishingly, given the crowds and heat, visitors actually stood and read the panels, which were in many cases about parts of the world unknown to them before September 11 and now of vital interest.

3. A highly decorated Pakistani truck was part of the Nomads section of the Smithsonian Folklife Festival in 2002. Photo by Barbara Kirshenblatt-Gimblett.

In creating the 2002 festival, the Smithsonian joined forces with the char-ismatic cellist Yo-Yo Ma, for whom music along the Silk Road offers historical evidence of fruitful cultural exchange and hope for the future. Ma has dubbed the staff of his Silk Road Project "venture culturalists," consistent with the idea of the Silk Road as a grand mercantile metaphor for cultural exchange, peace, and prosperity.[44] This multimillion-dollar project is funded by Ford, Siemens, and Sony, as well as by the Aga Khan Trust and private foundations and donors. Ma has stated his vision as follows: "We encounter voices that are not exclu-sive to one community. We discover transnational voices that belong to one world." Having traveled widely and encountered various musical traditions, Ma envisions a migration of ideas, voices, and instruments along "the historic trade route that connected the peoples and traditions of Asia with those of Europe." In that spirit, he created the Silk Road Ensemble, made up of musi-cians from "the Silk Road lands and the West." They perform both traditional music and compositions commissioned by the Silk Road Project.[45]

The 2002 festival was a tour de force in the way it broke out of the pattern of national representation and staged subnational cultural expressions within the supranational framework of a trade route, even though performers and craftspeople still understood themselves to be representing the countries from

which they had come. The festival also confounded easy distinctions between traditional and contemporary, high and low, by including the Tokyo Recycle Project, which makes contemporary fashion by recycling garments that clients provide, and Yo-Yo Ma's unique Silk Road Ensemble, which performs new works commissioned specially for it.

However, while this festival was an extraordinary performance of cultural diplomacy—the State Department could not have done a better job, and they know it—the Silk Road metaphor has its limits. The celebratory nature of the festival lends itself to the use of the Silk Road metaphor but not to a critique of it, though the Center for Folklife and Cultural Heritage was certainly aware of the issues. For instance, the Silk Road's history is equally one of invasions and wars, empires and vassal states, rebellions and tribal rivalries, forts and defensive walls, bandits and marauders, Crusaders and missionaries, terrorist networks and drug traffic. Its history extends from Alexander the Great to Genghis Khan. The Great Wall of China is as defining of the Silk Road as Marco Polo's voyages. Moreover, fortifications were not the only barriers to the free movement of people and ideas. Isolationist policies and the dangers of travel continue to restrict movement and communication.

Today, religious conflict poses a serious threat to "world heritage." The two gigantic Bamiyan Buddhas, which the Taliban destroyed in March 2001, appeared at the Smithsonian Festival intact as a mural, with the following caption: "Circa 600 C.E., Buddhist monks traveling from India to Central Asia carved huge monuments of Buddha into the cliffs of the Bamiyan Valley. The Bamiyan Buddhas were symbols of a secure haven for weary travelers, and were the gateway to South Asia." It could be assumed that visitors to the festival did not need reminding that the Bamiyan Buddhas no longer exist; their 2001 destruction provoked widespread protest and media coverage (see figure 4).[46]

They were, however, told about the negative effects of cultural tourism in Venice. The text panel in the Venice Piazza Learning Center on "Global/Local Connection" took up the theme "Safeguarding Cultural Heritage." UNESCO's International Campaign for the Safeguarding of Venice was launched in the 1960s to repair damage created by flooding. The text notes the decline in Venice's population from 170,000 at its peak to 65,000 today, while the number of tourists who visit Venice has surged to ten million a year. Not only do they strain the infrastructure of this small city (three square miles), but also such heavy dependence on the tourist economy has left few options for young Venetians who do not want to work in this sector: "Residents worry that Venice might turn into a cultural theme park and lose its soul." After all, visitors to the festival are participating in cultural tourism and might think twice about the impact of their visit to world heritage sites such as Venice.

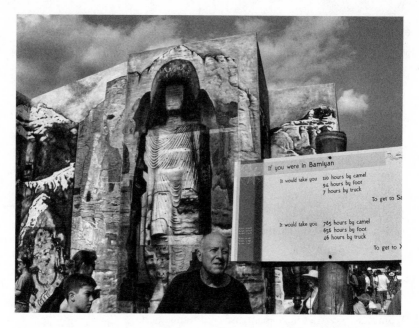

If you were in Bamiyan

It would take you 110 hours by camel
 94 hours by foot
 7 hours by truck
 To get to S

It would take you 765 hours by camel
 656 hours by foot
 46 hours by truck
 To get to)

4. Reproduction of the destroyed Bamiyan Buddhas in a mural at the 2002 Smithsonian Folklife Festival. Photo by Barbara Kirshenblatt-Gimblett.

Last but not least, the historical Silk Road, which declined in the fifteenth century when sea routes were adopted, is at a great historical remove from the lived reality of participants in the Smithsonian Folklife Festival and visitors to the festival from those regions. Many of those regions continue to suffer from the repercussions of war, nuclear testing, and HIV/AIDS, among other disasters. Residents of Xinjian province, which borders Kazakhstan and is part of the historic Silk Road, are sick and dying as a result of nuclear tests conducted by China until 1996, as are residents of northeastern Kazakhstan, where the Soviets conducted nuclear tests over a forty-year period. Along porous borders that foster a cash economy, sex workers serve long-haul truck drivers. As many as a thousand trucks a day line up at major checkpoints. Drivers are away from home for long periods of time and wait for days on end at border checkpoints for cargo to be transferred to trucks on the other side of the border. As Sally G. Cowall, a director of UNAIDS, said, "HIV does not need passports, nor does it require visas to cross international borders."[47] "HIV vulnerability caused by mobility related to development" is being addressed by India and Nepal, which are collaborating on cross-border interventions at checkpoint cities, as are other countries in the region.[48]

Clearly, the "party that scholarship gives" is not the time or place for such

topics. The party is a place to perform culture, not debate it. To its credit, however, the Smithsonian festival did try to raise some difficult issues, but with a light touch, in keeping with the urgency of the festival's themes (connection and trust); the riskiness of bringing together so many people from regions in conflict with each other and with the United States, which was in the midst of its war on terrorism; and the celebratory nature of the festival as a genre. Visitors to the festival included a large percentage of Americans with family connections to the regions represented in the Smithsonian festival. Their knowledgeable and enthusiastic presence amid visitors who had never heard such music was essential to the festival's success and something of an antidote to the "America first" spirit of patriotic displays after September 11 and the Patriot Act, which have made immigrants and visitors from many countries along the Silk Road vulnerable to suspicion.

The success of the Smithsonian Folklife Festival and the ongoing critical reflection that the Center for Folklife and Cultural Heritage brings to the festival and related undertakings have prepared the center for its recent leadership role in shaping the UNESCO initiative on intangible and cultural heritage.[49] The center has been trying to move UNESCO from a masterpiece orientation toward supporting local communities so that they can sustain cultural practices. The center, directed by Richard Kurin since 1987, brings theoretical sophistication to the enterprise. The Smithsonian Folklife Festival is considered exemplary and has set a high standard for the presentation of tangible and intangible heritage, to use UNESCO language, within the limitations of the festival as a metacultural form.

HERITAGE IS METACULTURAL

Whereas the list of Masterpieces of Oral and Intangible Heritage of Humanity is literally a text, the 2002 Smithsonian Folklife Festival brought living practitioners before a live audience and, in so doing, foregrounded the agency of those who perform the traditions that are to be safeguarded. Unlike other living entities, whether animals or plants, people are not only objects of cultural preservation but also subjects. They are not only cultural carriers and transmitters but also agents in the heritage enterprise itself. What the heritage protocols do not generally account for is a conscious, reflexive subject. They speak of collective creation. Performers are "carriers," "transmitters," and "bearers" of traditions, terms that connote a passive medium, conduit, or vessel, without volition, intention, or subjectivity.

"Living archive" and "library" are common metaphors. Such terms assert not a person's right to what he or she does but rather the individual's role in

keeping the culture going (for others). According to this model, people come and go, but culture persists, as one generation passes it along to the next. But all heritage interventions—like the globalizing pressures they are trying to counteract—change the relationship of people to what they do. They change how people understand their culture and themselves. They change the fundamental conditions for cultural production and reproduction. Change is intrinsic to culture, and measures intended to preserve, conserve, safeguard, and sustain particular cultural practices are caught between freezing the practice and addressing the inherently processual nature of culture.

Central to the metacultural nature of heritage is time. The asynchrony of historical, heritage, and habitus clocks and differential temporalities of things, persons, and events produce a tension between the contemporary and the contemporaneous (as discussed above), a confusion of evanescence with disappearance, and a paradox that is the condition of possibility for the world heritage enterprise, namely, the possession of heritage as a mark of modernity.

Heritage interventions attempt to slow the rate of change. *The Onion*, a humor newspaper in the United States with a national readership, published a 1997 article entitled "U.S. Dept. of Retro Warns: 'We May Be Running Out of Past'" (reprinted as a Document in this section).[50] The article quotes U.S. Retro Secretary Anson Williams: "If current levels of U.S. retro consumption are allowed to continue unchecked, we may run entirely out of past by as soon as 2005" and "We are talking about a potentially devastating crisis situation in which our society will express nostalgia for events which have yet to occur." In support of these predictions, the article explains that "[t]he National Retro Clock currently stands at 1990, an alarming 74 percent closer to the present than ten years ago, when it stood at 1969." As the retro clock speeds up, life becomes heritage almost before it has a chance to be lived, and heritage fills the life space.[51]

While the categories of tangible and intangible heritage distinguish things from events (and from knowledge, skills, and values), even things are events. First, as existential philosopher Stanley Eveling has remarked, "A thing is a slow event." This is a perceptual issue. The perception of change is a function of the relationship between the actual rate of change and "the windows of our awareness."[52] Things are events, not inert or deteriorating substance, in other senses as well. A thing can be an "affecting presence," in the words of Robert Plant Armstrong.[53]

Second, many things are renewable or replaceable under specified conditions. Every twenty years, the wooden sanctuaries at Ise Jingu, a sacred shrine in Japan, are rebuilt. The process takes about eight years, and the shrine has been rebuilt sixty-one times since the first rebuilding in 690. Known as "*shi-*

kinen sengu," this tradition involves not only construction but also ceremony and transmission of specialized knowledge: "The carpentry work is carried out by about one hundred men, the majority of whom are local carpenters who set aside their usual work for a privileged period of two to four years. No nails are used in the entire structure. Although the plans exist for every structure, the master carpenters must remember and pass on to apprentices their expert knowledge of how to put together the complex joints, using ancient and unfamiliar tools." This shrine represents "2000 Years of History, Yet Never Gets Older than 20."[54] But the insistence on the preservation of the original material as a prerequisite for world heritage status excluded such sites from the list. Ise Jingu is a slow event. Even heritage sites engage in regular rebuilding. At the re-created Plimoth Plantation, near Boston, buildings are torn down and rebuilt regularly in order to make the heritage clock stand still in the year 1627. At the time, the buildings would have been seven years old. Since the heritage site has now endured for more years than the settlement that it represents — Plimoth Plantation is about sixty years old as of this writing — rebuilding is a way of synchronizing the heritage clock with the historical clock.[55]

Third, intangibility and evanescence — the condition of all experience — should not be confused with disappearance. This is a case of misplaced concreteness or literal thinking. Conversations are intangible and evanescent, but that does not make the phenomenon of conversation vulnerable to disappearance. Peggy Phelan's now classic essay "The Ontology of Performance" takes up the idea that "performance's being . . . becomes itself through disappearance."[56] This issue has prompted a considerable theoretical literature and debates on the ontology of art and, in particular, of performance. Philosopher Nelson Goodman distinguishes between paintings or sculpture, which are autographic (the material instantiation and the work are one and the same), and performances (music, dance, theater), which are allographic (the work and its instantiations in performance are not one and the same). It could be said that the tangible heritage list is dedicated to the autographic and the intangible list to the allographic.[57]

Fourth, as those creating world heritage policy now realize, the division between tangible, natural, and intangible heritage and the creation of separate lists for each is arbitrary, though not without its history and logic. Increasingly, those dealing with natural heritage argue that most of the sites on the world natural heritage list are what they are by virtue of human interaction with the environment. Similarly, tangible heritage without intangible heritage is a mere husk or inert matter. As for intangible heritage, it is not only embodied but also inseparable from the material and social worlds of people.

"Africa loses a library when an old man dies," a quotation from Hampaté

Bâ, appears on the homepage of UNESCO's Intangible Heritage website.[58] While affirming the person, the library metaphor confuses archive and repertoire, a distinction that is particularly important to an understanding of intangible heritage as embodied knowledge and practice. According to Diana Taylor, the repertoire is always embodied and always manifested in performance, in action, in doing.[59] The repertoire is passed on through performance. This is different from recording and preserving the repertoire as documentation in the archive. The repertoire is about embodied knowledge and the social relations for its creation, enactment, transmission, and reproduction. It follows that intangible heritage is particularly vulnerable, according to UNESCO, precisely because it is intangible, although the historical record does not necessarily bear this out. Though the situation today is of a different order, Australian Aborigines maintained their "intangible heritage" for over thirty thousand years without the help of cultural policy. In contrast with the tangible heritage protected in the museum, intangible heritage consists of cultural manifestations (knowledge, skills, performance) that are inextricably linked to persons. It is not possible—or it is not as easy—to treat such manifestations as proxies for persons, even with recording technologies that can separate performances from performers and consign the repertoire to the archive.

While there is a vast literature on the heritage industry, much of it dealing with the politics of heritage, less attention has been paid to the enterprise as a metacultural phenomenon in its own right.[60] The great pressure to codify the metacultural operations, to create universal standards, obscures the historically and culturally specific character of heritage policy and practices. In the case of tangible heritage, is the goal to restore an object to its original state and to honor the artist's intention; to present an object in pristine perfection, untouched by time; to treat the object or site as a palimpsest by retaining, as much as possible, evidence of historical process, as at Hyde Park Barracks in Sydney, Australia, and in processual archaeology; to distinguish visually between the original material and what has been done to conserve or restore the object and to make restoration reversible; or to view the material object itself as expendable?[61] As long as there are people who know how to build the shrine, it is not necessary to preserve a single material manifestation of it, but it is necessary to support the continuity of knowledge and skill, as well as the conditions for creating these objects, as is the case at Ise Jingu shrine in Japan, discussed above. The form, the phenomenon, persists, but not the materials, which are replaced.

International heritage policy of the kind developed by UNESCO shapes national heritage policy, as can be seen from recent efforts in Vietnam and South Africa, among others, to create legal instruments for the protection of cultural

heritage. There is also movement in the opposite direction. The concept of National Living Treasure, which informs UNESCO's intangible heritage program, was developed decades earlier in Japan and Korea.

Finally, the possession of heritage—as opposed to the way of life that heritage safeguards—is an instrument of modernization and mark of modernity, particularly in the form of a museum: "To have no museums in today's circumstances is to admit that one is below the minimum level of civilization required of a modern state."[62] While persistence in old lifeways may not be economically viable and may well be inconsistent with economic development and with national ideologies, the valorization of those lifeways as heritage (and integration of heritage into economies of cultural tourism) is economically viable, is consistent with economic development theory, and can be brought into line with national ideologies of cultural uniqueness and modernity. Fundamental to this process is the heritage economy as a modern economy. For this and other reasons, heritage may well be preferred to the preheritage culture (cultural practices prior to their being designated heritage) that it is intended to safeguard. Such is the case at the Polynesian Cultural Center in Hawai'i, a Mormon operation where, since 1963, Mormon students at Brigham Young University Hawaii "keep alive and share their island heritage with visitors while working their way through school."[63]

Such cases point to the troubled history of museums and heritage as agents of deculturation, as the final resting place for evidence of the success of missionizing and colonizing efforts, among others, which preserve (in the museum) what was wiped out (in the community). Today's museums and heritage interventions may attempt to reverse course, but there is no way back, only a metacultural way forward.

HERITAGE OF HUMANITY

World heritage is predicated on the idea that those who produce culture do so by dint of their "diversity," while those who come to own those cultural assets as world heritage do so by dint of their "humanity." The descent heritage of particular groups becomes the consent heritage of all humanity thanks to the importance accorded the safeguarding of cultural diversity and the freedom to "choose" a particular heritage and cultural identity. In a sense, that freedom, which includes the possibility of refusing a heritage and cultural identity, makes the need to safeguard diversity all the more pressing. But for whom? What does it mean for humanity to own that which it did not create?

This question has been explored most extensively in the contexts of intellectual property law, around notions of public good and cultural commons

and the esoteric nature of cultural knowledge and practices. Of special importance is the following asymmetry. Patents, trademarks, trade secrets, and copyright protect the holder's rights and interests by restricting access, while heritage designations are intended to protect an object or practice from disappearing so that all may have access to it.[64] Safeguarding, whatever its local effects, ultimately protects the rights of humanity to world heritage. It is in these terms that the case must be made for why one cultural form rather than another should be designated a masterpiece of world heritage.[65] Willy-nilly, the case that is made must reconcile the exclusivity of cultural difference, which is predicated on prepolitical (that is, prior to or other than governmental) solidarity and boundaries, with the inclusivity of the "heritage of humanity," which is not.

Once cultural assets become world heritage, a shift occurs in the relation of heritage to its new beneficiary, that is, to humanity. First, humanity is not a collective in the way that heritage-producing communities are. Second, neither humanity as a whole nor the individuals who constitute humanity carry, bear, or transmit the heritage of humanity, let alone create and/or reproduce it. If and when they do, issues of appropriation and exploitation arise. Third, any rights one might assert to the heritage of humanity are first and foremost rights of access, consumption, and, in a general but not legal sense, inheritance.

Concepts of human and cultural rights are fundamental to the notion of humanity that defines world heritage. International courts that are intended to protect human and cultural rights locate humanity within a supranational realm of polity, governance, and the adjudication of claims. We might therefore distinguish rights based on *ancestry and inheritance* (people related to one another), *citizenship* (relationship of individual to the state), and *humanity* (relation of individual to international law). All three relationships are at play in heritage as a mode of metacultural production that moves cultural goods from one rights-based context to another. The enterprise effects a series of shifts, from local to national to world heritage — or, more recently, from local directly to world heritage, that is, from a privileged relationship to a cultural good deriving from notions of ancestry, descent, and inheritance to a relationship based on interest, choice, freedom, democratic notions of inclusion, participation, consent, and investment.[66]

Even those whose culture is declared a masterpiece of world heritage cannot claim ownership to it in a conventional legal sense. For decades, UNESCO approached the safeguarding of intangible heritage through intellectual property law, but without success. Intellectual property law is predicated on individual authorship and ownership, but UNESCO's notion of heritage assumes collective creation and, as world heritage, the widest possible collective ownership.

When culture becomes the heritage of humanity, the presumption is open access. Restricting access would be antithetical to economic development, particularly in the form of cultural tourism. Thus, intangible heritage goes straight into a global cultural commons, which is tantamount to a global public domain. What kind of social entity is this?

Sociologist Craig Calhoun notes the importance of solidarities based on a sense of belonging that is rooted in a sense of shared culture, history, and destiny. These commonalities are "embedded in a way of life," as lived reality. They produce a "multi-tiered sense of belonging" or "thick identities," in contrast with the "thin identities" associated with universalistic notions such as humanity.[67] Put another way, what is the habitus of a global polity? Is it necessary to loosen one set of ties (those of "associates of a polity" joined by "prepolitical cultural bonds") in order to create another set of ties that will bind humanity into a global polity? And is this desirable or even essential to achieving world peace? In what sense can humanity be said to have a common history, and is it the same as "world history"? The world heritage enterprise can be seen as an attempt to answer these questions by creating common ground. But humanity does not hold world heritage in common in the way that each "cultural masterpiece" is held in common by the community that sustains it.

UNIVERSALS, RELATIVITY, DIVERSITY

No more masterpieces. —Antonin Artaud[68]

By putting absolutism (universal human rights) in the service of relativism (cultural diversity), world heritage legislation recasts relativity as diversity. The universal standard of human rights is not subject to relativity, while cultural rights, as a subset of human rights, can be asserted only insofar as they do not violate human rights. Indeed, human and cultural rights may be in conflict. Human rights are predicated on the individual as a legal entity, on the primacy of rights over duties, and on recourse to law. In contrast, the exercise of cultural rights, while protected as freedom of choice, may entail very different assumptions, including the primacy of community, duties, and reconciliation or education, rather than legal measures.[69]

Cultural rights are asserted on the grounds of diversity as a universal principle. To assert cultural rights on the grounds of relativity as a universal principle is a contradiction in terms. This is why diversity is more compatible than relativity with the universalizing drive of world heritage, both cultural and natural. We can speak of natural diversity but not natural relativity. We can speak of cultural relativity but not heritage relativity, another indication of the

importance of natural heritage as a model for intangible heritage. We can speak of protecting and celebrating diversity but not of protecting and celebrating relativity. Why?

Cultural diversity refers to variety and affirms the value of difference. In contrast, cultural relativity indexes a relationship between terms in the spirit of neutrality, and, if anything, it is a defensive response to absolutes and universals, that is, to a hierarchical ordering of terms based on an absolute or universal standard. For this reason, the primary mechanism for creating world heritage—the creation of universal standards for designating masterpieces— is contrary to anthropological notions of relativity, which require the suspension of value judgments on culture (while not advocating moral relativity). The tensions between tolerance of cultural difference and upholding universal moral standards arise as well when there is a conflict between a human right and a particular cultural practice, for example, genital cutting.[70]

Cultural rights are a subset of human rights. Such rights are predicated on the notion of a universal human subject and the principle of rights and freedoms "for all without distinction," in the words of the United Nations Charter (1945) and subsequent documents. However, while all individuals and collectives have rights to culture, the imperative to tolerate differences (relativity) does not imply or require that others celebrate those differences (diversity). Thus, while all human beings are of equal value and have a right to their own culture, the world heritage enterprise does not accord all expressions of culture equal value. Not everything makes the heritage cut. You have a legal right to your culture, but there is no law guaranteeing that your culture will become world heritage. To qualify as a masterpiece of the heritage of humanity, a cultural expression must be not only *distinctive* but also *distinguished*. It must meet a universal standard, even as the world heritage enterprise attempts to make the lists more inclusive and representative.

There is a fundamental contradiction, then, between the celebration of diversity, on one hand, and the application of a universal standard for determining which cultural expressions will be designated masterpieces of the heritage of humanity, on the other. To meet the universal standard, a cultural expression must be unique, unusual, outstanding, exceptional, rare, particularly meaningful, or valuable in some other way. It should also be endangered, but sufficiently intact, to make a heritage investment worthwhile. In other words, human beings are "without distinction" when it comes to rights, but not when it comes to culture. Some cultural expressions are valued more highly, by a universal standard, than others. In a word, humanity does not want to inherit everything, just the best.

GLOBAL CULTURAL COMMONS AND GLOBAL PUBLIC SPHERES

What are global public spheres, how are they formed, and how are museums placed and
defined in such spheres? —Conference program, Museums and Global Public Spheres

How does world heritage figure in imagining, if not forming, a global pub-
lic sphere? Lourdes Arizpe, former assistant director general for culture at
UNESCO, has put forward the idea of a global cultural commons.[71] She suggests
that new technologies are creating spaces of instantaneous and ubiquitous
communication and global consciousness, and that mass media are creating a
lingua franca for a culturally fluid and increasingly cosmopolitan world. The
same forces are also changing (and threatening) the survival of local "human-
made cultural creations," which the heritage enterprise attempts to safeguard.
The threats are diverse and the term "safeguarding" is defensive. The idea of
safeguarding is consistent with a long history of rights as a defensive measure,
in the eighteenth-century sense of "attempting to limit the power of govern-
ments over its subjects."[72]

Designation as world heritage has local political effects that can run counter
to UNESCO's professed goals and produce not only resistance to normative
heritage interventions but also alternatives to those interventions. Moreover,
equity in the world heritage sphere can produce inequity on the ground. Heri-
tage development may displace living communities and supersede their needs,
as Lynn Meskell demonstrates in her account of Egyptian archaeology and the
case of Gurna (West Bank, Luxor), where the Gurwani community was forced
to relocate to make way for an open-air museum.[73] When they resisted, force
was used, including bulldozers and armed police, resulting in four deaths and
many injuries.[74] This community is in the process of creating its own museum.
In Egypt and elsewhere, luxury tourism stands in sharp contrast to the desper-
ate poverty of local communities, and fuels deep resentments that can erupt in
violence. Due to the vertical integration of the industry, particularly in high-
end tourism, the benefits to local populations fall far short of expectations.
Moreover, not only does an open-air museum displace a living community,
but also tourists may be viewed as immodest, immoral, and wasteful by local
standards.

Simon Jenkins, writing for *The Times* (London) about tourists in Luxor in
November 1997, commented that the Islamic fundamentalists responsible for
the violence there see tourism as a threat to Islam:

Islam is threatened by an imperialism even more menacing to its dogma than
the political imperialism of the 19th century. Mass tourism is the agency of this

aggression. The tourist is not a neutral bystander in the religious wars now being fought across the Islamic world. He is a participant. The Temple of Hatshepsut, where Monday's atrocity [murder of tourists] occurred, no longer "belongs" to Egypt but to the world. It is being restored by European archaeologists with UNESCO money. To the fundamentalist, Luxor is a cultural colony, occupied by the armies of world tourism.[75]

And, one might add, Luxor is world heritage, for reasons related to what Meskell identifies as the governing ethic in the heritage sphere, namely, social utility. In her view, codification—the global standard that UNESCO bodies establish—"represents a form of inert knowledge rather than knowledge produced in response to the context of application."[76] It is for this and other reasons that equity in the context of world heritage can produce inequity in local contexts. Cultural diversity and world heritage, cornerstones for the culture of peace envisioned by UNESCO, require more than mutual respect. There is unfinished business. At issue are past (and present) abuses and redressive steps, such as repatriation, restitution, and right of return.

While the commons is related to the public sphere, they are not the same thing. The concepts of "commons" and "public" have different though related histories. "Commons" is linked to community and to assets that a community holds in common, particularly land. The commons operates on the basis of consensus, without precluding conflict within a community and struggles between it and other interests. In Appalachia, the commons may be a forest where everyone can gather wild foods.[77] However, mining companies there are destroying the commons, there being no brake, such as a heritage designation, to stop them. Fights to defend the commons, in contrast with the commons itself, could be said to shape a public sphere. Defining characteristics of a public sphere are civic engagement and critical debate—that is, productive disagreement that can provide a counterweight to the state and the market.

We know from Jürgen Habermas and Benedict Anderson, among others, that publics can form without ever meeting one another face to face, though they may actually do so. Reading publics form imagined communities, while small circles of public conversation shape larger civic debates. In other words, Habermas puts forward an abstract (and rational) sphere of debate in which the interlocutors never convene in their entirety, a sphere that emerges from the exchange of ideas through mass media as well as in smaller face-to-face situations.

Global public sphere implies a different set of conditions, chief among them a global civil society that emerges from what has been called active cosmopolitan citizenship. Such citizenship is understood as arising from a series of

disarticulations (and resulting paradoxes and contradictions) associated with economic and political globalization. "New deliberative and decision-making bodies that emerge beyond national territory"—international (UNESCO), non-governmental (World Bank), multinational, or regional (European Union) entities or social movements (environmental, antiglobalization, etc.)—are engaging in "new forms of global governance." As states give up some of their autonomy, "collective decisions are made in contexts beyond government control."[78] While this sounds like a good thing, sociologist Saskia Sassen stresses that global economic processes are embedded in the national and that lived experience has a local character.[79] For Pierre Bourdieu, "unification profits the dominant" while dispossessing social agents who cannot compete on a cultural and economic playing field that is far from level—for example, by eliminating the self-sufficiency of small rural producers, an action that, I would add, prepares the ground for a heritage intervention.[80]

World heritage is one of several ways of envisioning and constituting a global polity. The goal is an active cosmopolitan citizenry, in the spirit of Kant's *Perpetual Peace* (1795).[81] To produce world heritage, supranational bodies disarticulate culture from nation and aggregate selected cultural manifestations into a category that imagines a polity wider than the nation-state. Paradoxically, world heritage simultaneously promotes cultural diversity and identity while loosening "the ties between the associates of a polity from pre-political cultural bonds" or helping to "disconnect citizenship from nationality."[82] Each disarticulation entails an articulation.

In this model, supranational developments are supposed to preclude or prevent resurgent nationalisms, devastating civil wars, and the fall of some states and the creation of new ones, and to deploy the arts—and museums and heritage—to such worthy ends. But, as can be seen in Rwanda, art can also be used to incite violence. Simon Bikindi, a popular Rwandan musician, has been accused of genocide and promoting hate through his songs. According to the prosecution, "Simon Bikindi's song lyrics manipulated the politics and history of Rwanda to promote Hutu solidarity."[83] The songs were broadcast on a hate radio station and from a vehicle, along with messages to exterminate Tutsis. A South African commentator, reflecting on similarities between Bikindi's songs and a controversial song about South Indians by Mbongeni Ngema, wrote:

> One should not underestimate the power of music. Rwandan genocide survivors describe the effect of Bikindi's song, and particularly the lines about the solidarity of Hutu brothers against the Tutsi enemy: "Hutu men (who had been organized into the infamous *interahamwe* militia) began behaving as if the devil had got into them. . . . They descended on Tutsi homes or hiding places in howl-

ing mobs baying for blood, cutting down with machetes every Tutsi they could find, clubbing them with *masus* [spiked clubs], raping and pillaging."[84]

Clearly, the power of the arts, which UNESCO mobilizes in the interest of peace, can also aid and abet hate and violence, a topic generally avoided in heritage discussions.

The heritage enterprise is energized by a sense of urgency, not only because of the endangered status of cultural assets, but also because of the role that heritage is expected to play in ameliorating conflict and alleviating poverty. While this sense of urgency is important for building consensus, contentious heritage is not what the UNESCO protocols are about. Rather, these protocols are an extension of diplomatic and ambassadorial modes of discourse in the service of harmony and goodwill. The modalities of heritage production— veneration and celebration—are largely ceremonial and festive in character and not conducive to·debate. Heritage itself is seen as inherently good and therefore cause for celebration. In reality, of course, heritage is hotly contested, ranging from conflicts over Japanese officials honoring their war dead to African Americans objecting to the flying of the Confederate flag over the South Carolina statehouse and the idealization of plantation heritage in the American South. However, the playing field is not level, and subnational polities are largely at the mercy and noblesse oblige of national and international bodies, policies, and laws.

While awarding prizes achieves certain objectives (and can also provoke controversy), such mechanisms do not invite the kind of debate and critique that define a public sphere. The heritage enterprise is by nature a consensual one, and world heritage aims to create the largest consensus of all. UNESCO's notion of the heritage of humanity—a kind of family-of-man idea and legacy of the Cold War—projects an ideal of consensus in diversity, where, in the final analysis, difference makes no difference and hence provokes no conflict, at least theoretically.[85] However differentiated the cultural contributors and heritage inputs, the outcome (world heritage list) and beneficiaries (humanity) are one. Thus, while the contributors have cultural identities (to be strengthened by heritage preservation), the beneficiaries (humanity) do not. The beneficiaries are understood to be individual personalities with human rights.

Historically, separating the individual from prepolitical cultural bonds (ethnic, religious, and other solidarities) was a way to bind citizenship to nationality. In contrast, world heritage weakens the link between citizenship and nationality (by affirming the prepolitical cultural bonds of subnational groups) in order to strengthen the bond between emerging cosmopolitan citizens and an emerging global polity. In other words, this move, unlike civilizing mis-

sions predicated on the monocultural universalism of "civilization," reverts to subnational as well as diasporic particularities in order, first, to transcend the national articulations of culture, and second, to rearticulate them supranationally.

Polities that are smaller than the state—those whose cultural claims are most strongly grounded in descent and notions of the primordial, autochthonous, ancestral, and inalienable—are the prime focus of intangible heritage initiatives, even if the list of masterpieces ends up being a showcase in many instances for national treasures. I say polities because while these entities may (or may not) begin as prepolitical solidarities, they become polities and come to assert their rights as such, including sovereignty rights. These rights may be exercised within particular territories (reservations in the case of Native Americans), by recourse to a founding treaty (the Treaty of Waitangi in the case of Maori) and policy of biculturalism (in the case of New Zealand), or movements for independent statehood (in cases such as Palestine).

Not all appeals to humanity, which are after all nothing new, are appeals to cosmopolitan citizenship, because humanity and global polity are not the same thing. Humanity is variously understood. First is humanity as an aggregate of individuals. It is the individual human being, the universal human subject, that is protected by human rights. Those rights come with birth, as do cultural rights understood as the right of the individual to choose culture. Second, humanity is understood as being made up of diverse constituent elements in the sense of individuals representing different cultures. World heritage, like humanity itself, is heterogeneous. Third, the term "humanity" may refer to a global polity. One of UNESCO's goals is to promote a sense of global solidarity and transnational identification; world heritage is intended to further that goal.

Appeals to humanity are assertions of a common human denominator, and it is the responsibility of each person to behave honorably to every other person regardless of differences, be they based on national identity, religion, gender, race, class, or disability. This is not the same as a global polity that understands itself and acts in terms of a notion of supranational solidarity, governance, and citizenship. UNESCO and other initiatives in the name of world heritage speak in terms of humanity, which is a weak concept politically. More precisely, the value of the term is precisely its standing as "not political," which signals that much of the world heritage discourse is diplomatic rather than political in a technical sense. This is why humanity is not strictly speaking a political entity and why humanity is such an attractive notion, as part of the language of diplomacy, for world heritage discourse.[86]

The formation of the European Union has prompted the formulation of cosmopolitan communitarianism or the combining of "multiple communitarian attachments" of different scales, with implications for national culture and world heritage. Democracy is the model for the larger world order as an idea of "global civil society" and "widening of the public sphere."[87] But globalization is producing a sphere of competitive economic actors more effectively than it is creating citizens with equal rights. De jure human rights are all too often not de facto human rights. This state of affairs is consistent with consumer models of citizenship in new right economies. While economics does not provide a level playing field, human and, by extension, cultural rights are intended to do just that. In other words, citizens bear a different relationship — ideally one of equality — to one another than do economic actors. The market as a space of competition among unequal actors is the opposite of and counterweight to what a public sphere is supposed to be and do.

CULTURAL ECONOMICS

Understood as a metacultural phenomenon, world heritage is in a different realm than the objects of heritage policy, which are understood as endangered cultural practices. Practically speaking, the objects are to be protected through metacultural operations and economic instrumentalization, the premise being that many cultural practices of subnational groups cannot withstand the pressures of globalization, economic development, political restructuring, and modernization (formal education, social reform, urbanization, industrialization, liberalization). The very grounds for these cultural practices — the people themselves and their life worlds, both habitat and habitus — are what are vulnerable.[88]

While a full discussion of the cultural economics of heritage is beyond the scope of this essay, a few words are in order, by way of conclusion. UNESCO's mission of peace and prosperity is the constructive face of war and poverty such that heritage interventions must play a role in alleviating conflict and contributing to development. The field of cultural economics is important to these efforts since heritage requires investment and investment is based on economic calculation.

Cultural economics draws on thinking in the environmental field. Much was learned from the lawsuits arising from the *Exxon Valdez* oil spill in 1989. This catastrophe required instruments for establishing damage awards based on more than the dollar value of barrels of oil or the cost of cleanup. Two other contexts in which cultural economics is figuring prominently are the World Bank, which now factors culture into its development projects and views cul-

ture itself as an investment opportunity, and the Getty Conservation Institute's Economics of Heritage Conservation project.[89]

The debate in cultural economics is between culturalists, as they are called by economists, and economists. As more and more of the world is declared heritage — and nothing on the list is deaccessioned — the financial commitment to conservation also grows. How are investors, be they the state, international bodies such as UNESCO, or NGOs, to determine where to put scarce resources? The moment something is declared heritage, it enters a complex sphere of calculation. *Valorization*, "the [re]appraisal of the heritage goods by means of deliberations, pleas by art historians, debates in public media," and proclamations by UNESCO, is followed by *valuation*, "the assessment of values that people actually attach to heritage goods," based on what they spend to consume them or to ensure that they exist, even if they do not consume them.[90]

Culturalists make their arguments in terms of peace. They tend to view economics as internal to culture. For culturalists, modes of production, exchange, and circulation are not independent of culture, but constitutive of it. In contrast, economists make their arguments in terms of prosperity. They tend to view culture as external to the market. That is, the market cannot account for culture (or taste). Nor can culture account for the market: "Externalities are benefits, or costs, of an economic good that are not accounted for by some kind of market transaction."[91] Culture is therefore something that can affect economic transactions but is external to the functioning of markets, strictly speaking. Accordingly, economists generally assume rational choice, the sovereign consumer, "the market as the most efficient allocator of scarce resources," and price as the keys to market equilibrium.[92]

Arjo Klamer and Peter-Wim Zuidhof, upon whose work this account is based, consider the inadequacies of this model for dealing with heritage in terms of market failure and for addressing what to do when the market fails to do for heritage what is needed, because a price for it, as a public good, cannot be set. "This occurs when no one can be excluded from the consumption of a good, and, if it is consumed by an individual, others cannot be prevented from consuming it as well. . . . The enjoyment of one does not come at the expense of another."[93] This is precisely the premise of "the heritage of humanity" concept, notwithstanding culturally specific understandings of proprietary rights, whether in connection with the dreamings of Australian Aborigines or the botanical knowledge of indigenous peoples.

In an effort to integrate economic and culturalist approaches, Klamer and Zuidhof acknowledge inadequacies of the market to provide equitably or appropriately for public goods and look to alternative ways of calculating the value of heritage. Basically, the task of cultural economics is to calculate the

value of goods when the market, for a variety of reasons, cannot set the price. Cultural economists Bruno S. Frey and Werner W. Pommerehne distinguish five types of value: option, existence, bequest, prestige, and education.[94]

Option value refers to the value of having the opportunity to benefit from an asset, whether or not one ever does. *Existence value* (also called non-use value) refers to the value one places on the mere existence of a cultural asset such as the Garifuna language, without reference to whether or not a global citizen will ever hear it or personally benefit from it in some way. *Bequest value*, as the term suggests, is the value the asset may have for later generations. *Prestige value*— the primary value of being proclaimed a masterpiece of world heritage—refers to the benefits that follow from being endowed with elevated status. This is the logic of awards, designations, proclamations, registers, and lists. Moreover, a rise in prestige value, while it may have economic benefits in terms of tourism, for example, may have negative effects on property value by limiting what the owner can do with a building. *Education value* refers to the value of the asset as an educational resource, understood in the context of UNESCO as contributing to positive identity, pluralism, dialogue, culture of peace, and economic development.

Stefano Pagiola, who works in the Environmental Department of the World Bank, also distinguishes *extractive use value* (this value is exploited by the *econ-omusée*, which combines exhibition with production and sale of such specialties as chocolate or honey), *non-extractive use value*, which includes *aesthetic and recreational value*, and *non-use value*, which includes *existence, option*, and *quasi-option values* (the possibility that a site that appears to have little value now might have more value in the future).[95] Recognizing the intangibility of heritage as well as its benefits, cultural economists use what is called contingent valuation. Though not perfect, contingent valuation does provide survey data indicating what people would be willing to pay (WTP) or willing to accept (WTA), consistent with the above values, in raised taxes, voluntary contributions, and trade-offs to safeguard or invest in culture.

Klamer and Zuihof recognize that measurements of intangible value, "in the absence of well-functioning and morally justifiable markets," not only lack precision but also do not take into account culturalist arguments for "valorization of goods as cultural heritage goods."[96] Consistent with the notion of heritage as a mode of cultural production in its own right and as a metacultural phenomenon, as discussed above, Klamer and Zuihof do note that "the way in which the heritage is funded may not only affect the appraisal of the heritage but may even contribute to the 'creation' of the heritage," while "valuation in the market can trigger a process of valorization in which (noneconomic) values come about."[97] In other words, valorization (awards and plaques) tends

to increase valuation, while valuation (discovering that an old table is worth real money) can lead to valorization by calling attention to values other than economic ones. All heritage is created, and economic arrangements are but one factor in shaping it.

While culture may be an externality in economic theories of markets, economics is not an externality in theories of culture. Cultural economics, perhaps because it tends to focus on tangible heritage, does not address the economic character of a phenomenon before it has been designated heritage. Such considerations are not factored into the model, which assumes no or low economic value as the starting point, followed by valorization and valuation, that is, by an increase in value. The unstated premise of cultural economics is a clear separation between the heritage economy and other economies, which culturalists would see as mutually constitutive of the cultural asset and its heritage incarnation, in the past and present.

The heritage economy makes a phenomenon into a particular kind of asset. It is not simply that something without economic value becomes valorized and valuated or the reverse. It is rather a question of the economic constitution of the phenomenon, the idea that economic relations—not only the market, but also the gift—are intrinsic to what a phenomenon is, both before and after it becomes heritage. Thus, among the nineteen Masterpieces of Oral and Intangible Heritage of Humanity on the UNESCO list are cultural forms that are state-supported centerpieces of pilgrimage and tourism (the royal ancestral rite and ritual music in Jongmyo shrine in South Korea) and others that have persisted for over two hundred years with no sign of letting up (the Oruro carnival in Bolivia). Some have lost their audiences and are gradually losing their performers (Sicilian puppet theater in Italy).

The conversion of habitus into heritage and heritage into cultural assets, cultural capital, and cultural good, a process that is integral to concepts of public domain, public goods, fair use, and global cultural commons, can engender the kind of public debate associated with a public sphere. For example, Giovanni Pinna, criticizing state-supported museums in Italy, distinguishes patrimony from cultural assets and demonstrates how the former becomes the latter through a process of "desymbolization" and revaluation in material terms. Pinna links this phenomenon to the national government, which, in its attempt to unify the country, transfers the "diaspora of cultural assets" to state ownership and centralizes their location and management. Because of legislation passed in 1993, Italian museums have become more visitor-oriented in terms of amenities and earned income, but their fundamental approach to heritage as cultural asset has not changed. Not only have museums removed assets from their places of origin, but also they prevent those assets "from be-

coming part of a complex of meanings, or in other words, an integral part of the cultural heritage," for reasons that Pinna links to an ideology of national unity and to a centralized bureaucracy that manages the nation's cultural assets.[98]

In June 2002, a year after Pinna's article appeared, the Italian parliament, in an effort to reduce the deficit, passed a bill to privatize "everything that at present belongs to the State—land, public buildings, monuments, museums, archives, libraries, estimated by the Ministry of the Economy to be worth £2000 billion," by transferring it all to two shareholding companies, one of which, "Patrimonio dello Stato spa (State heritage plc), will take over the ownership and exploitation, and even the eventual sale, of government property."[99] There has been intense opposition to this bill in Italy and internationally (World Wildlife Fund and Greenpeace are two opponents to the plan) and confusion as to the fate of cultural assets.

It is precisely such social dramas that precipitate the kinds of public debates associated with a public sphere. It is for this reason that debates arising from the valorization of cultural phenomena seeking world heritage status are a place to look for something like a global public sphere, however overdetermined it might be by institutional and professional actors. At the same time, intangible heritage, precisely because it is inseparable from the human actors who know, remember, embody, do, and perform what becomes heritage, brings their subjectivity and agency to the fore. Every effort to safeguard, preserve, sustain, and foster exemplary and endangered cultural practices—to declare them Masterpieces of Oral and Intangible Heritage of Humanity—alters the relationship of practitioners to their practices. The metacultural outcome—*heritage*, both the designated masterpieces and the heritage enterprise itself—is intended, if not designed, to be better adapted to the social, political, and economic conditions of our time than the endangered practices themselves (even were they not endangered). This is why heritage is a mode of metacultural production that produces something new, which, though it has recourse to the past, is fundamentally different from it. While this paradox would seem to indicate an imperfect realization of safeguarding and preservation goals, it highlights the centrality of the metacultural goals. Similarly, world heritage produces an asymmetry between the *diversity* of those who produce cultural assets in the first place and the *humanity* to which those assets come to belong in the service of similarly metacultural objectives. Undesignated, the masterpieces on UNESCO's intangible heritage list could never do the work that world heritage is intended to do, namely, to model a particular vision of humanity in terms of a global cultural commons.

NOTES

I would like to thank Richard Kurin, director of the Center for Folklife and Cultural Heritage at the Smithsonian Institution; Lourdes Arizpe, former assistant director general for culture, United Nations Educational, Scientific and Cultural Organization (UNESCO); Ilana Abramovitch, former manager of curriculum at New York's Museum of Jewish Heritage: A Living Memorial to the Holocaust; Ethel Raim, former executive and artistic director, Center for Traditional Music and Dance; Jan Turtinen; Max Gimblett; and my New York University colleagues Faye Ginsburg, Fred Myers, Diana Taylor, Leshu Torchin, Glenn Wharton, and George Yúdice for their generosity in sharing their insights; and Anurima Banerji for her editorial assistance.

1 This appears as an epigraph to an excerpt from the statement by Federico Mayor, director general of UNESCO, at the Conférence intergouvernementale sur les politiques culturelles pour le développement, Stockholm 1998. It appears on the International Directory of Intangible Cultural Heritage Web site, http://www.culturaldiversity.cioff .ch/en/patrimoine.html (accessed September 28, 2004).

2 UNESCO, "Emergency Inscription of Bamiyan and Ashur on World Heritage List," press release no. 2003-39, http://portal.unesco.org/en/ev.php-URL_ID=13285&URL _DO=DO_TOPIC&URL_SECTION=201.html (accessed August 12, 2005).

3 Associated Press, "King Day Honors the Man, His Message."

4 See the reports of the WTO (World Tourism Organization) Tourism Recovery Committee, http://www.world-tourism.org/mkt/recovery.html (accessed September 28, 2004).

5 Some cultural economists are trying to address this issue. See Throsby, "Economic and Cultural Value in the Work of Creative Artists," 26–31.

6 See Robertson, Globalization.

7 The work of George Yúdice and Toby Miller on cultural policy is relevant here. See Miller and Yúdice, Cultural Policy and Yúdice, The Expediency of Culture.

8 Several histories of UNESCO's heritage initiatives have been written. For a particularly thoughtful account, see Turtinen, "Globalising Heritage."

9 UNESCO, "Defining Our Heritage," January 15, 2003, http://www.unesco.org/whc/ intro-en.htm, (accessed September 28, 2004).

10 The World Intellectual Property Organization is making efforts to deal with these issues as are such organizations as Secretariat of the Pacific Community in Noumea, New Caledonia. See their Regional Framework for the Protection of Traditional Knowledge and Expressions of Culture.

11 UNESCO, "Recommendation on the Safeguarding of Traditional Culture and Folklore," adopted by the General Conference, Paris, November 15, 1989, http://www .unesco.org/culture/laws/paris/html_eng/page1.shtml (accessed September 28, 2004).

12 UNESCO, "Intangible Heritage," http://portal.unesco.org/culture/en/ev.php-URL_ ID=2225&URL_DO=DO_TOPIC&URL_SECTION=201.html (accessed September 28, 2004). This formulation is close to the one in UNESCO's 1989 Recommendation on the Safeguarding of Traditional Culture and Folklore.

13 Quoted in UNESCO, "Report on the Preliminary Study on the Advisability of Regulating Internationally, Through a New Standard-Setting Instrument, the Protection of Traditional Culture and Folklore," paragraph 26.

14 UNESCO, "Recommendation on the Safeguarding of Traditional Culture and Folklore."

15 UNESCO, "Intangible Heritage."

16 See the Musée du quai Branly Web site, http://www.quaibranly.fr (accessed September 28, 2004), and Musée des civilisations de l'Europe et de la Méditerranée, "Le projet," http://www.musee-europemediterranee.org/projet.html (accessed September 28, 2004).

17 See Jacques Chirac, speech delivered April 13, 2000, "Inauguration du pavillon des Sessions au musée du Louvre," http://www.quaibranly.fr/IMG/pdf/doc-718.pdf (accessed March 24, 2006).

18 Fénéon et al., *Iront-ils au Louvre?*

19 This account is based on the most recent draft, as of this writing in 2003, of the intangible heritage convention: "Consolidated Preliminary Draft Convention for the Safeguarding of Intangible Heritage."

20 For a detailed history and analysis of UNESCO's intangible heritage initiatives, see Hafstein, "The Making of Intangible Cultural Heritage." See also Sherkin, "A Historical Study on the Preparation of the 1989 Recommendation."

21 UNESCO, "Proclamation of Masterpieces of the Oral and Intangible Heritage of Humanity," press kit, http://www.unesco.org/bpi/intangible_heritage, and UNESCO, "Proclamation of Masterpieces of the Oral and Intangible Heritage of Humanity," http://portal.unesco.org/culture/en/ev.php-URL_ID=2226&URL_DO=DO_TOPIC &URL_SECTION=201.html (both accessed September 28, 2004).

22 Early and Seitel, "UNESCO Meeting in Rio," 13.

23 Seitel, *Safeguarding Traditional Cultures.*

24 See Kirshenblatt-Gimblett, "Destination Museum."

25 See Nas, "Masterpieces of Oral and Intangible Culture."

26 Murphy, "Immaterial Civilization." This gesture is reminiscent of Horace Miner's classic essay "Body Ritual Among the Nacirema." "Nacirema" is, of course, "American" spelled backward.

27 I am adapting a distinction made by Johannes Fabian in *Time and the Other.*

28 Good intentions create unintended distortions also familiar in arts funding in the United States, which divides the cultural field so that Western classical and contemporary art is funded through such categories as dance, music, theater, opera, musical theater, literature, design, and visual arts. At the National Endowment for the Arts, everything else goes under the category folk and traditional arts or multidisciplinary arts, which includes "interdisciplinary work deeply-rooted in traditional or folk forms that incorporates a contemporary aesthetic, theme, or interpretation" (http://www.nea.gov/artforms/Multi/Multi2.html, accessed October 23, 2003). At the New York State Council for the Arts (http://www.nysca.org, accessed September 28, 2004), the comparable divisions are folk arts ("living cultural heritage of folk art") and special arts services (support for "professional arts activities" in and

for "African/Caribbean, Latino/Hispanic, Asian/Pacific Islander, Native American/ Indian communities," and other distinctive ethnic communities).

29 On the distinction between descent and consent, see Sollors, *Beyond Ethnicity*.

30 On the list as an instrument of historic preservation, see Schuster, "Making a List and Checking It Twice."

31 This is the language in UNESCO, "Consolidated Preliminary Draft Convention for the Safeguarding of Intangible Heritage."

32 Ibid., Article 18, 1.

33 On the festival as a museum of live performance, see Kirshenblatt-Gimblett, "Objects of Ethnography."

34 UNESCO, "Intercultural Dialogue," http://www.unesco.org/culture/dialogue/html_eng/index_en.shtml (accessed September 28, 2004).

35 UNESCO, "Intercultural Dialogue in Central Asia," http://www.unesco.org/culture/dialogue/eastwest (accessed March 24, 2006).

36 See the Web site of the Silk Road Project, Inc., http://www.silkroadproject.org/ (accessed September 28, 2004), and Smithsonian Center for Folklife and Cultural Heritage, "The Silk Road: Connecting Cultures, Creating Trust," http://www.silkroadproject.org/smithsonian (accessed September 28, 2004).

37 See Kirshenblatt-Gimblett, "Mistaken Dichotomies."

38 For example, the 2001 festival featured Bermuda, New York City (it was exceptional to feature a city rather than a state), and "Masters of the Building Arts."

39 Trescott, " 'Silk Road' Traffic Jam."

40 Kennedy, "The Silk Road: Connecting Cultures, Creating Trust."

41 Adams, "Blue-and-White."

42 Small, "On the Road from the Secretary."

43 Some of the text panels can be found on the excellent Smithsonian Folklife Festival Web site, http://www.silkroadproject.org/smithsonian (accessed September 28, 2004).

44 The Silk Road Project, Inc., "About Us." http://www.silkroadproject.org/about/ (accessed September 28, 2004).

45 More could be said about this project, from the perspectives of both intercultural performance and world music. See, for example, Ley, *From Mimesis to Interculturalism*; Pavis, *The Intercultural Performance Reader*; Feld, "From Schizophonia to Schismogenesis."

46 On the issues raised by the destruction of the Bamiyan Buddhas, see Flood, "Between Cult and Culture."

47 Pradhan, "South Asia-AIDS," and Seitel, *Safeguarding Traditional Cultures*.

48 Guerny and Hsu, "Early Warning Rapid Response System."

49 See Kurin, *Reflections of a Culture Broker*.

50 "U.S. Dept. of Retro Warns: We May Be Running Out of Past," *The Onion*, reprinted in this volume.

51 "Heritage" is now used as an adjective, as in heritage center, corridor, trail, village, park, policy, fund, coalition, council, tourism, and industry. Ethnic communities and foreign languages spoken in the United States have become heritage communities and

heritage languages. See, for example, the Center for Applied Linguistics' Heritage Languages Initiative, http://www.cal.org/heritage (accessed September 28, 2004), and the Heritage Language Journal, http://www.heritagelanguages.org (accessed March 24, 2006). "Southern heritage groups" are neo-Confederates who support the flying of the Confederate flag and honoring Confederate soldiers who died during the Civil War, over the objections of African Americans, who are not characterized as a heritage group in this context. See Dinan, "Gilmore Surrenders Virginia's Heritage." These terminological innovations parallel the shift in terminology from "foreign student" to "international student" (as distinguished from the national or naturalized, that is, students who are American citizens) and, in museums, from anthropological or ethnographic collections to "world cultures." The term "heritage" is used by right-wing organizations such as the Heritage Foundation, founded in 1973 "to formulate and promote conservative public policies based on the principles of free enterprise, limited government, individual freedom, traditional American values, and a strong national defense," and the National Republican Heritage Groups Council, which was accused during the administrations of Ronald Reagan and George H. W. Bush of including right-wing extremists with fascist and Nazi sympathies, and which was reactivated in 2004 as the National Heritage Groups Committee. Its stated mission is: "As the American electorate grows in diversity, the NRHGC insures that all nationalities are properly represented and recruited by the Republican Party," http://www.sourcewatch.org/index.php?title=National_Republican _Heritage_Groups_Council (accessed March 24, 2006). "Heritage group" refers here to nationality—that is, ethnic—groups in the United States. For the Heritage Foundation, see http://www.heritage.org (accessed September 28, 2004). Declaring bankruptcy, Jim and Tammy Faye Bakker sold their Heritage Park, a Christian theme park, resort, retreat, and PTL headquarters in Fort Mill, South Carolina, in operation from 1978 to 1987. It was redeveloped as New Heritage Park USA, which went out of business in 1997. Retirement communities have become "heritage villages"; see http://www.villagers.com (accessed September 28, 2004).

52 Swade, "Virtual Objects: Threat or Salvation?"
53 Armstrong, *The Powers of Presence*, and Armstrong, *The Affecting Presence*. See also Gell, *Art and Agency*; Thompson, *African Art in Motion*; and Freedberg, *The Power of Images*.
54 "Jingu Shrine in Ise," Japan Atlas, http://web-japan.org/atlas/architecture/arc14.html (accessed February 26, 2006).
55 See Kirshenblatt-Gimblett, "Plimoth Plantation."
56 See Phelan, "The Ontology of Performance: Representation Without Reproduction," and reactions to her position by Philip Auslander in *Liveness*. Others have explored the relationship of performance (and intangible heritage) to recording media, not only as a way to capture or document, but also as an art practice, catalyst of cultural production, and basis for theorizing orality. See Kirshenblatt-Gimblett, "Folklore's Crisis."
57 Goodman, *Languages of Art*. Goodman's position has been critiqued and adapted to deal with phenomena that he did not consider, among them performances without

scores and scripts and digital media that can produce true copies. See Margolis, "The Autographic Nature of the Dance"; Armelagos and Sirridge, "The Role of 'Natural Expressiveness' in Explaining Dance"; Armelagos and Sirridge, "The Identity Crisis in Dance"; and Krauss, *The Originality of the Avant-Garde*.

58 UNESCO, "Intangible Heritage."

59 See Taylor, *Acts of Transfer*.

60 See, for example, Lowenthal, *The Heritage Crusade and the Spoils of History*, and Nora and Kritzman, *Realms of Memory*.

61 See Pearson and Shanks, *Theatre/Archaeology*.

62 Dellios, "The Museumification of the Village."

63 From the Web site of the Polynesian Cultural Center, http://web.archive.org/web/20040208144406/http://www.polynesia.com/aloha/history (dated February 8, 2004; accessed March 24, 2006). See also Ross, "Cultural Preservation in the Polynesia of the Latter Day Saints."

64 While intellectual property law, which protects what is understood as the creations and possessions of individuals, does address issues of fair use, public domain, and the like, the overwhelming concern is with protecting the rights of individual and corporate owners to their property, rather than with ensuring public access. Exceptions (and they are important) can be found in the open source software movement and anti-globalization movements. As Manuela Carneiro da Cunha observes, the expectations regarding traditional knowledge and contemporary Western systems of knowledge are reversed: "free access and public domain versus monopoly and secrecy; unlimited time frame for intellectual rights versus loss of intellectual rights after a certain time." See da Cunha, "The Role of UNESCO in the Defense of Traditional Knowledge."

65 This is of course a move that also operates nationally. The precedents for it are the Living National Treasures idea that Japan put into effect in 1950. Other countries followed suit: Korea, Philippines, Romania, and France.

66 What distinguishes heritage (and patrimony) from history is precisely the assumption of inheritance and ancestry, which are the basis for a privileged relationship to the cultural expression in question. On the heritage/history issue, see Pierre Nora, "Between Memory and History" and Schouten, "Heritage as Historical Reality."

67 Calhoun, "Imagining Solidarity."

68 Artaud, "No More Masterpieces." Artaud is objecting to the artistic status quo. Viewed historically, the term "masterpiece," like "*chef d'oeuvre*," appears in the medieval context of "regulatory legislation governing artisanal activity." That is, masterpiece is originally a legal concept associated with apprenticeship and guild control of trades. Cahn, *Masterpieces*, 3.

69 See Sinha, "Human Rights: A Non-Western View Point." Cultural rights of one group or person may be in conflict not only with the cultural rights of others but also with human rights, to cite only female circumcision. See Kratz, "Circumcision Debates and Asylum Cases."

70 See the special issue of *Journal of Anthropological Research* 53, 3 (1997), which focuses on universal human rights and cultural relativism.

71 See Arizpe, "Cultural Heritage and Globalization."

72 Meskell, "Sites of Violence," 5.

73 Meskell, "Sites of Violence." See also Mitchell, "Worlds Apart" and "Making the Nation." In addition, see the Chengde case discussed by Hevia in "World Heritage, National Culture, and the Restoration of Chengde."

74 Meskell, "Sites of Violence," 12.

75 Jenkins, "Hysteria Calls the Shots."

76 Meskell, "Sites of Violence." Meskell is drawing on Robert Goodin, "Utility and the Good" and Peter Pels, "Professions of Duplexity."

77 See Hufford, "Tending the Commons."

78 This discussion is indebted to Eriksen, "Globalization and Democracy."

79 Sassen, "Spatialities and Temporalities of the Global."

80 Bourdieu, "Uniting Better to Dominate," 1.

81 Kant, *Perpetual Peace*.

82 From Eriksen, "Globalization and Democracy."

83 Fondation Hirondelle and International Criminal Tribunal for Rwanda, "Musician Pleads Not Guilty to Genocide Charges," April 4, 2002, http://www.hirondelle.org/ hirondelle.nsf/caefd9edd48f5826c12564cf004f793d/4fc571f5e3e9dd55c1256a8a00006e7 5?OpenDocument (accessed September 24, 2004).

84 Kanuma, "Songs of Hate."

85 See Steichen, *The Family of Man*, and Sandeen, *Picturing an Exhibition*.

86 For the idea that humanity is not a political concept, see interview with Chantal Mouffe, "Every Form of Art Has a Political Dimension," 108.

87 From Eriksen, "Globalization and Democracy."

88 On world making as a way of thinking about culture, with implications for conceptualizing the phenomena included in intangible heritage, see Overing, "The Shaman as a Maker of Worlds."

89 For an example of the application of cultural economics to heritage in the context of World Bank initiatives, see Cernea, *Cultural Heritage and Development*. Proceedings of two Getty meetings have appeared, in addition to several articles. See Torre and Mason, *Economics and Heritage Conservation*; Avrami, Mason, and Torre, *Values and Heritage Conservation*; Klamer and Zuidhof, "The Values of Cultural Heritage."

90 Klamer and Zuidhof, "The Values of Cultural Heritage," 31.

91 Ibid., 29.

92 Ibid.

93 Ibid., 29. The 1993 exhibition "Secrecy: African Art That Conceals and Reveals," at the Museum for African Art in Manhattan, showed secrets without giving them away, thereby encapsulating the paradox of giving without giving away. See Roberts, *Secrecy*; Weiner, *Inalienable Possessions*, and Myers, *The Empire of Things*.

94 Frey and Pommerehne, *Muses and Markets*.

95 Pagiola, *Economic Analysis of Investments in Cultural Heritage*.

96 Klamer and Zuidhof, "Values of Cultural Heritage," 36.

97 Ibid., 46.

98 Pinna, "Heritage and 'Cultural Assets,'" 64.

99 "Lightning Law to Privatise 'la Bella Italia.'"

the ONION ®

| VOLUME 32 ISSUE 14 | AMERICA'S FINEST NEWS SOURCE™ | 5–11 NOVEMBER 1997 |

U.S. Dept. Of Retro Warns: 'We May Be Running Out Of Past'

WASHINGTON, DC—At a press conference Monday, U.S. Retro Secretary Anson Williams issued a strongly worded warning of an imminent "national retro crisis," cautioning that "if current levels of U.S. retro consumption are allowed to continue unchecked, we may run entirely out of past by as soon as 2005."

According to Williams—best known to most Americans as "Potsie" on the popular, '50s-nostalgia-themed 1970s sitcom Happy Days before being named head of the embattled Department of Retro by President Clinton in 1992—the U.S.'s exponentially decreasing retro gap is in danger of achieving parity with real-time historical events early in the next century, creating what leading retro experts call a "futurified recursion loop," or "retro-present warp," in the world of American pop-cultural kitsch appreciation.

Such a warp, Williams said, was never a danger in the past due to the longtime, standard two-decade-minimum retro waiting period. "However, the mid-'80s deregulation of retro under the Reagan Administration eliminated that safeguard," he explained, "leaving us to face the threat of retro-ironic appreciation being applied to present or even future events."

"We are talking about a potentially devastating crisis situation in which our society will express nostalgia for events which have yet to occur," Williams told reporters.

The National Retro Clock currently stands at 1990, an alarming 74 percent closer to the present than 10 years ago, when it stood at 1969.

Nowhere is the impending retro crisis more apparent, Williams said, than in the area of popular music. "To the true retrophile, disco parties and the like were common 10 years ago. Similarly, retro-intelligentsia have long viewed 'New Wave' and even late-'80s hair-metal retro as passé and no longer amusing as kitsch," Williams said. "We now face the unique situation of

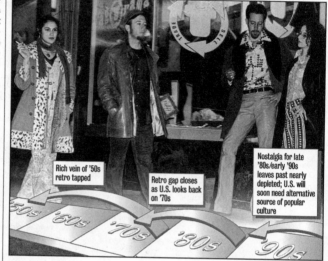

Rich vein of '50s retro tapped

Retro gap closes as U.S. looks back on '70s

Nostalgia for late '80s/early '90s leaves past nearly depleted; U.S. will soon need alternative source of popular culture

'50s '60s '70s '80s '90s

'90s retro, as evidenced by the current Jane's Addiction reunion tour: nostalgia for the decade in which we live."

"Before long," Williams warned, "the National Retro Clock will hit 1992, and we will witness a massive grunge-retro explosion, which will overlap with the late-period, mainstream-pop remnants of the original grunge movement itself. For the first time in history, a phenomenon and nostalgia for that particular phenomenon will actually meet."

"In other words, to quote '90s-retro kitsch figure David Lynch," Williams said, "'One of these days that gum you like is going to come back in style.'"

Anthropologists hold that retro began some 40,000 years ago with the early hominids' mental projection of trace infantile-dependency memories into a mythical "golden age." Continuing with the Renaissance's rediscovery of Greco-Roman homo-

eroticism and the mass "Egyptology" fashions of the Victorian Age, retro had, prior to this century, always been separated from the present age by a large buffer of intermediate history.

Since 1900, however, the retro parabolic curve has soared exponentially, with some generations experiencing several different forms of retro within a single lifetime.

"This rapidly shrinking gap between retro and the present day is like a noose closing ever tighter around the neck of American kitsch," said Harvard University professor of American culture Louis I. Szilard, "or, if you will, a warning light, similar to the electric buzzer-nose of the naked fat man in the Milton Bradley fun and skill game 'Operation.'"

The Department of Retro warning comes on the heels of its 750-page Report On Nostalgia Viability And Past-Depletion Reduction Strategies, which examined the effects

of the ever-increasing co-option of retro trends by the mainstream.

According to the report, retro-kitsch aesthetics—previously the domain of a tiny group of forward-thinking, backward-looking alterna-hipsters, or "retro-cognoscenti"—have become so prevalent in the national pop-culture psyche over the last decade that they have been absorbed into the marketing strategies of major retail chains and mass-media promotional campaigns. Cited as an example is Entertainment Weekly's "Dance Hits Of The '70s" free-with-subscription CD giveaway, which boldly includes the slogan "Retro's Hot!"

Such mainstreaming of retro, the report warned, has forced the hipster-elite element that formerly dominated the retro world to seek increasingly current forms of retro, a trend which threatens to consume the nation's past reserves faster than new past can be created.

The severity of the coming retro crisis, Williams said, is compounded by the increasing complexity of modern retro, evidenced in current youths' skewed perceptions of older generations who themselves were born and raised in a retro-aware environment.

"In the '70s, baby boomers enjoyed an escape from turbulence and social upheaval through a '50s-retro romanticization of the sock-hops and drive-ins of their teenage years," Williams said. "Yet today, '70s-retro-conscious Gen Xers now look upon pop-cultural figures of that '50s retro trend, such as myself and my close advisor, actor Donny Most, as '70s retro figures in our own right, viewing us not as idealized youth archetypes but rather as irony-tinged whimsical representations of cheesy, "square" adulthood—a form of self-referential meta-retro that science still does not fully understand."

It is hoped, Williams said, that such meta-retro recycling of older forms of retro may function as a safety valve to widen the retro gap.

"Department of Retro officials are closely studying new developments in meta-retro," Williams said, "including a dance sequence in the new film Boogie Nights, which is simultaneously a '70s retro allusion to Saturday Night Fever and a late-'80s retro allusion to the Beastie Boys' seminal '70s retro video "Hey Ladies"—an homage to an homage, if you will. While all the facts are still not in, this much is clear: Now, more than ever, we must conserve our precious pop-cultural past, for it is our future." ∅

PART 2
Tactical Museologies

Tactical Museologies

GUSTAVO BUNTINX AND IVAN KARP

W hat do an alternative museum of the contemporary arts that fantasizes itself exhibiting on a traveling minibus in Lima, Peru, an exhibition space and publishing house in Phnom Penh, a South African museum for a community dispersed more than thirty years previously by forced removals, and a union of community museums dispersed throughout Oaxaca, Mexico, have in common? All of them were developed to take advantage of the symbolic capital associated with the idea of the museum, but also to present an alternative to the claims made by better-established museums to define citizenship for a broad public and, often, to present a universal point of view (claims of the sort articulated in the "Declaration on Universal Museums," included in this section as a Document). The community museums that are largely the topic of this section of the volume display in their history, actions, and survival strategies a tactical sense of how to maneuver with and against other institutions. This sense of maneuver (which Gramsci termed a "war of position") is simultaneously the product of the alternative and provisional standing of these museums and their often antagonistic and frictional relationship either to established museums and/or to the broader social order. The museum frictions exhibited in this section are part and parcel of the guerrilla war often conducted among museums and other institutions of public culture. They share tactics with all

museums and institutions of public culture, but these tactics shift and change according to the pattern of development and standing of the museum.

The cases presented here exemplify the ways and means through which museums and the associated processes of displaying and collecting are utilized for, by, and even against communities, whether these be local communities, communities of artists, dispersed communities, or imagined communities. Our decision to call the section "Tactical Museologies" refers to processes whereby the museum idea is utilized, invoked, and even contested in the process of community formation. But this book situates museums in the context of global processes, and the most fundamental global process that makes the concept of the museum available as a tactical resource is that museums themselves travel. In the course of moving from one context to another and from one geographic space to another, they become "contact zones," as James Clifford (following Mary Louise Pratt) calls them, in which diverse and sometimes conflicting relations are enacted. That museums travel is not the product of a new global process but associated with older forms of globalization such as colonial expansion and domination and imperial rule. These long-standing global processes are often layered into museum collections and exhibitions.[1] Older global processes do not just fade away. The results of institutional transfer associated with colonial rule and the like are incorporated in local orders and interpreted in new ways, which are themselves associated with global processes.

All of the essays in this section describe "new" museums, including the Document on the Museo Salinas. Almost all of these museums are less than a decade old, and all of them can fairly be described as simultaneously drawing on global processes to justify their existence and, as a result, owing their existence, in part, to global processes. Yet they all define themselves as community museums and address a local or national subject in content and audience, sometimes simultaneously. These subjects range in scale from a displaced community (in the case of the District Six Museum) to the people of a region (in Oaxaca) and the problem of national art and patrimony (addressed in Phnom Penh and Lima). The first question we should ask, then, is what are the global processes that enable the tactics of newly established museums? The first, we have already said, is that of traveling institutions, the paths and processes by which the museum idea, the forms and practices associated with museums, and the museum effect have become embedded in postcolonial societies ranging from Peru and South Africa to postcolonial situations such as that related to immigration and ethnicity in the urban United States. Taken together, the essays show how the traveling institution of the museum and all that it implies provides cultural capital, a set of resources, a series of models,

means of community mobilization, and a social field in which identity and community are asserted and contested.

The only firm conclusion that can be drawn about traveling institutions as a global process is that how they travel and are reproduced from context to context is both conjunctural and dependent on local structures and conditions. Cape Town, South Africa, and Lima, Peru, provide vividly contrasting examples of localities where the configuration of cultural institutions affects the institutional tactics carried out in different contexts, as insightfully analyzed in essays by Ciraj Rassool and Gustavo Buntinx. The District Six Museum in Cape Town has become, first, a museum of memory and conscience and, second, an institution that seeks to give voice to and shape the identity of the community that will return to occupy the district. But embodied in its displays and manifested in the internal debates of the museum is an exquisite sense that what is being produced is *not* a museum that exhibits essentialized identities along lines consolidated in apartheid's museums and other cultural institutions.[2] The tactics of the District Six Museum thus have to take account of the local history of museums in South Africa, which themselves illustrate an earlier history of traveling institutions. In Lima, the Micromuseum, in the form and content of its displays, self-consciously works against what Gustavo Buntinx terms the condition of "marginal occidentality," a state of aping but never fully acquiring the cultural status and institutions of the West. In South Africa, the dispersal of the people who lived in District Six prevented any easy form of community organizing, but the processes of exhibiting and collecting testimony and objects that can be said to be fragments and traces of the memory of District Six provided a basis for community organizing during the transition from apartheid to democratic inclusion and community restoration in South Africa.

The second global process exhibited in the essays is one that provides the contexts that enable the tactical museologies that are the theme of this section. This is the increasing worldwide significance of nongovernmental organizations such as foundations, international organizations such as UNESCO, businesses, and even state-based aid organizations for the development and survival of museums in multiple local contexts. The District Six Museum was funded in its formative stages by the Swedish International Development Agency (SIDA); the different Cambodian museums and display organizations described by Ingrid Muan all survive through external support. The Oaxacan Union of Community Museums, described in the essay by Cuauhtémoc Camarena and Teresa Morales, is a foundation-supported project, and—to add one of many possible examples from the United States—the Museo del Barrio in

New York City also depends on external support for its projects and justifies its approach to foundations on its claim to represent the aesthetic experience of Latin America and its diaspora. Even the most contrasting case, the attempt to build a museum of contemporary art in Lima, founders on the inability to generate external support. In this case, one global process—the way that institutions travel—justifies the appeals made on the basis of another global process, the emergence of a non-nation-based world polity that uses the categories of Western experience, such as the museum or development itself, to organize the distribution of resources both through and outside the state. It is in relation to this process that the poignant case of the "museum void" described by Gustavo Buntinx is so important. The terms of discourse and rhetoric of values invoked define and shape actions even when the possibility of realizing them is highly unlikely.[3] The situation described by Ingrid Muan's essay illustrates the tense dialectic between opportunity and constraint that arises as international organizations increasingly provide the contexts for institutional development. In Cambodia the resources and opportunities available to the National Museum are structured both by the role the museum must inevitably assume as a heritage institution and by the limits it faces in terms of the resources it can claim and the audiences it can address. The sedimented history of the National Museum is, first of all, manifested in what Muan refers to as a "precipitate of definitions first set in play under the French protectorate," but these definitions are reproduced and reinforced by the ways that the museum addresses tourist audiences and potential funders.

In contrast, Muan's essay shows that the Reyum Institute of Arts and Culture in Phnom Penh (a contemporary arts space) has available a different array of local constituencies and a different cultural capital, which allow it to be more open to a variety of options that are themselves deemed fundable by organizations concerned with such matters as producing a viable civil society. In this case the development of an "art world" has been perceived as a critical means of strengthening civil society, and also of developing a strong national culture, itself deemed an essential component for Cambodia's participation in the international order. These attributes are congenial to the value set that has been attributed to the "world polity" and that is increasingly an aspect of international organizations since the Second World War.[4] This context and this political economy of converging orders and shifting locales are the battlefield on which the tactics of the community museum are enacted. These tactics are simultaneously defensive and offensive. For example, in Oaxaca the Union of Community Museums turns outward in its search for support and allies for the task of community development, but those very activities are defensive when it comes to retaining artifacts and claiming control over archaeological heritage.

The world polity provides the opportunity and rationale for Oaxacan community museums yet simultaneously reaches into communities in a way that they seek to defend themselves against.

When, and if, community museums expand, their tactics may lead them to a different set of tactics, and as a consequence of the tactical shift, a different definition of self. This has been the case of the Museo del Barrio in New York City.[5] Once a community museum that served a largely Puerto Rican constituency, it is now a museum of Latin American art, appealing to a broad array of international visitors and funders. The way that the Museo has shifted its subject position from community museum to mainstream museum, from an insurgent program to an assertion of universal values, displays both the opportunities afforded by tactical museologies and the tragic potential inherent in taking advantage of the options raised by the environment that might be described as "the new world order." From one perspective the Museo is a success, exhibiting all the aspects of a successful institution, including a new building, a larger audience, a roster of funders, and a growing collection. But at what cost? From another point of view the Museo has betrayed its origins and abandoned its primary constituency. Is this to be the ironic consequence of all tactical museologies? Does the very act of taking advantage of the changing international environment and its local agents subvert the very basis on which the community is founded? Is there no other choice? Is it in the nature of the insurgent community museum to be on one hand a utopian organization, seeking to promote the utopia of the community, and on the other hand a small organization continually encountering a crisis of reproduction? The unanswered question posed by the essays on tactical museologies is not "Do tactics prevent disappearance?" but "Do tactics inevitably lead to the betrayal of the utopian ideals of community development?"

PRAGMATICS, POLITICS, ETHICS, AND UTOPIAS

Throughout the second half of the 1990s, the streets of Mexico were cluttered by a dazzling variety of invective imagery deployed by popular artifacts to exorcise the corrupt figure of Carlos Salinas de Gortari, the runaway ex-president whose globalizing modernization policies had thrust the entire country into a moral and economic abyss. Portrayed alternatively as a vampire, a thief, a rat, or even a mythical *chupacabras*, his unbecoming appearance gave vent to a prodigious outburst of vernacular creativity.[6] And so it was perceived by Vicente Razo, a young conceptual artist who meticulously collected and displayed those grotesque pieces in his own bathroom, which he formally designated as the Museo Salinas (see figure 1 and the related Document in this

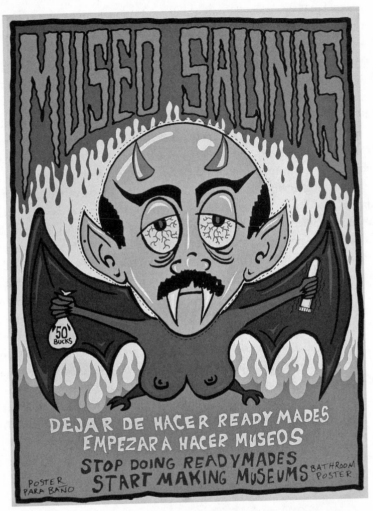

1. Calling itself a "bathroom poster," this glaring print acts as the visual manifesto of the Museo Salinas. Sardonically located in Vicente Razo's bathroom, this almost freakish institution collects and displays all forms of invective imagery popularly deployed in Mexico to exorcise the corrupt figure of Carlos Salinas de Gortari, the runaway ex-president whose globalizing modernization policies had thrust the country into a moral and economic abyss. But the political irony intended by Razo's gesture acts also as a retort to the Duchampian avant-garde and as a critical vindication of the very idea of the museum, radically redefined. Print by Rolo Castillo and Vicente Razo, 1996. Image courtesy of Museo Salinas.

section). As Cuauhtémoc Medina so elegantly explained, "If Duchamp put the urinal in the museum, Razo places the museum in the bathroom."

But the double irony intended (artistic and political) acted also as a critical vindication of the very idea of the museum. This complex and ambivalent gesture speaks to the heart and purpose of the texts assembled in this section, four case studies to be seen as fragmented but not disjointed narratives. An ethical undercurrent runs through them all as a binding political thread, confronting the international or globalized forms of museality that tend to be imposed as an ideological model—even where the museum itself fails to exist. But that ethical undercurrent is also a reconstructive ethos acting as a cunningly subtle retort to the extreme deconstructive perspectives that would do away with the very idea of the museum, judged to be inevitably ridden by regressive notions of authority and cultural power.

It is out of this double friction, this opposition to both the grand museum establishment and the terminal critique of museums, that the theory and practice of tactical museologies arise: the appropriation of the museum from a tactical perspective in a shifting sequence of opportune small moves that when taken together imply a strategic displacement. The experiences here presented do not propose institutions in order to make prestigious a self-fashioned marginality (another form of elitism) but to actively engage in the (re)construction of the very idea of community, no matter how prospective or even utopian it might in some cases seem to be. And given that vital necessity, they have no excessive qualms about being parasitically located in the seams and fissures of the globalized exhibitionary complex, or to speak out of its failed provincial stutterings.

This keen sense of being opportune is not to be confused with opportunism. What we are here confronted with is the *critical* appropriation of the very name and notion of the museum *for radical purposes*. This last term is to be taken almost etymologically: the utopian dimension of these situations paradoxically implies a conceptual and sensitive involvement with a troubled desire for roots—and the all-too-concrete threat (or reality) of continued "uprootedness." A longing for community increasingly requires the props and mechanisms of cultural artifacts to be devised politically. And poetically: at distinct moments, the power of these constructs lies in their willingness and capacity to compellingly objectify a lack and literally house the very sentiment of loss or even absence ("The Legacy of Absence" is the poignant title of one of Ingrid Muan's exhibits and catalogs).[7] This materialization of feeling, this pragmatics of emotion, makes it possible to capitalize defeat by turning it into experience. It makes it possible to valorize the scattered debris of repressed memories by

exposing—and catalyzing—in and through them the articulated remains of a resurrected history.

There is a peculiar transmutation suggested here—a collective thauma-turgy, a political archaeology. Sometimes this is literal: a crucial moment in the essay by Cuauhtémoc Camarena and Teresa Morales is the reference to the struggle of rural indigenous communities in Mexico to keep within their do-main pre-Hispanic finds that were routinely sent to regional or national muse-ums—or to the international market. The community museums thus formed can certainly be perceived as motivated by the understandable (and very tac-tical) expectation of obtaining revenues from tourism. But at the same time (and this is not necessarily a contradiction) they can also be read as an effort to turn those remainders into reminders—to *activate* those objects—by restor-ing them to an interrupted cultural continuum. As much is suggested by the displayed juxtaposition of those excised but rescued pieces with more contem-porary artifacts and practices. But it is suggested above all by the very position-ing of the museum itself in the community, perceived not as a geographical *place* but as a social *space*, a living process demanding of its members an active involvement in the decisions and functions that define the museum as much as other collective concerns.

The result is a deliberate and significant reversal of the decontextualizing "museum effect" so aptly described by Svetlana Alpers.[8] The objects here are not extracted from but reinscribed into a symbolic landscape that becomes re-newed by the very newness of a past recovered. The idea of the museum itself is thus relocated as a transformative site for a (tactically) mutating sense of community. And as a focus of social organization and mobilization. And as a healer—perhaps.

Perhaps a healer. "[T]here is a sense in Cambodia today that one should simply 'dig a hole and bury the past,'" writes Ingrid Muan in quoting a star-tlingly explicit declaration by Prime Minister Hun Sen. But what is buried tends to return, like a repressed memory, in uncanny and haunting ways. The efforts Muan and Ly Daravuth make through the Reyum Institute of Arts and Culture in Phnom Penh run against the very grain of this official politics of oblivion. In commissioning autobiographical paintings, in putting on display the native utilitarian tools becoming extinct, in publishing and discussing all that it all might mean, Reyum is presented as a minuscule but poignant locale for the cultural processing of absence and change in a decimated society, a critical exercise of memory that is also the cultural realization of the task of mourning.

Minuscule but crucial: in Muan's own words, Reyum acts as "some small space opened for public reflection and thinking," in contrast to the banal spec-

tacularization of the glories of the past and the horrors of the present, articulated by tourist routes that link the ancient temples of Angkor and the modern Tuol Sleng Prison Museum ("art in the morning, genocide in the afternoon, as some put it with cynical succinctness"). Despite the author's reluctance to define Reyum as a museum, the term obliquely suggests itself given the gallery's critical engagement with the very concept of memory in a context where memory is commodified for the tourist industry through a process that threatens to marginalize local communities from the sites of their own history. This yields a heritage increasingly replaced by the awe and wonder of a distant but revered consumer society barely glimpsed through amazed visits to the air-conditioned supermarket, with masses of spectators (rather than shoppers) gaping at the newness of the inaccessible products tantalizingly put on display—commodity fetishism and the museum experience unknowingly fused into one piece.

But there is a diversity to be perceived in the ways chosen to objectify threatened memory by the very different initiatives analyzed in this section. This is particularly evident in the distinct emphasis being put on forming a collection: clearly not a priority for the Reyum project, but one of the strong points in the Micromuseum experience, which despite its extremely frail economy has managed to salvage and circulate a most significant assemblage of Peruvian critical art, as well as a variety of relevant pieces eloquently expressive of local vernacular modernities. As Buntinx argues in his essay, the Micromuseum offers an archaeology of the contemporary, politically positing a prospective community to be culturally brought out of the transformative friction between the educated petty bourgeoisie and the emergent popular experience.

The pertinent question, of course, is how to recontextualize and activate those objectified memories. According to its Web site, the District Six Museum's original "collection" (note its own tactical use of quotation marks) "consisted of a cache of street signs, secretly saved, and a huge floor map where visitors could mark sites important to them. . . . [P]eople literally wrote themselves back into the center of the city."[9] The city is politically remapped by a crucial living gesture of inscription that projects apartheid's urban wasteland as a restored site of memories past—and memories to come. As Ciraj Rassool crucially establishes, the museum is here understood as a "hybrid space" in which scholarship, aesthetics, community forms of governance, and land claim politics productively intertwine. The peculiar friction thus generated is that of a history in the making, and of a prospective memory archaeology: "digging deeper"—the title of this museum's second landmark exhibition—is to be seen here as an unknowing but radically pertinent political response to the Cambodian government's call to "dig a hole and bury the past."

That response is ethical as well as political. Rassool rightly brings out the moral edge that "emerges in some of the ways in which the museum space has been used as a site of forgiveness and the 'healing of memories.'" It has been a site for truth and reconciliation, restitution and compensation, even in odd and unforeseen ways. Elsewhere Rassool has identified this museum's "mythical founding moment" in the discovery of District Six's street signs in the basement (the *basement!*) of the house of one of the white construction workers involved in the razing. The destroyer ironically turned into the unconscious preservationist of a memory thus available to be recuperated, even if for a small fee.

For a fee: in perusing these essays, the reader should be forewarned to avoid the risk of romanticizing experiences that are indeed utopian but also extremely pragmatic—and all the more political for it. And hence delicately vulnerable. Tactical museologies can prove to be surprisingly effective under specific circumstances, but there are serious issues related to the museums' long-term funding and conditions of existence.[10] Special attention should thus be paid to the endearing frailty of many of these efforts, sometimes all too dependent on individual economies and wills. Note that in varying ways these are all first-person narratives. As precious as they are precarious, some of the endeavors thus related could fragment and vanish with a single death, or even just a divorce. Such issues of sustainability can in some cases be alleviated, at least temporarily, by international aid and selective articulations with the progressive world polity. But there clearly is a need for alternative local supports— which in turn implies the (re)construction of communities in contexts where the very idea of community is continuously undermined.

Experiences such as those in Oaxaca and District Six speak eloquently of the factual possibility of a museum conceived not as a developmentalist tool of economic modernization but as a critical agent of radical citizenship—indeed, of an alternative sense of modernity itself, making difference productive in authentically contemporary terms: a theoretical distinction made explicit throughout Buntinx's essay, and particularly in his identification of a certain syndrome of marginal occidentality among Latin American elites engaged in such extravagant enterprises as the Peruvian Museum of Pictorial Reproductions. A mimetic delirium in the midst of a museum void to be confronted by radical desire: the Micromuseum conceived not as a means to mediate relations of cultural power between the elites of the center and those of the periphery, but to serve as a vehicle for the renewed construction of local communities of sense, communities of sentiment, providing, they hope, radical models for the organization and development of communities.

But relations between museums and the communities that they seek to represent are also often contentious. Perhaps it is the very idea of community—and not just that of the museum—that needs to be seriously reconsidered and problematized if it is to remain functional in such devilishly complex times.[11] Museums can play an important role in that task if they manage to place the issue of their own sustainability under the necessary critical perspective. As Corinne Kratz once informally suggested, if museums are so liberating, why do they have to be so expensive? Tactical museums seem to offer some alternatives to such dilemmas, but in trying to turn radical desire into institutional capacity, they too face the risk of becoming the establishment they simultaneously challenge.

To build is not to construct, and it is the (re)construction of a critical project —rather than a physical space or even a collection—that will give sustenance and endurance to the very idea of tactical museologies and museums. That and a continuing commitment to the local and the specific. Another way of reading these essays is as a retort to the "Declaration on the Importance and Value of Universal Museums," signed by eighteen of the world's richest and most powerful museums (reproduced as a Document in this section). Their pompous claim is to have converted the museum itself (the grand Euro–North American museum) into the final and totalizing context for cultural treasures plundered by the metropolitan countries since the Napoleonic wars and made available to the growing masses of affluent travelers in their cultural pilgrimages to the capitals of the First World. But the "universal museum" is here to be seen as nothing more than a poor euphemism for the imperial museum, and the idea of community posited by such terms as hopelessly exclusive and cosmopolitan. Indeed, the second Document in this section, the Association of Art Museum Directors statement "Art Museums and the International Exchange of Cultural Artifacts," asserts similar claims about adjudicating contemporary problems of plunder and illicit trade in art and heritage.

Needless to say, tactical museums and museologies are conceived in stark opposition to this established notion of the universal, embarked as they are in actively redefining the notion of heritage in opposition to the practice of tourism, serving communities rather than voyeurs. But they also pose themselves against a certain vacuous avant-garde and its nihilist extremes. "Emancipation is again today a vast question," proclaimed Derrida himself; "I have no tolerance for those—deconstructionists or not—that are ironic regarding the grand discourse of emancipation."[12] *Oublier* Baudrillard. Dump Duchamp. "Stop making ready-mades," reads the Museo Salinas manifesto: "Start making museums"—tactical ones.

NOTES

1 See the essays in Karp and Lavine, *Exhibiting Cultures.*
2 The term "apartheid" refers to the fifty years of rule by the Nationalist Party in South Africa and is not used to suggest here that segregation and inequality were not prevalent before the rise to power of the Nationalist Party. During the apartheid era, museums, particularly cultural history museums, increasingly celebrated European culture and achievements, to the exclusion of other peoples in South Africa.
3 Kratz, "Rhetorics of Value."
4 See Meyer, "Globalization."
5 See Dávila, "Latinizing Culture."
6 *Chupacabras* are powerful creatures that kill animals by sucking out all of their blood, rather like a vampire.
7 Davaruth and Muan, *The Legacy of Absence.*
8 Alpers, "The Museum as a Way of Seeing."
9 See the Web site of the District Six museum, http://www.districtsix.co.za.
10 Permanence and sustainability are often assumed to be goals or prerequisites for museums, yet it might be more appropriate or effective for some institutions and organizations to have a limited lifetime. In relation to community museums, for instance, such an institutional design could be connected to particular goals or campaigns. The larger point is that tactical museologies involve a number of different time scales and scopes of action, and museums themselves can also be seen as ranging from short-term to perennially enduring institutions.
11 See the earlier volume in this series, Karp, Kreamer, and Lavine, *Museums and Communities*, for a series of essays on the history of complex relationships between museums and multiple communities.
12 Derrida, "Remarks on Deconstruction and Pragmatism," 82.

Communities of Sense/Communities of Sentiment: Globalization and the Museum Void in an Extreme Periphery

GUSTAVO BUNTINX

A certain element of impertinence lurks behind the very idea of prioritizing the topic of the global public sphere as a privileged element in the broader discussion on museums. This is particularly the case in contexts such as those of Peru, whose cultural complexity is surpassed only by the country's economic and political miseries. Political above all: suffice it to mention the historical irresponsibility of Peruvian elites, proverbially known for being capable of dominating but not of conducting or leading, much less of providing a national vision even (or especially) in the decisive ambit of the cultural construction of an idea of community, no matter how imaginary or imagined.

Few situations are so openly symptomatic of this momentous failure as the clearly belated inauguration in 1961 of a most generic Museum of Art — broadly defined to encompass three thousand years of Peruvian culture — and the still absolute absence of a legitimate museum of modern or contemporary art in Lima (probably the only Latin American capital that can claim such a distinction). This is a radical absence: the theme here is not the deprived museum, disadvantaged by inadequate resources, but the greater deprivation provoked by the very lack of a museum — our grand museum void.

Implicit in that vacuum is a broader social void that the experience of globalization exacerbates by compensating for it in an illusory manner, linking local elites to cosmopolitan institutions perceived as the sole and final model

for any sense of museality, for the philosophical essence and institutional nature of the museum. The aspiration for museums closely related to local communities and local forms of (post)modernity is thus replaced by the felt need for a more fluid and fluent relationship with the artistic institutionality of the globalizing powers.[1]

The imitation of that unreachable paradigm sometimes generates the most naive aping, as in the case of the Museo de Reproducciones Pictóricas (MRP, Museum of Pictorial Reproductions), which was maintained for almost half a century, until recently, by Peru's principal university. But that mimicry also produces dubious reifications and fantasies, such as the so far fruitless efforts of the Instituto de Arte Contemporáneo (IAC, Contemporary Art Institute), which for more than twenty years has spent all its energies in projecting and announcing the imminent construction of one or another grandiose building to house a supposed Museo de Arte Contemporáneo (MAC, Contemporary Art Museum) that so far exists only as an eloquent succession of architectural maquettes. Above and beyond the economic justifications, there is an ideological horizon in permanent crisis to be perceived in such an abortive display: the dependence on anachronistically cosmopolitan models of modernization that prevent myopic, peripheral bourgeoisies from articulating a sense of (post)modernity that local communities can consider their own and at the same time truly contemporary — and viable.

But as eloquent as these stories of a prolonged museological failure is the different libido born out of the frustration among radicalized middle-class groups anxious to define a cultural space that is current and autonomous — an artistic materiality no longer conceived exclusively in terms of alliances with political and economic power, globally defined, but as a specific and local encounter of the lettered petite bourgeoisie and the emergent popular experience. As will be exemplified below, this perspective is inscribed in a variety of gestures and salient Peruvian works of art over the last thirty years. But it is also to be found in the desire for more institutional alternatives. At the risk of seeming self-referential, I must here make special claims for the concept of a Micromuseum (Micromuseo), which for almost two decades now, overcoming difficulties and interruptions, rehearsing different names and with the motto *"Al fondo hay sitio"* ("There's room in the back"), has been constructing a distinct collection and curatorial presence through the popular strategies of precariousness and itinerancy, assumed as symbolic capital to be critically empowered.[2]

Between one extreme and the other, between submissive mimicry and restless libido, lie unexpected complexities. The resulting tensions and differences reveal how the very idea of the museum constitutes a contentious space for

the performance of identities in permanent struggle and transformation, even when the institutional existence of the museum is uncertain or null.[3]

But such intensities cannot be grasped if they are perceived merely as the distorted or failed mirror of artistic systems in the so-called First World. It is necessary to take into account the particular forms of conflicted subjectivity generated within local elites by the displacement of such haughty models to the frailties and precariousness of an extreme periphery. And in the very same gesture we must identify the critical responses to that mimetic propensity, establishing the place in all of this for radical imagination. We must prod not just the museum void but also the museutopias constructed over that lack, that abyss.

That hole: the museum void can also be erotically perceived as something clamoring to be filled, but often condemned to be so in frustrating ways. It can be seen as a failure predetermined by the absence or marginalization of critical projects, which evolves into what might be referred to as a curatorial dearth. In that respect there probably is a certain museum void to be perceived even in contexts of apparent museum glut, as may be suggested by the lack of a national African American museum in the United States (although the creation of such an institution was mandated in 2003—see the essay by Fath Davis Ruffins in this volume). Or it might be noticed in the need for independent curatorial cooperatives such as Curare in Mexico, where the prolific presence of museums does not by itself guarantee the necessary supports for serious critical work.[4]

Indeed, there is a risk of understanding the museum void as a merely museographical challenge, rather than as a complex museological issue. The crux of the problem, however, lies not in the presence or lack of a building, fetishized as the prolongation of a collection's technical display (the strict task of museography), but rather in the very logic and ideology of the museum itself. That broad conception, historically founded and critically empowered, is where museology defines its own distinct realm as a construction of meaning, somewhat analogous to the ways in which Erwin Panofsky distinguishes iconography from iconology in his celebrated theories.[5]

The issues at hand are not solely concerned with what to collect and how to exhibit, but with the critical purpose and cultural intent of the very enterprise of museum-building. They relate not just to the ways and means but to the whys and the for whom. Out of the renewed consciousness of this fact an alternative sense of museality has given rise in Latin America to notable initiatives such as those of TEOR/éTica in Costa Rica and the Museo del Barro in Paraguay. Frail as they once may have seemed to be, they can now be perceived as concrete examples of a new and critical museology. Their innovative praxis defines a radical institutionality almost heroically gained by deliberately for-

saking the established demands for the long-term, the firmly located, and the well-endowed, opting instead for the small-scale, the mobile, the nimble, even the whimsical and the opportunistic. These are *tactical museologies*, which my essay will put to the test by confronting the even more precarious Peruvian experience.[6]

THE FANTASY OF THE GLOBAL

"If there are two nations in the world that are called to intimately tighten their relations out of reciprocal interest," wrote José Antonio de Lavalle y Arias in 1860,

> these are the French Empire and the Republic of Peru. Both nations are principally *populated by the Latin race* and both profess the same religion, which are the strongest bonds that unite men. The expansive and amiable character of the French agrees well with the character of the Peruvian. The language of Corneille is the language of every person who has obtained a respectable education. *Our frequent communication with Europe has caused a large part of our youth to reside for either a considerable or a short amount of time in France*, and they all retain the most pleasing memories of that beautiful and hospitable country.[7]

Such a bizarre statement (see italics) could induce an undue disregard toward the quote. In fact, the text is quite significant, coming as it does from one of the most prominent nineteenth-century Peruvian intellectuals, identified with a certain progressive disposition among the liberal elites of the time. Liberalism and the ideologies of progress, however, did not then necessarily imply for that *criollo* mentality a distancing from the racial prejudices that even today subsist in Peruvian society as a distinctive trait of its enduring colonial condition.[8]

This burden of fear and disdain for the popular and the local is the force moving that text to erase, literally with one pen stroke, the vast majorities of the Peruvian population, not as dark as they are darkened. Although this was not the sole position that existed among the educated circles of the time, without a doubt it reflected the predominant attitude.[9] This skewed yearning for modernization led Lavalle to also propose programs of massive European immigration, because "intelligence, civilization, strength, energy and physical beauty are fused" in those peoples, thus constituting "the best element of civilization, of advancement, of wealth and of social regeneration that could be applied to Peru. . . . We should procure that the white element dominates Peru, and that its population be enlarged by capable, intelligent, educated and civilized colonizers."[10] The phantasm of that which seems excessively local is thus confronted by the fantasy of the globalized.

A recurrent and compensatory fantasy of the global has been for some time now a trait of a certain neocolonial (I resist the use of the prefix "post-") subjectivity customary among significant portions of the dominant classes in those American countries referred to as "Latin." Starting with their own physical appearance, these social groups pretend to culturally and ideologically mark their distance from the more immediate forms of the popular, identifying themselves instead as peripheral members of an imperial civilization that, however, adopts them only in subordinate ways and without full recognition. The communities thus imagined respond to what we could simplistically call a *syndrome of marginal occidentality*: the anxious desire to belong to a model condition that is felt as one's own but unreachable at the same time. An imperfect nostalgia for Europe, as Jorge Luis Borges would put it. The results can often be traumatizing, as the recent Argentinean political experience makes pathetically evident.[11]

The construction of the national under such contexts is characteristically complex. Cultural definitions acquire a telling importance—culture and the value systems assigned to it, particularly through that dense institutionality that with excessive simplicity we tend to call museums. Note the plural: without a doubt, much of what has been argued so far is quite evident when talking about museums of archaeology, anthropology, and history (it is already symptomatic that this triple denomination—and in that order—is formally assumed as the name of the most important Peruvian museum). What I now prefer to explore is the institutional place (sometimes the nonplace) granted to the specifically artistic as a privileged sphere of the more "Western" and contemporary sensibility. Art as pure visuality is an all too European and recent invention, and as such it becomes a premier indicator of the processes that interest us here.

This topic defeats any generalizing temptation. At one extreme can be found the experiences of the so-called Southern Cone and its dominant pretensions of racial and cultural homogeneity with an artistically mimicked West. Even in 1987 the catalog for an official exhibition of Uruguayan painters conceived for the Argentinean National Museum of Fine Arts (Museo Nacional de Bellas Artes) could include as its principal theoretical text an essay by the then-president Julio María Sanguinetti, who unblushingly calls for a universalizing history of European art that should incorporate the apparent transatlantic developments of its processes and schools. He thus takes issue with European historiography for "having lost sight of the fact that in the Rio de la Plata we are also part of the Western world." "Our America," he adds in a peculiar twist on José Martí's celebrated phrase, "is not the Indian nor the African (which will end up culturally covered up by the European) but the originally Euro-

pean. . . . We in the entire Río de la Plata region [Uruguay and Argentina] are integrated into the vast space of Western civilization. And that is why the same humanistic, liberal values that are affirmative of human dignity and configure Western civilization are naturally part of the core of our peoples."[12]

Beneath the uncanny political moment in which those rhetorical words are published lurks the evidence of a certain common sense, consolidated for a long time among the liberal groups dominant in those nations.[13] That cultural superego is institutionally evidenced in a museum infrastructure modeled on European experience, to the point of incorporating into their collections important pieces of so-called Western art assumed as part of a shared tradition. Thanks to the "museum effect" — the museum as a decontextualizing mode of artistic vision — a globalized fiction is constructed: the transnational narrative of racial and cultural continuity (even a continuity of sensibilities) between the center and its thus erased peripheries.[14] By appealing to visual affinities, the roots of the Argentinean condition could be traced back all the way to Rome and Greece. This is precisely what the architect Alejandro Bustillo postulated during the 1930s when he proposed the creation of an "Argentine national classicism" ("Clásico Nacional Argentino") and even asserted that the structural characteristics of the Parthenon make it look "something like a monumental — and exquisite — 'rancho,'" alluding to the popular ranch houses scattered on the Argentinean great plains.[15]

THE MUSEUM EFFECT — WITHOUT THE MUSEUM

But perhaps the most instructive expressions of the syndrome of marginal occidentality are to be found not in the relatively privileged spaces of the Latin American periphery capable of constructing the cultural (and urbanistic) simulacrum of their globalizing fantasy (Buenos Aires, Montevideo, or São Paulo) but in those other societies that I prefer to call ultraperipheral, such as the Andean countries. These extreme peripheries hold no real possibility of materializing in serious museum terms mimetic deliriums like those implied in the texts by Lavalle already cited. Indeed, it is quite possible that the combined annual expenses of the various museums in just the city of New York exceed the entire budget of the Peruvian state. What becomes globalized in Peru is not the museum but its desires and effects. The *museum effect* without the museum. A compensatory fantasy fetishistically obtained by the ritualization of substitutes and fragments.

Examples of the latter are those mid-twentieth-century traveling exhibitions of pictorial reproductions with which UNESCO pretended to "place the works of the masters of painting within reach of the entire world."[16] Only in

Peru could this extravagance of European paternalism acquire the formality of an institution explicitly vindicated—and without any conscious irony—as a Museo de Reproducciones Pictóricas. Under that name and through acquisitions and foreign donations, in 1951 San Marcos University (the country's oldest and most important public institution of higher learning) assembled six hundred artistic facsimiles—from Giotto to Picasso—with which it put up elaborate shows for a variety of venues. Some of the more generic exhibitions were "From Impressionism to the Present Times" and "Vision of Western Art" (a great hit in the officers' school of the Peruvian Air Force). Other shows covered themes as illustrative as "Christmas in Art," "Flowers in Art," "Horses in Art," "Children in Art," and so on.

With time the Museo de Reproducciones Pictóricas would devolve toward strictly pedagogic functions, each one more elementary than the last, until it finally became irrelevant.[17] It is remarkable, however, the amount of attention and interest it was able to arouse at least during its first decade. Its relatively high profile is evidenced by the photographic and journalistic registers of the openings, conceived almost as society events, or by the thirty thousand spectators that made the 1954 showing of Leonardo reproductions the country's most visited exhibition that year.

Still, five years later this last ensemble of works was requested as a loan to help commemorate the Day of the Indian in the highland province of Puno—one of the most traditionally Native American regions of the country.[18] The friction thus suggested is instructive. Ivan Karp relates Walter Benjamin's auratic concept of art to the museum effect that is achieved through the decontextualization of "exotic" or "primitive" objects in displays where the exhibition of the product obliterates the process, generally for the benefit of Euro–North American audiences.[19] In the MRP, local peripheral communities see their own cultures exoticized by the imposition of a Western canon, offered to the "Third World" as superior and as a model even under the devalued condition of being a copy. The aura thus obtained lies in the cultural distance that is reaffirmed in the very same well-meaning gesture that attempts to reduce it.

This happens sometimes pathetically. Even though in its heyday the MRP tried to buy "authentic" plaster casts of Greco-Roman sculptures, by the late 1970s its acquisition policy was reduced to cutting out miniaturized artistic illustrations from calendars. On a different but complementary note, there is a moving letter sent by the MRP to the Peruvian Ministry of Public Education requesting official help for the enrichment of its collection with photographs of pre-Hispanic pieces illegally taken out of the country. The reproductions were to be obtained by diplomatic gestures toward the foreign museums that had bought the originals.[20] Not in between the lines but in the very lettering of such

bureaucratic letters there is inscribed the MRP's final abyss—the radical *mise-en-abyme* of a terminal colonial condition: the unconscious revelation of the MRP's function as a neocolonial compensation for the resources never invested in a museality that local communities could consider their own, much as there was practically no investment in a local sense of art, or in the conservation of a local historical patrimony.[21]

That letter and other surviving documents could also be read as an involuntary parody, almost surrealist in nature, of the cultural apparatus as a web of rhetorical formalities. Documents go all the way from the MRP founder's reasoned appraisals of the virtues and qualities of reproductions as both object and concept to his emotional epistles to Nelson Rockefeller and the authorities of the Metropolitan Museum of Art requesting the donation of a few dozen posters.[22] Nor should we forget the grandiloquent manifestations of the Brazilian critic Marc Berkowitz expressing his "great feeling of admiration and envy" when confronted with the fatuous museographical display of hundreds of reproductions. "I believe and trust," he declares improbably, "that one day in Brazil we will be able to have a museum [*sic*] of the same importance."[23]

But a tragic reading of the material accumulated in those archives is also possible. A (melo)dramatic reading: the complaints received about the irreverent and inappropriate behavior of schoolchildren forced to visit the exhibitions, or the protests of those enraged by the pornographic graffiti with which "anonymous hands turned those artistic creations into obscene paintings." "Such reprehensible actions," runs the telling conclusion, "cause enormous damage to our prestige in the eyes of the foreigner who, with much reason, still considers us a people of rudimentary culture and unable to appreciate the true worth of artistic works and scientific feats."[24] But perhaps there were even more pressing matters: the unresolved flooding of the spaces that for years served as the MRP's main site in the basement of the National Library (even the location was symptomatic) or the disrepair of the bus that attempted to take the art of these reproductions to the *barriadas* (marginal suburbs) of Lima.

Behind the increasing problems of insecurity and vandalism, of institutional precariousness, lurks the progressive ruin of that well-intentioned but oligarchic syndrome of marginal occidentality still dominant in Peru until the agrarian reform initiated by General Velasco after the coup d'état of 1968. The MRP expressed a seigneurial ethos that pretended to pedagogically introduce itself into popular cultures increasingly marked by the signs of a new *Otherness*: the violent syncretism that increasingly identifies the millions of peasants migrating into Lima and transforming the great capital as much as they are transformed by it. A screeching new (post)modernity arises out of all this, and with it a growing rebelliousness toward the very idea of a model.

I. "*¡Bajan en el Museo de Arte Moderno!*" (Stop at the Modern Art Museum!), 1980. Silkscreen on paper, 69.5 × 100 cm. Inspired by one of the aggressive commercial decals that turn public transportation vehicles into popular galleries, Mariella Zevallos stages a powerful cultural statement in the interior of a microbus. The habitual and exasperated demand for a Museum of Modern Art in Lima is harshly radicalized by this historic print, which questions the very concepts of "art" and "the modern" in a cultural context dominated by promiscuous and hybrid forms of visuality. By E. P. S. Huayco (Mariela Zevallos).

MUSEUM DESIRE

Where there is a void there is a desire. In May 1980, a youthful group poignantly named E. P. S. Huayco altered the habitual lethargy of the local art scene with a startlingly fresh exhibition. Among the pieces shown, a connotative silkscreen by Mariela Zevallos stood out. It reproduced, without any "artistic" reelaborations or concessions, one of the aggressive commercial decals that until recently could still be seen in the interior of Lima's microbuses. It is, in fact, one of those vehicles that is represented in the print, where an exuberant woman in a perilously short miniskirt makes the driver and the passengers salivate as they gawk at her with eyes popping out of their sockets (see figure 1).

In the original advertisement this most Limeña coquette pleads — transistor radio in hand — for the bus's door to be closed gently so that the resulting noise does not interfere with the reception of her favorite radio station ("Radio Mar"), whose exact frequency appears highlighted on the image's lower right corner. In E. P. S. Huayco's version that numeric identification is preserved, but

the woman's request has been replaced by a startling announcement: "¡*Bajan en el Museo de Arte Moderno!*" ("I'll get off at the Museum of Modern Art!"). The phrase itself is shocking, given the well-known absence of such a museum in Lima, but also because of the unusual context in which it is pronounced. Doubtless that print summarized the exasperated call for effective institutional support for contemporary visual manifestations. But this habitual demand here implies a radical questioning of the existing artistic circuit and the very idea of the (post)modern predominant within it.

This is demonstrated by the characters and the setting represented, as well as by the deliberately coarse and gaudy style that inscribes this artwork within what has been called "*achorado*" pop: an adjective derived from popular slang to describe the uninhibited, even insolent and "savage" attitudes that today predominate among the pauperized urban population and the new genera-tions of *mestizos* in their impetuous appropriations of all available symbolic resources for social upward mobility. Theirs is an effervescent cultural universe where mass visuality is combined with gross handicraft techniques, giving ex-pression to a new popular culture — a popular (post)modernity — generated by the processes of migration in the capital and its shantytown suburbs.[25] Certain artists assume that violent syncretism as the operative matrix for the incor-poration of cosmopolitan discursive strategies in response to local needs and referents.

This was precisely E. P. S. Huayco's proposal, as is made evident by the very suggestions of the native word assumed as the group's collective name, but also by the cultural scavenging and recycling practices that led its members to pick through the Dantesque garbage dumps of Lima for the raw materials that they incorporated into artworks that are both startlingly current and almost ancestral at the same time (see figure 2).[26] The result is an archaeology of the contemporary whose very logic brings out the explicit vindication of those in-finite oceans of trash as the only true and factual museum of contemporary art in Peru.[27]

That signaling marks a transcendental change of focus in the definition of what the Peruvian museum should be, even in the broadest terms. Since its first foundation in 1822, the concept of a Peruvian national museum has been the ideological expression of the most bourgeois and educated sectors of the local dominant class.[28] These groups find in traditional archaeology and in the national idea of Peru — a metaphysical Peru that transcends its historical frac-tures, its social divisions, its cultural misencounters — the justification of the hegemony they postulate.

The various entanglements and postponements that the national museum has suffered are in good measure the product of the belated penetration of capi-

2. Francisco Mariotti in the garbage dumps of Lima, ca. 1980. Inspired by popular recycling practices, artists such as Mariotti picked through Lima's Dantesque garbage dumps for the raw materials incorporated into artworks that are both startlingly current and almost ancestral at the same time. Their practice creates an archaeology of the contemporary whose logic explicitly vindicates those infinite oceans of trash as the only true and factual museum of contemporary art in Peru. Photo by Juan Javier Salazar. Micromuseo archives, Lima.

talism into the country's economy and the consequent weakness of the groups behind that effort. Only after the 1969 agrarian reform almost liquidated the feudal remnants in the countryside did it seem that "the great museum" was about to become a reality. But even under those circumstances the project would fail, and by the early 1980s the museological initiative had passed to the private sector and to the privileged ambit of the plastic arts. The panorama then offered by state-run institutions in that specific territory was rather dismal: static collections (the municipality of Lima), dismantled galleries turned into bureaucratic offices (Petroperú), even a public museum devastated by modifications done with no professional criteria (Museo de Arte Italiano).

The point, however, is not to lament, with seigneurial overtones, the disdain for the "fine arts" in Peru. These failings ought to be understood as significant in and of themselves. They are testimony to what the plastic arts have meant for an establishment that since the 1980s prefers to administer the artistic order through the more commercial mechanisms of the market. The only apparent exceptions were some lackadaisical gestures by which — until quite recently —

the notion of the contemporary was offered as an arbitrary and marginal coda after a tour through "three thousand years of art in Peru," to use the words of the official guide to the Museum of Art of Lima, an institution hardly identifiable at the time with the specificity of a museum of contemporary art — or even, until less than a generation ago, with a professional and current concept of the museum (although it is impressive how this has been very positively transformed in recent times). Such disregard for any critical sense of the contemporary not only complicates any serious reflection on Peruvian visual history but also marginalizes from this category those expressions that arise from the popular or that propose a genuine approach toward it — at least those (post)modern aspects of popular experience that due to their autonomy have been ignored by the various populist projects advanced by hegemonic culture.

All of this should be situated in the broader context of the ideological disputes within the Peruvian elite. Sebastián Salazar Bondy expressed it well in 1959 when he blamed the proverbial misery of Peruvian museums on the oligarchic hegemony. "The word *social* is key in the modern idea of the museum," he proclaimed in arguing against that domination while celebrating the partial opening of a section of the then projected Museum of Art of Lima, perceived as a sign "that the narrow oligarchic concept of the beautiful and the good as belonging only to the few has been replaced by another concept, a concept of social origin, of modern and progressive origin, that asserts that everything is for everybody, because we are all equal in the task of making the world a better place."[29] The *museum desire* in one of its clearest expressions — yet also one of its most illusory.

FROM IAC TO MAC

The facts would powerfully demonstrate the naiveté of equating conventional modernism with social justice. That position, however, was historically significant, since Salazar Bondy had been one of the founders of the Social Progressive Movement (Movimiento Social Progresista), an interesting nucleus of reformist thought and political action created in the mid-1950s. However, the entity that at the time attempted to assume and materialize the call for a renewed artistic institutionality was not so much the Museum of Art but, in its own way, the Instituto de Arte Contemporáneo, which for the decade after its founding in 1955 acted as the privileged site for cultural encounters between intellectuals, artists, and businessmen connected with the modern sector of the economy, as well as with the developmentalist project timidly assumed by the first administration (1963–68) of President Francisco Belaúnde — himself an architect, and the IAC's founding vice president.

Such interactions could not become very broad in the narrow Lima society of the time. Symptomatic to that effect was the IAC's decision to expel Salazar Bondy from its board because he had traveled to communist countries. Similarly, in organizing the First Lima Biennial in 1966 it marginalized young artists who—inspired by North American pop—attempted to introduce an irreverent tone into the solemn local art scene. Interestingly, those excluded reacted by hanging their pieces in an abandoned hardware store, which they playfully baptized as "Adam's navel" and even proposed as Lima's future museum of modern art.

The gesture was bold and could be considered a precursor of the attitude later taken to other extremes by E. P. S. Huayco. Indeed, although their critical sense was not as well developed, those earlier rebels made keenly evident the great institutional void in the Peruvian artistic scene. To be sure, the IAC gallery housed important exhibitions that went even beyond the confines of modern art to devote pioneering aesthetic attention to pre-Hispanic and popular expressions while managing to gather a modest collection of Latin American painting with the intention of creating a museum of contemporary art.[30] But internal and external limitations imposed on that last project created obstacles that proved impossible to overcome, even during the developmentalist euphoria of the 1960s. Principally funded by transnational corporations (the Cerro de Pasco Corporation, the Grace Corporation, the International Petroleum Company, International Business Machines, etc.) as well as by some local industrialists closely linked to the Belaúnde government, the IAC would find its very logic under serious challenge after the 1968 coup that introduced General Velasco's drastic populist reforms. Soon the interest and the possibilities of the IAC's patrons waned to the point that in 1974 it finally became necessary to close its doors.[31] With Belaúnde's return to power in 1980, the IAC was resurrected under the command of its old administrators (the prominent businessman and minister of economy Manuel Ulloa was one of its principal directors), but now with the sole purpose of creating the coveted Museo de Arte Contemporáneo, primarily conceived as a *Kunsthalle* with the necessary technical conditions for hosting traveling exhibitions originating in Europe and the United States.[32]

After some failed attempts, halfway through the 1980s a building project was unveiled. The model attempted to adapt to the peculiarities of the plot of land offered for that purpose by the municipality of the residential Miraflores district on the cliffs rising above the ocean. That location itself, however, made all too evident the biased criteria nurturing the MAC, making it ignore the serious problems of the chosen location. The instability of the ground implied a risk for the collection in the event of a major earthquake. Even under normal conditions, the pronounced overhang demanded strong investments

in the foundation required for the building. To top it all, the high salinity and humidity in that zone created inappropriate atmospheric conditions for the preservation of the works. Perhaps more relevant is the ideological dimension highlighted by the chosen zone—a very attractive one indeed, and with an ocean view. But this last can be too suggestive of the wrinkled cosmopolitan spirit nurturing such an undertaking. Eloquently enough, after that project's frustration, a Miami-style shopping center was built on the very same site.

Just as significant is the fact that the IAC would later stubbornly look for an even more revealing location: the food court of an underground mall, underneath a financial building. The great publicity campaign that accompanied the announcement of its imminent construction in 1999 made the predictable cancellation of the entire project even more noticeable. Now there is a more serious effort to build the MAC on several acres of greenery in the midst of one of the most endearing parks of Barranco, a traditional district of romantic connotations on the south shore of the city. The understandable ecological concerns of some of the residents, however, as well as insufficient funds and renewed internal disputes, cast doubts on the fate of this project too.

It is to be noted how each one of those locations disdains the historic center of the city—today marked by a decisive popular presence—giving instead privileged consideration to those districts where the middle and upper classes feel they can, all by themselves, engage in an exclusive cultural intercourse. It comes as no surprise that such interchange pretends to establish itself in terms that are increasingly international and distanced from local realities. Despite certain connotations in the IAC's name, there lingers among its principal spokesmen (no women among its directors) a radical incomprehension of radically contemporary proposals such as those of E. P. S. Huayco.

What seems to express itself through the IAC's reconstitution during Belaúnde's second administration (1980–85) is a private, almost nostalgic notion of the "modern," conceived in terms of an outdated modernization, not a current (post)modernity. Regardless of whether or not it manages to finally materialize, the very project of the IAC seems to have exhausted itself during the 1960s, under less complicated social conditions and more favorable political circumstances. The result is a cultural model incapable of reproducing difference, of making difference productive in authentically contemporary terms. Anachronistic by its very nature, this model has proven thoroughly incapable of being functional for the new demands of a society undergoing such brusque transformations as present-day Peru.

As much is suggested by the fact that in order to finance the perpetually projective condition of the MAC, the IAC has not appealed to the economic patronage of the very wealthy sectors represented in its board, preferring instead

to solicit artists to donate works that were immediately auctioned off rather than incorporated into the minimal collection of the supposed museum. It seems all too symptomatic that the auction conducted in 1999 for that purpose—under the control of Christie's, of course—would be virtually the only important public activity organized by the IAC in almost twenty-five years.[33] Since its rebirth in the early 1980s, the IAC has produced neither exhibitions nor publications, much less the accumulation of a group of works representative of the contemporary history of Peruvian arts. Almost two and a half static decades were consumed by an architectural fixation that could well be interpreted as the modernist (not modern) manifestation of the syndrome of marginal occidentality.

It is true that even with these reservations a truly functional MAC could accomplish some very useful and necessary tasks. In order to be genuinely (post)modern, though, the new museum should also fulfill the promise announced by the insolent E. P. S. Huayco silkscreen: to link the middle classes and the intellectual sectors with the broad category of popular experience that today redefines the very sense and meaning of living in a new megalopolis such as Lima, possibly the most important cultural laboratory for Latin America's extreme peripheries.

TOWARD AN ALTERNATIVE MUSEUM

It is in these terms that halfway through the 1980s a theoretical answer to MAC was advanced: a self-denominated Museo Alternativo (Alternative Museum), where it would become possible to wager on—and creatively approach—a different (post)modernity that articulates itself from within the massive phenomenon of urban migration. This popular (post)modernism strives to become autonomous and has served as inspiration and sustenance for a large part of Peru's most suggestive cultural production.

But the interest in this new reality would also have to include the efforts of intellectuals attempting to relate to it. As the E. P. S. Huayco experience makes splendidly evident, what granted a special sense and value to local artistic activity during the transition toward the eighties was precisely the encounter between the emerging popular experience and a dissident sector of hegemonic culture, a certain lettered petite bourgeoisie. Inspired by the promise contained in that experience, the Museo Alternativo proposed to combat the reversals that followed, the cultural defeats and political failures, but without excessive expectations. The intention was simply to work with the country's miseries in their creative density, in the utopian horizon that they sometimes breed.

To be viable in that context, the Museo Alternativo meant to coordinate the

resources of institutions and individuals whose full capacities remained unexplored because of a lack of means or initiatives. The idea was to link the existing but isolated organizations, the renovating but repressed vocations, the wasted talents, the dispersed works. The process was conceived to creatively explore the difference that could arise out of such encounters.

But the project also implied seeking out new patronages: municipalities, communities, labor unions, neighborhood organizations, centers of popular research and promotion, nuclei of support both within the country and abroad—even long-term partners and sponsors attracted by minimal economic investments that could be replaced by services rendered. The point was not merely to multiply contributions but to create a new social base for museological work in Peru—a material and ideological support whose different (post)modernity would be that of its pertinence and *pertenencia*, its sense of relevance and belonging. Faced with an uncertain and changing reality, it was necessary to relieve the Peruvian museum of its exclusive dependency on business interests or bureaucratic humors (these last with fatal consequences for any attempt at renovation—even of mere professionalization—in state-run entities). But this also implied a structure of support that would redefine the very meaning of the museum by inserting it into the quotidian life of the city, in daily engagement with concrete interests and preoccupations, with the living manifestations of contemporary urban culture.

The task at hand was not, for example, to circulate reproductions of classic European art through the *barriadas* (as the MRP had been doing with extravagant good intentions), but rather to appreciate and rescue local and current cultures by relating them to their immediate context and history, as well as to other manifestations of urban experience. That is one of the challenges (there are others) that in the long run the Museo Alternativo would have to confront: to make the popular not just the theme of its discourses or a sporadic gesture of social projection, but a basic support (not the only one) for the museum's work. The motivations and results of such a program would have to maintain close contact with that ignored context. Hence the circuit for the activities of such a museum would itself have to be an alternative one. Without discarding the possible use of more traditional venues, the ideal itinerary would include downtown Lima (a meeting place for both popular and middle-class sectors) and certain key areas of the urban belt where multitudes of *mestizo* migrants reside.

In each of these zones there seemed to exist the necessary resources to harbor and articulate the simultaneous activities of this Museo Alternativo, evidently conceived not as a static gallery but as a dynamic space for the research and promotion of visual manifestations. The institution thus postulated was

especially interested in those images that fostered analysis of the ways in which migration establishes new cultural patterns, but recognizing as well that these are often assumed by some unconventional artistic tendencies. The Museo Alternativo proposed both to study popular expressions and to rescue and restore those "erudite" artworks that, due to their heterodox nature, have been despised by the traditional art market, falling into deterioration and oblivion.

The attempt was not just to reconstitute the forgotten history of Peru's radical plastic arts but also to make materially possible its reactivation by supporting this type of production and recruiting its creators for other museum projects. Among the latter would be the generation of cultural workshops designed to satisfy the communicative and expressive visual needs of the *barriada*. These would be sites where the socialization of artistic techniques would also provide an opportunity for the encounter and exchange of experiences between the intellectual community and the new urban population.

Of course, a museum with such a vision could also support more academic and restricted projects, but these would be thematically and methodologically in line with the institution's central purpose. It would organize exhibitions and publications intent on disseminating critical artworks applying museographical techniques for historical and social — even political — purposes, rather than exclusively aesthetic ones. The Museo Alternativo thus proposed was not an end but a means. It was conceived as part of a larger project, associated with the radically impoverished reality of the country — and with broader cultural efforts to understand that reality by transforming it.

MICROMUSEUM ("THERE'S ROOM IN THE BACK")

"Young artists should try to make miracles, not to sell paintings to millionaires," Juan Javier Salazar used to say when he formed part of E. P. S. Huayco. Those were more hopeful times, but no less in need of miraculous vocations — or heroic ones. The present is also, in its own complicated way, a time of change, of arduous but indispensable transitions. For that very reason it acts as a challenge to the radical imagination, in the two meanings of that much abused term: to think things from their very roots implies carrying them to their extremes (or at least wandering through them). And in this case it implies stretching the artistic horizon to the very limits of the viable — or the imaginable.

Although conceived previously, the critique of the MAC and the proposal for a heterodox museology outlined above was formally written up in 1985, to be later presented at the 1986 First Conference on Peruvian Museums.[34] The ensuing economic catastrophe and the disasters of the (civil) war that rav-

3. *Algo va' pasar* (Something is about to happen), 1980. Silkscreen on paper, 69.5 × 100 cm. The telluric design for a popular matchbox is here subverted as the backdrop and scenery for revolutionary transformations encapsulated in the routes and images of the microbus used for public transportation in Lima. By E. P. S. Huayco (Juan Javier Salazar). Micromuseo ("al fondo hay sitio"), Lima.

aged Peruvian society during that decade finally aborted both the Museo de Arte Contemporáneo and the Museo Alternativo. The latter, however, managed to generate some concrete achievements and various utopian fantasies that today acquire renewed currency.[35] One of those inherited projects is that of the Micromuseum, a peculiar name whose meaning can be summarized in its motto "There's room in the back," that well-known phrase endlessly shouted as a litany by the drivers of Peruvian microbuses in an attempt to justify picking up more passengers than allowed by traffic regulations and the laws of physics. (The other characteristic cry is "*¡Lleva, lleva!*" — "Move on, move on!").

At least in cultural terms, however, there is indeed room in the back. That radical hope is memorably transfigured into the image of the microbus at distinct moments in recent Peruvian art — starting in 1980, with the E. P. S. Huayco print by Zevallos already discussed (*¡Bajan!*) and another equally important silkscreen produced by Salazar for the same group show (see figure 3). In it Manco Cápac oddly stands on the doorstep of a microbus that seems to unite the Andean high plains with the great city of Lima, and the capital's historic downtown area with the vast *barriadas* that surround it. The legendary founder of the Inka empire is presented as the driver of a public means of transporta-

tion that is also the vehicle for historical transformations: the Andean utopia of the return of Inkarri translated into the socialist utopia of a power exercised by the workers themselves. And all this in a textual and graphic context (quotes by José María Arguedas and Hugo Blanco, designs taken from the La Llama matchbox) that is also the stage for a utopian encounter of tradition and (post)modernity, of the emerging popular experience and the lettered petite bourgeoisie.[36]

The political frustration of this project does not impede its cultural compensation. With few exceptions, the most important portion of Peruvian alternative art in the last twenty-five years is to be found not in the collections connected to the establishment but rather in those constructed by the Micromuseum and some intellectuals and artists whose open-mindedness somehow made up for their lack of economic resources. It is interesting to note that in some of these cases, and particularly in the Micromuseum, the artworks brought together coexist with important ensembles of urban popular paintings. Glaring examples of a new streetwise visuality thus share their radical imprint with hundreds of significant pieces conceived for the art circuit but disdained by the market due to their critical content and daring imagery — including crucial works by now broadly recognized artists such as Christian Bendayán, Fernando Bryce, Claudia Coca, Mónica Gonzales Raaijen, Francisco Mariotti, Alfredo Márquez, Carlos Enrique Polanco, Carlos Runcie Tanaka, Juan Javier Salazar, Eduardo Tokeshi, Angel Valdez, Moico Yaker, and others.

Such a broad and complex assemblage offers endless opportunities for alternative cultural constructions. Despite the prolonged crisis of civil society during the dictatorship of Fujimori and Montesinos, in the last few years it has again become possible to imagine a reflexive and critical rapprochement between the different cultures thus brought together. Reflexive and autonomous: this gathering of works and wills is not dependent on the conflicts and interests of the establishment, but rather articulates itself to the democratic and generous callings that precisely gave rise to the original radicality of such notable pieces as those of E. P. S. Huayco.

That first radicality can only be assumed and projected by an entity that is independent of the powers that be, and of Power itself. To be truly operative, the Micromuseum must be ductile and mobile, willing to sustain its autonomy on an elementary but sufficient economy — such as that of an urban microbus. The prefix that defines this Micromuseum must be understood not only in its necessary vindication of the small, of the immediate and the accessible ("small is beautiful"), but also in its allegorical allusion to the microbus, that daily instrument of mobility and mobilization (in Spanish the word "*microbus*" tends

to be abbreviated into merely "*micro*") — a vehicle that could even be a possible site for this odd museum, this ambulatory Micromuseum for microexhibitions, micropublications, microsymposia . . .

The intent is to create microcircuits that articulate in a single and ambulatory gaze, for example, the sophisticated modernization of the elegant city with the syncretic popular (post)modernity of the gigantic street markets in the *barriadas* — or the new commercial technologies with the coarse hand-painted publicity found on the most densely traveled avenues. Such itineraries might simply signal the already given superpositions of central eccentricities such as those of the once-luxurious Embassy Cabaret, converted into a folkloric theater without any modifications of its pretentious brothel decor, much less of its preposterous English name.[37] Or the simulacrum of a pre-Hispanic tomb specially built in 1947 as a mausoleum for the embalmed body of the founder of the archaeological museum in which he is to this day buried.[38] Or the derelict remnants of a colonial mansion overlooking the principal sites of political and religious power in downtown Lima.[39] Et cetera.

But the allusions in the "micro-" prefix are here also a parody of that "combi capitalism" under whose kinetic label the Fujimori dictatorship pretended to rationalize its political arbitrariness by justifying the most extreme and savage economic informality — starting with the wrecked public transportation system.[40] The Micromuseum intends to subvert that reactionary populism through an autonomous and vital sense of circulation and itinerary. It wildly fantasizes itself as a wheeling museum, an ambulatory museum, with no directors or administrators, but with drivers and ticket-takers and mechanics; with official and clandestine stops; with legal and "pirate" vehicles. The transgressive flexibility thus obtained allows it to stage an installation, an exhibition, or a performance under the apparent format of a "*gran acto politico-cultural*" or a "*pollada bailable*." Such gestures productively confuse art with the sweaty social life of a megalopolis in the making: Lima the horrible and magnificent, a monstrous city called to metabolize the cultural processes of a whole continent as soon as it can perceive that the only (post)modernities that truly matter are those that do not repress difference but render it productive.[41]

This museum does not just accumulate objects — it circulates them. It does not consecrate or enshrine — it contextualizes. It does not have one location — it travels and distributes itself according to the characteristics of each of its activities, taking advantage of unused or underutilized spaces: tombs, cabarets, ruined mansions . . . also, to be sure, some of the best galleries in town, sporadically gained for temporary projects. The reception for many of these alternative experiences has often been overwhelming: the crowds and journalistic

attention generated during the final months of 1999 by the show "Emergencia artística" (whose total budget did not surpass two thousand dollars, provided by the curator and the artists themselves) were comparable to those motivated by the huge Lima Biennial held at the same time at a calculated cost of a million dollars.

The publics thus gained for a radical artistic praxis are as varied as they are broad and complex, depending on the nature of the specific activity involved. It is necessary here to note that Micromuseum's politics of multiple inscriptions also responds to the needs of originary accumulation of capital. It builds a symbolic capital whose privileged materialization is not in the object or in the collection or in the physical space, but in the *critical project* that articulates each of those elements, even in anticipation of their respective existence—the museum before the museum.

This is a crucial difference with the Museo de Arte Contemporáneo. Although aware of transnational developments, the Micromuseum does not nurture a universal vocation. Rather, it aspires to be rabidly specific with the hope of thus becoming a living and pertinent institution. Its horizon is not global but "glocal," to use an increasingly relevant term. A wheeling, ambulatory museum, it is conceived not to communicate relations of cultural power between the elites of the center and those of the periphery but to serve as a vehicle for new and local communities of sense, communities of sentiment. Motion and emotion are thus articulated by a mobile unit whose uncertain mixture of the most varied passengers could liberate the lettered petite bourgeoisie from its traditional cultural subjections to dominant groups that, in more than a century and a half of various hegemonies and enrichments, have shown themselves incapable of generating an elementary museality that could be properly called contemporary.

TO BUILD IS NOT TO CONSTRUCT (QUESTIONS OF EDIFICATION)

In Peru "small is beautiful" should be primarily understood as "small is viable." With neither financing nor salaries nor even a budget, the Micromuseum has managed to put together one of the most important local collections of (post)modern critical art. It has produced an incisive sequence of interventions on the cultural scene, including some of the most commented-upon exhibitions. It has created a major documentary archive of recent Peruvian art history. And it has put out a few specialized publications. All of this has been achieved under worrisome and precarious conditions that nevertheless acquire a sense of freshness when one considers that during the last two and a half

decades the IAC has raised (and partially lost) about a million dollars without achieving much more than displaying ambitious architectural models for future buildings that so far have not transcended the projective volume of a maquette.

A real-estate fixation depletes and exhausts all the IAC's resources and energies. There is a vulgar materialism in the very logic that, when confronted with the crucial idea of infrastructure, is able to perceive only a physical plant, principally conceived as a receptacle for the itinerant tours of cosmopolitan exhibitions. There is in all this a didactic demonstration of what the Chilean critic Justo Pastor Mellado describes as "service curatorship": that which is conceived as functional to the reproduction in the periphery of the globalizing museological models of cosmopolitan power.[42] In opposition to that submissive practice, Mellado proposes the independent attitude of the "curator as a constructor of infrastructure," a complex concept that relates this last category to critical notions of history, art, collecting, the archive, and the very nature of the museum itself, including the established or alternative notions of the social inevitably inscribed in such a structure of meaning.

All these topics are inscribed in the projection of the factual presence of the museum, of its materiality, broadly understood. "In our region the very decision of building a museum is an intervention in the work of history," Mellado pointedly points out. "It frequently occurs that the *building* of a museum is confused with *constructing* a museum. The constructability has a direct relationship with the exhibition of the process through which the museum's concept is transformed as a support for the interpretation of history. In that sense, it is very probable for museums to be built without being constructed, without being edified or even edifying, in the educational sense."[43] That deficient constructability is what seems to burden projects such as the Museo de Arte Contemporáneo. And it might continue to do so even if its latest efforts to acquire a site prove finally successful. As ought to be clear by now, it is not by erecting a building that the museum void is to be solved. To build is not to construct.

But the point here is not to undermine this or other comparable initiatives, which should always be welcomed in the impoverished Peruvian scene. The purpose is rather to empower those efforts through the friction provoked on them by the different libido of a new radicality dedicated to the recognition and installment of the critical project, understood as a crucial instance for any undertaking of this type.

To be truly critical, that project must also be transformative—of our art history and of our history plain and simple. In the inevitable displacements

between each category, the image of the microbus offers us, once again, one of the cultural figures par excellence of our promiscuous and crowded times. Times turned into scrap, but still they move.

Lleva, lleva.

NOTES

1 The very concept of modernity becomes problematic in historically fractured societies such as Peru. The issue becomes even more entangled if we try to encompass the notion of the postmodern. I prefer to put the prefix "post-" in parentheses, as a shorthand way of indicating the still fluid and uncertain nature of the cultural condition thus referred to.

2 Self-referential: Susana Torres and I are the people principally responsible for the continuity of the Micromuseum project, although many others have contributed to it at different times through their collaboration and encouragement. Among them I choose here to privilege the early support provided by Alberto Flores Galindo, a personal friend and historian prematurely disappeared.

3 On this point there are some keen observations made by Ivan Karp in his introductions to the texts on museums and communities that he helped compile in 1992. "This is how museums are perceived in this volume," Karp remarks: "as places for defining who people are and how they should act and as places for challenging those definitions." And further on: "As privileged agents of civil society, museums have a fundamental obligation to take sides in the struggle over identity (and indeed cannot avoid it)." Karp, "Introduction," 4, 15.

4 "As a cultural project, Curare inserts itself in the tradition of alternative spaces created by—and for—artists. Curare was conceived as well as a flexible and creative forum for the fostering of dialogue between artists, essayists, and their diverse audiences. Although we maintain relations with official and private museums, and with galleries, Curare seeks to respond to the sacralizing and dogmatic attitudes of those institutions. It also constitutes an alternative to the monopolic tendencies of the art market." "Qué es Curare," on the LaNeta Web site, http://www.laneta.apc.org/curare (accessed August 15, 2006).

5 "The discovery and interpretation of these 'symbolical' values (which are often unknown to the artist himself and may even emphatically differ from what he consciously intended to express) is the object of what we may call 'iconology' as opposed to 'iconography'. . . . [I]conography considers only a part of all those elements which enter into the intrinsic content of a work of art and must be made explicit if the perception of this content is to become articulate and communicable.

"It is because of these severe restrictions which common usage . . . places upon the term 'iconography' that I propose to revive the good old word 'iconology' wherever iconography is taken out of its isolation and integrated with whichever other method, historical, psychological or critical, we may attempt to use in solving the riddle of the sphinx. For as the suffix 'graphy' denotes something descriptive, so does the suffix

'logy' — derived from logos, which means 'thought' or 'reason' — denote something interpretive. . . . There is, however, admittedly some danger that iconology will behave, not like ethnology as opposed to ethnography, but like astrology as opposed to astrography." Panofsky, *Meaning in the Visual Arts*, 31–32.

6 "The name TEOR/éTica implies theory, aesthetics, and ethics. Among its ethical aspects, this project seeks not only to assume an artistic position, but also to define itself within a political sphere, in its wider and more philosophical sense." From the Fundación Ars TEOR/éTica Web site, www.teoretica.org (accessed August 15, 2006).

"The *Centro de Artes Visuales/Museo del Barro* is a glass case where diverse visual expressions from Paraguay and Latin America are exhibited, and where the pluricultural and multiethnic character of the country is shown. Native and popular art are treated the same as 'cultivated art.' " Museo del Barro, *Centro de Artes Visuales/Museo del Barro*.

7 Lavalle y Arias, "Crónica," 757–65. (The emphasis and the translation are mine.)

8 In Peru the word *criollo* traditionally refers to those born in the country but within "white" families of Spanish origin.

9 A different and more complex posture can be perceived in the painting and social criticism of an artist such as Francisco Laso (1823–1869). His dissidence, however, did not impede him from maintaining tight bonds with Lavalle, in whose *Revista de Lima* Laso published his most important and polemical texts on racial and political issues. For a specific analysis of this, see Buntinx, "El 'Indio alfarero' como construcción ideologica."

10 Lavalle y Arias, "Crónica," n.p. (The translation is mine.)

11 Suffice it to consider the comings and goings of Peronista discourse in the last two decades, from its originally nationalist populism to President Menem's ruthlessly frivolous recantation during his prolonged administration, proclaiming all through the nineties Argentina's insertion in the so-called First World and clamoring for "carnal relationships" with the United States. And the brutal epilogue to it all: the great political and economic debacle that for his successor Duhalde, also a Peronista, has left that country "outside the world" — that is to say, cut off from the privileged relations with those globalized entities (IMF, World Bank, etc.) that turned their back on Argentina, leaving it "on the border of an epic crumbling never before seen" (Duhalde's speech in Tucumán during the national holiday of July 9, 2002; the translation is mine). The devastated and apocalyptic tone of those words reveals a strong psychological element beneath the evident ideological orphanage.

12 "South America is still ignored," laments Sanguinetti, "it is as if in the history of Cubism Barradas or Petorutti could be ignored, or Carlos F. Saez in the history of the 'macchiaoli,' or Alejaidinho in the history of the Baroque." Sanguinetti, "Seis maestros. Una pintura. Una nación," 10. (The translation is mine.)

13 Both Uruguay and Argentina had just come out of particularly brutal dictatorial regimes, whose genocidal practices were justified as a necessary means of defending Western and Christian civilization (*"la civilización occidental y cristiana"*).

14 Svetlana Alpers defines this most useful category in a seminal essay: "The Museum as a Way of Seeing," 25–32.

15 Bustillo, *La belleza primero*, 171. (The translation is mine.) In fact, similar postures circulated throughout the Río de la Plata region beginning in the latter half of the nineteenth century. On this topic, see Buntinx, "La identidad como discurso."

16 "World Review: Una charla sobre los esfuerzos de la UNESCO para poner las obras maestras de la cultura al alcance del mundo entero," Paris, 1950. Document from the archives of the Museum of Art of the University of San Marcos, Lima, Peru. (Transcription from a radio program. The translation is mine.)

17 In 1997 the deteriorated remains of its collection were transferred to the Museum of Art of the University of San Marcos. During the Third Lima Biennial of Ibero-American Art (April-May 2002), a Peruvian artist, Fernando Bryce, integrated some of those reproductions into a keen installation that critically deconstructs the history of the MRP.

18 Letter from Victor Delfín Ramírez, director of the *Escuela Regional de Bellas Artes de Puno*, to Alejandro Miró Quesada Garland, Puno, June 2, 1959. Archives of the Museum of Art of the University of San Marcos, Lima, Peru. (The translation is mine.)

19 "In the case of exotic objects, the museum effect becomes an 'aura,' as Walter Benjamin called it, the consequence of which is to mask the intentions, meanings, and skills integral to the production and appreciation of the objects. These become irretrievably lost to the exhibition audience." Karp, "Culture and Representation," 16.

20 "Having ascertained the fact that numerous pieces of pre-Hispanic art that are essential for our culture have left the country, and given the magnificent quality of artistic reproductions, I ask that you consider the possibility of obtaining reproductions of these works from foreign museums, in order that they may be exhibited in the Museum of Pictorial Reproductions of the University of San Marcos." Letter from Alejandro Miró Quesada Garland to Manuel Vega Castillo, director of culture, archaeology, and history of the Ministry of Public Education, Lima, June 19, 1959. Archives of the Museum of Art of the University of San Marcos. (The translation is mine.)

21 "Given the current impossibility, due to lack of economic resources, of forming an art gallery with works by the principal masters of universal painting . . . I consider that the best solution to this problem is the creation of a Museum of Pictorial Reproductions associated with the University." Alejandro Miró Quesada Garland, "Proyecto para la creación de un Museo de Reproducciones Pictóricas," Lima, August 12, 1950. Archives of the Museum of Art of the University of San Marcos. (The translation is mine.)

22 "Regarding the reproductions themselves, I have been able to verify in European museums and in the recent UNESCO catalog that they have reached notable perfection. French critics of high prestige have even said that the experts themselves could be confounded by life-size reproductions if they are not analyzed in detail." Ibid. (The translation is mine.)

23 Undated document, Archives of the Museum of Art of the University of San Marcos. (The translation is mine.)

24 Letter from Alberto Carrillo Ramírez to the director of *El Comercio*, Lima, August 29, 1956. Archives of the Museum of Art of the University of San Marcos. (The translation is mine.)

25 The phrase "*pop achorado*" was originally coined by Jesús Ruiz Durand to define the style of the posters he designed for the agrarian reform during the government of General Velasco (1968–75). My use of this term attempts to theoretically develop this category in order to make it applicable to broader proposals and dimensions. For more on this point and for a broader analysis of the E. P. S. Huayco experience, see Buntinx, "El poder y la ilusión" and Buntinx, "Estética de proyección social." Regarding Jesús Ruiz Durand and the agrarian reform posters, see Buntinx, "Modernidad andina/Modernidad cosmopolita" and Buntinx, "Pintando el horror."

26 "E. P. S." was used as a playful reference to the Empresas de Propiedad Social, created as cooperative economic units during the Velasco regime. "*Huayco*" is the Quechua term for avalanches that descend from the highlands with a regenerating violence that both fecundates and devastates the land. Sometimes the word is used as a terrible metaphor for the great native migrations descending on Lima: the alluvial displacement of millions of Andean peasants that have irreversibly transformed the *criollo* capital and established the material and human foundations for the project of a different (post)modernity such as the one speculated on by this essay.

27 It was Francisco Mariotti, E. P. S. Huayco's most experienced member, who made this claim in 1980. Micromuseum rescued an important photographic testimony of this gesture (see figure 2). For more on Mariotti's specific works and proposals, see Buntinx, "El retorno de las luciérnagas."

28 For historical background, see Lumbreras, "Tres fundaciones" and Castrillón, *El museo peruano.*

29 "Profound culture was hidden away from the Peruvian people by the old dominant oligarchy. That oligarchy wanted the Indians to remain servile, and, therefore, it denied the beauty, the strength, the imagination, the intelligence reflected in their art.... That oligarchy wanted its privileges not to remain confined to its economic control and domination, and thus it opposed art museums for the people. Because that oligarchy was closed as a caste, as an aristocracy, as a hegemonic group, and the social foundation of the museum precisely breaks with the tradition of an aesthetic knowledge exclusive for the palaces, the 'villas,' the castles, isolated from and unreachable for the burgher, the farmer, and the guildsman." Salazar Bondy, "El sentido social y popular de los museos," 3. (The translation is mine.)

30 Although some signatures in that collection were respectable (Lam, Matta, Le Parc, etc.), the works tended to be minor, with the exception of a few pieces by Peruvian artists.

31 The architect Frederick Cooper Llosa, one of the IAC's current directors, has succinctly summarized that traumatic history from the IAC's perspective: "[The IAC] was created through the initiative of painters, businessmen and architects, in order to promote the knowledge of modern art in Peru. Had it not existed, Peruvian contemporary painters, and several Latin American ones, would have taken much longer to stand out. But the Instituto did not possess a site of its own. And finally it succumbed when the military government . . . threw us out of the Italian Art Museum, which had been ceded to us by Belaúnde. The claim was that we were an oligarchic enterprise living off imperialist money. The situation was aggravated by the expro-

priation of companies that supported us, as well as by the deportation of some of
our directors. We then decided to 'submerge' and the collection was given on loan to
the San Marcos University Art Museum." *El Comercio*, "Hacia el museo," C-3. (The
translation is mine.)

32 "It becomes more and more frustrating to find out that important collections of paint-
ings itinerate through the capitals of Latin America sponsored by European and North
American governments and museums but they cannot be received in Lima because we
do not count with a *museum* with adequate conditions of space, security and appear-
ance to host exhibitions of that type." Instituto de Arte Contemporáneo, *El Museo de
Arte Contemporáneo*, n.p. (The translation is mine.)

33 An exception is the 1986 exhibition of selected pieces of its collection as part of an-
other fund-raising drive.

34 Buntinx, "Museo moderno/Museo alternativo."

35 These included the beginnings of a serious collection of critical art, for example, and
an exhibition on *Amauta*, the outstanding journal published during the 1920s by Jose
Carlos Mariátegui linking Andean and popular experience with the liberating prom-
ises of modernity. It is important to point out the coherence between the contents
of that show and its itinerary through different cultural spaces—both in downtown
Lima (the Pancho Fierro Gallery of the metropolitan municipality and the Museum of
Popular Art at the Riva-Agüero Institute) and in the working-class districts of Vitarte
and Villa el Salvador.

36 Jose Maria Arguedas was the principal Peruvian novelist of the twentieth century, and
also the one more intimately linked to the agonies of Andean culture in the supreme
trance of its modernization. Hugo Blanco was the most important leader of peasant
revolts during the sixties, and also the visible head of a Trotskyite movement that
made an impressive showing during the 1978 elections. (Both sustained a moving cor-
respondence in Quechua when Blanco was in jail and shortly before Arguedas killed
himself in 1969.) Inkarri is the mythic name of the Inka-Rey, the Inka king decapi-
tated by the Spaniards whose body nevertheless is regenerating under the earth while
waiting for the proper moment to return to the surface and restore the interrupted
time of the natives. *"La llama"* is a loaded pun that gives its name to the most impor-
tant Peruvian brand of matches (the word *llama* means "flame," but it also refers to
a paradigmatically Andean animal). For a detailed reading of the Salazar silkscreen
and other important related works, see Buntinx, "La utopia perdida" and "Estética
de Proyección Social."

37 In 1999 the Micromuseum organized there an artistic outing that shortly afterward
proved instrumental for the first presentation in Lima of the Mexican performer
Astrid Hadad, a significant event for the development of certain critical tendencies
in Peruvian art.

38 Again in 1999 the Micromuseum resignified that bizarre space with a performatic con-
ference prodding the sexual and political overtones in the evolution of the cult most
closely related to the experience of popular (post)modernity. See Buntinx, *Sarita ilu-
minada*.

39 Toward the end of 1999 the Micromuseum used the particular connotations of that

dilapidated site to enhance the critical edge of the works assembled under the ambiva-lent name of "Emergencia artística" (which could be translated both as "emergent art" and "art in emergency") in a defining gesture of artistic resistance to the perpetuation of the Fujimori and Montesinos regime. See Buntinx, *Emergencia artística*.

40 In the name of economic freedom, Fujimori imposed a ruthless deregulation of public transportation that choked the streets and strangled the city with tens of thousands of used combi microbuses imported from countries where they had been declared unfit for circulation. As a result, Lima is now an environmental disaster area, and moving through it can be an endless nightmare.

41 "*Buses pirata*" is how popular slang refers to the vast majority of public transportation vehicles that operate illegally and with no formally established or authorized routes. "*Gran acto político-cultural*" is the term frequently used by all types of artistic events organized by leftist organizations. "*Pollada bailable*" is a festive popular means of obtaining funds by offering in the neighborhood an afternoon of (loud) music and (greasy) chickens. *Lima la horrible* is the celebrated title of the 1964 book in which Salazar Bondy articulated his most devastating critique of the city and the society created by the traditional Peruvian oligarchies.

42 Mellado, "El curador como productor de infraestructura," n.p. (The translation is mine.)

43 Ibid., n.p. (The translation is mine.)

Declaration on the Importance
and Value of Universal Museums:
"Museums Serve Every Nation"

Following is the full text of Declaration on the Importance and Value of Universal Museums signed by the directors of 18 European and American art museums. The declaration, which was issued in London last weekend, was prompted by the growing world-wide chorus calling for the return of such treasures as the Elgin Marbles and the Pergamon Altar, both masterpieces of ancient Greek art housed in, respectively, the British Museum and the Pergamon Museum in Berlin. The Greek government has been lobbying for the return of the Elgin Marbles in time for the 2004 Olympics in Athens. The Turkish government is claiming the Pergamon Altar.

It is rare for museum directors to speak out as a group on an issue. In March 2001, the Association of Art Museum Directors, representing museums in the United States, Canada and Mexico, issued a statement deploring the Taliban's destruction of the Buddhas of Bamiyan and other art objects in Afghanistan. And in 1988 the AAMD issued a set of guidelines for dealing with art confiscated by the Nazis during the Holocaust that has since turned up in museums.

The international museum community shares the conviction that illegal traffic in archaeological, artistic, and ethnic objects must be firmly discouraged. We should, however, recognize that objects acquired in earlier times must be viewed in the light of different sensitivities and values, reflective of the earlier era. The objects and monumental works that were installed decades and

even centuries ago in museums throughout Europe and America were acquired under conditions that are not comparable with current ones.

Over time, objects so acquired—whether by purchase, gift, or partage—have become part of the museums that have cared for them, and by extension, part of the heritage of the nations which house them. Today we are especially sensitive to the subject of a work's original context, but we should not lose sight of the fact that museums too provide a valid and valuable context for objects that were long ago displaced from their original source.

The universal admiration for ancient civilizations would not be so deeply established today were it not for the influence exercised by the artifacts of these cultures, widely available to an international public in major museums. Indeed, the sculpture of classical Greece, to take but one example, is an excellent illustration of this point and of the importance of public collecting. The centuries-long history of appreciation of Greek art began in antiquity, was renewed in Renaissance Italy, and subsequently spread through the rest of Europe and to the Americas. Its accession into the collections of public museums throughout the world marked the significance of Greek sculpture for mankind as a whole and its enduring value for the contemporary world. Moreover, the distinctly Greek aesthetic of these works appears all the more strongly as the result of their being seen and studied in direct proximity to products of other great civilizations.

Calls to repatriate objects that have belonged to museum collections for many years have become an important issue for museums. Although each case has to be judged individually, we should acknowledge that museums serve not just the citizens of one nation but the people of every nation. Museums are agents in the development of culture, whose mission is to foster knowledge by a continuous process of reinterpretation. Each object contributes to that process. To narrow the focus of museums whose collections are diverse and multifaceted would therefore be a disservice to all visitors.

Signed by the Directors of:

The Art Institute of Chicago
Bavarian State Museum, Munich (Alte Pinakothek, Neue Pinakothek)
State Museums, Berlin
Cleveland Museum of Art
J. Paul Getty Museum, Los Angeles
Solomon R. Guggenheim Museum of Art, New York
Los Angeles County Museum of Art
Louvre Museum, Paris
The Metropolitan Museum of Art, New York

The Museum of Fine Arts, Boston
The Museum of Modern Art, New York
Opificio delle Pietre Dure, Florence
Philadelphia Museum of Art
Prado Museum, Madrid
Rijksmuseum, Amsterdam
State Hermitage Museum, St. Petersburg
Thyssen-Bornemisza Museum, Madrid
Whitney Museum of American Art, New York

Art Museums and the International Exchange of Cultural Artifacts

ASSOCIATION OF ART MUSEUM DIRECTORS

The responsibility for the presentation, study, protection, and care of much of the artistic achievement of mankind rests with the world's art museums. Whether public or private, museums undertake this work in furtherance of the public good. The experience of art fosters the appreciation of beauty and human ingenuity, and promotes understanding among the diverse peoples and cultures of the world.

Acquiring works of art through gift or purchase is a vital part of a museum's mission. New acquisitions spur research, stimulate exhibitions, and contribute to the enjoyment and enlightenment of the visitor.

Acquisition of the arts of ancient cultures and indigenous peoples poses issues that must be addressed thoughtfully. Unscrupulous behavior on the part of some individuals and organizations has led to pillaging of archaeological sites, causing the destruction of cultural heritage and the unlawful, uncontrolled dispersal of artifacts. American museums, charged with the preservation of works of art, condemn actions that damage monuments, sites, or the integrity of an architectural structure. The exchange of cultural artifacts must be conducted according to the highest standards of ethical and professional practice.

The United States government has adopted a global perspective on culture, believing that citizens of other countries benefit from exposure to American works of art just as Americans benefit from exposure to the arts of other cultures. American museums are committed to the free exchange of ideas and the responsible acquisition of cultural artifacts. They support the view that the

artistic achievements of all civilizations should be represented in American museums where they may inspire and be enjoyed by all. The interests of the public at large are served through museums around the world working in partnership to preserve and interpret our shared cultural heritage.

Conducting research, and publishing the results of that research, are key components of a museum's educational mission. While it is highly desirable to know the archaeological context in which an artifact was discovered because this can reveal information about the origin of the work and the culture that produced it, this is not always possible. Nevertheless, much information may be gleaned from works of art even when the circumstances of their discovery are unknown. Indeed, most of what we know about early civilizations has been learned from artifacts whose archaeological context has been lost.

In addition to researching works already in their collections, museums also research proposed acquisitions. They seek to verify the authenticity of the work, address its relevance to the museum's collections and its community, affirm that the seller or donor has good title, and determine that it has not been illegally imported into the United States. Conclusive proof is not always possible, because documentation and physical evidence may be inaccessible or lost. Still, American museums proceed with the utmost caution and respect in acquiring works of art from other countries.

To deter illicit trade and to ensure that the importation of art and artifacts from other countries is conducted in a lawful and responsible manner, museum directors consider the following questions when acquiring the arts of ancient cultures and indigenous peoples:

Is a country's cultural patrimony in jeopardy from pillage of archaeological and ethnological materials and/or other illegal actions and how will the acquisition affect such activity?

Is the importation of the cultural artifacts consistent with the interests of the international community, especially for scientific, cultural, and/or educational purposes?

Is the importation consistent with applicable law, including relevant international conventions?

How did the work come into the possession of the seller?

Is there information and documentation that can be reasonably obtained to shed further light on the origins of the work and the circumstances of its acquisition?

Is there evidence that the work is being legally exported?

The institutions represented by the membership of the Association of Art Museum Directors (AAMD) address these issues according to the mandates of their individual missions and guidelines. Museums operate with a system of checks and balances by which museum directors, trustees, and staff evaluate and decide upon the appropriate course of action in acquiring works of art. Core values guide all aspects of a museum's work: fulfillment of its mission to serve the public through art and education, adherence to the AAMD's professional standards of quality while serving the specific interests of its community, accountability, integrity, clarity of purpose and openness in communications. The AAMD promulgates fundamental standards by which art museums should be governed and managed. These principles are found in the publication *Professional Practices in Art Museums*, which has been revised at ten-year intervals since 1971.

The AAMD is a membership organization that represents 175 directors of the major art museums in the United States, Canada, and Mexico. The President for 2001–2002, the year when this document was drafted and issued, was James Cuno, Elizabeth and John Moors Cabot Director of the Harvard University Art Museums. AAMD's Executive Director at the time was Millicent Hall Gaudieri, who still held that position in 2006.

Reprinted with permission of the Association of Art Museum Directors.

Museo Salinas: A Proactive Space Within the Legal Frame, Some Words from the Director

Un Espacio de Participación Activa en un Marco de Legalidad, unas Palabras del Director

VICENTE RAZO

FROM "THE OFFICIAL MUSEO SALINAS GUIDE"

During the revolution General Francisco Villa was faced with a grave problem: there was a serious shortage of money throughout the territory he had just liberated. His political counselors were highly concerned that this situation might hinder the progress of the revolution. General Villa—a great military strategist—came up with a simple answer to the dilemma: he ordered the manufacture of money. Why raise funds when you can create your own? Why seek out museums or wait for museums to seek you out when you can start up your own? To form an autonomous zone, a possible space of power and resistance—whether it be a museum or an autonomous district—all you need is an idea.

Durante le Revolución, entre los múltiples problemas que el General Francisco Villa enfrentó a lo largo del territorio que recién había liberado, destacaba el de la escasez de dinero. Sus consejeros politicos se hallaban inquietos ante las posibles consecuencias que la carencia de liquidez supondría para el buen curso de la Revolución. El General Villa—gran estratega military—resolvió el dilemma con una simple maniobra: ordenó la fabricación de más dinero. ¿Por qué esperar o buscar al museo, si se puede empezar uno proprio? Para crear una zona autónoma, un possible espacio de poder y resistencia lo único que se necesita es una idea.

Y así, en marzo de 1996, inauguré el Museo Salinas. Coloqué mi colec-

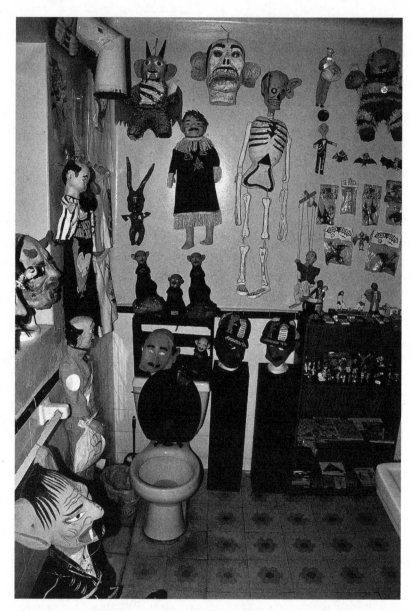

1. Museo Salinas (View at Veracruz #27—3 Colonia Condesa, Mexico City), 1996. By Vicente Razo. Image courtesy of Museo Salinas. See also the Museo Salinas Bathroom Poster included in the Tactical Museologies introduction (page 212).

In March 1996 I opened the Museo Salinas. I arranged my collection of Salinas trinkets, which I'd bought in the streets, in the bathroom of my apartment; I hung a sign on the door and had business cards made with the inscription "Vicente Razo, Museo Salinas Director." That's all I needed to do to create an autonomous space.

And that's when I found out that the response elicited by the word "museum" was very similar to that of Pavlov's famous dogs: in the art beast, it leads to a conditioned, constant, and fluid reflex, an intellectual secretion that my museum uses and abuses as if it were casting a spell. An invisible pedestal is created thanks to the power of the word "museum." The simple action of christening my toilet a museum had a magical effect: everyone from artists and homemakers to bureaucrats and reporters from all over the world filed through the bathroom-museum.

When I founded the Museo Salinas, I had in mind the importance and function of the museum within society's psyche. Psychologically, the museum can be seen as the filter that regulates and selects which objects or historical documents migrate towards society's conscious or articulated side, and which are forgotten or ignored, cast onto the rubbish heap of a society's unconscious or latent side.

Considering this, and considering the torpid state of Mexican mu-

ción de objetos callejeros sobre Salinas en el baño de mi casa, puse un letrero en la puerta y me mandé hacer una tarjeta de presentación con la leyenda Vicente Razo, Director Museo Salinas. Fue todo cuanto hizo falta para fundar un espacio autónomo.

Entonces descubrí que la respuesta a la palabra museo es muy parecida a aquella de los famosos perros de Pavlov: provoca en la bestia artística una replica condicionada, constante y fluida; una secreción intelectual usada y abusada—a manera de encantamiento—, que levanta un pedestal invisible a lo que muestra gracias al artificio y poder de la palabra museo. El simple acto de bautizar a mi baño como museo produjo efectos mágicos: desde artistas— pasando por amas de casas y burócratas—hasta periodistas de todas nacionalidades transitaron por mi museo-baño.

Cuando fundé el Museo Salinas, tenía en menta la importancia y el rol que la institución-museo juega en la pisque social. El museo puede ser visto, psicológicamente, como un filtro que regula y selecciona qué objetos o documentos de la historia migrant hacia el lado consciente o articulado de la sociedad, y cuáles permanecen olvidados o despreciados, destinados a subsistir como despojos en el lado inconsciente or marginal de una sociedad.

A partir de estas reflexiones y considerando el entumecido estado

seums—which are immersed in a colonized and elitist agenda, with an atrophied bureaucratic corps afraid of any fragment of reality they might be expected to present—I decided that it would be a healthy and necessary act to grant these singular testimonies of contemporary Mexican history a space in a museum: I wanted to "activate" these objects.

My primary goal was to document and safeguard a key element in the country's art practice, to preserve these radical works—at once extremely beautiful and with an ephemeral street-based lifespan—which would have been forgotten, doomed to be scoffed at by the powers that be, had they not been collected.

The Museo Salinas and its public dissemination functioned—and, in the manner of a myth, continue to do so—like a trench of resistance for an army of knick-knacks perfectly suited to public political intrigue.

To paraphrase Diego Rivera writing about Posada: "Certainly no other president has been so unlucky as to have the incomparable makers of these objects as the narrators and judges of his ways, deeds, and adventures."

de los museos mexicanos—inmersos en una agenda colonizada y elitista, con un cuerpo burocrático atrofiado, y temerosos de todo fragmento de ralidad que tengan que afrontar—decidí que sería un acto saludable y necesario otorgarles el espacio de un Museo a estos singulars testimonios de la historia contemporánea de México: activar estos objetos.

Mi intención principal fue registrar y atesorar un punto clave en la práctica artística nacional; preserver estas radicals obras—de belleza extrema y de existencia efímera y callejera—que, de no haber sido recolectadas, habrían sido olvidadas, destinadas al menosprecio del poder.

El Museo Salinas y su diffusion funcionaron—y lo continúan haciendo a manera de mito—como una trinchera de resistencia para un ejército de bagatelas cabales y efectivas en la intriga publica y política.

Termino parafraseando a Diego Rivera cuando escribió sobre Posada: "Seguramenta, ningún presidente ha tenido tan mala suerte, por haber tenido como relator y justiciero de sus modos, acciones y andanzas, a los incomparables creadores de estos objetos."

Musings on Museums from Phnom Penh

INGRID MUAN

At all times, whenever the notion of the arts has appeared over the ages, it has been consecrated by civilised peoples through the creation of museums. The ancients drew together public collections of the art of their time in suitable temples. During the Middle Ages, the churches and the monasteries served as the refuge, the guardians of treasures, of manuscripts, of works of art. In contemporary and modern times, the organisms which receive collections are truly public institutions.

> —Speech by Baudoin (the French resident superior of
> Cambodia) at the inauguration of the Albert Sarraut
> Museum in Phnom Penh, April 13, 1920

[The planned] museum will show artifacts found during past and ongoing excavations, as well as a group of objects recently found lying above ground at sites just discovered in the region. Such exhibits, and the stories they tell, will show the general public the work of their ancestors from many centuries ago. The establishment of this museum is important to the development of culture in the region and will draw both national and international tourists to the region in order to view the displays and understand about the life of the local people.

> —From "The Memot Centre for Archaeology,"
> by Heng Sophady, in the *Bulletin of the Students of
> the Department of Archaeology*, vol. II, 2002

More than eighty years separate the two quotes that open this chapter, the first inaugurating a self-consciously modern and public museum, the second asserting a global audience for displays of local life. This essay considers the period in between, teasing out a sediment of impulses that inflect and afflict the idea of the museum in the area today known as Cambodia. As my title indicates, these are musings woven together in response to an invitation to think about museums and public spheres. The fragmented character of what follows reflects both the disjointed accumulation of colonial and postcolonial agendas that makes up the cultural history of twentieth-century Cambodia, as well as my own embedded and entangled position as a foreigner participating in some of what I sketch here.

A LANDSCAPE OF THE PRESENT

Over the last ten years, Cambodia has settled into a certain peace. The Paris Peace Accords and the United Nations Transitional Authority for Cambodia (UNTAC) formed the bridge from the Vietnamese-sponsored, Soviet-allied regime of the 1980s to Cambodia's official reintegration into the "international community" during the early 1990s.[1] UNTAC-sponsored elections installed an often stumbling but always internationally supported regime of reconstruc-

tion that, on the surface at least, espouses peace, democracy, free markets, and above all "development."

The particular details of Cambodia's political and social shift during the late 1980s and early 1990s seem to have been of interest to the art world only because peace finally made the famous ninth-through-twelfth-century temple complex of Angkor "reaccessible." After decades of languishing in war zones, kept out of mainstream circuits by taboos on tourist expeditions to so-called communist countries, Angkor (in this line of thinking) has finally been re-integrated into the world of culture. In the early 1990s, Angkor was hurriedly inscribed on the World Heritage List, international restoration teams rushed to the site, and increasing numbers of foreign tourists came to visit the temples with each passing year of relative peace. The surge in foreign interest was complemented by a rapid increase in the number of Cambodians visiting Angkor as well, both as tourists and as religious pilgrims. In addition, a vast crowd of beggars, moto drivers, craft vendors, postcard peddlers, food sellers, and petty thieves was drawn to the temple site from across the region by the simple logic that "this is where money is."[2]

Despite economic and political incentives to get along, the parties to peace engaged in a brief but well-publicized episode of fighting in the streets of Phnom Penh in 1997 (some called it a "coup," others a "defense"; the most neutral and enduring label for the shelling and political murders remains "the events of July 1997"). News of the unrest made Cambodia once again seem unsafe. The government hastily abandoned a policy that forced all foreign visitors to pass through Phnom Penh before going to Angkor, a policy based on the simple logic that the longer foreign visitors could be made to stay in Cambodia, the more money they would spend. Under the resulting "open skies" policy, planes of a wide range of national and corporate interests now fly directly to Siem Reap, the town closest to the temples. This new pattern of passage allows foreign tourists to efficiently experience the wonders of the temples while avoiding Cambodia almost entirely.

While international heritage experts emphasize the quality of aesthetic experience and the environment of the park in attempting to limit the number of daily visitors to Angkor, local and government officials focus on the potential of the temples to make much-needed income (for Cambodia's development as a whole, as well as to line private pockets and shore up various political interests). Either position has a stake in keeping local tourists and pilgrims from neighboring countries out of the temples, since these groups will come in the greatest numbers and typically spend the least amount of money. In the discourse of international heritage management, the temples have a "carry-

ing capacity," and "culturally motivated tourists" from "markets" in "Europe, Japan, North America and New Zealand/Australia" should be targeted in order to ensure a "high-price policy."[3]

The "aesthetic experience" promised by such planning curiously mixes the myth of "rediscovery" with the faded tones of late-nineteenth-century photography.[4] What foreign visitors seem to want to experience is a sense of being alone in the jungle with massive deserted temples in a state of monochromatic half-ruin. They do not wish to see the gilded towers and painted sanctuaries that thirteenth-century eyewitness accounts indicate were in fact the "original" state of Angkor, nor do they want to encounter today's Cambodia with its crowds of domestic tourists in *Titanic* T-shirts followed by a wake of Coke vendors and beggars. Instead they fly in to see a centuries-old pastness, a glorious decay elaborated in nineteenth-century travel accounts, and illuminated in monochromatic images that fill the frame of a snapshot with no trace of the present.[5] If Angkor is "well managed," they will fly out again, fully satisfied with the purity of this experience.

The missing pieces of this experience still motivate some to venture to Phnom Penh, since many Angkorian sculptures are today housed in the National Museum of Cambodia.[6] The museum has collections of ancient ceramics, weapons, tools, silks, and paintings as well, which are gradually being brought up from basement storerooms and installed as somewhat haphazard pre- and post-Angkorian bookends to the famous sculpture collection. Over the last decade, the National Museum of Cambodia has been included in broader international campaigns to "aid" Cambodia. Museum professionals from Australia, England, France, Japan, and the United States have come to train various staff in a range of tasks, while National Museum staff have traveled abroad to view other museums and participate in training programs. There has been help in cataloging, organizing, computerizing, labeling, lighting, restoring, cleaning, de-batting, publicizing, and presenting—in short, in everything that is required to make a proper museum.

The state of Cambodia ten years ago seemed so clearly desperate in many ways that there was little discussion of what models such aid should rely on. For the museum, established models of administration, cataloging, and restoring were introduced, and little of the more questioning rethinkings of museums, their roles, their communities, or indeed their reason for existing—critiques prevalent in the West during the 1990s—were imported to Cambodia.[7] The classical museum had to first be reconstructed, it seems, before its critique could even begin, just as the monument and the archaeological park had to be reestablished and promoted as a wonder of the world before recent deconstructions of such an idea could be set in play.[8]

THE MUSEUM TODAY

The National Museum of Cambodia today reads as a muddle of expectations and imitations, caught in an influx of aid and a surplus of models, in transit to becoming proper. In a sense, the current state of the museum is refreshing, since a visit to it refuses to coalesce into the seamless package of wonder or information that results from visits to more polished museums. In the main Angkorian galleries of the museum, sculptures are set on pedestals and con-figured in careful arrangements. This form of display seems to wish to present the collection as a series of individual floodlit masterpieces, an array of "art" recalling classical museum rooms of the West.[9] The museum cannot as yet muster spotlights, however, and its walls remain an obstinately dirty cream. Large open windows and doors dissolve the space of the galleries into the gar-den courtyard, where side alcoves fill with an overflow of lintels and bound-ary markers. Sparrows fly in and out, flies buzz in the galleries, and ants and geckos crawl on the sculptures. In such an atmosphere, the pieces are unable to seem transformed and untouchable. Indeed, while foreigners keep to their well-learned museum attitudes of viewing from a distance, local audiences are eager to rub and physically engage with the sculptures. Touching is, of course, to be educated out of local audiences as the pieces transit from use to art and the museum becomes securely proper. For today, however, female employees of the museum, assigned to provide flowers and incense to those wishing to make offerings to certain sculptures, still stash their purses between the legs of sculptures for safekeeping.

It is in these differences of behavior—in the uneasy seams where different habits and intentions meet—that this museum remains unsettled, unsure, un-fixed. It is a shaky institution, its properness still "endangered," as they say about Angkor as well. It's not entirely clear what echo of the West (or not) this curiously colonial and twenty-first-century museum will become. Several paths can be discerned in the tentative initiatives to script the displays.[10]

One obvious impulse is the increasingly "scientific" management and "pro-fessional" presentation of the collection to the public. During the decade of aid, each object on display has acquired a label in Khmer, English, and French stating the title of the piece along with its catalog number, provenance, ma-terial, assigned style, and estimated century date. Foreign visitors—used by now, it seems, to an audio track that organizes the visual into the packaged narrative of a tour—engage guides who elaborate on these labels by dutifully reciting memorized passages from guidebooks and glossy coffee-table books in the language required by the visitor (English, French, Japanese, or lately Chinese).

Images surround the sculptures as well. In the galleries of "Angkorian Art," for example, laminated color photocopies are stuck to the walls behind various pieces. These small images reproduce misty shots of the temples gleaned from recent coffee-table books on Angkor.[11] Floating as odd glossy spots on the huge dirty walls, these images seem to wish to contextualize the sculptures within the nonspecific glory of Angkor as a wonder of the world, although the technical means for doing so are clearly lacking. Enlarged into wall-sized murals to form huge backdrops behind spotlit sculptures, this version of the (air-conditioned) museum could eventually offer a surrogate experience, providing the sheer visual magnificence of Angkor to those unwilling or unable to climb its stairs.[12]

Another set of laminated texts speaks instead to the impulse of the museum to explain, to educate, and therefore — in a sense — to demystify wonder.[13] Between the glossy images described above, there are laminated texts that explicate, for example, "why Vishnu rides a Garuda" or what "the story of the Vessantara Jataka" is. Along with scattered maps and plans of Angkor (gleaned from a variety of French, English, and Khmer sources) and a "Biography of Jayavarman VII," these texts seem to frame the collection as objects to be iconographically explained and historically located, placed within a particular civilizational context that is to be learned about. The more radical paths such a museum could pursue are hinted at by one label that provides a stunningly concise, but probably inadvertent, lesson in colonial collecting. The photocopied image of a stone head, taken from an art history text, is tacked on the wall behind a headless statue of Harihara. The caption reads simply: "Today the head of this statue is in the Guimet Museum (France)."

There is not yet a coherent script, an overarching intention to these explanations, nor even a decision on the realms which explanation should consider. There is a label on history (Jayavarman VII's life), a label on religious iconography (Vishnu and his Garuda), an oblique reference to the colonial origin of the collection in general, and a map of the Angkorian empire (inexplicably hung at the end of the Angkorian section rather than at its beginning). Among this scattered information, I find a detailed text on the "restoration" of "the Buddha of Vat Kompong Luong."

This particular statue, the label tells us, was brought from the temple complex of Kompong Luong to the museum in 1944. "According to village elders, the figure was highly venerated," and when the statue arrived at the museum it had just been "freshly painted."[14] An accompanying black-and-white photograph, presumably taken in 1944, shows that the sandstone Buddha was indeed coated with gold paint and also had painted facial features and black hair. "Before conservation treatment of the figure began at the Museum's conserva-

tion workshop [in 1999]," the label tells us, "the original image of the Buddha, in carved sandstone, was masked under numerous layers of old restorations." It is a curious sentence that returns us to the monochrome of nineteenth-century photographs. The "original image" is defined as the "carved sandstone," which—in this version of things—is "masked" by painted layers of "restorations." These layers of "restoration" are attributed—through a startling retrojection of museum culture into the preceding centuries—to "restorations" of the statue as "art," done (the label implies) by restoration workshops just like the one laboring today in the museum. The gold and lacquer added to the statue's surface over the centuries are not described as repaintings in a context of worship where to repaint is to devote anew, to reconsecrate, to add to the past. The "original image," for museum culture, is that of the cleaned stone, thus securely fixing the figure in the assumed monochrome of sculpture rather than in the painted and sometimes touchable realm of worship. A "scientific analysis" of the layers of paint covering the "original image," the label continues, "showed, in fact, four principal restorations" (again that word "restoration"). Removal of the 1944 gold layer—dismissed as a layer of "hardware-store paint"—revealed gold leaf on red lacquer, a layer of worship fixed by the faithful. Since this layer was not only older but also quite beautiful and made of materials considered as the ingredients of "art," there was apparently some debate over whether to "continue on to lower layers of restoration." It was finally decided "to uncover as much as possible of the original surface," while leaving a small square of the red lacquer and gold coating on the back of the Buddha's right leg as a record of what this "restoration" had looked like.

Despite such attempts to securely precipitate "art" out of religious use, religion and the court still permeate the museum today. Nowhere is this more clear than in the final "gallery of post-Angkorian Buddhas." Here, the entire collection of the museum's post-Angkorian Buddhas is installed in an elevated cluster. Mats are laid on the floor in front of the Buddhas, and offering plates encourage viewers to worship as well as to view. The display of the Buddhas has three goals, a museum pamphlet explains: (1) first and foremost, to celebrate the king and wish for his longevity and thus the country's prosperity, (2) to encourage peace and the following of the Buddha's precepts, and (3) to educate the public about post-Angkorian art and types of representations of the Buddha. The court, religion, and art history are all in play here. Many of the Buddhas are covered with remnants of paint, gold leaf, and lacquer, testifying to their use as religious images. Although no new gold is to be added to the surface of these museum pieces, worship from afar is encouraged and the transition back to a shrine is at least partially accomplished.[15] The gallery in which the post-Angkorian Buddhas are being shown was initially meant

to house temporary exhibitions, both curated from within and invited from without. In an official change of heart, the gallery of the post-Angkorian Buddhas has now been declared a permanent shrine. The roots of such initiatives and reversals lie in an earlier time when "art" was first distilled from religion, and when all our current terms — "art," "museum," "monument," "collection," "preservation," and "tourist" — first arrive (or is it emerge?) in the place that was not yet Cambodia.

THE BEGINNINGS OF THE MUSEUM

The Albert Sarraut Museum (today the National Museum of Cambodia) was established between 1917 and 1920, due largely to the urgings and efforts of George Groslier (figure 1).[16] The founding of the museum — and the interlocking system of cultural management that accompanied it — emerged from Groslier's evolving perspective of local culture under the French protectorate.

Initially Groslier was simply one of a succession of early visitors who urged the adoption of both the portable painted form of Western art as well as its institutions and social meanings. The entrepreneur Caraman, for example, had "fifty copies of paintings by Rembrandt and other European masters" added to a 1873 shopping list that, he claimed, would provide King Norodom with all the accouterments proper to a king.[17] In 1911, Groslier wrote to King Sisowath asking permission to paint his portrait and suggesting that the resulting picture could be the first contribution to a "gallery" of "portraits of the rulers of Cambodia."[18] The following year, Groslier angled eagerly for a commission to decorate the Throne Hall as part of ongoing renovations of the Royal Palace. A series of commissions were granted to French painters who rendered traditional Khmer subject matter (the Reamker) in a decorative realist style.[19] Through such initiatives, Western forms of representation as well as institutions such as the gallery were simply to be imported virtually unchanged from France to Cambodia. As the decade proceeded, however, Groslier changed his point of view. Seeing what he came to consider as the rapid erosion of traditional forms of making brought on by the French presence, Groslier would dedicate the rest of his life to building institutions that would carefully cordon off a "pure" Cambodian art from Western influence.

To the mature Groslier, the hybrid forms, the Western quotations, the changing codes of dress, and the new behaviors and aspirations he witnessed in Phnom Penh during the early part of the twentieth century were disastrous devolutions brought about by the coming of the French. Dismayed at these changes, Groslier developed a particular stance toward modernization. While he had no objection to changes in "intellectual matters," which he felt should

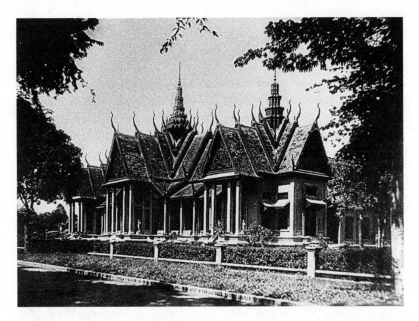

1. The Albert Sarraut Museum (today the National Museum of Cambodia) was designed by George Groslier in a "plan after Preah Vihear and portions of Angkor Wat . . . slightly modified because of its new function." Photo (ca. 1924) courtesy of the National Archives of Cambodia.

indeed introduce ideas of "universal usage" into Cambodian society, art was a very different matter.[20] While Groslier agreed that, through "less regrettable blows," Cambodians should "no longer put hot coals under their new mothers, [should] drink proper water, clean their wounds with antiseptic . . . and make use of proper pens," these changes should not cause the loss of "their patient chiselers, their weavers . . . [and] vigorous sculptors in wood."[21] In other words, forms of artisanal hand labor were to be preserved in the face of other modernizing projects.

The paradoxes of this position were freely admitted by Groslier. With the coming of French power, displaced aristocrats and local potentates copied the visually available signs for Frenchness, abandoning local commissioning habits in favor of the purchase of French products.[22] Markets filled with manufactured goods, which local populations eagerly substituted for previously handmade things.[23] Groslier accepted such social sea changes as unavoidable and irreversible, just as he sought ways to foster traditional forms of production within the context of modernity:

> In our age, as all the great countries of the Orient and Asia modernise themselves, the West becomes more and more the client of the traditional arts which

they abandon. If they were to make Turkish carpets and only sell them in Turkey, they would go bankrupt. It is because they had only Cambodians for their clients that the Cambodian arts have collapsed over the last forty years.[24]

By the 1920s, a steady stream of tourists was coming to Cambodia, lured by newspaper accounts of the temples as well as the active publicity campaign pursued by Groslier's arts administration.[25] It was to this foreign audience that "pure Cambodian Art" would now be sold, since the "traveler" standing "in view of Angkor" would "only be interested because the art is indigenous, Cambodian, and thus different from Western art."[26] In the curious geography of consumption that ensued, Cambodians would produce "traditional" handmade things for a distant clientele while relying on French-manufactured goods for their everyday modern lives.

What was the role of the French administration, and Groslier himself, in such a "pure" Cambodian art, especially if, as Groslier explicitly stated, he could never teach at the School of Cambodian Arts since "I am not Khmer"?[27] According to Groslier, the "Cambodian Arts" had become "strange to themselves," incorporating, hybridizing, and changing their centuries-old form. It was necessary, Groslier declared, "to go backward thirty years in order to re-find the national art in its authentic forms and in the last stages of its natural and historical evolution."[28] The labor of excavating, illuminating, and defining unadulterated Cambodian art provided the French with their "magnificent role": "we profit from procedures that [the Cambodians] ignore . . . we know research methods that they don't even imagine."[29] Through a process of "nutrition and selection," colonial administrators would distill authentic Cambodian art, "rendering it accessible to its practitioners," and giving them access once again to "their history [and] their past."[30] The Albert Sarraut Museum (today the National Museum of Cambodia) stood at the center of this project to define the "Cambodian Arts."

In a sense, the founding of the museum simply formalized what had preceded it. One of the first activities French explorers and then administrators pursued upon their arrival in the region was collecting. Not only did they collect things they identified as "art," but they also assembled a wide variety of other objects (tools, prehistoric implements, fishing equipment, baskets, ceramics, etc.), as well as collecting views (through drawings and photographs), inscriptions (through rubbings), habits (through ethnographic notes), and songs (through their notation), removing their so-called discoveries from the fabric of life and fixing them in documentary form. During the first few decades of the protectorate, increasingly comprehensive collections of things were transported back to France to create the pictures of Cambodia fea-

tured at colonial exhibitions and in the first tentative displays of "Indochinese art."[31] At the 1900 Colonial Exhibition, for example, the exhibits on "Cambodge" included sculptures, molds, paintings, musical instruments, weavings, silks, ropes, monks' clothing, temple furniture, bells, gongs, dancers' clothing, masks for theater, scale models of Cambodian houses, farming tools, fishing tools, model boats, an oxcart, medicines, animal skins, mats of all kinds, pots, ceramics, prehistoric tools, weapons, minerals, resins, types of rice, types of wood, tobacco, cardamom, pepper, rubber, cotton, maps, and views.[32] From all of these objects—and the attempts to understand and contextualize them through field research, translations of inscriptions, and readings of local texts —the study of "Cambodge" became a "scientific" pursuit that produced Cambodia as an object described by foreigners.[33]

Although the Albert Sarraut Museum engaged in similarly comprehensive collecting, the museum was explicitly founded to stop the flow of original artifacts to France. "From the beginning," the director of the Ecole Française d'Extrême-Orient wrote to the resident superior of Cambodia on March 3, 1905, "our ambition has been to distance as little as possible objects uncovered from their site of discovery and thus to create a Khmer museum in Phnom Penh, and a Cham Museum [in Annam]."[34] Throughout the 1920s, Groslier's teams searched for, bought, borrowed for copying, and photographed all they could find in the countryside that they considered authentic and pure.[35] "Everything concerning artistic, monumental, documentary and historic Cambodge," Groslier wrote, "will be centralized in a group of buildings that the tourist, intellectual, artist can traverse from one side to the other in a single trajectory. . . . [F]or the native artist, the School will become more and more his home, and the Museum his treasure."[36] While the Albert Sarraut Museum was to assemble "original" models under one roof, the School of Cambodian Arts would teach aspiring youths to faithfully reproduce them. Through the double operation of this complex, "the complete education of the foreigner . . . as well as the reeducation of the Khmer people" would be ensured.[37]

From the start, the Albert Sarraut Museum was "the object of numerous visits" by "the indigenous population," and Groslier noted that "among these visitors, the majority of them are monks who frequently contribute lessons about the statues, or deposit what they have been able to transport to the museum."[38] It seems, then, that the notion of collecting was not an entirely foreign impulse. Indeed, local temples in what, at the turn of the century, was just becoming knit together as the Cambodian countryside had been collecting and storing—if not displaying—old sculptures, manuscripts, precious objects, and oddities. Temples were also the site of ongoing production—making anew in

the form of the old, passing forms of making on to younger generations. Visual objects made in religious and courtly contexts generally seem to have carried social meanings of devotion or tribute. Before the coming of the protectorate, "art" was not generally recognized as portable objects to be sold.[39]

Hints of this different past tinge and perhaps perturb museum culture in Cambodia today. Both in Buddhist temple complexes and at the site of Angkor itself, there are centuries-old practices of building and painting over, of doing again. The old is incorporated into the new by building on and sometimes covering over it. New temple halls replace decaying older ones; fresh temple murals are painted over fading images.[40] Such activities are thought to bring merit to those who sponsored the renovations (as opposed to restorations), confirming the ongoing sacredness of a site thus reused. This tendency to rebuild, to incorporate, and to continue on can be read as a long-standing irreverence toward what the West understands as keeping, enshrining, and preserving. Put differently, this kind of past becomes an ongoing process rather than a final product, a building up of layers in which the surface will look new while bearing with it (in social memory at least) all its preceding layers. This is a past that refutes the logic of the snapshot, the claim that the past can be captured as a surface in a picture taken today.

THE AGE OF DISPLAY

Ordinary things seem to have had different meanings prior to the inauguration of the museum. Remaining responses to a survey of 1917 tell of local villagers simply disposing of things that were old in favor of things that they considered "new."[41] Manufactured cloth replaced hand-woven cottons and silks, old bamboo and lacquer vessels were thrown away in favor of manufactured metal bowls, handmade tools were discarded in favor of manufactured equipment introduced by traveling merchants. To keep these old things did not seem to have occurred to villagers who had not yet become nostalgic for what was passing.[42] Why should one keep the past, especially if it had become broken and useless? Making was in the name of going on, and survey responses note a shift in village commissions toward "new" styles. The wooden tool, the lacquer bowl, or the oxcart were not to be cut out of the fabric of life as artifacts. If they had no use, they were discarded.

There were objects, however, that were collected and displayed by local authorities in the early years of the protectorate, prior to Groslier's reorganizations. What was on display initially were the objects that embodied the new relations brought on by the protectorate and the more general onset of modernity. Accounts published in 1904 and 1912 describe a ceremony called Tang

Tok (which roughly translates as "display table"), held in celebration of the king's birthday.[43] The ceremony was a recently established rite that enlisted collecting and display in the effort to knit together an as yet incoherent "nation" of Cambodia. Officials from an ever-widening swath of territory were compelled to travel annually to Phnom Penh, bringing with them their collections of objects to be presented on tables in the Royal Palace in honor of the king. The early displays seem to have been curiously detached from local identities, at least to the eyes of foreign observers. Writing in 1912, Ménétrier describes objects "from all over the place," displayed under the "most varied lights: lamps, candelabras, photophores": "French or German clocks, Chinese or Japanese statues, artificial flowers, the horn of a buffalo, Cambodian art objects," the most "strangely disparate objects" all jumbled together, "costly or pleasing pieces right next to baubles without value." It was incomprehensible (to Ménétrier) that the advertising mascot for Le Nil cigarette papers (a cardboard elephant with a moveable head) could "be enthroned in the place of honor" on one table. To officials of the countryside, however, the point seems not to have been to assemble "Cambodian" things, particularly since such a national identity did not securely exist as yet.[44] Rather, everything wonderful or strange, whether local or distant, was assembled in tribute to the king. The greater the abundance and diversity of objects offered, the more wonder was assembled and the more homage paid.[45] Local audiences came to look without buying, and this scene of marvel was repeated year after year.

The displays of Tang Tok seem to have irritated Groslier and French administrators for many reasons.[46] Not only did provincial authorities refuse to submit their objects to what, for French administrators, were the self-evident organizational categories of "art," "industry," and "agriculture," but they jumbled objects of varying value together, allowing "natural oddities," "man-made trinkets," and what these administrators saw as "high art" to be displayed all together on a single table. The stasis of the displays worried the French administrators as well—the same objects appeared year after year, as local authorities found no reason to change the objects they offered in homage to the king. In other words, the objects on display refused to disappear into a circulation that would allow new objects to appear.[47] By 1925, Tang Tok had come under the full authority of a protectorate-appointed commissioner, and objects were separated into broad categories of "agriculture," "industry," and "art." Monetary prizes were awarded, and sales of displayed objects were encouraged. No object could win a prize twice, and redisplay was discouraged.

New protectorate directives instructed that the displays of Tang Tok were to "throw into relief" the "economic characteristics" of each region of the country.[48] No longer was the permeation of Cambodia by foreign products to be

put on display. Rather, France and Cambodia were to be clearly delineated and firmly pulled apart in the displays. By the 1930s, officially approved Cambodian stands were only exhibiting hand-woven silks, handmade silver, ancient tools, and natural products, carefully categorized according to the local areas to which they were considered "native." The Nil elephant, agricultural equipment, the factory-made tools, and French furniture were all firmly back in the exhibits of French companies seeking markets for their products in Indochina. In this new order of nations, Cambodia was the land of the handmade and the ancient singular, while France was represented through the mass-produced multiple. German clocks and Chinese statues were nowhere to be found.

If Tang Tok served as a source for originals dredged up from the countryside (Groslier had first option to claim any object on display for the museum collections), then the annual displays — and the searching and collecting they inspired — also came to provide a curious forum for research and development of that paradoxical object, the new yet traditional Cambodian art object.[49] Existing "tradition" was, after all, a limited store. While individual original "models," enshrined in the museum, could be replicated through the corporation system, consumer demand required a continual stream of new traditional objects as well.[50] In Groslier's system, the past was not just to be the past, housed in a museum and set off for viewing. Instead, the past was to become productive, brought into the present and proposed as the future, a future past in which Cambodia would be enshrined and then would work to continually reproduce itself. This emphasis on production was clear in Groslier's early description of the planned museum to the local artisans he was trying to entice to join the corporations:

> Do you know that in the coming year, the School will build a big house [the museum], and all of you can take the things you want to sell and exhibit them in that house. You have to begin to prepare things to exhibit starting now. At present, there are not many things, but tomorrow there will be more things, and the day after ever more things.[51]

By the late 1930s, the "Cambodian Arts" were sold in outlets in a startlingly wide (global?) network of cities, including Port Said (Egypt); San Francisco, Santa Barbara, Los Angeles, Washington, D.C. (United States); Algiers (Algeria); Papeete (Tahiti); Bangkok (Thailand); Batavia (Dutch East Indies, i.e., Indonesia); Singapore; and Medan, while ventures such as the traveling Houtmann ship brought displays of Cambodian arts to African shores.

THE ERA OF INFORMATION

After independence in 1953, display was put to a different purpose. During the 1950s and early 1960s, the United States Information Service (USIS) engaged in a campaign to "present an image of the United States" to the Cambodian public as part of a larger effort to win hearts and minds over to the so-called free side in the Cold War.[52] Through the "dramatization" of United States aid projects in Cambodia, "evidence" was presented of U.S. "support for, and strengthening of Cambodian independence." "American life" was also displayed as a distant ideal for Cambodians to aspire to. Through exhibitions, public film screenings, and illustrated magazines, USIS aimed to create the "desired stereotype of the US" and thus to convert Cambodians to "our way of life."

The range of images, events, and information brought to Cambodia as part of this campaign (which was counteracted by an equally active flow of images, events, and information from so-called communist countries) dramatically increased (or established?) cultural flows pouring into Cambodia from the "advanced" or "developed" world. USIS displays presented in Cambodia during 1958, for example, included "Space Unlimited," "Sports in the USA," "Contemporary American Prints," and "American Architecture" (all offered as "modest" exhibits of eight-by-ten photographs in public spaces). The richly illustrated USIS magazine *Free World* (distributed free in print runs of seventy thousand by the end of the 1950s) presented an extensive range of Khmer-language articles on topics (just to cite from the arts and culture sections) such as Stieglitz's work, underwater photography, modern art education at the Pratt Art Institute, beauty contests, modern apartments and their furnishings, hair fashions, and various traditional arts of Southeast Asia. Marian Anderson, Benny Goodman, and other famous entertainers performed in Phnom Penh, while *Life in Kansas* and other documentaries about regional and city life in the United States graced mobile movie screens set up throughout the Cambodian countryside. As the U.S. government's 1961 Country Assessment concluded, such images and texts, circulating in public arenas, "were particularly useful in trying to get across the story of American education and scientific achievements."[53]

Although we can retrospectively dismiss this stream of images and information as propaganda, we should also perhaps use it to reconsider contemporary global cultural flows. For the elderly painters and sculptors who remember the 1950s and early 1960s in Phnom Penh recall the books of the American library, the USIS films, and the *Free World* articles as part of an influx of new information and models that fundamentally changed Cambodia following independence.[54] Indeed, as the pamphlet for the 1955 International Exhibition of

Phnom Penh put it, such displays allowed local viewers to "look at the interna-
tional."[55] While under the French protectorate Cambodia had been hemmed
into the limited network of the metropole and its colonies, now "the world"
was seemingly coming to Cambodia, according to the author of the pamphlet.
Local viewers could "compare" the "economy, progress and culture" of other
countries to that of Cambodia. At the International Exhibition, the normal
distances of geographical separation were transcended, and visitors could see
the world "clearly together."[56]

With the hindsight of almost fifty years, we can say that what was seen
in such forums of the 1950s was primarily Cold War propaganda, "images"
and "stereotypes" carefully edited into public presentations. Still, from recol-
lections of its local reception, it is somewhat disconcerting to realize that the
architecture of the Cold War made minor countries such as Cambodia much
more central and information-filled than they are in the configurations of the
present. With the political fears of the Cold War gone, governments by and
large no longer find it worth the effort to bring such information to Cambodia
today.[57] If I try to think of what does come in and out, I come up with the fol-
lowing. Tourists come to Angkor, of course, and to the museum in Phnom Penh
as well as to the as yet "undeveloped" beaches in southern Cambodia. In other
words, they come to pockets—particularly cultural pockets—of the country.
Foreign aid workers dot selected areas of the countryside as well, with their
surveys and pilot projects. Since the "reopening" of the country in the early
1990s, products have poured in: Marlboro cigarettes and Coca-Cola to even
the most remote countryside; Caltex Star marts, imitation McDonald's burger
joints, modern supermarkets, and boutiques to the cities, particularly Phnom
Penh. But the equivalent of Benny Goodman, an exhibition of photographs of
contemporary visual art from the States, or an explanation of education at a
United States college written in Khmer—that would never come today. Instead
a reverse flow increasingly exports the most canonical forms of Cambodian
culture as spectacle to Western venues, adding to the ever-diversifying menu
of cultural entertainment offered to audiences of the developed world. A large
show of Angkorian sculpture toured France, the United States, and Japan in
the 1990s, and the National Dance Troupe has completed a series of widely ac-
claimed foreign tours, marred only by an alarming rate of defections among
the performers. Indeed, despite the talk of global flows and unprecedented
mobility, life in Cambodia today seems entirely fixed, rooted in a limited hori-
zon of everyday life that is mobile only within national borders.[58] There is the
near impossibility of getting a visa to go anywhere (especially overseas), let
alone having the money to pay for such a passage. What kind of a global public
sphere is it when it is so clearly divided between those who travel and those

who stay, those who come to see and those who are on exhibit, things that move and people that stay here?

There are some who say that technology is overcoming such rootedness. Indeed, the national television station in Cambodia presents a stream of foreign movies, Thai soap operas, reruns of old U.S. television shows (including *Starsky and Hutch*), Hong Kong kung fu movies, and delayed soccer matches. But for the vast majority of viewers, there is no cable. The international news is cribbed from various services in ten-second image clips running over and over again as the narrator dutifully recites basic information of plane crashes, tornadoes, and church sieges. Any larger context or analysis of the relation of such news to local lives is entirely missing, and the relatively incomprehensible information thus gleaned is often creatively reprocessed through the points of reference of local life.[59] There is no ability to ask why and how and whether it should be like this. There is, as Arjun Appadurai tells us, a gap between the "knowledge of globalisation and globalisation of knowledge."[60]

THE TEMPTATIONS OF TRAVEL

If I try to describe these configurations of the present in a more concrete, immediate, and small way, then I turn to myself as a foreigner, serving as co-director of an otherwise self-consciously "Cambodian" cultural institution in Phnom Penh. With Ly Daravuth, I run a storefront exhibition space called Reyum, which has also become a small publishing house. Reyum started as a single exhibition held in late 1998, following the decision of the curators of the First Fukuoka Art Triennale (Japan) to include Cambodia in their exhibition.[61] The curators distributed information on the Triennale and its theme, "Communication," and asked interested people to prepare "art" for their visit to Phnom Penh, which took place in August 1998. While the curators explicitly said that they wanted the Triennale to include artists from as many countries in Asia as possible, they seemed somewhat dismayed by the type of work they found in Cambodia. There was no "performance" work, nothing similar to the kind of "identity" installations that were making several Thai and Vietnamese artists increasingly well known at that time. The curators chose one painter's work to show and invited one sculptor to do a residency at Fukuoka. Then they left town. Daravuth and I had written the survey article for the Fukuoka catalog, and we decided, somewhat on the spur of the moment, to show the work that had been done for the curators' consideration. It was the first time that many of the younger professors at the Department of Fine Arts had made work since they returned home from MFA studies in the former Soviet Union, Poland, Hungary, and Bulgaria.[62] Instead of the usual indiffer-

ence to or complete incomprehension of their work found among domestic audiences, Fukuoka was an opportunity, particularly since there was travel and money on offer. We decided that all the work that had been produced, whether selected or not, should be shown in Phnom Penh.

We arranged with Bill Herod, a friend of ours, to use the front of what was then KIDS Internet Café, a space that today is the entrance foyer of Reyum. The space is located directly across from the National Museum and the southern campus of the Royal University of Fine Arts. We painted the walls white and added track lighting, turning the foyer into what I recognized—with some degree of unease—as the well-lit white box of the typical Western art gallery. The younger artists we showed were eager to claim such an "art" space for their work, and they were irritated by the one elderly painter, Svay Ken (ironically the one chosen to show in Fukuoka), whose work was hung in stacked rows, recalling what the younger artists considered the format of the tourist painting shops that surround Reyum.[63] We printed invitation cards on a computer printer and put up posters publicizing our opening. In other words, we produced "contemporary art." Visitors came and the newspapers wrote about "modern Cambodian art."[64]

Our second exhibition, in the same space, featured the work of three elderly "masters," as we called them. We could have used "craftsmen," "artisans," or "traditional artists," all labels now used to describe them. The silver work of Som Samai, the masks of An Sok, and the paintings of Chet Chan were featured, again hung in gallery style with labels and a price list. This time we produced "traditional Khmer art." Again, visitors came and the newspapers wrote about "rebirth" and "saving a nation's soul."[65] Our third and final show in the small space was a project that we more actively initiated. We commissioned five large paintings from Pech Song, a painter who had painted for each of the last five political regimes to rule Cambodia. We asked him simply to make a painting representing each of these regimes as he saw fit.

Retrospectively these three shows traced a trajectory of available possibilities. The first show was perhaps the easiest possible path, given our backgrounds and the state of the contemporary art world. After Vietnam, Cambodia was next on curators' shopping lists. The only problem was that there was almost no "work" that could fit the conceptions of "contemporary art" carried by those who came looking for it. We could have become an art gallery with a small stable of artists whom we would cultivate as performance and installation artists, constructing identities out of Angkor and genocide. Their work would increasingly be included in international exhibitions whose curators seem eager to include artists from an ever-growing list of nations. The moves seemed so clear and yet so forced and hollow. The second show pointed

to another path, that of "saving," "preserving," and "cultivating" the myth of the "last." The last Khmer silversmith, the struggling master mask maker, the aging traditional painter—these were tropes that collectors are eager to embrace. To market such figures, however, one must disregard all evidence suggesting that longstanding ways of making are relatively easily reborn by well-trained young practitioners if a luxury market can be found for their products. As Groslier noted astutely more than eighty years ago now, the tourist market will encourage and support ways of making that have lost their original social meaning if they can find new markets as souvenirs within the configurations of modernity. As we worked with the elderly "masters," we were forced to recognize an uglier fact as well: in Cambodia, the "lastness" of such figures is primarily due to their refusal to adequately teach anyone else their craft, preferring for economic reasons to keep their knowledge secure within a tight family circle of sons (or daughters in the case of weaving). Quick tradition in such monopolies becomes easy, with corners cut in the painstaking labor of production since there are no other makers, and the quality of the work is uneven at best.

Our third show, with Pech Song, perhaps pointed to where we find ourselves now. In order to make his paintings, he did research of sorts, going to various photo banks to find propaganda images with which he made the pastiches that became his paintings. On their surfaces were the main characters of the last thirty years of Cambodian history: Sihanouk, Lon Nol, the Khmer Rouge, and Heng Samrin, as well as the potentates and disempowered citizens of today. Since, in the much quoted words of Prime Minister Hun Sen, there is a sense in Cambodia today that one should simply "dig a hole and bury the past," it was unusual to find such images of recent history in a public space. People came off the streets, looked at the paintings, and started to talk. In particular, they told their children what had happened to them during the times that seemed to be pinned to the wall by the images of their principal players. Reyum became a space where information was presented for free, where there were things to see that might make someone think, readily accessible as images and easy-to-read Khmer-language texts. In other words, some small space opened for public reflection and thinking.

As we continued on, we have made more shows that we hoped would open up such forums. A show on tools and practices borrowed so-called traditional tools from their makers and considered how everyday practices change as the store-bought is substituted for the handmade. A collection of work considering absences brought on by the Khmer Rouge regime brought the issue of remembering (and forgetting) those years into a public forum. A recent show surveyed many forms of culture immediately after independence in Cambodia,

thus illuminating a time when forms of self-consciously "modern" Cambodian visual art, architecture, film, music, and theater were proposed. Such exhibitions do not have objects for sale. They are, however, accompanied by catalogs and increasingly ambitious books whose intention is to allow audiences to take the ponderings of the exhibition home and to allow those who cannot come to Reyum to see and think about what we present. At least that is how we frame what we intend to do.

But for Pech Song, his show was a failure. The paintings didn't sell. Although a few articles came out, his life wasn't transformed, and today, four years later, he still paints scenes of Angkor Vat and idyllic landscapes of the Cambodian countryside to make his living. Although some students and townspeople came to see his show—and some painters claimed to be inspired by its possibilities—it hasn't really encouraged others to take a chance and make paintings either about history or about contemporary social reality. After all, the paintings didn't sell. It is a fact that the vast majority of Cambodians (and Reyum addresses only a tiny elite urban audience of students and townspeople) are simply trying to eke out bearable livings based on subsistence farming. The population in the Cambodian countryside today still lives largely outside of modernity in wooden huts without electricity or running water. The outside world does filter in via black-and-white televisions attached to car batteries. But it is not cable. And museums, galleries, books, and ponderings on culture are far from these lives.

Recently there have been suggestions—temptations—of taking our exhibitions abroad, and (especially for Daravuth) of traveling to events at which he will present what we do and of course represent Cambodia. But for what? Cambodia is a blank, people tell us, and we are eager to fill it in. We could become "consultants," give lectures, and never really be here in the frustrating and endless process of trying to work together, to train young researchers, to develop the exhibitions, and then to edit and present them to the limited local audience that was and still is our first priority. There are two elsewheres, then, where we could take our shows. One is the vast and neglected dusty Cambodian countryside, where there are rarely things to see. The other is the world of the West, with its many galleries and eagerly interested audiences. As we ponder these two alternative sets of travel plans, a rather one-way street emerges. It seems that developed venues (with their established spaces, fund-raising capabilities, and tour experiences) can take anything and display it in the name of programming diversification and cultural edification, often making beautiful and informative exhibitions about countries and cultures that themselves remain pockets of the unglobal, places that simply provide the materials for such edification while never becoming the venues of its display.

2. The entrance to Lucky Market in downtown Phnom Penh. Photo by Ingrid Muan.

A CLOSING VIGNETTE

Lucky Market is packed with people on Sunday evenings. Entire families—
babies and grandmothers in tow—clog the aisles. Sunday is the night for going
out on the town in Phnom Penh, and Lucky Market—one of an increasing
number of air-conditioned supermarkets to open in the course of the last ten
years—has become a popular destination—not for shopping necessarily, but
for looking (figure 2). Its shelves are stocked with a modest selection of pack-
aged food and household products (or at least modest when compared to the
mind-boggling array of products found in the aisles of suburban U.S. super-
stores). For the average inhabitant of Phnom Penh, however, Lucky Market is
a place of wonder, their point of comparison the open-air markets where most
women shop twice a day; there, piles of rice, stacks of vegetables, hunks of
freshly slaughtered pork and beef, still writhing fish, and fruits of the season
are laid out on bare wooden tables—often teeming with flies—for the inspec-
tion and prodding of bargaining buyers (figure 3). In Lucky Market, however,
food is at a distance, not for handling, sealed in plastic, packed in boxes, set on
shelves, and shifted from the horizontal of a table to a vertical axis of viewing
from afar. On Sunday nights in Lucky Market, there are hushed conversations
in front of plastic-wrapped Styrofoam trays of "fresh" vegetables. Not daring
to touch, women peer at the produce, reading price labels in awe. The frozen
food section is a marvel, many of the ice cream products incomprehensible to

3. Chicken for sale in the Central Market of Phnom Penh. Photo by Ingrid Muan.

4. The meat aisle in Lucky Market. Photo by Ingrid Muan.

those not yet sensibilized by television advertising. Boneless chicken breasts are dubbed "chickens who stepped on a mine" in order to explain the headless, legless, wingless mounds of flesh (eerie beyond belief to those accustomed to buying living birds and slaughtering them in a country that has been heavily mined) (figure 4). In front of skin-whitening creams, hair sprays, and conditioners, people simply stand, looking back at the products. It occurred to me one Sunday that this reverent looking from afar, these hushed conversations of surprise and wonder, this leaving without taking anything away, are behaviors associated with classical museum going. Could it be that for the average local audience in Phnom Penh today, the most popular contemporary museum is Lucky Market, where all that is wondrous and unattainable from the outside is on display? Along its spotless aisles and in its ringing cash registers, the gap between the hot, dusty chaos of local lives and the far-off air-conditioned (and imaginary) order of "developed" lands is displayed for those who cannot travel.

NOTES

1 "International community" translates here more accurately as the United States, the European Community, Japan, Australia, and (later in the 1990s) the ASEAN countries.
2 Conversation with a boy selling souvenirs at Chau Say Tevoda temple, Angkor Archaeological Park, 1998.
3 Wager, *Zoning and Environmental Management Plan for the Siem Reap/Angkor Region*. In this formulation, "culturally motivated tourists" do not exist among Cambodians or those coming from neighboring countries.
4 Henri Mouhot is frequently said to have "discovered" the temples in the 1860s despite ample evidence that the site was inhabited and used by local communities continuously from the age of Angkor through the advent of the French protectorate in 1863.
5 Frow, "Tourism and the Semiotics of Nostalgia."
6 Three main sites have been officially labeled "museums" over the last two decades in Cambodia: the National Museum of Cambodia, the Tuol Sleng Prison Museum, and the Museum of the Former Palace. The Tuol Sleng Prison Museum was established in 1979–80 to document the horrors that took place on the grounds of the former school during the Khmer Rouge regime (1975–79). Photographs of prisoners, taken when they arrived at the prison, fill the walls. A series of paintings by Vann Nath, one of the prison's few survivors, are said to replicate real scenes of torture, while other eerie remainders—iron bed frames used to chain prisoners, shackles, holding cells, and until recently a map of human skulls—complete the museum tour. The National Museum of Cambodia and the Tuol Sleng Prison Museum typically fill the one-day itinerary of the foreign tourist to Phnom Penh—art in the morning and genocide in the afternoon, as some put it with cynical succinctness. Few Cambodians visit Tuol Sleng Prison Museum, but the National Museum is often filled on official holidays

with visiting villagers. A third, now less securely labeled "museum" in Phnom Penh attracts both villagers and foreign visitors. During the 1980s, under the People's Republic of Kampuchea, the Royal Palace became known as the Museum of the Former Palace. With the return of the monarchy, the word "museum" has been dropped from its title and the Royal Palace is now a "former museum" instead. Unlike many other cities in Southeast Asia today, Phnom Penh has neither a contemporary art museum nor a history museum, although plans for more museums are in the works. The Ministry of Culture and Fine Arts intends to revitalize a set of small provincial museums established after independence. Foreign initiatives, such as the planned museum at the Memot Centre of Archaeology, aim to establish provincial displays as well. A Japanese company has proposed a joint-venture Angkor Vat museum near the site of the famous temple. And recently there has been talk of an Anlong Veng museum, which will display life in the last outpost of the Khmer Rouge. Few, if any, of these initiatives are born from the communities in which the museums will be placed. Rather, they are planned from afar and are at least partially (if not completely) motivated by the fact that museums can charge admission and, given the increasing number of tourists coming to Cambodia, thus promise a steady stream of income to those who establish them.

7 See Karp and Lavine, *Exhibiting Cultures*, and Karp, Kreamer, and Lavine, *Museums and Communities*.

8 In other words, well-worn definitions and ways of doing things are brought to Cambodia in the name of "reconstruction," but what will be constructed is precisely what is now in question in some spheres of the West. To leapfrog to the stage of the critique, however, seems impossible as well, since the critique — and the understanding that generated it — are based on having lived through and with what came before. For interesting deconstructions of world heritage sites, see Castañeda, *In the Museum of Maya Culture* and Clifford, "Palenque Log."

9 Svetlana Alpers calls it "the museum effect": "the tendency to isolate something from its world, to offer it up for attentive looking, and thus to transform it into art like our own." See Alpers, "The Museum as a Way of Seeing," 27.

10 By scripting I mean the text, the images, the lights — all that surrounds, guides, narrates, and comes to determine the experience of the collection, fixing it according to by now well-worn codes and conceptions of museums.

11 As I was finishing this essay, a set of equally misty framed black-and-white photographs of temples, taken recently by John McDermott, were hung at scattered intervals on the museum walls as well.

12 A visit to Angkor can be quite physically challenging to an out-of-shape tourist. There are long causeways to cover and steep steps to climb, all in often extreme tropical heat.

13 See Stephen Greenblatt's formulation of "two distinct models for the exhibition of works of art," that of "wonder" and that of "resonance," in Greenblatt, "Resonance and Wonder," 42.

14 Quoted passages in this paragraph come from the National Museum of Cambodia label for the Buddha of Vat Kompong Luong.

15 The practice of making offerings to statues in the museum collection involves on-going negotiations between restoration culture and practices of worship. Many of the sculptures in the museum now have separate bases for offering flowers and incense so that the organic materials do not come into contact with the stone sculptures. In the Cambodia of reconstruction, however, few things are as they seem, and religion too has become commercialized in creative ways. Museum guards have turned the act of offering into a "cultural experience" in which foreign visitors are urged to participate. Jasmine flowers are sold to potential worshipers, and guards presumably collect the money left as offerings on plates in front of particular sculptures.

16 Groslier (b. 1887) was the first French baby born in Phnom Penh. He was sent to France as a small boy and was trained as a painter at the Ecole Nationale des Beaux Arts, Paris. Groslier returned to Cambodia on several study tours before permanently settling in Phnom Penh in 1917. A small museum was already established in Phnom Penh by French administrators in 1905, and the Albert Sarraut Museum grew out of this existing collection. For more on art and art education during the French protectorate, see Muan, "Citing Angkor."

17 Muller, "Visions of Grandeur," 136.

18 National Archives of Cambodia #2007 (RSC).

19 National Archives of Cambodia #9755, #10204, #17661, #23706 (RSC).

20 Groslier, "La Tradition Cambodgienne," 469.

21 Ibid.

22 Ibid., 459.

23 Survey responses in National Archives of Cambodia #8126, 15200 (RSC).

24 Groslier, "L'Enseignement et la mise en pratique des arts indigènes," 7.

25 The early tourists came primarily from within Indochina, as well as from France, other European countries, and the United States. See Groslier's annual statistics of visitors in National Archives of Cambodia #2010, 2017, 17503, 16445 (RSC).

26 Groslier, "Rapport sur les arts indigènes au Cambodge," 1925, National Archives of Cambodia #11322 (RSC), and Groslier, "L'Enseignement et la mise en pratique des arts indigènes," 9.

27 The "fundamental" principle of the school was "only to make Cambodian art and only to have it made by Cambodians." See Groslier, "Rapport sur les arts indigènes," as well as correspondence in National Archives of Cambodia #9084 (RSC).

28 See Groslier, "L'Enseignement et la mise en pratique des arts indigènes," 7.

29 Groslier, "Inauguration du Musée Albert Sarraut et de l'Ecole des Arts Cambodgiens," 6.

30 Ibid.

31 Dagens, *Angkor: Heart of an Asian Empire*.

32 National Archives of Cambodia #425 (RSC).

33 See Edwards, *Cambodge: The Cultivation of a Nation* for a detailed discussion of this process.

34 National Archives of Cambodia #14617 (RSC).

35 The scope of this collecting is perhaps best captured in Groslier's own words. His

system to save and promote the Cambodian arts would first have to "fill itself," "identifying" and "fixing the Cambodian Arts." Each "tentacle" of his "octopus" considered a "dying artistic industry": "The jewelry tentacle wanders through the country sucking in formulas, processes, traditions, examples [and] materials which are in this way centralised by a handful of skilled workers who will fix them [as models within the system]. The same action is undertaken by the sculpture and architecture tentacles." In 1918, the "octopus was working in Phnom Penh" since "one must begin in the places most frequented by Europeans, where the old things are the most rare and the most threatened." In subsequent years, collection teams covered ever greater swaths of countryside. By 1925, Groslier's description of the museum's collection reads like an avalanche: "[W]e have in the Museum, at the present time, 547 first-class bronzes of all dimensions, statuettes which offer innumerable data on Buddhist and Brahmanic iconography, decorations for vehicles and buildings, many ritual objects: bells, casks, conches, molds for ex voto, pieces of harnesses and various other accessories; 519 pieces of Chinese ceramics imported into Cambodia (since the T'ang era), as well as Khmer ceramics of an original shape but inspired by these Chinese types; vases in the form of animals; containers for oil and lime; perfume jars; architectural elements; tiles . . . 300 statues of stone and 110 pieces of architectural details, examples of all the stages of Khmer statuary from the 1st centuries of our era onwards; 500 jewels of all kinds . . . equipment for preparing betel, bowls, enameled objects, niello, objects of ivory, lacquered wood, gilded wood, pieces charting the evolution of the Khmer arts since the 15th century to the 19th century; musical instruments; theater accessories; theater costumes; the sedan-chairs of Kings; coins; weapons; illuminated manuscripts; 120 gold threaded silks . . . some pieces belonging to the Treasures of the Crown that have been deposited in the Museum by King Sisovath." See Groslier, "La prise en charge des arts cambodgien," 258, and "Rapport sur les arts indigènes au Cambodge."

36 Groslier, "La convalescence des arts cambodgiens," 884.

37 See Groslier, "Rapport sur les arts indigenes au Cambodge."

38 Groslier, "Rapport sur le fonctionnement de l'Ecole des Arts cambodgiens, fin 1920," National Archives of Cambodia #8336 (RSC). According to Groslier's attendance records, in 1920, 436 Europeans visited the museum and 904 "natives"; by 1924, 2,039 Europeans visited along with 11,661 "natives." See Groslier, "Le Service des Arts cambodgiens du 1er Avril 1922 au 1er Avril 1924," National Archives of Cambodia #2010 (RSC).

39 See the 1917 survey responses in National Archives of Cambodia #8126 and #15200 (RSC). In the existing palace workshops, for example, the best artisans of the country were called together to work for the king, producing high-quality objects for the court, for temples built under royal patronage, and perhaps for gifts for foreign dignitaries. The palace workshops were preoccupied with this labor and did not produce surplus for sale. Early French administrators found these workshops "unprofitable" and, as early as 1907, tried to establish a store in the palace where a "surplus" was to be sold as art objects.

40 For examples of reuse and rebuilding, see APSARA, *Guide to Angkor Thom*. See the survey responses in National Archives of Cambodia #8126 and #15200 (RSC).

41 The 1917 survey responses also note "foreigners" beginning to travel in the countryside who were interested in "buying and taking away old things." See National Archives of Cambodia #8126 and #15200 (RSC).

42 My description of Tang Tok relies on Leclère, "Cambodge: Le Tang Tok" and Ménétrier, "Les Fêtes du Tang-tok à Pnom-Penh."

43 Edwards, *Cambodge: The Cultivation of a Nation*.

44 Wonder is "as much about possession as display," Greenblatt tells us. Here officials offer up their possessions to the king in displays that double the wonder through the display of obedience.

45 See National Archives of Cambodia #2427, #5603, and #11402 (RSC).

46 "Putting the sculptures back into circulation" is the charming phrase Clara Malraux used to retrospectively justify the famous Malraux affair of 1923–24 in which the couple, having established that there were as yet no firm laws against the trafficking of artifacts in Indochina, embarked on an archaeological expedition to Banteay Srei, during which they removed several sculptures that they intended to ship back to France. Malraux was arrested in Phnom Penh, and the trial became a focal point for debates on the "looting" of "cultural heritage." See Dagens, *Angkor: Heart of an Asian Empire*.

47 By transforming the display of wonder into a sale of products, colonial authorities felt that they had "very successfully taken advantage of this ancient custom in order to create competition between the Cambodians and to encourage them to develop themselves in the artistic domain as in the economic domain." See the draft report on Tang Tok (mid-1920s), National Archives of Cambodia #2000 (RSC).

48 For more on this system of designing "new" traditional objects, see Muan, "Citing Angkor."

49 Groslier soon realized that French administrators working in Indochina represented a significant repeat clientele for Cambodian art if his system could produce new traditional products annually.

50 See the flier announcing the formation of the corporations in National Archives of Cambodia #394 (RSC).

51 See National Archives of Cambodia #2135 (RSC); Mission de Propagande Indochinoise au bord du S/S Houtmann, 1933 pamphlet, National Museum of Cambodia; and the 1940 report in National Archives of Cambodia #2135 (RSC).

52 For discussions of this "image campaign" see Country Assessment Reports 1959, 1960, 1961, RG 59, General Records of the Department of State, Bureau of Cultural Affairs, Planning and Development Staff, Country Files 1955–1964, Box 220, United States National Archives at College Park, Maryland. Quotes in this section refer to passages from these reports.

53 Country Assessment Reports 1961, RG 59, General Records of the Department of State, Bureau of Cultural Affairs, Planning and Development Staff, Country Files 1955–1964, Box 220, United States National Archives at College Park, Maryland.

54 Interviews with Pen Tra, Sem Kem Chang, Tang Hor Yi, Srieng Y, and An Sok, Phnom
 Penh, 1997–2000.

55 International Exhibition pamphlet. National Archives of Cambodia, Box 215 (Docu-
 ments of Cambodia).

56 Ibid. The "world" on display was the particular so-called free one, with France, Japan,
 the United States, Holland, India, Laos, the Federation of Malaya and Singapore,
 Thailand, and Vietnam creating individual pavilions for the exhibition.

57 A notable exception was the Polish Film Festival sponsored in Phnom Penh in 2002
 by His Excellency Kazimierz A. Duchowski. Since September 11, 2001, the U.S. gov-
 ernment is resuscitating notions of information (and misinformation) reminiscent of
 the Information Service of the 1950s. An exhibition recently sponsored by the State
 Department at the National Gallery of Thailand (Bangkok) displayed large-format
 photographs of the ruined World Trade Center site as part of an effort to dramatize
 and win support for the war on terrorism (CNN report, May 15, 2002).

58 The mobility within borders of, for example, the *moto dup* drivers who come to
 Phnom Penh and Siem Reap to work, leaving their families in the countryside; the
 taxi drivers who are also government civil servants, driving to the border and back in
 order to supplement their meager state salaries through the transport of passengers
 and foreign goods; or yet again, the young women drawn to the garment factories
 and brothels of the city and its outskirts under varying conditions of coercion.

59 Someone I know routinely refers to "the American king, what's his name? Bush."

60 Appadurai, "Grassroots Globalisation," 4.

61 The 1st Fukuoka Art Triennale grew out of a set of preceding Asian art shows orga-
 nized by the Fukuoka Asian Art Museum at five-year intervals since 1980 in order to
 highlight contemporary Asian art. The 1st Triennale took the theme of "communica-
 tion." As the curator, Kuroda Raiji, put it, "[W]hat is necessary for us is a courageous
 attempt to actively communicate . . . with various kinds of 'the others,' from a resident
 in a next door house to people living in [the] remote world connected by technology."
 Chief curator Ushiroshoji Masahiro added: "From the beginning, we have not refused
 to include works on the grounds that they were not like contemporary art from our
 [the Japanese curators'] perspective — in other words because they did not seem to
 advance a step beyond existing aesthetics. Nor have we excluded from the exhibitions
 any country [in Asia] on the grounds that it produces only art that lies within the
 boundaries of existing aesthetics." See Fukuoka Asian Art Museum, *The 1st Fukuoka
 Asian Art Triennale 1999*.

62 Many of the young professors teaching today at the Department of Fine Arts (RUFA)
 were sent abroad to study for MFAS at Eastern European art academies in the waning
 days of the "socialist brotherhood." Picking up stylistic notions of "modern art,"
 which they combine with self-consciously "Khmer" subject matter (heavenly dancers,
 characters from the Khmer version of the Reamker, traditional ceremonies and fes-
 tivals), these young artists are increasingly invited to participate in international ex-
 hibitions as "modern Cambodian artists." Their bodies of work, single paintings or
 at most groups of paintings, are almost exclusively generated for these occasions.

63 In these shops, repetitive oil paintings of Angkor Vat and idyllic Cambodian land-

scapes based on postcards and photographs are on offer by the yard to tourists and nostalgic Khmer expatriates (their most frequent purchaser). See my essay with Ly Daravuth in *The Legacy of Absence* for a brief discussion of these paintings as possible symptoms of trauma.

64 Smith, "Cambodian Art Seeks a Market."
65 Stephens, "The Art of Saving a Nation's Soul."

Community Museums, Memory Politics,

and Social Transformation in South Africa:

Histories, Possibilities, and Limits

CIRAJ RASSOOL

The District Six Museum opened its doors in Cape Town in December 1994, at the end of the year in which South Africa became a democracy. The museum was created as a project that worked with the histories of District Six, the experiences of forced removal, and memory and cultural expression as resources for solidarity and restitution. Its emergence was the culmination of more than five years of planning, dreaming, and imagining on the part of the District Six Museum Foundation. The foundation had been set up in 1989 by the Hands Off District Six committee, a body that had agitated against initiatives by big business and the city to develop District Six along middle-class, "multiracial" lines as part of the effort to "reform" apartheid alongside the operation of its repressive apparatus.[1]

Since the 1840s, District Six was home to "virtually the whole range of contemporary Cape Town society" and later developed a reputation as a "vibrant, cosmopolitan community" that was a "melting pot of class, race and culture." By the late nineteenth century, as wealthier Capetonians moved out to the suburbs, District Six became mainly a working-class area, whose inhabitants (identified by the state mainly as "malay," "mixed," and "coloured") were dependent on the city for employment. Proximity to the docks ensured the entry of immigrants from foreign shores (Europe, Asia, Australia, the Caribbean) as well as Xhosa-speakers from the eastern Cape.[2] With an increasing popu-

1. Stone Street, District Six, shortly before the removals (ca. 1970). Photo by David Dent. National Library of South Africa Collection.

lation, a growing housing shortage, the prevalence of slum landlordism, and a decline in the quality of municipal services, living conditions in District Six deteriorated over the decades.³

As white Capetonians feared a "black invasion," the spread of bubonic plague in 1901 became a pretext for the removal of African residents of District Six to a camp at Uitvlugt (later Ndabeni) on the outskirts of the city. With nothing done to alleviate the shortage of housing, worsening poverty, overcrowding, and urban decay, the advent of the Group Areas Act in 1950 gave the state the power to complete the dispossession and relocation of the inhabitants of "some of the most potentially valuable land in the Republic," and to clear black people from Cape Town's "white space" as part of the modernist planning of a garrison city. The forced removals and relocation of sixty thousand people from District Six to the Cape Flats took place in the 1970s and early 1980s, after the area was declared white in 1966. Once the supposed "slum" of District Six was razed to the ground, a new white residential area of townhouses and high-rise apartments was envisaged as taking its place.⁴

The District Six Museum Foundation was one of a number of nongovernmental organizations and cultural projects that had come into existence between the 1970s and the 1990s to preserve the memory of District Six. In 1992, the foundation held a two-week photographic exhibition in the Central Meth-

odist Mission Church in Buitenkant Street on the edge of District Six. Former residents assembled in the pews of the old District Six church to exclaim their recollections, as a powerful body of photographs and the enlarged images of projected slides and old film footage sent them back into their pasts in the district. It was this desire to reassemble and restore the corporeal integrity of District Six through memory that created the District Six Museum itself two years later.

The cultural work of the District Six Museum Foundation also supported the institution of a land claim in respect to District Six, instituted under the Restitution of Land Rights Act.[5] This land claim, led by organized formations of former District Six residents, including the District Six Civic Association, advocated the reconstruction of District Six and the return of its community that had been expelled through the operation of the apartheid state's Group Areas Act. Removals in the 1970s and early 1980s had sought to destroy the social fabric of the area, while its edifices and material landscapes, apart from mosques and some churches, had been razed to the ground. During the process of the land claim, the museum consistently asked questions about how a restitution and redevelopment process, with its primary focus on housing and integrated urban development, could give attention to issues of history and memorialization. The emergence of the District Six Museum can also be understood in relation to the creation of the Truth and Reconciliation Commission, partly because of the common features of "unearthing" pasts and recording memory of traumatic experience.[6] This association reflects a moral dimension of the museum's work of defending human rights, and emerges in some of the ways in which the museum space has been used as a site of forgiveness and the "healing of memories."[7]

Since its creation, the District Six Museum has been an inspiration for a number of community-based memory projects and fledgling "community museums" elsewhere in South Africa, in areas such as Lwandle in Somerset West, Crossroads and Protea Village in Cape Town, East Bank in East London, and South End in Port Elizabeth. Much like the District Six Museum, these new museums have emerged largely on the margins, outside the structure of national museums and national heritage, and thus exist outside the official circuits of national funding for arts, culture, and heritage.[8] While this has resulted in tangible institutional vulnerability and a reliance on the vicissitudes of donor funding, the exclusion of these new and fledgling museums from the structures and national heritage priorities of the state has also created a sense of an independent cultural platform and has had the unintended consequence of enhancing the possibilities of constituting a vibrant, independent, contested public culture.

While these local initiatives and community-based cultural projects have attracted ad hoc grants from local, provincial, and national political authorities, they have also been connected into international circuits of cultural heritage development aid. This international assistance has taken the form of grants from U.S. and European donors and governments for project-related work, in accordance with the strategic funding priorities and interests. It has also taken the form of inclusion into structured international "partnerships," with U.S. and European universities and museums, in projects styled as "cultural heritage training," or "museum twinships."

These initiatives have opened up ways of giving South African local institutions some access to international expertise and experience, and were intended to contribute to processes of professionalization and organizational development. They have also had the effect of escalating widespread and pervasive pressures on local cultural initiatives to embrace commercial models for thinking about collections, exhibitions, the structure of museums, and the terms of their development. Beyond this, other partnerships have sought to go beyond the West, offering international forums on the "reconstruction of wartorn communities" and coalitions for "stimulating dialogue on pressing social issues and promoting humanitarian and democratic values."[9]

In South Africa the category of "community museum" has come to be associated strongly with the cultural work of the District Six Museum. The local museums that have begun to emerge in different parts of South Africa in the wake of—and premised on the model of—the District Six Museum have also begun to refer to themselves as "community museums." Since 1999, two conferences have been held to discuss, among other things, the potential of creating a coalition of independent and community museum projects in South Africa, both as a funding mechanism and as a strategic cultural initiative.[10] The time has come to take stock of the notion of "community museum," to understand the debates and contests that have accompanied its inauguration as a cultural category in the growing museum field in South Africa and beyond, and to consider its varied intellectual and political genealogies. This also requires us to revisit the category of "community" and the kinds of identity and identification it desires and asserts, as well as the ways that it has been put to work in cultural claims and projects. These are important investigations to carry out so that the category becomes more than just a technical term for a museum genre as new local museums are created and features of the District Six Museum are replicated.

It is imperative that this investigation start by revisiting the District Six Museum. We need to understand the particular histories and conditions of its creation in 1994, and the specific features and relationships that characterized

the early period of its life. These characteristics have remained decisive aspects of the museum's character as it has developed in institutional and exhibition-ary complexity, and as it has had to address the challenges and dilemmas of museumization and commercialism. The focus on the history of District Six and national experiences of forced removals might be at the core of the museum's work. But its key features are methodological. Since its inception as a museum of the city of Cape Town, the District Six Museum has been an independent site of engagement, a space of questioning and interrogation of the terms of the postapartheid present, and the institutions, relations, and discourses embedded in its production and reproduction. It has also operated as a hybrid space of research, representation, and pedagogy, through which relations of knowledge and varied kinds of intellectual and cultural practice have been brokered and mediated between different sites, institutions, and sociological domains.[11]

MAKING A MUSEUM

The exhibition with which the District Six Museum opened in 1994 was called "Streets: Retracing District Six." It was created out of residues and materials from the landscape of District Six, and made use of documents, photographs, memorabilia, and artifacts. The exhibition contained a large map painting of District Six, which spread over most of the floor space. The original old street-name signs from the district hung in columns overlooking the map. This collection of street signs had been acquired from the leader of the demolition team that had bulldozed District Six, and who had saved them in his cellar. Displayed in the museum, they became tangible signifiers of the materiality of the district. Rows of large-scale portraits of former residents, printed on transparent architectural paper and hung from the balconies, gazed down upon visitors. In alcoves to the side of the map, photographs (drawn from albums and collections donated by former residents) bore testimony to social life and cultural expression in the district through visual documentation. At the map's edges, transparent display cases containing District Six earth and stones revealed the excavated fragments of domestic life: bottles, sherds of crockery, cutlery, and children's toys.[12] Visitors to the exhibition were able to annotate the large floor map (which was covered with a strong transparent layer) to show the locations of homes and shops, add omitted streets and names, and leave comments and messages. Another crucial interactive element of the exhibition was a long calico cloth on which visitors wrote their names, messages, and other information, turning the calico into a "memory cloth."

Through the "Streets" exhibition, with its layering of visual representation,

recovered artifacts, and detailed documentation in the re-created spaces of the district, the museum constituted an "archaeology of memory" that attempted to reconstruct the material fabric and social landscape of District Six in imaginative terms. The installation in the "unbroken spatial arena" of the old Freedom Church, once a place of worship for descendants of slaves and later a place of refuge for political activists, was a stratigraphy of experience, meaning, and interpretation that would open up the possibility of healing the "ravaged community" of District Six.[13] It was not surprising that soon after its creation, many visitors began to refer to the museum simply as "District Six," as the site of District Six's memorialization and commemoration had to perform the work of satisfying the desire for the real.

In the museum, an aesthetic arena for working with memory provided a place "for the community to come together and share their experiences and memories."[14] These acts and processes were often ephemeral and fleeting. It was the eloquence of voice through which the museum alcoves were "witness to poignant stories hitherto untold," as well as the performance of inscription on the map and the cloth, that gave the museum's curatorial features their dramatic meaning. The museum became an "interactive public space" where "people's response to District Six" provided its "drama and fabric."[15] Unlike the conventional "connoisseurial 'silence'" of the museum experience, but somewhat like Homi Bhabha's concept of "conversational art," this was a museum where annunciation, conversation, and debate were part of its creative and curatorial process and memory politics, changing people's sense of art and visual representation and asking them "to rethink fundamental questions concerned with the category of the aesthetic."[16]

The spaces of the museum were filled with argumentation and debate about cultural expression, social history, and political life in the district, about local history and national pasts, and about how best to reflect these in the work of the museum. Members of the museum also spoke of challenging some of the stereotypes that had begun to crystallize of the people of District Six as happy, gap-toothed, and picturesque, as well as merry, musical, and rhythmic. They wanted to counteract a pervasive idea that had become almost settled truth, that the district had merely been a "slum." At the same time, members of the museum began to debate ways of addressing a wider history of social engineering in Cape Town and experiences of forced removal in other parts of South Africa. There was an acknowledgment that District Six's symbolic status had served to obscure the experience of removals elsewhere.

Nevertheless, the District Six land claim process created opportunities for the museum to intervene in debates about the future of Cape Town and processes of civic and social regeneration in the city. It became one of the few sites

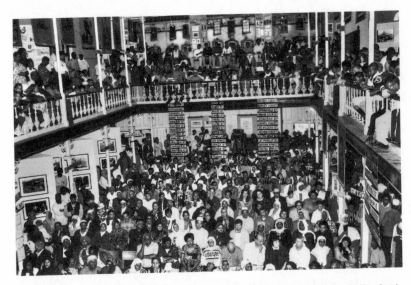

2. The Museum as Forum: Land Restitution Meeting, District Six Museum, 1998. Photo by Tina Smith. District Six Museum Collection.

in the city with a sense of legitimacy "to talk to and about the future of all its citizens." The museum "created the space for ordinary people to intervene in the bigger politics of urban renewal and to express their views about the future of the city."[17] The most powerful expression of the District Six Museum having the character of a forum has occurred when its spaces have hosted official land restitution hearings. In 1997, in an effort to resolve a controversy over a premature attempt to draw all claims into an integrated development plan, the Land Claims Court held a special session in the museum to ratify a local government decision to recognize individual claims. The following year, a packed museum building witnessed the signing of a record of understanding by central and city government and by the Beneficiary Trust, which was aimed at facilitating a difficult land restitution process, which had many stakeholders. As a place of gathering over the future of the landscape of District Six, and drawing on an understanding of the "heritage" of District Six as a place that "provided refuge to all and sundry," with an "ability to assimilate into its fold new individuals and communities," the District Six Museum was the appropriate space for the performance and witnessing of an inclusive, negotiated process.[18]

Sometimes these debates and engagements concerned the nature of the museum, as well as the cultural politics of the very notion of "museum" itself, the category that the District Six Museum Foundation chose to define its project of history and memory. In the mid- to late 1990s, these discussions and arguments

occurred as a new policy framework for heritage in democratic South Africa began to be clarified. A white paper on arts and culture was published in 1996, whose provisions sought to put into effect the recommendations of the Arts and Culture Task Group (ACTAG), which had been circulated the year before.[19] As discussions and negotiations got under way within the government and the old national museums about the creation of new national "flagship" museum institutions along the lines of the Smithsonian Institution in the United States, the District Six Museum tried to make a case for incorporation into this process as a potential new national museum. Such incorporation would have ensured that the museum had access to funds and subsidies for core staffing, and, as it was argued at the time, would have given structural shape to the claim by the museum that its work on forced removal and memory was of national significance and required official, institutional recognition.

Disappointingly at the time, but in retrospect fortuitously, demands to be included in the flagship scenarios came to naught. It might have been that the independent origins of the District Six Museum were regarded as inimical to the cultural agenda of the new state. Moreover, the social and cultural histories, as well as the memory politics that the museum worked with, might not have cohered with emerging priorities for new national museums of resistance, reconciliation, and "the triumph of the human spirit."[20] A suggestion by a middle-level official provided a few clues to the thinking of some staff in the Department of Arts, Culture, Science and Technology (DACST): he asked that the District Six Museum consider remodeling its mission so that it would develop as a "coloured museum" in the city of Cape Town, hinting at the possibility of multicultural inclusion on an ethnic basis. It was in the nature of the District Six Museum that this suggestion was rejected outright. Thus, with its relationship with DACST limited to ad hoc grants, the museum was forced to turn almost fully to foreign donors and governments to develop a viable funding base.

This experience of being somewhat snubbed by the state served to reaffirm the museum's independence as a space of knowledge production and cultural representation. This self-determining position was asserted in relation to the state and the academy. Indeed, these efforts at self-definition went further. Policy and planning discussions revealed a productive ambivalence about the categories of "museum" and "exhibition." When the District Six Museum Foundation was created and the museum itself formed, the choice of the category of "museum" did not necessarily express a specific commitment to the institution of the museum. The foundation certainly wanted a project through which it would be able to contest the past and use history and memory as the means of mobilization around the traumatic landscape of District Six. Records

of the early days of the museum's existence reveal a debate about what the priorities of the museum should be and where it should allocate its energies and capacities. While some were concerned about the links between the District Six Museum and other museums in South Africa and beyond, a strong position was articulated that the mission of the museum was *not* to network with the official museum structure but to mobilize the masses of ex-residents and their descendants into a movement of land restitution, community development, and political consciousness.

Nevertheless, it was indeed fortuitous that a District Six museum was created as a cultural institution at the same time as the challenges of museum and heritage transformation in South Africa were being identified and the frameworks for such processes of transformation created. As a museum, it was an independent, nongovernmental organization. It was relatively untainted and unburdened by an inheritance of old collections and outdated museum classificatory systems.[21] And as a new independent local museum, it did not face any pressure to conform to the state authorities and emerging, centrally directed national heritage policies or frameworks. Yet in many ways the District Six Museum had appropriated an elite cultural institution for its own cultural purposes. And as an independent space of knowledge creation that was confident about its achievements and ways of working, and which was also attempting to address its shortcomings, the museum wanted to tell its story nationally and internationally, thereby intervening in the fields of cultural representation and public education.

In some ways, the assertion of independence from the academy was a more complex matter. In appropriating the category of "museum," even for strategic purposes, the District Six Museum had indeed taken unto itself an organizational genre with a vast accumulated institutional history of collecting, curatorship, and cultural display. Museums might indeed be institutions of public culture, but, as sites of knowledge creation, assembly, and dissemination, they also contained identifiable features of the academy. They incorporated research, they worked with models of education, and they were sites in which expertise was exercised and expressed. Their collections, systems of classification, research procedures, and exhibitionary techniques tended to be shaped by particular disciplines. Moreover, in the case of the District Six Museum, some of their trustees were academics, whose research, teaching, and expertise as educators, historians, artists, architects, and planners were undoubtedly drawn upon by the museum. In addition, the collections and exhibitionary work of the museum either drew on or had to take account of frames and methods in the disciplines of art history, archaeology, anthropology, and ethnomusicology. And, almost from the beginning, the museum attracted a

range of academic attention, from foreign and local academics to graduate students in search of the fine detail and experience of apartheid's past, the performance of restitution politics, or ethnographies of cultural expression.

But the District Six Museum's ambivalent relationship with the academy held an implicit critique of the latter's histories of appropriation and hierarchies of knowledge, which privileged scholarly procedures of research and modes of authorship, and which presumed particular flows of knowledge and forms of "seepage" or "trickling down" out of universities and into the public domain. Skepticism was being articulated more generally of the claims of academic knowledge, a knowledge relation that actively produced marginality and subalternity.[22] Around the time of the formation of the District Six Museum, a more conscious autocritique had begun to emerge in some left-wing South African scholarship of the ventriloquism of social history and of the claims of people's history to recover ordinary experience from the proverbial "enormous condescension of posterity."[23] The oral history practice of South African social history had been criticized for its failure to move beyond oral history as evidence and beyond conventional hierarchies of voice and writing, orality and history.[24] The creation and development of the museum were influenced both by social history research on the history of Cape Town and by approaches that drew attention to social history's limitations.[25]

The suspicion of universities and academics held within the District Six Museum also needs to be understood as an effect of a racialized order of university education in South Africa. This entailed systematic forms of exclusion from most universities, with severe limits placed on black access. The 1960s had seen the creation of "deformed" and largely resourceless universities or "bush colleges" as features of academic life. In the face of decades of systematic exclusion, partial access through a permit system, and resource starvation in universities designed to be inferior, alternative knowledge domains in the public sphere became the only option. These were the circumstances that saw the creation of a combative intellectual culture in the public domain since the 1930s and 1940s. At best, the South African academy came to be associated with liberal paternalism and a cultural politics of service, which led to disempowerment, incorporation, and the dilution of any sharp edge of social criticism and mobilization.

The District Six Museum emerged partly out of this legacy as a combative and contested forum of public scholarship, which was ambivalent about academic forms of knowledge but which was nevertheless defined and marked by its disciplinary structures and methods. Indeed, the museum needs to be understood as a hybrid space that combined scholarship, research, collection, and museum aesthetics with community forms of governance and account-

ability, and land claim politics of representivity and restitution. It brought together community-connected academics, some of whom saw themselves as activist intellectuals, but who often bore the restrictive marks of the academy, and former residents, many of whom had been activist intellectuals for decades, with their roots in District Six–based political and cultural organizations. The structures and programs of the museum served to mediate and broker exchanges and transactions of knowledge genre and cultural expression and to blend these interactions into the riffs and rhythms of its work. The synergies and contests of such a membership mix have been at the heart of the curatorial methods and reflexive pedagogy of the District Six Museum.

REMAKING A MUSEUM

Out of these debates and transactions, the District Six Museum constantly made and remade itself. While the "Streets: Retracing District Six" exhibition became the core of its exhibitionary work for the first four years of its life, a number of other exhibitions and heritage projects were created alongside it. These gave shape to the museum's desires to tell more complex stories, to work with different mediums, to address specific audiences, and even to go beyond the story of District Six. They gave expression to the museum's institutional growth and to the outcomes of disputes and debates over its mission, as well as to the ways in which a range of publics took ownership of the museum as a site of resources, skills, and experience.[26]

Three memory projects that the District Six Museum undertook at this time are significant in different ways. "Tramway Road" was an exhibition about the experience and social effects of forced removals in Sea Point, Cape Town, and attempts to build community through reunions and the lodging of a land claim.[27] A sculpture festival was held on the traumatized landscape of District Six, on its architectural remains and archaeological residues, in a project that saw public art enter the memory space of the artifact.[28] The museum's Sound Archive was created to formalize and institutionalize the collection of oral history, and research was carried out on Cape music performance as well as on the concert and carnival traditions of District Six. Each of these projects demonstrates various ways in which the District Six Museum is best understood through its processes of conversation and debate.

The "Tramway Road" exhibition was held in 1997 to coincide with the seventy-fifth anniversary of the Anglican Church in the old area of Sea Point, Cape Town, from which the first Group Areas Act removals occurred from the slopes of Table Mountain in the early 1960s. Through the mediation and agency of graduate student Michelle Paulse, the museum was able to build on a

series of reunions that former Tramway Road residents had organized in order to reconstruct ties of community. This exhibition was curated on an upstairs balcony of the District Six Museum. It drew documents, artifacts, and photographs of family, community, and reunion commemorations into the visual world of a reconstructed museum streetscape, as former residents of Tramway Road gathered to observe and draw strength from another milestone on the road of their land claim. This exhibition gave the District Six Museum the opportunity "to broaden the story of forced removals and to make a connection with one of more than 40 other forced removal sites in Cape Town."[29]

In the museum debates and discussions of the time, this exhibition was conceptualized as the start of a process of going beyond the boundaries of the "Streets" exhibition and the focus on District Six. The focus on District Six was "part of a bigger struggle for land and home," it was argued, and was merely "a valuable point of departure in this bigger story." Organizationally, this line of thinking began to be conceptualized in programming and planning terms as "District Six and Beyond." The seeds of this broader research and exhibitions path had been sown the year before in the sports exhibition "(Dis)playing the Game," which had documented the imaginative reconstruction of civic and cultural life through sporting codes and achievement on the part of various communities in the Western Cape who had been affected by the Group Areas Act and the apartheid system.

Beginning with "Tramway Road," the museum wanted to trace dispersal from Ndabeni, Kensington, Protea Village, and nearly forty other sites in the Western Cape. The "diaspora of apartheid," it argued, now lived on the Cape Flats and further afield. The museum wanted to explore the township locations of Langa, Bonteheuwel, Bridgetown, and Manenberg, to which people had been removed. Sometimes thought of as mere "dumping grounds," these were indeed places that people came to call home. The museum was interested in understanding the texture and quality of home life on the Cape Flats. What did people take with them to these places? How did they reconstruct home and community life?[30] Within this broader framework of wanting to examine patterns of urban social engineering, the museum began to address the criticism that it had privileged the District Six case of removals and the quest for restitution.

The museum also became more purposeful about making connections between aesthetic production, memory work, and the District Six land claim process. On Heritage Day 1997, District Six's scarred and overgrown remains, already reluctantly monumentalized in its emptiness, was turned into a curatorial landscape in the form of a sculpture festival. In a politics of production that saw the District Six Museum act as institutional base, facilitator, and

broker, ninety-six artists were brought into a collaborative curatorial process with the members of civic bodies and associations of visual arts and heritage. Nine months of preparation, workshops, and debate by a forum of artists, ex-residents, and others resulted in a set of principles and parameters being created for the process of placing artworks on a landscape that would eventually be redeveloped and reinhabited.

The notion of memorial artworks as "permanent fixtures" was cast aside in favor of an approach that proposed "transient markers," which could be "triggers of recognition, association and memory," and "physically vulnerable structures" that would be "indicative of the fragilities that they infer/recall." Artists were given the opportunity to work with the museum's collection and encouraged to "consult ex-residents." The outcome was a map of sculptures that "evoked remembrance, respect, dignity and worth to those things absent" and stood as "beacons that declared a history in the process of being boldly reclaimed." Sculptures were created from affordable and found objects, including broken glass, bricks, ceramic sherds, stone, plastic, and building foundations. And on Heritage Day 1997 thousands of people came to District Six to wander among the installations, listen to the music of choirs and bands, and share in the food on offer from a variety of food stalls.[31] In Martin Hall's terms, all the artworks were "social archaeology," where meaning was created from artifacts and with "material things as a medium to comment on the past and the present."[32] Through the social archaeology of the sculpture festival, the District Six Museum was able to assert a central place for memory work in the midst of the brick-and-mortar questions of redevelopment.

As the key organizing principle in the District Six Museum was the "collection of memory," with some of the earliest memory work in the museum taking the form of the collection of testimonies about lives in District Six, it was almost a natural step that one of the first major ways in which the District Six Museum grew institutionally was through the creation of its Sound Archive in 1997. The museum wanted to be able to collect and manage sound recordings relevant to the story of forced removals and "to document the many extraordinary lives of people living on the Cape Flats." One of the main goals set at the time of its emergence was to serve as a "memory booth" for ex-residents of District Six and other areas. The Sound Archive was also conceived of as a space of musical research and collections, whose success would depend on mastering technological and intellectual issues. The range of collectible materials included interviews with ex-residents, video footage of the removals, and recordings of music. From its earliest days, staff of the museum's Sound Archive spoke of the importance of taking professional care of collections and of ensuring that materials could be used by future generations.[33] But the Sound Archive's

potential extended beyond the technical and the documentary, opening up new challenges for the museum in the relationships between collection and research, the technological and the intellectual, and the aural and the visual.[34]

If the Sound Archive's creation reflected the increasing institutionalization and professionalization of the District Six Museum's management and direction, then its exhibition "Digging Deeper" signaled a more complex approach to museum display and public culture. This was the exhibition with which the museum returned in 2000 to the renovated and restored church building in Buitenkant Street, the site of the museum's original exhibition. While a desire to work beyond District Six was retained, it could not reopen as the *District Six* Museum without a clear focus on the district. Now, no longer was District Six before removals merely represented through the eyes of nostalgia as a multicultural idyll—a "fairyland"—that could be willed into existence again through the invocation of memory.[35]

As a self-conscious and self-reflexive exhibition, "Digging Deeper" sought to address impatience within the museum, expressed through long-standing debate, to tell the story of District Six with greater nuance and complexity. Whereas the "Streets" exhibition tended to focus on public spaces and lives constructed in public, "Digging Deeper" sought to examine the private and interior spaces of people's lives. In making "Digging Deeper," the museum chose to inquire into its collections and processes and ask more complex questions about the district. The approach in the new exhibition avoided taking a single, safe narrative and set out consciously to disrupt and unsettle certain conventions about District Six's past: that the district was a "coloured" place and that social life in District Six was without contradiction. The memorial text at the entrance to the refurbished museum reflected this desire to ask difficult questions: "we seek to work with our memories, our achievements *and our shames,* our moments of glory, courage and love for one another, *and also the hurts we inflicted upon each other.*"[36] In aesthetic terms, museum trustee and artist Peggy Delport has referred to the "materiality, transparency, flexibility and layering" of "Digging Deeper" and to the "particularity of softnesses and roughnesses" of its material surfaces, which offset the photographic and digitally created elements. Enlarged wallpapered and painted photographic images have been presented in lifelike re-creations, while historical panels, timelines, a sequence of maps, and life history texts drawn from oral history research presented District Six's cultural, intellectual, and political growth with attention to complexity and nuance. Handmade appliquéd and embroidered banners reflected the wide range of institutions in the public sphere of District Six: the religious and the political, the educational and the cultural. Soundscapes transmitted through sound domes in different museum spaces echoed the voices of nar-

3. Museum education on the map
of District Six, District Six Museum,
2000. Photo by Paul Grendon.
District Six Museum Collection.

rators, "the major content and life-source of the museum." An installation of
the interior of a District Six room — "Nomvuyo's Room" — drew on life history
research to convey a sense of the lived environment of the multipurpose room,
which was the basis of survival for many of the poor.[37] The map, cloth, street
signs, and enlarged portraits, now with greater attention to conservation and
spatial issues, have remained central elements of the exhibition.

Out of a conscious research and curatorial project, the museum was refig-
ured through participation by artists, researchers, volunteers, and embroidery
groups, and through the ongoing contributions of former residents of District
Six. A visual and spatial framework was created for an exhibition "made of
the evidence of experience and expressive elements woven together into an
interrelated whole." As a direct consequence of criticism and questioning, the
museum boldly and deliberately re-created its "live, generative space" so that it
would continue to resist being turned into "an object, to be consumed, merely
looked at and left behind untouched." Instead, the museum space would be
"continually shifted, layered and subverted by its visitors."[38] In adopting this
provocative and unconventional approach, the District Six Museum reiterated
that it was neither a space of innocence nor one of simplistic authenticity. Its
integrity and long-term sustainability were predicated on defending its inde-
pendent spaces of articulation and criticism and on ensuring a continuing pro-
cess of constructing its object and its community through practices of ongoing
dialogue, interpretation, and debate.

MUSEUMIZATION, COMMERCE, AND COMMUNITY

In spite of the uneasiness and ambivalence that has existed in the District Six Museum about the concepts of "museum" and "exhibition," it must be understood that virtually from its inception, the museum has undergone deep and substantial processes of "museumization." The formalization of the museum has involved the professionalization of almost every facet of its institutional life, the emergence of a division of labor between collections and documentation, exhibitions and education, and a turn against volunteerism. As museumization has taken place at a steady pace, the museum is also beginning to feel pressure to think of itself as a business, to become a space of commerce and enter into business transactions over its collections and exhibitions. The museum has been challenged to demonstrate that it can embrace the possibilities of institutional development and address the issue of sustainability without retreating from its mission of enabling an independent, analytical space of cultural and historical production to flourish as part of the emergence of a critical citizenship.

Institutionalization and professionalization have been consequences as well as requirements of growth and development. An early introduction to the world and language of organizational development for the museum involved being put through its paces in heritage transformation and "vision and mission" workshops coordinated by Amareswar Galla, who had been brought to South Africa by DACST. Galla, an Australian global cultural broker with ICOM and Commonwealth Association of Museums connections, bestrode South African heritage institutions for a few years, billed as a "top specialist in the field of cross-cultural heritage management."[39] Armed mainly with a dazzling PowerPoint presentation including lists, charts, and diagrams on museum management, Galla addressed the possibilities of transformation and introduced South Africans to museum lessons from an array of international case studies of museum creation and change. Members of the District Six Museum nevertheless learned from these workshops that it was possible to be a museum while holding on to its desire for independence, process, and participation.

With no sure access to state funding after its emergence, and with a sense of independence and self-purpose, the District Six Museum turned to foreign governments and foundations to ensure that it had access to the financial resources and experience necessary to develop a museum. The decision to raise funds in this way was a significant step in the life of the museum. Until as late as the early 1990s, in the context of an antiapartheid struggle with international dimensions, strong legacies had built up of being suspicious of such

sources because of the possibility of strings being attached to grants. While the first donor grant came from the Netherlands government, the most significant source of funding for the museum from 1996 came from the Swedes, who had also generously supported the antiapartheid struggle in the 1980s. The funding took the form of grants from the Swedish International Development Authority (SIDA) as well as the opportunity to participate in the Swedish African Museum Programme (SAMP), a network of twinships and partnerships in exhibitions, project development, education, and management between Swedish and African museums. Through SAMP, the District Six Museum, one of thirteen museums from nine African countries to participate, became a partner of the Malmö City Museum.[40]

Initiated by the Swedish National Committee of the International Council of Museums (ICOM) in 1984, and supported by SIDA out of a cultural policy that emphasized the need for the "internationalization" of culture, SAMP was designed to "strengthen the role of museums in society." The development emphasis in SAMP was on nurturing exchanges "in order to build co-operation based on mutual benefit" rather than on providing aid. Such relationships sought to develop staff skills, improve museum exhibits, broaden networking, and enhance "a more international view" of museums.[41] One strategic opportunity of this "internationalization" for the District Six Museum was that it was brought into a direct relationship with a range of African museums, and platforms were created for intellectual exchange around common legacies of colonialism and of culture framed as ethnicity.[42]

The benefits for the museum have mostly been of a technical and formal nature, with SAMP providing a framework for organizational development. The museum has participated in a management development program and was introduced to methods of project identification, of creating project documents and reports. Emphasis has been placed on managerial tools and on creating an organizational structure with clear hierarchies and relations of governance, management, and responsibility. Other benefits for the museum have emerged out of being able to experience the institutional structure of the Malmö City Museum at work: its organization and division of labor, collections system, methods of exhibition preparation, and education programs. Perhaps most influential were the opportunities to witness the practice of the Swedish project of documentation and contemporary archiving (SAMDOK) and to see the workings of a *faktrumet*, or integrated resource center, in the life of a museum.[43]

As much as the District Six Museum defined itself as a museum of process, as a space that was continually being made and remade through inscription, articulation, debate, and contestation, in many ways it came to acquire quite conventional features of museums in the sense of an organized structure that

managed collections. The entry of objects into the life of the museum might
have occurred initially through informal systems of borrowing domestic items
and old photographs from former residents for the purposes of display. The
idea that the museum had a collection might have had its origins in the ac-
quisition of the street signs, and perhaps in the steady growth of the inscribed
lengths of calico. But once artifacts, documents, and photographs were do-
nated, responsibilities for care and conservation were placed on the museum's
shoulders. And the entry of objects and artifacts involved a documented legal
transaction, which set out each party's rights and obligations and authorized
the use of the items in the public sphere, with those who gave their papers and
images formally designated as "donors."

In the storage rooms and exhibition spaces of the museum, the donated
objects and images acquired complex social lives as they entered a knowledge
world of archiving, classification, and display.[44] Photographs and albums of
former residents, previously stored away in shoe boxes, in family chests, or
on wardrobe shelves, or displayed on wallpapered walls or in glass cabinets,
entered the museum as records of lives and identities. They enabled a mapping
of family connections and social life, forming elements of a recovered public
history. In the public domain of the museum, the private family photograph
encountered the world of the social documentary.[45] Those who had given their
photographs to the museum in order to effect an arrival in a new kind of hall
of recognition, where the images of those previously "hidden from history"
would at last hang triumphantly, expressed some disappointment that they
had once again seemingly been "hidden away."[46]

Indeed, personal photographs (and artifacts) were now institutionalized in
a more intricate and multifaceted museum system and structure in which they
acquired new meanings as they were "*applied* within a process of interpreta-
tion."[47] The museum-as-collection was also a space for the performance of his-
tory in the archive, as the "inherently unstable signifiers" of the photographs,
which belied their seeming "stillness and frame," were also "sites of semiotic
energy" that enabled changes of meaning.[48] Meanings shifted in the archive,
from the individual and the personal to the generic and the typical, distanced
in archival systems from their meanings at the point of collection. And at times
they even ran the risk of attracting racialized meanings that the museum had
sought to contain and challenge.[49]

The process of museumization has also expressed itself in the profession-
alization of staff that accompanied the emergence of a clear staffing structure
with systems of management and the clear delineation of areas of responsi-
bility. What began as a museum center staffed by ex-resident volunteers be-
came an institution in which specific kinds of specialized knowledge began

to be expressed in the fields of exhibition design, audiovisual documentation, museum education, and the management of oral history and music collections as well as photographic collections. At one level, this expertise is technological, in ensuring knowledge of varieties of sound recording and playback equipment, the arena of digital image collections, and the domain of design software and large-scale printing. Sometimes the expertise lies in the memory and resourcefulness of the institution, enabling a creative and participatory process, as in the decision to conserve inscriptions on calico through an ongoing embroidery project. But the expertise is also intellectual and reflects the capacity and necessity of the museum to understand and critically engage with the disciplinary knowledge that surrounds and informs its work. The presence of expertise and specialized knowledge in a small independent museum that locates itself in the public domain creates certain energies and capacities that have given the District Six Museum a distinctive character.

The museum as a disciplinary institution makes its presence felt at every level in the choices and intellectual decisions that are made about the acquisition of objects and collections and in the course of the museum life of these collections. While the Sound Archive engages with technological questions of sound recording conservation, it also has to reflect on its intellectual practices in relation to those of collecting and the disciplines of ethnomusicology, social history, and ethnography, especially in their southern African forms. In collections work and research on carnival and music in Cape Town, it has been important to be able to draw on and engage with insights and categories from such disciplinary knowledges, while being able to assess their discourses and frames from the perspectives of the museum's independent position. From the vantage point of the District Six Museum, tremendous energy and power accompany an assessment of anthropological knowledge of culture and music, such as the representations of I. D. du Plessis on the "malay" culture and "tricks," or the collections and studies of indigenous music forms by Hugh Tracy.[50]

Perhaps more challenging have been engagements with more critical and socially engaged academic debates and discourses that have specifically sought to go beyond the boundaries of the university and broaden access to academic knowledge. Attention has already been drawn to the formative influences on the District Six Museum of South African social history research and intellectual practices, especially those that emerged in the Western Cape Oral History Project (WCOHP) in the 1980s and early 1990s. In the late 1990s, the museum continued to benefit from a partnership with the WCOHP in drawing on the project's oral history collections and placing museum members in its internship program to be trained in oral history interviewing techniques. These benefits for the museum have been understood by the University of Cape Town

as part of an exercise in ensuring that the university's "expertise can be of benefit to the wider public." The work of the WCOHP is seen as part of the service and outreach work that the university performs for society.[51] However, it is possible to understand this relationship as flowing equally if not more in the other direction. The WCOHP and hence the university have indeed been beneficiaries of the District Six Museum's expertise in disciplinary questions of archiving, digitization, and more generally the cultural politics of oral memory and visual representation. In 2001 the WCOHP was restyled and relaunched as the Centre for Popular Memory, and its annual report for that year reveals the extent to which its programs in archiving, training, and research have been substantially influenced by the District Six Museum's growth and development and the challenges it has faced.[52]

The District Six Museum has also had substantial engagements with the discipline of archaeology in relation to excavations and research findings in District Six as well as around the cultural politics of the discipline's attempts to address and engage popular audiences. Archaeological research was conducted on the District Six landscape in the 1990s by University of Cape Town archaeologists and graduate students. In addition, District Six excavations in the mid-1990s served as sites for enabling school learners to unearth artifacts under supervision and to understand how archaeological knowledge is created.[53] These archaeological projects were designed "in close collaboration" with the District Six Museum as part of the attempt to find ways of "involving both former residents and today's wider community of Cape Town and its suburbs in what we are doing." This was part of what Martin Hall has referred to as "public archaeology," in which archaeologists are seen as mediators between contemporary people and their past. The task of archaeologists is "to show how things that we may not be able to see (because they are buried in the ground), or that we take for granted, can create and sustain a sense of history." By "offering evidence and interpretations which will allow people to see themselves as deeply grounded within the Cape's rich history," the field of public archaeology enables reclamation, assisting "communities in asserting their rights to a history and to the material traces that it has left behind."[54]

Within this perspective, the archaeological displays in the District Six Museum have provided archaeologists with a platform for this mediation, allowing them to access a wider public. The creation of a display about Horstley Street in 2000 as part of "Digging Deeper" shows both the achievements and limits of this public archaeology in its attempts at mediation and in its efforts to enable "rights to a history and to the material traces" to be asserted. In the Horstley Street display, the museum drew on excavations and research findings to present a set of arguments about a longer history of settlement patterns

and processes of social engineering in District Six. Horstley Street was not only the site of the final removals from District Six in the early 1980s, as popularized in film.[55] It was also one of the sites of Cape Town's first forced removal, of African people from the city at the beginning of the twentieth century.

Although the exhibit "Nomvuyo's Room" has come to be read as the space in "Digging Deeper" where the museum has made a supposed "token gesture" of reflecting on the "African" presence in District Six, the Horstley Street archaeological display has enabled the museum to shift the politics of the demand to move away from an unconscious focus on coloureds.[56] Indeed, the Horstley Street display enabled the museum to shift the methodological focus from the question "Where are the Africans?" to one that asked how the museum could reflect on removals in District Six in a way that did not generate a coloured focus. By giving the experience of removals a longer history than that occasioned by the 1966 proclamation, and by drawing on the offerings of public archaeology, the museum has indeed created a display with some power. This display is the focus of the argument on the part of the museum for Horstley Street to be the site of a memorial park in a reconstructed District Six. Horstley Street residents who had been removed in the 1980s and who had submitted land claims were quite stunned to discover, in workshops conducted by the museum about the memorial park, that African people had experienced removals from the very sites of their homes almost a century before.

The limits of public archaeology relate to the difficulties it has in transcending the paradigm of service and outreach as the basis for its mediations.[57] It is this framework of the academy's engagement with institutions and sites of public culture that the District Six Museum has been ambivalent about, because of the ways in which its claims of "offering" and empowering are at the same time the very basis of disempowerment.[58] The preparation of the Horstley Street display involved quite complex negotiations over the ownership of archaeological knowledge and the "rights to the history and material traces." And it proved almost impossible to dislodge the prior claims asserted by the archaeologists to being the authors and the authorities of the Horstley Street archaeological knowledge in their mediations through the museum. It was clear that the archaeological research had "been designed in close collaboration" with the museum. The memory of the archaeologists was that they had approached the museum to work with them; one trustee of the museum was adamant that it was at the District Six Museum Foundation's initiative that the archaeologists were approached to conduct District Six excavations; another trustee records simply that District Six was the site of a "joint archaeological project" by the museum and the archaeologists.[59] The limits of public archaeology's paradigm of mediation should also be understood as a product of the

mystique of scientific knowledge and of an expertise that has expressed itself through the discipline's long-standing heroic traditions, and to legislative restrictions placed on the right to excavate. Indeed, in the ways in which the museum was intended to be a broker of knowledge transactions, the "rights to history and to the material traces" proved to be more difficult to claim than it seemed.

In order to address such political and cultural questions of knowledge relations alongside the professional work of documentation, collection, and display, the museum created a special forum of staff, trustees, and cultural activists that would serve both as a "creative engine" as well as a resource for problem solving in all idea-generating areas of the museum's work. Styled as the Curatorial and Research Committee, this forum had its origins in the hands-on working group that drove the process of making the "Digging Deeper" exhibition. While public education forums may have been important in ensuring a participatory museum and an ethos of debate, it was this committee that attempted to connect political questions of land restitution with the museum's curatorial and aesthetic processes and memory work.[60]

It is in the interchanges and transactions in this Curatorial and Research Committee between staff, trustees, and cultural activists that the difficult tasks of mediating different knowledge forms were undertaken. Questions about conservation, documentation, and display were tested alongside pressing political issues about restitution and the restoration of dignity. The participatory and mobilizing features of the "democratic community museum" required a rigorous and enabling disciplinary museum in order to be effective, while disciplinary knowledge needed to hold on to a critical, politicized edge. In this negotiation, the museum's commitment to enabling the "reconstruction of the landscape and community of District Six in both material and cultural terms" proved to be difficult to achieve. Indeed, the process of "digging deeper" required a concomitant process of "digging wider."[61]

Along with experiences of professionalization and museumization, the District Six Museum has also had to contend with a creeping commercialism and business approach. One almost unavoidable component of its work on a daily basis has been to manage the ways in which the museum has been turned into a destination.[62] The museum became a surrogate site for tourists to engage with apartheid and romanticized preapartheid pasts, perhaps just before they set off to experience the redemptive offerings of a township tour of reconstruction and development.[63] The museum has attempted to engage this audience of foreign visitors by making comparative references to international histories of urban renewal.[64] As the tourist gaze on South Africa has consolidated itself as a "world in one country," the museum has almost been discursively

propelled into being related to as a theater of otherness, which facilitates a commoditized performance of District Six pasts and culture for a tourist audience. These contests over the imaging of the District Six Museum have played themselves out in the museum shop, where museum memorabilia, historical publications, and printed artworks and postcards jostle for tourists' attention with curio-style spice packages and ethnic dolls.

As tourists have continued to traffic through the spaces of the District Six Museum in search of simulated sites of South African pasts, its exhibitions and collections have become sources of visual appropriation and attempted replication by businesses in search of instant heritage-themed environments. The museum has had to find ways of dealing with restaurants that have decorated their walls with District Six images copied from its Web site and exhibition catalogs, and casino designers conducting opportunistic visual research in the museum's exhibition spaces for inspiration in creating a District Six–themed leisure environment.[65] The museum has also been approached directly by a music shop wanting to purchase and replicate its exhibition designs in a new store to be themed after Cape musical heritage. Apart from the issues of intellectual property, the museum's attitude toward these desires for District Six simulacra (whose own creation sought to copy the simulacral museum) has been to reject any approach that seeks to reduce the museum's aesthetics to a veneer of images and designs, a mere backdrop, immediately capable of replication as commodity.

The problem of commerce has also begun to confront the internal operations of the District Six Museum itself, and started to influence possible policy directions for its collections management. The museum is under pressure to think of its collections as commodities and to take steps to resolve issues of intellectual property that apply to them. The museum is being encouraged to digitize its oral history collections, to make them available on its Web site, and to create an enabling environment in which transactions can easily be entered into for their use. These pressures, of digitization and commerce, have come ironically in the form of a broader training partnership in cultural heritage management, which promises access to pioneering digital archiving systems and to the technology for conserving audiovisual recordings. While the stated purposes of this initiative are to enable greater museum access to technology and collections management training, and to increase public access to archival holdings in South Africa, the effect of this initiative would be to render South African collections as commodities with a price, and to make them more easily available in an unequal international knowledge economy.[66]

A related line of thought about museum and cultural resources development in South Africa suggests that museums should be understood primarily

as a specific form of business. In this model, strategies for success and for cre-
ating sustainable museum structures are drawn from economic institutions
and the financial challenges of business development and entrepreneurship.
The museum is understood as a kind of leisure attraction or entertainment
genre that needs to compete in a leisure market for the attention of tourists and
audiences. And the model of museum education that most fully expresses the
character of this museum world of cultural entrepreneurs, magical entertain-
ment, and the audience as consumer is the MBA in museum management, de-
signed to "educate future museum managers on how to use a range of business
and entrepreneurial tools," thereby solving "a leadership vacuum."[67] For this
approach, the economic challenge for museums is to create "vibrant, colourful,
and . . . people-friendly spaces," and for this, "the key is design." New audi-
ences can be attracted and more enjoyable experiences can be created through
"new design techniques" in museums where the focus has shifted to a "whole
gallery experience" as the basis of "product competitiveness." And the creation
of the new museum experience depends on being able to purchase the skills
and the "particular brand of magic" of the creative consultant expert drawn
from "a skilled army of craftsmen, engineers and designers."[68]

In January 2001, a who's who of Britain's museum and heritage industry,
including exhibition designers, specialists in exhibition and scenery construc-
tion, and audiovisual and project management consultants, paid a visit to
South Africa to "secure new business opportunities" and to find out about "a
series of museum development projects across the country."[69] The "museum
mission" heard presentations from fledgling museum projects from around
South Africa with an eye on selling them the expertise of Britain, "recognised as
leading the world in the design of museums."[70] South African museums, large
and small, were encouraged to reorient their focus along business lines and to
draw on this expertise, because after all, Britain had "great strength in depth
when it comes to designing and constructing interpretation projects." Prob-
lems of infrastructure and finance in South Africa compelled the mission to
move into the domain of charity. A visit to Khayelitsha in Cape Town brought
forth an outpouring of sympathy for the "creative talents" and entrepreneurial
spirit of its residents. It was envisaged that Khayelitsha would become a focus
for efforts by the British experts to utilize their skills "to encourage the tourist
trade to visit the township." Khayelitsha would be "a starting point for a num-
ber of South African museum projects, some altruistic, others commercial"
that would draw on British expertise.[71]

While some might look forward to the expertise of British museum de-
signers being employed at the cutting edge of museum creation in post-
apartheid South Africa, the commercial model of museums has also seen the

emergence of a new cultural apparatus in South Africa—that of the exhibition design and heritage management consultancy. National and community museums as well as exhibitions in such institutions have been planned, designed, and even installed pursuant to professional contracts. In this model, institutional integrity does not derive from the nature of the museum's structures, participatory processes, or internal capacities. Indeed, these aspects of the museum are considered secondary, even unnecessary, when it is possible, almost in an instant, to create some of the most impressive designs or exhibitions through the curatorial magic of the expert who is parachuted in and who flies out once the contract is complete. All that is needed is a suitable budget, derived either from the national treasury in the case of national museums, from municipal coffers or poverty relief budgets in the case of local projects, or from the lottery fund or a casino, those newly created instruments of social development. Once budgets have been spent on the experts, communities are often called upon, as an afterthought, to volunteer their memories in oral history projects. And the museum that is created is often little more than a specialist display environment, accompanied perhaps by a curio shop, through which a site has been turned into a destination.[72]

As the District Six Museum has begun to address the challenges of sustainability and self-reliance, the business model of museum development has certainly reared its head. But at the museum this impetus has been placed in a framework in which sustainability is understood as more than just an economic question. Indeed, sustainability is seen more properly as the creation of a strong infrastructure precisely in order to reinforce the core values, mission, political culture and distinctive pedagogy of the museum. By subordinating commercial possibilities to the political and cultural challenges of the museum's mission and to the participatory and conversational features of its process, a stand has been taken against the potentially disempowering and disorganizing tendencies of the business model. The forms of professionalization that have occurred in the museum have been geared toward enhancing its own institutional capacities, curatorial skills, and collections management expertise, rather than purchasing the expertise of the outside consultant. The District Six Museum has been able to marshal the growing expertise and museum experience of its staff as one of the key elements of its internal institutional synergies generated by activist intellectuals, artists, and public scholars in an ongoing project of creating a community museum.[73]

From a variety of perspectives, the category of "community museum" is one that has been used to describe the District Six Museum. It is also a concept that is deployed deliberately by the museum to define the cultural politics of its memory work. The museum's use of "community" is not naive but con-

scious and strategic. As Homi Bhabha has argued in another context, "there is no shortcut to the democratization of artistic production or circulation."[74] The museum insists on utilizing this concept as an organizational device, in asserting a particular politics of governance and institutional orientation, and in expressing a particular commitment to social mobilization and to constructing and defending independent spaces of articulation and contestation in the public domain. This strategic position emanates from a complex museum institution that has created a hybrid space of cultural and intellectual production of contests and transactions among activist intellectuals, purveyors of academic knowledge, museum professionals, and performers of "authentic voice." The possibilities of this space have no doubt been opened up by the democratic offerings and "arm's-length" framework of postapartheid cultural policy, which wants to facilitate expressions of civic autonomy and nongovernmental initiative. But the central features of the District Six Museum as a space of knowledge draw on a genealogy of forums of intellectual, cultural, and political expression in District Six, which came into existence beginning in the 1930s, as well as the politics of community organizing in the 1980s.

The idea of a "community museum" tends to conjure up notions of authenticity and representativeness in a local institution that supposedly works with an audience considered as a bounded community. The interests and worldview of the community museum are supposedly circumscribed by locality. With a history of racialized group areas in South Africa, this conception of community, defined by seemingly natural ethnic markers, is an ever-present danger. In a typological system of museums, where there is a continuum of rank, community museums are sometimes understood as one of the simplest units of museum structures, and national museums are seen as more complex.[75] In this framework, the notions of "community" and "community museum" invite a paternalist sentiment and ideas of innocence and naiveté, as the community now has access to modes of cultural and historical expression from which it had previously been excluded. The idea of the community museum also raises the idea of a museum as a focus of educational and cultural services. Here the museum seeks to reach certain audiences and to deliver "benefits to specific, geographically defined communities" through strategies of inclusion.[76] The museum here is understood as distinct from communities with which it may wish to develop formal relations of service and consultation, and with which it may even introduce forms of partnership, joint management, and relations of reciprocity.

The concept of "community museum" has posed a range of difficulties in the District Six Museum and has been the focus of much debate. In the first place, the concept of "community" has been the subject of much suspicion,

because under apartheid, community was defined in racial and ethnic ways through the workings of the state and its apparatuses. Even when understood in geopolitical terms to refer to localities and neighborhoods where people lived, it was racialized because of the operation of racial legislation. One of the ironies of the postapartheid period is that ethnic forms of community identity and identification have had new life as primordial and static cultures are reproduced either for tourism or in search of state benefits through land claims.[77] But community was also the focus of antiapartheid mobilization, particularly in the 1980s, when community organizing emerged as one of the most decisive sites of struggle. With the emergence of community organizations in the form of civic bodies and tenant structures, "community" also became a category through which to think about local social history as a means of questioning the teleologies of national history.[78]

The District Six Museum defined itself as a "community museum" because it sees its work as a locus of social organizing and mobilization. This definition also signaled a desire to create a participatory and enabling framework of interpretation and empowerment, and to generate the museum project as an ongoing process. In seeking to place itself at the heart of the process of reconstructing District Six, and committing itself to "participating in the cause of the returning community," however, the museum has sometimes lost sight of its responsibility to ensure the ongoing development of its professional and disciplinary capacities to tell the stories of forced removals through its collections, exhibitions, and education programs.[79]

The deployment of museum resources on the administration of restitution and the "homecoming" of District Six land claimants, in line with its mission and in support of the Redevelopment and Beneficiary Trust, at times occurred at the expense of consistent attention to infrastructure, resources, and managed "museumization."[80] A community museum wishing to influence the identity-making processes of re-creating and redefining a community from the ruins of apartheid's destruction required a strong museum infrastructure and more decisive means of balancing social activism with professional museum skills. The work of balancing these productive tensions strategically and finding the appropriate means of determining priorities under rapidly shifting cultural and political conditions remains one of the most important challenges of the District Six Museum's creative development. As the land in District Six was being prepared for the first phase of redevelopment for a reconstituted District Six community, it was clear that the work of the District Six Museum, far from being over, had entered a new phase of intervening in the cultural and political work of reconstituting community out of a disparate layer of re-

4. Earthmovers prepare the ground for Phase One of the redevelopment of District Six, 2003. Photo by Thulani Nxumalo. District Six Museum Collection.

5. Healing the landscape? Phase One of the redevelopment of District Six begins, 2003. Photo by Thulani Nxumalo. District Six Museum Collection.

turnees, who had experienced apartheid's lived spaces and mind-sets.[81] It was hoped that the interchanges and transactions in the museum's forums would enable the challenges of community formation to be faced successfully. In this new phase of "Hands On District Six," new challenges were emerging for the museum, of memory work and memorial inscription in relation to a reconstructed landscape.

Finally, the community museum as a project can have longevity and sustainability only through the generation of internal institutional capacity and expertise, and through enhancing internal processes of debate and argumentation. While the museum's existence parallels the prosecution and ongoing settlement of land claims by a legally defined claimant community, primarily of tenants, the notions of "communityness" that it works with are not determined by descent, mere historical claim, or spatial presence. Instead the museum's idea of community is strategic, and expresses a desire for particular forms of social reconstruction. Community itself is an imagined identity of commonality and interest. Its parameters are the very essence of contestation. Through its exhibitions, programs, and forums, and in its internal processes of negotiation and brokerage, the District Six Museum is constantly involved in redefining and reframing its notions of community. It continues to be a site where postapartheid identities are being imagined and self-fashioned, and not simply imbibed passively from those that apartheid produced.

NOTES

This paper is based upon research conducted for the Project on Public Pasts (POPP), based in the History Department at the University of the Western Cape, and funded by the National Research Foundation (NRF) in South Africa. Financial support by the NRF is hereby acknowledged. However, views expressed in this article represent those of the author and are not to be attributed to the NRF. I would also like to acknowledge the stimulating critical discussions held with staff and fellow trustees of the District Six Museum, which are ongoing, and from which I continue to benefit.

1 For an account of the history of forced removals from District Six, the Hands Off District Six (HODS) campaign, of the emergence of District Six as "salted earth," and of aspects of the cultural and political history of the area, see Jeppie and Soudien, *The Struggle for District Six*. This book emerged out of presentations made to a conference convened by HODS in District Six in 1988. Among several resolutions passed at the conference were the demand that redevelopment in District Six not take place without the central involvement of ex-residents and a motion that called for the creation of a museum for District Six.

2 By the nineteenth century, the terms "malay" and "coloured" (or "mixed") (written here deliberately in all lowercase to indicate their constructedness as part of a racial

order) were used to identify Muslim and Christian people, respectively, who were descended from Cape slaves (mainly of Malagasy origin but also African and South and Southeast Asian), indigenous Khoisan groups, other Africans, and/or Europeans. In cultural expression, they constituted an African creole segment of Cape society, often a feature of colonial port cities. In class terms, "coloured" also emerged as a category of self-definition, taken on by a nascent middle class intent on distinguishing itself from Africans. From the 1960s, the term "coloured" (by then a legislated racial category) was increasingly rejected as a category of racial domination, as people increasingly defined themselves as "black," a political category through which all segments of South African society that were not white united against apartheid. But since at least the 1940s, in the nonracial movement, racial terms such as "coloured" came to be prefaced by the term "so-called," or were placed in quotation marks to call attention to racial categories as impositions of a racist political order.

3 Bickford-Smith, Field, and Glaser, "The Western Cape Oral History Project," 35–37; Hart, "Political Manipulation of Urban Space," 119–20.

4 Hart, "Political Manipulation of Urban Space," 120–31; Pinnock, "Ideology and Urban Planning," 150–68. While some limited settlement by lower-middle-class whites and state employees occurred in the early 1980s, the most visible expression of the imposition of whiteness on District Six's landscape was the creation of the Cape Technikon, a technical college for whites, built, in part, perversely out of the material remains of District Six's edifice. In official terms, District Six was renamed "Zonnebloem."

5 The Restitution of Land Rights Act No. 22 of 1994, one of the mechanisms instituted by the postapartheid state to resolve conflicts of the past, created a highly contested framework for land restitution, and established a Commission on Restitution of Land Rights to oversee the process.

6 Ingrid de Kok explores this association in "Cracked Heirlooms."

7 See, for example, the approach to the museum reflected in Abrahams, "A Place of Sanctuary."

8 For a discussion of the cultural frameworks and institutions of a hegemonic national memory in South Africa as well as their discontents, see Rassool, "The Rise of Heritage." This hegemonic national memory, as expressed at new national museums such as the Robben Island and Nelson Mandela museums, narrates a national political history of resistance and reconciliation and the "triumph of the human spirit over adversity," in which the biographies of political leaders, particularly of Nelson Mandela, have been the central focus. This hegemonic narrative has been contested inside these national museums as well as through independent projects and frameworks.

9 Rassool and Prosalendis, Recalling Community in Cape Town, inside back cover; Abram, "Harnessing the Power of History." The District Six Museum was invited to participate in an international project on the Reconstruction of War-torn Communities in the Middle East, Africa, and the Red Sea Region. The first international conference took place in May 2001 in Cairo.

10 A Community Development and Heritage Seminar was convened by the District Six Museum at the South African Museum on November 24, 1999, as part of a week of discussion of Swedish–South African cultural, civic, and academic cooperation; the

second took the form of a workshop, "Mapping Alternatives: Debating New Heritage Practices in South Africa," convened by the University of the Western Cape's Project on Public Pasts (POPP) and the University of Cape Town's RESUNACT on September 25–26, 2001.

11 As a space of intellectual and cultural exchange and transaction, there are some parallels here with Clifford's concept of museums as "contact zones" (*Routes*, chapter 7). See also Karp's discussion ("Introduction: Museums and Communities") of museums, communities and citizenship, which addresses some of the Museum's central features.

12 See the detailed descriptions of the exhibition characteristics in Delport's interpretive essay of the District Six Museum's aesthetic work, "Signposts for Retrieval."

13 Ibid.; Morphet, "An Archaeology of Memory."

14 District Six Museum, undated and untitled information leaflet.

15 Prosalendis et al., "Punctuations," 75–76.

16 Bhabha, "Conversational Art," 39–40.

17 District Six Museum, "The Objectives of the District Six Museum."

18 Prosalendis et al., "Punctuations," 84–87.

19 Department of Arts, Culture, Science and Technology, *White Paper on Arts, Culture and Heritage*; Arts and Culture Task Group, *Report of the Arts and Culture Task Group*.

20 See Deacon, "Remembering Tragedy, Constructing Modernity" for a discussion of the debates and contests over the public memory of Robben Island, which was reconfigured as the first national museum of the new nation in 1997. See also Minkley, Rassool, and Witz, "Thresholds, Gateways and Spectacles." Later, the South African state's centralized project of national heritage came to be articulated more systematically in Department of of Arts, Culture, Science, and Technology, "The Portfolio of Legacy Projects." See Rassool, "The Rise of Heritage," for an analysis of this Legacy Project program.

21 On the challenges of transforming old museums and refiguring old collections in South Africa, see Witz, Rassool, and Minkley, "The Boer War, Museums and Ratanga Junction." See also ka Mpumlwana et al., "Inclusion and the Power of Representation."

22 On academic knowledge and the limits of representational capacities, see Beverley, *Subalternity and Representation*.

23 Thompson, *Making of the English Working Class*, 12–13.

24 Nicolene Rousseau's analysis of the radical claims of South African popular history ("Popular History in South Africa in the 1980s") and Isabel Hofmeyr's critique of the literate appropriations of orality by South African social historians (*"We Spend Our Years as a Tale That Is Told"*) were significant interventions. See also Minkley and Rassool, "Orality, Memory and Social History in South Africa."

25 See, for example, Jeppie, "Popular Culture and Carnival in Cape Town" and Nasson, "Oral History and the Reconstruction of District Six." The research of the Western Cape Oral History Project at the University of Cape Town connected into the Hands Off District Six campaign in the late 1980s, and District Six was a key area of oral history research in this project for many years. The methods and approaches of this research are discussed in Bickford-Smith, Field, and Glaser, "The Western Cape Oral

History Project." See also Field, *Lost Communities, Living Memories*, which represents a belated culmination of this oral history research.

26 "(Dis)playing the Game," an exhibition about the dignity that oppressed sportspeople derived through sporting organization and achievement, was curated at the initiative of former activists who had prosecuted the "sports struggle" under apartheid. "The Last Days of District Six: Photographs by Jan Greshoff" was a display of the architecture of the district before its bulldozing, and reflected further desires to reenter the materiality of the topography of District Six. "Buckingham Palace" was based on author Richard Rive's book *Buckingham Palace, District Six* and addressed itself to school learners.

27 For histories of Tramway Road and removals, see Mesthrie, "The Tramway Road Removals" and Paulse, "Everyone Had Their Differences but There Was Always Comradeship."

28 Soudien and Meyer, *The District Six Public Sculpture Project*; Hall, "Social Archaeology and the Theatres of Memory."

29 District Six Museum, *District Six Museum Newsletter*, August 1998.

30 Ibid.

31 Bedford and Murinik, "Re-membering That Place."

32 Hall, "Social Archaeology and the Theatres of Memory."

33 District Six Museum, *District Six Museum Newsletter*, August 1998; Layne and Rassool, "Memory Rooms."

34 Layne, "Public Knowledge and Music History in Cape Town."

35 Zuleiga Adams ("Memory, Imagination and Removal") has argued that the story of District Six's destruction in theater, literature, and elements of the "Streets" exhibition tended to depict the loss of a childhood paradise, as processed through the organization of memory. In the magical place that was District Six, the child is presumed to have been innocent and naive, and accounts of rituals of childish games and views of the adult world have provided a stamp of authenticity.

36 Rassool and Prosalendis, *Recalling Community in Cape Town*, vi (emphasis added).

37 Delport, "Digging Deeper in District Six"; District Six Museum, *A Guide to the District Six Museum and the "Digging Deeper" Exhibition*.

38 Ibid.

39 National Monuments Council, "Cross-cultural Heritage Management Workshops."

40 Much of the early fund-raising successes were due to the efforts of the District Six Museum's project director, Sandra Prosalendis.

41 Kenny and Kasale, "Swedish African Museum Programme"; Olofsson, "Growing from Challenge"; Ekarv, *Cultural Adventures*.

42 Swedish African Museum Programme, "SAMP 2001: Strengthening the Network" (a meeting for African museums taking part in SAMP), August 22–27, 1999.

43 A *faktrumet* (literally translated, "fact room") is an integrated resource center. For a discussion of the influence of the Swedish *faktrumet* on the creation of the District Six Museum's Sound Archive, see Layne and Rassool, "Memory Rooms."

44 On the lives of photographs, see Pinney, *Camera Indica* and Kratz, *The Ones That Are Wanted*.

45 Smith and Rassool, "History in Photographs at the District Six Museum."

46 This was one among a range of concerns and issues aired at a series of public forums held as part as the programming work of *Digging Deeper* in 2001–2002; see Houston, "Consultative Workshops Report."

47 Delport, "Digging Deeper in District Six," 158.

48 Ibid.

49 One historian combed the District Six Museum's collections in search of photographs of "Indians," in the preparation of a photographic book in which heritage recovery, which drew some inspiration from diaspora studies, slid uneasily back into visual codes and identifications of race, with more than a passing resemblance to colonial physical anthropology. See Dhupelia-Mesthrie, *From Cane Fields to Freedom*.

50 Layne, "Public Knowledge and Music History in Cape Town."

51 University of Cape Town, *Impact: A Report on Research and Outreach*, 21.

52 Centre for Popular Memory, *Annual Report*.

53 See http://web.uct.ac.za/depts./archaeology/index.html (accessed March 23, 2006) for information about work done by the Research Unit on the Archaeology of Cape Town (RESUNACT) with schools at an excavation site in Tennant Street, District Six, as well as about work done with schools more generally.

54 Hall, "District Six March," District Six Museum Web site, http://www.districtsix.co.za/archte.htm (accessed July 10, 2002). Elsewhere, of course, Hall has argued for the intellectual terrain and cultural practice of "social archaeology." See Hall, "Social Archaeology and the Theatres of Memory."

55 There is haunting footage of the removal of the Abrahams family in Lindy Wilson's film *Last Supper at Horstley Street* (produced and directed by Lindy Wilson, 1983, distributed by Film Resources Unit, Johannesburg).

56 In spite of the museum's nonracial intentions, the "Streets" exhibition was criticized strongly for privileging the experience of coloureds in the history of removals. This was among the issues debated in the "Digging Deeper" workshops conducted in 2001–2002. See Houston, "Consultative Workshops Report"; see also the critical discussion of "Nomvuyo's Room" by District Six collections coordinator Haajirah Esau in "Nomvuyo's Room: Please Enter" (visual history research project, University of the Western Cape, 2002, in author's possession). "Nomvuyo's Room," of course, was based on descriptions of life in District Six in Ngcelwane, *Sala Kahle*.

57 The simultaneous possibilities and limits of public archaeology's modes of empowerment are also apparent in other archaeological projects in the Western Cape. See, for example, Parkington, "Clanwilliam Living Landscape Project"; see also University of Cape Town, *Impact: A Report on Research and Outreach*, 25.

58 Members of the District Six Museum have, for instance, taken exception to the implication that the museum was really little more than a creation by academics, who had "played a major role" in setting it up, having "partly organised" the conference in 1988 out of which "the Museum grew," and who had made these contributions out of a spirit of university service and outreach. See University of Cape Town, *Impact: A Report on Research and Outreach*, 25.

59 Delport, "Signposts for Retrieval," 44.
60 District Six Museum, "District Six Museum Curatorial and Research Committee: Terms of Reference" (internal discussion document).
61 District Six Museum, "Mission Statement"; Houston, "Consultative Workshops Report."
62 Kirshenblatt-Gimblett, *Destination Culture*.
63 Witz, "Museums on Cape Town's Township Tours."
64 Adams, in "Memory, Imagination and Removal," also makes the insightful argument that the District Six Museum also unintentionally frames a redemptive experience, which resonates with the universal loss of childhood.
65 Drawing on this visual research in the District Six Museum, a leisure environment of restaurants, jazz clubs, and revue bars adjacent to the main gambling hall at Grand West Casino in Cape Town was themed after District Six, partly as a means of claiming authenticity and legitimacy. Gamblers and other patrons are able to eat and relax in an ambiance of re-created walkways and facades that draw on an "olde worlde" concept of District Six architectural heritage, replete with rusting street signs and depoliticized notions of cultural expression. More generally, culture and heritage themes have been a central feature of postapartheid casino development in major urban areas, and the main means by which casinos have laid claim to "adding social value," as required by their casino licenses. The most significant casino museum, the Apartheid Museum in Johannesburg, was built as part of the development of the Gold Reef City Casino, owned by the Krok brothers, manufacturers of skin-lightening creams under apartheid. It is indeed ironic that a private museum, with suspect business origins and doubtful integrity, has been able to take the gap afforded by the currency of commercialized heritage frameworks to utilize the best social history research and architectural and museum design expertise to create a profound museum experience of apartheid's history. The Apartheid Museum now graces the South African museum landscape with a seemingly unassailable gravity as a must-visit destination on tourist itineraries and as a site of education for students in search of evidence of apartheid.
66 This seems to be the character of the South African National Cultural Heritage Training and Technology Project, based rather curiously at Michigan State University in the United States. For a contrary approach, one that seeks to utilize Web-based and digital technologies to build communities and which is critical of the commercialization of museums, libraries, and other institutions of a nonprofit nature, see Reilly, "Merging or Diverging?"
67 On National Youth Day 2002, the creation of an MBA "for the museum business" was announced, involving a claimed partnership between Iziko Museums of Cape Town and the University of Cape Town's Graduate School of Business, but driven essentially by one of the leading proponents of the museum-as-business model, Jack Lohman, then CEO of Iziko Museums of Cape Town; see the *Sunday Independent*, June 16, 2002, 10. During the brief tenure of his leadership of one of the two national "flagship" museums created from the old museum collections (the other is the Northern Flagship Museum in Gauteng), Lohman's advocacy of commercial approaches attracted some

support from government officials, weary of being targets of public criticism of in-
adequate public funding for the conservation and management of national museum
collections.

68 British Trade International, *Heritage, Tourism and Museums*, 36–40. This booklet was
created for British Trade International and the Foreign and Commonwealth Office as
part of the British government's Creative Industries Initiative, Heritage and Tourism
Cluster Group.

69 Laurie Stewart, "Museum Mission," www.opportunityafrica.org.uk/members/20010
30111-19.pdf (accessed July 10, 2002). The visit was facilitated by Jack Lohman, then
newly appointed CEO of Iziko.

70 Stewart, "Museum Mission," 14; British Trade International, *Heritage, Tourism and
Museums*, 36. These presentations were made at a seminar on the Museums Projects,
South African Museum, January 15, 2001. The absence of even the most rudimentary
conception of cultural imperialism was indeed startling.

71 Stewart, "Museum Mission," 14–15; British Trade International, *Heritage, Tourism and
Museums*, 36–38.

72 It is to be expected that this conception of a museum as little more than an expertly
created exhibition environment will characterize a casino "rogue" museum such as
the Apartheid Museum in Gauteng. This market-driven model of museum creation,
however, has also been a feature of national and local museums created with public
funds. The creation of the Nelson Mandela National Museum in Umtata (now known
as Mthatha), as one of two new national museums, saw the entry of an outside expert
design team, which was contracted to create an impressive multimedia exhibition on
Nelson Mandela's "long walk to freedom" at the Bhunga Building. This emphasis on
expertise, outsider skills, and the mystique of design precluded the possibility of effec-
tive participation in the curatorial process by surrounding communities for whose
benefit the museum was created. Similarly, a plan to create a "museum of apartheid"
in Port Elizabeth's Red Location seemed poised to falter after the bulk of resources
had been expended on creating a design model for an intended museum building.
The focus on the great designer or design team for the creation of instant museums
and exhibitions may indeed have impeded the need to ensure institutional longevity
and sustainability based on participatory structures and processes, especially in the
creative work of the museums.

73 In the early years of the museum's existence, its core staff were three or four former
residents who started off as volunteers, led by a project director with experience in
the NGO sector. Later, the museum also recruited a layer of three or four younger
professional staff members, with academic training in key heritage disciplines. Many
of these staffers had also been activists in youth and civic politics or in the cultural
sector, and some of them came from District Six families. While professionalization
of its staff and structure has been a feature of the museum's development as it grew
to its current staff of around twenty, it has continued to draw upon the skills and
knowledge of former residents on its staff as a decisive aspect of its work.

74 Bhabha, "Conversational Art," 40.

75 This idea of community museums as local and simple as opposed to "more complex"

national museums, considered in a hierarchy of importance and stature, is certainly to be found in ka Mpumlwana et al., "Inclusion and the Power of Representation."

76 Sandell, "Museums and the Combating of Social Inequality," 7.

77 Witz, "Transforming Museums on Postapartheid Tourist Routes," in this volume; Bunn, "The Museum Outdoors," in this volume.

78 Bozzoli, *Class, Community and Conflict.*

79 District Six Museum, "Mission Statement" and "The Objectives of the District Six Museum."

80 In 2000, President Thabo Mbeki handed over ownership of the land in District Six to District Six claimants, and responsibility for District Six's redevelopment was given to the District Six Beneficiary Trust in partnership with the City Council and the Land Claims Commission. When the District Six Museum acquired a new building on the edge of District Six for the purposes of facilitating the redevelopment and reintegration process, two floors were given to the renamed District Six Redevelopment and Beneficiary Trust to start a Homecoming Centre for the counseling of claimant returnees, "to facilitate their readjustment" and "to offer them a healing opportunity to come to terms with the past" (Anwah Nagia, address to the official opening of the Homecoming Centre—District Six Redevelopment and Beneficiary Trust Offices at the Sacks Futeran Building, Cape Town, March 1, 2003). Part of the integrated development plans envisaged the creation of a "social compact" as a means of defining community and setting limits on the buying and selling of District Six land.

81 As it became clear that the struggle for District Six was going to culminate in redevelopment after a successful struggle for land restitution, one or two people suggested, rather naively, that because the mission of the District Six Museum had almost been accomplished, the museum needed to make preparations for its own closure.

Community Museums and Global

Connections: The Union of Community

Museums of Oaxaca

CUAUHTÉMOC CAMARENA AND TERESA MORALES

In this essay we will discuss three points: first, how globalizing processes have impacted rural, indigenous communities in general terms; second, how we can understand community museums as one of the multiple strategies communities have developed to resist imposition and strengthen their own culture in the context of globalization; and third, how local community museums have become a vehicle for international and global connections. To illustrate this last point we will develop a brief case study of the Union of Community Museums of Oaxaca, an association of nineteen villages in the state of Oaxaca, Mexico, that grew out of exchanges on a state level, and subsequently promoted the development of networks throughout Mexico and several countries of America.

GLOBALIZATION

Recent global changes, such as the transformations springing from the gigantic world market, the increasingly complex division of labor, the accelerated development of means of transportation and communication, and the concentration of immense resources and power in the hands of a few nations and corporations, have led to radical changes in the relationships between different cultures and societies.[1] The Brazilian anthropologist Gilberto Velho asserts that different cultures were affected by external forces that in many cases were

enormously harmful and destructive as they acted upon their physical environments, traditions, and values. As a result, in the last two centuries, hundreds of traditional and tribal societies were destroyed or seriously damaged. Jason Clay of the human rights group Cultural Survival offers a summary of this situation:

> The outlook for indigenous peoples, who number 600 million worldwide and live in more than 5,000 groups, is deteriorating. In excess of 5.5 million tribal people have been killed as the result of warfare waged by their own governments since World War II, and 150 million have been displaced. This century has witnessed more extinctions of native peoples than any other.[2]

Development experts demonstrate, such as Kevin Healy does for the case of Bolivia, that globalization has brought indigenous communities under tremendous strain: as unemployment and underemployment grow, income distribution is remaining the same or worsening, domestic markets are flooded with imported agricultural goods that local producers cannot compete with, and migration rapidly escalates. Easy access to Western artifacts contributes to cultural homogenization, and migration erodes local cultural identity. On the other hand, there are some global trends that offer limited economic opportunities to local indigenous communities. For example, wealthy societies have grown to value indigenous designs, intricate craftsmanship, and organic produce. There is also an expansion of small-scale adventure travel and ecological and community tourism.[3]

Nestor García Canclini has a somewhat different focus. He defines globalization as a stage of history that took shape in the second phase of the twentieth century, in which economic, financial, communication, and migratory processes converged, accentuating the interdependence between vast sectors of many societies and generating new dynamics and structures of supranational connections. He argues that globalization heightens international competition and dismantles endogenous cultural production, favoring the expansion of cultural industries that have the capacity to both homogenize and attend to diverse sectors and regions. It destroys or debilitates inefficient producers, and concedes to peripheral cultures the possibility of remaining encapsulated in local traditions. In a few cases, it offers these cultures the possibility of becoming stylized and disseminating their music, festivities, and culinary traditions through transnational companies.[4]

García Canclini considers that the central dilemma is not between the defense of local identities and the acceptance of globalization. He argues that the challenge is to understand the opportunities for action and being with others, how to face heterogeneity, differences, and inequalities. More than confronting

"essential" identities with globalization, he proposes to explore whether it is possible to construct subjects in expanded social structures. "It is true that the greater part of current production and consumption is organized in scenarios we do not control, and often do not even understand, but within the tendencies towards globalization, the social actors can open new interconnections between cultures and circuits that catalyze social initiatives."[5]

As García Canclini goes on to discuss who the current social actors are, he includes NGOs that link distant local movements, networks dedicated to the "negotiation of diversity," and civil organizations that project the perspective of peripheral societies on a transnational scale. We think, however, that he does not sufficiently acknowledge that many such networks and organizations are mobilized precisely by the defense of diversity, by the defense of specific cultures, not as ideal "essences" but as dynamic ways of life. Are not members of local cultures and subcultures important social actors of the future? Diverse cultures are demanding respect for their own projects and visions of the reciprocal influences and interactions they wish to participate in, and will have an impact on the kind of globalization that will develop in the years to come.

By emphasizing the need to comprehend interdependence, heterogeneity, and the complex transmutations between global and local dimensions (how the global is stationed in each culture and how the local tries to survive in exchanges that are becoming global), García Canclini downplays the role of contradiction and struggle. We think it is useful to consider the notion of civil society developed by Antonio Gramsci, as Ivan Karp proposes. Karp asserts that "civil society includes . . . the social apparatuses [families, voluntary associations, ethnic groups and associations, educational organizations, etc.] responsible for providing the arenas and contexts in which people define, debate, and contest their identities and produce and reproduce their living circumstances, their beliefs and values, and ultimately their social order." Karp clarifies that the process of social reproduction and education is not always harmonious and benign. Class, ethnic, and racial conflict is a basic characteristic of civil society. We can visualize civil society as "a stage, an arena in which values are asserted and attempts at legitimation made and contested."[6]

In this sense, globalization can be seen as the expansion of the relations of civil society to global dimensions. On this global stage, agents of wealthy industrialized societies have enormous resources to expand the consensus around their own social ideas and moral values. But other cultural groups, including indigenous communities, contest these ideas and struggle against the imposition of identity. Perhaps many agents of industrialized societies relate to traditional, indigenous communities of peripheral cultures as a new kind

of commodity that can be stylized and marketed through their exotic expressions in music, festivities, and cooking. But these communities have a different vision of themselves. Wealthy industrialized societies expend significant resources attempting to direct the processes of social change throughout the world, but diverse societies and communities have different values and projects of the future they would build for themselves, and propose to others as well.

Paradoxically, while globalization has contributed to the destruction of indigenous communities, as they are increasingly dispossessed of their territory and resources, increasingly marginalized or transformed into commodities, it also increases their access to new tools to impact global awareness and defend their integrity.

On one hand, globalization has made possible the transference of technology for communication and cultural expression to local communities on an unprecedented scale. The use of the World Wide Web to mobilize public opinion, the development of community radio, indigenous video programs, and community museums all offer examples of the appropriation of Western technologies by local communities. Projects using Web sites include fascinating cases such as the Ashaninkas, a people who live in fifty indigenous villages in the Amazon jungle in Peru and who organized their own Internet server and Web site to tell their story, using Web-based educational tools and village Internet kiosks to enable small villages to communicate with one another.[7]

On the other hand, globalization has made possible the development of networks of local communities and social organizations that did not exist previously. It has facilitated communication between remote communities and made it easier for them to identify with one another. New international organizations are being created. For example, Via Campesina is an international peasant union uniting farmers, rural women, indigenous groups, and the landless. It has members in France, Brazil, Thailand, India, Bangladesh, Ecuador, New Zealand, Mexico, Colombia, and Nigeria, who belong to organizations such as the French Conféderation Paysanne, the Landless of Brazil (MST), and the Karnataka State Farmers' Association.[8]

COMMUNITY MUSEUMS

Community museums are a good example of the imaginative strategies communities have developed to sustain their culture, appropriating tools for cultural preservation and expression originated in a different context. A cultural institution created by the dominant classes of eighteenth-century Europe, the museum is transformed as it comes into the hands of different social agents.

However, to clarify some of the challenges a community museum faces, it is helpful to reexamine the idea of community.

The concept "community" is vague and problematic. Hector Tejera Gaona points out that many of its constituent elements appear in romantic, conservative reactions following the French Revolution. What was perceived as social upheaval and chaos was contrasted with a period of idyllic order and harmony, in which nonindustrial communities were sustained by unifying beliefs in family and religion. He traces, from Bonald and Maistre to Comte and Durkheim, how romantic and nonhistorical perspectives were adopted in anthropology and sociology. In intellectuals' search for a world apart from modern society, tribal, peasant, and indigenous societies were portrayed as the "other," communities that represented harmony, solidarity, and the absence of conflict. In this way the concept of community was constructed as a utopian ideal, outside of history.[9]

The idea of community can also be the antithesis of an ideal. It has been manipulated to justify policies and power structures. In Mexico, for example, "colonial and modern state policy of isolating communities and reinforcing the importance of locality has limited the possibility for regional movements of ethnic autonomy."[10] In this volume, Ciraj Rassool points out that "community was defined in racial and ethnic ways through the workings of the state and its apparatuses. Even when understood in geopolitical terms to refer to localities and neighborhoods where people lived, it was racialized because of the operation of racial legislation."[11] In Mexico, the state has used the concept of the indigenous community to propose new legislation that recognizes the rights of small, local communities while refusing to consider the rights of indigenous peoples.[12]

However, we think it is possible to argue that as a tool for constructing a site of engagement and contestation, the idea of community has retained a great deal of significance and power. As "an imagined identity of communality and interest," it is often the most direct reference for what people sense is worth defending, and it becomes the center around which many of the greatest social struggles and commitments emerge.[13]

The concept of community is the touchstone for a tradition of grassroots struggles and organizations in many parts of the world. In South Africa "community was also the focus of antiapartheid mobilization, particularly in the 1980s, when community organizing emerged as one of the most decisive sites of struggle."[14] The *comunidades de base* (grassroots communities) promoted by advocates of liberation theology were the catalysts behind popular organizations all throughout Latin America beginning in the 1970s. In Mexico, the

1. Villagers meet to discuss the museum at the community assembly of San Martin Huamelulpan, Oaxaca, Mexico, July 1991. Photo by Teresa Morales.

idea of community has been appropriated by small rural, and especially indigenous, populations, and it is the term they use to define themselves.[15]

For us, a community is a group that shares a territory, a common history, and a memory of its history. Its constituents have a common experience of constructing meaning and a way of life. It is a group capable of collective action in the interest of its members, capable of developing initiatives and struggles to contest those who act against its interests.

The concept of community museum we propose builds on the idea of community as a site for contestation and struggle. As communities contest the imposition of cultural practices and values, the museum becomes a useful instrument. George Orwell has said, "Whoever controls the past, controls the future; whoever controls the present, controls the past."[16] The community museum is a strategy for communities to control their future by controlling their past. To control the past, communities take action regarding their cultural heritage. They struggle to possess their material heritage, which has often been expropriated by private or public agents. They struggle to preserve their own symbols and their own meanings, and to legitimize these meanings through the museum. The histories and memories that are not told in official textbooks come to life. As the process of collecting and representing stories develops, the community museum also becomes a vehicle for a collective process of interpretation, through which new elements of debate and consensus are created.

The museum requires the community to make decisions: decisions about what the museum will speak about, how its contents will be represented, who

will organize and direct it, even where it will be built. These decisions require the community to strengthen and expand consensus-creating mechanisms, reinforcing forms of self-government and community engagement.

In this sense, far from being predicated on the absence of conflict, the community museum can be understood as a dynamic tool communities use to create consensus and manage conflict from within, as well as a method to resist imposition from the outside.[17] In general, it reinforces the group's capacity to be a community, to imagine its identity collectively, and to project its imagination in action.

The community museum is a platform for a wide variety of actions that respond to community needs. The museum can develop effective ways to engage and educate children and young people, strengthening their bonds to community culture, and offering new skills for creative expression. The museum can contribute to the revitalization of a great variety of cultural traditions, including dance, music, and native languages. The museum can make diverse forms of training available and provide skills that allow community members to develop projects that respond to their own needs and aspirations. The museum can become a window through which the community relates to other communities, carrying out cultural exchange and building networks to impact diverse projects and policies. Through the museum a community can organize services for visitors, designed by community members, in a respectful and orderly exchange, instead of remaining an object of consumption by commercial tourism agencies.

While the museum rebuilds community from within, it also strengthens community resistance to pressures from without. It is difficult to appreciate the dimensions of this task without remembering the almost overwhelming challenges involved. As already pointed out, globalizing processes have seriously compromised the economic sustainability of local communities, disarticulating community life and values. National institutions reinforce this process, instead of counteracting it, and the centralization of power and wealth continues. The proposal to create a community museum is part of a strategy of community resistance.

Resistance implies the mobilization of important resources. In the museum, material heritage, collective property, the effort of its members through community service, and a reservoir of traditional knowledge are channeled to sustain the collective existence of the community at a moment of accelerated change. But to rebuild community means to reimagine the future, and in the museum a central challenge is to contribute new visions and skills to make that future possible.

THE UNION OF COMMUNITY MUSEUMS OF OAXACA

One element that can help construct skills and provide vision for the future is the development of networks that link communities with common interests and enable them to act jointly. In this sense, community museums have been able to generate regional, national, and international connections. These networks allow communities to put their own experience in a wider framework and develop projects that go beyond the strictly local dimension. The challenge is to create networks that allow local communities to exercise ownership over regional, national, and even international projects, and at the same time to nourish their community base and capacity to respond to local needs. To illustrate this point we will examine the case of the Union of Community Museums of Oaxaca, an association developed by a group of indigenous and mestizo communities in the state of Oaxaca, in the south of Mexico.

Oaxaca is one of the most mountainous states of Mexico, somewhat smaller than the country of Guatemala, with great biodiversity and multiple ecosystems. Of its population of 3.4 million, 49 percent belong to indigenous communities, who have been grouped into fifteen different ethnic categories according to the native languages they speak. Oaxaca has 570 municipalities, a fourth of all the municipalities in Mexico. The majority of the state's population lives in small communities of less than 2,500 inhabitants.[18]

Oaxaca is considered one of the poorest states in Mexico. The indicator of poverty used by the Mexican government shows that 80 percent of the population is considered poor or very poor. In 2000, more than half of the working population earned less than U.S. $4 a day. The majority of the active labor force in Oaxaca is employed in agriculture, primarily for subsistence. Most farmers work small plots of less than five hectares and struggle annually to meet their subsistence needs. The average number of years of formal education is 5.9, much less than the national average, 7.8 years. Illiteracy is estimated to be around 22 percent.[19]

Approximately 1 million people have migrated from Oaxaca to other states in Mexico, the United States, and Canada. It has been estimated that U.S. $20 million was received in remittances during 2000 in the region of the Central Valleys of Oaxaca alone, an amount that represents five times the federal government's investment in the region for the same period.[20]

Although a significant proportion of the population is highly mobile on a national and international scale, the indigenous population of Oaxaca has an extremely localized sense of community and ethnic identity. The political fragmentation of Oaxaca through the colonial and postindependence actions

of the state and the national policies in the twentieth century aimed at integrating the indigenous communities in an isolated fashion have contributed to this development.[21]

Today, indigenous communities in Oaxaca consist of a group of families linked by blood and ritual kinship who have lived in a common territory for hundreds of years. Their inhabitants identify themselves as members of a community sharing the culture of their ancestors. Families are linked in an intricate web of reciprocal relationships. Each family possesses a plot for their home and a plot for cultivation, but the lands are communal property. The land is not only an economic value but a sacred space linked to supernatural forces that community members interact with individually and collectively.[22]

To be a member of the community, it is not enough to have been born there. One must repeatedly show the will to fulfill community obligations, in communal government, communal labor, and communal celebrations. All adult men, as heads of households, have the obligation to participate in the village assembly, which is the main decision-making body. They also must fulfill the *cargos*, or positions of civil and religious responsibility. In Oaxaca, more than 400 of the 570 municipalities have chosen to elect their municipal authorities through the system of customary law,[23] which means that the *cargo* system extends to all the positions of civil government within the municipality. But not only the municipal authorities fulfill *cargos*; there is also a large group of committees elected by the village assembly that must create and sustain diverse community services. There are committees to support public schools, health clinics, public works, and so forth. In this way there can be almost two hundred heads of households performing community service without any pay in towns of six hundred families.[24]

We began working with indigenous communities to create museums in 1985, as social anthropologists working for the National Institute of Anthropology and History of Mexico (INAH), the federal agency in charge of the research, conservation, and dissemination of the cultural patrimony of the nation. Most of our background was in formal and informal education, focusing on anthropology as a tool for community development. In 1985 the community of Santa Ana del Valle requested the support of INAH to create a community museum. We responded to their request and began working in this field.

There was already a federal program to develop community museums in existence, but it was not operating in the state of Oaxaca. We learned about its methods, which had been developed from the experience of Casa del Museo, a program of the National Museum of Anthropology and History from 1972 to 1979, and the program of "school museums," also initiated in 1972. From our point of view, the great disadvantage of this program was that its top-

down promotion methods frankly contradicted its stated objectives. Although it claimed to represent the cutting edge of the "new museology" in Mexico, it trained elementary school teachers to select appropriate communities and convince them of the benefits of a community museum, without attention to community initiatives or strategies to construct grassroots community organizations.[25]

We decided to continue in an independent fashion and began to develop the community museum program of Oaxaca by supporting the communities that manifested interest in creating museums, guiding them in a process to build consensus and organization around the museum project, and offering academic and technical assistance together with our co-workers at INAH, archaeologists, exhibition designers, restoration specialists, and staff of the regional museum. Since 1987 we have been the only INAH personnel dedicated to the program in Oaxaca on a full-time basis; our colleagues collaborate occasionally as their workload permits.

The interest in community museums in Oaxaca grew very rapidly. Although few inhabitants of the communities had ever been to a museum, commerce and migration were creating opportunities to see the Regional Museum of Oaxaca, an impressive facility presenting the archaeology and ethnography of the state, and the National Museum of Anthropology, a museum internationally famous for its dramatic presentation of pre-Columbian artifacts. Archaeological excavations carried out in San José Mogote, San Martín Huamelulpan, and Santiago Suchilquitongo also fueled interest in these communities. Fortuitous discoveries of archaeological remains were very frequent, as they are today, and communities began to demand that these artifacts remain in their possession, instead of becoming part of the collection of regional and national museums. The possession of extraordinary historical documents from the colonial period and the need to reconstruct the history of land tenure also triggered interest in many communities. These concerns were complemented by a growing desire to attract tourism, which has been quickly expanding in Oaxaca.

Over the years we developed a methodology to enable these communities to create their museums. We envisioned the first stage to be focused on developing the basic consensus around the project and the establishment of a team of community representatives to plan and coordinate its activities. A second stage includes orienting the team to construct and manage the project, while continuously identifying segments of the community and strategies to involve them. In this phase, fund-raising, the adaptation of the building, and a participatory process for the research and design of exhibits are central elements.[26]

In Oaxaca it quickly became apparent that to develop consensus around

2. The museum committee accepts new donations, Santa Ana del Valle, Oaxaca, Mexico, July 1992.
Photo by Cuauhtémoc Camarena.

the museum project it was necessary to establish direct links to the funda-
mental decision-making body (the village assembly) and to traditions of local
self-government (the *cargo* system). Decisions concerning the museums are
brought continuously to the attention of the village assemblies. The assembly
determines the themes to be addressed and the building to be occupied, as
well as dealing with any specific conflict that might arise. Assemblies together
with municipal authorities promote campaigns for donations to the museums,
agree to dedicate *tequio* (days of collective community labor) to the museums,
and hear the museum committee's proposals and reports. Village assemblies
also call to account people who are reluctant to preserve historical objects and
sites, individuals who try to obtain personal gain from museum projects, and
committee members who spend funds in a fraudulent manner.

Throughout this process the museums are developed and directed by mu-
seum committees established in the same fashion as all the other village
committees.[27] By their appointment through the *cargo* system, the museum
committees are constituted as legitimate community representatives, with the
moral authority to invite and engage community participation.

At the same time, the museum committees reflect the patterns of exclusion
that are practiced in the community. For example, the committee members
elected by the assembly are most often men, as men are still considered the

heads of households and are responsible for performing community service through the *cargo* system. This pattern is changing as women gain greater access to education and as they become heads of households when their husbands migrate.

Throughout the process of developing the museum we work with the committees to implement methods to include individuals of different age groups and community organizations in the creative and technical tasks of the museum. These methods include planning techniques, strategies to organize festivals and events, and organization of meetings and workshops that enable community members to participate collectively in choosing and collecting objects, in researching and analyzing their history and culture, and in representing their stories through drawings, murals, photographs, scale models, and life-size installations. In this process the participants have the opportunity to become dynamically engaged, strengthening and developing direct, personal bonds to their collective identity. They also have the opportunity to share a learning experience and collectively analyze the elements of community unity and conflict through a process of creative interpretation.[28]

Since the themes represented in the museums are chosen through a series of community consultations, the exhibitions are very diverse. However, all of the fifteen museums, except one, include a section on the pre-Columbian past, since this theme remains one of the communities' fundamental interests. The exception was the museum of Natividad, Ixtlán, which the community chose to develop around the history of their gold mine and the miners union. Since all the museums, except Natividad, include two or three exhibitions, there is a wide variety. For example, there is an exhibition concerning a period of the Mexican Revolution (1915–20) in which the community of Santa Ana del Valle was practically destroyed in the process of resistance to federal troops. There are exhibitions concerning the struggle to possess the land of the hacienda, or the history of conflicts over land tenure with haciendas and neighboring communities. There are many exhibitions on folk art: weaving with the Spanish loom, backstrap weaving, basketry, stone carving, and palm-leaf weaving. There are exhibitions explaining the institution of the *mayordomía* (an important community resource to sustain the fiesta), displays on traditional medicine, and a very elaborate exhibition on the *gal ruuchi nia sa guili*, translated from Zapoteco as the "wedding with music," created by the community of Teotitlán del Valle to represent their traditional weddings.

Once the museum is open, it faces the challenge of translating the vision of what has been collectively represented into concrete actions that continue to strengthen and re-create the community. In Oaxaca the museums carry out a variety of initiatives and grassroots projects. The museum committee con-

3. Archaeological exhibition at the community museum Hitalulu, San Martín Huamelulpan, Oaxaca, Mexico, November 1991. Photo by Jorge Acevedo.

tinues to play a critical role: their members direct, administer, open the museum to the public, and create projects according to the work plan they establish at the beginning of their term. We offer them guidance and training to fulfill this role.

The initiatives and projects have been very diverse. A large part of the museums' projects have focused on cultural revitalization. Museum committees from several villages have identified the need to revitalize traditional dances, and established dance groups that involved up to forty young people over several years, training and performing within their community and other locations. Others have carried out oral history workshops and created temporary exhibits to revitalize traditional medicine and traditional knowledge used in crafts. Several museums have supported traditional music by organizing groups, celebrating festivals, and donating instruments. Two communities have organized festivals around traditional cooking, and another two have organized workshops to revitalize the use of their native language, training young people to write legends in Mixteco. Several museums have developed radio programs and projects to create videos to document and disseminate traditional culture.

Another group of initiatives is related to income-generating activities. Eight of the fifteen museums present exhibitions describing the history and social impact of different forms of folk art. The communities use these to promote

the sales of local products, either directly from artisans or through the museum store. Temporary exhibitions of folk art have traveled and generated sales in several states of Mexico and in southern California. In one community, a traveling exhibition motivated a group of artisans to set up a cooperative, through which they bought raw materials and opened access to new markets, increasing the income of a group of twenty-five artisans over a period of approximately five years.[29]

The organization of services for tourists is another important area the museums contribute to. The museum committees together with the municipal authorities have designed offerings for national and international tourists, including visits to the museum, to historical and natural sites, and to artisans' workshops, and demonstrations of how traditional food is prepared. These visits are designed to share local culture in a framework of respect and mutual exchange. The communities close to the city of Oaxaca attract more visitors, but even in some more remote ones these visits generate supplementary income for community guides, artisans, and families who prepare meals. In two communities the museums have generated projects to create lodging for visitors.

Since community members consider that the museum must serve community needs in general, they often become a vehicle to address needs for diverse forms of training. Several communities have organized workshops on organic fertilizers, reforestation techniques, and nature conservation. As we will see, the communities jointly organize training events in leadership development, including workshops in strategic planning, project development, fund-raising, and how to develop a community newspaper to publish on the Internet.

All the museums organize services for children, such as programs to visit the museum and a variety of workshops. These include initiatives to strengthen children's bonds with their traditional culture and to also offer new methods of creative expression. There are workshops in traditional crafts, traditional medicine, archaeology for children, restoration, creative writing, photography, and mural painting.

The museums are sustainable in the sense that they are linked to fundamental community organizations: the village assembly, the *cargo* system, and the municipal authorities. They have a presence and a role in the community. They are also economically sustainable in the sense that funds from the municipality and the entrance fees cover basic maintenance costs, and committee members open and maintain the facility without charging for their services.

However, the scope and creativity of the museum programs vary according to the dynamics of specific groups within the community. A teacher with a history of cultural activism will provide different leadership than will someone in

the process of migrating outside the country. Many museum committees are able to respond effectively to community needs and interests in the projects they propose and carry out. However, because the term of each committee lasts for only a year or two, it is often difficult to maintain the momentum and commitment behind these projects. Again, the museums reflect the patterns and tensions of community organization as a whole.

On the other hand, the museum is not only a reflection; it also impacts and expands the experience of community members. The experience of studying, representing their own history and culture, and participating in keeping traditions alive provides increased self-esteem and identity in ways that are difficult to document but which testimonies and evaluations offer evidence of. Through the museum community members learn new skills in planning, negotiating, raising funds, and developing projects. They establish new relationships to other communities, to public and private organizations, and to institutions that can enrich community life. Several people who have been members of museum committees and later went on to become municipal authorities affirm that their experience in the museum was particularly valuable.

In several cases, the museum has gained such presence and momentum that it generates support not only for the museum itself but for other important community projects: the reconstruction of the hacienda in San José Mogote, the reconstruction of the church and other historical monuments of San Miguel Tequixtepec, and the creation of the children's museum in Santa Ana del Valle.

To offer the museum committees training, motivation, and organizational support, in 1988 we began to organize meetings to bring the committees from different communities together once every two months. Over the years, these meetings allowed the different community representatives to identify with one another, recognizing common problems, learning from mistakes, and taking inspiration from the successes of their peers. The training sessions provided a framework to continuously clarify their vision of the community museum and its role. They decided to formalize their network, to develop and raise funds for individual and collective projects. In 1991 the Union of Community Museums of Oaxaca was established as a formal, nonprofit association.

The first projects included a program of traveling exhibits, the publication of brochures and guides, a project to create radio programs, and a project to create an international traveling exhibition. They were granted support from the National Institute of Anthropology and History, the National Indigenous Peoples Institute, the Directorate of Popular Culture, the French-Swiss foundation Traditions for Tomorrow, and most of all the Inter-American Foundation.

Eventually, the Union of Community Museums of Oaxaca was able to hire

4. Meetings of the network of community museums in Oaxaca include training, planning, and group exercises. Teotitlán del Valle, Oaxaca, Mexico, February 1993. Photo by Jorge Acevedo.

a team of anthropologists and community organizers to support their efforts. This represented a fundamental step, allowing the network to provide ongoing guidance and training to the museum committees. The continuity of this team and the community representatives that participate in the leadership of the union has provided a new platform to strengthen collective projects.

At present, the mission statement of the union is as follows: "The mission of the Union of Community Museums of Oaxaca is to support each participating community in the task of creating and strengthening their community museums, to know who we have been, who we are today, and who we can become, building a future rooted in the ancestral values of our peoples; to unite all our communities, exchanging our experiences and establishing a network to face our common problems, at a state, national and international scale; and to strengthen our community action in education, training, promotion of local art, and community tourism, through collective projects."[30]

Currently the union is concentrating on two main projects, the Training Center and the Cooperative for Community Tourism. The Training Center was established in 1997 with the objective of providing a more systematic series of training services to museum committees, municipal authorities, and community groups. It was designed to facilitate community participation in the creation of the museums, to help each museum respond more fully to

community needs, to develop multiple relations with other nongovernmental organizations and private and public institutions, and to strengthen the autonomy of the association. At present it is offering workshops in five different areas: creation of community museums, development of community museums, strengthening children's bonds to traditional culture, leadership development, and community capacity building.

During a four-and-a-half-year period the Training Center offered 196 workshops to 4,550 participants of nineteen communities that belong to the union, seven communities of Oaxaca that are not yet members, and fifty-four communities from other states in Mexico. It has facilitated the creation of four community museums and developed collaborative relations with twenty-five nongovernmental associations, eleven governmental institutions, five educational institutions, and one private enterprise. The center has begun to generate income for operating expenses by offering training services to the study-abroad programs of Kalamazoo College and the School for International Training. Its programs have been supported by the Inter-American Foundation and the Rockefeller Foundation.[31]

The Cooperative for Community Tourism was created in 1996. Its mission is "to provide community tourism services, as an alternative form of cultural and ecological tourism generated by indigenous and mestizo communities of Oaxaca, who plan, design, and control the services offered, with the objective of developing, protecting, and conserving their natural and cultural heritage, promoting an exchange between visitors and community members in a framework of mutual respect." A small central staff guides the museum committees in a process to design visits, and markets them to specialized travel agencies, local schools, and universities in Mexico City, the United States, and Canada. Income is generated for the community museum, community guides, families who provide meals, folk artists, and people who lend their bicycles and horses. The economic success of the cooperative is modest, but significant for the communities involved.[32]

In this sense, the Union of Community Museums of Oaxaca (UMCO) has been able to expand the scope of local projects without losing sight of the community base. Only together were these communities capable of creating their own training center, which in turn is able to provide new visions and tools to community groups in each village. Together they have been able to organize and market community tourism services they could not have promoted individually. As collaborations are constructed from the horizontal relationships between villages instead of out of vertical relationships between villages and central institutions, UMCO has given the participating communities a sense of organization, unity, and power.

NATIONAL AND INTERNATIONAL NETWORKS

As Kevin Healy has pointed out, the social process of "federating" is a common element in the history of many grassroots organizations, but not often found in cultural associations. In the museum field, networks exist among professionals but not among the communities that are involved in the museums. Even the International Movement for the New Museology (MINOM), which championed the idea of alternative, community-based museums, did not build links between community groups. However, when the Union of Community Museums of Oaxaca began to be recognized as a model that could be developed in other parts of Mexico, its most significant characteristic was that it brought together representatives of grassroots community organizations. Thus, the proposal was unusual in that it developed a "federating" process of grassroots organizations in a cultural project, but even more so because it did so in the museum field, which had rarely linked communities in networks.

This proposal responded to a need so keenly felt that when the first national meeting of community museums was held in Oaxaca in 1994, community representatives from eighty-two towns and villages belonging to sixteen states immediately agreed to establish the National Union of Community Museums and Ecomuseums.[33] They quickly saw the advantage of building an organization in which they could be empowered to develop their own initiatives in the areas of training, fund-raising, exchange programs, and dissemination. The self-representation they had begun to develop in their museums could now be expanded by joining in a larger network that could represent and respond to their interests without governmental intervention. Each small, community-based museum had little opportunity to make its voice heard if it continued in an isolated fashion, but as a member of a state and national network, it could tell the story of its past and work to create its own future with new and more powerful resources. These resources could be developed from the independent association of similar community groups, instead of through negotiations on the basis of unfavorable terms with, or subordination to, official institutions.

One of the outstanding characteristics of the National Union is the great diversity of the groups involved. There are indigenous communities that are represented by committees elected in their general assembly, as in Oaxaca. There are mestizo communities that are represented by volunteer groups organized into nonprofit associations. Most of the participating communities are rural, but urban communities are represented as well. None of the community representatives is a museum professional or receives payment for his or her work in the museum. They include peasants, artisans, teachers, employees, and owners of small businesses. But they are united by their aspiration to

know and represent their own history, to strengthen their cultures, and to offer their communities new instruments for change and development.

The diversity of the communities involved, the opposition of governmental agencies, the precarious nature of several of the museum projects, and the distances involved have made it difficult for the National Union to advance in its goals as quickly as it would have liked. However, it has organized national meetings every year since 1994, including discussions of a wide variety of issues such as sustainable development, education, tourism, management of cultural patrimony, and changes in legislation regarding cultural property. Planning meetings, diverse workshops, and exchanges for youth and children have been carried out. Recently the National Union received a grant from the Inter-American Foundation to organize national workshops in leadership development and in state and national exchanges, as well as supporting the development of museum stores, traveling exhibitions, and fairs as venues for local folk artists.[34]

With this experience, the Union of Community Museums of Oaxaca decided to expand the initiative of creating networks to an international level. The basic principle was the same: grassroots community groups could achieve their own goals more effectively by joining forces with similar groups. In an independent network of their peers they could develop resources to respond to community needs, not the needs of other institutions and power groups. As the network grew in variety and scope, its potential strength grew as well. Because the challenges that local communities faced were generated by global economics and new processes of cultural domination, the response to this situation had to be global as well.

UMCO thus invited representatives from five states in Mexico and ten countries of the Americas, including the United States, Guatemala, El Salvador, Nicaragua, Costa Rica, Panama, Venezuela, Ecuador, and Bolivia, to come together in Oaxaca in the year 2000. A large proportion of the participants represented indigenous communities that had created or wanted to create museums to represent themselves, instead of being represented by others. Another concern of many participants from Central America was to represent what had happened during recent wars, to preserve the memory and the lessons of these conflicts. All were concerned with finding new tools for community self-determination.

The group agreed to set up a coordinating committee to continue and consolidate the network, and to organize a second meeting in Rabinal, Guatemala. There was also consensus around the need to develop a communication network, training programs, funding strategies, and cultural exchanges.

Since then, the network has been able to organize workshops for the cre-

5. A workshop on the creation of community museums, organized in coordination with the Museo de Arte Indígena, helps expand the network. Sucre, Bolivia, October 2001. Photo by Cuauhtémoc Camarena.

ation of community museums in nine countries (2001) and hold another two international meetings in Guatemala (2002) and El Salvador (2003). The subsequent meetings included representatives from Honduras and Brazil, and the workshops reached 288 people from 107 communities, belonging to thirty-two indigenous groups. Support for this effort has been received from the Inter-American Foundation, UNESCO, and the Rockefeller Foundation.[35]

The network functions as a support system for community efforts carried out in very difficult and precarious conditions. It provides community representatives support to clarify their objectives, build new skills, and learn from one another. The group strengthens each one as it offers a sense of common vision, commitment, and motivation. One participant commented: "What is most important [about the network] is the learning, the orientation, the motivation, the hope, the energy to continue. The globalization of the unity between our first peoples to make our voice heard in the continent."

CONCLUSION

Globalizing processes have confronted local communities with the need to invent new ways to maintain their unity and solidarity. In Oaxaca, one of the most disruptive processes is the massive migration of community members to the United States. Community representatives of the Union of Community Museums of Oaxaca wanted to respond to this situation, reinforcing their

bonds with the migrant community and helping them gain greater presence in their current circumstances, presenting them as the heirs to a rich and valuable cultural tradition. From 1991 to 1993 they worked on an exhibition of communities and folk art to be sent to southern California. "Our countrymen deserve our support," said one of the committee members. "It's our turn to help them show that our culture is important here and anywhere." They negotiated the aid of several institutions and managed to present the exhibition in San Diego, Los Angeles, and Fresno. The community museums had become an instrument to re-create identity and affirm their cultures' value beyond national borders.

As Ivan Karp argues, museums are one of the social apparatuses of civil society, in which "values are asserted and attempts at legitimation made and contested." Thus the community museums are vehicles for local cultures and subcultures to legitimize their presence in global civil society. On one hand, they can contest the imposition of moral ideas and social values of wealthy industrialized societies by validating their own worldviews and histories. In this sense, the role for community members is to build and rebuild identity, rescuing their own perspective, spanning enormous distances in time and space to recover their own story in the face of social and economic upheaval. On the other hand, community museums are also platforms for people outside of the community and culture to recognize a value in lifestyles different from their own. They are messages in a language that global technologies have made intelligible to a supranational audience. Finally, they are also vehicles for many local communities to come together in networks that reach the international scale. In these networks, many communities speaking from their own locality can find a common voice. They are able to identify common causes and build linkages that bring them new strengths to face the challenges to their survival. In this way, it is possible for globalizing processes to bring not only destruction of local cultures but also new capacities to act on the global stage.

NOTES

1 Velho, "Cambios globales y diversidad cultural," 57–59.
2 Clay, "Radios in the Rain Forest."
3 Healy, *Llamas, Weavings, and Organic Chocolate*, 417–28.
4 García Canclini, *La globalización imaginada*, 24, 63.
5 Ibid., 30–31.
6 Karp, "Introduction, Museums and Communities," 4–6.
7 Frishberg, "Local Access."
8 Ainger, "To Open a Crack in History."
9 Tejera Gaona, "La comunidad indígena en México," 217–27.

10 Stephen, *Zapotec Women*, 19.
11 Rassool, "Community Museums, Memory Politics, and Social Transformation in South Africa," in this volume.
12 Maldonado Alvarado, *Autonomía y comunalidad india*, 9–18.
13 Rassool, "Community Museums, Memory Politics, and Social Transformation in South Africa."
14 Ibid.
15 Monaghan, *The Covenants with Earth and Rain*, 3.
16 Quoted in Ansaldi, "La memoria, el olvido y el poder," 1.
17 For a discussion of the notion of resistance that underlines how it does not imply complete isolation and rejection of the dominant culture, see Stephen, *Zapotec Women*, 13.
18 Instituto Nacional de Estadística, Geografía e Informática, *Tabulados básicos, Estados Unidos Mexicanos, XII Censo General de Población y Vivienda, 2000.*
19 Dirección General de Población del Gobierno del Estado de Oaxaca–Instituto Nacional de Estadística, Geografía e Informática, *Marginación municipal Oaxaca*; Informe Anual de la Red Oaxaqueña de Derechos Humanos, *Los derechos de los pueblos indígenas en el estado de Oaxaca*; Gobierno del Estado de Oaxaca–INEGI, *Anuario estadístico del estado de Oaxaca.*
20 Centro de Apoyo al Movimiento Popular Oaxaqueño, A.C., *Oaxaca, Land of Contrasts.*
21 Stephen, *Zapotec Women*, 19.
22 Maldonado Alvarado, *Autonomía y comunalidad india*, 1–21.
23 The system of customary law, locally known as "usages and customs," was recognized as legally binding for municipal elections through a modification of the state code for electoral procedures in 1995.
24 Maldonado Alvarado, *Autonomía y comunalidad india*, 1–21; Barabas and Bartolomé, *Configuraciones étnicas en Oaxaca, Vol. I*, 30.
25 Camarena and Morales, "Community Museums and the Conservation of Heritage."
26 Camarena et al., *Pasos para crear un museo comunitario*; Camarena and Morales, *Fortaleciendo lo propio*; Camarena and Morales, *Communities Creating Exhibitions.*
27 Camarena and Morales, "Los museos comunitarios de Oaxaca."
28 Camarena and Morales, "Ideas on Starting a Community Museum." The concept of community museum shares many aspects with the concept of ecomuseum. See Fuller, "The Museum as a Vehicle for Community Empowerment," 327–65; Rivard, *Opening Up the Museum*; Hauenschild, "Claims and Reality of the New Museology."
29 Camarena and Morales, "The Community Museums of Oaxaca as Economic Catalysts."
30 Union of Community Museums of Oaxaca, "Mission of the Union of Community Museums of Oaxaca."
31 Union of Community Museums of Oaxaca, activity reports; Union of Community Museums of Oaxaca, "Final Report: Community Workshops, Training Center of the Union of Community Museums of Oaxaca, Jan. 1, 2001–March 31, 2002."
32 In the eight months from September 2001 to April 2002, the cooperative organized services for 599 visitors and generated sales of U.S. $11,850. This amount does not

include the sales local artisans make during visits. See Cooperative of Community Museums of Oaxaca, "Financial Report to the General Assembly of the Union of Community Museums of Oaxaca," May 19, 2002.

33 The extension of the network was facilitated, in part, by the development of a national program for community museums and ecomuseums, created jointly by the National Institute of Anthropology and History and the Directorate of Popular Culture in 1993. This program was based on the methodology developed in Oaxaca, and concentrated on identifying community initiatives, strengthening them, and building links between them, in contrast to the previous INAH program.

34 National Union of Community Museums and Ecomuseums, "Memoria del primer encuentro nacional de museos comunitarios y ecomuseos."

35 Union of Community Museums of Oaxaca, "Pilot Project: Workshops for the Creation of Community Museums of the Americas, Oaxaca"; "Final Report: Community Workshops, Training Center of the Union of Community Museums of Oaxaca, Jan. 1, 2001–March 31, 2002"; "Compartiendo experiencias: segundo encuentro de museos comunitarios de las Américas, Oaxaca."

PART 3

Remapping the Museum

Remapping the Museum

CORINNE A. KRATZ AND CIRAJ RASSOOL

T he cases and issues discussed in the first two sections of this volume suggest that museum frictions being produced and negotiated in a disparate set of institutional sites are, in effect, remapping the museum. Essays in this final section examine how those remappings are opened up, their range, and their implications for understanding the forms and workings of public cultures. The "Exhibitionary Complexes" section began the book by addressing ways that understandings of museums, exhibitions, and relations among institutions of public culture have been transforming over the last fifteen years in the context of international debates and exchanges. "Tactical Museologies" then explored how museological processes become cultural and political resources in the inevitable contests over these transformations, yet simultaneously produce new questions and ambiguities. Carrying forward the themes and concerns of previous sections, this last section explores ways that institutional conjunctions and museological moves are recharting and shifting the contours of museum practice.

The museum is being remapped in a number of ways: as site, as institution, as category, as a set of social processes, as a technology through which values are produced, and as a domain of interaction. These essays describe the overlapping engagements, contradictory intentions, multiple mediations, and critical reformulations through which such remappings emerge. They consider a broad spectrum of cases, including the changing meanings and museo-

logical processes involved in the history of border control in nature reserves and heritage landscapes in South Africa (Bunn, the Document on repatriating Baghdad's lions), contested sites and approaches for displaying the history of slavery in the United States and Ghana (Ruffins, Kreamer), a collection practice characterized by delayed destruction of Junkanoo festival costumes in the Bahamas (the Document on the Junkanoo Museum), and ways that Aboriginal art has crossed contexts to figure in exhibitions, performances, and symposia in Australia and New York (Morphy, Myers). The two pairs of related essays (Ruffins/Kreamer, Morphy/Myers) themselves encapsulate this sense of remapping and the more relational standpoint that accompanies it. Each takes different perspectives and considers different locales where kindred issues play out in relation to common material, crossing national and cultural boundaries in each case. Together the essays in this section show how central aspects of museum practice are being recast: exhibitions and objects move in and out of the museum, the museum itself might be taken outside, and contests between different parties produce an ongoing tug-of-war that constantly decenters the values and expectations of those involved.

These remappings take place in part through the crosscutting articulation of different sites, different domains of activity and knowledge, and different organizational levels, articulations that have been central to this volume's concern with the production of public cultures and global transformations. For instance, authors in this section describe institutions, events, and circumstances that entail links and interactions between game park, museum, and zoo; between ritual performance, exhibition, and symposium; between Ghana and the United States by way of tourism, UNESCO, and the Smithsonian Institution; between Canberra, Sydney, and Northeast Arnhem Land by way of intercultural performance and national exhibition; between Australia and the United States by way of international art markets, geopolitical realignments, tourism, and the Asia Society. In each case, the articulations cross a series of administrative levels and organizational scopes, whether this reaches, as Bunn describes, from sociopolitical relations between local chiefs in South Africa to regimes of animal hygiene and health to national structures of land management that incorporate people as natural resources and to the new transnational administration of a cross-border nature reserve, or, in the event described by Myers, from the New York–based Asia Society to networks of international scholars and to Australian artists, art centers, and communities. As these processes produce exhibitionary genres that transcend national boundaries and address a variety of audiences, they remap the museum conceptually. The very notion of what exhibitions are changes by extending their spatial and temporal boundaries and including the wider range of processes that go into their making.[1] In

some cases, illustrated particularly in the essays by Morphy, Bunn, and Myers, certain kinds of habitus become heritage for display, with "real life" and the world outside understood in exhibitionary terms. This is the very process that Kirshenblatt-Gimblett describes earlier in this volume in relation to UNESCO's intangible heritage initiative, providing examples of the metacultural operations to which she draws attention.

When people, projects, ideas, and institutions cross sites and domains in this way, the transactions involved require negotiations over different aesthetic values, epistemologies, and realms of knowledge production. They can produce fraught contests with highly consequential stakes: land claims, moral claims, identity claims, and claims to define national histories. These claims remap and renarrate both landscape and history, creating palimpsests of meaning that ground the moral economies at issue. Bunn shows how a dump of cattle bones becomes a marker of tragic meaning for former residents in southwestern Kruger National Park, just as creating exhibitions about slavery presents a way to identify, locate, and recognize the associated sites of memory and history, including plantations, sunken ships, and the Ghanaian Cape Coast Castle that Kreamer's essay addresses. Ruffins's description of the recent surge in slavery exhibitions in museums in the United States and Kreamer's account of the making of the "Crossroads of People, Crossroads of Trade" exhibition in Ghana demonstrate how remapping the museum can also remap the nation, whether by admitting slavery as central to the United States' national story or by remapping the Ghanaian nation into a site for African American imaginaries, a displaced American remapping that renders Ghanaian history a mere footnote in Ghanaians' own nation. This disjunctive museological landscaping stretches still further into international domains through the UNESCO Slave Route project.[2]

As the museum is being remapped through such global, international, national, and regional articulations, the frictions that arise — sometimes pointedly, sometimes poignantly — remind us that the global is often (if not always) intercultural as well. "Core values" and "natural practices" that are assumed by one group of people in a particular time and place are constantly being dislodged, decentered, and destabilized through juxtapositions with other "core values" and "natural practices," equally strongly held and felt. Artifacts, works of art, indigenous knowledge, and museum technologies have traversed spaces and entered diverse sites as part of the production of social and cultural value and the creation of different sites of persuasion, visibility, and recognition. Both remapping the museum and global transformations, then, always entail translations and mediations in confronting and managing the frictions that arise.

The people and institutions involved in these tasks are embedded in complex situations that both produce and constrain possibilities for social and political action. These transactions involve curators, museum professionals, historians, anthropologists, art critics, and social advocates, seeking at times to move beyond the constraints of category and history. Their capacities, responsibilities, and range of action and agency are defined in relation to projects and institutions at hand, as well as in relation to articulations that reach beyond their most immediate circumstances. Indeed, the essays in this section show that the museum can be understood as constituted and defined by a set of processes that involve a multiplicity of knowledge transactions in a variety of sites and spaces. These transactions have involved different domains of knowledge production and flows of ideas between the academy and institutions of public culture, the world of indigenous knowledge and the art market, and legal systems and structures of government.

Beyond remapping the museum and recasting notions related to exhibitions and collections, several essays show how the museum process has also, simultaneously and reciprocally, posed challenges for global structures and the very categories of national and international relations. During the U.S. war on Iraq that began in 2003, news stories assimilated zoo animals to refugees, and their asylum issues led to negotiations with South Africa and Greece, as seen in the first Document in this section. Bunn examines how southern African national borders and the demarcated boundaries of game parks began to weaken in the face of the imperatives of conservation, heritage, and the land claims of history. Commemorations of slavery formed the subject of contestations within and across national histories as the shame of slavery's holocaust in the United States began to be repositioned in the museum as the basis of national narration (Ruffins), while museologies of slave trading on the Ghanaian coast provided an entry into networks of tourism and development (Kreamer). In Australia, Indigenous land rights and native assertions of history and autonomy took center stage as Aboriginal cultural production entered the new national museum (Morphy). At the same time, Australia was being repositioned in the setting of the Asia Society in New York (Myers) and developing stronger Asia-Pacific regional ties and identities. As these intricate studies show, remapping the museum often forges a charged and potent nexus where debates about identity, history, land, legal rights, and tourism come together in various ways, providing a terrain on which local, national, and regional contests are played out through international projects and in which global structures themselves come to bear the imprint of such museological maneuverings.

Museum mediations become apparent through public processes of exhibition making and symposiums, but some aspects of these interactions, fric-

tions, and recastings do not culminate in public rituals of value negotiation and not all are destined for national arenas. As these essays show, the translations and performance of value also foreground a history of constraints on agency, involvement, and claims of public identity in different fields of cultural production. Bunn explains how the massacre of cattle and the heaping of their skeletons were a means of curtailing mobility in Kruger National Park, while this also occurred through the demarcation of land as "nature." Foot-and-mouth controls for cattle were overlaid by the operation of the system of Bantu Authorities for controlling people, as well as by a longer national memory of cattle killings as colonization, as the border between "nature" and "native" was staked out in the process of creating ethnicity in South Africa.

For a long time, Ruffins notes, the experience of slavery was a shame that could not be admitted as a basis for annunciated identity in the United States. Yet the recent museumization in the United States of Europe's Holocaust has fueled imaginaries representing traumatic pasts, such as that of slavery, and encouraged wider applications of the notion of "holocaust" to other histories of atrocity, making a case for transcending claims that would limit its use. The museumization of slave history is further constrained by a multicultural politics of identity, as well as simplistic frameworks that strive to admit everyone's trauma. The "Crossroads of People, Crossroads of Trade" exhibition in Ghana was a transnational museumizing initiative that had to address the slave trade as one among many topics. As Kreamer describes, that project was constrained by the limits of resource and artifact, but also by desires for tourism to bring development and the imperatives of producing an appealing destination. International aid relations and developmentalist approaches provided the project's underpinning and saw the Smithsonian Institution turned into an agency of multilateral development. In addition, the museumizing process underestimated the strength of claims and the extent of emotional investment in remapping Ghana on the part of expatriate African Americans, resulting in questions about to whom the exhibition was addressed. The conjunction defined by this complex array of actors, interests, and resources set parameters within which Ghanaians and Americans had to work while producing the exhibition, resulting in compromises that were frustrating to all concerned but nonetheless allowed the project to reach completion.

The Yingapungapu exhibition that Morphy addresses offered a platform for Indigenous displays and performances of identity and history in the National Museum of Australia, configuring it as a site of persuasion. This process unfolded in relation to the constraining legacies of evolutionary paradigms, widely differing colonial experiences, and official efforts to contain a focus on violence, invasion, and forced removal, despite the intention of reconciliation.

Displays of culture have proven enabling and adaptive in spite of constraints posed by museum spaces. Nevertheless, as art artifacts have encountered new audiences on their travels and their political significance has been asserted within new domains, Indigenous people and anthropologists have felt constrained by what cultural meanings could be presented, enacted, and communicated for particular audiences. The New York symposium that Myers discusses provides a striking example of this process.

The essays on Aboriginal art and performance highlight two further dimensions that connect the essays in this section. The remappings they explore emerge from de- and recenterings that arise as marginalized, subordinated, or minority groups contest histories of disempowerment and exploitation, as well as the institutional structures and representations that have defined those histories. The essays are not only about situations where political and representational power has been shifting but also about recasting those very histories and how we understand them. Morphy shows how Yingapungapu ceremonies and symbols have long served Yolngu people in Australia as a means of intercultural engagement and initiative in shaping relations with traders, colonizers, and government officials. Kreamer examines difficulties found when such contests collide. As histories of slavery and colonialism at Cape Coast Castle coincided with histories of national pride and cultural splendor, different constituencies sought ways to balance these stories or to subsume the site and demote the long, multifaceted history of the very country and region where it is found. The modes of cultural expression studied in this section emerge out of long, complex histories of engagement with different national and international domains and structures of power. One might fruitfully ask what kinds of political and representational power inform contemporary negotiations and contests, how they differ from earlier situations, and what roles international and global interchanges have played over time.

While we see the situations and negotiations described in this book as indicative of an ongoing remapping of the museum, they have been portrayed in other ways as well, ways that typically ignore longer histories of engagement. Yet, as Morphy notes in the Aboriginal case, the frictions of museum meaning and cultural transaction are almost entirely lost in approaches that insist on a framework of encapsulation and domestication as the only means of understanding the entry of Indigenous art into Western systems. Indeed, this paradigm of "cultural taming" has tended more generally to reduce Indigenous cultural production to a simple authenticity, encapsulated conceptually within a bounded indigeneity. It has underestimated the communicative and educative power of Indigenous art forms, and the modes of agency and transformation they have demonstrated in their cultural journeys, as spaces

of cultural formation were mobilized to project alternative modernities and national imaginings.

In South Africa, people demanding land restitution and reconnection with the land have drawn attention to the evidence of mounds of cattle bones to challenge representations of nature as unmarked by human cultures. Yet difficulties abound as the tourist gaze on South Africa continues to prioritize reserves of wildlife conservation over landscapes with markers of Indigenous pasts. Moreover, tourism continues to reproduce older conceptions of culture, as cultural village performances and repetitive craft production imitate a seemingly naturalized ethnological order that draws on notions of encapsulated authenticity. Nevertheless, new possibilities for a regional, even postnational order of heritage and museum meanings are opened up by reconfigured transfrontier parks that Bunn describes in his conclusion, as animal border crossings raise further questions about transnational cultural histories of migrancy, guerrilla warfare, and exile — some corresponding human aspects of the transfrontier park area.

Kreamer shows that a different disjunction of frameworks was at work on the coast of Ghana in the 1990s. As noted before, a museum exhibition at a site connected to the history of slavery became a means of making different moral claims on spaces and institutional structures and of mobilizing museum resources. Ghanaians sought to utilize a world heritage framework to address the history of slavery in relation to broader themes of economic and political interaction with Europe, the struggle for independence, and present-day Ghanaian cultural production. For them, the exhibition at the Cape Coast Castle Museum would also mobilize resources for museum education, job creation, and the development of tourism infrastructure, critical matters in contemporary Ghana.

In trying to reconcile themselves with the suffering of their enslaved ancestors on the West African coast, African American expatriates, tourists, and tour operators laid emotional claim to the site and exhibition. They did so through a framework that encapsulated Africa and the Castle through a narrow slice of its history, voicing concerns for an authenticity and reverence that fit contemporary cultural politics in the United States. African American visitor systems bypassed Ghanaian museum professionals. More generally, this perspective turned Ghanaians into descendants of African slavers, who needed to atone for the complicity of their ancestors and had no valid claim themselves on the historic site. At the Cape Coast Castle Museum, the "voices of the African diaspora" began to drown out Ghanaian claims as the story of Ghana's freedom receded from view. The exhibition itself, in trying to achieve a Smithsonian "look," created an imposed museum model that failed to intersect fully

with Ghanaian aesthetic concentrations and, further, could not be sustained in relation to local economic capacities.

Just as the story of the slave trade on the west coast of Africa was subject to competing claims of history, identity, and belonging, contestations began to emerge over what narratives of slavery's history should be presented in museums in the United States. As part of the "never-ending war" over the memory of slavery, exhibitions were being created at memory institutions of the old Confederacy of the Civil War with presentations not merely of black Confederates but of blacks who willingly supported slavery. In contrast, and partly in the wake of unexpected pressure arising from television and film presentations, others began to insist that a national museum focused on slavery was necessary in order to reflect the extent to which the United States had been built by slave labor and the degree to which the nation had been forged through the slave experience. The focus would not merely be on abolitionism but would also seek to educate visitors about slave lives and culture.

As the idea of a museum of slavery was taking root as part of the process through which U.S. society comes to recognize and be reconciled to one of its national shames, it was clear that the long silence over the shame and "insurmountable difficulties" of slavery's representation in American museums was over. This case evokes comparisons with transformations in postapartheid South Africa, post–*Mabo* decision Australia, and New Zealand after the Treaty of Waitangi. Together, these raise the larger issue of how questions of conscience and redress are addressed through museums, exhibitions, and other modes of display and performance, and how points of shame, stigma, and disidentification can then become points of identification at particular historical moments.

The different frameworks through which circumstances and stakes have been defined in each case again foreground the varied spatial and institutional articulations and the sometimes delicate and difficult mediations of knowledge and value through which museum remappings are emerging. The ways that differently positioned actors and institutions vie over meanings, perspectives, and resources (both material and symbolic) are also a potent reminder that many ways of belonging can be layered into the museum. This is a point that Tomás Ybarra-Frausto made in discussion during the Museum Frictions "next-generation" workshop in Atlanta, underlining the fact that the museum is not only multifaceted but mixed-media. This also means that situations and processes involved in remapping the museum hold both pedagogical potential and an open, improvisational character, being patterned but not entirely predictable.

While the museum is being remapped as a structure and institution in rela-
tion to shifting local, national, and international articulations and economic
demands (as Andrea Fraser underlines tellingly in this book's first section),
the workings and activities of museums also shift along with the identities and
ways of belonging demanded by and offered to a range of constituencies. At
times the remappings found in this section's essays—and in the book more
generally—decenter the object and exhibition focus typically associated with
the museum, even as exhibition itself is extended to include a broader set of
events and becomes seen as a process of production. As Myers notes in his
essay, this draws attention to the nature of an exhibition "as the complex social
process that it is."[3] This more process- and event-oriented sense of exhibition
also has implications for how we think about objects, collections, and other
aspects of museums and their connections with other institutions of public
culture. At times remappings also involve the tactical sense highlighted in the
second section of the book, with the concept of the museum used in rhetorical
senses to de- and recenter public debate and awareness, simultaneously refor-
mulating histories, identities, and notions of the nation, as seen in the United
States in relation to slavery and the Holocaust and in South African cases de-
scribed by Witz and Rassool in other sections.

As understandings of the museum, the exhibition, the collection, and the
ways that different constituencies engage with them are reconfigured, other
modes of cultural display, collection, and public culture are also brought under
these conceptual umbrellas (even if fleetingly), raising further questions and
possibilities. From establishing a changing and ephemeral archive of Junkanoo
costume to the commemorative display of a refrigerator in South Africa and to
Ghanaian debates on heritage and tourism, these essays incorporate a range of
improvisation and performative action in their remappings. In this sense, they
hark back to the essays by Bennett, Hall, and Witz in the first section of this
book, and their concerns with notions of pluralism, experiential paradigms,
and institutional transformation in museums, values related to authentic ob-
jects and cultural display. As performance itself can be fragile, resilient, and
not entirely predictable, the remappings under consideration here show that
those engaged with museums and associated realms of action through cultural
display, heritage, collection practice, and related projects must be ready to ac-
commodate the unexpected and anticipate future frictions.

When Aboriginal performance is a mode of cultural pedagogy staged in the
museum and Australian Aboriginal artists engage in the modernist forum of
the art symposium, we can begin to see how these settings can be harnessed to
other kinds of exchange and political ends through articulations that cross sites

and institutions. The many ways of belonging are layered onto the museum along with other meanings and narratives in such performative forums and through such social action, redefining museum, exhibition, and public cultures in the process. It is essential to keep in mind that these recastings, remappings, and reorganizations always require negotiating the political economies of resources and power that help define the very terms of engagement. But these are challenges that must be undertaken boldly, with no fear of friction.

NOTES

1 See Griffin, "Global Tendencies" for an interesting discussion of issues involved with large-scale art exhibitions that pursue such extensions.
2 On the UNESCO Slave Route project, see http://www.unesco.org/culture/dialogue/slave (accessed May 4, 2006).
3 Compare Kratz, *The Ones That Are Wanted.*

The Museum Outdoors: Heritage,

Cattle, and Permeable Borders in the

Southwestern Kruger National Park

DAVID BUNN

In settler societies such as Australia and South Africa, the importance of museums in the contestation over national memory and national identity is often exaggerated. In fact, in such communities, debates about the politics of museum display are really at their most heated when the further connection is made between heritage and topos. In South Africa, the white imagination was obsessed with the metaphor of landscape embodiment.[1] This was matched by an equally resistant set of African topographical imperatives that took their force from the oral tradition and which were strengthened even further by the individual narratives of millions of people forcibly removed from their homes in over fifty years of apartheid. As though mirroring these priorities, and with a few singular exceptions, the museums that had the most impact as sites of contested heritage were almost always situated in broadly symbolic landscape contexts: District Six, the Voortrekker Monument, and Robben Island.

Even at the height of the South African mass democratic struggle in the 1970s and 1980s, the battle over heritage was hardly ever thought of as a storming of the battlements of museums. Instead, the national topographical obsession bound notions of lost heritage to the idea of collective spatial displacement. It follows, then, that without studying what one might call "heritage landscapes," only a very limited understanding of changes in the rhetoric of heritage and value, and of articulated regimes of display, could ever be

achieved. To understand the changing representation of national memory, we have to go outside the museum, or to the museum outside.

What might it mean to go outside the museum? In the first and most important sense, this would imply the recognition that museum space is never singular. Instead, it should be understood as one element of a series of real or imaginary articulated zones, and it is that very articulation that makes possible what Tony Bennett calls in this volume "the development of new forms of civic self-fashioning." To take one obvious example: museum dioramas, in this understanding, can no longer simply be thought of as an ossified version of the ethnographic gaze; rather, they are also a response to the deep desire of museum audiences to be in the place of expert knowledge, in the position of fieldwork. But there is another sense in which this essay wishes us to move beyond the museum, and that is in the sense that museological processes may be appropriated for a variety of other purposes, in other spaces external to the museum. Howard Morphy, in this volume, provides an extraordinary case study of one such example. He shows how Yolngu *yingapungapu* sand sculpture ceremonies performed at the opening of the new National Museum of Australia are meant to evoke, in the minds of officials, another linked landscape and a relationship of title to that landscape: the contested coastal waters of Blue Mud Bay. Yolngu performances, by bringing external issues of land and native title back inside, amount to a political restatement of rights.

My main concern in this essay is with just such wider museological processes, in which museum-like visualizations of ethnicity are exteriorized and recontextualized in cultural villages and game reserves. In her classic study of Teddy Roosevelt and Carl Akeley, Donna Haraway reminded us that African game reserves have had a long association with museums, functioning as storehouses, field sites, and collecting zones. But there is a stronger sense in which game reserves are themselves exteriorized forms of the museum, with their logic of preservation, display, and audience instruction. Taken together, therefore, national parks, museums, and cultural villages form part of the wider exhibitionary process in which kinds of citizenship impossible to imagine elsewhere become fantastically naturalized.[2]

What new associations are being made between the museum and its field sites? In answering this question, it is instructive to survey the changing scope of terms in the statutes of the International Council of Museums. In 1946, the term *museum* referred to a variety of collections, "including zoos and botanic gardens." By 1969, Article 4 of the new statutes of ICOM had spread the definitional net even wider, to include "nature reserves."[3] This essay is about just such an outdoor museum, one of the best-known heritage landscapes in Africa: the Kruger National Park. Soon to be one of the largest conservation areas on the

planet, this game reserve has always functioned as a sort of landscape machine, maintaining a balance between conservation and memorialization and keeping intact a complex metaphoric link between the administration of citizens and the naturalization of forms of inequality.

My argument arises out of the context of the post-1994 land restitution process in South Africa, a process in which new conceptions of postapartheid citizenship became associated with the retributive reallocation of land. Its starting point is a land claim entered by a local community in South Africa's Mpumalanga province, requesting the return of a small section of South Africa's most famous game reserve.[4] More particularly, it is a genealogy of an imaginary border, an exploration of the various symbolic regimes associated with disease control, cattle movement, and water provision that came to collectively demarcate the western edge of the Kruger National Park. These controls were affected in different ways in different epochs, and underlying each was a distinct understanding of the relationship between landscape, heritage, and citizenship. In the postapartheid period, some of the same associations between conservation landscape and national heritage have persisted; others have been violently changed.

BORDERS AND OSSUARIES

Like so many tales of traumatic reconstruction, this story begins with bones. A few years ago, when walking in the deep bush north of Pretoriuskop—one of the southern tourist camps in the Kruger National Park—looking for evidence of old settlements, we came upon a large, grassy hillock, about ten feet high and thirty feet in length. This, my Xitsonga-speaking guide explained, was one of several cattle mass burial sites, confirming stories I had been told in interviews with young men and women in the Numbi district, near the western entrance gate. When speaking to me of land loss and local genealogy, twenty-year-old Philemon Ngomane, of the Numbi Craft Collective, had paused reflectively and said: "Once my family was rich, but we lost our birthright when the Boers shot our cattle." Trying to make sense of that statement has taken me on a long journey that led, finally, to a new understanding of the relationship between traumatic memory, the management of tourist landscapes, and conceptions of the native subject.

In the first and most general sense, these bone dumps need to be understood as straddling the epochal difference between two management regimes in the Kruger National Park, before and after World War II. For the first decade of its existence, until 1910, the laissez-faire management regime imposed by Warden Stevenson-Hamilton in the Sabi Reserve, as Kruger was then called,

encouraged an imaginary association between the gentle control of the wildlife population and benevolent colonial governance elsewhere.[5] The association became even stronger after 1910 because of the close link between conservation authorities and a new system of native commissioners, exercising loose paternal control over large districts through appointed paramount chiefs and long, dawdling tax collection tours.[6] Warden Stevenson-Hamilton was himself appointed Sub Native Commissioner in 1903, with wide powers of prosecution over a district that extended beyond the park borders. In time, however, this landscape of informal rule increasingly came into conflict with the neighboring "native reserves" and trust lands that bordered it to the west, places of death, desiccation, and forced migration that were visible evidence of the legacy of authoritarian colonial control.[7] From this point on, the nature reserve became increasingly important as a corrective example of how natural and social heritage could be properly managed, outside of contradictions evident in colonial land resettlement policy.

THE SOFT BORDER

I wish to speak about four major phases of heritage management and border control in the southwestern part of the Kruger National Park. First, there is an era characterized by what one might call the soft border. This is followed by the introduction of buffer zones, then staggered forms of border closure, and finally the nationalization of the fencing regimes. In the first phase, the reserve was closely associated with the idea of freely circulating movement and of liberal citizenship. Nowhere is this better epitomized than in the national white obsession with Sir Percy Fitzpatrick's brilliantly sentimental autobiographical work *Jock of the Bushveld*. The eponymous hero of this hugely successful tale is Jock, a Staffordshire bull terrier, who accompanies his master on wanderings and expeditions that meander around the main transport rider's trails to Delagoa Bay.[8] Many of their adventures track through the area of the present game reserve.

Fitzpatrick was an important Unionist politician and a friend of Rudyard Kipling, who was imprisoned briefly by the Transvaal government because of his part in the Jameson Raid.[9] But it is the landscape impress of his "Jock" stories that was best remembered by early visitors to the Kruger National Park. For most English-speaking tourists, the southern Kruger National Park topography was closely associated with the idyllic wanderings of the pioneer man and dog, and shortly after the opening of the national reserve, memorial plaques were erected and roads renamed in reference to the novel. So perva-

sive was this literary reinscription of the tourist landscape in the south that Afrikaner nationalists later came to regard it as an offensive ideogram of the English presence: "*Hoekom*," one remarked, "*word elke patryspaadjie 'n 'Jock of the Bushveld' pad genome?*" ("Why is it that every obscure pheasant track becomes known as a *Jock of the Bushveld* road?").

For early Liberal segregationists, the Kruger landscape required a gentle, framing control. This extended to management of the approximately three thousand African game guards, laborers, domestic workers, and their families who lived in the reserve, cultivating crops and keeping small domestic herds of cattle. Of course, the image of an apparently pastoral, contented African village in harmony with nature in the game reserve also suggested the possibility of beneficial, regulatory white management of the so-called rural native reserves nearby. This visible contrast took on an increasing ideological importance in the 1930s, when the rhetoric of soil conservation provided a scientific alibi to help explain away the catastrophic poverty and land shortages in these resettlement areas. Massive seizure of African land between the two land acts of 1913 and 1936, and then the relocation of peasant populations, resulted in serious overcrowding in the rural reserves. Likening the reserves to a kind of prison, activist Sol Plaatjie blamed the British Parliament for agreeing to "herd us into concentration camps, with the additional recommendation that besides breeding slaves for our masters, we should be made to pay for the upkeep of the camps."[10] In stark contrast, Prime Minister Hertzog's 1932 Native Economic Commission report laid the blame for rural impoverishment on the primitive, unecological, and unreformed cultivation methods of African peasants themselves, especially with regard to their notorious "cattle complex," which led to overstocking.[11]

To understand the relationship between conceptions of heritage value and landscape in South Africa, it is necessary to address the problem of cattle. Early modernist ethnographies of southern Bantu-speaking peoples established the centrality of cattle as a form of exchange value; later in the century, structuralist archaeology began to emphasize the spatial imprint of this system, referring to it as "the Central Cattle Pattern [which is] restricted to patrilineal Eastern Bantu speakers who exchange cattle for wives."[12] Insofar as early-twentieth-century anthropology was an outgrowth of the imperial museum complex, ethnological museum displays relating to cattle culture, to the practice of *lobola* (bridewealth), and to artifacts and architectures associated with cattle keeping were still closely associated with colonial missionary conceptions of cattle wealth as a fetishistic and irrational form of exchange. These museological explanatory narratives were given additional force in South Africa by the linger-

ing memory of colonial encounters with millenarian resistance in the Eastern Cape, resistance that involved the apparently irrational mass sacrifice of cattle, the so-called Xhosa cattle killing of 1856–57.[13]

Even Isaac Schapera (the founder of modern social anthropology in South Africa), in his nuanced analysis of the relationship between labor migration and cattle stocking in Bechuanaland, saw the system of bovine value being in part responsible for ecological disaster. He expresses the hope that through improved cultivation in the reserves, "the more disastrous effects of contact with European civilisation will in great measure be avoided."[14] In fact, so-called betterment schemes (introduced by the government), advertised as benevolent attempts to reduce stocking and improve cultivation, argued that soil erosion might in the first instance "be attributed to the first impact of White civilisation upon a conservative Native population with only a rudimentary knowledge of agriculture."[15] Africans not protected from the accelerating effects of modernization would in turn, it was claimed, have a catastrophic impact on the environment.

In the 1930s, therefore, the Kruger National Park with its settled African residents became a crucial signifier of proper land management. It was an instructive example of the principle of proper stocking and of nature's apparent adherence to the law of carrying capacity, and it was also evidence of how enlightened veld management led to a natural succession of ordered grazing patterns, all at the very edge of the zone of death and famine in the native reserves. The visible evidence of this enlightened control was there for all to see: the western boundary of the Kruger National Park remained unfenced, with only rudimentary markers such as occasional painted canvas signs.

Thus, as I have argued elsewhere, until the 1940s the most critical imaginary aspect of the park border was its perceived ability to exert a moral and educative influence on the Africans who lived within its protective environment. Within a few kilometers of the boundary zone, Stevenson-Hamilton believed, the light of this instructive influence was dimmed. "I would like to point out," he said, in his annual report for 1929, "the very noticeable difference in the manners and ways of the Park residents as compared with those living outside."[16] "Whereas our natives are always civil and obliging to Europeans," he continued, "those living along the Crocodile River especially close outside our borders are just the reverse, and seem permeated with political propaganda."[17] The Kruger National Park, in other words, was a political museum of sorts, preserving, for whites, the record of an achieved racial settlement of a special kind that was at the same time reminiscent of an older, semifeudal type of fealty.

Seen in this light, managed game reserve landscapes are a critical extension

of the racialized form of civic instruction embodied in the early-twentieth-century museum. Before fencing took place, the southwestern edge of the Kruger National Park was conceived of in highly moral terms. Throughout this period, the park was seen to preserve intact a relationship of species to original habitat, figure to ground, and gentle management control to wilderness freedom that itself amounted to the preservation of national heritage. As a spatial ideogram, the reserve was one of the most important and most stable signifiers of the relationship between heritage and governance.

But perhaps it is possible to reach an even more radical conclusion. In an intriguing modification to his thesis on the "exhibitionary complex," Tony Bennett has recently shown that the exhibition practices of evolutionary museums depended on a narrow understanding of personhood, citizenship, and the transmission of cultural value. In Walter Bagehot's late Victorian theory of "stored virtue," Bennett shows, a social Darwinist understanding incorporates a belief that the civilized skills of white metropolitan subjects are preserved in muscular mnemonics and transmitted generationally.[18] Museums, in Bennett's fine analysis, are a key mechanism for work upon the category of personhood required by particular kinds of modernizing democracies. But for Bagehot, Bennett demonstrates, the bad examples of the past are also stored in the very bodies of the working-class subjects he wishes to retrain, and for this reason the museum is closely associated with the idea of bodily reform.

Such stratigraphic conceptions of the reformable self originate in Romantic metaphors of the self's inner journey into darkness, and develop into classic Conradian early-twentieth-century colonial narratives. In the famous riverbank scenes of Conrad's *Heart of Darkness*, the journey upriver culminates in a moment when the civilized self has dramatized for itself an apparent reciprocity between its id-like deeper reaches and the primitive signaling from the bank. This is not so much a moment of sameness as the imaginary infolding of the Other. This scenario—and I use the word in the sense of an imaginary investment—is fundamental to what we know as modernism, whether we are speaking about Picasso and the Trocadéro or D. H. Lawrence's Mexico. For modern personhood to advance beyond the erosive and deadening sensory effects of industrialization, the European avant-garde often claimed, it has to renew itself through contact with a dangerous, unalienated space. The museum, with its ethnographic displays, enables one form of that contact and renewal. However, the museum alone cannot offer a full enough imaginary experience for the development of emerging citizens. To deliver a more dramatic kind of work upon the subject, the museum space has to come in contact with a wider landscape: this is what Aldous Huxley imagined as the "Reservation" in *Brave New World*, but it is also contained in the perennial links between mu-

seums and the wider landscapes of amusement parks, with their allusions to museological display.

So for the space of the museum to function fully as a machine for work upon the layered self, it has to come into association with some sort of field site. Most typically, in postcolonial cultures, the museum performs its work of civic instruction in close association with the game reserve. From the outset, tourist travel to the Kruger National Park was conceived of as travel back in time to a different moment in which the self was closer to its unconscious origins, and when the senses were sharper and more attuned to the environment. Of course, in South Africa this is also a strongly racialized narrative. In the 1920s and 1930s, there was a great deal of uncertainty about the future of white citizenship in a changing South Africa. Patterns of urbanization and industrialization had their impact on black and white, and for urbanizing "poor white" Afrikaners especially, access to jobs required a consolidation of separate racial identity. Throughout the early popular literature on the Kruger National Park, game reserve visits were seen also to be healthily instructive for white working-class subjects. It was, in this sense, a safe training ground for working-class sensibility dulled by industrial labor. Even more vividly, in this place where visibly loyal native subjects abounded, the educative aspects of the sensory experience in the bushveld stabilized the uncertain relationship between race and citizenship: a trip to the reserve was a somatic renewal, clarifying the terms of one's relations of difference with black subjects, who were not citizens of any country except natural landscape. The stability of this instructional field depends on the association of the game reserve with the museum, where black personhood is removed from the domain of time and history and is instead protected and enclaved.

Who were these subjects who were not citizens, the game guards and "police boys" so admired for their loyalty by generations of white tourists? Let us turn to a closer study of one such group, and to an analysis of the careful management of notions of provisional citizenship in the area near Pretoriuskop in the south of the game reserve. It was here, more than elsewhere in the reserve, that ambiguities around the visible presence of African employees developed into conflict and crisis. This case will also introduce the second regime of border management of the Kruger National Park's natural heritage.

HERITAGE IN THE BUFFER ZONE

In 1999, as I have mentioned, a land claim was entered against a section of the province of Mpumalanga, including the southwestern section of the Kruger National Park. For ease of reference, I will refer to this as the Albasini region.

By 1918, seven years before the proclamation of the Kruger National Park, the larger Sabi reserve still included considerable tracts of state land that had been used in winter months as grazing by sheep farmers from Lydenburg and elsewhere.[19] Shortly before the proclamation of the Kruger National Park in 1926, a huge section of this western area of the old Sabi game reserve was excised. As Stevenson-Hamilton explained, the effect "was to take out one million acres of private land and some five hundred thousand which were the property of the government, the latter including the sheep grazing area West of Pretorius-kop."[20] But it was in the immediate postwar period that the most complicated changes in land tenure took place.

A key figure in the postwar debate over conservation land was the colorful early ranger Harry Wolhuter, whose patrol district included Pretorius-kop and who employed a group of African "police boys" living around the kraal of Doispane and then at Albasini. These individuals were the "gate guards," "police boys," and "lookout men" frequently commented on in early tourist narratives about game-watching adventures in the Pretoriuskop region. Superbly knowledgeable as trackers, and with a profound understanding of the ecosystems of the southern park, they were iconographic subjects of tourist photography. Behind the scenes, they were responsible for training their younger white ranger bosses and keeping them from danger. Despite the fact that this was an ethnically diverse group, speaking several languages, they were almost uniformly referred to as "Shangaans."[21]

Most of the employees lived with their families in the area near the ranger post. Most kept small herds of cattle, donkeys for transport, and other livestock. They were perhaps able to maintain a coherent pastoral existence because they were in a relatively remote area, and tourists only seldom encountered their picturesque kraals with patchy maize fields fenced with knobthorn posts and rusty tin can alarm systems to keep out elephants. As the group grew in size, however, Stevenson-Hamilton ordered some of them to move, and eventually a new settlement grew at Albasini around heads of household Nkayinkayi Mavundla, Elphas Nkuna, Willie Nkuna, and others.[22] Theirs was a very unusual and parochial relationship. Resident Africans relied on goodwill and unspoken agreements with the Parks Board, which granted them limited tenure in the bush until each head of household died, at which point the family was issued with a "trek pass" and had to leave.[23] It was a remarkable but informal arrangement that continued up until the year 2000, when the last male head of household, Nkayinkayi Mavundla, died. Today, the graves, hut floors, and empty kraals are scattered around Albasini, and it is on the basis of that unbroken residency that the land restitution claim was entered. At the same time, a key element in the case put to the Land Claims court was that the resi-

dents and descendants of the Albasini settlement constituted a community, which was dispossessed not only of its rights in land but also of its heritage.

DISEASE AND INTERDICTION

I have jumped ahead in the narrative, and would now like to return to the idea of the border as a buffer zone, the second form of natural heritage management applied to this part of the park. Labor tenants and "squatters" on British colonial Crown lands such as game reserves were allowed to keep small herds of livestock and cultivate subsistence crops. Collectively, these could amount to quite considerable numbers. Before 1926, and swelled by the incursion of white farmers' flocks in the winter grazing period, herds of up to ten thousand domestic animals shared the main water source near Pretoriuskop with wild animals.[24]

Elsewhere in Africa, the principle of game animals mixing with flocks and herds kept by pastoralists was well established. In Kenya, and despite settler protests, Maasai herders shared winter grazing with migratory wildlife populations in their Southern Reserve and the redefined Amboseli National Reserve.[25] In South Africa, however, with the rapid rise of Afrikaner segregationist sentiment, considerable pressure was placed on National Parks Board officials to rid the Pretoriuskop region of native stock and to change the nature of the border from a place of zonal permeability to one of legal interdiction. Ironically, there may be another reason for the demand for species segregation being so actively applied in the southwest: from the early 1930s onward, the Pretoriuskop region came to be closely associated with Afrikaner origins. Gradually, the memorializing focus on the transport riders' route to Delagoa Bay was displaced; it was marginalized because of a concerted effort by Afrikaner nationalist historians such as Gustav Preller to inscribe the topographical memory of some of the early Voortrekker journeys from the Transvaal to the Mozambique coast.[26] Still today, the selfsame crossroad in the Kruger National Park is indicated both as an important point on the "*Jock of the Bushveld* trail" and as the beginning of the "Voortrekker route," marking the overlap of two distinct regimes of imperial and nationalist heritage inscription.

The Pretoriuskop region was especially important for this revision of heritage landscape, which marked a break from the older empire heritage tradition that had been established by British colonial historians across the country.[27] The game reserve landscape, in other words, provided a unique opportunity to spatialize, narrativize, and naturalize the museological displays of nationalist origins being introduced in public institutions elsewhere. By most accounts, the hill (the suffix -*kop* in Pretoriuskop) and then the tourist camp took their

1. Controversial even when it was first erected in the years of "grand apartheid," the bust of Paul
Kruger, which broods over the main entrance to the national park, is now under threat from those
who wish to downplay the influence on early conservation policy of this first president of the Boer
republic. Kruger National Park, February 2002. Photo by David Bunn.

names from the nearby grave of Willem Pretorius, one of the members of a
Voortrekker party led by Karel Trichardt from Ohrigstad to Delagoa Bay who
died of fever in 1848. Because of the topographical association between south-
ern Kruger and the routes of early Afrikaner pioneers and trekkers, nation-
alist historians were effectively able to combat the English heritage landscape
inscription that had preceded it. This affective association between the south-
west and nationalism was sharply felt, to the extent that some English visitors
later began to avoid staying at Pretoriuskop. Work upon the Afrikaner land-
scape heritage continued throughout the 1950s and 1960s in southern Kruger,
culminating in the controversy over a plan to carve a Mount Rushmore–size
likeness of Paul Kruger (the last president of the Transvaal Republic) in a gran-
ite kopje (outcropping) near the Sabi River (figure 1). This, in turn, was a direct
response to the British colonial habit of monumental burial that saw Cecil John
Rhodes entombed in the Matoppos and Stevenson-Hamilton's ashes interred
in a spectacular granite outcrop south of Skukuza.[28]

In the late 1930s, the Afrikaner demand for segregation, and for a heritage
landscape swept clear of Africans and cattle, came suddenly to intersect with
new regimes of disease control. Nineteen thirty-nine was a disastrous year for

the workers at Albasini: out of nowhere, it seemed, veterinary health authorities descended upon the region, systematically culling all cloven-hoofed animals. Cows that had been known by individual praise names were shot and their carcasses summarily dumped into mass graves. When interviewed some sixty years later, eighty-year-old Nkayinkayi Samuel Mavundla still vividly recalled the sound of the gunfire on that day, and the utter destruction of the community's meager wealth.

The 1938 foot-and-mouth epidemic first affected a small herd kept by the ranger at Satara camp within the Kruger National Park. Shortly after that, the diagnostic lesions were detected in Stevenson-Hamilton's animals at Skukuza, then on the farm Toulon along the western border, and veterinary authorities in the distant capital gave the order for the elimination of all cloven-hoofed animals in the area. Early the next year, the chief native commissioner for the northern areas recounted how in the Kruger National Park "some 1200 cattle belonging to its Native population of some 2000 souls [have] . . . been slaughtered to establish a cattle free zone between Portuguese territory and the Transvaal."[29] Significantly, Stevenson-Hamilton vigorously opposed the culling measures. In response to his outraged claim that Africans in the park were in danger of starving, and that there would be a sharp increase in child mortality, the commissioner authorized the warden to purchase a single case of condensed milk for emergency supplies! A 1960s commission of inquiry into the control of foot-and-mouth disease reported that in Kruger itself, in the 1939 campaign, 1,313 head of cattle, 321 sheep and goats, and 6 pigs were killed; in the neighboring Crocodile River district alone, however, where the poorest of peasant African farmers lived, almost 14,000 animals were shot.[30]

In the present-day Albasini land claim court documents, the plaintiff community describes the cattle killing as one of the key instances of a collective dispossession of rights. Court records speak of "the destruction of more than 3000 head of . . . cattle and goats without compensation in or about 1939 to make way for a game reserve for white people only." Despite the emotional charge of this statement, it confuses the facts of the case. Nonetheless, the shock association of this animal holocaust with the idea of lost heritage is registered strongly in all the contemporary oral histories, often in a significantly confused form. But there is a more general reason for the seeming inaccuracy of community memory. To this day, in the broad region including the southwestern areas of the Kruger National Park, the combined effects of impoverishment, community fragmentation, migrancy, and ecological catastrophe have produced a general sense of malaise so profound that it has attached itself to notions of landscape, all but severing the relationship between ontology and habitus: it has effectively disrupted what Derrida has called "ontopology," or "the axiom-

atics linking indissociably the ontological value of present-being to its *situa-tion*, to the stable and presentable determination of a locality."[31] Given the gen-eralized and unlocated sense of absence that still prevails, it is not surprising to find youth reaching for some originary historical moment responsible for the collapse of the symbolic order. Throughout the region, in interviews over the past years, I have found youth associating cattle massacres with the origins of economic and affective disaster, and linking these with the mound graves they knew about in the Kruger National Park. On closer inspection, though, these narratives also turn out to be about spatiality. Cattle, in the memory of residents, were a means by which meaning traveled and value was inscribed through localized movement. The historical loss of cattle wealth helped to ex-plain their own present sense of being stranded outside of the main currents of history.

Youths such as Philemon Ngomane also frequently mistook the timing and sequence of events leading up to the cattle genocide: for them, it was under-stood not as a prewar event, but rather was associated with 1970s apartheid, the directly traumatizing period within their own generational experience. Broadly, these animal deaths were also indistinctly associated with the loss of land in the Kruger National Park, and these youths and others referred back to their knowledge of topographical markers in the reserve, including regularly visited ancestral graves.

GRAVES AS HERITAGE MARKERS

It is worth pausing to consider the vital, if seemingly obvious, role played by graves in the competing geographies of land claims cases. In the case of the Albasini area of the Kruger National Park, a tiny zone was inscribed and re-inscribed by different authorities: generations of land surveyors, veterinary authorities, game reserve legislators, fire regimen controllers, railway authori-ties, and the like. By the 1990s, in other words, there was a dense, horizontal stratigraphy of layered semiotic systems that had all but obscured any claims to African ownership. These systems were at the same time discursively ar-ticulated, producing a limited set of subject positions for landscape presence. Given this dense layering of alien meaning, ideologically associated with the National Parks Board and government authority, the indigenous understand-ing of spatiotemporal being was severely eroded, leaving only the evidence of graves to refer to. The importance of graves as signs of ownership was also, of course, exaggerated, because of the legal parameters of the land restitution process. Land claims legislation in the postapartheid period set a cutoff date of 1913 (the time of the first land act), and petitions based on dispossession

prior to that date were rejected. It made emotional sense, then, for claimants to believe in the present, definitional power of graves.

But the loss of cattle herds was, if anything, even more important. The very movement of cattle across the border zones was a critical way in which individuals such as Nkayinkayi Mavundla were able to retain a sense of coherent community identity, as they connected with other kin and members of the community. With the final loss of cattle in the late 1930s, a significant way of understanding the world disappeared, one that had associated ecological connections, pathways, and waterholes with community value. This was replaced by a zone of veterinary proscription. The net effect, in other words, was to replace complex spatiotemporal experience with a concentration on locatedness alone. Instead of being agents in the region, with ties to other communities some time and distance away, the Albasini group fell more and more within the logic of tourism, and under the direct control of the Parks Board, as though both rooted and posed. For white tourists to the Kruger National Park between 1939 and 1960, it was this fixed and posed aspect of African identity that was most memorable. In truth, though, this was evidence of two converging forces: the destruction of habitus associated with the loss of cattle, and the museological process already beginning to convert habitus to ethnographical typicality.[32]

Nkayinkayi Mavundla and his co-workers played a crucial role in the history of conservation. With the epistemic shock of the cattle genocide, however, this community fell almost completely under the paternalistic authority of white game rangers. Over the next decades Albasini increasingly became a sort of model village. In the 1970s, when it was feared that certain of Kruger's tourist camps would come under rocket attack from Frelimo forces in Mozambique, the exemplary loyalty of the black rangers at Albasini became exaggeratedly important.[33] As each of the original band of patriarchs died, an increasingly emotional and nostalgic investment on the part of white game reserve authorities became visible at memorial ceremonies. The 1975 funeral of Helfas Nkuna was a case in point. One of the most remarkable and dedicated of the early field rangers, he served the National Parks Board for forty-six years and survived a leopard attack. Nkuna was buried very formally at the village site near Albasini, and there is an extraordinary outpouring of white emotion in the Parks Board journal account of the event: "He was a child of the veld. He was born some 80 years ago among the bushes of Phabene, not far from Pretoriuskop. And he knew no other world—only the veld existed for him, its beauty and its dangers."[34] The evocative account continues with a description of the burial itself, with the coffin being wrapped in the skin of a slaughtered ox, and then covered with his uniform, with the ranger's hat set on top. In cus-

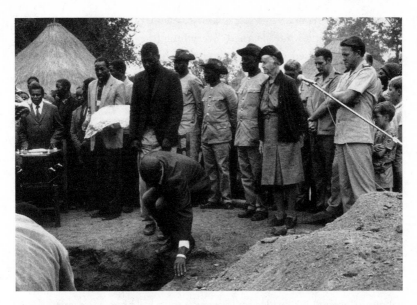

2. Rangers, senior park officials, and Stevenson-Hamilton's widow gather respectfully at the funeral of Helfas Nkuna, one of the legendary African field rangers who lived near Albasini. Phabene village, near Albasini, Kruger National Park, April 5, 1975. Image courtesy of South African National Parks.

tomary fashion, the tunic buttons were cut off before the grave was filled with earth (figure 2).

This account of the funeral of Helfas Nkuna reveals how, even by 1975, a strong association between Kruger's heritage landscape and the bodies of black rangers was being maintained. In the imagination of his white managers, Nkuna *is* the veld. One year before the historic 1976 Soweto rebellion, the funeral of this field ranger serves as a reminder of how apartheid managers conceived of ideal race relations with African subjects: Helfas is African identity read as landscape, and his very committal to the earth, his grave itself, is a memorial to state practices already seeming to go awry elsewhere. For nationalist conservation authorities, the wide veld, with its scattered graves, becomes a museum of the old state's truer intentions.

The fate of the Albasini group is an awkward reminder of the relationship between race, tourism, and modernity generally. The National Parks Board, as an arm of the state, required specimens of native loyalty, and these became rooted and grounded in a special form of the heritage landscape that provided an important educative function for white tourists. In the field, though, things were rather different. Without exception, in all rangers from this period that I interviewed, there was a strong sense of a common, heroic purpose for loyal

black and white conservationists alike. This sense of a common vision, and the fact that young whites learned "everything [they] knew about the bush" from blacks, provided what most perceived to be a historically unique opportunity for equal labor, even bodily proximity, sealed off from the shocks of apartheid South Africa. White rangers who had worked in remote areas in the 1950s and 1960s spoke with great passion about the democracy of their field expeditions, when black and white men would share the same dangers, hard labor, food, cooking utensils, and even clothing and bedding. The vehemence of their memory is an indication of how unusual an experience this was for young men raised in a completely segregated society.

For those rural black South Africans on tourism's periphery, however, the accelerating, modernist time-space compression that delivers global white tourism to game reserves such as Kruger also produced in them a feeling of hollowed-out, ahistorical, and spatialized ghostliness. Apartheid's special brand of modernization, not unlike other kinds of metropolitan modernism, could not accept the present time of blackness. For every act of technological improvement, be it bridge building or train travel, there is nostalgic reference made to the imagined ghost of the premodern. In many of the triumphal images of progress from this period, technological advancement is shadowed by the necessary specter of the tribal past, without reference to which apartheid modernism could not advance.

So to return to the example of memorial practices, it is not surprising, then, that with state bureaucracy having absorbed the domain of meaning that stretched horizontally across the landscape, Kruger's neighboring African communities placed increasing emphasis on the meaning of vertical markers such as graves. In the Albasini land claim, the grave of Nkayinkayi Mavundla's own mother, as well as an abandoned 1939 cattle dip, played a punctuating role in the land claims arguments that followed. Reference to a grave enables a special sort of claim to be made: it is an epitome of past being, full of presence, a full sign that reaches down and past the more recent colonial stratigraphy to a deeper significance. Even if the grave cannot be found, this sense of vertical and indexical presence is often carried in the idea of an unshriven spirit: land claims cases are full of stories of unhappy ancestral spirits, pointing the way to some now obscured point of contact with other worlds. According to informants, the western edge of the Kruger National Park is a place teeming with spirits. These are not "ghosts" in the Western literary landscape tradition of Thomas Gray's "Elegy," yet they are spirits that seem to be traumatically tied to a place. In most communities in the Lowveld, the dangerous aspect of corpses and spirits who are not properly honored consists in their not having been able to make the transition to full ancestor status. Alienated and unhappy spirits

are the remnants of the old, replete time-world of the Other. Like the Albasini community themselves, these specters are unhappily rooted and without meaningful connection.

Recent land claims testimony in South Africa is replete with accounts by informants of this sense of spectral remainders. Similarly, having lost the complex, somatically defined sense of place, people feel their own incompleteness when they return to a familiar locale. Andrew Spiegel, in a recent land claims case in KwaZulu Natal, describes how local elders, when walking in areas they had last occupied decades before, were able to pinpoint invisible sites with unerring accuracy.[35] This ability they ascribed to forms of bodily experience and somatic memory. However, in regions where government tree plantations had both erased local signs and cut off the view of the horizon, this embodied orientation failed utterly.

SEGMENTED CLOSURES

Let us return now to our narrative history of heritage management in the southwest of Kruger. Fencing controls against foot-and-mouth disease that followed in the 1950s and 1960s meant that all free movement between the park and surrounding reserves was eventually cut off.[36] This was a process of slow strangulation. Section by section, the border zone became an area of interdiction. Foot-and-mouth, as is well known, requires a highly regimented system of spatial control, proscription, and disinfection, involving the blockading of movement and a complex system of dipping and spraying of animals, trucks, bicycles, and feet, to prevent the spread of the acutely infectious virus, which not only is present in the vesicles in animal mouths and on feet but may also be subject to airborne transmission.

Disease control, as Foucault famously demonstrated, requires a segmenting and compartmentalizing of space, and a bureaucratic definition of the subject.[37] Consider this: in 1940, because of the loss of draft animals, Albasini residents applied for permission to use donkeys in place of oxen for plowing the fields to grow subsistence crops. Donkeys are reluctant servants at best. Far less maize was produced, and so residents had to supplement their store with bags of ground meal purchased from Hazyview station. But to get the maize, they had to use the donkeys as transport, and to move the donkeys through the border zone, they had to apply in writing for a veterinary services official to meet them at the border to wash the animals' hooves. The application process itself took weeks. So the spatial interdiction is supplemented by a swarming of bureaucratic authority that is brought to bear on citizens in the zone.

In the memory of elders I interviewed, there was a utopian time before

3. Surveyor's Sketch Map of Tribal Authority in the Nsikazi District, sketch map of Numbi gate area, southwestern Kruger National Park. The 1950s Rabie survey, designed to formulate and fix the western boundary of the Kruger National Park, alludes to intersecting zones of chiefly authority bordering the game reserve. Image courtesy of South African National Parks.

the erection of the western veterinary fence when, as one put it, "large animals like kudu would sometimes come home with [the] cattle."[38] Foot-and-mouth changed everything. With the closure of the western veterinary fences, an epoch of zonal understanding came to an end. Until then, many Africans were in a sense citizens of the blurred border, able to live within the very thickness of the line drawn on the map. With the staggered arrival of sections of fence, existing forms of class and gender asymmetry became exaggerated. Some communities benefited from continued access to the resources of the park, while others were blocked completely. Overnight, the ability to enforce poaching laws in certain areas was massively enhanced. It was around this time, his widow told us, that Nkayinkayi Mavundla caught his own brother coming through the fence at Hazyview station and was forced to arrest him as a poacher.

Because the staggered introduction of fencing in the 1950s and 1960s privileged certain groups and not others, it closely mirrored changing apartheid government attitudes toward forms of chiefly rule. In the 1950s, government surveyors attempted to produce a rough sketch map of areas of chiefly control in the region (figure 3). Glancing at these charts, it may be immediately observed that the board felt itself to be dealing with the territorial authority of three chiefs: Chief Jacob Mdluli, in the immediate area of Numbi and Pre-

toriuskop; Chief Mphunzane Mhaule, in the zone stretching alongside the park north of the Mdluli area up to the Sabie River; and Chief Joseph Masoyi. By now, in other words, the easy regional administration of the Stevenson-Hamilton epoch had given way to a more specific form of tribalized, chief-based control. African employees in the border zone had dual citizenship, determined first by National Parks Board authority and second by the imaginary authority of compliant chiefs in the neighboring Native Reserves destined to be incorporated into the Kangwane "homeland."[39] In the Skukuza archives, there are comprehensive records of returns for squatter's rent, and each of the thirty to fifty heads of household in the Albasini group is listed as being employed by the National Parks Board *and* as owing allegiance to one of the three chiefs. In the very acts of division that determined the western boundary of the game reserve, in other words, may be found the shadow of a changing, generalized system of native administration.

Segmented closure of the western border also meant that other rights of local citizens could finally be denied. Traditional rights to riverbank property — such as access to the Nsikazi River — were finally blocked: since the park now defined its borders on the far bank of rivers, the new fences were the beginning of the end of access to water for animals owned by Africans. This had not always been the case. The original legislation defined boundaries at midstream, and for Stevenson-Hamilton in the 1920s, this meant that the rivers, too, were a completely indistinct zone of control. "A boundary taken at midstream," he argued, "at least so far as the lowveld rivers are concerned, with their numerous reed covered and wooded islets, their densely reed fringed banks, and hidden channels, is in practice no boundary at all."[40]

THE NATIONALIZATION OF THE FRAME

By the 1960s, the topographical violence of apartheid could no longer be ignored by visitors to the Kruger National Park. Rural reserves had given way to massive resettlements in the "released areas" of the Nsikazi district, and these were the beginning of the next phase of apartheid spatial control: the construction of "Bantustans," separate states that would in the future rob Africans of their South African citizenship. These displacements began to impinge directly on the experience of tourists approaching the Numbi gate. White farmers in the area reacted hysterically to the increasing numbers of resettled Africans. In 1966, the Southern Low Veld Farmers' Union wrote a sharp letter to the secretary for Bantu administration, in which it claimed that "many fine scenic drives are being spoilt by what [may be described] as SHANTY TOWNS."[41] Interestingly, the writer claims that "in the case of the Transkei, these villages add

rather than detract from the countryside." The approach road, in other words, is understood to play out, progressively, an allegory of the evolution of different forms of racialized control, culminating in the natural management system of the Kruger National Park itself. For that reason, the writer says, "the picture should present . . . one of careful planning under the guidance of European supervisors." To maintain this allegorized approach, through different, symbolically defined zones of landscape heritage, a more radical form of spatial management became necessary. By late 1966, most argued that a second fence was necessary, joining the park's western boundary at a right angle. One vehement proponent of the new fence described it as follows: "*dit 'n heining van Nasionale belang is aangesien dit die skeiding tussen Blanke-en Bantoe gebied vorm*" ("It is a fence of national importance, given the fact that it will form the boundary between white and Bantu districts").[42]

In the end, an absurd compromise between hard and soft boundaries was reached. In a letter commenting on "Scenic Motor Drives in the Eastern Transvaal," the Bantu affairs commissioner at Bushbuckridge describes how 500,000 papaya trees have been grown "and will be issued to the Bantu in these residential areas to be planted in their stands."[43] In a massive intervention that marks the inextricable connection between aesthetics and power, the state arranged for the Numbi access road to Kruger to be fringed by a dense screen of tropical trees, which softened the visual impact of the settlements. This may also have been a way of managing the metonymic relationship between landscape and time: the homeland resettlement areas were the final, brutal conclusion of a racist attempt to sequester forms of modernized black citizenship in controllable zones. Unlike other modernizing states, however, white South Africa did not conceive of black citizenship within the reconceived boundaries of the nation-state as a whole. For that reason, the allegorical transition from Johannesburg to the homelands, with their separate, sequestered forms of racialized citizenship, and then to the Kruger National Park was also a passage through several contradictory zones of time, until the encounter with timeless, spatialized aspects of native being in the game reserve itself. For this critical narrative to survive the spatial contradictions of grand apartheid, it became increasingly necessary to bracket off the catastrophic time of the Bantustans and to spatialize them and aestheticize them with a decorative tropical screen. For landscape heritage to survive, in other words, it required a second fence.

It is worth noting, by the way, that within a year of their being planted, every single one of the papaya trees was dead or dying, for there was not enough water to sustain them or the communities whose members were forced to carry tins of the precious liquid to try to save them. The state then grew new seedlings, planted half a million replacement trees, and provided more available

irrigation. There is a lesson for all cultural historians that hides in this image of the withering groves: the national fence signals the full extension of Kruger's western boundary into the logic of the state. Even in this final metamorphosis, however, the contending authorities were unified in their understanding that the success of any border resides not only in its ability to barricade but also in the way that it is able to naturalize its control.

KRUGER TODAY: HERITAGE ACROSS BORDERS

The Albasini land claim against the Kruger National Park was only the second in a series of legal actions against conservation areas that will be moving through the South African courts for years to come. Despite any sympathy we may feel for the rights of these heroic men and women, they were, in the end, a "community" only in the sense of their being employees of the Parks Board. Furthermore, on closer inspection, the claim seems to have been shadowed by several dubious special interest groups and casino developers, intent, as the new director of the park put it, "on the Balkanization of the Kruger National Park."

Even in the preliminary stages of evidence from land claim cases such as these, telling patterns are beginning to emerge. First, the claims themselves are almost always syntactically associated with other claims. In the Albasini example, reference is made to the conditions governing the more famous Makuleke settlement in the north, where a community won back a large tract of national park land for limited use for hunting concessions and ecotourism. Second, underlying many land restitution claims against national parks is a bitter, older rivalry among chiefs, originating in the heyday of apartheid. So, for example, the Albasini claim may also derive from historical bitterness over a clandestine deal made with Chief Mdluli in the 1990s, where access to a section of southwestern Kruger was given back to a powerful but cooperative local black authority.[44] Finally, almost all the present claims are characterized by a deep worry over the conflict between the pressure of mass game reserve tourism and local memorialization.

Game reserves are perhaps the most important single element in the reorientation of South Africa's economy. As Leslie Witz shows in this volume, it is express government policy to substantially increase the contribution of tourism as a percentage of the country's gross domestic product, with the eventual outcome that it will outstrip both mining and manufacture. For some of the new black managers in South African national parks, the sheer pressure of the new wildlife tourism (with more than a million tourists a year now visiting Kruger) presents obstacles to the formation of newly democratic heritage

landscapes. Wildlife tourism, for some newly appointed black park rangers and local guides and teachers, is often described as a violent form of landscape overlay. In the Mopane region of the Kruger National Park, for instance, H. P. Chauke suggested to me that the newest tourist camp was built on the now erased graves of ancestors and that I should avoid huts with certain numbers for fear of unshriven spirits. Moreover, the horizontal, stratified impress of tourist roads, signage, and national parks administration had produced a problem of spiritual disenfranchisement, he claimed, visible in the recurrent droughts that struck the area. These, he suggested, were a direct result of the expulsion of "water-loving spirits" (*nzuzu*) that normally inhabited vleis and wetlands, part of the deep presencing of the landscape. The disappearance of these signifiers of power had resulted not only in a crisis of symbolic hydraulics but also in chaos in the entire chain of interpretation.

Dramatic contradictions between the new tourism and older ideas of memorialization are being made even harsher because of wider changes to burial practices in the past decade. In 2000, when I returned with two African field ranger friends to the now deserted Albasini settlement, there was a special melancholy to the scene. An era had clearly passed, and the last and final grave in the sequence of patriarchal residents, that of Nkayinkayi Mavundla, now lay alongside that of his mother. There was also a significant visible contrast between the two graves: whereas his was unembellished and rectangular, hers had a now fully grown *Zizyphus mucronata*, or buffalo thorn tree, sprouting from it, from a branch placed there in reverent care many decades before by the dutiful son (figure 4). This tree, used extensively throughout southern Africa in memorial rituals, is taken to be a sign of special reciprocity between ancestors and mourners, mainly because of the propensity of cut branches laid on graves to take root and grow. Other Albasini graves, too, show evidence of the changing nature of ritual belief. Many of the older graves hidden in the veld have household utensils, ranging from earthenware pots to enamel bowls and mugs, placed carefully upon them. Typically, these items have a hole punched in the bottom, identifying them as symbolic grave markers, their use value destroyed (figure 5). As the widows and children of the last black Albasini rangers age, so the community memory fades. The previous Easter — and Easter is the traditional time for care and maintenance of graves — only four of the memorials were obviously tended.

Without a resident community to serve it, the small, symbolically significant, and potentially counterhegemonic heritage landscape around Albasini will become an isthmus, then an island, and eventually erode away. There are other signs of its imminent demise. Willie Sambo's grave near the Phabene Stream is still well tended and fenced. However, it is overlooked by a beauti-

4. Nkayinkayi Mavundla, the last of the Albasini patriarchs, is buried in a more conventional grave alongside the buffalo-thorn tree that marks his mother's final resting place. Albasini ruins, Kruger National Park, February 2002. Photo by David Bunn.

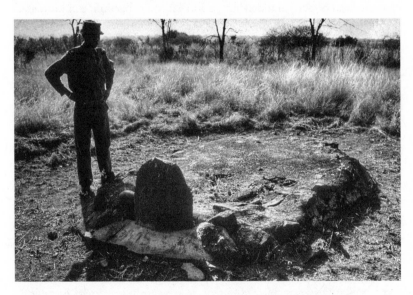

5. In the southwestern section of the reserve, older graves are frequently indicated by the presence of deliberately holed clay beer pots, while those from the sixties or seventies are often adorned with cheap enamel plates or mugs that have holes punched into them to destroy their utility. Albasini district, Kruger National Park, July 2001. Photo by David Bunn.

fully strange sentinel: a rusting kerosene refrigerator with the words "*i fridge xa Willie Sambo*" ("the fridge of Willie Sambo") scratched into its side. Presumably, this most precious object, gutted to render it useless, originally stood in a syntactical relationship to the grave itself. It distinguished the status of the departed owner from that of other, poorer members of the community, and it was clearly a gathering point for mourners arriving to drink together and pour *inqombothi* (sorghum beer) on the grave. Today, that synecdochic association is increasingly obscure and unobserved, and the grave is losing its landscape function.

When we came upon the last grave of the day, that of an elder named Dandile, it was obvious that it too had been recently tended. In the dying light, Patrick Khoza, one of the older members of the Social Ecology Department in that region, told us something of his experience of changing funerary practice. His mother, for instance, had placed clothes and significant personal items into his grandfather's grave, and she had burned every image of the old man at the time of his passing. Her grandchildren, however, had desperately wanted to see photographs of the old man. Responding angrily, the old woman told them that the only function of a photograph was to preserve the dead in a troubling state, a state that "made you cry," and it was customary for all affect-laden items to be buried or burned. For her, the very indexicality of photographs kept the dead present to the living, in a melancholic relation, and prevented them from making the transition to ancestorhood.[45]

What I have described as the battle over landscape heritage continues to play a major role in the politics of memory, monumentality, and display in contemporary South Africa. In the imagination of conservation authorities in the Kruger National Park, the control of biodiversity—and of human intruders—required an increased regimentation and surveillance of the western border; in contrast, this also required a simultaneous aesthetization of the fence as a frame. For those Africans living to the west of the reserve, the Kruger National Park was experienced as a kind of force. Living within its penumbral shade, they found that their poverty seemed exaggerated by the rich resources visible through the fence alongside.

In the 1970s and 1980s, the contradictions around the Kruger National Park border control were of course even more extreme because of the nature of authoritarian governance in what was effectively a semiautonomous state. South Africa's biggest wildlife preserve was in fact a highly militarized zone, with secret military bases established in remote areas to control guerrilla infiltration from Zimbabwe and Mozambique, and to provide clandestine support for right-wing counterrevolutionary forces such as Renamo, opposing the Frelimo government in Mozambique. Like in colonial East Africa, the culture and train-

ing regimens of game ranging were also military in method. As David Fig and Jackie Cock describe it, "all the bureaucrats in central government responsible for biodiversity protection were members of the old guard." This highly conservative staffing core continued past the symbolic transition to democracy in 1994, largely because of the negotiated nature of the South African revolution. The negotiated settlement contained an infamous "sunset clause," allowing old-style bureaucrats to remain in place for a period after the transition.

For the Kruger National Park in the 1990s, therefore, the hostile and embittered communities to the west represented a major public relations problem. To manage this vicious contradiction, an entirely new, social solution to the problem of the western boundary was required, one that entailed a softening and rezoning of the old hard line. This change was effected through the establishment of a special new administrative division, one charged with the specific responsibility of engaging with neighboring communities. Known first as the Community Development Unit, then renamed the Social Conservation Unit (a change reflective, by the way, of the dominance of the "parent" discipline, Nature Conservation), it consisted of a large cadre of young, mainly African officials. In retrospect, it is significant that this is still the only division in Kruger with a majority of senior black staff members; it was, in this sense, a way of containing the problem of race and equity, because it was only in 1997, when the unit changed its name to Social Ecology, that it was promoted to full directorate status.

Social Ecology, as a division, was invented to deal with the problem of the hard western edge; its identity also derives from post-1995 changes in legislature and governance in South Africa. In the words of its mission statement, it tries to embody "a new philosophy and approach to conservation in which ecological, cultural, and socio-economic issues are recognised as critical to the management of national parks."[46] Still today, emphasis continues to be placed on community relations, and the trope of the fence:

> [Communities] are not all the same and the new generation of conservationists require both social and biological knowledge. It is a cutting-edge solution to removing the invisible fences of the past, since it will establish and build partnerships that serve the best interests of all stakeholders while at the same time protecting the natural resources.[47]

The five main functions of the unit include community facilitation, economic empowerment, environmental education, cultural heritage resource management, and research and monitoring. Poorly resourced, the unit was largely ignored by the master discipline, Nature Conservation, until a new management team led by David Mabunda, Kruger's first African director, took

charge in February 1998. Nonetheless, one of Social Ecology's biggest successes was to develop a series of innovative public forums, designed to alleviate tensions in communities along the western edge.

Unfortunately, even these promising new departures were hampered by the older museological conservatism. Trying to help communities escape from the landscape imprint of the Kruger National Park, social ecologists concentrated on developing the only resources the eroded communities were perceived to have retained: their heritage and culture. In the area we have been discussing and near tourist entrance gates further north, craft production centers were established, producing ethnicized curio art for the tourist market. Near Numbi gate, the Lubambiswayo forum built a picturesque pole-and-thatch shelter, reminiscent of "Shangaan" dwellings, where carvers could sell their wares. Elsewhere, some limited success was achieved with projects to share natural resources (thatching grasses, and the allocation of animal body parts and skins from predator kills), but for the most part social ecology contributed to the accelerated conversion of local space into tourist space, of habitus into heritage.[48] The attempt to ameliorate the sharp divisions between the national park and its neighbors on the western edge, in other words, resulted in an extension of tourist spatial understanding. Western Kruger, more and more, became the realm of the pose, repeating a pattern around the country where impoverished rural communities were beginning to establish "cultural villages" that imitated the worst excesses of ethnological typification.

The singular exception to this pattern of converting habitus into tourist heritage display was the spectacular success of a land claim in the far north of the park, driven by the political energy of the Makuleke community. Having been violently displaced in the late 1960s from the triangle of land between the Luvuvhu and Limpopo rivers, the Makuleke embarked on a long, difficult process of political mobilization. Through the help of European donor organizations, and opposed by Kruger Park authorities, they won back the land that had been lost, in the first and most highly publicized victory in South Africa's new land restitution policy. In the process, they established a highly sophisticated model for co-management of the northern section of the park. Significantly, this model was based not on the increasingly common pattern of cultural villages and craft production but on the training of community members for direct participation in the ecotourism and hunting industry.

In the years leading up to South Africa's first democratic election, the department of Social Ecology was set up with the primary purpose of discharging the pent-up anger and suspicion that constituted the real western boundary of the Kruger National Park. Many of the individuals whom I came to know in this period did much to build new community relations, but they were signifi-

cantly hampered by lack of central support. Ironically, it was at Numbi gate, the same tourist entrance that had been the subject of so much controversy in the 1950s, that one of their most significant failures occurred. Not even the elaborate community empowerment programs were enough to stop the steady erosion of tourist confidence in an entrance gate located in the center of black, rural overpopulation. In 2005, in a move full of the historical irony this essay has tried to detail, the Numbi gate to the Kruger National Park was finally closed. In its place, a new entrance was established some twenty kilometers north. Known as the Phabene gate, this major new point of egress is at the very place where Nkayinkayi Mavundla, Willie Nkuna, and others are buried. Sadly, it is as though the main effect of their lives was to prepare for this moment, as though their loyalty, finally, has meant that they will continue to serve as a symbolic portal to the reserve.

CODA: THE GREEN FRONTIER

Changes in the nature of tourist experience, population management, and heritage landscape in the southern sections of the Kruger National Park are all closely associated, I have shown, with the different epochs of state control. They also fall within a wider logic, in which the work of the museum cannot be completed without an associated or implied field site. In the end, though, a more general conclusion is required, with regard to heritage landscapes in the context of what has been called global public spheres. For that, we have to consider the recent history of the Kruger National Park not only as a landscape, but as a spatial system that straddles the borders of three nations.

Border control in the Albasini region evolved toward a closed, defensible system; it was only with this degree of direct exclusion that the landscape system could continue to function as an allegory of good governance, by whites, over unequal citizenship. Elsewhere in the park, an even more spectacular form of defensive exclusion was required: after the end of Portuguese colonialism with the 1975 Mozambique revolution, South African authorities erected a vast electric fence along Kruger's eastern border with that country. Exemplifying the spatial logic of the grand apartheid period, the fence was until recently turned to a killing voltage.

Fences that define the borders of the Kruger National Park continue to play a critical role in new national narratives about our open democracy. Under the second president of the postapartheid state, there has been a significant new policy change, focusing on the promotion of African styles of democratic governance and strengthened economic partnerships, exemplified by the regional NEPAD (New Program for Africa's Development) agreements and

Thabo Mbeki's idea of an African renaissance. One of the most dramatic manifestations of this new vision is the idea of a vast, transfrontier game reserve stretching across three countries and without internal border controls. In December 2002, three southern African presidents, Robert Mugabe of Zimbabwe, Joachim Chissano of Mozambique, and Thabo Mbeki of South Africa, met to sign a historic trilateral agreement to create this reserve. Known as the Great Limpopo Transfrontier Park (GLTP), it is a gigantic 35,771 km² in extent; however, it will in turn form part of a larger Great Limpopo Transfrontier Conservation Area of 99,000 km², the largest conservation area on the planet.

According to Mohammed Valli Moosa, until 2003 South Africa's dynamic and effective minister of environmental affairs and tourism, the main aim of the megapark is to "restore the integrity of an ecosystem artificially segmented by colonial boundaries." But there is also, in this massive conservation venture, an important symbolic function: "More than the economic and environmental value of this great park," Moosa continues, "is that it serves as a concrete tribute to the defeat of apartheid and colonialism." The Great Limpopo Transfrontier Park, therefore, is a monument to postcolonial southern African "economic and social unity," founded on the idea of tourist value and natural heritage.

Most dramatically, the GLTP has begun to effect the demolition of that ultimate symbol of apartheid paranoia, the Mozambican electric fence. In time, the plan is to join the northeastern section of the Kruger National Park, through a corridor through the Sengwe communal area, to Zimbabwe's Gonarezhou National Park and Mozambique's Limpopo Park (formerly known as the Coutada 16 Hunting Concession). As a second symbolic step toward the recognition of joint administration, over the next three years a thousand elephants will be translocated into specially prepared holding camps between South Africa and Mozambique, thereby also contributing to the reestablishment of ancient east-west animal migration routes that predate colonialism. For the Kruger National Park, this ability to translocate large numbers of elephants was a major factor in their support for the new park. When the scientific culling of elephants in the Kruger National Park was stopped in the late 1980s, their numbers began to increase rapidly, multiplying to an unsustainable population density. Authorities were caught between the international wildlife lobby and donors, who together with East African savanna ecologists vigorously opposed culling, and SADEC (Southern African Development Community) region reserve managers, who believed they were being punished for managing their large mammal populations effectively, and who wished to resume monitored culling and ivory sales.

The Great Limpopo Transfrontier Park provides South African authorities with a potential solution to their most intractable conservation problem; in

the image of unfettered migratory flows of animals, however, it also provides a powerful spatial metaphor for what it might mean to bring down the colonial fences and establish new forms of wider southern African citizenship. In truth, though, the metaphor of transfrontier flows also distracts attention away from the actual catastrophic history of illegal transborder human movement that has been increasing in scale over the past decade. Establishing a park that will take joint responsibility for a coherent transfrontier ecosystem—the needs of animals, if you like—may be a way of avoiding the rights of refugees and those escaping the widespread violations of human rights in Zimbabwe.

What does it mean, finally, to have this massive extension of trilateral authority over heritage landscapes? Let us consider the other beneficiaries of this scheme. For Moosa and President Mbeki, the GLTP is considered to be an early and spectacular manifestation of changed regional policy, in particular NEPAD, "an expression of the collective conviction of Africans that we are at the dawn of an African Renaissance."[49] Even more significantly, perhaps, the idea of transborder conservation areas has been actively advocated by a South African consortium called the Peace Parks Foundation, led by industrialist Anton Rupert. As Maano Ramutsindela has pointed out, the Peace Parks Foundation is taking advantage of priorities established by the World Conservation Union (IUCN) and their "drive towards global ecological governance," as supported by SADEC. This splicing together of conservation rhetoric with the language of governance is evident throughout Peace Parks publications. "SADEC governments," they say in a recent report, "have recognised that peace parks have the potential to promote sustainable economic development, biodiversity conservation and regional peace and stability." Following their active lead, there has been a very significant increase in the number of proposed transfrontier conservation areas in Africa, with the foundation actively advancing the case for twenty-two new reserves over 50 million hectares.

As an extension of the idea of transfrontier parks, the plan for new "peace parks" deliberately takes conservation into the realm of direct governance: when weak or corrupt African governments fail to prevent wars (the most compelling current example being conflict in the Democratic Republic of Congo), these new conservation zones, it is believed, will be a buffer to absorb the violence. At the same time, because the development of peace parks is often coupled with a drive toward the declaration of World Heritage Site status, it places responsibility for the conservation of certain forms of human and natural value in the hands of international agencies. This in turn opens opportunities for specialist conservation entrepreneurs eager to enter into partnerships independent of local governments. One of the most significant of these commercial organizations is Conservation Corporation Africa (CC Africa), a

South African firm operating specialty wilderness lodges throughout Africa. "Imagine an Africa," their publicity brochure declares, "where animals roam free across international boundaries, where fences come down, where fragmented conservation areas are consolidated into vast open spaces and ancient migration routes are restored." Significantly, CC Africa works closely with the Peace Parks Foundation to "advance the green frontier and stabilize wildlife real estate."

CC Africa is not a company one can easily dismiss. It is a sophisticated and politically astute organization with long experience in community resource management and sustainable development. It also has significant, gender-sensitive community job creation and training programs. Nonetheless, as a collaborator in the development of conservation management systems that bypass forms of national authority, CC Africa is part of a wider, globalizing trend that must be addressed: what Barbara Kirshenblatt-Gimblett has described as the systematic transformation in which "world heritage weakens the link between citizenship and nationality . . . in order to strengthen the bond between emerging cosmopolitan citizens and an emerging global polity."[50] In these developments, the combined natural heritage and social history resources are seen to be under threat from inept governments, and corporations are called upon to help watch over transnational heritage, receiving additional funding support from agencies such as UNESCO, the IUCN, and the World Bank, thus bypassing the complexity of local political battles. The idea of landscape is a key vector for the development of these new systems, and here too the museum indoors has been a model. As the museum experience converges with that of the theme park, so too the idea of the educative tourist experience extends to include movement between fixed viewsights, and the transfrontier national park makes this kind of untrammeled passage possible. "Routes and roads, along with networks and webs," says Barbara Kirshenblatt-Gimblett, offer a "strategy for linking subnational phenomena to transnational ones in the face of intractable intranational and international conflicts."[51]

Transfrontier conservation areas mark the extension of the idea of natural heritage into the domain of citizenship. But in bypassing the mediation of the state, the intricate connection between conservation and the improvement of forms of regional governance is severed. In some respects, those in Zimbabwe's Sengwe corridor will be given a new form of transnational identity that amounts to a sort of provisional citizenship. Ironically, however, this is very close to the form of background landscape presence that apartheid conservation authorities allowed for the African residents of the Kruger National Park. It also marks a return to what Nancy Fraser identified in *Unruly Prac-*

tices, her classic modification of Habermas, as a needs-versus-rights discourse. Citizens of the transfrontier zone are not citizens at all; rather, they are the beneficiaries of aid from a variety of sources, without any legislated claim upon the state or government. In the process, too, the newly declared permeable frontiers may protect and prolong the rule of the very corrupt governments that conservation authorities are seeking to bypass: corruption, torture, and tyranny characterize the latter-day regime of Robert Mugabe in Zimbabwe, but the GLTP provides him with a metaphor of lenient governance, and of liberal flows. For the thousands of refugees escaping persecution by Mugabe's ZANU/PF squads, the fact that their route takes them through a massive Peace Park will be of little comfort. As always, the new landscape will provide a way of constituting fantastical forms of citizenship not possible outside the system, and it will delay confrontation with the rights of refugees and immigration policy. Residents without citizenship in these transnational zones continue to fall under the shadow of a logic that evolved for museum management and is now moving outdoors: in a sense, they are living in a condition of fixity, as though in defended dioramas between which other, more mobile agents and subjects may pass.

The genealogy of the western fence of the Kruger National Park is a complex one, rising to crisis in the zone that I have examined, and coming into complex association with the idea of heritage. In the post-1994 period, a different set of contradictions has begun to take hold. Achille Mbembe, John and Jean Comaroff, and a variety of other thinkers have explored the peculiar problem of the frontier in postcolonies such as South Africa, striving for nationhood at a time when the global neoliberal order seems to encourage "the unregulated flow across them of currencies and commercial instruments, of labor and commodities, of information, illegal substances, and unwanted aliens."[52] For South Africa, this has resulted in extreme forms of official xenophobia and paranoia, especially regarding the flow of illegal immigrants through the Kruger National Park, and even the traffic of illegal antiretroviral drugs. In early 2002, two forms of rhetoric began to appear that took the metonymic relationships between game reserve borders, governance, and disease control to an absurd new height. First and foremost, the fear was expressed that the Great Limpopo Transfrontier Park could itself be the occasion for new vectors of disease. Second, in a hugely embarrassing public document issued by the African National Congress, in part also the work of HIV/AIDS dissidents in the United States, the following extraordinary claim is made: "Nobody has seen the HIV virus, [and] the generic system used to test for the virus is also used to test for foot and mouth disease in cattle and has been found to be faulty."[53] I find it hugely

ironic that in this time of severe testing for new notions of democracy and citizenship in South Africa, the specter of veterinary disease control has once again risen from the grave.

For young and old alike, and even for those local villagers who have not seen them, the large mounds of cattle graves in the southwestern Kruger National Park lie at the heart of the argument for a new kind of memorial practice. Over the years, all my African colleagues have been visibly moved by the experience of visiting these ossuaries, and several of them have urged me to use my influence to make them part of a new outdoor museum site. It may be, in this time of plague and uncertain tourist economies, that the only possible way forward for a new museum policy in this exemplary game reserve, a policy that links questions of heritage to issues of citizenship and rights, is to start with the public mourning of long-dead cattle.

NOTES

1 The classic statement on this South African obsession is J. M. Coetzee's *White Writing*, which may be usefully compared to Paul Carter's *The Road to Botany Bay*.

2 Tony Bennett's groundbreaking original statement of the argument about an "exhibitionary complex" (in his 1988 essay of the same name) has been significantly modified over the years. The present volume is in many respects an attempt to understand the changed global conditions that work to link all kinds of new museum spaces with new forms of citizenship and civic self-identification.

3 "Development of the Museum Definition According to ICOM Statutes (1946–2001)," http://icom.museum/ICOM/hist_def_eng.html (accessed September 8, 2004).

4 My relationship to this claim is a very personal one. For some months, I acted as an independent historical researcher, drawing up a comprehensive report on the evidence for South African National Parks. Aside from this arduous period of very charged research, however, I have spent almost a decade working on the complex history of conservation landscapes in this and other areas of the Kruger National Park.

5 Bunn, "An Unnatural State," 204.

6 Delius, *A Lion Among the Cattle*, 17–18.

7 Literally, lands that were reserved for the use of the original inhabitants. However, the identification of reserve tribal land was in many instances arbitrary, and in most cases resulted in communities losing large tracts of ground to which they had historically laid claim.

8 That is, Lourenco Marques, as it was referred to under Portuguese colonial rule, or Maputo, as the present capital of Mozambique is known today.

9 The infamous Jameson Raid was an attempt by a private group of English settlers to overthrow the Boer Republic of the Transvaal.

10 Plaatje, *Native Life in South Africa*, 435–36.

11 Delius, *A Lion Among the Cattle*, 53.

12 Huffman, *Snakes and Crocodiles*, 5.

13 For the classic analysis of the Xhosa cattle killing, see Peires, *The Dead Will Arise*, and Crais, *The Making of the Colonial Order*.

14 Schapera, "Economic Conditions," 655.

15 Roberts, *Betterment for the Bantu*, 3.

16 Stevenson-Hamilton, NKW Warden's Annual Report 1929, Kruger National Park Nature Conservation Archives, 3.

17 According to Stevenson-Hamilton, this lack of respect for neighboring white authority was most noticeable at the trials of poachers: "When caught and tried in Court they display far more erudition and cleverness than was the case only a few years ago" (NKW Warden's Annual Report 1929, 4).

18 Bennett, *Pasts Beyond Memory*.

19 *Report of the Game Reserves Commission*, 1918, TP5 18, Transvaal Archives Depot (Pretoria), 7.

20 Stevenson-Hamilton, *South African Eden*, 184.

21 The term "Shangaan" has a very complicated history. In general, it refers to groups of people whose ethnic origins lie in Mozambique and who originally fled to South Africa in the mid- to late nineteenth century to escape wars of chiefly succession and Portuguese colonial violence. That much said, self-identified Shangaans entered into complex alliances with local South African chieftainships and, eventually, with the apartheid state, which created a separate ethnically defined Bantustan for Shangaans, Gazankulu (literally "greater Gaza," a reference to the southern Mozambique province from which many were thought to have originated). For many South Africans in the apartheid period, the word "Shangaan" was often used in a highly pejorative sense, alluding to unsure identities, migrancy, and political compromise. In the post-apartheid period, the term continues to be a controversial one, bound up with the widespread xenophobic attitudes in South Africa toward migrant and refugee Mozambicans. See Harries, "The Roots of Ethnicity," and Polzer, " 'We Are All South Africans Now.' " It is significant that until recently, by far the majority of black field rangers and game guards employed by the Kruger National Park were "Shangaans."

22 These same individuals were cited as key ancestral members of the claimant community. The Albasini region, where they were located, gets its name from the ruins of João Albasini's trading post. Albasini was one of the first Portuguese settlers in the region in the nineteenth century, and established himself as an important political and military force. In the twentieth century, Kruger authorities established a tourist heritage display site in the region, focused on the ruins.

23 At the time, a "trek pass" was a document giving permission for the movement of cattle and goods. In truth, though, it was one of the many pieces of documentary evidence needed by Africans who wished to move between distinct zones of local authority. In Kruger National Park, it seems also at times to have had the effect of an eviction order.

24 Pienaar, "Indications of Progressive Dessication," 103.

25 Ibid., 102.

26 See Hofmeyr, "Popularising History."

27 For a comprehensive survey of these two successive traditions, see Peter Merrington's fine article on the work of heritage by Milner's "kindergarten," "Pageantry and Primitivism," and Ciraj Rassool and Leslie Witz's synoptic study of the van Riebeeck festival and the rise of nationalist history, "The 1952 Jan van Riebeeck Tercentenary Festival."

28 For a fuller account of these monumental controversies in Kruger National Park, see my "Whited Sepulchres: On the Reluctance of Monuments," 109–11.

29 Letter from the Chief Native Commissioner, Northern Areas, to the Secretary for Native Affairs, "Foot and Mouth Disease: Kruger National Park," April 3, 1939, NTS 6803 28/316/8, Transvaal Archives Depot (Pretoria).

30 Ibid.

31 Derrida, *Specters of Marx*, 82.

32 See Kirshenblatt-Gimblett, "World Heritage and Cultural Economics," this volume.

33 The true history of this period has yet to be written. Kruger contained several secret military bases, and black game guards played an important but completely covert role in aiding the South African Defence Force in counterinsurgency offensives against Umkhonto we Sizwe and Frelimo guerrillas. One of these selfsame ANC cadres who moved secretly through Kruger National Park, keeping weapons caches in neighboring Mozambique, was the present director of Kruger, David Mabunda (personal communication).

34 "Pabene Se Gryskop Begrawe," 13.

35 Spiegel, "Moving Memories."

36 This practice was part of the attempt to create a buffer zone between the park proper and the local people.

37 Foucault, *Discipline and Punish*, 195.

38 Chauke interviews, 1997.

39 The term "homeland" refers to the last stage of racist spatial planning under grand apartheid. Black South Africans were effectively robbed of their citizenship and consigned to so-called self-governing states called homelands or Bantustans. The Kangwane Bantustan was established alongside the western edge of Kruger National Park.

40 NKW Warden's Reports 1935, Kruger National Park Nature Conservation Archives. This report, dated November 9, 1935, was submitted to the Irrigation Commission of 1935.

41 Letter from the Southern Low Veld Farmer's Union to the Secretary, Department of Bantu Administration, June 22, 1967. BAO 1/795/16/7/65. Transvaal Archives Depot (Pretoria), 47.

42 "Aanwesighied van Bantoe in Nsigazi." Nov. 28, 1966. BAO 1/795/16/7/65. Transvaal Archives Depot (Pretoria), 33–35.

43 Ibid., 49.

44 In 1994, in a gesture no doubt designed to improve the public image of the Kruger Park at a critical moment of political transition, then warden Salomen Joubert reached agreement with Chief Mdluli that the farm Daannell, within the fenced area of Kruger National Park, would be put in trust for the Mdluli community. The Parks Board would continue to manage the area. This settlement has been bitterly contested, and

it is still the subject of controversy, especially around community plans to hand out
hotel or casino construction rights for the area.

45 It might seem, at face value, that the rise of bourgeois mourning practices and the
rise of the memorial photograph is a logical next step in the evolution and textu-
alizing of postapartheid heritage practices. In truth, though, another form of cata-
strophic rupture is accelerating changes in heritage practice throughout Mpumalanga
and Limpopo province. With the rapid escalation of the HIV/AIDS pandemic (glob-
ally, two-thirds of all HIV-positive patients are Africans), and the community denial
encouraged by the present South African government's policies on AIDS, the entire
fabric of memorial practice is being shredded. More and more funerals, it is claimed,
are rushed because the deceased were known AIDS sufferers; prolonged ritual mourn-
ing, it is said, only extends the period of social disgrace for survivors.

46 South African National Parks, mission statement for Social Ecology, http://www
.parks-sa.co.za/conservation/social_ecology.html (accessed August 29, 2004). In 2004
the Department of Social Ecology changed its name to "People and Conservation."

47 Ibid.

48 Kirshenblatt-Gimblett, "World Heritage and Cultural Economics," this volume.

49 Valli Moosa, "Truly the Greatest Animal Kingdom," *Sunday Times*, September 30,
2001, 27.

50 Kirshenblatt-Gimblett, "World Heritage and Cultural Economics," this volume.

51 Ibid.

52 Comaroff and Comaroff, "Naturing the Nation," 16.

53 African National Congress, "Castro Hlongwane."

Baghdad Lions to Be Relocated to South Africa

SAHM VENTER

ASSOCIATED PRESS

Johannesburg, South Africa—Six lion cubs born in the cramped zoo owned by Saddam Hussein's son Odai will find freedom in the African bush.

The nonprofit SanWild Wildlife Sanctuary has secured the release of the six cubs, their mother and two other lions.

"I am just sorry we could not get all the animals out," Louise Joubert, founder of the group based in the northern Limpopo Province, told the Associated Press.

American troops rescued the lions in April, along with two cheetahs and a blind bear from a private zoo set up by Odai in one of Baghdad's presidential palaces, and moved them to the Baghdad municipal zoo. There was so little food to feed the lions that they had to snack on military rations U.S. soldiers tossed inside their cages. Most other animals were set loose by the troops or looters.

The lions are scheduled to arrive in South Africa in July and will be taken to SanWild, about 280 miles north of Johannesburg.

The lioness and her six cubs will be in isolation for 10 months to a year before being taken as a group to the Ngome Community Reserve in the KwaZulu-Natal province, Joubert said.

The other two lions will remain at SanWild, where they will be placed with a brother and sister pair in the hope that they would be incorporated into the group, she said.

"On the trauma side there is not much that one can do. They will be in nature which will enable them to be lions again. There is nothing like nature to heal," Joubert said. "Lions never lose their natural instincts to hunt. They just have to be allowed to get used to hunting again."

The bear is expected to be sent to Greece, where it will be operated on by a Johannesburg veterinarian who has volunteered to help it see again free of charge, Joubert said.

Another South African veterinarian will travel to Baghdad with a SanWild employee to accompany the lions back to South Africa, she said.

The South Africans have joined forces with Care for the Wild International to raise funds to improve the conditions for the remaining animals at Baghdad Zoo, Joubert said.

Revisiting the Old Plantation:

Reparations, Reconciliation, and

Museumizing American Slavery

FATH DAVIS RUFFINS

Over the last forty years, there has been a tremendous growth in the number and range of African American museums, as well as exhibitions on African American subjects in historically white museums in the United States. By its nature, slavery is a global subject, ancient in origin and appearing in many societies on all the continents. Even restricting discussion to the transatlantic slave trade that emerged after Christopher Columbus's arrival in the Caribbean in 1492 involves examining sociohistorical processes that radically enriched Western European societies while fundamentally changing West and Central African ones. Within the Americas, the institution of slavery and the cash crops the slaves grew were key to the near destruction of many First Nations. This radically reshaped social landscape provided the basic platform upon which the new, creolized American cultures emerged. However, most scholars, filmmakers, and museums in the United States have presented American slavery only within a national, rather than international, context.

Before 1980, there was a virtual silence about slavery in American museums. Even in those places where slavery was clearly historically present, such as Colonial Williamsburg, there was no mention of the system of labor that allowed the colonial elite to live so well. Even in the more than one hundred African American museums, most exhibitions have explored the postslavery history of achievements in art and science. Many of the newest museums ex-

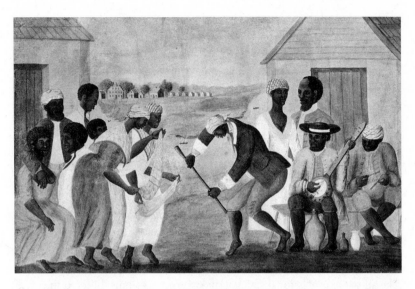

1. "The Old Plantation," artist unidentified, probably South Carolina, ca. 1795. This painting shows a picture of a manor house and slave quarters on a rice plantation in the late eighteenth century. In this image, the slave quarters are in the foreground, but we do not have any clear sense of the people who live there and what they might be doing. In a way, this image is a metaphor for how many people today experience the "silences" of slavery. Image courtesy of Abby Aldrich Rockefeller Folk Art Museum, Colonial Williamsburg Foundation, Williamsburg, Va.

plore the history of the modern civil rights movement, especially in the South. However, by 2005 a number of important, though controversial, exhibitions about slavery had appeared in large museums in England, France, and the United States. Various aspects of the slave trade such as the Middle Passage have become the specific focus of plays, dances, public conferences, and memorials. In several states — Mississippi, South Carolina, and Virginia — well-connected politicians have proposed building entire museums devoted to the presentation of slavery's history in the United States.

How did this change occur over the past twenty-five years? This essay is an investigation into the complex meanings, metaphors, and modes of presentation that characterize this new moment in U.S. cultural history. What new elements in American public culture have coalesced so as to make the discussion and presentation of slavery more possible? What kinds of museums or memorials are being proposed?[1] Of the thousands of stories that could be told about American slavery, which histories are emerging as the most meaningful to which groups of people? Who are the backers, funders, and intended audiences of these slavery museums and memorials? What cultural influences do they intend by focusing on slavery as a central story of the American past?

At the same time, the examples and processes examined in this essay also show that the perception and representation of slavery in museums is affected by processes external to the United States. This is a global topic that involves debates such as the UNESCO work on slave route heritage, the arguments over the slave graveyards in Cape Town, South Africa, and the history of slavery as exhibited at the Cape Coast Castle Museum in Ghana (see Christine Mullen Kreamer's essay in this volume).

"NEGATIVE HISTORY" AND THE UNITED STATES
HOLOCAUST MEMORIAL MUSEUM

In earlier generations, slavery as a subject posed what were thought to be insurmountable problems of presentation. As is well known, the United States was a formally segregated society—de jure and de facto—between about 1880 and 1965. Unsurprisingly, the history of cultural memory was also segregated. The all-white professional staffs of mainstream museums followed the available scholarship and widespread white public opinion, which relegated slavery to the margins of American history.[2] Slavery was considered an exclusively southern story and therefore "regional." There was no clear reason why U.S. museums in the East and Midwest, such as the New-York Historical Society or the Ohio Historical Society, should devote floor space or collections attention to the subject of slavery. Most of these museums interpreted the "boys in blue" as having fought to save the Union, not to end slavery. Many Civil War battlefields, monuments, and memorials emphasized the military strategies, individual heroism, and sheer sacrifice of America's bloodiest war. What slavery was and why Americans fought a civil war that ended it were left out of these exhibitions.

Within the South itself, powerful traditions of memory had unlinked the history of slavery from the history of the Confederacy and the "Lost Cause."[3] As portrayed in mythic movies such as *Gone with the Wind* (1939), slavery was merely the happy backdrop to a world of civility and grandeur. According to the southern mythos, the heroic Confederates had fought to preserve this grand and decorous world of their forefathers. Enslaved Afro-Americans were present primarily to enact and uphold these traditions: serving a mint julep perfectly made or putting the final touches on a ball gown perfectly sewn. When that world was crushed by the Yankees, loyal slaves continued to live and serve "their white people" in a protective and supportive way. The large number of southern plantation homes that were redone as historic houses offering public tours tended to refer, if necessary, to "servants." If still present on the

property, slave quarters were not part of the tour and were often allowed to go derelict.

When the Smithsonian opened the Museum of History and Technology in 1964, these differing interpretations worked together to aid in leaving slavery out of its inaugural historical exhibitions, "Growth of the United States" and "The Hall of Everyday Life in the American Past."[4] Slavery seemed a regional issue, not a national one. There were no slave-made artifacts in the national museum's collection, nor was there any clear mandate to acquire any. Afro-Americans were not seen as part of "everyday life." There were only one or two Afro-American objects in the collection, such as two coiled grass baskets from South Carolina. This kind of curatorial and administrative thinking was nothing new and followed long-established patterns of presenting American history as a relentless forward movement of technological and cultural progress. Unpleasant social issues were simply ignored, as their inclusion did not fit with this positive and progressive story.

The congressional authorization and administrative planning for the Museum of History and Technology lasted from the late 1940s through the 1950s. By 1959, most curators and designers for the new museum were in place, shaped by previous traditions of segregated American history in scholarship and in exhibitions. Yet the five years between 1959 and 1964 contained some of the most explosive changes in American life. In August 1963 the famous March on Washington came to the Mall in hopes of putting pressure on a recalcitrant Congress to pass the Civil Rights Act then being debated. The next month four little girls were killed in the infamous bombing of a church in Birmingham, Alabama. In November 1963 President John F. Kennedy was killed. By the time the museum opened in 1964, President Lyndon Johnson had engineered the passage of the Civil Rights Act. Within this context, the newly hired, suitably patrician secretary of the Smithsonian, Dr. Dillon Ripley, wanted the institution to become "the people's museum." By 1966, the Smithsonian had inaugurated the Folklife Festival, modeled on the explicitly countercultural Newport Folk Festivals of the 1950s and early 1960s. These cultural changes encouraged new and wider audiences to visit the museum.

When new and younger staff members, such as Ralph Rinzler, founder of the Folklife Festival, confronted the director and curators about the absence of Afro-American artifacts, people, and subjects such as slavery, the officials responded from a long tradition of silence.[5] This silence enclosed not only the complex history of a slave nation but also other negative aspects of the American past such as segregation, racial and religious discrimination against various ethnic groups, and the disappearance and reservationizing of native popula-

tions in the United States. Such was the state of affairs during the 1960s and most of the 1970s. As the country was riven by conflicts of the Vietnam era, the modern civil rights movement, and the resistance to it, historically white museums showed little change.

The pressure to change museum stories in order to make them more inclusive came from some unexpected places. In the 1970s, two television programs had an especially powerful impact. In 1977, the NBC television network released the first television miniseries, *Roots*, based on Alex Haley's best-seller, which had been published a year earlier as a family history with fictional elements.[6] Based on oral histories, documentary research, dogged genealogical work, and an apparently thorough culling of literary and folklore sources, Haley's book was the first unified portrayal of the African and African American experience of slavery from the perspective of the enslaved. Most crucially, through additional work in African oral history sources and contacts made possible by his fame as co-author of Malcolm X's autobiography, Haley had apparently tracked down his original African ancestor to arrive in America: Kunta Kinte, from Juffure village in Gambia, West Africa. Haley had found the Black genealogical holy grail—the original African ancestor and his original home.[7]

Record numbers of Americans watched this new television format, the miniseries, which allowed more complex stories to be told over several evenings, rather than within a one- or two-hour period. Media interviews suggested that most people had never known about the violence and personal humiliations of slavery. Black people were especially interested to learn about escape attempts, personal resistance, and slave rebellions. Unquestionably, the study of genealogy skyrocketed in the United States after *Roots*, and not only among Black Americans. Interest in "Black history" and Black cultural institutions rose rapidly. In Chicago, Detroit, and a few other cities, some African American museums were newly able to achieve public funding. By the late 1970s, the newest efforts were launched to propose building a national Afro-American museum on the Mall in Washington, D.C. Yet none of these efforts even reached the status of a formal bill in Congress at that time.

Roots was such a success that other networks began to search for a story of equal power, multifaceted enough to warrant a miniseries format. In 1978, the ABC television network released *Holocaust*. Equally successful as *Roots* and far less controversial, *Holocaust* also broke viewing records. Many Americans, including members of Congress, were stunned by this film on the European Holocaust, which focused almost exclusively on the millions of Jewish victims. That same year, President Jimmy Carter appointed a presidential panel to study whether and how the Holocaust should be memorialized. This presidential commission issued a report calling for both a national holiday and a

museum on the Mall. In 1979, a rare unanimous vote in both the House and the Senate authorized a Holocaust Memorial Commission. In 1980, facing a tough election year in which he had approved the sale of AWACS planes to Saudi Arabia, President Carter approved establishment of a formal commission, charged it with developing a memorial, and appropriated the necessary federal funds to support it.

The United States Holocaust Memorial Museum took thirteen years and over $200 million to move from a set of ideas to an imposing building near the Mall, not far from the Washington Memorial.[8] In 1989, there were a little over thirty Holocaust memorials worldwide, with only six in the United States. This new museum was conceived as a prominent entry onto the world scene, telling a specific story with universal meaning. From the moment of its opening, it was hailed as one of the greatest of all memorials. In newspaper interviews and museum surveys, many visitors described this Holocaust Memorial as a must-see museum that presented a horrific story with dignity, provided irrefutable evidence of historical evil, and respectfully acknowledged the millions of lives lost.

While current estimates suggest that Jewish victims account for less than half of the total number killed in the Holocaust, in the United States the Holocaust is popularly seen as a Jewish story. Further, this is a story over which Jewish Holocaust survivors and their descendants have claimed exclusive authority to speak. Indeed, the question of whether the Holocaust was unique or not significantly delayed the opening of the museum. The uniqueness issue was debated over and over among the many planning and donor groups, boards of advisors, scholarly consultants, and others involved in the museum's development.

Even though many Jewish Americans have argued vociferously for the absolute uniqueness of the Shoah, the success of this museum has had a profound impact on how many people in the United States want to have their ethnic story memorialized. The U.S. Holocaust Memorial Museum has become a symbolic archetype, architectural and exhibitionary, for expressing the sacrifices and tragedies of a people's collective identity. Before the Holocaust Museum opened, African American museum professionals began to talk among themselves about the possible impact this could have on previously silent areas of American history, such as slavery.

African Americans were not the first people who felt that the Holocaust Memorial Museum showed the best way for their own historical experiences to be memorialized as part of national or world historical memory. By the early 1990s, books began to be published discussing the "American Holocaust," that is, the genocide of native peoples in the early centuries of American history.[9]

In 1995, the state of New Jersey Commission on Holocaust Education issued guidelines explaining how any group could propose a "holocaust curriculum." The first approved was the "Irish Holocaust," the series of potato famines in Ireland in the 1840s and 1850s that resulted in significant immigration to the United States.[10] In 2001, a memorial to the Irish Holocaust was erected facing the harbor in New York City. In 2003, the Downtown DC development corporation opened a formal bid for planning an Armenian Holocaust Memorial Museum in Washington, close to the White House. Based on the philanthropy of the Armenian American community, several historic buildings have already been purchased in order to tell the world the story of the genocide of Armenians in Turkey before and during World War I.[11]

These examples demonstrate the profound difference that the Holocaust Memorial Museum has made to public discussion of tragic parts of American and other national histories. In both these cases, the Armenian and the Irish, a holocaust in another part of the world resulted in major immigration to the United States. While both these ethnic groups may have been successful in the United States, there are important internal political and symbolic reasons to call attention to these earlier episodes of victimization. Instead of eliminating or silencing these negative histories, now many Americans seemed to feel it was essential to describe their particular ethnohistorical experiences as a holocaust. As a metaphor, the term *holocaust* seemed to confer a centrality, a gravitas, to an American ethnic history that had never before had that power.

The social maneuvering from which these negative histories emerge is extraordinarily complex and so much a part of the culture wars of contemporary American life that it has not yet been the subject of historical analysis. Ironically, while the United States is often described in the popular press as "the last remaining superpower," many ordinary Americans are now explaining their collective historical experiences by representing themselves as "victims" of one or another form of oppression. The proliferation of holocaust descriptions for various kinds of historical experiences reinforces the notion that victimhood has social value within American society.[12] Further, the fact that the Holocaust Memorial Museum preserves the memory of a holocaust that took place outside the United States has made the previous European history of many American immigrant groups that much more socially relevant. While the Irish or the Armenians, for example, may not have experienced a holocaust within American history, they can still be seen as morally innocent victims of a prior holocaust in Europe, perhaps thereby lessening their culpability in oppressing people within U.S. history.

Within the spectrum of American ethnicity, African Americans have always had an ambiguous and uncomfortable status, one that has not been well repre-

sented in the public sphere. Their presence in the population does not derive primarily from voluntary migration. In general, African Americans do not have an Ellis Island–type story similar to that of Irish, Italian, or Jewish Americans. More to the point, if the Middle Passage or slavery can be described as a holocaust, then the villains were not distant, in England or Turkey or Eastern Europe. Rather, some villains of the Black Holocaust (or their descendants) are Americans too. Steven Newsome, director of the Smithsonian's Anacostia Museum from 1991 to 2004, put these thoughts very succinctly:

> We want to combat the idea that there is "no present responsibility" because slavery did not happen recently. The human horror of it all is what gives African Americans equity in pain. Black people want everyone to see the pain, the suffering, the violence, and the evil done. They see slavery and the Holocaust as bookends on human injustice and suffering. The Holocaust Museum's building was itself designed to convey the sense of isolation and the monumental sense of a crushing weight falling down upon the spirit. People want that same sense of monumentality given to their story, particularly since the institution of slavery is central to the definition of the American character.[13]

For a number of African Americans, the U.S. Holocaust Memorial Museum has provided new ways to talk about the African American experience and new modes of presenting that experience to others. In using the metaphor of a holocaust, African American cultural activists seek to claim an authority for their story that they feel has long been missing. In the last decade, the exhibitionary silence about American slavery has been forcefully broken and this new paradigm of holocaust has been a key element in unlocking interpretations of this past.

SLAVERY IN THE MEDIA AND IN MUSEUMS

Any discussion of slavery in museum displays has to examine how this topic has been affected by, and affects, the representation of slavery in other media. Museums play a critical but restricted role in the ways that slavery has or has not been represented. Media representations of slavery and the slave experience have sometimes led to museum exhibits, and these exhibits have provided a sense of permanency to representations in more ephemeral media, as well as a sense of legitimacy to the public presentations of slavery that African Americans have sought in recent years. Here I present a brief chronological history of an increasing interest in and acceptance of presentations of slavery that have had some influence on the museum world, just as the museum world has solidified advances made in other media, such as film and television.

In 1979, the Smithsonian's Anacostia Neighborhood Museum produced a landmark exhibition entitled "Out of Africa."[14] This exhibition was an early attempt by an African American institution to produce an exhibition about the transatlantic slave trade and the early years of American enslavement. Though hampered by a small exhibition gallery, "Out of Africa" broke the silence about slavery at the Smithsonian. This exhibition gave voice and agency to enslaved African peoples and their pain, their sacrifices, and their deaths.

"Out of Africa" used historically accurate visual sources, and it did not have fancy video or audio components, as would be required today. People in the Black museum community traveled to Washington from around the country to see the exhibition. Few had seen these paintings and graphics depicting the economic platform for the pathos and tragedy of the slave trade. Reproduced images from eighteenth- and nineteenth-century French and British paintings, map and book illustrations, and a few objects told a tale unfamiliar to many. After this exhibition, a number of African American museums revamped their offerings to include more information about the slave trade and slavery, such as the Du Sable Museum in Chicago and the African American Museum in Detroit. However, most of these institutions did not have the resources to produce a large-scale definitive exhibition. In the early 1980s, Colonial Williamsburg—a living history site established at the restored colonial capital of Virginia—began to change. Rex Ellis, an African American actor and historian, initiated a series of "first-person interpretations" that highlighted the once overlooked lives of Williamsburg's African Americans, both enslaved and free (historically, Afro-Americans were just over 50 percent of the Williamsburg population in the 1770s). At one time, Colonial Williamsburg's presentations had lagged woefully behind the ever growing scholarship on slavery. However, by the mid-1980s, Williamsburg had become a leader in the burgeoning efforts to discuss slavery in a public context and an important source of archaeological and documentary research. These programs became legendary for their effective use of drama, folklore, folk songs, and deft presentations to the public.[15] For the first time in many decades, visitors could see African Americans inside the Governor's Palace, outside the blacksmith shop and the kitchen, and along the streets of Williamsburg.

In 1985, the Smithsonian's National Museum of American History opened its first social history exhibition: "After the Revolution: Everyday Life in America 1780–1800." For the first time, this national museum integrated the history of the slave trade, slavery, and the voices and families of enslaved people into a spacious presentation of American life.[16] Enslaved people appeared in two sections: one devoted entirely to African American culture in the Chesapeake region and the second on class and social status in Virginia. "After the Revolu-

tion" also included a section on the free Black community of Philadelphia. This exhibition was noted as well for its greater accuracy and inclusive presentation of native peoples, such as the Iroquois Confederacy. While some tentative steps were being taken by a large Smithsonian museum, a study by Jim Horton and Spencer Crew soon thereafter indicated that most museums had not yet included slavery in their exhibitions.[17]

This silence began to change in part due to the release of several important novels and films. In 1989, the film *Glory* was released, a portrayal of the Massachusetts 54th, the first Colored volunteer unit in the Civil War. This Colored unit fought fiercely and bravely, even though they knew that they were especially targeted by Confederate troops.[18] *Glory* reached millions in movie theaters (and on video) who had never read any of the scholarly literature. Scores of Americans were shocked to discover that heroic Colored troops fought for freedom during the Civil War, as their stories had routinely been left out of textbooks, Hollywood movies, and other popular accounts.

Debbie Allen, an African American choreographer and entertainer, had spent years trying to get someone in Hollywood to produce the story of the *Amistad* mutiny. The *Amistad* story involved one of the most gripping of the antebellum U. S. Supreme Court cases about slavery. The *Amistad* was a slave ship bound for Cuba whose cargo of Africans rebelled and wound up in the United States, where it was determined by the United States Supreme Court that, ironically, since they had never been slaves, they were free men.

Debbie Allen had been moved by this story since she first heard it in the 1970s. Through various contacts, she was able to get the attention of Steven Spielberg, who had just released his Holocaust film, *Schindler's List* (1993). *Schindler's List* was a resounding success, though not an uncontroversial film.[19] This movie told the story of a German factory owner who saved a number of Jewish lives during the Holocaust. Allen hoped that Spielberg could bring some of his ineffable magic to the *Amistad* story. Spielberg's production values and due diligence ensured that *Amistad*, like *Glory*, was guided by unassailable historical research. Spielberg assembled a multinational cast and filmed on location in many places. Even though *Amistad* had the benefit of a fairly large publicity budget, it was a financial flop when released in 1997. These bottom-line issues point to probable, though as yet undefined, resistance or apathy in the American film audience to the subject of slavery.

A year later, in 1998, Oprah Winfrey released *Beloved*, the film version of the Pulitzer Prize–winning novel of the same name by writer Toni Morrison. Published in 1987, the best-selling novel was a largely internal discussion between a mother and her ghostly spirit child, the "beloved" of the title. Winfrey played the protagonist, a woman who had escaped from slavery with her children yet

had killed her baby when surrounded by slave catchers in order to prevent the child from being reenslaved. Based loosely on the real incident involving Margaret Garner in Cincinnati, Ohio, in 1856, Morrison's novel was a best-seller, but again the film flopped commercially. Nonetheless, the film *Beloved* became a significant landmark in the representation of slavery to the general public, by focusing for the first time in film history on the distinctive ways that enslavement affected women and their children. Further, the fact that a Hollywood film had been produced by a newly wealthy African American celebrity with her own production company was a point of pride for many Black viewers. However, the lack of financial success that plagued both *Beloved* and *Amistad* may explain why no other Hollywood films on the subject of slavery have been released since.

Yet all three of these films were at least shown to millions, rather than the scores who read academic work. Taken together, these films resulted in greater public knowledge of slavery and its consequences. *Amistad* caused an upsurge of interest in slave rebellions and other forms of resistance, a subject of perennial concern to Black audiences. Eventually, a replica of the *Amistad* was built at Mystic Seaport, a maritime museum in Connecticut.[20] The ship is now traveling around the country (by river), docking at various locations and presenting public interpretations of the case itself and a broader history of the slave trade.

By the 1990s the public interest aroused through other media, novels as well as films, began to affect museums, especially in terms of audience interest in and demands for exhibitions on slavery. Virtually all Hollywood films have far larger audiences than museums, especially once released on video. Television and film audiences often vastly increase the number of visitors at museums who ask why certain subjects are or are not included. New visitors are also more likely to attend a historical exhibition if they have seen or heard of a related film. Consequently, although most museum exhibitions emerge from a distinctively different cultural production process than film, television and film have a major, if not fully quantifiable, impact on the size of museum audiences. Therefore, it is striking to perceive that after the production of several films, some major museums risked breaching the silence on slavery in their public spaces.

In 1990, the Chicago Historical Society opened a new permanent exhibition gallery with "A House Divided: America in the Age of Lincoln."[21] Curated jointly by noted historian Eric Foner and a CHS staff member, Olivia Mahoney, this was the first effort to present the complexities of slavery within antebellum life and purposely signal that the issue of slavery was indeed the principal cause of the Civil War. The exhibition gave Abraham Lincoln's voice primacy but

used his evolving thinking about racial issues and emancipation to interpret sectional conflicts over slavery. The exhibition gave voice to African Americans who had been enslaved as well as those who had been free before the Civil War. "A House Divided" was a detailed public reinforcement of the importance of slavery to understanding the whole history of the nation. While this was not news to scholars, this exhibition was the first on the map to put such unprecedented interpretations out to the general public.

In 1991, the Museum of the Confederacy in Richmond opened an unprecedented exhibition on slavery, "Before Freedom Came."[22] This was a courageous move for the Museum of the Confederacy, one that challenged not only the nationwide silence about slavery but also the outright rejection of slavery as the crucial element of southern life for which the Confederates fought. With items gleaned from plantation collections, historic southern homes, and museums, the exhibition, produced by guest curator Kym Rice, presented an intricate picture of the intimate relations between southern gentility, social status, and slavery. While including and critiquing sentimental touches so dear to southern mythology such as the loyal slave who stays with the family after freedom, Rice presented the predominant conflictual elements of the slave experience. Her exhibition demonstrated how owners and enslaved people saw the world in radically different ways. After the death of even a beloved "master," enslaved families were often separated by sales needed to pay off debts, pay out inheritances, and cope with other financial realities faced by the white slave-owning family. This exhibition was quite influential in demonstrating that 130 years after slavery had ended, it was now possible for even the Museum of the Confederacy to acknowledge the crucial relationship between the "southern way of life" and slavery. Consequently, "Before Freedom Came" was a landmark exhibition, presenting not only what a southern museum *could* say but also what it *should* say about those historical connections.[23]

In 1992, artist Fred Wilson curated "Mining the Museum," a striking, disturbing, and acclaimed exhibition at the Maryland Historical Society in Baltimore.[24] Using an artist's sensibility to present historical objects, Wilson commented on the silences about slavery contained in the Historical Society's venerable and traditional collection. He juxtaposed typical blacksmith's objects, such as a fire toaster and other pots and pans, with the objects of restraint such as handcuffs and chains that a blacksmith also made. By skillful use of portraits, reproduction clothing, and pieces that he created (such as mannequins), Wilson put African American slaves and evidence of their labor and oppression physically back into the elegant rooms and juxtaposed them with the objects and portraits of slave owners. "Mining the Museum" tore down the wall of silence about slavery and its brutality within one of the

most precious and renowned antebellum collections. Since Maryland was a slave state but did not secede with the Confederacy, "Mining the Museum" urgently pointed to the wider complicity for slavery within American society. Further, Wilson included contemporary elements, such as an installation presenting the experiences of African American guards at the Historical Society who were often subjected to racist comments by visitors. Drawing a direct link between the guards' experiences (never heard before by the curators), Wilson underscored the contemporary silences about the continuum of experiences linking America's racial present with its slave past.

Beginning in 1994, a photography exhibition began to travel around the country, "Back of the Big House."[25] Curated by John Vlach, an academic folklorist, the exhibition interpreted the images of enslaved people in and near their cabins. The photographs were culled from the precious few taken from the mid-1840s to the Civil War. This exhibition had traveled with no particular controversy, appearing mostly at African American museums. However, its last stop was the Library of Congress in Washington, D.C., in 1995. This was a small, library-scale exhibition and included only about sixty photographs. However, it disturbed African American library technicians who were installing it. Before the labels were even put up, the employees complained vociferously to the administration. "The Library of Congress itself is a plantation" was one quote circulating in the hubbub that made its way to the local newspaper. Further, at the time of the exhibition, the Library of Congress was defending itself against a long-running civil suit in which current and former employees charged the institution with a pattern of discriminatory hiring and promotion. No doubt all these factors contributed to the decision of the library administrators to cancel the exhibition before it could be completely installed.

The Library of Congress's internal censorship sparked another kind of public debate. Curator John Vlach was incensed; historians around the country wrote in protest. Some local people, especially African Americans, wondered whether this was a plot to keep discussions of slavery hidden and off view. After private negotiations, "Back of the Big House" opened at the Martin Luther King Jr. Public Library, the central facility in the Washington, D.C., library system. In a completely different public context, the original exhibition went off without a hitch and was crowded throughout its brief run. However, the controversy about the exhibition once again underscored that slavery was not simply a historical topic, safely dead, but rather a living, fire-breathing subject that many saw as deeply relevant to the American present.

In 1994, Colonial Williamsburg opened for visitation Carter's Grove, a large plantation site six miles from the center of town. A sizable Georgian manor house was the principal building. The scion of a very wealthy Virginia family,

Carter Burwell, established the plantation in 1750, on land originally owned by his grandfather, Robert "King" Carter, once the richest man in all of Virginia. After conducting extensive archaeological surveys, slave quarters that had once stood on the property were rebuilt on the original sites and interpreted as dwellings for field slaves. Carter's Grove was developed to provide a "field site" in contrast to the urban slave settings within the historic town itself.

In 1999, the African American interpreters, then headed by Christy Matthews Coleman, thought that they and their audiences had matured to the point that Williamsburg could attempt some special programming: a slave auction. Of course, slave sales were a fundamental part of the slave system, and one of the biggest slave markets was in nearby Richmond, Virginia. However, no one had yet tried to present an auction as part of living history interpretations. Previous programming was certainly accurate and emphasized the dignity and agency of enslaved African Americans, but many Black staff members felt that the institution itself, as well as visitors, had not yet confronted some of the brutal realities of slavery. While no one was ready to reenact public whippings or other personal violence associated with slavery, an auction seemed an appropriate, richly documented, and edgy piece of theater. When the auction plan was leaked to the press, protests poured in. The local NAACP chapter threatened to sue, and others threatened Colonial Williamsburg with boycotts.[26] To its credit, though clearly nervous, Colonial Williamsburg did go through with the auction. While stirring up animosity across the country, the auction meant that nonetheless slavery and the particular role that Virginia had played in it were again on the front pages. Although the auction has never been repeated, Colonial Williamsburg has continued to produce programming that dramatically presents the dilemmas of enslaved people. This includes an "escaped slave" program, begun in 2000, in which guests are approached by a runaway slave. Surrounded by slave catchers, the park's guests must react instinctively to the situation. This has turned out to be a really intense visitor experience and is one of its most popular programs.

In 1998, an influential permanent exhibition opened at the Merseyside Museum in Liverpool, England. "Captive Passage" is a comprehensive presentation of the transatlantic slave trade that fills in the European side of the trade, the part most unknown to Americans. Because the curators at Merseyside researched the exhibition extensively in the United States and the Caribbean, many American museum professionals were aware of the opening of the permanent gallery. Some American curators have remarked that they learned much more from this exhibition about the operation of the slave trade and the material culture associated with it than they had ever known before.[27] "Captive

Passage" went a long way toward demonstrating the global economic reach of the hemispheric American slave system.

After significant revisions (fewer objects and a much shorter exhibition text), a traveling version of "Captive Passage" began touring the United States in 2002.[28] The first stop was at the Mariner's Museum in Newport News, Virginia, where it was acclaimed. In early 2003, the same exhibition opened at the Smithsonian's Anacostia Museum in Washington, D.C. From the moment it opened, the Anacostia's exhibition was embroiled in controversy. Several newspapers reported that the exhibition argued that slavery in Africa was less harsh and brutal than slavery in the Americas.[29] The Anacostia Museum staff privately communicated that they had received more letters and e-mails, including actual hate mail, on this exhibition than on any other in the museum's nearly thirty-year history.[30] The virulence of these comments reinforces the continuing strains and debates that are generated by the discussion of slavery, and the degree to which this topic has not been resolved for the American public. It continues to be an issue that exposes fissures between racial groups and wide differences in public opinion.

Since 1990, numerous exhibitions about the slave trade and slavery have appeared for the first time in major museums as well as in African American museums. Previously unthinkable images of enslaved people have appeared on the big screen and entered the secondary video and school market. As Ira Berlin, noted historian of antebellum America, has written:

> There hasn't been this much interest in slavery since 1865. Today, colleges and universities are offering courses on the history and sometimes even the literature of slavery! Slavery is more likely to be linked to an understanding of developments in world events and scholars and lay people are realizing that coming to grips with slavery is critical to understanding the great question of the 20th century because slavery is inescapably linked to racism.[31]

Taken together as a growing body of public interpretation, these distinctly different exhibitions have shown that the social and political space now exists to discuss slavery. While slavery and its contested effects remain controversial, in recent years slavery has emerged as an element essential to understand American history. Many African Americans have their own ambivalences about exhibiting slavery, as the Library of Congress censored exhibition and the responses to the Williamsburg auction show. Vivid disagreements remain about how best to present slavery to the public. The lack of financial success of the films *Beloved* and *Amistad* suggests that there may be limits to an interracial audience as well. Conflicts over the meaning of the Confederate flag and the harshness of American slavery may indicate that there are significant south-

ern, white, and/or non–African American voices that will resist the increasing inclusion of slavery into contemporary public life and debate.

A large new body of scholarship and a growing number of museum exhibitions and private collections have continued to influence the media, especially television and cable productions. Since about 2000, televised interpretations of slavery have moved decisively away from the fictionalized approach of *Roots* and toward a presentation based much more completely on original historical documents and recorded oral testimony. For example, in February 2003 the HBO cable network released *Unchained Memories: Readings from the Slave Narratives.*[32] This two-hour documentary consisted entirely of selected readings from the Library of Congress collections of slave narratives recorded in the 1930s. Well-known African American actors such as Danny Glover and Oprah Winfrey, dressed starkly in black with dark backgrounds, read the exact lines originally spoken by a formerly enslaved person seventy years ago. While this treasure trove of information—thousands of narratives in more than twenty states—has been known to scholars for some time, nothing like this had ever been previously produced by the media. The power of the work had much to do with the "authenticity" of the voices presented based on the oral testimony of people who had actually been enslaved, not a novelist's or filmmaker's interpretation thereof.[33] In February 2005, PBS released four one-hour documentaries in a series entitled *Slavery and the Making of America.* This set of documentaries was quite different from any previous work as well. The filmmakers used re-creations of scenes and interpretations by scholarly talking heads, as had other shows, but what was new about this presentation was that the re-creations were "full body" but silent—the actors within the drama do not speak to each other. Instead, we hear a voice-over reading directly from the historical records: court cases, estate inventories, letters, and other primary documents. Again, the incredible power of these films comes from the authentic voices of the time.[34] Second, these new films attempt to clarify for the public the central relationship between slavery and the development of their nation. As historian Jim Horton says in the documentary, "Slavery is not a side story in American history; it is the main story."

Of these contemporary debates, none is more charged than discussions of "apologies" or "reparations" for slavery. The growing presence of exhibitions about slavery has occurred within a heated set of public arguments about whether or how to compensate African Americans for enslavement. Interestingly, none of the exhibitions cited above explicitly used the metaphor of a holocaust to characterize the experience of slavery, perhaps because they were all produced by seasoned curators with the key participation of university-based scholars—people who would be meticulous about attributions, prove-

nances, and metaphors. Yet many African American voices outside academia have labeled the slave trade, Middle Passage, and enslavement experiences a holocaust. In this public context, the holocaust metaphor becomes an essential element in making both economic and symbolic claims on state and federal governments, private American institutions such as insurance companies, and even private individuals (as would be the case with a proposed tax exemption).[35] What do African American cultural activists seek to accomplish by using the holocaust metaphor and by locating it in museums?

THE BLACK HOLOCAUST CONCEPT

The U.S. Holocaust Memorial Museum opened in 1993. One year later, in 1994, Howard University in Washington, D.C., hosted the first large-scale Black Holocaust conference in the country. Blending Afrocentric academics with cultural activists, poets and other artists with cultural analysts, rappers with nationalists from the Nation of Islam, the conference has provided a wide venue for exploring the many meanings of the term *holocaust* in relation to African American history. This first conference focused fairly tightly on the experiences of the Middle Passage and served as a crucial early national platform for calls for reparations.[36] The Black Holocaust conference has been held every year since, always at Howard, and has widened to include many subjects beyond slavery. Many people in the mainstream news media first encountered the description of the African American experience as a holocaust as a result of publicity for this Howard conference.

Today in Black communities nationwide, the term *holocaust* has become a common phrase, referred to as a well-accepted notion. In old-style local Black newspapers, new-style slam poetry, and African American museum exhibitions, the term *holocaust* appears as a specific representation or descriptor of the African American experience in the United States (or the Americas). Some people use the term *holocaust* for the transatlantic slave trade and specifically the now hallowed Middle Passage. However, there is debate among African Americans as to just what elements are included in the Black Holocaust. Some people use *holocaust* to mean the entire experience of enslavement in the Americas, especially the United States. Some definitions are far more expansive than slavery, applying the word to everything that has happened to people of African descent, including enslavement, segregation, violence (especially lynchings and race riots of whites against Blacks), and the discrimination experienced in a legally desegregated America. America's Black Holocaust Museum, operating in Milwaukee, Wisconsin, since 1988, deals very little with slavery and far more with segregation and especially lynching.[37]

Another example of the wider view is the Yale–New Haven Teachers Institute's curriculum, entitled "The Negro Holocaust: Lynching and Race Riots in the United States, 1880–1950":

> The United States has a brutal history of domestic violence. It is an ugly episode in our national history that has long been neglected. Of the several varieties of American violence, one type stands out as one of the most inhuman chapters in the history of the world—the violence committed against Negro citizens in America by white people. This unit of post-Reconstruction Afro-American history will examine anti-Black violence from the 1880s–1950s. The phenomenon of lynching and the major race riots of this period, called the American Dark Ages by historian Rayford W. Logan, will be covered.

The unit is divided into three sections: lynchings, the most significant race riots between 1898 and 1943, and the Black response to these acts of violence.[38]

The term *holocaust* is especially common among local groups in communities around the nation that are creating organizations to produce memorials and/or museums dedicated to victims of specific lynchings as well as whole towns attacked during race riots after Reconstruction ended in 1876.[39] While some of these groups may have been organizing earlier, their efforts were spurred—once again—by a film and an exhibition. The film was John Singleton's *Rosewood* (1997); the exhibition was "Without Sanctuary," which opened at the New-York Historical Society in 2001.[40] *Rosewood* is a fictionalized version of a real race riot that took place in Florida in 1923. A small Negro town with businesses, churches, landowners, and schools, Rosewood was overrun by marauding whites from surrounding areas. Plans for the attack were published in local newspapers, drawing hundreds by railroad and car for the killing spree. Although a number of men in the Negro community returned fire, they were eventually overwhelmed. Some people were killed, the rest were driven away, and the town was essentially burned to the ground. In the aftermath of this atrocity, no one was paid anything for the loss of property or the deaths of loved ones.

Based on the collection of two individuals, James Allen and John Littlefield, "Without Sanctuary" shows postcards, photographs, news clippings, and other objects documenting the highly public nature of lynchings in the South. Many in the visiting public were stunned. Most people younger than fifty had never realized the lewdly public and highly sanctioned nature of these lynchings. "Without Sanctuary" was still traveling around the country as this book went to press and has stimulated various local communities to find out about their history of violence.[41]

Existing mostly on the World Wide Web, there are even larger definitions of

the Black Holocaust, encompassing all the experiences of darker peoples in the Americas and beyond. One site specifically seeks to define "darker peoples," including all African peoples as well as the Aboriginal peoples of Australia.[42] The ever-widening expansion of the term bears witness to its growing importance to American ethnic groups in defining their own experience of victimization on a global basis, a process enhanced by international organizations such as UNESCO and private NGOs. Yet when many African Americans talk about "their holocaust," one subject emerges again and again: the Middle Passage.

During the last decade, the Middle Passage has passed into public usage as a concept and as mythos.[43] Monuments, memorials, and various conferences have been devoted to the Middle Passage. These public expressions of grief and a grim commitment to "never forgetting" have resulted in wildly ballooning figures for the number of Africans who were caught up in the Middle Passage. Today most respected estimates suggest that 12 million to 15 million people were transported in the Atlantic slave trade from 1501 to 1888. Yet, inflamed by the need to get mainstream recognition for their suffering, some sources estimate as many as 80 million to 100 million people lost, while a number of popular authors have set the figure at 50 or 60 million.[44] The exact meaning of these estimates may be hard to fix; however, they seem to represent the desire to quantify the magnitude of the suffering of the Middle Passage by ensuring the attention that large numbers bring.

Despite the potential conflict between narrow definitions of the Black Holocaust as restricted to the Middle Passage and broader, ever expanding definitions that encompass more than the slavery experience itself, the Middle Passage remains the epitome, the essence, of the Black Holocaust. The Middle Passage as an individual journey seems much more like a "death train" than does the full institution of slavery, which existed primarily to organize and manage unfree labor.[45] African Americans living today are the descendants of those who survived (not those who died), but that aspect is often downplayed. Many died, whether through suicide, in rebellion, or in sheer misery from the disease and fetid conditions of the ships themselves, but the final numbers may never be known. Memorials, plaques, plays and novels, and even academic conferences focusing on the Middle Passage have tended to be "death-centric."

The Middle Passage is not only displayed in writing and through objects but also performed, and this is critical for understanding its place in African American consciousness as a paradigm of the Black Holocaust. The memorialization of the Middle Passage has now been performed in so many different African American museums and conferences that these public rituals have taken on formulaic qualities. Middle Passage events resemble traditional Black

Protestant funerals in many ways: there are invocations, a good soloist sings, and then the audience or congregation is led in song. "Lift Every Voice and Sing," once known as the "Negro national anthem," is generally performed. Often one or more groups of children sing or perform a dance. However, the person officiating would not necessarily be a Protestant minister. If present, the Protestant minister would likely be sharing the dais with an Akan or Yoruba priest or priestess who had poured a libation, a self-appointed Khemetic priest, and/or another practitioner of an African-based but newly emergent religious tradition. Sometimes a Native American representative or an Islamic imam is also there to bless the ceremonies. In these outpourings of public grief, people often pass in front much like at a communion service, leaving flowers, shells, messages, and other small offerings at nondenominational "ancestor" altars.[46] These public rituals have become an increasingly important part of programming in all African American and some other museums.

Yet one significant problem in representing the Middle Passage in exhibitions was that virtually no real objects associated with it were known to exist. Still, museum visitors, especially African American ones, wanted to see "pieces of the true cross" displayed, that is, objects actually touched, used, and/or made by formerly free, newly enslaved people. Until the 1990s, such desires were simply unfulfilled. Yet in the last decade, historical and marine archaeology has dramatically changed the number and range of possible objects to be studied, and it has provided new evidence that recontextualizes previously known information about enslaved people. Newly surveyed trash heaps, slave cabin sites, and graveyards have uncovered skeletal remains and have revealed unimagined riches of information. Marine sites, often discovered by treasure hunters, have added new objects of veneration for the Middle Passage, including objects recovered from sunken slave ships such as the *Henrietta Marie*, found off the Florida coast. Most of this archaeology and biological anthropology has occurred on the East Coast from Boston south to Fort Mose in Florida. Scholars now know much more about the lives of enslaved people, even on the earliest Spanish plantations. For example, enslaved people had lively interplantation associations involving trade, religion, courtship, marriage, and child rearing. Evidence of ornamentation with shells and buttons has been found to be a key aspect of slave costume, even including coded or hidden symbolisms such as cowrie shells. This brief summary does not do justice to the wealth of information gleaned from such rich, previously unexamined sources.

The site that received the most public attention was an area in New York City known in the eighteenth century as the "Negro Burying Ground," but known

today as the African Burial Ground. Uncovered inadvertently by the federal government's General Services Administration in the course of excavating for the foundation of an office building in 1990, the African Burial Ground became a contentious cultural phenomenon, resulting in public demonstrations and eventually an elaborate, federally funded research project. Busloads of African Americans visit the still undeveloped site, accompanied by prayer services, healing ceremonies, and all forms of remembrances (such as leaving flowers, shells, etc.). Without question, the New York African Burial Ground project generated an extraordinary amount of public attention to the enslaved dead, and has increasingly served as a model for slavery memorials and museums.

After nearly ten years of study at Howard University under the direction of Michael Blakey, the ancestral remains were placed in small coffins individually built in Ghana. Under the aegis of Howard Dodson, director of the Schomburg Center for Research in Black Culture (New York Public Library), all 491 sets of remains were returned to New York City and reburied in October 2003. Four symbolic and representative remains were accompanied by elaborate ceremonies all the way up the East Coast from Washington, D.C., to New York. I attended the ceremonies at Howard University, which were held at the famous Rankin Chapel and involved elements of both Protestant African American and West African religious traditions. Obsequies were also held in Baltimore, Philadelphia, Wilmington, and Newark, New Jersey, to which the remains and their retinue were taken by train. In New Jersey, the remains were transferred to two boats and crossed the Hudson River into lower Manhattan by water, as the living people had once come.[47]

Both in human remains and in the few precious objects found buried in this seventeenth-century potter's field, the archaeological finds from the New York project constituted pieces of the "true cross," however small, however humbly buried, however fragmentary. Spurred on by the prominence of the African Burial Ground project, efforts are under way in dozens of cities, especially in the South, to save graveyards under similar conditions of rescue archaeology. While enormously worthwhile, especially at the local level, this burgeoning concern with death and dying reinforces a larger tendency to focus on the Middle Passage itself as the most important prism through which to view the African American holocaust experience.

Taken together, this new evidence from the burial grounds on land and sea have provided historical support for a set of emotional desires that have collective force within African American communities. Some people have taken to calling this concept "race memory." Influenced, perhaps unknowingly, by Carl Jung, a number of African Americans talk about feeling viscerally over-

whelmed and psychologically overthrown by visiting slave castles or viewing documentaries such as *Slavery and the Making of America*. These people talk about feeling "as if they were there" and "knowing in their bones what the slaves went through." Historians are apt to feel that such experiences reflect present-day involvements, not actual information about the past. However, the sense of collective possibility is part of ongoing discussion by African American museum professionals, as evidenced by recent conventions of the Association of African American Museums. When asked why people in AAAM continue to invoke the U.S. Holocaust Memorial Museum as their model for what a slavery museum should do, the association's former president, William Gwaltney, answered:

> What do people want? Why do they keep saying that we need "our" holocaust museum? There is this comparison between "my" holocaust and "your" holocaust. People wonder whether "ours" will be as big as "theirs" is. Certainly the issue of the Holocaust Museum as theater—that museum sets a new standard of emotional comparison. People want any depiction of slavery to have that same power. People are looking for the display of the horror. Black people want "them" to see how badly they treated "us."[48]

As the new conversations fill the previous silences, it is evident that many African Americans want "their holocaust" treated with the same dignity, public involvement, and formal memorials as those that now preserve the memory of the European holocaust before and during World War II. The result has been that the history and experience of slavery and the Middle Passage in particular have now become the subject of renewed scholarly attention and a major focus in public culture for the first time in U.S. history. This is not a subject that is treated in a coldly objective fashion in the public sphere, any more than the Holocaust has been. Instead, the Middle Passage has been as much memorialized as it has been historicized, and is often accompanied by the apparatus of the sacred, including elaborate ceremonies and veneration of sacred objects. Slavery in general and the Middle Passage in particular are key elements in the new public demands that these issues be recognized as central to the American experience. Long part of the academic record, slavery and its central role in American history are becoming the subject of debates in newspapers and magazines and on television, cable, and the Internet. As this history moves increasingly into museums, its sacred character produces some special problems for museum collections and displays—particularly as the issue of what social remedies should follow from the display of slavery becomes the focus of attention.

EMERGING MUSEUMS OF SLAVERY:
REPARATIONS OR RECONCILIATION?

Beginning about 1990, the public presence of slavery as a subject increased dramatically. New movies were released, though none to blockbuster financial success; major museums produced exhibitions, some quite controversial; novels and new scholarly books were published at a furious rate.[49] This cultural process was accompanied by an increasing insistence on political acknowledgment of and economic compensation for the injuries of slavery. Among African Americans, calls for reparations have only increased, become more central to political debate, and come to involve much more highly credible people such as Harvard Law School professor Charles Ogletree.[50] Among many other Americans, greater awareness of the profound pain and long duration of American slavery has stimulated calls for public apologies and searches for positive examples of interracial cooperation. For example, in Ohio, Tony Hall, a Democratic state legislator, was instrumental in passing a one-sentence official apology for slavery by the state legislature. However, producing museums about slavery is a very difficult and expensive form of cultural production that—unlike a film—is presumed to last in perpetuity. The politics of garnering public support (especially for the use of public funds), the strategies for fund-raising, the means of acquiring collections, and the various plans for targeted audiences—all these issues make the development of a full-scale museum a singularly complicated endeavor. Randall Robinson has taken the lead in arguing that reparations could take a number of forms. Instead of individual payments, he has suggested that support of various institutions, including historically Black colleges and universities, would be one way to structure reparations. Such resources could also be expended on cultural entities such as memorials and museums.[51] This is not often recognized as a type of reparation that combines with public acknowledgment, but it shares many motivations with the demand for reparations in the strict sense and encounters some of the same obstacles. Yet it can also mobilize coalitions that include groups broader than the injured community.

This final section briefly examines two opposite trends that seem to motivate the various parties interested in "museumizing" slavery—one toward the memorialization of slavery and its injustices in order to argue for reparations, and the other toward "racial reconciliation." While there are partisans of all hues on either side, the first trend—toward the description of slavery as a holocaust and therefore seeking financial compensation—principally emerges from an Afrocentric framework and political base. The second trend also has a significant Afro-American component, but in general seeking to understand

the past as a way to provide dialogue leading to racial reconciliation tends to originate from interracial frameworks and a predominantly non-Black political base. Several new museums are being planned that take the history of slavery as their central subject and raison d'être. Most of these slavery museums are still on the drawing board and not yet fully developed. However, the founders are clearly developing the base structures that are both necessary for raising millions of dollars, publicly and privately, and essential for growing a significant audience. The leaders of these emerging cultural institutions will have to negotiate a sociopolitical environment in which issues of reconciliation and reparations constitute the two key public paradigms for discussing slavery.

A prominent slavery project started by former Virginia governor Douglas Wilder generated the greatest media wattage. In 1990, Wilder, the grandson of enslaved people, became the first and only African American elected governor of Virginia or any state. In early 2001, Wilder announced that he had found a site in Fredericksburg, Virginia, on which to develop the National Slavery Museum. Wilder said that he got the idea for a slavery museum while on a 1993 trade mission to Libreville, Gabon. There he visited a spot where newly captured Africans had waited to be put on ships. "As I sat staring through that window of no return, I felt a feeling of uplift, a feeling of overcoming obstacles. The thought of my forebears leaving from this place and having one of their descendants become the governor of a state they may have gone to—well, that is a long distance to have come."[52] Wilder's celebrity as a former governor has garnered prominence for the project, despite some negative comments from a few African American residents of Fredericksburg, who felt that the planned museum's proximity to a new shopping mall devalues the memories of slavery.

Governor Wilder organized two national planning conferences to discuss his projected museum. The first, much larger one was at Howard University Law School in March 2002. The entire conference was videotaped for archival purposes, and Wilder's opening speech was televised on the cable networks CNN and C-SPAN. A distinguished alumnus of Howard's law school, Wilder chose the school as a symbolic site for his inaugural conference. He invited nationally recognized scholars as well as a large contingent of congressional representatives such as John Lewis, television and print journalists, and entertainers such as Debbie Allen of *Amistad* fame, who is also a Howard University alumna. A number of the professionals whom Wilder hired as consultants had previous associations with the Holocaust Memorial Museum, including Dr. Michael Neiditch, who was previously a director of endowment development there. The second, much smaller organizing conference was held in May 2003 at the Chicago Historical Society.[53]

At these meetings, various Black people voiced a profound sense of pain, their "sense of loss," of "what was done to us," and asserted that these feelings should be the basis for the museum's primary interpretive strategy.[54] Questions about who will come to see this, about who will be the audience for this or any slavery museum, are yet to be answered. Will African Americans who want to experience a kind of catharsis through this pain be the primary audience? Or is the primary audience conceived of as white Americans, perhaps driven by guilt and shame?

The issues of intended audience impact and how to raise funds for such an enterprise were not as clearly addressed. Unlike some other ethnic communities, African Americans historically have needed significant government funds to inaugurate or to stabilize large-scale cultural projects. The history of slavery and segregation has made for a poorer national philanthropic community of African Americans compared to some other groups. By comparison, funding plans were completely different from the ones for the U.S. Holocaust Memorial Museum, for example. At the Holocaust Museum, private funds from communities of Jews around the world paid for construction of the building and initial exhibitions, although funds for the maintenance of the building and its staff are supplied by the U.S. government through tax dollars. Consequently, it was critical to consider how to successfully market a slavery institution to legislatures and chief executives at the local, state, or federal level for public money or by appealing to historically white corporate institutions or wealthy white private individuals. The fact that Governor Wilder was formerly a state chief executive with powerful contacts within the Democratic Party and among more liberal wealthy white individuals in Virginia should make it possible for him to raise the $200 million he says he needs for this institution. However, whether he can do that remains to be seen.

At virtually the same time as Governor Wilder, though on a smaller scale, the longtime mayor of Charleston, South Carolina, Joseph Riley, conceived of a similar idea. Riley wants to build a museum that would focus on Charleston specifically, then South Carolina and the Lowcountry more generally. Some years earlier, Riley had gone on a trip with his adult children to Salvador da Bahia, the colonial capital of Brazil. As a city, Salvador is known worldwide for its African-infused culture, where Candomble, capoeira, and samba all originated. While there, Riley visited Salvador's Door of No Return.[55] He said that he stood in that narrow doorway and was overcome with emotion. He had heard (accurately) that the port of Charleston received between 30 and 40 percent of the newly enslaved Africans who survived the Middle Passage and were brought to North America. He felt that in some way Charleston needed to confront its own "door of no return."

Such profound sentiments of loss and awe are invoked repeatedly in public discussions of the Middle Passage and the need for slavery museums. At various times, in many places, I have heard people voice these historical losses as being palpably and personally present (not as if they were really in the past). How contemporary African Americans may be experiencing psychic losses associated with this history has yet to be fully studied in the psychological literature. In listening to testimonials on this point, I am struck by how many people talk about a sense of pain and loss, even when they have not visited one of these slave trading sites. Perhaps they saw the documentary by noted historian John Hope Franklin, filmed on Gorée Island, near Dakar, Senegal. Perhaps public television viewers saw the PBS documentary on Africans in America before 1820, which aired in 1998. However generated, these feelings of profound sacrifice and loss dominate the public discourse when slavery is the subject. "Lest we forget" and "never again" are oft repeated as the bedrock values these new slavery institutions should invoke.

One small slavery museum opened in summer 2003, the revamped Old Slave Mart Museum in Charleston, South Carolina. The executive director of tourism, Vanessa Turner-Maybank, was pictured on the front of *USA Today* during the museum's planning, holding a set of rusty brown shackles. Her interview underscored an unexpected source of enthusiasm for slavery museums—the local businesses and officials who want to stimulate "heritage tourism" in their locales.[56] The *USA Today* article quotes Turner-Maybank as saying, "There's been this thirst for knowledge of African American history." The article continues:

> Charleston's efforts are part of a trend sweeping the USA. Several major museums exploring slavery or African American history are planned. "We counted 19 new projects just last year, and we knew there were several more," says Bill Gwaltney, president of the Association of African American Museums. "Clearly, there are several dozen more that are anticipated in 2002. They are all over the country, too. They're in the Midwest, the West, the Northeast and the South. It represents a maturation of thought about the breadth and depth of American history."
>
> The surge in Black museums is fueled by grass-roots pressure from African-Americans who want a say in how their past is portrayed. . . .
>
> Many white baby boomers and their children also are interested in learning about a part of the nation's past that was skimmed over in history books, if addressed at all.
>
> Frances Smiley, an Alabama tourism official, was surprised at the popularity of a tour of black heritage sites put together by her office. "We had many mis-

conceptions about where the interest would come from," she says. "We have found that the bulk of people who have requested the black heritage guide are not black people."[57]

Newspaper articles like the one quoted here are appearing in publications all around the country. As heritage tourism within the United States grows, African American stories are increasingly seen as popular with younger and more diverse audiences, not just Black people.

As popular awareness of slavery has increased in public visibility, different segments of the American population are struggling to come to terms with it in quite dissimilar ways. At one end of the spectrum, some African Americans see the Middle Passage and its horrors as the fundamental metaphor for being Black in America. For these people, *holocaust* is a term that seems eminently appropriate. At the other end of the spectrum, some white Americans continue to deny that slavery and race have any relevance to the glorious story of American freedom. The keepers of Confederate memory continue to deny that slavery has had any fundamental connection to its origins and defeat. As cultural institutions emerge whose mission is to interpret America's racialized past, they will be buffeted by these conflicting opinions.

While increased interest in slave society America has stimulated calls for reparations among African Americans, this same concern has aroused great interest in the concept of "racial reconciliation" among many Americans, including some Black people. People concerned with "reconciliation" want American institutions to acknowledge their agency and complicity in the system of enslavement that structurally impoverished native-born African Americans for twenty generations. Such acknowledgment might express itself as a formal resolution by a state legislature, as in Ohio, or even by the U.S. Congress. However, calls for a formal apology are only the most obvious of the efforts to come to terms with this enslaved past. Within the world of cultural institutions, the 1990s also saw the rise of a dramatically increased interest in the Underground Railroad. Beginning at the grassroots level, public interest surged about this rare effort at interracial cooperation in the racially polarized antebellum United States.

Historically, the Underground Railroad was a loosely organized network of individuals and some institutions, such as African American churches and antislavery societies, whose members aided escaping slaves. Self-emancipating slaves and people who helped them appear from the first moments of the slave trade. Between the 1830s and the 1860s in the United States, this loose underground network of safe houses and safe travel operated in great secrecy, especially after the Fugitive Slave Act was passed in 1850. That act required all

Americans, whatever their personal persuasions, to assist slave owners in re-capturing escaping slaves. This act produced large demonstrations and court-room battles in the northern and western states as abolitionists sought to challenge the law's morality. Yet for many decades, the story of the Underground Railroad network had become submerged in the larger silences about slavery and the full cause and meaning of the Civil War.[58]

A few pioneers, such as bibliophile and collector Charles Blockson in Penn-sylvania, actively worked to commemorate the Underground Railroad. A voice crying in the wilderness, Blockson spent thirty years making sure that stations on the Underground Railroad were commemorated with plaques and other kinds of memorials. For many years, Blockson worked nearly alone. Similar pioneers worked in small groups in their respective states, especially in Ohio, Illinois, and New York.

In 1990, this growing public interest was formalized as a congressional man-date. The National Park Service was authorized to research and publish a re-port on the history of the Underground Railroad. Published in 1995, this re-port documented over four hundred stations on the Underground Railroad throughout the United States, Canada, Mexico, and the Caribbean.[59] It pro-vides a road map of documented Underground Railroad sites and points to the historic preservation of places not yet under formal protection. A num-ber of these places were already well known, such as African American and Quaker churches in the northern states and Canada, but the National Park Service report pointed to more than these few already established sites.

This upsurge of interest generated lots of cultural activities, such as local history Underground Railroad tours and living history interpretations of the experience of escape such as at Connor Prairie in Fishers, Indiana. Frequent newspaper articles have stimulated public interest in both well-documented and highly suspect findings of new root cellars, tunnels, hidden rooms, and other efforts to claim the mantle of the Underground Railroad. The real Under-ground Railroad was a truly secretive and dangerous effort in which a small number of courageous people risked their lives. The Underground Railroad of 1990s public acclamation was a widespread, widely sanctioned activity that pointed up white support for freedom against slavery. To many professional historians, these claims are simply unsubstantiated and therefore not credible. At the same time, these popular claims represent an attempt to include oneself, one's family, and one's locale into a more liberating narrative of the Ameri-can past.

One emerging institution fueled by this enthusiasm is the National Under-ground Railroad Freedom Center, which opened in Cincinnati, Ohio, in Au-gust 2004. Development of the Freedom Center has been supported by more

than $30 million in state and federal dollars, as well as by private individuals such as Robert "Bob" Johnson, founder of Black Entertainment Television and the first African American billionaire, and corporate philanthropy led by Procter & Gamble, a Fortune 500 corporation headquartered in Cincinnati, for a total of $110 million. The original notion for this cultural center devoted to the ideals of the Underground Railroad came from an unusual source: the National Conference of Community and Justice (NCCJ). Founded in the late 1920s as the National Conference of Christians and Jews, the NCCJ is dedicated to interfaith education and tolerance. The mission statement of the Freedom Center therefore reflects its origins in an organization devoted to social change.

> The National Underground Railroad Freedom Center educates the public about the historic struggle to abolish human enslavement and secure freedom for all people. The Freedom Center teaches lessons of courage and cooperation from Underground Railroad history to promote collaborative learning, dialogue, and action in order to inspire today's freedom movements.[60]

This statement reflects a sensibility at some distance from the slavery-as-holocaust concept. Indeed, the emphasis here is on a heroic struggle in the service of freedom as the most crucial legacy of the antebellum years.

As part of the planning for its new facility, the Freedom Center sponsored a variety of audience samples and surveys. Many of these proprietary findings confirm that there is a wide cultural distance between reparations and reconciliation. Many more African Americans say that the evils of slavery and racism have never been admitted, and therefore reconciliation cannot happen before an original conciliation that has not yet occurred. Many more white Americans (especially in the racially polarized Midwest) suggest that it is important not to dwell on slavery and its outcome but rather to celebrate those foresighted individuals who fought for racial justice, even during the slavery period. In that formulation, the Underground Railroad is the best example of interracial cooperation before the Civil War. The notion of racial reconciliation appears to be a primary source of inspiration to the heavily corporate board of the Freedom Center and is clearly central to the messages of various elected officials involved in the project at both the state and national levels. The Freedom Center has received grants totaling more than $1 million from corporations such as Toyota, Ford, Xerox, Deloitte Touche Tohmatsu, General Electric, and Procter & Gamble. The center has received considerable support from the Ohio delegation in the U.S. Congress, made up mostly of Republicans. The success of the Freedom Center points to significant rhetorical changes in American public debates in the last ten years. In the early 1990s, those conceiving and supporting entities such as an African American Museum on the Mall and the Freedom

Center tended to be liberal in their politics and were often former activists in the modern civil rights movement, as befitting the Freedom Center's origins in the NCCJ. In the last few years, however, major conservative figures in the Republican Party have become supporters of various kinds of memorials to the Underground Railroad in general and to the Freedom Center in particular.[61]

However, the audience surveys strongly suggest that many African Americans do *not* want to rush toward reconciliation, but rather wish to have institutions that squarely place the blame where it is deserved. "Never forget our ancestors' pain" is awfully close to the "never forget" concept key to the Holocaust Memorial Museum. In the European Holocaust, the perpetrators were Germans, not Americans. While the most globally visible monument to Holocaust victims may exist in Washington, D.C., the Holocaust itself took place safely overseas. Producing slavery museums in the United States is tantamount to producing Holocaust memorials at Auschwitz or other camps and locations of mass murder. Such memorials have been enormously controversial. International political debates have raged over exactly who is being memorialized at various death camp sites. American slavery museums can expect an experience far more akin to the significantly delayed Holocaust memorial that recently opened in Berlin than the triumphant support for such a memorial in Washington, D.C.

One emerging institution sits squarely on the horns of this debate: the Tredegar National Civil War Center. Led by progressive southerners with impeccable ties to the Confederacy, the Tredegar Foundation plans to build a museum next to the historic Tredegar Iron Works in Richmond, Virginia. The Tredegar Iron Works was the largest and most important factory in the South, producing ordnance, ammunition, and other supplies for the Confederate Army. The site is now owned by the National Park Service, and the Tredegar Foundation's mission is to present a unified history of the Civil War, incorporating the "three views" — northern, southern, and African American.[62] In their interpretive framework, northerners fought for the Union, southerners were protecting their home, and African Americans sought freedom. This effort to tell three contradictory stories about the Civil War in the former capital of the Confederacy is nothing less than a brave enterprise.[63]

The emerging institutions dedicated to the substantive treatment of slavery and racial discrimination face many and various challenges in the years ahead. Raising funds for new institutions may well prove difficult in a sluggish economy. The supporters of slavery museums face a daunting process of cultural construction, inevitably shaped by diametrically opposed ideas about the meaning of slavery (and race) in the American past. Are certain kinds of goals for these emerging slavery museums actually incompatible? Will placing the

blame squarely serve to support racial reconciliation? What does racial recon-
ciliation really mean symbolically, politically, and socially? Is it the same as
a formal apology by the U.S. Congress and president? Does racial reconcilia-
tion serve to support the argument for reparations, or would a truly reconciled
United States not need this debate?

In recent years, the long-standing silence about slavery has ended. Films
and museum exhibitions have changed the terms of debate, and new cultural
institutions are beginning to explore how to present continuing dissimilar
views of the role of slavery in the American past. Once the most specific of ref-
erences, the concept of a holocaust has become a transnational metaphor now
used by many as a way of expressing death-centric collective historical experi-
ences. The appropriation of the term *holocaust* to describe the Middle Passage
or slavery comes out of a desire to force most Americans to acknowledge the
horror of what was done to the ancestors of African Americans. But the de-
bates over slavery and its meaning are not limited to the holocaust metaphor.
Supporters of the Confederacy, social justice activists, politicians interested in
finding a middle ground between conflicting constituencies, and many others
may well have their own reasons for resisting the metaphor.

While many American museums may confront the issue of presenting slav-
ery in the next few years, in one anticipated institution these issues will be
crucial: an African American museum on the Mall in Washington, D.C. The
idea of putting something on the Mall to honor African Americans is not new.
About 1915, a group of Afro-Americans proposed a memorial to Colored sol-
diers from earlier wars.[64] However, none of these earlier plans came to fruition
for a complex series of reasons, mostly having to do with the lack of political
power of Afro-American voting blocs and the stiff opposition of Dixiecrats. In
the late 1980s, another serious attempt to establish a Black museum on the Mall
occurred when Tom Mack, a local African American entrepreneur, started a
foundation for that purpose. Initially, Mack planned a "museum of slavery,"
along with an economic research institute and other elements.

Mack's original proposal attracted backers in the U.S. House of Repre-
sentatives, especially among the Congressional Black Caucus. With support
from Congressional representatives Mickey Leland (D-Tex.) and John Lewis
(D-Ga.), a commission was established to study the issue, under the aegis of the
Smithsonian Institution. However, the legislation to authorize such a museum
was never passed, due to complex political machinations.[65] In 2002, President
George W. Bush appointed twenty-one members of another presidential com-
mission to study the matter, under the aegis of the National Park Service and
with the support of Representative J. C. Watts from Oklahoma, then the only
Black Republican in Congress.[66] In May 2003, that commission produced its

official report, calling for a museum to be built on the Mall and specifying about $150 million in public funds and $150 million in private funds to be raised.[67]

The support for this endeavor in the U.S. Congress was very complicated, bringing together liberal Democratic congressman John Lewis (D-Ga.), who is a veteran of the modern civil rights movement, with Senator Sam Brownback, a conservative Republican from Kansas. A member of the Promise Keepers, an evangelical Christian organization for men, Senator Brownback has said that he received a message from the Lord that he should support this endeavor: "I hesitate to say it, because it sounds hokey, but I can honestly say it was divine intervention. . . . I saw a museum, and I saw it as a vehicle for racial reconciliation."[68] Consequently, Senator Brownback teamed up with then Senator Max Cleland, a Democrat also from Georgia, and sponsored the museum bill. Legislation to support a bill for a museum passed the U.S. Senate by a rare unanimous vote on June 23, 2003. Although the House of Representatives voted to pass the resolution in November 2003, the vote was far from unanimous. Indeed, a contentious discussion broke out about the possible location of the museum on or off the Mall. On December 16, 2003, President George W. Bush signed this legislation into law, creating the National Museum of African American History and Culture within the Smithsonian Institution. Through a series of legislative errors, no actual dollars were appropriated in 2004 to work on the development of the museum. However, the Smithsonian Secretary Lawrence Small appointed a founding director, Lonnie Bunch, in the spring of 2005. By December 2005, a nineteen-person advisory council had been named for the museum, including African American business figures such as Robert Johnson (founder of Black Entertainment Television), Oprah Winfrey (TV star and CEO of Harpo Productions), Richard Parsons (CEO of Time Warner) and others. The Smithsonian Board of Regents selected a site for the new museum on a plot of land at Fifteenth Street and Constitution Avenue, next to the Washington Monument and the National Museum of American History. The museum's current mission involves the "documentation of African American life, art, history and culture."[69]

The history of the American public memory of slavery is largely one of amnesia or a "moonlight and magnolias" view of the Old South. Any historically accurate portrayal of slavery will tear the veiling away from those stories and implicate the Confederacy, sacred to many white southerners. Will the memory of slavery be constituted as a holocaust, a death-centric institution bent on destroying all people of African descent? Will the story of African American victimization be primary? Or will the history of the Underground Railroad serve as a form of reassurance to the majority of white Americans from the

North and West? How will such a museum speak to the descendants of the European populations who arrived in the United States long after the end of slavery? And what would be the overall purpose of an African American museum on the Mall: to show the complete and violent history of slavery and segregation, pointing out to the white millions the evil of their ancestors, or to serve as a bridge from the past to a future of racial reconciliation? The resolution of these issues lies in an unfolding future.

New voices have emerged to debate the proper place of slavery in the larger history of the United States. New institutions devoted to slavery as a subject will have to place themselves definitively within this contentious environment so as to garner financial and other forms of public support. In that complex process, a new synthesis may appear that honors both the suffering of the enslaved and their contributions to American society. One such effort recently appeared from the Schomburg Center in New York. In 2002, the center produced an exhibition and released a book entitled *Jubilee*. This exhibition and book suggest an interpretive pathway that may resolve some of the raging debates. In the book's introduction, Howard Dodson writes:

> *Jubilee: The Emergence of African American Culture* presents a new perspective on slavery and the slave trade. Unlike many previous accounts, it does not focus on blacks as victims. Rather, it focuses on the cultural, political, economic, and social activities that enslaved Africans took in the midst of slavery to redefine themselves and their world and reshape their own destinies. It is the story of the ways in which enslaved African human beings made themselves history- and culture-makers and transformed themselves. . . .
>
> Studying their lives can teach us much about the capacity of human beings to develop even under dehumanizing conditions. It can teach us some of the diverse ways in which oppressed human beings confront and transcend oppression. It can teach us about living, surviving, and winning in the face of seemingly insurmountable odds. *Jubilee* documents and interprets these obstacle-ridden, but life-affirming experiences of enslaved African peoples in the Americas, especially in the United States.[70]

NOTES

1 The recent shift in public cultural recognition and commemoration of the history of slavery is more widespread as well. See Oostindie, *Facing Up to the Past*.
2 New scholarship has begun to focus on the segregated nature of memory itself. A key work in that new scholarship is Blight, *Race and Reunion*.
3 There are many southern names for the Civil War that reflect a distinctive regional

interpretation, such as the War Between the States, the Second American Revolution, and the War of Northern Aggression. Though none of these names is used in textbooks outside the South, they were routinely used there until the 1970s and are still used at certain times and in certain places, such as at the Museum of the Confederacy. This notion encompasses the belief that southerners fought the war to protect home, family, and the principle of states' rights, that is, the right to determine all social issues locally. Therefore, it entails the idea that Confederate veterans should be honored as heroes who simply fought for a "Lost Cause" rather than be reviled as rebels who opposed the Union. During the war itself and afterward, many U.S. Army and Navy veterans called this the War of Southern Rebellion. Crucially, in this interpretation, the Confederates fought to defend not slavery but rather the "southern way of life." Over decades, the "Lost Cause" generated songs, novels, movies, and memorials to this noble but defeated ideal.

4 Moresi, "Exhibiting Race, Creating Nation."

5 Ralph Rinzler, assistant secretary for public service emeritus, Smithsonian Institution, interviews with the author, June 26, 1990, and September 14, 1990.

6 Haley, *Roots.*

7 Malcolm X, *The Autobiography of Malcolm X.*

8 For a discussion of this new museum, see Novick, *The Holocaust in American Life.* See also Young, *The Art of Memory.*

9 For example, see Stannard, *American Holocaust.*

10 See the New Jersey Commission on Holocaust Education's Web site, http://www.state .nj.us/njded/ holocaust, and its Holocaust and Genocide Curriculum, which now includes curricula on "The Armenian Genocide," "The Forced Famine in the Ukraine 1932–1933," "The Great Irish Famine," "The Right to Live—The American Indian," "The Killings in Cambodia," and current information on Rwanda, Serbia, and Kosovo. A new unit on African American slavery was also developed. See http:// www.state.nj.us/njded/holocaust/about_us/holocaust_ed.html (accessed March 30, 2006).

11 For further information on the Armenian Genocide Museum and Memorial, see: http: // www.armenian-genocide.org / Memorial.139 / current_category.75 / memorials_ detail.html (accessed March 30, 2006). There has been considerable controversy in both the U.S. Holocaust Memorial Museum and the Simon Wiesenthal Museum of Tolerance over their lack of information about the Armenian Holocaust. See Reynolds, "Armenians Seek Place in Museum," and Zinn, "Respecting the Holocaust." See also the Armenian Library and Museum of America site: http://www.almainc.org (accessed March 30, 2006).

12 Over the last decade, a number of politically conservative social commentators have begun to attack these notions of "victimhood," often as part of anti-affirmative-action arguments. The three most significant African American voices have all been involved in the politics of the University of California's affirmative action policies: Ward Connerly, Shelby Steele, and John McWhorter. In particular, Ward Connerly was the African American regent of the University of California who led the successful effort to pass Proposition 209, which forced the university to abandon its previous use of "race"

as a criterion for admission. For more information, see Connerly, *Creating Equal*; Steele, *The Content of Our Character* and *A Dream Deferred*; McWhorter, *Authentically Black* and *Losing the Race*. Some non–African American voices with similar viewpoints include Horowitz, *Hating Whitey*; Collier and Horowitz, *The Race Card* and *Second Thoughts About Race in America*. See also David Horowitz's Web site for *Front Page* magazine, available at http://www.frontpagemag.com/AboutHorowitz/index.asp (accessed August 11, 2004). Also see George A. Smith, "Birth of a Champion — Avoiding Victimhood Through Spiritual Strength," on the Web site of America's Voices: A Forum for Conservative Americans, http://www.americasvoices.org (accessed June 19, 2003).

13 Steven Newsome, interview with the author, March 2003.

14 See Hutchinson, *Out of Africa*.

15 For more on this part of Colonial Williamsburg's history, see Ruffins, "Mythos, Memory, and History." See also Handler and Gable, *The New History in an Old Museum*.

16 The author was the project director for this exhibition, which was called the "Life in America Project" during its development between 1980 and 1985.

17 Horton and Crew, "Afro-American Museums: Toward a Policy of Inclusion."

18 Robert Gould Shaw and the Massachusetts 54th are the subject of an important memorial sculpture in Boston Commons in Boston, Massachusetts. Augustus Saint-Gaudens sculpted the memorial, which was erected in 1897.

19 The original book, *Schindler's Ark*, by Thomas Kenneally, won the British Booker Prize in 1982 but did not become a best-seller in the United States until the movie was released in 1993.

20 The *Amistad* reproduction was built at the Mystic Seaport Museum of America and the Sea and launched in 2000. Known as the *Freedom Schooner the Amistad*, the ship is owned and operated by Amistad America, Inc., which is a nonprofit group comprising numerous African American individuals, historically Black colleges and universities, and business supporters such as the History Channel, Phoenix Mutual Life Insurance, and others. The organization is based in New Haven, Connecticut. Their Web site is http://www.amistadamerica.org (accessed March 30, 2006). The author saw the ship when it was docked at Sag Harbor, New York, in the summer of 2002.

21 Foner and Mahoney, *A House Divided*.

22 Campbell and Rice, *Before Freedom Came*.

23 While duly celebrating the courage of the Museum of the Confederacy in 1991, it is important to point out that soon after the exhibition opened, the director and some of the board members who supported "Before Freedom Came" left the institution. Throughout the South, debates over the flying of a Confederate flag raged throughout the 1990s, and the symbol of the Confederate flag is very much a current and contentious issue in the region. In 2003, individuals described in newspaper reports as "loyalists" were running the Museum of the Confederacy. Inside, a new exhibition entitled "The Confederate Nation" takes on another deeply controversial subject: whether any African Americans (enslaved or free) voluntarily fought for the Confederacy. The juxtaposition of these two exhibitions points to the continuing vigor and

rancor of the cultural debate in the South about slavery and its meaning in southern history and therefore national history. An important book that talks about the identification of many living southerners with the Confederacy is Horwitz, *Confederates in the Attic*. It won the Pulitzer Prize in 1999.

24 A catalog for this exhibition was published several years later, and there are many interviews with the artist in which he talks about it. See Corrin, *Mining the Museum*. The author visited the installation in 1992. See also Karp and Wilson, "Constructing the Spectacle of Culture in Museums."

25 Vlach, *Back of the Big House: The Architecture of Plantation Slavery*. This book was published prior to the exhibition. For more information about the controversy and for photos of the exhibition while up at the Martin Luther King Jr. Library, see "Picturing Slavery," transcript of an interview of Vlach by Charlayne Hunter-Gault that was broadcast on the *NewsHour with Jim Lehrer* in 1996. Available at http://www.pbs.org/newshour/bb/race_relations/picturing_2-5.html (accessed March 30, 2006).

26 For information about the controversy see Eggen, "In Williamsburg, the Painful Reality of Slavery."

27 Private conversations with the author, including those of curator Martha Katz-Hyman of Colonial Williamsburg in May 2002.

28 Mariners' Museum, *Captive Passage*.

29 This historical interpretation appears in the essay by Thornton, "Africa: The Source," 35–51, and is repeated in the exhibition labels. The author saw this exhibition at the Anacostia Museum in spring 2003.

30 Private conversations with author by members of Anacostia Museum staff, spring 2003.

31 Quote by Ira Berlin in Ruffins, "The Peculiar Institution," 29.

32 For more information on *Unchained Memories*, see http://www.hbo.com/docs/programs/unchained_memories (accessed September 1, 2004). Along with the release of the documentary, the National Underground Railroad Freedom Museum produced a small traveling exhibition. Spencer Crew, executive director of the Freedom Center, and Cynthia Goodman curated the exhibition, which toured throughout the country for a year beginning in February 2003; information on the exhibition can be found at the Web site mentioned above. This collaboration points to the growing direct connections between museums and media.

33 For detailed information about the Slave Narratives Collection at the Library of Congress, go to the library's Web site: http://www.loc.gov (accessed September 1, 2004).

34 I was able to preview these documentaries (in part) at the national conference of the Association of African American Museums in Raleigh, North Carolina, in August 2004. For more information about these documentaries, see http://www.slaveryinamerica.org (accessed September 1, 2004), which is dedicated to teachers, lesson plans, and the accompanying educational mission of the documentary series. The four parts of the documentary include: *The Downward Spiral* (1619–1739); *Freedom Is in the Air* (1740–1830); *Seeds of Destruction* (1840s–1860s); and *The Challenge of Freedom* (Civil War stories and aftermath). Interestingly, this documentary was

largely sponsored by the New York Life Insurance Company. In recent years, venerable and large insurance companies have come under scrutiny as possible private defendants in lawsuits about reparations for slavery.

35 For a number of years, some African American nationalist organizations and individuals argued that Black Americans should get a tax exemption from the Internal Revenue Service for the enslavement of their ancestors. Before long, this became a full-fledged tax movement in which more than 80,000 Black Americans withheld taxes from their payments or demanded "reparation refunds" of $2.7 billion (2001 figures). You can find out more information about this from the official IRS Web site, http://www.irs.gov/compliance/enforcement/article/0,,id=105789,00.html (accessed August 15, 2006). This Web site is devoted to a variety of tax scams and provides various details. In 2002, Representative Eddie Bernice Johnson (D-Tex.) released a formal statement on this, available on the Web site listed above:

> Once again, African Americans have become the focus of a potentially major crime network involving slavery reparations through false tax claims. These predators mostly target church congregations and the elderly, preying on their frustrations and their feelings of injustice. The issue of reparations continues to be an issue for the Congressional Black Caucus (CBC). In every Congress since 1989, the Dean of the CBC, Rep. John Conyers has introduced his legislation, H.R. 40, Commission to Study Reparation Proposals for African Americans Act and he has pledged to continue to do so until it is passed into law. Unfortunately, that day has not yet come. Furthermore, we condemn those degenerates that would exploit a culture of Americans that is the least deserving of any more hardships inflicted upon them by this country, by falsifying such a claim.

36 This Black Holocaust conference at Howard became quite controversial in 1995 when a notorious anti-Semitic former member of the Nation of Islam, Khalid Muhammad (now deceased), served as a key speaker at the conference. For an adoring view of Khalid Muhammad, see http://www.thetalkingdrum.com/khallid.html (accessed March 30, 2006). There are a number of sites associated with the notion of the Black Holocaust. Some emerge from the Shrine of the Black Madonna in Detroit, Michigan, which served as an important institution for those calling for reparations when this was still a fringe idea. See the work of Velma Maia Thomas, a longtime employee of the Shrine, who published an interactive book, *Lest We Forget*, based on a long-running exhibition at the shrine. For more information, see http://www.emory.edu/EMORY_MAGAZINE/summer98/briefs.html#anchor1290864 (accessed March 30, 2006).

37 The founder, James Cameron, has been documented as surviving a lynching in 1930. Two other young men were killed, but an "angelic voice" told the mob that he had had nothing to do with any assault against a white couple. For more information on the Black Holocaust Museum, see http://www.blackholocaustmuseum.org (accessed March 30, 2006).

38 See the Yale–New Haven Teachers Institute Web site at http://www.yale.edu/ynhti/curriculum/units/1979/2/79.02.04.x.html (accessed March 30, 2006).

39 In Wilmington, South Carolina; Tulsa, Oklahoma; Rosewood, Florida; and other places, local groups are actively organizing to commemorate horrific events from American history, events that document racially motivated violence against African Americans. In 1898 in Wilmington, South Carolina, the elected city council (most of whom were African American) and the mayor (who was African American) were run out of town, three hundred people were killed, and the "Black section" of town was demolished. In this case, in addition to this destruction, the unseating of the elected government signaled the end of any pretense of Black voting participation in the town. In 1997, a movement developed to produce a memorial to the community that was lost. The author was a consultant to this group, aiding in the selection of the artists who were to compete for completing the final memorial.

40 Allen, *Without Sanctuary*.

41 In October 2001, when *Without Sanctuary* was being shown at the Martin Luther King Jr. Historic Site, Emory University sponsored a conference called "Lifting the Veil of Silence: Workshop on Racial Violence and Reconciliation" that recognized this burgeoning grassroots effort and brought together these smaller groups to share ideas and strategies and to probe the nature of exhibitionary change. For more information, see http://www.emory.edu/COLLEGE/MARIAL/calendar/01-02/veil/program.html (accessed March 30, 2006).

42 A Web site about the Maafa (African Holocaust) is at http://www.swagga.com/maafa .htm (accessed March 30, 2006).

43 An earlier novel on the subject was Johnson, *Middle Passage*. Interestingly, the protagonist of this novel is a freed slave who is about to be forced into marriage and is in debt to gangsters in New Orleans. He stows away on what turns out to be a slave ship. This book won the National Book Award in 1990 but never received the same level of critical and public attention as *Beloved*, perhaps because of the flawed nature of the protagonist and the moral ambiguity of his presence on the slave ship. Johnson, along with Patricia Smith and the WGBH Series Research Team, also wrote the accompanying book to the series *Africans in America: America's Journey Through Slavery*.

44 Toni Morrison dedicated her novel *Beloved* (1987) to the "sixty million" lost in the Middle Passage. In a popular interactive book, author Velma Maia Thomas estimates that 50 million Africans died. Velma Maia Thomas is the author of several books and the developer of the Black Holocaust exhibition at the Shrine of the Black Madonna in Detroit. Her Web site, http://www.velmamaiathomas.com (accessed March 30, 2006), discusses the plight of 100 million Africans. A number of current best-selling novels deal with the subjects of slavery, including Randall, *The Wind Done Gone*, which includes the "back story" behind the southern "Lost Cause" classic *Gone with the Wind* by Margaret Mitchell (1936), and Jones, *The Known World*, a novel about a Black slave owner in antebellum Virginia.

45 While the history of the transatlantic slave trade is nearly four hundred years long, any individual person would normally experience the Middle Passage only once. Sailors and cabin boys enslaved to captains might have traversed the ocean more than once, but almost no one else would have. The historical experience of the Middle Passage has

within it diversity, such as different groups of Africans (Yoruba, Akan, Fon, Congo-Angolan), different nationalities of European slavers (Dutch, French, Spanish, Portuguese, English), different kinds of ships, and legal and illegal variants of the trade. In addition, there was basic historical change over centuries; the sixteenth century was not exactly like the late nineteenth century. Regardless of these factors, each survivor would have individually gone through a near-death experience.

46 The author has attended many of these events. I served as the co-chair for a Middle Passage conference at the National Museum of American History in February 2000.

47 At present the remains have been reburied; however, the Interpretative Center has not yet opened and the Memorial Sculpture has not yet been completed. The Web site is http://www.africanburialground.com (accessed March 30, 2006). See also Prince, "Manhattan Africans."

48 William Gwaltney, interview with the author, March 2002.

49 In this essay, I have not examined the changes (or lack thereof) in historic house museums on plantations. I have been primarily concerned with institutions that are large enough or prominent enough to have a national focus. However, an important study of plantation museums is Eichstedt and Small, *Representations of Slavery*.

50 For more on Ogletree and his thoughts on these subjects, see Ogletree, *All Deliberate Speed*. In many ways a personal memoir as well as a legal argument, this book details Ogletree's life as the child of sharecroppers from the South who moved to the Central Valley of California as agricultural workers. The first person in his family to finish high school, Ogletree became the first Black student government president at Stanford University and went on to become a full professor at Harvard University. He is among a group of leading lawyers and legal thinkers organizing reparations suits, perhaps against private companies such as insurance companies and also against government entities.

51 Randall Robinson was the founder of Transafrica, the leading U.S. organization that spearheaded American support for the anti-apartheid movement in South Africa during the 1980s and early 1990s. See Robinson, *The Debt: What America Owes to Blacks*. Robinson also has Web sites, including http://www.randallrobinson.com/debt.html (accessed March 30, 2006). There is a growing conservative backlash arguing directly against Robinson and the pro-reparations point of view. See http://www.front pagemag.com/Articles/ReadArticle.asp?ID=12140 (accessed March 30, 2006). Front pagemag.com is a leading reactionary Web site and reprints articles from numerous publications.

52 Shin, "Mall and Chains."

53 The author was present at both national meetings. My references to these meetings come from my personal notes taken during the various sessions.

54 For example: "The Middle Passage was more than just a shared physical experience for those who survived it. It was and is a metaphor for the suffering of African peoples born of their enslavement, of severed ties, of longing for a lost homeland, of a forced exile. Its meaning cannot be derived solely from an analysis of the tonnage of the slave ships, the cramped quarters of the human cargo, the grim catalog of disease and death, or even the dramatic tales of resistance. It is a living and wrenching aspect of

the history of the peoples of the African diaspora, an inescapable part of their present, impossible to erase or exorcise. A gruesome reminder of things past, it is simultaneously a signifier of a people's capacity to survive and to refuse to be vanquished." Palmer, "The Middle Passage," in *Captive Passage*, 75.

55 The author was present at an early set of meetings about the Charleston project in December 2001. My information about this meeting is taken from my personal notes taken during the various sessions.

56 Copeland, "From a Whisper to a Shout," 1A–2A.

57 Ibid., 2A.

58 The Fugitive Slave Act was part of a complex series of laws known in U.S. history as the Compromise of 1850. This compromise between northern and western free states and mostly southern slave states had many elements, including accepting California into the Union as a free state. However, the Fugitive Slave Act, which southerners argued with legal precedent was only restating the U.S. Constitution (1787), required all Americans to assist slaveholders in recapturing escaped slaves. Efforts to retake these freedom seekers resulted in court trials and abolitionist riots in numerous northern cities. Consequently, the Fugitive Slave Act is generally seen by scholars as one of the key turning points that led to the Civil War.

59 National Park Service, "Underground Railroad Special Resources Study."

60 This wording of the mission statement was on the center's Web site in June 2003. The current version reads: "The National Underground Railroad Freedom Center brings to life the inspiring, heroic stories of courage, cooperation, and perseverance in the pursuit of freedom, especially from Underground Railroad history. We provide forums for inclusive dialogue, and encourage every individual to take a journey that advances freedom and personal growth." See http://www.freedomcenter.org/index.cfm?fuseaction=home.viewPage&page_id=0A3E68C7-FAF7-4C82-BEB117FC2F7505A5 (accessed August 24, 2004).

61 Historically, what is now the Republican Party developed in the late 1840s and 1850s as the party of men who opposed the *expansion* of slavery. This is an important detail. Most white Americans and most early Republicans, such as Abraham Lincoln, concluded that the U.S. Constitution protected slavery where it already existed. This was quite true. However, they opposed the expansion of slavery into previously free territory in part because free men could not compete economically against enslaved labor. Although this aspect of the Republican heritage has been relatively silent in its growth through the southern states since the 1970s, these older notions of Republicanism have come into clearer view in recent slogans of "compassionate conservatism" and especially during the campaigning related to the presidential election in 2004. Representative Rob Portman (R-Ohio) introduced the first legislation to support the Freedom Center with some federal funds in 1999; President Bush and then Secretary of State Colin Powell visited the Freedom Center in summer 2004 before its opening. At its dedication in August 2004, First Lady Laura Bush attended and spoke to the thousands waiting to enter the new facility.

62 The author has been involved in several conferences and planning meetings associated with the Tredegar Civil War Center, including a public conference in Richmond

in October 2002 and a second public conference at the Levine Museum of the New South in Charlotte, North Carolina, in April 2003. For more information on the Tredegar National Civil War Center, see http://www.civilwarnews.com/archive/articles/tredegar_mus.htm and http://www.nps.gov/rich/summoop6.html (accessed March 30, 2006).

63 In April 2003, the unusually sensitive nature of this enterprise was brought home when the National Park Service erected a statue of President Abraham Lincoln in the entrance area of the Tredegar site. In the months leading up to the installation, the Park Service received thousands of letters and e-mails, many of which were against putting Lincoln's statue up. Some letters cited the "War of Northern Aggression" and the notion that Lincoln was a despot who wanted to destroy the southern way of life. On the day of the unveiling, during a muted ceremony attended by the current lieutenant governor of Virginia, the Sons and Daughters of the Confederacy picketed and protested.

64 See Robert L. Wilkins, "The Quest over Four Generations to Bring a National Museum Dedicated to African American History and Culture to the National Mall." This is a self-published paper available from Wilkins's Web site, http://www.aamuseum.org/ForgottenMuseum.pdf (accessed March 30, 2006). Wilkins is the president of the National African American Museum and Cultural Complex, Inc., a lawyer, and a member of the presidential commission.

65 See Ruffins, "Culture Wars Won and Lost."

66 President Bush signed Public Law 107-106 in January 2004. The full title was the National Museum of African American History and Culture Presidential Commission Act.

67 There are many articles reporting this news. See Cubé, "Site Search Narrows for African American History Museum"; Kantor, "Time Running Out for Black Museum"; Trescott, "Capitol Site Favored for Black History Museum." See also the Smithsonian's Web site on the museum, http://www.si.edu/nmaahc (accessed September 1, 2004).

68 Clemetson, "Long Quest, Unlikely Allies."

69 The museum's Web site, http://nmaahc.si.edu (accessed March 30, 2006), includes the full text of the bill introduced by Congressman John Lewis (D-Ga.), HR 3491.

70 Dodson, *Jubilee*, 14–15.

Shared Heritage, Contested Terrain:

Cultural Negotiation and Ghana's

Cape Coast Castle Museum Exhibition

"Crossroads of People, Crossroads of Trade"

CHRISTINE MULLEN KREAMER

IN EVERLASTING MEMORY
Of the anguish of our ancestors.
May those who died rest in peace.
May those who return find their roots.
May humanity never again perpetuate
Such injustice against humanity.
We, the living, vow to uphold this.
—Inscription at Cape Coast Castle

The exhibition "Crossroads of People, Crossroads of Trade" opened in December 1994 at the Cape Coast Castle Museum in Ghana (figure 1). The exhibition, designed to last for years but by no means envisioned as the permanent installation it has become, spans some five hundred years of Ghana's history and places the country's historic forts and castles within broad economic, political, and historical contexts, including the contexts of the transatlantic slave trade and its legacy. I don't recall whether the inscription noted above was in place near the entrance to the castle dungeon at the time the exhibition opened. However, it is there now—a testament to the terrible history of the slave trade and the place of Cape Coast Castle in it; a tribute and prayer to those who were enslaved and forced from home to endure the horrors of the Middle Passage, the brutality of enslave-

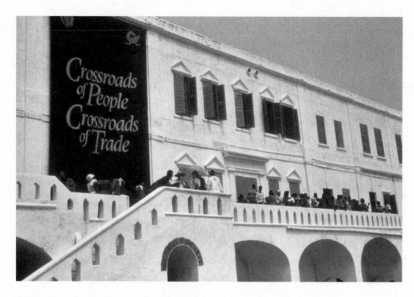

I. Cape Coast Castle, Ghana, at the opening of the exhibition "Crossroads of People, Crossroads of Trade." December 1994. © 2005 by Tom Lamb/Tom Lamb Studio.

ment, and the struggle for freedom; and a challenge to all of us to keep alive the memory of this tragic chapter in human history so that such inhumanity will never occur again. It is likely that the plaque was installed after the opening of the "Crossroads" exhibition, perhaps as a way to begin a process of reconciliation following years of tense and at times acrimonious debate about the ownership, use, and interpretation of Cape Coast Castle and, by extension, other historic sites associated with the slave trade. The debates were articulated by individuals and groups—local Ghanaian citizens, but especially museum and government officials; an international team (largely American) of technical experts, myself included; resident expatriate African Americans; and international tourists to Ghana, primarily African Americans and others of African descent who were and remain particularly invested in visiting Ghana's historic sites.

This essay explores aspects of globalization and the politics of cultural representation through a case study of an international museum project set in Ghana, West Africa, in the first half of the 1990s. The Ghana Natural Resource Conservation and Historic Preservation Project—within which the "Crossroads" exhibition was produced—was part of a broader integrated development project located in Ghana's Central Region. This discussion articulates the dynamics of such large-scale cultural development initiatives that, by their very nature, involve multiple constituents who bring to the process their own

interests, expectations, and perceptions of project objectives and outcomes —
factors that lead, at times, to contradictions, misunderstandings, and power
struggles. Add to the mix a large influx of U.S. donor agency funds, the desig-
nation of the Ghanaian sites as UNESCO World Heritage monuments, and the
financial implications of increasing cultural tourism, and the potential is high
for multiple sites of contestation that pit the local against the global. Indeed,
the process of cultural development, as explored here, is the outcome of global
and transnational social relations that suggest broader implications in three
key areas: (1) tourism and the ways in which many parts of the world are being
configured as tourist destinations, (2) international relations and the flow of
development aid from developed to underdeveloped countries, and (3) global,
transnational identities and the multiple claims of ownership and authenticity
that inform cultural heritage preservation.[1] Together, these processes shaped
the structure of the Ghana project I discuss here as well as the interpretation
of the sites to and by the public.

There is, to be sure, an extensive body of literature devoted to cultural tour-
ism and historical sites, particularly those associated with the transatlantic
slave trade.[2] Indeed, a number of sources have specifically focused on the sites
of Cape Coast and Elmina castles, which I consider here.[3] What is absent in
these studies, however, is a detailed analysis of the globalizing processes that
influenced the work of preserving and interpreting these sites, and the debates
this work engendered, from the early phases of the project through and be-
yond the project's conclusion. The essay details two broad aspects of the project
that intersect the globalization themes of this volume: (1) the cumbersome
apparatus, bureaucracy, and diplomacy involved in constituting the project,
which preceded anything actually happening on the ground, and (2) an ac-
count, once the project was in motion, of the more specific negotiations and
issues that arose as the project was implemented and as different constituents
and agendas came into play. Ultimately, the specific outcomes and products of
the negotiations were taken by local and international constituents as signs of
the successes and failures of the larger bureaucracy that it took to set the project
into motion. In outlining the history of this complex, internationally financed
cultural heritage and tourism project, I offer insights into the evolving nature
of collaboration and decision making among representatives of Ghanaian and
international institutions charged with implementation. Additionally, I con-
sider the multiple perspectives and expectations (at times conflicting) of the
many constituents who, to varying degrees, claimed ownership of the use and
interpretation of Ghana's historic forts and castles.

The geography of contestation is, in this instance, particularly significant,
for it concerns sites in Ghana associated with the transatlantic slave trade. As

both objects and spaces, Cape Coast Castle and Elmina Castle are imbued with multiple interpretations of history and memory by the different constituencies laying claim to these sites. They are viewed as the cultural heritage and responsibility of the nation of Ghana, on whose soil these sites reside; at the same time, they are collectively claimed by the world by virtue of their UNESCO World Heritage monument designations. Their international tourism potential marks them as a "value-added industry" capable of bringing economic benefits to the national coffers as well as to local and international entrepreneurs.[4] Furthermore, because communities often look to museums and historic sites as places in which identity is articulated, a subsection of international interest in Ghana's heritage sites resides most powerfully with peoples of African descent, particularly African Americans, many of whom see these sites as places of pilgrimage and memory where they may pay homage to their enslaved ancestors.[5]

The development and content of the exhibition "Crossroads of People, Crossroads of Trade" were affected by a range of globalizing processes that were in play during the run of the project. While different aspects of the process will be examined in detail, before moving on it seems useful to summarize and question some of the critical elements: content, audience, funding, and collaboration.

From the outset, the exhibition project adopted both a local and a global view. Exhibition content was designed to address the five-hundred-year history of Ghana's interactions with European economic and political interests, to celebrate Ghana's struggle for freedom and independence from colonial domination, and to underscore the continued flourishing of Central Region culture today. At the same time, a broader international story would also be told: the history of the transatlantic slave trade in the region and the struggle for freedom and equality of peoples of African descent in the Americas. How was content shaped? To what extent did those represented in the content participate in its interpretation? What were the challenges inherent in representing global processes of different times and places — notably the slave trade and diaspora of centuries before, Africa's struggle for freedom and Ghana's own history as the first sub-Saharan nation to gain independence from colonial rule, and Ghana's current interests in promoting its cultural treasures to attract large numbers of international tourists?

The exhibition addresses multiple target audiences: Ghanaians, both local and national, civilian and governmental; African Americans, both local expatriate residents of Ghana and those living in the Americas who travel to Ghana as part of heritage tours; general international tourists; and, finally,

those from international organizations such as embassies, donor agencies, and cultural heritage groups. How did different constituencies participate in and shape the process and the product? Where was emphasis placed, and what factors determined where authority resided?

The government of Ghana provided considerable logistical support but limited financial backing. The bulk of the project's funding was provided by international donor agencies, particularly the United States Agency for International Development and, earlier in project development, the United Nations Development Programme. What were the dynamics between funding and authority? What were the pressures facing host-country organizations in meeting the objectives of a project funded largely from outside sources?

The funding and broad scope of the project led to the formation of a consortium of Ghanaian and American institutions that provided individuals to furnish technical expertise and oversight of different components of the project. How were decisions made and common goals determined? How did the notion of collaboration play out as the project unfolded and in what areas were powers shared or withheld?

As different aspects of this essay will detail, the global processes noted above operated at different temporal and intellectual levels, resulting in inherently conflicting interests and expectations of the many parties involved in the project. Indeed, elements of the Cape Coast Castle project discussed here share striking similarities with Ebron's analysis of a 1994 heritage tour to Senegal and Gambia in which "transnational trends and ideas about culture and identity converged with the strategies of multinational capitalists, the dreams of diasporic communities, and the income-generating plans of African national governments to produce Africa as a commodified cultural object of global significance."[6] Thus, the Ghana project illustrates what Kirshenblatt-Gimblett identifies as "the metacultural operation by which habitus is transformed into heritage and by which local or national heritage is transformed into world heritage or the heritage of humanity."[7] It demonstrates how museums and world heritage sites are modes of cultural production—in this case the production of knowledge and memory—and how the interpretive work of museums animates the public sphere by fostering, among diverse constituents, lively and ongoing dialogues and debates that bridge the local and the global. Furthermore, because heritage tends to be claimed by multiple partners, it is essentially contested.[8]

EXHIBITION WALK-THROUGH

The "Crossroads of People, Crossroads of Trade" exhibition stands as one of the more tangible and long-lived outcomes of the Ghana project and serves as background to the larger issues of globalization that this essay addresses. Though some content and design details of the exhibition are specific to the Cape Coast site and the museum's collections, the general approach and exhibition layout correspond to other exhibitions focusing on the slave trade.[9] The Cape Coast Castle exhibition, however, differs from some of the more notable exhibitions on slavery in two important ways. First, it is located within a historic structure actually used in the past to enslave Africans. Second, the exhibition content was brought right up to the present with a deliberate focus on contemporary culture in the region as a way to underscore that there are many stories to tell about the history of Cape Coast Castle and its environs, including, but not limited to, the slave trade and its legacy. As we will see, both distinctions played significant roles in the political controversies surrounding the project's exhibition and historic preservation work.

The exhibition encompasses three connected rooms located on the second floor of one wing of Cape Coast Castle. The three rooms are organized into five galleries of unequal size. Visitors move through "Crossroads" in a linear fashion, from the early periods of the region's history to more contemporary times. A spacious entry gallery and three small adjacent galleries are devoted to historical treatments that focus on trade (including the trade in enslaved Africans), the Middle Passage, and the African diaspora. A fifteen-to-twenty-minute film was commissioned from the noted Ghanaian filmmaker Kwaw Ansah in order to orient visitors to the themes of the exhibition. However, in the hands of this talented director, the scope of the film transformed into a forty-five-minute dramatized narrative that set the emotional tone for the exhibition's exploration of the region's turbulent history and rich cultural heritage. For visitors on a brief tour of Cape Coast Castle and the "Crossroads" exhibition, the film was sometimes bypassed because of its length, and I am uncertain if it continues to be screened regularly as part of the exhibition.

The exhibition begins prior to European contact (figure 2), with a few cases and text devoted to archaeological material. Locally made nineteenth-century brass weights, measures and spoons used for gold dust, and eighteenth- and nineteenth-century European artifacts are exhibited along with photo murals of seventeenth-century illustrations of coastal life to explore the early trade in gold, salt, cloth, metals and, eventually, slaves in the "Gold Coast" (as Ghana was referred to at the time by foreigners).

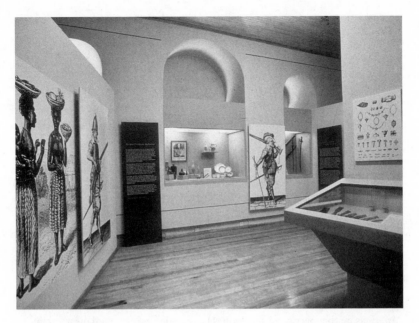

2. Historical gallery, "Crossroads of People, Crossroads of Trade" exhibition, Cape Coast Castle, December 1994. © 2005 by Tom Lamb/Tom Lamb Studio.

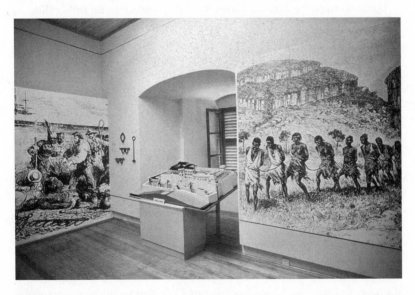

3. Images of enslavement in the historical gallery: Cape Coast Castle. A branding iron and shackles from the museum's collection are mounted on the wall in the "Crossroads of People, Crossroads of Trade" exhibition. December 1994. © 2005 by Tom Lamb/Tom Lamb Studio.

The latter section of the first historical gallery focuses on the forts and castles that line Ghana's coast and stand as testimony to the nation's turbulent history of trade and political relations with European powers. A series of large black-and-white photo murals of early illustrations of the slave trade (figure 3) were chosen less for their historical accuracy in documenting the slave trade in the Gold Coast centuries ago and more for their emotional content in conveying the general horror and inhumanity of this commerce that was undertaken, as we know, in different parts of Africa. Exhibition texts discuss the nature of local exchanges, the details of the larger triangle trade (a network of trade between Africa, Europe, and the Americas), and the fact that millions of Africans were enslaved and forced from their homelands in the African interior. Chains, shackles, cuffs, and a branding iron—all from the museum's collections—are grouped together and mounted on the wall.

Smaller adjacent galleries evoke a slave ship hold (figure 4) and an auction block (figure 5), reproducing familiar exhibition strategies to convey the horrors of the Middle Passage and arrival in the Americas. The next gallery utilizes black-and-white photo murals and text to discuss slavery and resistance in the Americas, with a particular focus on the struggle against racial discrimination in the United States (figure 6).[10] It highlights some of the men and women who were leaders in the struggle for freedom and equality, such as Sojourner Truth, Toussaint Louverture, Marcus Garvey, W. E. B. Du Bois, Martin Luther King Jr., and Malcolm X. A photo collage on an adjacent wall features prominent African Americans in sports, entertainment, and politics, including Muhammad Ali, Angela Davis, Joe Louis, Jesse Jackson, Duke Ellington, Billie Holliday, Stevie Wonder, and Elijah Muhammad.

This story of diasporic resistance, heroism, and hard-won freedom was meant to link to Ghana's own story of the struggle for independence from colonial rule. Indeed, the original intention of the exhibition design and development was to tell parallel stories of the struggle for freedom in the Americas and in Ghana, with greater emphasis on Ghana's struggle to free itself from colonial domination. However, for reasons that will be explained later, the history of the diaspora ended up dominating 90 percent of the space in this section, completely eclipsing Ghana's own freedom story, which was reduced to just one text panel and a single photo of Kwame Nkrumah, Ghana's first president.

The fifth and final section of the exhibition is full of light, color, and a wealth of objects. It is a celebration of the present-day Central Region, highlighting the arts of pottery, woodcarving, bead making, and weaving, and recognizing the cultural contributions of ordinary labor, such as fishing—a primary occupation along Ghana's coast (figure 7). Through large color photo murals, the entire gallery, including a special section on chieftaincy complete with rep-

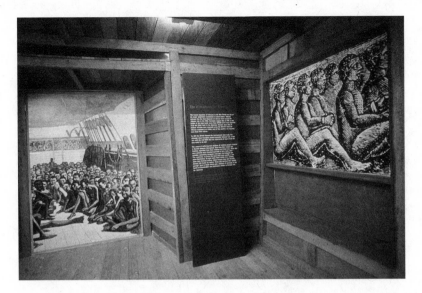

4. Evocation of the hold in a slaving ship: A darkened interior and large photo murals reproducing historical illustrations evoke the cramped and inhuman conditions endured by enslaved Africans during their Middle Passage journey. An audio tape of waves lapping against the side of a boat suggests the ocean voyage. Photo by Christine Mullen Kreamer, December 1994.

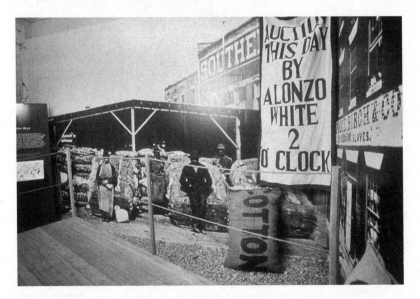

5. Evocation of an auction block: Visitors emerge onto a wooden platform and may be unsettled as they face large, near life-sized black and white photo murals of enslaved Africans in the Americas who stare silently back from the photos at eye level with visitors. Photo by Christine Mullen Kreamer, December 1994.

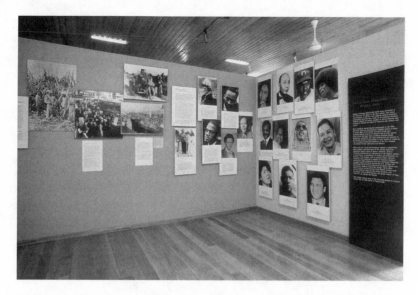

6. Exhibition section devoted to the African diaspora. December 1994. © 2005 by Tom Lamb/Tom Lamb Studio.

7. This full-size fishing canoe was purchased at a nearby village from fishermen who had never been to Cape Coast Castle or a museum before. Giving them a guided tour of the museum on opening day, and seeing their interest in so many of the stories told there, remains one of the highlights of my professional experience. Photo by Christine Mullen Kreamer, December 1994.

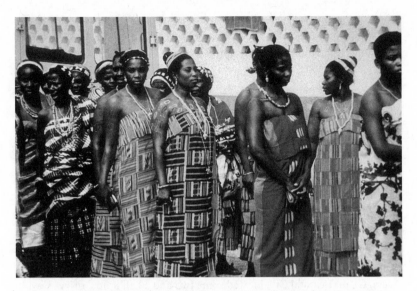

8. Festival on opening day of the exhibition "Crossroads of People, Crossroads of Trade," Cape Coast Castle. December 1994. © 2005 by Tom Lamb/Tom Lamb Studio.

licated chiefly and clan regalia, evokes a sense of celebration and festival—something for which the Central Region is especially well known (figure 8). This final gallery of the "Crossroads" exhibition consciously seeks to provide a contrast to the sober themes of the previous exhibition rooms. Further, it is meant to remind visitors—both foreign and domestic—that these forts and castles, while steeped in the tragedy of the history of the slave trade, are and have been part of the rich and vibrant cultures of Ghana's Central Region.

PROJECT BACKGROUND: GHANAIAN INITIATIVE

The Ghana Natural Resource Conservation and Historic Preservation Project targeted the improvement of tourist facilities and related tourism infrastructure; the development and interpretation of a national park (located within an hour's drive of Cape Coast, the capital of the Central Region) that includes a rainforest canopy walkway, guided nature trails, and an exhibition; and the architectural conservation and site interpretation of the major tourist draws to the region, the UNESCO World Heritage monuments of Elmina Castle and Cape Coast Castle.[11] Background on the early stages of project development and implementation illustrates the cumbersome and complex bureaucracy of such a large-scale cooperative endeavor. The project was the brainchild of a group of forward-looking, innovative Ghanaians from the Central Regional

Office of the Ghana Tourist Board and the Central Region Economic Development Commission who, in the late 1980s, heeded the government's appeal to revamp the nation's tourism industry. Their early pre-feasibility study of the Central Region's tourism potential, funded by the United Nations Development Programme, rightly asserted that the "Central Region possesses much of Ghana's prime tourist assets:—forts and castles, sandy and picturesque beaches, wildlife, culture and good weather ... With the cream of the nation's tourism endowments, the Central Region stands to attract a large share of Ghana's future tourism market and therefore constitutes the focus for any national tourism development programme."[12] The report suggested that a diversified economy, job creation, natural resource conservation, and preservation of valuable cultural resources would result from a well-planned, well-financed scheme to increase tourism to the region.

The idea was to develop sufficient attractions and facilities so that tourists would spend more time in the Central Region than the typical day trip from Accra, Ghana's capital city, located some two and a half hours' drive away. In addition to infrastructure improvements and training programs, the project emphasized the link between tourism and museum exhibitions by identifying important forts and castles — prime tourist destinations — needing conservation and museum facilities needing improvement in order to better serve tourists to the region.

INTERNATIONAL COLLABORATION AND
CULTURAL NEGOTIATION

The considerable funds needed to realize the project, and its goals to increase international tourism to Ghana's Central Region, led the Ghanaian planners to seek multilateral partners who would contribute funds and expertise to the project. To secure such partners, the United States Agency for International Development (USAID) facilitated a visit in 1989 to the United States by high-level representatives of the Ghanaian team. During their visit they presented the project to small groups of staff from the U.S. Committee of the International Council of Monuments and Sites, Conservation International, and the Smithsonian Institution. The idea was to build enthusiasm among selected U.S. institutions that would team up with their Ghanaian counterpart organizations and provide needed technical expertise to help realize the project.[13]

Representatives of the U.S. consortium members made an exploratory trip to Ghana in March 1990 to meet with Ghanaian counterparts. Together, the group reviewed and assessed project assets and drafted a report outlining areas of potential assistance and collaboration. The plan envisioned a new, more

comprehensive exhibition of Central Region history and culture at the museum already located at Cape Coast Castle, and the preparation of new exhibition spaces at Elmina Castle, Fort St. Jago, and Kakum National Park.[14] A schedule of activities was proposed, with an initial phase to focus on Elmina's Fort St. Jago, the smallest of the historic structures and one that would serve as a manageable demonstration site to test and fine-tune preservation and interpretative strategies identified during project-related research and training activities.[15] Museum-related outcomes, in addition to exhibitions, included training in museum education and exhibit design and fabrication, a forty-five-minute film by the noted Ghanaian filmmaker Kwaw Ansah, the strengthening of museum management, the creation of a museum shop, and the development of public programs and educational outreach.[16] Clearly understanding the link between economic and cultural development and tourism, USAID confirmed its interest in co-funding the project with the government of Ghana.

Smithsonian participation focused on training and technical assistance in museum exhibition research, design, and production and in museum management. In the consortium-wide funding proposal submitted to USAID, a constituent-centered process of cultural negotiation formed the basis for a range of objectives and activities articulated for the Interpretive Services components of the project that would be undertaken by the Smithsonian Institution in collaboration with the Ghana Museums and Monuments Board.[17] Francis Duah, director of the Central Region office of the Ghana Museums and Monuments Board, was charged with supervision of much of the Interpretive Services work, in collaboration with the Central Region Economic Development Commission and the Smithsonian Institution and/or the Project Consortium Steering Committee.[18] The final technical assistance proposal for the Natural Resource Conservation and Historic Preservation project, dated May 30, 1991, was funded by USAID in an agreement signed on Capitol Hill on September 19, 1991—and the work could then move forward.[19]

EXHIBITION DEVELOPMENT:
TRAINING AND CULTURAL NEGOTIATION

Exhibition research and hands-on training activities guided the "Crossroads" exhibition process and were designed to ensure sustainability in the future. For the Interpretive Services component, five Ghanaians were identified to travel to Washington in 1992 for three-to-six-month trainings at the Smithsonian Institution. Each focused on a different area central to creating exhibitions: design, fabrication, graphics, photography, and education. Most remained associated with the project for the duration, though additional graphics and fabrication

personnel were trained at later stages in the project to replace those who left to pursue other employment opportunities.

With the exception of the photo murals and text and object labels, which were produced in the United States, the exhibition was fabricated in Cape Coast at the museum's newly constructed workshop, located about three miles inland, sufficiently beyond the corrosive salt air of the castle's seaside environment. The workshop was well equipped with usable though slightly outdated equipment donated by the Smithsonian's Office of Exhibits Central. It was intended as a sustainable income-generating branch of the museum, staffed with Smithsonian-trained exhibition designers and fabricators, who would be able to design, produce, and continue to maintain high-quality exhibits for museums located both within and outside Ghana. The dream of sustainability was marginally successful for four or five years after the workshop's inaugural 1994 exhibition. During that period the workshop staff turned out about a half dozen exhibitions in Ghana, assisted exhibition projects in other parts of West Africa, and hosted a number of inspection tours of African museum professionals anxious to see for themselves the facilities and exhibitions they had heard about through the press and by word of mouth. However, workshop management was unable to generate private-sector work once international funding for Central Region exhibition projects dried up in mid-1997. For marketing and financial reasons the workshop has since closed, and at present its future remains uncertain.

An education department was formed, and a museum educator trained at the Smithsonian for six months. During the years leading up to the "Crossroads" exhibition, the Education Department (which expanded with two additional hires) developed a range of programs and outreach services targeting primary and secondary students. Public programs for adults were also developed. The Education Department also organized training programs for tour guides at Cape Coast and Elmina castles and other historic sites in and around the Central Region.

Content development for "Crossroads of People, Crossroads of Trade" was a collaboration among Ghanaian scholars and museum professionals from Accra and Cape Coast and American museum representatives from the Smithsonian Institution. A Ghanaian content team, led by James Anquandah, an archaeologist at the University of Ghana, Legon, determined the themes the exhibition addressed and wrote content essays delineating the details of the topics and some of the objects and illustrations that could support them in the exhibition. This Ghanaian group identified four key themes and wrote essays to support them: the early history of trade and interaction on the coast that

led to the construction and flourishing of Ghana's European forts and castles, the period of the transatlantic slave trade, the African diaspora and Ghana's struggle for independence, and the culture of the Central Region today. Professor Anquandah edited these into a summary document that was used to craft the exhibition script.[20] Draft and final exhibition texts were reviewed by members of the content team for their edits and approval.

The limited collections of the Cape Coast Castle Museum were augmented with research documenting contemporary culture in the region and with the commissioning of new objects, including chiefly regalia, for the exhibition section devoted to contemporary life in the Central Region. Content and objects research was conducted by a museum-based team led by Kwesi Myles, a retired Ghanaian museum specialist who was hired on contract to serve as the exhibition coordinator.[21] As part of the work, the team embarked on a multiyear process of cultural negotiation to brief individuals and groups in the Central Region about the exhibition, solicit their ideas for permanent and temporary exhibition themes, and encourage local interest in and support of the project. Meetings were held with local chiefs and elders, government and civic leaders, members of Cape Coast's Asafo (traditional military) companies, potters, fishermen, shrine priests and priestesses, blacksmiths, historians, and others about the project. A broad sense of ownership of the exhibition content emerged as the opening deadline approached. In late November 1994, as the exhibits team completed case work and text panels, made new object brackets, and installed the exhibition in a record-breaking three weeks, clerical workers, shrine priestesses, fishermen, day laborers, and even the local fire marshal, as well as much of the staff of the castle, came to see the exhibition take shape. Many individuals suggested improvements to certain displays (some of which were implemented on the spot) and praised the work, their comments suggesting a sense of responsibility and investment in the final product. When the exhibition opened to the public in December 1994, political leaders, museum staff and administrators, foreign diplomats and development workers, and key local and expatriate residents of surrounding communities were there in force, though their attendance did not signal approval of the final product in every case.[22]

Over the course of the project a number of discussions were held with several expatriate African American residents of Ghana, and in particular with Nana Ben Robinson and Imahkus Vienna Robinson, who lived in Iture village near Elmina. The Robinsons had set up the Educational Sponsorship Program, designed to assist children living in and around Iture with educational, health care, and other needs; they also operated a small business conducting special

tours of Iture and Cape Coast and Elmina castles for visiting African American tour groups. As Central Region residents, the Robinsons had demonstrated an early interest in the tourism projects proposed for Cape Coast and Elmina.[23] Though discussions with the Robinsons—usually held with the museum director, Francis Duah, and other key members of the exhibition team, myself included—confirmed that there was a mutual interest in enhancing tourism to the Central Region and the recognition that improved museum exhibitions were part of the equation, there were disagreements about the direction and scope of the exhibition and the architectural conservation work on the castle structures (discussed below). The Robinsons wanted greater emphasis on the story of slavery and emancipation in the United States, as they felt that would resonate more with the growing number of African American tourists visiting Cape Coast Castle each year. They suggested that the Cape Coast Castle Museum consider borrowing slavery artifacts from American collections to tell that story. The director and the rest of the Ghanaian content team preferred a broader sweep in telling the history of the African diaspora and wanted to ensure that the limited exhibition spaces were focused more on Ghanaian history and Central Region cultures. I supported the viewpoints of my Ghanaian colleagues on these matters. Consensus was never reached on solutions that would satisfy these clearly distinct points of view, and the lack of process to engage the Robinsons in a more formalized way no doubt exacerbated their sense of exclusion from meaningful input on critical areas of the project.

CHALLENGES AND CONTROVERSIES

Usually a point of pride for the host country, a site designated as a UNESCO World Heritage monument carries with it added responsibilities and new challenges to ensure site preservation and public access. In addition to the budgetary and technical concerns that accompany the care of a place that has come into the world spotlight, the host country must contend with the multiple interests of different global constituents who now claim a measure of ownership of the site because of its World Heritage status. The influx of international funds and expertise to assist the host country following World Heritage designation tends to complicate matters further. Tensions arise as different expectations and interests are articulated, and frustrations inevitably result. Resolving complex issues of national and international management and care and ownership of World Heritage sites involves time and well-conceived processes that take the considerations of multiple constituents into account. In the interim, as such measures are outlined and adapted, changes occur and challenges and controversies are likely to arise. The Ghana project provides some examples.

Logistical and Budgetary Issues

Challenges in implementing the shared goals and objectives of the Ghana Natural Resource and Historic Preservation Project arose fairly early in the process when the Ghanaian planners reorganized a previously agreed-upon project schedule and identified Cape Coast Castle as the first major component of the project. The revised schedule coincided with Central Region government interests in completing the Cape Coast Castle phase in time for the second international Pan-African Historical Theatre Festival (PANAFEST), slated for Cape Coast in December 1994. However, for many of the international consortium members, the schedule change raised the anxiety quotient by eliminating work at the small, manageable site of Fort St. Jago that was to serve as a testing ground for preservation work and interpretive services training. The change of schedule may have been the result of frustrations over the multiyear delay in project start-up due, in part, to the complicated paperwork required to secure USAID funding. By the time funding was received, Ghanaian planners may well have felt compelled to focus on Cape Coast, given the Central Region's interest in hosting PANAFEST there.

Despite limits to project funding, the scope of work for the Cape Coast exhibition was expanded by Ghanaian planners. As increasing national and international attention was focused on the project, Ghanaian planners determined that the single room identified for museum exhibitions (the exhibition area of the former Museum of West African History, renamed in 1994 the Cape Coast Castle Museum) was inadequate, and so, more than a year or so into the research and planning phase, they decided that the exhibition area would expand to include two adjacent rooms—a move that more than doubled the space originally identified for the exhibition. This posed a range of challenges, including increased stabilization and restoration work on the additional rooms, an increased area that required climate control for protection of artifacts and exhibition texts and photo murals, and expanding production costs and collection needs. Ghanaian museum staff and American consultants alike felt pressured to figure out how to prepare and fill the additional exhibition spaces. In addition, all parties were concerned about the budgetary implications of an expanded first phase for the future availability of funds to complete later phases of the project at Elmina Castle and Fort St. Jago.

Controversies over Conservation Work

The most significant controversies over the project arose in the area of conservation work at Cape Coast and Elmina castles, and it brought to light fundamental issues of power and control over World Heritage sites. The decision by

the Ghanaian government to restore some of the forts and castles to conditions that would stimulate increased local and international tourism ignited an acrimonious debate among local and international constituents over how much these World Heritage sites, and particularly the dungeons, should be restored. The debate, as articulated in the local and international press and at special events and meetings held in Ghana in 1994–95, centered on whether African Americans deserved as much say in that decision as Ghana's government. The most visible evidence of project work, and thus a target of critics, was the historic preservation efforts at Elmina and Cape Coast castles launched under the direction of three Ghanaian preservationists trained in Britain and an expatriate technical expert working with the U.S. branch of the International Council of Monuments and Sites. In the international press, articles with such titles as "Is the Black Man's History Being Whitewashed?" and "Heritage Battle Rages at Slavery's Sacred Sites" give a sense of the nature and tone of the debate that emerged.[24]

Ghanaians are proud of their monuments and wish to keep them in good condition. Because of that, they have, on a fairly regular basis over the centuries, applied a mixture of lime, sand, and (later) cement to protect the walls and ramparts from the corrosive effects of the coastal salt air. Far from "whitewashing" history, Ghanaians see this work as necessary to preserve the structures for the future—and a fulfillment of their charge to maintain these sites, some of which have recently received World Heritage status. Opposition to this conservation and stabilization work rested with a small group of African American expatriate residents in Ghana, particularly Nana and Imahkus Robinson (mentioned earlier), who engendered the support of other African American individuals representing, among other interests, the tourist trade and the Nation of Islam. The critiques advocated returning the sites to their "original condition"—something that had less to do with historical accuracy and more to do with a feeling of something old, dark, tragic, and to some degree terrifying.[25] This image did not fit with freshly whitewashed walls and new windows and doors, many replacing fixtures that dated back only thirty to fifty years. Such repairs were perceived as potentially jarring, especially to tourists from the African diaspora, who might feel it interfered with their connection "with the African past [that] is an integral part of the pilgrimage tour."[26] What was overlooked was that within less than six months the brightly whitewashed walls and ramparts would begin to show the dark stains and peelings that come with the high-salt coastal environment.

Similarly, electric lighting, installed decades ago to allow visitors to see within the dark recesses of the castle dungeons, was viewed as inappropriate and detracting from the horrors experienced by enslaved Africans who were

held in dark captivity there hundreds of years ago. Erroneous reports that the dungeons were to be painted a festive yellow further fueled the debate.

Critics of the architectural conservation work saw it as "beautifying" structures with such a terrible history and, thus, according to one article, creating "a false, superficial, and artificial appearance or effect."[27] Rather than stabilization and restoration, African Americans critical of the project charged that the historical conservation work was renovation and destruction "of an important monument of the African holocaust that befell [African] people over four hundred years ago."[28] For many African Americans, the legacy of slavery designates Cape Coast Castle and Elmina Castle in general, and the dungeons in particular, as hallowed grounds. Interestingly, the site at Cape Coast Castle is also sacred for local priests and priestesses, who regularly perform offerings and libations for one of Cape Coast's major deities, whose shrine is located inside the castle's male dungeon. A locally popular restaurant and beer bar situated on the ramparts above the dungeons of Cape Coast Castle was shut down when a group of visiting Jamaican performers felt that the lively atmosphere, which included Ghanaian highlife music played from a boom box, was disrespectful to the memories of those who had been enslaved and held in the dungeons centuries before.[29] Thus, a profitable moneymaker that had provided discounts to museum staff working year-round in the castle was closed, and tourists who visited the castle were obliged to leave the castle grounds for refreshments. Though museum management understood the sensitivities expressed by the Jamaican delegation, the inconvenience to local patrons and the loss of income to the castle were noted. These debates cast in sharp relief two distinct approaches in promoting tourism at sites associated with the slave trade: "thanatourism," which seeks to reproduce the conditions of terror and death as part of the tourist experience, and heritage tourism, which seeks to display cultural and historical products and achievement.[30] These are critically different goals that, in the case of the "Crossroads" exhibition project, led to conflicts—some unresolved—between some Ghanaian and African diasporic constituents invested in the project.

Money, Power, and Influence

Concerns over the conservation work were linked to exhibition content, as both were thought by critics—primarily African American residents of and visitors to Ghana—to be directed by foreigners, particularly the Smithsonian. As noted earlier, controversies over exhibition content centered on the extent to which the exhibition would address the topics of slavery and the African diaspora, particularly the experiences in the United States of peoples of African descent. By far the most compelling story to be told in Cape Coast Castle is the

history of slavery, but it was and is viewed by many Ghanaians as one part of the long history of the region. A predominant focus on slavery did not fit with the vision of the exhibition content team, who saw the exhibition as an opportunity to educate visitors about many aspects of the Central Region's cultural heritage. Members of the content team wrote essays on a range of topics — archaeology, trade, European contact, slavery, the freedom struggle, education, religion, and the cultural and the contemporary economic life of the Central Region — that were selected to redress what they felt was a one-dimensional view of the forts and castles in Central Region history, namely, that of slavery.[31] The Smithsonian project director grew increasingly concerned about mounting criticism of the exhibition content and decided to hire as a subcontractor an African American curator to draft the exhibition text for the section on the African diaspora.[32]

As architectural conservation and exhibition work continued apace, the debates became more pointed and heated. Bowing in May 1994 to internal and external pressure, Ghana's Museums and Monuments Board and the National Commission on Culture hosted in Cape Coast an international symposium on the restoration, use, and management of Ghana's historic forts and castles. The symposium was designed to discuss and possibly resolve some of the concerns voiced by both tourists and expatriate residents of Ghana and aired in the local and international press. The symposium sought compromise by agreeing that "the cultural heritage of all the different epochs and powers should be presented, but also that areas symbolizing the slave trade be given reverential treatment."[33] The symposium proposal to change the name from Elmina Castle to "Elmina Castle and Dungeons" was not implemented, nor was a similar proposal for Cape Coast Castle. However, some tourist brochures produced outside Ghana identify the castles in these terms.[34]

During the symposium and in subsequent newspaper interviews, some African American participants living within and outside of Ghana charged Ghanaian officials and project leaders with being "handcuffed" by white institutions such as the Smithsonian and USAID (the latter the primary source of project funding). Ghanaians who were interviewed by the press countered with accusations that African Americans were being overly sensitive and trying to force through their own political agendas without making any financial commitments.[35] Indeed, high hopes for collaboration between Cape Coast Castle and African American entertainers such as Isaac Hayes and Dionne Warwick met with few tangible results. The two entertainers visited Cape Coast Castle in 1991 on a tour sponsored by the Nation of Islam (figure 9). During their visit, they met with the museum director and discussed an interest in raising funds to support the work at the castle. A 1992 signing of a memo of under-

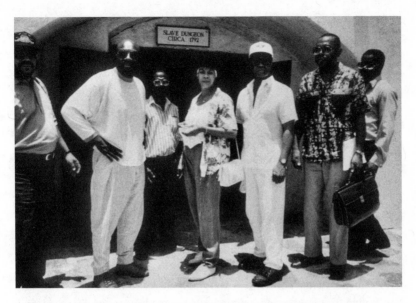

9. American entertainers Isaac Hayes and Dionne Warwick standing outside the entrance to the dungeon during a 1991 tour of Cape Coast Castle sponsored by the Nation of Islam. Photo by Christine Mullen Kreamer.

standing between the government of Ghana and the newly formed African American Society to Preserve Cape Coast Castle, represented by Isaac Hayes, pledged to raise $10 million to support preservation and interpretive work at Cape Coast Castle. But by the late 1990s no money had been raised. In an April 1995 interview with *Washington Post* foreign correspondent Stephen Buckley, Francis Duah, the regional director of the Museums and Monuments Board, expressed frustration and disenchantment over the lack of financial support by African Americans, who then wanted "a big say in what we do."[36] In the same article, the charge was countered by Kohain Halevi, an African American resident living in Elmina, Ghana, who noted: "[Ghanaians] talk about how we need to contribute financially if we want more of a voice in this project. . . . My response is that the ancestors of African Americans paid the highest price already."[37]

THE POLITICS OF MEMORY

One of the subtexts in this controversy has been the extent to which Ghanaians are willing to remember and discuss the role of their ancestors in facilitating the slave trade.[38] Opoku-Agyemang reminds us that as early as the 1970s scholars recognized the lack of attention paid to the social and moral effects of slavery

in Africa and on the Africans who bought and sold slaves in the trade that spanned close to four centuries.[39] Though never overtly expressed during content development, the "Crossroads" exhibition's absence of details on African complicity in the slave trade could be interpreted as selectively avoiding uncomfortable content that might offend Ghanaian visitors and detract from a positive tourist experience. In a similar way, critiques of the ways in which historical sites in the Caribbean have been appropriated by the tourism industry center on the "selective inclusion of certain historical representations" that "peddle a form of a-historicism in the name of tourism promotion."[40]

Indeed, among some African American residents of Ghana, there is an expressed desire to "educate" Ghanaians about the slave trade, including African complicity. Beginning in 1992, the private foundation called One Africa Productions, run by Nana Ben Robinson and Imahkus Vienna Robinson (the African American residents of Iture village outside Elmina), has sponsored educational programs for local Ghanaians at Cape Coast Castle called Juneteenth to commemorate the last day of slavery in America, June 19, 1865. Throughout the 1990s One Africa Productions also offered "a special ceremony and program for returning Africans of the Diaspora" at Cape Coast Castle called "Through the Door of No Return, the Return." This two-hour program, also open to other tourists not of African descent, included a tour of the castle, cultural drumming and dancing, a procession to the dungeons, and a candle-light vigil inside the dungeons, where prayers and libations to the ancestors were offered. Participants were then led "through the door of no return" to the street outside the castle.[41] Then, with drums playing, participants returned to the castle, back through "the door of no return," to symbolize their return to Mother Africa.[42]

During the early 1990s, Cape Coast Castle Museum staff—including the director, conservators, educators, and tour guides—voiced concerns over tours of the castle operated by outside tour groups, including those sponsored by One Africa Productions and the Nation of Islam, which usually bypassed the museum guides trained and employed by the Ghana Museums and Monuments Board. This concern was also linked to special tours such as "Through the Door of No Return," which generated considerable fees, only a fraction of which were shared with the museum to help it with its operating funds.[43] Issues of protocol and profit sharing were areas of frustration voiced by some Ghanaian museum staff who felt overlooked by the "outsider" tours.

Given the acrimonious debates surrounding the Cape Coast Castle project, efforts were made by the Central Region government and local leaders to promote healing and reconciliation with members of African diasporic communities. In December 1994, shortly after the "Crossroads" exhibition opened,

10. African Americans participating in a commemorative ceremony at Cape Coast Castle, December 1994. © 2005 by Tom Lamb/Tom Lamb Studio.

a ceremony at Cape Coast Castle was performed for visiting African Americans (figure 10) by some local Ghanaian chiefs to atone for the complicity of their ancestors in the slave trade. This event, which was part of the scheduled PANAFEST activities, was received with mixed reviews by Ghanaians, some of whom felt offended and coerced to participate in the ceremony or to admit that their ancestors played a role in the trade. Imahkus Vienna Robinson commented to the press about the event, noting, "Until there is an admission by Africans that they were involved in the slave trade, the healing process will be difficult to realize."[44] A 1995 newspaper article entitled "Ghana Still Hears Rattle of Slaves' Chains" presented a different point of view. It quoted Kwame Arhin, head of the Institute of African Studies at the University of Ghana, Legon, as saying that many Ghanaians found the ceremony "offensive." He stated, "Why should I apologize for something I didn't do? I find them all [African American critics] a bit demanding, and if you don't think the way they do, they say you're an Uncle Tom. It's rather harsh . . . because we're suffering more than they are suffering."[45] Indeed, the disparity in standards of living between Ghana and the United States runs like an undercurrent in these debates. Ghanaians are anxious to bring to their economy much-needed hard currency, and tourism seems to offer one way to get it. In conversations with me, Ghanaian members of the project had mentioned that they felt threatened by and

resentful of outside pressures that might detract from their vision of economic and cultural development partially supported by tourism dollars. The feelings are particularly acute when foreign critics of Ghanaian policies do not seem to offer alternative funding to support their own ideas of how the forts and castles should be managed.

At the August 1997 opening ceremonies for the third Pan-African Historical Theatre Festival (PANAFEST), another atonement ceremony was held that included chiefs and members of the local communities who mourned those who had been sold into slavery and commemorated victims of the anticolonial struggle as well as departed leaders.[46] In August 1995, a U.S. tour of atonement by several Ghanaian chiefs included a visit to the African Burial Ground in New York City and an inspection of skeletal remains being studied in a lab at Washington, D.C.'s Howard University. Since 1998, Emancipation Day—August 1—has been celebrated in Ghana as part of an international effort to commemorate emancipation from slavery. It was incorporated as Ghana's strategy "to link its past history of slavery and the slave trade to the development of the nation's tourism industry" when it was formalized as part of the biennial PANAFEST programs, with the 1999 program advertised as "PANAFEST '99 & Emancipation Day."[47] It also formed part of the PANAFEST 2001 program, with a vigil held the night before and a durbar scheduled the next day at Assin Manso, a town outside of Cape Coast where, centuries before, slave traders reportedly checked the fitness of the captives and had them bathe in the river before concluding their march to the coast.[48]

ARTIFACTS OF MEMORY

Artifacts are more than silent witnesses to lives and times past or present. Along with the historical evidence that artifacts can provide, the social life of things—as Arjun Appadurai put it—sheds light on the many ways objects are used and interpreted and the changing meanings objects have over their life histories.[49] The power of objects to move us—to inspire resonance and wonder, as Stephen Greenblatt noted some years back—is precisely because each of us brings our own experiences, insights, and memories to our encounters with artifacts.[50] This sense of identification allows us to make objects our own and to feel, on some level, a relationship—whether positive or negative—with inanimate things.

Part of the power of objects is vested in the spaces in which they are made, used, or eventually reside. Because of that, spaces are imbued with much the same set of interpretations assigned to artifacts and, in fact, become artifacts in their own right, rich with history, meaning, and memory.[51] The fifteenth-,

sixteenth-, and seventeenth-century forts and castles that line Ghana's coast speak of the nation's long, complex, and largely tragic history of trade and interaction with Europe and the Americas. Centuries ago, these structures served as trading lodges, storehouses, residences, schools, and churches for Europeans and some Africans working together, although not equally, in the trade.[52] Some sites served as points of embarkation for enslaved Africans forced from their homelands and shipped as commodities to distant shores in Europe and the Americas. Some of these structures were the final resting places of those men, women, and children who died before they began their Middle Passage journey.

In more recent times, several of these forts and castles have served as prisons, training colleges, administrative offices, museums, and post offices, and one in Accra remains the presidential headquarters of Ghana's republic. More than a confrontation with the colonial past — several of these structures functioned as administrative centers for European colonial authority — the forts and castles speak of an even longer history of foreign political and economic imperialism whose legacy continues to challenge the nation of Ghana today.

For many national and international visitors who tour these impressive buildings and ruins each year, Ghana's coastal monuments are places of pilgrimage. As visitors move through these spaces, tour the dungeons, and admire the ocean views from long ramparts lined with ancient cannons, many are impressed with the size, grandeur, and sheer age of the buildings. At the same time they are horrified at the incomprehensible inhumanity of enslavement that is part of the legacy of these historic sites. No one can remain unmoved upon entering one of the dungeons of Cape Coast Castle, dating to 1653, where the stench of all manner of human suffering still lingers after hundreds of years. The same can be said for the earliest of Ghana's forts, the nearby Elmina Castle, which dates to 1482. The emotional impact of moving through these spaces at Cape Coast and Elmina castles inspires visitors to write in comment books that "we must never again allow such unspeakable cruelty" to exist anywhere in the world. Visitors — particularly those of African descent — often emerge from the dungeons angry, in tears, and emotionally drained. This is coupled with respect and admiration for those who survived, resisted, and lived to talk about the horrors of captivity, the wretched conditions of the Middle Passage journey, and the brutality of working conditions in the Americas. It is the rare visitor who remains unmoved.

As Ebron points out, "Travel routes in such contemporary 'return' journeys to the continent are maps of collective memory; to participants the visit becomes a 'revisit,' tending to the trauma of capture — the capture of Africans taken to the New World as slaves."[53] Kugelmass notes similar experiences as

American Jewish tourists visited sites of the Jewish Holocaust, including concentration camps. Such visits relive a painful history, where time and space are compressed and the history of their community is reexperienced, "invoking the spirits of the tribe and laying claim to their martyrdom, but they are also making past time present."[54] As these two sources note, and as the dynamics of the "Crossroads" exhibition illustrate, memories of diaspora stretch across national boundaries and extend into the global arena, raising complex problems and issues that must be resolved by taking the concerns of both local and global constituents into account.

As powerful places of memory, as pilgrimage sites particularly for African Americans who come to Ghana's Central Region to pay homage to their ancestors, Ghana's forts and castles are tangible sacred links with a complex and largely tragic past. For many African American visitors, the journey to Ghana — to Africa — becomes a search for peace and renewal through return to the homeland. The journeys are part of what Ebron articulates as how "African American transatlantic imaginaries create *history* and *memory* scapes."[55]

The controversy over the use and interpretation of Cape Coast Castle is but one example of an increasing sense of ownership among people of African descent for sites in Africa associated with the transatlantic slave trade. From a diasporic perspective, places such as Gorée (off the coast of Senegal), Elmina and Cape Coast castles, and the UNESCO Slave Route (in Benin) are akin to shrines where people of African descent come to mourn their enslaved ancestors, to question the culpability of Africans during nearly four centuries of the trade, and to create mechanisms that allow for reconciliation. These places are, to borrow Pierre Nora's terminology, "sites of memory" and places where "memory crystallizes and secretes itself."[56] However, the African owners and custodians of these historic structures are often reluctant to reduce their commemorative meaning to the singular theme of the slave trade. This is not to diminish the compelling and tragic history of enslavement that imbues these sites with great pathos; rather, it reflects the differing sensibilities, experiences, and memories that Africans and people of African descent bring to the sites. Further, the sites offer significant tourism potential for Ghana and are thus seen as monuments that must be preserved for multiple uses and diverse audiences. Finally, moving beyond the issue of the slave trade allows Ghanaians to tell other stories deemed important to them, including those that celebrate the vibrant cultural life of communities surrounding the forts and castles today.

The disjuncture in how these sites were and continue to be perceived and used by local and international audiences fueled the debates surrounding the Cape Coast Castle project in the first half of the 1990s. The discourse was at times dramatic and emotional, associated as memory is with "trauma, mourn-

ing, sublime, apocalypse, fragment, identity, redemption, healing, catharsis, cure, witnessing . . . soul."[57] The debate goes on as the Ghanaians immediately responsible for managing these World Heritage sites continue to grapple with issues of ownership and representation in the face of increasing annual numbers of international tourists.

CONCLUSIONS

Ghana's Natural Resource Conservation and Historic Preservation Project illustrates a process of global and transnational social relations that brings together international development assistance and heritage tourism. Guided by the opportunities and structures these two elements provide, the project's exhibition, "Crossroads of People, Crossroads of Trade," got entangled in problems inherent in representing a number of global processes of distinct temporal frames that nonetheless exert compelling influences on the present. These include the longer-term global process of the transatlantic slave trade and its legacy worldwide, both historically and today. It includes as well the more recent global dimensions of Ghana's and, by extension, Africa's struggle for freedom from colonial domination in the nineteenth and early to mid-twentieth centuries and the creation of independent African nations in the mid- to late twentieth century. These histories and their contemporary legacies influence how one thinks about and experiences sites associated with slavery and domination. These factors shaped the content of the "Crossroads" exhibition project as well and influenced the nature of the debates surrounding preservation and use of Ghana's Cape Coast and Elmina castles. Indeed, throughout the five-year span of the project, the "Crossroads" exhibition was the predominant idiom by which the project was judged, as critiques often conflated exhibition content and historic preservation work—two very distinct components of the larger project. Perhaps this was because the exhibition represented a more permanent vehicle for the representation of history and held the potential for inclusion or exclusion of multiple viewpoints and claims of ownership. The "Crossroads" project underscores a point Ivan Karp made in an essay in the *Exhibiting Cultures* volume about the power and consequences of creating exhibitions and "the problems that arise when different cultures and perspectives come into contact."[58] Indeed, *Exhibiting Cultures* and its companion volume *Museums and Communities* both emphasize how exhibitions are powerful agents for the articulation of identity and thus are sites of potential conflict as invested constituents struggle to secure a voice in the telling of their own stories. There remains an ongoing need for museums to accommodate alternative perspectives. Exhibitions that evoke particularly strong criti-

cisms tend to repeat an unfortunate pattern of marginalizing, intentionally or not, certain constituents whose interest in participating and, to some degree, controlling the exhibition process has been seriously underestimated.

Globalization is not just a dichotomy of local/global, insider/outsider. Rather, it speaks to a rearrangement of relationships, including power, that occurs when temporal and spatial distinctions that previously separated cultures are abolished as part of the global movement of people and ideas. Indeed, globalization links communities of discourse that are not necessarily grounded in locality but that do address shared concerns. That being said, constituents bring to the global dialogue their own perspectives, which are often shaped by the particularities of their histories and the specifics of their geographic locales. In the case of the "Crossroads" exhibition, though shared concerns were addressed, the linked communities—diasporic African Americans and continental Ghanaians—held multiple and at times conflicting perspectives on critical areas of conservation, interpretation, and community inclusion. Thus, the paradox of globalization is, perhaps, how local the debates often are. Furthermore, it is worth noting that ordinary Ghanaian visitors to Cape Coast and Elmina castles were not usually interviewed by local or international press regarding their opinions about the controversies surrounding the conservation work on the castles or the "Crossroads" exhibition content. Thus, their perspectives were not part of the discourse in any significant way, though some local buy-in to the project was achieved through the community-based research conducted during content development. Indeed, most Ghanaians interviewed about the project were those associated in some way with it or with tourism promotion in Ghana. Similarly, the vast majority of African American tourists to Ghana were not approached to voice their opinions of the successes or failures of the project. Thus, the debates that circulated around the Ghana project did not form a seamless whole within any one constituency; rather, they represented the viewpoints of a small group of individuals who might be said to be invested in and sensitized to the political dynamics of representation and heritage tourism at sites associated with the slave trade.

On the surface, what the public can see in the "Crossroads" exhibition at Cape Coast Castle is that the voices of the African diaspora have diminished the voices of the Ghanaians in the representation of this site.[59] Indeed, some Ghanaian tourists as well as some project members remain concerned at the lack of representation of Ghana's own freedom story in the exhibition. On a deeper level, of course, the controversies surrounding the project speak to the complex circumstances of the nearly five-year project and to competing claims to ownership and power over both place and the interpretation of mem-

ory. They illustrate the "complex and dialectical contradictions" that Elliott Skinner noted exist in relations between people in the diasporas and their ancestral homeland.[60] As Colin Palmer points out in his comments about an exhibition in Florida dealing with the transatlantic slave trade, "The Atlantic slave trade has been ended for about a century and a half. Yet it continues to command our interest as it offends our sense of decency and our humanity. Understandably, the trade is more of a living part of the consciousness of blacks in the Americas than it is for contemporary Africans."[61]

This is part of what is at the heart of the debate over the representation of enslavement in the Cape Coast Castle Museum. Greater dialogue from the onset of any such exhibition project would go a long way toward resolving some of the issues over use and interpretation. While the project's process of cultural negotiation managed to provide a good measure of Ghanaian participation in developing the content and design of the exhibition, the process failed to include in any substantive way members of Ghana's African American community, who were understandably invested in the sites and clearly wanted a voice. The commitment and genuine concern that fueled critiques of the project have identified a community that clearly feels a keen sense of responsibility for, and ownership of, Ghana's forts and castles. This is a community that deserves continued engagement by Ghana's Museums and Monuments Boards in the interpretation of sites associated with the transatlantic slave trade. Such engagement, however, requires a process of mutual respect and cultural sensitivity that would avoid the acrimonious rhetoric of the "Crossroads" exhibition, which tended to pit African Americans against their Ghanaian hosts, thus reproducing what some Ghanaians characterized as interference from Western imperialists and a carry-over of the colonial experience.

"Memory is a means of making loss survivable, but it is also therefore a means of allowing the past to have closure."[62] Part of the ongoing debates about the representation of sites of enslavement reflects the tension between memory and forgetting and the fact there is no closure—nor should there be—on so tragic a chapter in human history. Until the time when true justice, equality, and access are realities for both Africans and African Americans, there can be no closure on the painful memories that are the legacies of enslavement and racism. The sense of memory and identity that many African Americans have with sites of enslavement fosters a feeling of shared ownership of these heritage sites, which often comes into conflict with African visions of their use and disposition, thus producing contested terrain.[63]

NOTES

I am grateful to Ivan Karp and Cory Kratz for their helpful comments and insights as I prepared this paper for this volume. An abbreviated version of this essay, entitled "The Politics of Memory: Ghana's Cape Coast Castle Museum Exhibition 'Crossroads of People, Crossroads of Trade,'" is forthcoming (2006) in a special issue of the *Ghana Studies Journal*, published annually by the University of Wisconsin. The special issue, entitled "Sites/Sights of Memory in Ghana's Cultural Landscapes," is edited by Ray Silverman, who chaired a double panel on that topic at the 2004 annual meetings of the African Studies Association.

1 For related discussions, see Kirshenblatt-Gimblett's essay in this volume and her *Destination Culture*; and Bruner and Kirshenblatt-Gimblett, "Maasai on the Lawn."

2 Graham M. S. Dann and Robert B. Potter, for example, identified perceived parallels between tourism and slavery in the ways that Caribbean plantations have recently been resurrected to serve as tourist attractions. They raised concerns about history that is "watered down by financial interests to a [low] common denominator . . . in order to cater to the presumed tastes of . . . tourists," yet they acknowledge the commercial potential of this heritage (Dann and Potter, "Supplanting the Planters," 55–56). Jennifer L. Eichstedt and Stephen Small's *Representations of Slavery* explores race and ideology in the interpretations of southern plantations.

3 Bruner, "Tourism in Ghana"; Schildkrout, "Kingdom of Gold"; and Essah, "Slavery, Heritage and Tourism in Ghana" address some of the political ramifications of how history and enslavement are represented in Ghana's Elmina and Cape Coast castles, and the expectations of cultural heritage tourists who visit these sites each year.

4 Kirshenblatt-Gimblett, *Destination Culture*, 150.

5 Relevant to this discussion is Paulla Ebron's account of a 1994 McDonald's-sponsored African American homeland "Roots" tour to Senegal and the Gambia. In her essay, Ebron discusses the "tourist as pilgrim" and the "ties contemporary African Americans forge with Africa as they remap the exit routes from Africa centuries ago" (Ebron, "Tourists as Pilgrims," 910–12). In a similar way, an earlier essay by Jack Kugelmass ("The Rites of the Tribe") interprets American Jewish tourism to Poland as a ritual of return in which the past can overdetermine views of the present.

6 Ebron, "Tourists as Pilgrims," 912.

7 Kirshenblatt-Gimblett, "Museums, World Heritage, and Cultural Economics," 2.

8 See Arens and Karp's discussion of the dynamics of power relationships where "dependence and control are shared unequally among the actors" ("Introduction," xvi).

9 There have been a number of exhibitions—temporary and permanent—that have dealt specifically with the artifacts and history of the transatlantic slave trade. Among those is the two-year exhibition at the main French slaving port, Nantes, "Les Anneaux de la Mémoire" ("Chains of Memory"), which closed in May 1994. The exhibition, organized by a group of Nantes citizens from diverse walks of life, focused on the history of Nantes mercantile companies, the products of that trade, and the tragedy of the immoral commerce of slavery. For discussion of an exhibition in Liverpool and

the traveling exhibit on the wrecked slave ship *Henrietta Marie*, see Burnside, *A Slave Ship Speaks*. In April 2002, the Mariners' Museum in Newport News, Virginia, opened a major traveling exhibition that focused on the transatlantic slave trade. Historic Jamestown, Virginia, is also planning a major interpretive component on the slave trade for 2007.

10 Throughout the exhibition, text is written in the passive voice, a technique that has been criticized in other representations of slavery as a strategy of symbolic annihilation of the institution of slavery (see, for example, Eichstedt and Small, *Representations of Slavery*). I find this an intriguing idea, though in the case of the "Crossroads" exhibition in Ghana, choice of the passive voice was unintentional and simply the result of how the content was developed. Unfortunately, we did not consider the strategy of first-person narratives to convey the horror and inhumanity of the trade, nor did we seek out resource material that would allow us to draft a more engaging exhibition text using first-person accounts and poignant quotes.

11 An exhibition at the temporary park headquarters was set up in 1995. When the new Kakum National Park headquarters was built, it included a large roofed but open-air exhibition space that housed "Hidden Connections," an exhibition that opened in April 1997. I served as one of the expatriate technical assistants for that exhibition project, too.

12 Quoted from Executive Summary, "Pre-feasibility Study Report on Tourism Development Scheme for the Central Region," prepared by the Preparatory Committee on Tourism Development Scheme for the Central Region, March 1989, sections 2.1.1 and 2.1.3.

13 The Midwest Universities Consortium for International Activities (MUCIA) was identified as the umbrella organization to direct the U.S. side of the collaboration, with member universities providing particular assistance in tourism development.

14 Cape Coast Castle housed the Museum of West African History, established in the early 1970s to tell a broader story of history and culture in West Africa. The museum, which included a single exhibit hall, a conservation lab, storage facilities, and administrative offices, envisioned its potential as a center of research and scholarly exchange between European and African scholars. It was, and remains, under the direction of the Central Region office of the Ghana Museums and Monuments Board (GMMB). See Duah, "Ghana Museums and History."

15 Cape Coast Castle was proposed for Phase II; Elmina Castle was slated for Phase III. In internal memos, dated December 1, 1989, and May 15, 1990, to staff of the Smithsonian's International Center, I advocated for a community-centered approach to the project and a process of cultural negotiation that would establish meaningful links between project goals and community concerns.

16 Contrary to the assertion that "USAID consultants did not encourage the Ghanaians to develop public programmes that would address the interests of their varied audiences" (Singleton, "The Slave Trade Remembered," 158), a Smithsonian-trained museum educator developed a series of primary and secondary school programs, public symposia, several music and film programs, at least one fashion show, and other ac-

tivities generated to bring new, local audiences to the museum. I have not recently followed up to determine how sustained this outreach has been in subsequent years since my last visit to Ghana in 1997.

17 Smithsonian's part of the USAID project proposal was drafted in collaboration with representatives of GMMB.

18 Vera Hyatt, of the Smithsonian Institution's International Center, served as project director for the Smithsonian's work in the project. I provided technical assistance for the research and cultural negotiation work and assisted, when needed, with other project objectives.

19 USAID was approached to finance the bulk of the dollar and local currency expenses and to assist with private-sector donations of local currency expenditures, with the government of Ghana providing logistical support and human resources and monies from debt-for-development blocked currency transactions (local funds made available from cancelled foreign debts and earmarked for domestic projects). U.S. consortium members, including the Smithsonian, served as subcontractors and pledged to devote three person-months per year to the project and to contribute 50 percent of this time, or six person-weeks per year. In terms of funding levels, "USAID awarded $5.6 million to the project . . . MUCIA would manage the grant . . . and $1,082,000 would be spent on Interpretive Services. Of that, $353,000 was managed by MUCIA/Ghana for infrastructure development and, as a subcontractor, the Smithsonian received and managed a grant of $729,000 for museum development." See Hyatt, *Ghana: The Chronicles of a Museum Development Project*, 6.

20 I worked closely with Kwesi Myles, the exhibition coordinator, and the staff at the Cape Coast Castle Museum to help shape the exhibition content.

21 During this phase, I served in an advisory capacity to tailor the content to an exhibit format and to ensure that object research was undertaken to support the topics.

22 As with many museum openings, the general public was admitted only later in the day.

23 In a proposal to the Central Regional Administration dated August 1, 1990, they listed guiding principles and local resources for their vision of tourism and cooperative economics in Elmina and Cape Coast. The proposal did not provide specific objectives and measures to achieve them, and the Robinsons were not approached by either the government of Ghana or the international donor community to provide technical assistance to the project.

24 See Robinson, "Is the Black Man's History Being Whitewashed?"; Buckley, "U.S., African Blacks Differ on Turning Slave Dungeons into Tourist Attractions" and "Heritage Battle Rages at Slavery's Sacred Sites"; Ransdell, "Africa's Cleaned-Up Slave Castle."

25 In a conversation I had with an African American assistant director of the acclaimed Haile Gerima film *Sankofa*, filmed at Cape Coast Castle, she disagreed with the restoration work and noted that she would not have been able to film in the castle some years back if the walls had at that time been stabilized with the lime mixture. She maintained that the emotional impact of the space would have been diminished. This is not unlike Ziva Freiman's response to the National Holocaust Museum in Washington, where the building's restrained architecture and exhibit design seems to downplay the emotional impact connected with the memorials. Freiman notes, "The architec-

ture simply does not do enough to put people emotionally on the spot" ("Memory Too Politic," 63).

26 Ebron, "Tourists as Pilgrims," 923.

27 Robinson, "Is the Black Man's History Being Whitewashed?" 49.

28 Ibid., 48.

29 I heard an updated variation on this controversy in a National Public Radio report, aired February 24, 2003, on *Morning Edition*, that an African American resident in Ghana criticized Black Entertainment Television (BET) as "disrespectful" for its plans to schedule a two-day jazz concert at Cape Coast Castle. The report noted that "BET felt otherwise"; I am not aware if BET carried forward these plans.

30 Dann and Seaton, *Slavery, Contested Heritage and Thanatourism.*

31 Members of the content team expressed to me dismay at foreign tourists on one-day bus tours from the capital Accra, some two and a half hours away from Cape Coast, who would visit the castles yet get no sense of the Central Region's present cultural life.

32 Fath Davis Ruffins, a well-respected historian and curator at the Smithsonian's National Museum of American History, was hired in this capacity.

33 Unpublished conference proceedings summary, 1994.

34 See Hyland, "Monuments Conservation Practice in Ghana," 61.

35 Local Ghanaian visitors to Cape Coast and Elmina castles were rarely interviewed by local or international press regarding the controversies surrounding the project or to solicit their impressions of the conservation work or the exhibition.

36 Buckley, "U.S., African Blacks Differ on Turning Slave Dungeons into Tourist Attractions."

37 Ibid.

38 Shaw, *Memories of the Slave Trade* demonstrates that there are other ways of remembering the past than by speaking about it.

39 Opoku-Agyemang, "A Crisis of Balance."

40 Dann and Potter, "Supplanting the Planters," 70, 62.

41 Cape Coast Castle's actual "door of no return" has been blocked for ages, so a gateway leading out to the beach of the fishing community next door to the castle is used for this tour. Tour participants who are not of African descent are prohibited from walking through "the door of no return" because it was not something their ancestors had experienced.

42 Nana Okoko (Ben) Robinson and Imahkus Vienna Robinson, "Through the Door of No Return—The Return," unpublished draft of tour brochure, One Africa Productions, Iture, Ghana, 1991.

43 I haven't tracked this issue since the late 1990s and I am uncertain whether, in the intervening years, a better balance of revenue sharing has been reached between the museum and private tour operators.

44 French, "On Slavery, Africans Say the Guilt Is Theirs, Too." Robinson is identified in the article by her Ghanaian name, Imakus Nzinga Okofo.

45 See Sly, "Ghana Still Hears Rattle of Slaves' Chains." See also Sutherland, "In Memory of the Slaves."

46 See Quainoo, "Elmina Mourns Slaves." Caryl Phillips offers a fairly sour commentary

of PANAFEST (1997, I believe), including the "Day of Memorial and Remembrance" held in Elmina as part of events intended to draw "exiled" blacks back "home" to Africa. It draws a biting portrait of organizers of the commemoration, noting that one wears a "bright yellow costume which is decorated with a drawing of human cargo that is laid out in the hold of a slave ship . . . [with] the words 'Never forgive, Never forget'" written above it (Phillips, *The Atlantic Sound*, 172). Phillips characterizes the festival's rhetoric about the legacy of enslavement in the Americas as a "rush to over-statement that is causing him to suffer from 'diasporan fatigue'" (ibid., 186). He comes to understand the frustration of some Ghanaians who see "people of the diaspora [as those] who expect the continent to solve whatever psychological problems they possess . . . They have deep wounds that need to be healed, but if 'their' Africa fails them . . . they will immediately accuse 'these Africans' of catering to the white man" (ibid., 215–16). Phillips also sketches his experience of participating in the "Through the Door of No Return" tour.

47 Essah, "Slavery, Heritage and Tourism in Ghana," 46–47.
48 Emancipation Day and PANAFEST events are advertised on a number of Web sites offering package tours to Ghana; see Schramm, "'Coming Home to the Motherland.'"
49 Appadurai, *The Social Life of Things*.
50 Greenblatt, "Resonance and Wonder."
51 See Baer, "To Give Memory a Place"; Bachelard, *The Poetics of Space*.
52 See van Dantzig, *Forts and Castles of Ghana*.
53 Ebron, "Tourists as Pilgrims," 912.
54 Kugelmass, "The Rites of the Tribe," 411.
55 Ebron, "Tourists as Pilgrims," 910.
56 Nora, "Between Memory and History," 7.
57 Klein, "On the Emergence of *Memory* in Historical Discourse," 145.
58 Karp, "Culture and Representation," 12.
59 Both Bruner, "Tourism in Ghana," and Schildkrout, "Kingdom of Gold" note this in their articles about the exhibit.
60 Skinner, "The Dialectic Between Diasporas and Homelands," 17.
61 Palmer, "The Middle Passage," in *A Slave Ship Speaks*, 22.
62 Laquer, "Introduction," 8.
63 See Larson, *History and Memory in the Age of Enslavement*, 278.

Sites of Persuasion: *Yingapungapu* at the National Museum of Australia

HOWARD MORPHY

The National Museum of Australia opened in March 2001, in the year of the centenary of Australia's Federation. It was Prime Minister John Howard's 100th birthday present to the nation. The museum's birth was delayed until after the establishment of the National Library of Australia (1960) and the National Gallery of Australia (1982), and for a while it appeared likely to be stillborn. While the idea of a national museum may lurk inevitably behind the idea of a national capital, as one of the symbols of nationhood, in Australia's case the gestation period was long and the birth late. The delay has had a significant impact on the final form of the museum, since it finally came into being at a moment when Indigenous Australians began once again to occupy a central space in Australian political and cultural life.[1]

The 1960s had seen the significant emergence of Indigenous Australians into the national political arena. The 1960s and 1970s saw the development of the campaign for land rights in the north of Australia, the demand for equal wages in the cattle industry, the end of segregation in New South Wales country towns, and a burgeoning civil rights movement that set much of the national political agenda. At the same time, Aboriginal culture, which had been rendered almost invisible by the evolutionary lens through which it was seen, began to make an increasing impact on Australia's cultural life. The place of Aborigines in the Australian nation and the redressing of their disadvantage

became major issues that presented no easy solution. Australian governments in the last quarter of the twentieth century tackled many of the problems associated with discrimination and introduced land rights and native title legislation. They also increased the resources allocated to overcome the problems of two centuries of colonization. While none of these problems has been resolved, the national agenda has moved since the 1990s toward seeking a state of reconciliation, in which Indigenous Australians and non–Indigenous Australians, while acknowledging their differences and the past history of injustice and indifference, will work together in a process of nation building. This hopeful agenda has been somewhat undermined by the prime minister's personal determination not to actually apologize for past injustices and by the watering down of beneficial native title legislation.

In 1965, the anthropologist W. E. H. Stanner wrote an influential article in the *Canberra Times* under the headline "Gallery for Southern Man for Canberra." He argued that such a gallery would tell "the story of the discovery, mastery and enrichment of the continent by the Aborigines . . . one of the most splendid tales of its kind that any country in the world can offer."[2] Stanner was an influential public figure in the small-town capital city that Canberra then was, and the idea of a museum that celebrated Australia's Indigenous heritage proved fertile. The Whitlam Labor government was elected in 1972 with, among other initiatives, a major agenda on Aboriginal rights and cultural heritage. It commissioned a report by Peter Pigott on the establishment of a national museum; this report contained the summary of a separate report on a Gallery of Aboriginal Australia.[3] The recommendation resulted in the establishment of what amounted to an imagined museum that for some time seemed destined never to find a home. Successive governments were elected with a mandate to build a national museum, but it was not until the election of the Howard coalition government in 1996 that the promise was fulfilled. The museum that was built was smaller in scale than the one recommended by the Pigott report, and it focused on three central themes: land, people, and nation. In addition, a major section of the museum was to be set aside for the development of the First Australians Gallery.

The central role played by the First Australians Gallery in the National Museum of Australia is a reflection of a number of factors. Some of these connect to an earlier history of museums and collections, while others reflect the national purpose and the political issues of the time. The museum already had a collection-in-waiting, the National Ethnographic Collection, which was housed in the Institute of Anatomy together with the National War Wounds Collection. The ethnographic collection largely comprised objects collected by researchers from the Australian Institute of Aboriginal and Torres Strait

Islander Studies, itself founded in the 1960s, together with some earlier collections from Australia and elsewhere in the Pacific made by government officers.

The purpose of an exhibition or an institution is likely to be radically influenced by its historical positioning. The National Museum of Australia's late arrival on the scene required it to contextualize Aboriginal artifacts in a very different manner from how they might have been fifty years earlier, or even in Stanner's imagined Gallery for Southern Man. There was likely to be less emphasis on the "traditional" past and more emphasis on contemporary ways of life, more emphasis on history and politics and less emphasis on culture. During the period of the museum's gestation, Aborigines had moved from past to present, from assimilation to self-determination, from public invisibility to considerable prominence.[4] Aborigines were part of the national agenda and part of Australia's developing image. Their political prominence made both their cultural products and their civil rights matters of international interest. The directors appointed to oversee the development stage of the National Museum of Australia and its opening exhibitions were both Indigenous Australians — Bill Jonas (an academic) followed by Dawn Casey (a leading public servant).

Museums are complex institutions with multiple functions. At the core of most museums are two activities: the making and preservation of collections, and the display and interpretation of those collections to the public. Both of these activities are what I have referred to elsewhere as "value creation processes."[5] These processes are ones in which particular kinds of interpretations and evaluations of objects are presented and disseminated. Museums as authoritative cultural institutions with large audiences are ideally positioned to create value and influence people's conceptions of their past. Value creation processes influence both the sociocultural and economic value of things: value can be converted into economic return both through the increasing market value of the object and by increasing the resources devoted to its conservation, display, and dissemination.[6] Interpretation can change the way people think about objects and the cultural and historical contexts in which those objects can be placed and framed. The balance between objects and interpretation has shifted somewhat over time as the "age of mechanical reproduction" allows for ever-increasing substitutions and additions to the "exhibit." Indeed, the interpretative purpose can be conceived of as being relatively autonomous of objects.[7] The National Museum of Australia has foregrounded storytelling as its exhibitionary genre, fitting neatly Tony Bennett's encapsulating phrase that "the power to 'show and tell'" has become the rhetoric of the new museum.[8]

As integral components of value creation processes, museums become sites of persuasion that people attempt to use to get their version of history and

their regime of value acknowledged and disseminated to wider audiences. The board of the museum, the political sponsors, the curators, and the public are all pressing "museums to display the version of history [they] prefer."[9] A national museum has as part of its agenda the representation of the nation to itself. But that view of the nation's self has to be constructed and must acknowledge or deny the diversity of the people who are contained within it. The ideology of the National Museum of Australia's planners, perhaps somewhat radically, was to recognize the unfinished and contested nature of national identity: "The museum where appropriate should display controversial issues. In our view too many museums concentrate on certainty and dogma, thereby forsaking the function of stimulating doubt and thoughtful discussion."[10] Somewhat presciently, as it proved, the director of the museum, Dawn Casey, wrote: "We are opening and presenting our messages to the public at a time when the issue of 'Australianness' is being debated possibly more vigorously than in any other period of the nation's history. . . . We accept from the outset that there will be disagreements about the way we examine historic processes or about our very choice of themes and stories and issues."[11] However, it was not so much Australianness as a general concept but rather the representation of Aborigines and Aboriginal history that became the focus of controversy.

In developing the First Australians Gallery, the members of the curatorial team were presented with a number of issues. They had to confront the colonization of Australia, the history of massacres and population decline, of disadvantage and deprivation, and they had to show the diversity of lifestyles and values of contemporary Indigenous Australians. The greatest resource that the museum possessed in terms of collections was items of material culture and art that reflected the traditional way of life of Australian hunters and gatherers as they had been at the time of European colonization. While this was acknowledged as an important resource connected to Australia's history and prehistory, the curators recognized the need to avoid a past-oriented view of Aboriginal Australians or one that positioned Aborigines low down in an evolutionary sequence of human cultures. The curators needed both to separate Aboriginal culture from its association with evolutionist perspectives on Aboriginal Australians and yet at the same time allow Aboriginal people who continued to practice traditional ways of life to be counted as contemporary Australians. The task is a difficult one since contemporary Indigenous Australians, while sharing much in common across Australia, have had very different colonial histories and differing and sometimes competing conceptions of their identity. The exhibitions have had to confront the fact that while some Indigenous Australians are lawyers, leading public servants, or museum directors, others are oriented toward a hunter-gatherer way of life and continue into the present

holding to beliefs and practices that for much of Australia's colonial history were associated with a disappearing and devalued way of life.

The most controversial aspects of the First Australians Gallery proved to be the sections dealing with colonial history and the conquest of Aboriginal land, in particular the issue of frontier conflict.[12] The issue of frontier conflict, the invasion of Aboriginal land, and the forced removal of Aboriginal children are painful issues to most Aboriginal Australians but unproblematic in the sense that they happened and had a major impact on their lives and histories.[13] However, some members of the museum's council and conservative historians conducted a strong campaign against the museum's representation of frontier violence. The exhibition planner's original intention was that such representations would be a step toward reconciliation through admitting the injustices of the past. Other areas of the First Australians Gallery have been much less subject to controversy. Among these was the "Yingapungapu" exhibition.

The agency of Indigenous Australians from northeast Arnhem Land, and in particular Yolngu people from Blue Mud Bay, was centrally involved in curating this exhibition.[14] While on the surface it appeared apolitical, it reflected an ongoing campaign to protect their rights in law and maintain their autonomy. In the colonial history of Australia the frontier at times moved more slowly than at others, and the people of northeast Arnhem Land came under colonial rule as late as the 1930s. Their history of resistance has been as strong as that of other Indigenous Australians, but the timing of the invasion of their lands enabled them to avoid the worst of the massacres and eventually retain control over most of their land. To them, their distinctive way of life is not a sign of past ways of life but a motivation for their present political action. The "Yingapungapu" exhibition was not singled out for political controversy because it could be interpreted by others as a representation of a traditional way of life associated with the past, yet it is every bit as political and entangled in value creation processes as the more overtly political aspects of the opening displays. Indeed, the main motivation for the Yolngu to take part in the exhibition was that while they have secure tenure over their land, they are still involved in the struggle to gain rights in the sea, which they see as an indissoluble part of their inheritance.

One of the main changes in museums over the last thirty years has been a greatly increased involvement of indigenous people. This has taken many different forms: involvement in the planning of exhibitions has influenced the ways in which cultures are represented, active participation in the curation of collections has enabled people to regain some control over their objects, and roles in the management of museums have enabled them to gain a stake. The forms of involvement vary greatly according to the colonial history of the

particular state and the degree of empowerment accorded to its indigenous populations.[15] In Australia these developments are probably as far-reaching as anywhere else. Exhibitions routinely involve consultation with the indigenous group concerned, museums facilitate access to collections, considerable potential control is exercised over collections by the object's makers and their descendants, and Indigenous Australians are playing an increasing role as museum professionals in managing and curating collections.

There is a danger that these changes of the last thirty years may mask longer-enduring continuities of cultural process and engagement and may result in the downplaying and even denial of ongoing indigenous agency. I would argue that the value creation processes of museums have been influenced strongly by indigenous peoples. They have been more active agents in their own representation than has often been allowed. The revisionist position (which is mine as well) holds that in two areas — the building of collections and cultural performance — indigenous people have been more than passive subjects. The majority of objects in museum collections are ones that have been manufactured for sale by indigenous people. The circumstances of the sale have varied greatly: sometimes they have involved seizing limited economic opportunities provided in oppressive colonial regimes, while in other contexts purchases by museums have been a component in an expanding trading system.[16] However, the sale or exchange of goods has seldom been for economic reasons alone. Artifacts have entered museums as part of processes of value exchange, and of internal adjustment and transformation. Material culture is a means of educating the outsider into the beliefs and value systems of a society, a means of asserting that objects of value exist within it; transactions involving material culture are a means to lock outsiders into commitments and cycles of exchange.[17] This dimension of the artifact trade is one that until recently has been neglected, yet it is one for which, at least in Australia, convincing evidence exists. It was masked partly by the criterion of authenticity once used by museums. "Authentic" objects could be used for internal exchange, but their involvement in transactions with Europeans ran counter to the view that they emanated from isolated, self-contained, uncontaminated societies. It is also the case that until recently there was little contextual data on collecting, and evidence of indigenous agency went unrecorded.

Similar considerations apply to the cultural performances associated with museums. They have been doubly problematic: the radical cultural critic views them as appropriations whose form is constrained by an alien performance context, and the anthropologist too often sees them as an inauthentic pastiche.[18] There has always been a relationship between museums and other forms of public entertainment. People have often used museums as part of

the process of performing difference. The Enlightenment brought Omai from Tahiti to the salons of Europe; anthropology helped bring Ishi into the museum in San Francisco.[19] There is a clear link between the way the artifacts are displayed and the way the performance is understood. People, it might be argued, go to the performance to see the exotic, to seize their last chance of seeing the "savage," captured and safely displayed, before he disappears. Yet there is a danger, in making this argument, of failing to see and understand the motives of the indigenous performer — indeed, of not seeing these as an issue at all.

The exhibition, titled "Yingapungapu," occupies the temporary exhibition space in the First Australians Gallery. The exhibition is a collaborative effort that involved a continuous process of consultation with Yolngu people from Blue Mud Bay, from the inception of the idea to the opening ceremony. The exhibition primarily consists of objects, "props," labels, and photographs, but there is a strong performance element to it. The focus of the exhibition is a *yingapungapu* sand sculpture, in the center of which are three hollow-log coffins. The sand sculpture was made in a ceremonial performance, and in a sense continues to mark a ceremonial space (figures 1 and 2). Films, made for the exhibition, that contextualize the sand sculpture are continuously screened in an adjacent mini-theater. My aim in this essay is to place the exhibition in the context of the recent history of Yolngu involvement in cultural events, to consider both their motivations and the consequences that such participation has within Yolngu society. Yolngu view museums as sites of persuasion, where the dominant society is seen to include Yolngu cultural performance in its own world and to learn something of Yolngu values and way of life. Recent Yolngu engagements with museums and national cultural events are part of a much longer history of exchange and involvement with people from other cultures and with public spheres of different scopes. Over time, those involved in such exchanges and negotiations with Yolngu have changed, at times becoming increasingly global in nature and reach. Recognizing the ways that Yolngu have communicated and acted as brokers in shaping these relations is also important because their roles would seem to confound a number of categories and expectations in recent literature on museums and exhibitions.

THE "YINGAPUNGAPU" EXHIBITION

Cross-cultural events and performances often involve mediators and entrepreneurs who move between different frames of cultural action. A major component of the National Ethnographic Collection, which became the core of the Museum of Australia's collection, was built up as a result of research by grantees of the Australian Institute of Aboriginal and Torres Strait Islander

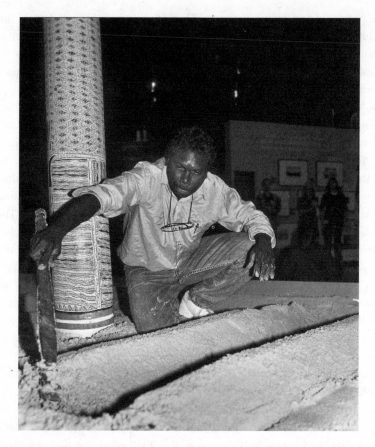

1. Wanyubi Marika uses his spearthrower to sculpt out the final shape of the *yingapungapu* sand sculpture at the National Museum of Australia. Wanyubi's mother belonged to the Dhalwangu, one of the clans that own the *yingapungapu*, and he has the responsibility to set the form of the sculpture. Beside him is a hollow log coffin belonging to the Madarrpa clan, painted by Djambawa Marawili. The diamond design represents the fire pattern associated with the crocodile ancestral being Baru. The design at the bottom is associated with the ancestral snake Mundukul at Baraltja. Photo by George Serras, National Museum of Australia.

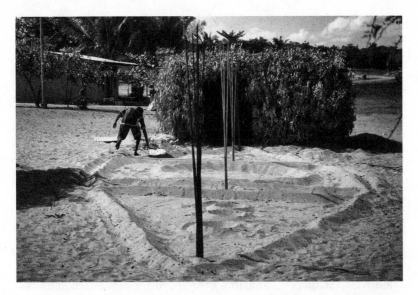

2. This sand sculpture at Yilpara was made the day after the burial ceremony for a Madarrpa elder. The *yingapungapu* stands in front of the hut in which the man's body lay for the duration of the ceremony. The three sets of spears represent the three peninsulas associated with the ancestral Wuradilaku women: Garrapara closest to the camera, then Yilpara, and finally Djarrakpi. After the participants have been "freed" from pollution by washing and by being brushed with smoldering branches, the hut is set on fire. Photo by Howard Morphy.

Studies, and I was one of those grantees. I had made a collection of some 150 paintings from eastern Arnhem Land during fieldwork for my doctoral dissertation in the mid-1970s.[20] In the early stages of planning for the museum's opening exhibitions, Luke Taylor, who was then responsible for developing the First Australians Gallery, approached me and asked if I would like to put forward a proposal to curate a segment on Narritjin Maymuru (1912–1981) and the art of the Manggalili clan. Narritjin was a leading bark painter and carver who played a major role in the Yolngu struggle for land rights. My current research centered on writing his biography, and the museum has what is probably the largest single collection of his paintings. I expressed an interest, but did not take things further until when, in conversation one day at Yirrkala in northeast Arnhem Land with Narritjin's "daughter" Naminapu, I was struck with the idea of curating an exhibition based on a *yingapungapu* sand sculpture.

A *yingapungapu* sand sculpture is an elliptical form used in mortuary rituals to contain pollution associated with a burial ceremony and to cleanse people after the burial has taken place.[21] Between 10 and 20 m² in size, the sculpture can be made at different stages of a funeral. It can be made at the beginning to

contain the shelter where the dead body lies or made toward the end to purify those who took part in the ritual. The construction itself is a part of the ritual performance. In the purifactory stage of the performance it provides the arena for washing and smoking ceremonies in which certain categories of relatives, or people who have performed particular roles in the ceremony, are "freed" so that they can return to everyday life. Today it is also used for purifying vehicles that were used in the ceremony to carry the body, or objects used in the ritual. It can also be a context in which people express anger at those believed to have caused the death, and discharge feelings of aggression.

As with any Yolngu ritual artifact, the *yingapungapu* sand sculpture has a place in a social system confirmed by its mythological or ancestral heritage. *Yingapungapu* sand sculptures belong to four clans of the Yirritja moiety linked by the myth of the Wuradilaku sisters, ancestral women who traveled from Groote Eylandt to the mainland, creating sites along the coast. Three of the clans — the Dhalwangu, the Madarrpa, and the Manggalili — are closely linked through intermarriage.[22] The fourth, a Gupapuyngu group, is considered distant from the others. The Wuradilaku sisters were said to hide from men; they were women of extreme modesty who fished and collected shellfish offshore from the coastal dunes. They covered their bodies with sheets of stringy bark or hid inside giant shells. When they had eaten their fill they buried the fish remains in shallow scooped-out ovals in the sand, where maggots gathered to clean up the remnants. These scooped-out hollows became the model for the *yingapungapu* sand sculpture used in mortuary rituals to contain pollution, and the mythic journey of the Wuradilaku women provides the basic structure followed in the ritual. The Wuradilaku women are particularly closely associated with places on three peninsulas that extend out into the north of Blue Mud Bay: Garrapara of the Dhalwangu clan, Yilpara of the Madarrpa clan, and Djarrakpi of the Manggalili clan. Each of these places is the site for historic burial grounds where people have been interred for generations (figure 3).

A TRAVELING CEREMONY

The recent history of the *yingapungapu* sand sculpture, however, includes extending its use to give Europeans access to ceremonial performance. I have argued elsewhere that Yolngu have a history of using art and performance as a means of attempting to persuade outsiders of the value of Yolngu culture.[23] While the early history of such exchanges is hard to document, there is strong evidence for the involvement of the Macassans in Yolngu ceremony, perhaps for several centuries before European colonization.[24] Yolngu mythology is in part an ethnography of the outsiders they have encountered, from the de-

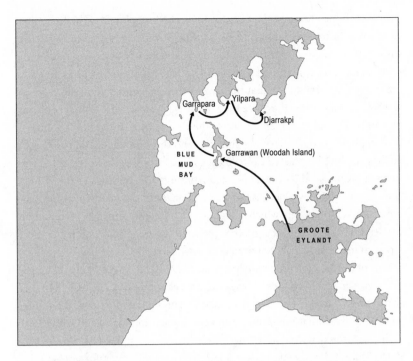

3. Journey of the Wuradilaku spirit women. Map by the Centre for Cross-Cultural Research, Australian National University.

tailed accounts of the activities of the Macassans to those of Yolngu neighbors the Groote Eylandters, in the Wuradilaku mythology.[25] Yolngu exchanged names with Macassan sea captains, and there are many Macassan references in Yolngu rituals.[26] This history of exchange may explain in part the willingness of Yolngu to allow anthropologists such as Donald Thompson (1949), Ronald and Catherine Berndt (1954), and Lloyd Warner (1958) access to ceremonial performance, and to engage in the sale of art and material culture. I have, in fact, argued that this may be a much more general characteristic of Aboriginal colonial history.[27] The many early accounts and engravings of ceremonial performance suggest that, where they were able to, Aboriginal people attempted to use ceremony as a form of engagement, only for their actions to be rebuffed or misinterpreted. In eastern Arnhem Land, Yolngu have from the beginning extended ceremonial performance to intercultural occasions such as the farewell of a missionary or the welcoming of a politician, and with time these events have become increasingly elaborate.

In 1971 Narritjin Maymuru decided to open up the memorial ceremony commemorating his brother Nanyin, who had died the previous year, to the

people of the newly established mining town of Nhulunbuy.[28] He had a number of different purposes in mind. Today it would be called a gesture of reconciliation. After years of opposition to the development of bauxite mining on the Gove peninsula, Yolngu had lost the Gove land rights case and mining had commenced. Narritjin felt that the more Europeans understood the values of the Yolngu way of life, the more they would be sympathetic to their concerns. Narritjin also saw the opening out of the ceremony as providing a source of income, both through a paying audience and through the sale of paintings it could generate. He created his own art gallery from sheets of corrugated iron outside his house at Yirrkala and sold paintings and carvings to the visitors. The ceremony that was performed centered on the construction of a *yingapungapu* sand sculpture into which a large and elaborately painted box, containing his dead brother's clothes and other possessions, was placed before burial. In a speech to the audience, Narritjin drew an analogy between gifts of money as means of purification and white paint, arguing that it was unlikely that European women would choose to cover themselves with clay, so instead their husbands might hand over a dollar on their behalf—if the men paid, the women would be "free," that is, cleansed from ritual pollution associated with death.

Tracing the origin of an event such as this is a complex task. At the time it seemed a unique, extraordinary, and to an extent uncomfortable event— the opening out of Yolngu mortuary ritual to outsiders for money. Yet further research shows it as part of a historical process that arises equally out of Yolngu cultural practice, their engagement with outsiders, and the trajectory of Narritjin's own life. Purification rituals are among the most public and the most lighthearted of Yolngu rituals. They are as far "outside" as Yolngu rituals go and involve the equal participation of men and women. Their objective is to "free" participants. The dances performed are often both joyous and humorous, and they are intended to generate a sense of well-being. Before the purification ceremony participants are often anxious and nervous about moving around the community, food cannot be consumed, and the local shop will be closed. Afterward people can resume normal activities.

Narritjin had himself taken a very active role in engaging with Europeans in the past. He worked as an assistant for the two Europeans who first established long-term relations with Yolngu: the trepanger (gatherer of bêche-de-mer, a type of sea cucumber) and pearler Fred Grey, and the founding missionary Wilbur Chaseling. Narritjin was an active bark painter who was very concerned to get a fair return for his work. In the early 1960s he is reported to have organized a strike of artists against the mission. He participated over a number of years in the Darwin Eisteddfod (a multicultural arts festival) and in 1962 toured venues in Melbourne and Sydney with a group of Aboriginal dancers

from Arnhem Land sponsored by the Elizabethan Theatre Trust. On that visit he was impressed by the Art Gallery of New South Wales, where bark paintings from Yirrkala hung in galleries adjacent to those holding European works. He saw this as a sign of their equivalent status. Narritjin produced *yingapungapu* paintings (which incorporate iconography associated with the sand sculpture, the mortuary ceremonies, and the Wuradilaku sisters' myth) for sale to Ron Berndt and the anthropologist Charles Mountford in the 1940s, and I was not at all surprised to see that the dances he led in Melbourne and Sydney were ones usually performed in a *yingapungapu* ceremony. Narritjin's opening up of his *yingapungapu* thus can be understood as part of a conscious process of engagement with outsiders that took account of both the consequences for the internal structure of Yolngu society and its appropriateness to the new context. The objectives were broad ones and not necessarily shared by all of the participants, but they included economic and political objectives as well as more abstract exchanges of value. Narritjin died in 1981, but the *yingapungapu* has continued to be used in new contexts. The most significant event was the construction of three *yingapungapu* sand sculptures outside the Museum of Contemporary Arts in Sydney in 1996 as part of the "Native Born" exhibition, curated by Djon Mundine. The exhibition was associated with both claims of native title to land and the related issue of copyright in Indigenous artworks, as well as the sculptures featured in Cathy Eatock's film *Copyrites*. The exhibition was the idea of Gawirrin Gumana, a minister of the Uniting Church, artist and leader of the Dhal̲wangu clan, and Andrew Blake, then arts advisor for Buku Larrnggay Mulka (an art cooperative), and was devised in order to demonstrate the operation of native title in Blue Mud Bay and the ownership of designs and ceremonies by interrelated groups. The connection with Narritjin's ceremony was recognized by dedicating the event to his memory (figure 4).

It should by now be apparent why I thought that the *yingapungapu* would provide a good subject for an exhibition at the opening of the new National Museum of Australia (NMA). The spectacular ceremony is one that Yolngu have long used in their engagements with outsiders, and as a cultural broker, I could feel confident that I was following a direction that Yolngu had already taken.

CURATING THE EXHIBITION

The initial stage of curating the exhibition was to get agreement from the leaders of the respective clans and begin discussing with them the possible scope of the exhibition.[29] I hoped to restrict the exhibition to the three Blue Mud Bay clans strongly associated with Yirrkala, but was concerned that

4. Sisters Ralwurrandji Wanambi Marawili and Boliny Wanambi stand by a photograph of their grand-father Narritjin Maymuru in the exhibition at the National Museum. They are in front of the section on Djarrakpi, their grandfather's country. A photograph of Djarrakpi provides the display's background. Narritjin looks out from the lake, framed by carvings and paintings he made. The exhibition evoked the relation between people, time, and place with sets of images extending out from the surface of the landscape and leading the viewer back into the place. The sisters' presence enhances this dimension of the exhibition, bringing it into the present. Photo by Dean Golja, National Museum of Australia.

Yolngu protocol might not allow for the exclusion of the fourth group. However, Gawirrin Gumana, the distinguished leader of the Dhalwangu, argued strongly that the focus should be on the Blue Mud Bay clans since they had a long history of working together.

He and the other clan leaders also saw an exhibition in Canberra as a means of continuing to demonstrate to a national audience their native title rights over the coastal waters of Blue Mud Bay. The people involved had been among the initiators of the Saltwater Country project two years earlier and saw the *yingapungapu* exhibition as a means of continuing the argument.[30] The Salt-water paintings were a set of large bark paintings produced in response to the illegal activities of barramundi fishermen in the coastal waters of Blue Mud Bay. The paintings were designed to show that Yolngu ritual law covered the sea as much as the land. The paintings toured Australia and have been purchased by the National Maritime Museum in Sydney. The native title focus may subsequently have been reinforced by the fact that a native title claim to the waters of Blue Mud Bay is now under way.

The initial discussions I had with leaders of the Dhalwangu, Manggalili, and

Madarrpa clans suggested general support for the idea of a *yingapungapu* exhibition. However, I felt I could not take anything for granted, since lines of authority in Yolngu society are complex and there are major internal divisions within some of the clans involved. Moreover, it is necessary to maintain the support of the *waku* group, that is, children of women of the clan who would actually make the sand sculpture and authorize its use. Agreements are fragile because Yolngu political processes, as Nancy Williams has argued, are oriented toward consensus, and the public disagreement of any party can prevent a decision from being taken.[31]

Once the Yolngu had agreed to take part in the exhibition, I suggested that the museum make a contract with Buku Larrnggay Mulka, a local art center, to help facilitate the exhibition process. This was partly because it proved necessary to commission a number of objects for the exhibition. In addition, art centers in Aboriginal communities have developed as mediating institutions partly because they lie outside the bureaucratic and functional constraints of other local organizations. The Buku Larrnggay art center is governed by a board of artists drawn from each clan. It has taken on the responsibility for copyright and other areas of cultural liaison with the outside world. The exhibition would require the participation of a group of Yolngu dancers at the opening, and the art center had experience in organizing such events.

INTERACTIVE DESIGN

The exhibition design developed over a period of two years and involved liaison with Yolngu and NMA staff but also with the Boston-based design team that won the contract to oversee the overall project, as well as the Acton Alliance, a Canberra-based consortium of government and business that was responsible for the building and the installation of the exhibition. The latter was being carried out by museum staff in association with a private contractor, Thylacine. Creating the national museum and its exhibitions, then, was an international project that entailed negotiating a range of local and international interests and agendas, as well as different ways of working and imagining the final product. Liaison with Yolngu was by far the easiest part of the process.

Anthropologist and co-curator Pip Deveson and I developed a simple design that aimed to explicate the sand sculpture and place it in context. We wanted to show how the sand sculpture related to place and how it was used in ritual contexts, to represent the symbolic themes it contained, and so on. For an organizing structure we decided to focus on the journey of the Wuradilaku women as they visited each place in turn. We would emphasize the differences and similarities between the places and put them in the context

of their ancestral and human history. While each place has a *yingapungapu* sand sculpture, each differs in subtle ways from the others. We intended to use this as a way of showing the uniqueness of each place and clan, yet also their interconnectedness.

Curating an exhibition in a museum is a complex process, made more complex in the case of the NMA by the constraints of the building and the division of functions. When it was first suggested that I should curate an exhibition, the design competition for the building had not been held, and in my imagination I had been designing the exhibition for an unbounded free space, or for a large boxlike structure with straight walls. We were going to reconstruct the coastline of Blue Mud Bay so that the audience could visit each place in turn. The myth and history of each place would be represented through paintings, sculptures, and historical and contemporary photographs. In front of each "place" would be the *yingapungapu* associated with the respective clan in question, although we also considered the possibility that space constraints would require a single sand sculpture to represent all three. When the design of the museum space finally arrived, we realized that we had no option but to have a single sculpture. We were allocated the largest open space in the museum, but it was neither unbounded nor regular. Like every space in the museum, the room has walls at irregular angles that intersect in every way imaginable. The space was divided in half by a grand staircase. We realized that the shape of the gallery had two consequences: one was that the sand sculpture would have to be constructed in one half and the contextualizing exhibitions in the other. The second was that the geographical order of places would have to be reversed. The entry point to the exhibition meant that the visitor had to walk along the coastline from east to west, but the ancestral women had journeyed from west to east. We had to either reverse the order of the journey of the ancestral women or swap the locations of Garrapara and Djarrakpi, the journey's two endpoints.

When Pip and I returned to Yirrkala, then, we had two problems that needed solving: (1) Could one sand sculpture represent all three places? (2) Did it matter that we could not follow the geographic logic of the landscape?

The first problem solved itself in two stages. Mungurrapin Maymuru, a Manggalili elder, argued that since the sand sculptures were differentiated on the basis of the number of holes that were inscribed within them, a sand sculpture without any would function for all three. When I put this proposal forward at a subsequent meeting no one disagreed with Mungurrapin's suggestion, but they were reluctant to merge all differences. The problem was solved when Djambawa Marawili, the chairman of the artist's committee, suggested that a hollow-log coffin belonging to each clan, each with its own distinctive

clan designs, should be placed inside the *yingapungapu*, thus representing both similarity and difference.

The geographical conundrum seemed unproblematic to most but came closest to causing the house of cards to fall. The first people I asked understood the problem and felt that as long as the viewers approached each place in the right order, that would be sufficient. It did not matter that Garrapara was in the "wrong" geographical position as long as it was the first place visited, as that was the direction of travel of the Wuradilaku. I had only one other group to discuss the matter with — the Manggalili. They had previously been happy with the order of the exhibition, but a senior Manggalili woman now argued that geographic logic *did* matter and that in any case if the places were correctly in geographic space, this was indeed the correct order in which the places should be seen. Certainly the women had traveled from west to east, but they really belonged to each place. The real order should be from Djarrakpi to Yilpara to Garrapara, as that reflected the relationship between the clans. Manggalili were mother's mothers to both Madarrpa and Dhalwangu and hence should have precedence over them. I spent a long time discussing this issue, explaining that each place would be treated equally in the exhibition. I also felt that the concept of the journey of the Wuradilaku would be easier for the non-Yolngu audience to grasp as an introductory concept than one requiring an understanding of Yolngu kinship. Eventually all agreed to follow the theme of the women's journey.

Many details of the exhibition were added by Yolngu or resulted from discussions with individuals. It was Djambawa, for instance, who suggested that we put up a Macassan sail on the wall opposite displays representing the promontories of Garrapara, Yilpara, and Djarrakpi, to give the feeling of looking out to sea and to show the symbolic connections between the sail and the cloud. *Yingapungapu* sculptures and paintings both condense multiple layers of symbolic meaning, combining references to Yolngu myth and history, mortuary ceremonies, and community understandings of death, and also evoking a related range of heightened emotional experiences — all organized through the story of the Wuradilaku women's journey across the land. Incorporating this complex world of meaning and evocation in ways that were simultaneously satisfactory to Yolngu and comprehensible to museum visitors was part of our challenge in creating the exhibition. A key element of the iconography of *yingapungapu* paintings, for instance, is an anvil-shaped figure representing a wet-season cloud. The shape of the cloud varies for each clan. The cloud is a central component of Yirritja moiety mortuary symbolism. A distant cloud is the sign of a storm at sea and a portent of death. Clouds also symbolize the emotion generated by a death. However, clouds also call to mind the Macassan voyagers

who once set sail for northeast Arnhem Land each wet season to trade with the Yolngu. The cloud design is similar in shape to the sails of the Macassan praus, which, when first sighted from the shore, appeared like the cumulus clouds on the horizon. The Macassans in turn are connected both with Yirritja mortuary rituals and with the Wuradilaku women. The farewell ceremonies held for the Macassans at the end of the wet season when they returned with their catch to Sulawesi were a time of sadness and celebration. In mortuary rituals the farewell to the Macassans is an analogue for saying farewell to the spirit of the departed. The blue-and-white cloth shade placed over the grave today is shaped like a Macassan sail. The Wuradilaku women are associated with both the cloud and the sail. The clouds are seen as spirits of the Wuradilaku women's breasts billowing out on the horizon. They voyaged from Groote Eylandt and are associated with the Macassan voyagers, who also traveled between Groote Eylandt and the mainland.

We discussed the content of each place represented in the exhibition with the clan leader concerned, and for the section on Garrapara, Gawirrin produced a new carving. We had originally wanted to have a scooped-out hollow of sand with a skeleton of a parrot fish laid in it. We wanted to show with this the relationship between the ancestral women, the burial of fish, and the invention of the *yingapungapu*. The museum staff were unhappy with the idea of fish bones, and the scooped-out hollow of sand did not fit in with the designer's overall design concept. So Gawirrin instead carved a figure of the ancestral woman from Garrapara in the form of her digging stick, with a *yingapungapu* engraved on it and a fish carved in relief inside (figure 5).

Yolngu came down to Canberra on three occasions to discuss the plans for the exhibition, look at the site, and finally to check that it met with their approval. Their response to the exhibition was generous: they were happy with how it finally looked and pleased with the prominent place it had in the museum building. It is difficult for me to apportion responsibility for the exhibition between the Yolngu and non-Yolngu curators. I have worked with the people from Blue Mud Bay for nearly thirty years and have written much about *yingapungapu* sand sculptures from paintings of them. The objects in the exhibition were all produced by Yolngu, and the way we organized them to show the relationship between components, as well as the images we constructed to illustrate their symbolic referents, simply reflected the way I had been taught to see them by Narritjin, Gawirrin, and Djambawa. Clearly, incorporating these understandings and explanations into an exhibition format creates a context that is very different from the *yingapungapu* ceremony as a means of communicating ideas and meanings. However, the ceremonial performance itself is only one of the contexts in which Yolngu themselves learn about the mean-

5. Gawirrin Gumana looking at his carving of Mamaparra, the spirit woman at Garrapara associated with the *yingapungapu*. Gawirrin's sculpture combines key elements of the *yingapungapu* mythology. Digging sticks that the women used to gather food are carved as raised elements on either side of the sculpture. The woman's body is represented by the oval shape of a *yingapungapu* with a fish carved in the center. Her head is represented in skeletal form surmounted by a representation of the cloud that signaled the death of the fishermen out at sea. Howard Morphy stands beside Gawirrin. Photo by George Serras, National Museum of Australia.

ings that are experienced and conveyed. Yolngu learning involves producing and looking at paintings, learning songs and dances, traveling to significant places, and walking through landscapes, as well as (today) books, film, and digital media. The exhibition becomes another way in which the forms and ideas can be presented. The new context is added to the variety of contexts in which Yolngu perform elements of the *yingapungapu* complex, a modification influenced by the demands, potentialities, and constraints of the situation. The museum audience itself has a more limited means of accessing the Indigenous experience of the *yingapungapu*, and the performative elements can only be glimpsed through the windows provided by the accompanying video or imagined by the space created by the sand sculpture.

Teaching is an integral part of Yolngu cultural performance, and teaching outsiders is an extension of Indigenous practice. Ceremonies are put on partly to show people something that they have never seen before, partly for the joy of the experience, and partly to gain knowledge. This was brought home to me most profoundly when years ago I attended the funeral of a Dhaḻwangu

boy, an eldest son of great potential who had died tragically in a car accident, one of the first Yolngu victims of alcohol. During his burial ceremony a whole series of dances from restricted regional ceremonies were performed. The explanation was that people were sad that he was going to miss those ceremonies in his life, so they performed them for him at his burial. The exhibition at NMA was treated as an education for the audience and its preparation as part of my continuing education. Although I had written much about *yingapungapu* ceremonies and documented Ian Dunlop's 1987 film of Narritjin's ceremony, I had never actually been at a performance. In August 2002 I was asked by Djambawa to come to Yilpara for a week to film a burial ceremony of a Madarrpa elder. The day after the ceremony I was told to get ready to film the cleansing ceremony. I do not think it was a coincidence that it was done through the performance of a *yingapungapu*, enabling me to film it and incorporate it within the exhibition—though I had never mentioned the possibility to anyone.[32]

YINGAPUNGAPU IN CANBERRA

The opening of the National Museum had been planned to be one of the major events in celebration of the centenary of Australia federation. It was a major international event with a large gathering of media, yet simultaneously designed as a party for the people of Canberra, the nation's capital. The strong emphasis on Indigenous Australia in the conception of the museum meant that a strong Indigenous presence was required in the opening performances, and performance at the opening became the means by which a group of Yolngu dancers was able to attend the event.

The culmination of the exhibition, as far as I was concerned, was the building of the sand sculpture at the museum the day before the opening of the exhibition. The plans for the opening performance were in a continual state of flux over the two and half years of preparation for the exhibition. It was always understood that Yolngu would build the sand sculpture as part of a ceremonial performance at the time of the opening. The one thing that was made clear to me at the start by the clan leaders was that they and a representative group of dancers would have to be involved in the opening of the museum. The sculpture could only be made as part of ritual performance. Djambawa's original idea was that they would make the sand sculpture one day and install the hollow-log coffins in a public performance the following day. However, this was not possible both because of the constraints of space and because of the staff's fear of spreading sand all over the museum. In the end it was decided that they would make the sand sculpture in a private ceremony the day before the museum opening and in the evening introduce the prime minister to

the exhibition in between courses of the celebratory dinner. They would perform publicly on the opening afternoon in the Garden of Australian Dreams — a concrete architectural feature that occupies the museum's central courtyard.

On the day the Yolngu arrived in Canberra plans changed on an hourly basis as the museum tried to fit all of the events into its busy schedule. The Yolngu were originally going to build the sculpture in the afternoon, following the blessing of the Torres Strait Islands canoe. But at an hour's notice the performance was switched to the morning. The performance for the prime minister was originally curtailed for scheduling reasons, but it turned out that in any case he had double-booked for dinner. The Yolngu were extremely disappointed, as they had worked out precisely the dance that they would perform for the prime minister: its English gloss is "wake up!" They assured me it was nonviolent.

The *yingapungapu* sand sculpture was made in a large tray of sand, in the center of which the three hollow coffins had already been fixed. The ceremony started, as Yolngu ceremonies do, with the almost desultory tapping of a clapstick, then a song or two followed by an interval. This allowed the audience of museum staff, a contingent of the international media, and a few distinguished visitors to build up. The performance when it began was full of drama, the floodlit patch of sand and hollow-log coffins standing out against the subdued lighting of the interior of the museum. The large photograph of the lake of Djarrakpi on the far wall created an ambiguous sense of place. The sand sculpture was made rapidly and energetically by the *waku* (children of women of the clan) under the watchful eye of Gawirrin. Next the dancers bunched together, gripping tightly the bundle of spears held between them while shaking, quivering, and rattling the spears to evoke the aggression of the *makarrata* (a peacemaking ritual). Finally they stepped into the sand sculpture and placed the spears against the hollow-log coffins (figure 6). While this final episode was going on I had been called aside to talk to the international press who were observing the event. At the height of the drama a French woman journalist took me aside and asked, "Is it real?" I replied, "What do you think?" and she said, "It looks real."

IS IT REAL?

The question of whether the performance is real is an interesting one, raising as it does all those issues of authenticity. It is possible to ridicule the French journalist's query: did she think the people weren't real? Alternatively, we could position her as someone holding a stereotypic view of what indigenous reality is, as someone who came to the museum with the expectation of seeing the

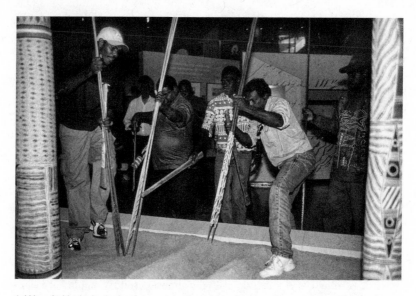

6. Wanyubi Marika leads the dancers into the sand sculpture on its completion. The dancers, as hunters and warriors, spear the ground. They then jointly hold the bundle of spears together in the center of the *yingapungapu*, vigorously shaking them as a symbol of strength and unity. Photo by George Serras, National Museum of Australia.

authentic, uncontaminated Aboriginal person, the human equivalent of the artifact honed with stone tools and picked up by the first European to set foot in the desert. Instead I am going to take the question as it was intended and look at different criteria whereby the ceremony's reality might be defined and assessed.

The dances and songs were taken from the sets associated with the respective clans' *yingapungapu*. I had seen them performed on many different occasions in different contexts. The set of dancers who came down from Yirrkala reflected the right-holders in the ceremony. The owning clans were represented by their clan leaders, the *waku* were drawn from five of the clans into which women of the owning clans married, and three of the representatives were the senior *djunggayi* (ritual experts) of the clans, the people who would mark out the ground in indigenous ceremonial contexts. Djambawa, the Madarrpa leader, and Baluka, the leader of the Manggalili, were both accompanied by their eldest sons. Djambawa said that it was the first time his son had been outside Arnhem Land, and he had decided it was time to begin training him to take over on public occasions. Djambawa himself played a different role from the one he had taken at the *yingapungapu* opening at the Museum of Contemporary Arts in Sydney six years before. On that occasion he had led the

dancing, while Gawirrin was the senior songman. On this occasion Djambawa joined Gawirrin as songman. If one considers the general form of dances and songs performed and the right and authority to perform them, then the NMA opening did not differ from what might have taken place in Arnhem Land. What other aspects of the performance might make it "real" or "unreal," from whose point of view?

The event seemed charged with emotion to me, and Yolngu said that they felt the emotion too. Gawirrin said that when the *waku* began to make the *yingapungapu* he had felt pain in his gut, his *gulun*, which to Yolngu is the seat of the emotions. Yolngu see the performance of ceremonies on occasions such as this as the giving of a gift, an opening up of something potentially powerful to outsiders.[33] The emotional tenor and texture of a performance and appropriate definition of the occasion for performance are also part of what might make it seem "real," but considering these aspects brings to light differences of opinion as well.

While the participants were confident in what they were doing, not all Yolngu felt as certain. A senior Manggalili woman had expressed disquiet to me some months before the event. She was not sure whether her father, Narritjin, and the other men of the previous generation had been right to open things up so much to Europeans. Inevitably that meant an opening up of things within the society, to women in particular, and perhaps this endangered them. She stayed with us the week before the opening of the Museum and deliberately chose not to stay on for the performance. Her concern was a general one since the *yingapungapu* ceremony itself and the dances and songs that are performed are public ones (*garma*), open to all members of society. On other occasions she has celebrated her father's vision in opening out ceremonial performance and encouraging women like herself to produce clan paintings. Her concern at that moment reflected contingent factors but also expressed the dialogic nature of change, in which individuals often contain within themselves the tension of alternative courses of action.

Disquiet is sometimes associated with a feeling that Yolngu get insufficient return for their gift. While some Yolngu see such events as a propaganda exercise, part of a process of persuasion that will bring long-term rewards, others are concerned with more immediate returns—or lack of them. I think that to the Yolngu participants the ceremony in Canberra was no more and no less real than any other *yingapungapu*: it was a context for the transmission of knowledge, for exercising ritual roles, for passing on authority, for entering into exchanges. It was a powerful experience and potentially a dangerous one.

Was it "real" in the sense of being uninfluenced by Australia's history and by its transformed context? Of course not, but then Yolngu reality is dynamic.

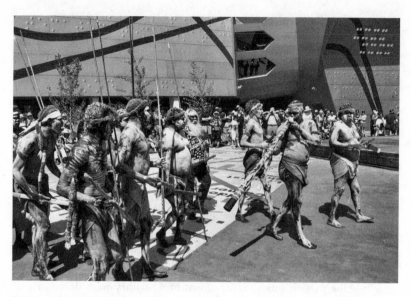

7. Yolngu dancers led by Djambawa Marawili perform at the opening of the National Museum of Australia, Canberra, on March 11, 2001. Photo by Howard Morphy.

This in itself can be interpreted merely as a cliché: all societies change, all people have to adapt to different circumstances. But I mean it in a stronger sense than that. Adapting ceremonial performance to the constraints of space is unproblematic to Yolngu; problems of scale are hardly problems at all. In their visual art Yolngu can create objects that fill a room or fit into a matchbox if required. In the case of dance, performance may take place with equal impact in a room of fifty people crammed around a corpse or in a football oval. This was demonstrated clearly in the dancing on the afternoon of the opening. The day before, we were told that the performance would take place on special mats provided by the Bangara dance group. These would protect people's feet from the hard, hot concrete of the Garden of Australian Dreams. On the day of the performance we were told that Bangara's mats had gone and that a stage had been erected for the performance and they would have to dance on that. With five minutes to go, they were told that the previous dance group from the Torres Straits had found the stage too hot and burned their feet, so they would have to dance on the concrete floor of the Garden of Australian Dreams (figure 7). The Yolngu seemed quite undaunted by all this. Their intention had always been to do a series of dances that followed journeys between places, interspersed with more static performances. Of course they could not resist trying out the hot stage that had defeated the Torres Strait dancers. The hollow stage vibrated with the dancers' feet as they transformed it into a giant musical

instrument, pounding it into submission in a spear dance. It was, however, too hot, and for the remainder of the performance they moved around all corners of the arena, dancing in front of different segments of the crowd.

What is real depends on the criteria employed and the expectations of participants in an event. In cross-cultural events involving local and global participants and audiences, what appears to be "real" to particular individuals will produce a polythetic set of reactions and interpretations that reflect different presuppositions about the nature of the event itself. There are potential areas of overlap in the experience of the real between Yolngu and their diverse audiences. Yolngu dancers and many of the outside audience shared criteria of authenticity: that this was a performance charged with emotion that could have been performed in the Yolngu homeland of Blue Mud Bay. The majority of the audience, of course, would have no basis for knowing whether this was actually the case and could only intuit it from their sense of the performance and how it resonated to them. They would also have imagined the Blue Mud Bay homeland as being more cut off than in reality it is, a separation confounded by the very context of the performance itself in the National Museum, but still present in the European imagination of the indigenous other.

Indeed, this imagined raw, cut-off, emotional world makes it harder for the audience to imagine other components of the Yolngu reality: the intention to hold a ceremony in Canberra to open up the minds of politicians to the recognition of their rights to the sea and to help expand global markets for their art and cultural performance. To Yolngu there is no incompatibility between the authenticity of their ritual performance and the contemporary reality of their lives, involving a homeland in which vehicles and shotguns are a component of hunting and gathering and a way of life that requires the lobbying of politicians and the marketing of art. Gradually audiences are becoming more aware of Yolngu conceptions of their contemporary reality, which in turn provides a challenge to preconceptions of the authentic primitive.

CONCLUSION: A PROCESS OF PERSUASION

It has been all too easy for some to assume that at the end of a colonial process all that is left is a pastiche of indigenous performance—tamed, safe, and encapsulated—cut to fit the interests of the colonizing. This view in its most simplistic is encapsulated in Fry and Willis's critique: " 'Aboriginal' culture is something manufactured within the parameters of professional norms of careerists; it becomes a culture from which Aboriginal people are excluded either literally or by having to assume subject positions made available only by 'the oppressor.' "[34] However, that view is often not substantiated by historical

research. Two fundamental problems with the view are that it presumes that the colonial process has ended and can no longer be resisted, and that it deems irrelevant the motivations and aspirations of the performers.[35]

From the beginning of the invasion of Australia in 1788, with the establishment of the British colony at Botany Bay, there is evidence that Aboriginal people tried to engage Europeans in the values of their culture by including them in ceremonial performances and trying to enter into relations of exchange. The record of those encounters is limited, however, and Aboriginal performance was soon masked by a "history of indifference."[36] The motivations of the Aboriginal people concerned have been little explored, though even in the Sydney region evidence of continuing cultural processes exists into the present. In eastern Arnhem Land the evidence is much richer and Aboriginal people can clearly be seen to have been involved in a long-term process of resistance and persuasion. The Yolngu have had a long history of encounters with outsiders — with traders from eastern Indonesia, European voyagers, and police punitive expeditions. In the 1930s, with the establishment of the first mission stations in the region, they came under effective colonial rule for the first time. For much of their colonial history they too have been met by an indifference that at times threatened to mask their agency. But Yolngu have continued to move their performances and artifacts into colonial spaces, occupying stages that they have helped to create. Such forms of cultural display are contexts and modes of interaction and communication through which different values and relations of power are negotiated. For Yolngu, *yingapungapu* have been a regular part of these processes, even as the nature and scope of the negotiations have changed over time to include various national and global circumstances.

From the 1930s onward, Europeans are likely to have been present at the performance of a *yingapungapu* ceremony on many occasions. The anthropologist Donald Thomson, who was sent by the government to eastern Arnhem Land in 1933 in lieu of a punitive expedition, recorded and photographed a *yingapungapu* sculpture. In the mid-1940s Berndt recorded details of the mythology and Mountford collected a number of *yingapungapu* paintings. In 1963 Yolngu dancers in Sydney and Melbourne performed *yingapungapu* dances to a backdrop of bark paintings by Narritjin Maymuru, and in 1971 Narritjin opened out his brother's *yingapungapu* ceremony to the miners of Nhulunbuy and Ian Dunlop filmed the ceremony. At some point during this process Yolngu began to see these events as a means of persuading Europeans of the value of their culture and way of life. They also began explicitly to see the recording of their cultural performances and the creation of archives and collections of their paintings as a means of preserving a record for future generations.

Over time the spaces their cultural performances can occupy have expanded. In 2000 Yolngu dancers (and a Yolngu rock group) performed at the opening of the Sydney Olympics before a global audience. From an external, presentist perspective it may appear that the dances at the opening of the National Museum or at the Sydney Olympics are the result of a colonial cultural process that has produced essentialized and distilled images of otherness performed to satisfy the imaginations of the dominant audience. From a Yolngu perspective, what that overlooks is the decades of resistance to their performances, the difficulties of gaining spaces for their art, the failure on the part of the wider society to show any interest in the meanings of their dances — in other words, the history of indifference to their cultural production. Ironically, what can be seen from one perspective as the production of stereotypes can be seen from another as a process of restatement, in which Yolngu again and again inserted particular ceremonial performances into different public contexts as the opportunities arose.

The performances have always required involvement with the colonial other in the form of anthropologist, missionary, government official, arts advisor, theatrical impresario, or miner, acting as anything from audience to entrepreneur. On many occasions the Yolngu themselves have been the entrepreneurs, controlling the stage and setting the conditions of the performance. On other occasions they have had many collaborators, some working with them, some indifferent to their motivations. Yolngu have been forced to deal with constraints of space, with misguided objectives, with inappropriate framings of their actions, and so on. But the process of persuasion goes on — a process in which their understanding of the dynamics and structure of the worlds into which they are moving develops as their agency extends into them.

While it may be the case that in the nineteenth century exhibitions were used to position indigenous peoples at the bottom of an evolutionary hierarchy, that should not deny their descendants in the twenty-first century the opportunity to present analogous cultural performances and displays as a means of asserting their autonomy and independence.[37] Indeed, to continue to argue that such exhibitions inevitably position Indigenous societies in the past would be to implicitly accept the validity of the nineteenth-century interpretations imposed on their material culture, positioned forever by a semiotic analysis of nineteenth-century motivations. Indigenous societies have to use the very institutions that created earlier interpretations to change the climate of opinion about their way of life. The more successfully they achieve this, the more they will be involved in a process that influences the very way in which the institutions themselves change. This kind of dynamic is one that may well affect the future shape of projects of international (global?) as well as national

scope, as indigenous peoples in different parts of the world consult with one another and form networks and associations of exchange/interchange on their specific situations, tactics, and strategies. Interestingly, as far as the audience is concerned, most of the negotiations that went on over the *yingapungapu* exhibition will make little difference. They have no concern about which way the ancestral women traveled around the coast, or details of the kinship relations between clans. Indeed, the audience may see relatively little difference between an exhibition in which Yolngu have a major curatorial role and one based on the same sets of artifacts in which they intervened less. To an audience that knows little about Yolngu culture, the initial impact is made by the objects themselves and the films and photographs that contextualize them. However, the fact of Yolngu engagement is fundamentally significant. The museum provides an arena, a frame of action, that enables them to work out ways of engaging with the wider society within which they are encapsulated. This is part of a process that ultimately ranges in scale from local festivals to national museums to the globally televised Olympic games. Moreover, the wider society—in the form of the curators and the museum staff and hierarchy—also has to acknowledge certain rules of engagement. Over time, as the concepts that underlie exhibitions change, Indigenous agency will be part of that process.

Perhaps there is no such entity as an "exhibitionary complex." At times, the institutional configurations and relations that the concept invokes may draw attention away from the very people, events, and social processes that the notion encapsulates. Rather, exhibitions involve complex interweavings of motivations and negotiated outcomes between individuals and institutions with different objectives, all of whom believe that they can gain something from participating in the enterprise. At particular moments of history certain dominant sets of interests and institutional agendas may combine to give the appearance of an exhibitionary complex with a temporary coherence and sense of direction. Bennett argued convincingly that the modern museum originated in the movement of collections, during the eighteenth and nineteenth centuries, from enclosed and private domains to the public arena, "where, through the representations to which they were subjected, they formed vehicles for inscribing and broadcasting messages of power . . . throughout society."[38] However, museums continue to involve discourse that occurs in the private spaces created by the curation and development of exhibitions, and those spaces provide opportunities for Indigenous people who are gradually reclaiming ownership of their collections to influence the messages that are broadcast on their behalf.

NOTES

1 In this essay I use two terminologies — "Aborigines" (Aboriginal Australians, Austra-
 lian Aborigines) and "Indigenous Australians" — to refer to the same sets of people in
 different contexts. "Indigenous Australians" has recently gained some currency as a
 term that includes both Aborigines and Torres Strait Islanders under the same rubric.
 It is also valued by some Australian Aborigines as having more positive connotations
 than the term "Aborigine" itself. I have used "Indigenous" primarily in the first sense,
 as a term that includes all the indigenous people of Australia, and have used the word
 "Aborigine" to refer to the Yolngu people of eastern Arnhem Land, as that is the word
 they currently use to refer to themselves.

2 This piece was reprinted in Stanner, *White Man Got No Dreaming*, 192.

3 Australia: Committee of Inquiry on Museums and National Collections, *Museums in
 Australia 1975*.

4 See Meekison, "Indigenous Presence in the Olympic Games" for a relevant discussion.

5 Morphy, "Elite Art for Cultural Elites," 129.

6 The concept of value creation has been frequently used in the analysis of the Euro-
 American category of fine art (see Becker, *Art Worlds*) and been applied to the process
 of category shift for non-Western art (e.g., Clifford, "Four Northwest Coast Muse-
 ums," 241; Morphy, "Aboriginal Art in a Global Context"). I am most influenced by
 Nancy Munn's analysis in *The Fame of Gawa*, which has shown how value creation
 processes in general are integral to the reproduction (and transformation) of society.

7 This view is reflected in the introduction by Darryl McIntyre and Kirsten Wehner
 to the National Museum of Australia's publication *Negotiating Histories* when they
 write, "Histories of colonialism and imperialism led to the formation of many national
 museum collections and the discourses of racial and social hierarchy and exclusion
 through which these were displayed. An increasing awareness of these discourses has
 meant that many museums often find their own collections something of a problem.
 This condition has perhaps fuelled a new understanding of museums . . . as no longer
 essentially repositories for material culture but rather as media of communication"
 (McIntyre and Wehner, "Introduction," xvii).

8 Bennett, *The Birth of the Museum*, 87.

9 Lowenthal, "National Museums and Historical Truth," 166.

10 Australia: Committee of Inquiry on Museums and National Collections, *Museums in
 Australia 1975*, 73.

11 Dawn Casey, quoted in McIntyre and Wehner, "Introduction," 9.

12 See Attwood and Foster, *Frontier Conflict*, 12.

13 The "stolen generation" refers to Aboriginal children who, often without the permis-
 sion of their parents, were taken away from their homes and placed in institutions or
 adopted out. In 1995 the government set up a National Inquiry into the Separation of
 Aboriginal and Torres Strait Islander Children from Their Families. Documentary ac-
 counts of experiences of children taken away from their homes are provided in Mellor
 and Haebich, *Many Voices*.

14 "Yolngu" is the term used today to apply to the Aboriginal people of northeast Arn-

hem Land in northern Australia, people referred to by Lloyd Warner (in *A Black Civilization*) as the Murngin. Yolngu society consists of a network of intermarrying clans divided into two moieties, Dhuwa and Yirritja (Morphy, *Ancestral Connections*). The people involved in the "Yingapungapu" exhibition belong to the southern Yolngu clans from the north of Blue Mud Bay, where they live today. Many of them have strong historic connections with the former mission station of Yirrkala 150 miles to the north.

15 Ruth Philips in "Show Times" has outlined how such processes have affected displays of First Nations' art and material culture. James Clifford ("Four Northwest Coast Museums") early on drew attention to similar processes happening at a more regional scale.

16 See essays in O'Hanlon and Welsch, *Hunting the Gatherers*.

17 For an African example see Kreamer and Fee, *Objects as Envoys*.

18 See Kirshenblatt-Gimblett, "Objects of Ethnography" for a relevant discussion.

19 National Library of Australia, *Cook and Omai*.

20 Morphy, *Ancestral Connections*.

21 See Morphy, "Manggalili Art and the Promised Land" for a discussion.

22 An underlined consonant (as in the names Dhalwangu and Madarrpa) signifies a retroflex pronunciation.

23 Morphy, " 'Now You Understand' "; Morphy, *Ancestral Connections*.

24 The Macassans were traders from South Sulawesi in today's Indonesia who for some two hundred to three hundred years regularly spent the wet season in northern Australia gathering and curing trepang (bêche-de-mer, a large sea cucumber) until they were prevented from doing so by the Australian government in 1905. They established trading relations with Aboriginal groups they encountered on a regular basis. See McIntosh, "The Birrinydji Legacy."

25 Berndt, "The Wuradilagu Song Cycle of North East Arnhem Land."

26 MacKnight, *The Voyage to Marege*.

27 Morphy, "Beginnings Without End."

28 Dunlop, *One Man's Response*.

29 The exhibition was primarily curated by myself and Pip Deveson, an anthropologist and filmmaker who had spent many years working with Ian Dunlop of Film Australia making films on Yolngu people of the Yirrkala region. During the three years we worked on the exhibition, Luke Taylor, Djon Mundine, and Margo Neale followed one after another as senior curators of the First Australians Gallery. We were given considerable autonomy by the museum. We worked with the leaders of the respective owning clans—Gawirrin Gumana of the Dhalwangu clan, Djambawa Marrawili of the Madarrpa clan, and Baluka Maymuru of the Manggalili clan—throughout the planning stages of the exhibition. The organization of Yolngu participation was greatly facilitated by the Buku Larrnggay Art Centre at Yirrkala and their art coordinators, Andrew Blake and Will Stubbs.

30 Buku-Larrnggay Mulka Centre, *Saltwater*.

31 Williams, "On Aboriginal Decision Making."

32 If this was the case, no one made it explicit to me, since, engrossed in conversation, I missed filming the initial stages of making the sculpture.
33 See Myers, "Representing Culture."
34 Fry and Willis, "Aboriginal Art: Symptom or Success?" 160.
35 See Myers, "Representing Culture."
36 Stanner, *White Man Got No Dreaming*.
37 See, e.g., Bennett, *Birth of the Museum*, 83.
38 Ibid., 60.

Destroying While Preserving Junkanoo:

The Junkanoo Museum in the Bahamas

KRISTA A. THOMPSON

As New Year's day breaks in Nassau, capital of the Bahamas, the sun rises to find the main street littered with abandoned Junkanoo costumes, vacant shells left over from the biannual parade which filled the streets in the dark hours of the morning.

The tradition of costuming in Junkanoo (or John Canoe) has been a part of Christmas celebrations in the Bahamas (and other parts of the Anglophone Caribbean) since at least the mid-nineteenth century, when black Bahamians clothed in ribbons and others on stilts poured into the streets on Boxing Day morning. Since the early twentieth century, participants have used a variety of materials to create Junkanoo costumes including wire-mesh masks, sponges, newspapers, and, more recently, colorful fringed crepe-paper, glitter, and feathers. Between the hours of 12:00 AM through the early morning on Boxing Day and New Year's mornings, Junkanoo participants transform the main streets of the capital through a brilliant display and energetic performance of their costumes, against the musical backdrop of a pulsating drumbeat.

For decades many Junkanooers abandoned their handmade costumes immediately after the festivities, despite the months of preparation that went into pasting the elaborate and sometimes costly crepe-papered creations. Some participants explain that this practice stems from their belief that the costumes are no longer meaningful outside of their communal creation and public performance. The abandonment and immediate destruction of the costumes became

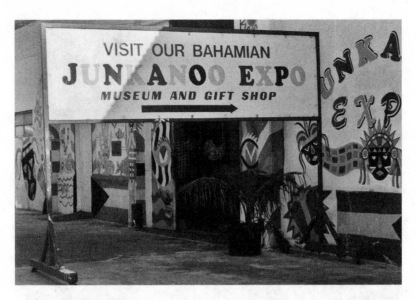

1. Junkanoo Expo Entrance, 1997. Photo by Krista Thompson.

2. Junkanoo costume, "The Final Mission," 1997. Photo by Krista Thompson.

DOCUMENT

3. Junkanoo costume, 1997. Photo by Krista Thompson.

a part of the cycle of Junkanoo or "junk-a-new," as some Junkanooers describe the artistic process of destruction and recreation.

In 1992, a museum, the Junkanoo Expo, opened in Nassau, saving some of the costumes from their ritual abandonment. The museum collected and exhibited many of the larger pieces used in the street parade, especially those that had been awarded prizes in the judging competition. The museum provided the first public exhibition context for costumes outside of the performance frame of the parade. But was the museum, in its efforts to display costumes which were typically discarded after the festivities, interceding into the cycle of costume creation and destruction? Was the museum inherently unsuitable for the display of the traditionally temporal arts of Junkanoo?

Significantly, the Junkanoo museum started to reproduce some of the cyclical practices inherent in Junkanoo. On a yearly basis the museum's staff would destroy the majority of the costumes on exhibition to make room for the newest ones. In this way the museum interceded into, yet reproduced, the cycle of renewal and destruction evident in Junkanoo. Indeed, parts of the costumes removed from the museum could reappear in upcoming parades. As a museum which destroys, the Junkanoo Expo's collection and annual active deaccession policies reflected some of the long-standing local practices that surrounded the temporary use and display of Junkanoo costumes in Bahamian society.

The Complicity of Cultural Production:

The Contingencies of Performance in

Globalizing Museum Practices

FRED MYERS

This essay is concerned with an often-ignored component of museum practice: the symposium. Symposia deserve to be considered as part of what I want to call—combining Bennett's groundbreaking articulation of the "exhibitionary complex" and Bourdieu's theorizing of the "field of cultural production"—the "exhibitionary field of cultural production."[1] These activities of education are also performances and offer an epistemologically interesting location for the study of institutionally complex meaning production. I bring a particular perspective to bear on contemporary museum practices, drawing on my experience with Indigenous Australian art as it has come to circulate internationally and through a variety of museum and gallery sites.

With all due respect to the concept of the "exhibitionary complex," which identified a hegemonic regime of display, over the past twenty years the struggle of indigenous people to represent themselves in all domains has productively entered the field of museum practices.[2] They have sought to claim the space of cultural display for themselves and to displace the devastatingly appropriative regime of the earlier history of museums. Museums are evolving institutions, and at the risk of sounding like an optimist, by calling attention to exhibition as a field of cultural production, as something processual, I call attention to the capacities of minoritized subjects to gain a purchase in the world of representation. This purchase is also not total and complete. Exhibitions are

themselves points of cultural process and do not statically represent what is "out there." More likely they cunningly recontextualize forms and practices, producing something new. It is in this uncertain form that I wish to regard the museum as a site of cultural production in a globalizing cultural economy. That these processes are not straightforward and that they take place in ironic fashion is the point of my story.

The concept of the exhibitionary field has a specific logic for investing value in objects, distinct from that of the commodity process. Exhibitions, of course, are venues for defining the relationships among people and things, while Bourdieu's conception of a "field of cultural production" provides a useful framework for recognizing the dynamic part that participants play in defining the value of objects — understanding the movement or transmission of cultural forms as a form of social action. This seemed especially important for a consideration of the impact of museum exhibitions; curators themselves hardly imagine that a single exhibition will transform the situation of those represented, but they do imagine that a single exhibition might be part of a process of resignifying or reconceptualizing its object. By offering a more complex approach to the intentions of participants, to the identities of the parties, and also to the distinctiveness of the moment of communication, a focus on cultural production moves beyond the frameworks that were built largely on critique of the representation of indigenous cultural forms as little more than "appropriation."

In failing to address any aspect of the agency of production, through which representations are actually made, these critiques betray a Saussurian heritage in a theory of signification that can hardly imagine change.[3] Nicholas Thomas has argued that the conceptual frameworks of "domination" and "appropriation" hardly seem to exhaust the import of exchange over time; instead, he suggests we view cultural exchange in terms of "recontextualization."[4] With the expectation that these matters look different if we step outside of what has been largely a textual criticism of representation, I want to consider the museum process of recontextualization as a broader activity of cultural or discursive *production* in which the representation of culture is significant. In this way, it is possible to recognize in exhibitions more than the simple instantiation of preexisting discourses. As participants can tell us, exhibitions are real-life organizations of resources, imagination, and power — in short, social practices. In approaching these activities of circulation as cultural production, I believe, one finds the possibility of understanding exhibitions as instructive, transformative, educational — as interventions on/in culture and not simply repetitions.

In the aftermath of the critiques in *Writing Culture* and *Exhibiting Cul-*

tures, and in response to criticisms of the authenticity of intercultural exchange under conditions of severe inequality, my approach to respecting the agency of indigenous participants has been to focus on their work of *producing* culture.[5] Conceived as cultural producers rather than as culture bearers, anthropology's subjects could be understood not just as objects of Western regard but as making their culture and themselves visible.[6] And there are many different kinds of "natives" in this exhibitionary complex, including those of us who participate as scholars but who surely must be recognized—reflexively—as situated culture bearers ourselves.[7] One should, therefore, approach the exhibition—the production of representations—as the complex social process it is.

When culture making is understood as a signifying practice (a materiality), it warrants a theoretical shift from an emphasis on representation to one on cultural production and a methodological attention to social actors in different sites, relations, and fields of production, as well as their collaborations and complicities.[8] Analysis can draw on "what the natives know," but it is not identical with that. A focus on the political economy and the social relationships of producing culture, rather than the critical analysis of representations, not only allows for recognition of the possibility of agency (within limits) on the part of the various participants but also engages the rather complex intersections and reorganizations of interest that are inevitably involved in any production of culture.

My interest was originally engaged by the critical responses to the popular exhibition of examples of Australian Aboriginal visual culture at the Asia Society Galleries in New York (October 6–December 31, 1988).[9] "Dreamings: The Art of Aboriginal Australia" drew the largest attendance (27,000 visitors) of any exhibition ever held at the Asia Society. On display were 103 objects, mainly of five types and from four different "cultural areas" in Australia: wood sculptures from Cape York Peninsula, bark paintings from Arnhem Land, acrylic paintings and shields from central Australia, and small carved pieces known as *toas* or message sticks from the Lake Eyre region. The exhibition—combined with a magnificent catalog and symposia that included Aboriginal artists, films, a lecture, and a sand painting performance by two Papunya Tula painters—was widely reviewed in New York before traveling to Chicago, Los Angeles, and then back to Melbourne and Adelaide.[10]

As Ian McLean has written, this exhibition was a transformative moment in the history of Aboriginal art:

> By the late 1980s, Aboriginal art had achieved an unprecedented popularity and exposure in commercial and state public galleries, culminating in the Dream-

I. C. V. Starr Gallery
at the Asia Society ex-
hibition of "Dreamings:
The Art of Aboriginal
Australia." Courtesy of
Asia Society.

ings exhibition which opened in 1988. Significantly, Dreamings was not organ-
ised by art curators, critics, theorists or historians, but by the anthropology
division of the South Australia Museum which, under Peter Sutton, effortlessly
presented Aboriginal art as a continuity of traditional and contemporary prac-
tices that engaged with Aboriginal relations to land in religious, colonial and
postcolonial contexts. The impact of the Dreamings exhibition was profound.
Before 1988 Aboriginal art had barely penetrated New York; by 1989 it was clear
to most commentators that "the acrylic movement has revolutionised the way
we see Aboriginal art," both in Australia and overseas.[11]

I concur wholeheartedly with this evaluation, which refers principally to
the recognition of bark painting from northern Australia and acrylic paintings
on canvas from central Australia.[12] Surely this "event" must be considered a
significant moment of intercultural communication and exchange.

This particular exhibition, further, must be understood as part of a broader
category of similar events. Museum exhibitions now constitute sites of cul-
tural production that are of relevance to indigenous people whose lives are not
bound to single locations, part of the broader structure that Appadurai and
Breckenridge call "the global cultural ecumene."[13] Terence Turner has argued
that indigenous people occupy a specific place in this ecumene, what he de-
scribes as the "contemporary global conjuncture," in which the expansion of
capitalism and consumerism has intensified the value of "culture" and indige-
nous identities (which were once supposed to disappear).[14] Presumably it is on
this basis in general that the curation of these cultures has been able to proceed.
While there is no time to consider it here, there is also a specific political econ-
omy involving Australia, its tourist industry, its changed geopolitical situation,
and the connections among elites that underlies the particular formation of
the Asia Society exhibition.[15]

Outlines of Turner's scenario—or something like it—are recognizable in the Australian case. While undertaken in the expectation of payment and not for their own consumption, Indigenous paintings on bark or with acrylics on canvas were almost entirely defined at the point of their making by their own goals and meanings. The entry of the paintings into the international art market coincides with significant changes in the whole structure and process of the definition of meaningful local identities in a national/international world order. But their value nonetheless continues to rely on their presumed authenticity, their capacity to represent Aboriginal self-production.

ABORIGINAL IMAGE MAKING

Painting on bark in Arnhem Land or with acrylics on canvas in central Australia involves the transfer of Indigenous religious imagery into a somewhat new form for sale. Although intended for intercultural exchange, the painted objects are still anchored in Indigenous systems of image making that draw upon the institutions, practices, and relationships to country typically subsumed in The Dreaming (the invisible ancestral realm or state in which the visible world acquired its shape and being).[16] The paintings are held to be iconic and indexical images that represent events of this realm. The social practices of Indigenous image making reflect its embeddedness in these story-song-design complexes of ritual, stories also manifest in the medium of the land and owned by specific groups of people who hold the right to reveal them to others.

We know that many Indigenous artists in central and northern Australia have agreed to—and even initiated—the circulation of some forms of their religious imagery into commodified spaces of exchange. At the same time, they seem to insist that their paintings retain some of their Indigenous meaning and value. Indeed, such designs constituted the famous Yolngu bark petition presented to the Australian Parliament in 1963 and were part of other ritual diplomatic exchanges such as the performances described in this volume by Morphy. The movement of Aboriginal Australian painting illustrates a transformation of what are essentially Aboriginal inalienable possessions in the form of sacred designs as they circulate into commodities and then into fine art—supposedly emptied of ethnicity—as curators elevate their value in Western terms into a museum's inalienable possessions.[17] Despite this, Aboriginal regimes of value have been surprisingly resilient.[18] While Aboriginal makers of these images can imagine conditions under which legitimate holders of these designs can circulate them, they object to their use by those without the au-

thority to do so. Images painted by recently deceased artists have been removed from display, in recognition of Indigenous custom. It is possible, then, to partially translate Aboriginal social practices of image circulation into Western terms of intellectual property, of ownership and copyright—an issue to which I shall return.

Unlike Western concepts of cultural copyright, it is not fundamentally human creativity that is considered to be objectified in the form of painting, but identity.[19] Design (or the right to make and circulate, or show, designs related to specific stories) is a focus of regulation under what I call the "revelatory regime of value," to distinguish it from other systems of value. In this revelatory regime, designs and stories can be given or exchanged, both with the expectation of some return gift and also in the understanding that this exchange produces some transfer of or bestowal of identity between giver and receiver— an identity objectified in the sharing of rights to ritual, stories, or land. In such a regime of value, it might be said that no one can use your image, that it is an inalienable possession that cannot be fully removed from its "owner."[20] The concern in such a regime is to limit dispersal, to control the potential or actual manifestations of The Dreaming to those entitled to them. These objectifications of ancestral subjectivity are identified with people and groups who are their custodians but not their creators. The focus of such a revelatory regime is to control not only the rights to reproduce images as well but also the rights to see them.

Objectification in this form of painting, the materiality of this knowledge, has distinctive consequences. For one thing, Aboriginal myth and ritual knowledge have material qualities beyond the narrative structure; they have extension in space, insofar as the stories are linked to specific places, an important material component of formulating a social identity among those with rights to the stories.[21] Stories and the ceremonies reenacting them, along with the associated paraphernalia and designs, can also be owned and exchanged; rights to speak and transmit them can become the objects of social and political organization. What might we imagine to occur when these images and practices, and the concern for dispersal, are transported to another venue of objectification—a symposium in New York at the Asia Society?

My concern is to understand a particularly unstable moment in this process of recontextualization, as—I believe—the concept of cultural production recommends. To ask what actually happens when such objects circulate into an international art movement, how they are made meaningful at the sites of exhibition, is to ask how meanings and values are produced, inflected, and invoked in concrete institutional settings. What are the particular mediations

through which phenomena such as "Aboriginal art" are produced and made meaningful as these enter into arenas with particular audiences, technologies, and presumptions?

Thus, I propose a close-up look at the processes of circulation and exhibition as necessary to do justice to the work of cultural exchange. For the purposes of this discussion, I want to explore the significance of global cultural relocations *within* performances at a single institution by focusing on the symposium held at the Asia Society Gallery as part of the "Dreamings" exhibition. Such symposia, which frequently accompany exhibitions in museums, have been ignored as significant intercultural phenomena despite their growing significance to the way knowledge is produced for new audiences encountering exhibitions of unfamiliar and indigenous "art." Through such events, exhibitions constitute a site of political dialogue that recombines distinctive identities within a social space. I am concerned with the implications of a fundamental dislocation between audiences, speakers, and other participants in these new global spheres of cultural translation.[22]

THE COMPLICITY OF CULTURAL PRODUCTION

Let us look, then, at globalization through this particular case and the mediations through which phenomena such as "Aboriginal art" are produced and made meaningful as they enter into different cultural arenas with particular audiences, technologies, and presumptions.

We must begin with the Asia Society. The Asia Society produces programs and publications on the arts and cultures of Asia, presenting some eight special exhibitions each year; previous exhibitions had included "The Real, the Fake, the Masterpiece," "The Chinese Scholar's Studio," and "Akbar's India." It has a staff organized for such activity—design consultants, catalog editors, fund-raisers, performance coordinators, and so on—and relies, moreover, on a network of designers and consultants who work in other cultural institutions in New York, suggesting that the exhibition techniques and ideologies of this institution draw on those more widely shared in other exhibitionary venues, from the China Institute and Japan House to the Metropolitan Museum of Art.

As one might expect, this history and institutional context provided a framework for the presentation of Aboriginal paintings, a framework that is neither that of an art museum or gallery nor that of a museum of natural history—the two exhibitionary complexes most commonly considered by scholars.[23] Indeed, this particular history should make the Asia Society's production of an exhibition quite distinct from the more or less concurrent exhibition of Aboriginal painting at Brisbane's more festival-like Expo 88.[24]

The situating of Aboriginal art at the Asia Society deserves a short explanation. The connection is not obvious, but owes something to Australia's effort to reposition itself in the 1980s as regionally part of a greater Asian political economic sphere. This transformation was well under way by the late 1970s, as ties with England were severed after World War II and new relations were forged in alliance as America's "junior partner." The shift to this new positioning outside the ambit of its colonial British heritage by cultural allegiance on the part of Australia's new elite to a kind of modernist internationalism itself began to falter with the economic downturn of the mid-1970s and Australia's detachment from the "American century" and its turn to Asia. The "Dreamings" exhibition was initiated, in fact, in discussions between Australia's consul general in New York and the Asia Society and no doubt owed considerably to the desire to project an Australian tourist identity for Americans.[25]

While the Asia Society could very well use the discursive formulations of "art" developed and deployed in dedicated museums of art, it has a somewhat more pointedly educational slant — dedicated to promoting "understanding of Asia and its growing importance to the United States and to world relations." This slant shapes a policy of education, an approach inaugurated through the patronage of the wealthy Mr. and Mrs. John D. Rockefeller III — who, one presumes, hoped to spread their enthusiasm for Asian culture more widely. Nonprofit and nonpartisan as it may be, the Asia Society is not a public institution in the same fashion as many museums considered in the literature. A somewhat hybrid cultural institution, the Asia Society is nonetheless organized within the parameters made possible by other histories and institutions of display and exhibition and their presumption of audience, visuality, and knowledge.

Exhibitions are a distinctive technology of presentation. As Ward has pointed out, exhibitions face the problem of representing a totality or entity greater than themselves, and different types of exhibition address the problem in distinctive ways.[26] They signify their object accordingly. For example, art exhibitions since the nineteenth century have tended to be in format either the monographic or retrospective show or the "art movement" show. Scholars have pointed out that museums of history and memory or universal expositions have and had distinctive formats as well, and they have recognized that their capacities to represent a larger totality have relied on events besides the exhibition narrowly conceived.[27]

There has been also a trajectory in the development of the institutions of exhibition as they have become increasingly public (rather than private) and legitimated through their attendance: they have become involved in producing "events." These include not only exhibitions, which are different from permanent installations, but also a range of other educational activities and public

programs. Typically, such activities are said to be educational — drawing on the nineteenth-century concern with "uplift" and the socialization of citizens.[28] The more general effort to make museums "eventful," as Barbara Kirshenblatt-Gimblett phrased it, should be recognized as part of their emerging structure, a movement that is making museums something more like public forums than temples of civilization as they enter into spaces of the bourgeois public sphere in which controversial interpretive exhibitions might be held and symposia might bring interlocutors face to face.[29] They are, that is, shaped by the broader social context — democratization, popularization, Disneyfication — and its changes. It should not be forgotten that "eventfulness" is suited to the problem of bringing people to the museum, to reaching out and justifying their existence in one kind of measurement of effect. Events such as lectures, performances, openings, symposia, and tours punctuate the "slow event" of the exhibition with "fast events."

In the "Dreamings" exhibition, the Asia Society had proposed not just to exhibit art but to communicate about a relatively unknown culture through its art. It promised to introduce to the public both the "amazingly complex and rich culture of Aboriginal Australians, and the strength of this surviving and adapting culture as manifest in the vibrant artistic productions of the last 100 years."[30] The timeliness of the exhibition, the curators argued, lay in the recent recognition of the paintings and sculptures in contrast to earlier — more negative — reactions to Aboriginal art. In formulating the "value" of Aboriginal painting in this way, not only in the planning document's discourse but also in subsequent realizations, the exhibition repeatedly tapped into particular connections between art and spirituality in the process of transferring the Australian context to that of the Asia Society. The theme was especially marked in the punctuating events that were held at the Asia Society itself. They followed the grooves of an American preoccupation with non-Western or alternative spirituality and wisdom.

This was to be, as the NEH Implementation Proposal outlined, "a unique international exhibition" that would "reveal the creativity and depth of an extraordinary artistic *heritage*."[31] Furthermore, it was

> to demonstrate that traditionally-minded Aboriginals have been able to preserve and invigorate a tradition that stretches back over twenty thousand years. This exhibition will also indicate the depth of cultural and spiritual meaning that lies behind many of the designs in these paintings. Such works of art are extremely important to their makers and Aboriginal appreciators because they contain complex and subtle expressions of fundamental ideas of the nature of the world and the sources of life.[32]

To represent the "difference" (or differentness) of Aboriginal culture provided a challenge to the "Dreamings" exhibition, which also planned to explore commonalities in the notion of artistry within this difference. The curators understood that there were obstacles to the recognition of Aboriginal artworks as of cultural value: both the unintelligibility of Aboriginal worldviews, symbolic systems, and visual conventions to Westerners, and the unwillingness of most non-Aborigines to work to overcome this problem.[33]

One attempt to address these problems within the exhibitionary complex itself was the two-day symposium that presented five Aboriginal artists, one art advisor, and four anthropological experts on Aboriginal art and culture. The symposium was one of two events in which Aboriginal participants represented their own art and culture. That it was an event that largely depended on speaking should not prevent us from recognizing its performative qualities as well. Such events are useful in order to provide some distance—a degree of estrangement—from an exhibitionary context that has become seemingly transparent to many educated Westerners. Without this estrangement, the cultural complexity of recontextualization—of "education" or "communication"—may be obscured. If this was a transparency shared by many of the participants, it was not familiar to all. Certainly, "exhibition to the public" has not been a meaningful framework to most Aboriginal people.

My argument in this essay is that it is important to consider how the symposium offered an alternative interpretive practice for the exhibition, and how it revealed a dramatic change in the practice of anthropology and translation that is also part of changing museological practice. The case exemplifies some of the complexities of even these best-intended efforts at indigenous control over cultural translation. With the co-presence of anthropologists and Aboriginal painters on the stage, the symposium represented a moment in which the conceits of a "bounded culture" to be translated were set forth just as they began to fall apart. This unraveling coincided with a complex collapse and performance of the usual tropes defining the regulative ideals for justifiable relationships— "rapport"—with our subjects.

I was myself in this event, participating, performing the role of an anthropologist. But I was beginning to see the event itself as an instance of an increasingly important cultural formation and not just a reenactment of "being there." The disjunctions and anxieties of the event were characteristic of a situation that George Marcus has articulated in his observations on the "complicity" of fieldwork. "In any particular location," he has written,

> certain practices, anxieties, and ambivalences are present as specific responses to the intimate functioning of nonlocal agencies and causes—and for which

there are no common-sense understandings. The basic condition that defines the altered mise-en-scène for which complicity rather than rapport is a more appropriate figure is an awareness of existential doubleness on the part of *both* anthropologist and subject; this derives from having a sense of being *here* where major transformations are under way that are tied to things happening simultaneously *elsewhere*, but not having a certainty or authoritative representation of what those connections are.[34]

Indeed, "the sense of the object of study being 'here and there' has," as Marcus put it, "begun to wreak productive havoc on the 'being there' of classic ethnographic authority."[35]

The symposium was planned mainly at the insistence of Peter Sutton and Chris Anderson, the anthropologists/curators from the South Australian Museum (SAM), who pressured the Asia Society for artists to be present. It seems to have had a lower priority for the Asia Society, but SAM's legitimacy with Aboriginal representatives would have been compromised without this participation. Nonetheless, the participation was itself hybrid, articulating Western notions of representation with presumptions of Aboriginal ones that may not have been those of people from remote communities. Ironically, according to Françoise Dussart, these particular Aboriginal participants did not especially want to come, but were persuaded to do so by the curators.[36] Thus, their presence was itself a concession to the occasion, and simply inviting them may have sufficiently acknowledged their rights as authorities.

Sutton's catalog for "Dreamings" had given focus both to the style and artistry/content of Aboriginal visual culture and also to the intrinsically political dimension of Aboriginal art and—with some reflexivity—to the (related) historical development of interest in it. The symposium, however, was advertised on flyers in terms that some of the participants found to be a little more ethereal, as "Dreamings—An Exploration of Aboriginal Art and Culture." The flyer explained that "Aboriginal art, called both the newest and oldest art form in the world, links contemporary media with tens of thousands of years of religious and intellectual experience." The audience was invited to "[e]xplore the complexity of this unique artistic tradition through two days of special discussions and films at The Asia Society. Symposium participants include Aboriginal artists and scholars from America, Europe and Australia."

The cost of attendance for members was $35 for one day and $45 for both days, while nonmembers paid slightly more. The anthropologists found the disappearance of the usual gritty sociopolitical context of Aboriginal art problematic, and they were particularly uncomfortable with the Asia Society's program's emphasis on a cleaned-up "spirituality."

THE ASIA SOCIETY
PRESENTS
A TWO-DAY SYMPOSIUM WITH FILMS

DREAMINGS

AN EXPLORATION OF
AUSTRALIAN ABORIGINAL
ART AND CULTURE

SATURDAY, OCTOBER 22 AND SUNDAY, OCTOBER 23
AT THE ASIA SOCIETY, 725 PARK AVENUE AT 70TH STREET

2. Brochure advertising the two-day symposium for "Dreamings." Courtesy of Asia Society.

During the first day of the symposium, October 22, 1988, entitled "The Continuum of Art and Culture," the panel discussed two topics: "The Land, Symbols and Spirituality in Aboriginal Art" and "Art and the Social Order: Who May Paint What." Two films involving Arnhem Land bark painting were also scheduled, Ian Dunlop's *One Man's Response* and *Narritjin at Djarrakpi*, both of which seek to establish the political context of Aboriginal visual culture at the time and are embedded less in the spirituality of Aboriginal cultural traditions than in the relations between blacks and whites in Australia and the attempt of the bark painter Narritjin Maymuru to assimilate these relations within terms meaningful to an Aboriginal culture.[37]

On the second day of the symposium, "Understanding and Appreciating Aboriginal Art," the panel members were to discuss "Form and Feeling: Responding to Aboriginal Art" and "Aboriginal Art, Markets and Collectors." Two more films accompanied the discussion—Curtis Levy's *Sons of Namatjira* and Mike Edol's *When the Snake Bites the Sun*.

SYMPOSIUM

For most of the 27,000 visitors to "Dreamings" at the Asia Society, the visual exhibition, framed by text panels and video interpretation, stood alone as a representation. The committed viewer might have turned to the catalog for an important elaboration and contextualization of themes that could only be hinted at in the show. For a few hundred others, however, the visual display was further mediated through the symposium. We might regard this event in the semiotic terms of the philosopher C. S. Peirce as an "interpretant." Peirce argued that *all* signs are comprehended only through other signs—their inter-pretants—in an endless chain of semiosis.[38] However apprehended by planners and participants, the symposium activity provided another means to achieve some sort of referentiality in representation, to reach the object—the other—through extended linguistic activity. The panelists were Westerners who had "been there," at the scene of the art production, anthropological guides who could speak with the producers (and who were certified as "experts"), as well as some of the Aboriginal people who currently make the objects. I spoke as the anthropologist/New Yorker, a local who had "been there."

Inevitably, such a task of interpretation tends to consist of mediating be-tween Aboriginal cultural categories or signs—what these objects mean for them—and those of the audience. Many anthropologists have been caught in the web of appealing to the dominant culture's categories in order to legitimate local practices—to argue that they qualify as what is socially valued as "art"—rather than analyzing the relationships involved in the activity of mediation.[39] That is, this practice of interpretation is itself caught up in the structures of cultural hegemony. Cultural translation of this kind is, to be sure, somewhat self-conscious, undertaken with a degree of ironic distance. It openly declares a complicity with power (who needs to be translated to whom?) and threat-ens, therefore, to expose an anthropologist's uncomfortable identifications. Anthropologists have typically been trained to be sensitive to the ethnocentric imposition of their own culture's judgments and categories onto the practices of others. But how does one avoid it?

Such long-standing problems took on renewed significance in the exhibi-tion context of 1988, a context within which—after the "Primitivism" con-troversies—the representation of the other had become a politicized, defining issue.[40] Consultation, representation, permission, and presence were some of the numerous strategies invoked to address the problem of museum media-tion. They were not magical antidotes to the power of representation, however. After all, Aboriginal and other native peoples have themselves long been ob-

jects of exhibition, and the shadow of these earlier practices seems inevitably to trail subsequent revisions. What actually happens when museums try to invite indigenous people to represent themselves? Can the indigenous people become the subjects of enunciation, collaborators in interpretation?

There were five Aboriginal artists at the symposium, four from remote, traditional communities and one urban bilingual woman. Two acrylic painters, Dolly Granites Nampitjinpa and June Walker Napanangka, came from the Warlpiri community at Yuendumu; two bark painters, Jimmy Wululu and David Malangi, came from Ramangining in Arnhem Land; and one contemporary urban Aboriginal artist, Kerry Giles, came from Adelaide. Giles's participation as an urban Indigenous person partially responded to the exhibition's focus on what Peter Sutton later called "the classical tradition" of Aboriginal art, an exclusion of urban art that replicated a problematic historical divide between urban and traditional communities. The participating anthropologists were Peter Sutton and Christopher Anderson, from the South Australian Museum; Françoise Dussart, who had done primary research with the women at Yuendumu and had collaborated in parts of the exhibition; and myself—invited as an acknowledgment of my academic presence in New York and my published work on central Australia. The art advisor was Djon Mundine, an urban Aboriginal from southeastern Australia who had been working as art advisor at Ramangining for several years.

The presence of five Aboriginal artists at the symposium represented an important statement about the right of painters to represent their work and the political context of this work. The curators and participants were well aware of the recent concern—raised in cultural criticism as well as by Aboriginal critics—about "speaking for the other," about appropriating their products and dominating them by Western discourse. Equally important, and not unrelated, in speaking for themselves, the Aboriginal people enacted some Aboriginal principles of presentation, whereby only those with legitimate rights to designs and stories may discuss them.

While many in the audience appreciated this significance of Aboriginal participation, for others their presence no doubt had a less esoteric and more exotic value. To see, and meet, the actual Aboriginal painters was certainly the "real thing" in another way, as signs asserting the genuine presence of the other in the paintings: a spectacle, not a dialogue or a conversation. If, inescapably, by appearing before an American audience, the Aboriginal people and their understandings of their own work could become objects, indexes of their culture, what these representatives said and did could also challenge the viewer.

INTERPRETING ABORIGINAL PAINTINGS

Thus it was that at noon on October 22, 1988, ten of us sat at a table on the Asia Society stage, five Aboriginal painters, an art advisor, and four anthropologists. The traditional Aboriginal painters did not look like any black people the American audience might have seen in the United States, and thus their unfamiliarity had to dominate efforts at making them intelligible. The two women from central Australia were striking in their dress—running shoes and high athletic socks visible beneath the symposium table, Dolly's knitted watch cap and rugby shirt, and June's orange tunic a jolting accompaniment to the dark skin of their broad faces shining under the lights. The men from the "Top End," Arnhem Land, found a certain dignified formality in the use of suit jackets. Malangi's scarf was dramatically thrown over his right shoulder, making him resemble nothing more strongly than a World War I aviator.[41]

We anthropologists were also dressed for the role. Peter Sutton was in a (borrowed) pinstriped suit and tie, hair parted down the middle in a way I thought indexed the artistic nature of the event. The Indigenous art advisor (and later curator) Djon Mundine wore a striped shirt with a white collar and tie, overwhelmed by his abundant dreadlocks. Dussart, her short blond hair pulled back into a small ponytail, wore a black sweater and a single strand of pearls, along with blue jeans and boots. Anderson wore a sport jacket and tie, with his own blond hair done in a little ponytail that echoed Dussart's. Less formally—perhaps marking a status I felt to be less official than that of my colleagues—I wore a black sweater over a white shirt. Whatever identities these signified, clothing was part of the staging of a performance, a presentation in a sloping auditorium with a lighted stage, microphones, slide projectors, and a videographer recording it all. This kind of cultural event, the symposium, puts experts on a stage in front of an audience, assigns them roles in the performance, and occupies a specified time frame. A weekend performance imagines an audience of the curious, most often members of the Asia Society, who might be free from working at this time and able to acquire further education to accompany the exhibition.

The staging was evident. By plan, the symposium began with an introduction to the event by Andrew Pekarik, the Asia Society's curator, who then left the stage. But the panel itself began directly—and perhaps somewhat shockingly—with a brief statement by Dolly Granites Nampitjinpa, who spoke in Warlpiri. To avoid speaking "for her" and framing her as someone who could not represent herself, no background or interpretive framework was offered beforehand. This was a confounding moment: her speaking was unintelligible except as an expression of friendly otherness. Except for the few who might

3. Françoise Dussart interprets and translates for the Warlpiri painter Dolly Granites Nampitjinpa during the symposium. Courtesy of Asia Society.

have understood Warlpiri, Dolly's words were available only in the translation of the anthropologist Françoise Dussart. When she finished, Dolly leaned with a slight smile toward Françoise, who was sitting close beside her, raised an eyebrow, and paused.

Françoise spoke into the microphone they shared: "Dolly says that she holds the Dreaming from her father."

More words from Dolly, and the translation: "She holds the Dreaming from her father's father, and she holds many Dreamings in her country."

Another pause, and again the translation: "She also holds the Dreaming from her mother. She holds the Dreaming from her father's father and from her father's mother."

With that, Dolly indicated she was finished. Only later did the audience learn from other speakers that Dolly was suggesting the source of her paintings and the rights through which she reproduces them. When Dolly completed her speech, Françoise turned to Peter, who indicated to his right for Djon Mundine. Mundine turned to David Malangi and whispered to him; there seemed to be no direct eye contact, making David remote from the audience — echoing the distance of Dolly's reserve. A double image of one of Malangi's paintings was projected on the screen behind them, one image of the painting and a second of a drawing outlining the iconography. David and Jimmy Wululu turned around in their seats and began to look at the image, pointing and whispering. This seemed a further hitch in the genre of presentation, but the painters' distance, or holding back, was real, rooted in Aboriginal protocols appropriate for those on the stage. The women, for example, were embarrassed to speak in front of the men, whom they didn't know, and afraid of offending them by appearing to speak on their behalf or violating their own rules.[42] The women therefore restricted their comments to the most narrow frame of reference.[43] Had the symposium happened after the painters had established what their

4. Djon Mundine (right) sets up the microphone for the famous Arnhem Land painter David Malangi. Courtesy of Asia Society.

kinship relations were, rather than so shortly after their arrival, perhaps this event would have worked better. But other protocols also guided the performance. As "owners," the painters had the right to speak publicly about their works, but as strangers in New York, they were also shy and hesitant—appropriately respectful. And also, as an owner, one does not necessarily wish to make one's knowledge—that which distinguishes one—freely or equally available. The two men gathered in the image, and finally David turned back toward Djon and the microphone. With a slight smile, but surely recognizing the length of the pause, he began. A thin man distinguished by his silvery white hair and mustache, Malangi spoke briefly into the microphone in his own language.[44] When he stopped, Jimmy Wululu began to translate:

> Uncle David said, that painting over there is his father's, his father's father. . . . That bone up there, that [is] his sacred site country. And that fish been going into that waterhole, and two—what you call them?—clapping sticks.

David spoke further, and Jimmy translated:

> And Uncle David said, that fresh water that is called Djamara; that two ladies was walking through there, you know, two Djangkaos—and, uh, they got a walking stick down there, too.

Again Malangi spoke, and Jimmy repeated in English:

> And that fish over there—you can see, catfish—we used to call him Djikara. That Djikara been going into that waterhole there. That's Uncle David's country. And [it shows] that—what you call, snail?—we used to call Tukarayi—maybe you call snail? Something like that . . .
>
> That's true story. Not Uncle David's story . . . but through, from, you know, ceremony. And his father and his grandfather, and his grandfather's father, and so on, you know. That's true story. Truly!

Malangi's final words were brief. Jimmy translated: "That's all. Thanks." To the anthropologists onstage, these statements were examples of a discourse of explanation with which we were familiar, drawn—as Geertz once said—from a universe of signs in which they were meaningful.[45] It is a particular routine common to presenting paintings to outsiders but also similar to the discursive routine through which Aboriginal people communicate to each other. This discourse drew on widespread traditional Aboriginal ideas, and for us these statements would have needed no further explication. The Aboriginal painters had told the audience what they thought should be said. From their point of view, no doubt, the act of presenting themselves to the audience had performed their identities, their courage, and their confidence. The senior painters spoke of what they knew, in their own languages. They made little attempt at deeper contact with the audience, at trying to imagine what intervention would help them understand, as if it were enough to speak the words. They knew they spoke with authority, but it was not quite the same as "being there" at Yuendumu or Ramangining.

Acting as moderator, Peter Sutton clearly perceived that more interpretation was needed for the audience. So it became Djon Mundine's turn to speak, art advisors being another kind of intermediary for painters, particularly given his own Aboriginal identity. However necessary, this direction threatened to displace the authority away from the Aboriginal spokesman. Aware of the senior man's presence and authority over the story, Mundine spoke in a manner that suggested a degree of reluctance. Having now to stand in for the Aboriginal artist he represented, Mundine explained:

> Just for those people who didn't quite grasp the English we use . . . what both speakers have done is to try to explain the painting in terms of their Dreaming, or their religious creation beliefs, and how it relates back to their land and to their families, and how their families and their ancestors, and their families going back ad infinitum, belong to the landscape and how they are given that land by these creative beings and how they came to own that land and the ceremonies and practices that ensure the continuity of the landscape and the environment.

It is important to note that Mundine claims no authority for his own voice, but implicitly claims to be translating. Nonetheless, his words begin the process by which explication takes place, by which an audience applies categories, has them provisionally checked, and learns. They are directed to recognize the verbal sign "Dreaming" as an interpretant, a sign applied to the previous signs—sacred sites, country, fish, ceremony—just as these signs informed the signification of "Dreaming."[46]

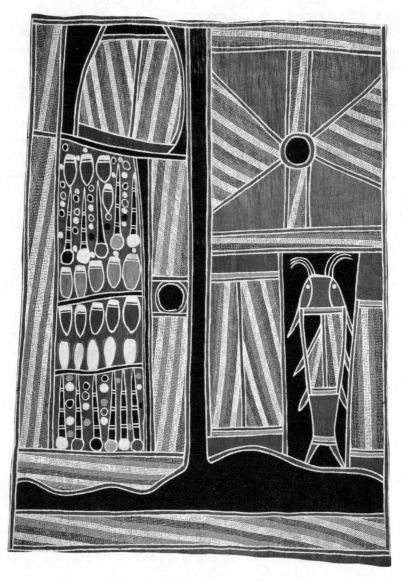

5. "Sacred Places at Milmindjarr," 1982. David Malangi. Ochre on bark. 107 × 77 cm. A67852, South Australian Museum. © David Malangi (Daymirringu). Licensed by VISCOPY, Australia, 2005.

6. Curator Peter Sutton explains the title of the exhibition and the Aboriginal concept of "Dreaming." Courtesy of Asia Society.

Peter Sutton, speaking next in the symposium, sought to explain the significance of choices made in the translation of Aboriginal culture. Offering a metacommentary on the concept of Dreamings, he also drew attention to what, over a longer period of time and conversation, listeners would have recognized as context — meaningful repetitions and themes:

> One of the first titles that we rejected for this exhibition was "Totemic Landscapes." We thought that sounded obscure and a bit academic, so it was replaced later by "Dreamings." "Dreamings" is even more obscure, perhaps, to people from other parts of the world than Australia, partly because the word isn't used that way in English, but also because the concept itself is very complex. It really can only be understood by gradually building up more and more fragments of the sort that we've just been listening to. Gradually, you get a deeper and fuller sense of what is being spoken about.

Sutton thus tried to show how anthropological representations might relate to the phenomena engaged in our experience, to people's ways of talking and expressing their realities.[47] The symposium was almost like having fieldwork performed and interpreted onstage.

POLITICS

A major concern of the exhibition curators had been to ensure that the paintings are understood as part of the social and historical context of Australia as a country, that they not be separated off from their real-life circumstances. Chris Anderson, therefore, spoke of the devastation of settlement, conflict, disease, and way of life — devastation within which the survival of cultural traditions was significant as an assertion of continued Aboriginal presence. The paintings in the exhibition, he pointed out, were expressions and assertions of the same

process that saw the government-produced mixed settlements giving way to more homogeneous outstation communities.

> Despite enormous pressures exerted on it, Aboriginal culture has retained its uniqueness and much of its strength. It is a way of life that has many continuities with its precolonial past. At the same time, much of its nature stems from Aboriginal responses to the European presence and to forces external to Aborigines and their society. . . .
>
> I think that's probably, in my own view, the best way to look at the art that has been produced over the last century in Australia.

I organized my own speech in the context established by those preceding me (and have analyzed the videotape of it). I was introduced as the New Yorker who had spent many years in Aboriginal Australia. In the presence of Aboriginal people from areas different from those I knew well, and just returned from several months in Australia, I was very self-conscious about seeming to speak "about" them.[48] The understood call of the audience for interpretation and explanation provided me with an identity (i.e., "expert") that competed with the identity I might have as a part of an Aboriginal community (i.e., not to speak for others). This was a problem. I found a resolution in the way that the Pintupi community had defined my presence, as one who should "help" Aboriginal people. I made myself an extension of their authority. Unlike Dussart or Mundine, I was not accompanied by any particular and close Aboriginal acquaintance. The representational strategy of my speaking was to defer my authority by talking about what I learned from people at Yayayi, what they insisted I understand — implying, thereby, what they wanted me to bring back. This involved summarizing what the stories represent, what their value is, what their context might be as people had explained them to me in order for me to represent them. Rather than speaking on behalf of "Aboriginal authorities," in relying on my personal experience I enacted a mediating position, speaking to what I had been told and how I had learned it, sharing my experience with the audience as their representative but also as a Pintupi extension.

My comments were oriented to the essentially political issues that I understood to define the context of painting, insisting, however, that these did not represent a break with a distinctively different Indigenous past. The overall thrust was to overcome the Western distinctions between religion and politics that I sensed to be operating in the way painting was understood. The political aspirations encoded in the paintings tended, I thought, to be neglected or ignored in American settings. That the paintings articulated, in part, the relations of Aborigines to the larger society — and indeed their aspirations for self-determination — offered a meaningful continuity with the past in which

ritual production and ritual knowledge articulated the relationships between persons and groups.

I built on Anderson's depiction of the paintings as "assertions," arguing for the complexity and authenticity of the assertions represented by the paintings and the deeply social meaning of country:

> So, there's a message in these paintings that comes out about the recognition of who the painters are and what their rights are. And they continue to be bewildered, in a way, that those who see these paintings do not recognize all that is encoded in the right to paint them. Now, . . . one shouldn't think out of this that Europeans are unique in not being able to recognize the deeply encoded messages of other cultures. There's nothing special to us about that, but nonetheless there's a kind of poignant message in all this: that we buy and sell their art and we like it, and at the same time, the political aspirations that are often encoded in it are neglected as well.
>
> There are other features of this, and in terms of the translation I just want to give one other point. The Pintupi, when I worked with them, were not living in their own country, which placed them at a disadvantage with other Aboriginal people. They didn't have the confidence that comes from being in a place to which you have unequivocal rights. In 1981 they did move out to their own country. I've been back to visit them several times since then. All the places that they had been painting about in their stories, they now can visit. They can take children out to see them, and they are just part of the regular course of people's lives. But before that, that tradition was passed on and sustained through this somewhat more secularized tradition of painting.
>
> In the course of developing commercial paintings for sale, the people of central Australia and Arnhem Land have had to make decisions about what they could show to outsiders, as opposed to what they would show to people within their society. In the early period of acrylic painting, they painted a lot of designs which wouldn't ordinarily have been shown to women and children of their own society. They didn't really ever think that these things would get back to their own society. Subsequently, if you look at the catalog, you'll see that there has been a change over time. When I first started working out there, the men used to do these paintings and put them in my camp, apart from the women and children, and then they would be sold. Subsequently, as they've come to know us better and they've come to understand their relationship to the larger world and the possibilities of it, they have made decisions as to what designs can be shown. Women have to make the same decisions. And so we are seeing in Aboriginal art also a recognition of their relationship to us and of the relationship between our society and their society as they offer us that part of their

vision that they think can be fitted into their own expectations and not do harm to their own society.

When we returned after the film screening for the next session of the symposium, June Walker spoke — briefly, as her predecessors did, but in English for herself — about how one acquires the rights to paint and what these rights consist of. These remarks were expanded by Chris Anderson and Djon Mundine to a more general discussion of the problems of compensation and of copyright. Mundine spoke as an art advisor, remarking on the growing tourist interest in Aboriginal art and culture and the "growing rip-off of Aboriginal artists":

> It's a real crime that's being committed. . . . Aboriginals in Australia have been deprived of many things. They've been deprived of their land, for one thing. In many cases, all they have left is their language, culture, and identity. Many white people in Australia think there is nothing wrong with people taking that last thing that Aboriginals have — their culture and their identity — away from them, by reproducing their designs without acknowledging the artist, without making appropriate payment, and quite often in what are quite inappropriate circumstances. What I've found is that Aboriginal artists are not opposed to using their images or their art to sell to tourists; it's just that they would like to have some control over their own art and get some return for that art.

Finally, the audience heard from Kerry Giles, the South Australian artist, commenting on what Peter Sutton introduced as "the issue of who may paint what in an area where the older Law no longer obtains." Kerry represented what has come to be known as "Koori art," or urban Aboriginal art, marking its difference from the painting that emanates from less interrupted cultural tradition. Her lighter-skinned appearance and overall presentation would challenge purist notions of an "authentic" Aboriginal, but because of her cultural familiarity she also could bring the discussion down to the ground. Kerry began by saying she could only go on her own experience. She is, she said, careful not to offend other Aboriginal people in Australia, but "the art that I do is Aboriginal in the sense that it is searching for grassroots and identity." Her approach was to talk about a painting she had done the week before, discussing it in far greater detail than did the other artists.

AFTERMATHS

These, then, were the topics set forth by the speakers at that first day of the symposium, the one on which our agenda was created in the doing. We had not known what to expect. The audience questions were varied and more

numerous than I had expected: How are "guardians" (*kurtungurlu*) — a term
Françoise had introduced to discuss the limits on individual painterly activity
— assigned to a person? Why do you have to attain a level of seniority to have
the right to paint? What is the relationship between dreams and painting? How
do Aboriginal people respond to their art — what makes it good, strong, or
important? Why do dots predominate so much? What does it mean for the
art to be "dangerous"? What are the differences between men's paintings and
women's paintings?

June Walker was the only traditional painter to answer one of these ques-
tions. She had the best English of this group and was persuaded to respond
to the question of how they told stories a hundred years ago — before they
painted in this way. Shyly and with a smile indicating her discomfort in speak-
ing authoritatively with her seniors present, June told about learning from her
parents, from ceremony. Her answer was very brief and partial, compared to
what anthropological observers have written about iconographic practices in
her own community of Yuendumu.[49] Françoise reminded her of the drawings
in the sand that Nancy Munn had described for Yuendumu women, suppos-
edly the originary site of the iconography. June acknowledged and reasserted
this information, growing more confident as she proceeded, not so much say-
ing things that hadn't been heard before but reiterating what she had heard
others say and giving it her voice.

PERSONAL: KEEPING WHILE GIVING KNOWLEDGE

The sense of the object of study being "here and there" has begun to wreak
productive havoc on the "being there" of classic ethnographic authority.[50] In
her volume *Inalienable Possessions*, Annette Weiner developed a paradigm of
exchange in which she pointed out how much of exchange or "gifting" is con-
cerned equally to keep control over those possessions that constitute one's
identity even while seeming to give them away.[51] In representing the Aborigi-
nal painters at the symposium, anthropologists were producing themselves in
the moment of giving. Our activities undoubtedly contributed to the interpre-
tation of Aboriginal painting, but it seems equally true that as "experts" we
could not ignore our activity as part of a field of cultural production or the
identities that would be available for us in speaking. We had to perform re-
spect for the Aboriginal speakers as the true or first owners of this knowledge,
but we had to enact this respect in ways other than those expressed in what
had become clichés of a colonial anthropology — the recourse to claims about
initiation into the communities, special ties of kinship, or "rapport."

We were, nonetheless, professionally committed to some possibility of "representing" Aboriginal culture. This theoretical debate actually is an important context in which the exhibition of Aboriginal art has been framed. One side of the debate was articulated by two Australian critics, Fry and Willis, who have stated (in Peter Sutton's rendition) that "ethnographic and art-critical discourse harnesses Aboriginal art to the dominant culture's notions of art" and that "Aboriginal art thus becomes a commodity in the trade of 'othernesses' in which anthropologists and curators are the profiting merchants."[52] This view, Sutton notes, would threaten to silence all anthropological commentary:

> [Fry and Willis's] solution to all this, in part at least, is to remove people such as myself from even speaking about the subject and to let Aboriginal voices present their own culture in their own way and on their own terms, making use, for example, of the new culture of television (a "late-modern cultural space"), thus empowering Aborigines in the process of producing not only culture but its representation to others.[53]

The evidence of the symposium, however, was that Aborigines might not always be able to represent their culture adequately for a non-Aboriginal audience.

What, then, was being performed at the Asia Society symposium? It was, in some ways, a kind of fieldwork "here," in public, about fieldwork "there." I began to see that what was happening at the symposium itself was not just an evanescent moment of translation, something apart from the real work of ethnography "there." It was an example of an increasingly important site in the circulation of Aboriginal culture, a location that cannot be simply dismissed as inauthentic or irrelevant to the continued life of Aboriginal people. The Asia Society symposium was on its way to becoming a "there"—a significant site of intercultural practice.

At the symposium, the Aboriginal participants performed their authority and rights, in speaking for themselves, and they acknowledged the context in expecting their intermediaries to carry the interpretation to the audience. There was no sign of dissatisfaction with being represented, even as the anthropologists performed their own tangible discomfort with representing those equally present with them, and also their difference from the audience they addressed—an audience apparently consumed with a need for a "spiritual other," if the questions were any indication. Much as the anthropologists suspected this "spiritualization" as yet another falling back into the primitivist stereotypes so much under critical attention elsewhere, as hosts they could hardly draw out what they (we) understood as a fuller picture of Aboriginal difference from the Western spiritual ideal.[54]

The performance of Aboriginal authority deserves a short discussion here as an enactment of the fundamental paradox of "giving while keeping," of controlling the dispersal of sacred knowledge, a paradox at the heart of formulations of indigenous cultural property that have become important in museums and elsewhere.[55] Aboriginal artists recognize a resemblance of their understandings to practices of intellectual property, of ownership and copyright, yet their performance of their rights and authority over cultural property is distinguished by something other than exclusive possession, something that might be understood as the potential to create identity.[56] "Ownership," in this sense, as Marilyn Strathern has written, "gathers things momentarily to a point by locating them in the owner, halting endless dissemination, effecting an identity."[57] Rosemary Coombe has brilliantly summarized the way in which indigenous relationships to cultural forms may challenge the legalisms of ordinary property law:

> For Native peoples in Canada, culture is not a fixed and frozen entity that can be objectified in reified forms that express its identity, but an ongoing living process that cannot be severed from the ecological relationships in which it lives and grows. By dividing ideas and expressions, oral traditions and written forms, intangible works and cultural objects, the law rips asunder what many First Nations people view as integrally related — freezing into categories what Native peoples find flowing in relationships. For those sympathetic to their ends to attempt to reduce these claims to assertions of intellectual property rights is simultaneously to neglect significant dimensions of Native aspiration and impose colonial juridical categories on postcolonial struggles in a fashion that reenacts the cultural violence of colonization.[58]

The promiscuity of knowledge to form new connections makes it a site for varying kinds of control. For Aboriginal Australians such as the painters at the symposium, knowledge has the form of an object, something that can be given, held, revealed, or withheld. Its possession can differentiate those with authority and those without; it is also subject to dispersal and loss. While the symposium participants want the audience to understand, or perhaps to acknowledge, they also wish to restrict the information they give — quite in accordance with Indigenous practice in which different levels of knowledge are preserved in consonance with the deployment of knowledge's potential for distribution as an objectification of shared identity. In so doing, they retain for their knowledge a series of properties and values that are not reduced by the market and which recognize the interests of those beyond the artist or the performer. Defying the definition of cultural property within the framework of "possessive individualism," this represents a limitation of any attempt to con-

ceive of the objects, knowledge, or their performances within the regime that has been developed for property in general.[59] They want to give something, but to perform at all is to expose oneself to the risk of revealing inappropriately that which is held by a larger group than oneself. In this sense, the exchange is a particular formulation of intellectual or cultural property that must be distinguished from a simple commoditization.

In this crosscutting field of specific relationships as well as preexisting discourses, something known as "Aboriginal art" comes to be imagined and produced. I was not only in it but also studying this very new formation in which my acts of representation were a part.

THE DANGER OF CIRCULATION AND THE POLITICS OF KNOWLEDGE

The specter of authenticity seemed inescapable — or perhaps its reappearance made it seem an inexhaustible presence. The entire "Dreaming" event took place in the shadow of the increasingly frequent criticisms of anthropological representation and authority. What anthropologist could *not* share the radical critics' suspicion of our culture's rather complacent consumption of the apparently exotic, or their sense of regret at the loss of local people's self-definition? Was anthropology enacting such a complacent consumption, even while intervening against a projected "spirituality"? What anxieties might have been betrayed in these public performances, at the intersections of culture on the stage of a museum, despite the confidence of our immediate possession of knowledge?

The positions given voice in these questions are recognizably part of Western culture's tradition. Sometimes, indeed, this critical opposition — embodied, for example, in the work of the Frankfurt School — has itself been attacked as elitist and too heavily freighted with romantic nostalgia. Is the hesitation performed about the traffic in Aboriginal culture grounded only in a romantic remorse at the passing of distinctive traditions, in imperial nostalgia?[60] Are these suspicions, in part, *our* arguments, often going on outside the concern and interest of the Aboriginal people themselves, who want their paintings exhibited? Are ethnocentric appropriations of Aboriginal art something to worry about? One needs also to recognize the value of Aboriginal work being displayed on the world stage, acquiring the cultural capital of an elite museum in New York. This gain in cultural capital cannot be denied as part of a benefit that we can help to develop.

In the community constituted by the art scene and the soft politics of the 1980s, knowledge had a different material significance for most: it could be-

come little more than a badge of distinction, a value excised from the social world in which it originally existed and exchanged like a commodity in conversations of self-production. I wanted connoisseurs to know that they did not know much, that something eluded their grasp and thereby challenged their modes of being. Perhaps more than this, I was disturbed by what these representations of Aboriginal cultures — like any construction, really — excluded, all the dimensions of Aboriginal life that do not fit their frame.

There are concrete reasons, grounded in the political relations between Aborigines and whites, for being suspicious of the way knowledge circulates about Aborigines. In what I now see echoes Sutton's concerns about the different ontologies, the reality gaps "between Aboriginal 'art' and the culture that buys and collects it," I would like the art world to be subject to Aboriginal conventions of representing and respecting others, to have the standards of the community of study prevail over those of the representer.[61] In this sense, the emergence of Aboriginal curators — Hetti Perkins at the Art Gallery of New South Wales, Brenda Croft at the National Museum of Australia, and others — is an important and positive trend.

Something like these standards have for some time been the conditions of most contemporary ethnography in Australia.[62] To respect these conditions has not been a simple task, but anthropologists have attempted to mediate between their responsibility to the conventions of the local communities in which they study — communities that may seek to apply their standards to all representations, giving no exempt status to "science" — and the interests and values of the scholarly world for whom, largely, they write. These problems are necessarily the stuff of recontextualization in an exhibition, but the transformation of context is not all one-directional. Increasingly, respect for and accountability to Aboriginal protocols have entered into the exhibitionary practices of the Australian art world: the names of deceased artists are not mentioned, communities are consulted about exhibitions, painters are invited to visit exhibitions to represent themselves, and copyright recognition has been extended to Indigenous designs. While there was nothing simple about the settling of such terms in relation to exhibition, the changing relations of power between the knower and the known can at least make the relationship explicit and negotiable.

The expressions of ambivalence about the art world and its criticisms are all evidence of the emerging new forms and values of the reorganization of intercultural space. They are also evidence of what might be called a "struggle" over the meaning of the exhibition, suggesting that this exhibition and exhibitions generally came to have a meaning (were placed in a context and a context produced) through a social process. Thus, for example, John Von Sturmer criticized the show as the South Australian Museum's effort to turn itself into

a "treasure house" rather than a storehouse, buying into a masterpiece frame-
work of art and ignoring the grit of Aboriginal life, while Sutton replied that
the museum was interested in both representativity and the exceptional.[63]

In what complicities, therefore, were we embedded in our mediation? And
what do these particular complicities signal about what Marcus called "the
changing mise-en-scène" of fieldwork? The participants embrace the Asia So-
ciety, only to distance themselves from its assumed project of making knowl-
edge available. They (we) criticize the category of "art" while insisting on its
value to communicate about Aboriginal painting and sculpture. How were we
to maintain the rapport with Aboriginal participants established by living in
their communities in new fields of power, definition and performance? Sutton,
as we saw, ultimately opted for the primacy of his relationship to his Aborigi-
nal "mentors," who, he wrote, "have made it clear they see my responsibility
to explain the high value of their culture and the defensibility of their political
position to my other mob, my tribe of origin."[64]

Despite this recognition of our multiple identities, it does seem in retro-
spect as if the anthropologists found it hardest to acknowledge their relation-
ship to the immediate community—the audience of the symposium. To be
one of "them," seekers after some truth about the Other, was deferred by a
range of strategies of affiliating with the Aboriginal speakers without claiming
to share their identity. In this circumstance, particularly, we could not claim
a special identity, either as ethnic or as professional, or—for myself and Dus-
sart—even as national. After all, returned from an intense four-month field
trip in Australia, I knew too much to be part of the audience and felt too much
the estrangement of that long-delayed return trip to identify myself easily with
Aboriginals.

The exhibitionary context cannot replicate what it represents. It necessarily
recontextualizes what it shows, producing something new. However, what the
symposium produced as "Aboriginal art" was not identical with what the ex-
hibition or the catalog imagined. What the event format accomplished instead
was a rearrangement of the relations of Aboriginal and white individuals as
specialists on culture and art, to show them both as participants in the emerg-
ing art world of Aboriginal art.

NOTES

I thank Françoise Dussart, Faye Ginsburg, George Marcus, and Peter Sutton for their
comments and suggestions on drafts of this essay. I would also like to thank the editors
of the volume for their helpful suggestions.
1 Bennett, The Birth of the Museum; Bourdieu, The Field of Cultural Production.

2 Bennett, *The Birth of the Museum.*

3 See Sahlins, *Historical Metaphors and Mythical Realities.*

4 For examples, see also Kirshenblatt-Gimblett, "Objects of Ethnography" and "Confusing Pleasures."

5 Clifford and Marcus, *Writing Culture*; Karp and Lavine, *Exhibiting Cultures.*

6 See Dussart, "A Body Painting in Translation"; Morphy, " 'Now You Understand' "; Ginsburg, "Aboriginal Media and the Australian Imaginary"; Mahon, "The Visible Evidence of Cultural Producers."

7 Clifford, *The Predicament of Culture*; Fabian, *Time and the Other*; Ginsburg, "The Parallax Effect."

8 See Turner, *Dramas, Fields and Metaphors.*

9 I have discussed other dimensions of this exhibition extensively elsewhere (Myers, *Pintupi Country*; "Culture-Making"; *Painting Culture*).

10 The catalog is Sutton, *Dreamings: The Art of Aboriginal Australia.* See also Myers, "Culture-Making."

11 McLean, *White Aborigines*, 129.

12 See Morphy, *Ancestral Connections* (bark painting); Myers, *Painting Culture* (acrylic on canvas paintings). See also Myers, "Representing Culture."

13 Appadurai and Breckenridge, "Why Public Culture?"

14 Turner, "Anthropology and Multiculturalism," 427, and "Indigenous and Culturalist Movements."

15 See Myers, *Painting Culture.*

16 See Stanner, "The Dreaming."

17 See Weiner, *Inalienable Possessions*; Myers, "The Wizards of Oz."

18 See Johnson, "Art and Aboriginality."

19 See Coombe, "The Properties of Culture and the Possession of Identity"; Sax, *Playing Darts with a Rembrandt*; Strathern, "What Is Intellectual Property After?"

20 Weiner, *Inalienable Possessions.*

21 See Myers, *Pintupi Country.*

22 Constraints of time and length preclude discussion of how audiences in fact responded to this kind of production. Whether "audience" is researchable is a question I want to open even if I cannot resolve it. We can begin to understand what the issues might be.

23 Underlying the movement of Aboriginal painting into the category "fine art" are concrete examples of the practices and institutions that shape the process of classification (for others, see Beidelman, "Promoting African Art"; George, "Objects on the Loose"). The movement of Aboriginal paintings into the zone of fine art necessitates the recognition of the art gallery rather than the natural history museum, aesthetics rather than context, and perhaps art history rather than anthropology.

24 See Bennett, *The Birth of the Museum*; West, *The Inspired Dream.*

25 For a consideration of the relationships among elites that underlay the development of this exhibition, see Myers, *Painting Culture.*

26 Ward, "What's Important About the History of Exhibition," 458.

27 Bann, *The Clothing of Clio* (museums of history and memory); Mitchell, "The World as Exhibition" (universal expositions).

28 See Bennett, *The Birth of the Museum*.

29 Personal communication, September 18, 1999.

30 Asia Society, NEH Implementation Grant Proposal.

31 Ibid., my emphasis.

32 Ibid.

33 See Sutton, *Dreamings*, 34.

34 Marcus, *Ethnography Through Thick and Thin*, 118.

35 Ibid., 117.

36 Personal communication, September 22, 1999.

37 See Morphy, this volume.

38 Peirce, "Logic as Semiotic."

39 See Myers, "Locating Ethnographic Practice."

40 Clifford, *The Predicament of Culture*; Foster, "The 'Primitive' Unconscious"; Rubin, "Modernist Primitivism."

41 This was something quite different from anything Malinowski had conceived when he trumpeted the birth of traditional ethnography in the famous words of his introduction to *Argonauts of the Pacific*. "Imagine," he wrote, "yourself suddenly set down surrounded by all your gear, alone on a tropical beach close to a native village, while the launch or dinghy which has brought you sails away out of sight" (Malinowski, *Argonauts of the Pacific*, 4). We were there to explain, to be ethnographers. We had, once upon a time, been set down somewhere surrounded by our gear, but the native villagers did not remain behind, isolated, when the dinghy sailed. The Asia Society stage was not simply a locus of representing that other place we had all once been; it was itself an exemplar of many new sites for the ethnography of Aboriginal social life in which intercultural activities are themselves significant.

42 The men and women were from different regions of Australia and had only just met. They spoke different languages as well, although they could communicate with each other in English to some extent.

43 Françoise Dussart, personal communication, September 22, 1999.

44 Malangi was a famous artist whose painting was used by Australia in its $1 note. Because of problems or miscommunication in the agreement for this usage, and certainly the neglect of his rights, there was eventually litigation that resulted in compensation and recognition of his copyright ownership of the image.

45 Geertz, "From the Native's Point of View."

46 Peirce, "Logic as Semiotic."

47 See Geertz, "From the Native's Point of View."

48 My own research has been mainly with Pintupi-speaking Western Desert people over the years—1973–75, 1979, 1981, 1982, 1983, 1984, 1988.

49 Munn, *Walbiri Iconography*.

50 Marcus, *Ethnography Through Thick and Thin*, 117.

51 Weiner, *Inalienable Possessions*.

52 Sutton, "Reading 'Aboriginal Art,'" 30.

53 Ibid.

54 The principal critique of such primitivist stereotypes is that the other is not regarded

as he/she actually is, but rendered intelligible only through the interests of the Western viewer. Among the effects of this framework, as Johannes Fabian has argued in *Time and the Other*, is the removal of indigenous people from having a history connected to us, removal of them from the actual political relationship in which we and they coexist.

55 Weiner, *Inalienable Possessions*.

56 See Marika, *Wandjuk Marika*.

57 Strathern, "What Is Intellectual Property After?" 177.

58 Coombe, "The Properties of Culture," 92.

59 Handler, "Who Owns the Past?"

60 See Rosaldo, "Imperialist Nostalgia."

61 Sutton, "Reading 'Aboriginal Art,'" 31.

62 See Myers, "The Politics of Representation."

63 See von Sturmer, "Aborigines, Representation, Necrophilia," and Sutton's "Reply to von Sturmer," 2.

64 Sutton, "Reading 'Aboriginal Art,'" 33.

BIBLIOGRAPHY

Abrahams, Stan. "A Place of Sanctuary." In Rassool and Prosalendis, *Recalling Community in Cape Town*.

Abrahams, Yvette. "Miscast." *South African Review of Books* 44 (1996): 15–16.

Abram, Ruth. "Harnessing the Power of History." In Sandell, *Museums, Society, Inequality*.

Adams, Robert McCormick. "Blue-and-White." In Borden, *Program Book for the 36th Annual Smithsonian Folklife Festival*.

———. "Creating Trust." In Borden, *Program Book for the 36th Annual Smithsonian Folklife Festival*.

Adams, Zuleiga. "Memory, Imagination and Removal: Remembering and Forgetting District Six." M.A. mini-thesis, University of the Western Cape, 2002.

African National Congress. "Castro Hlongwane, Caravans, Cats, Geese, Foot and Mouth and Statistics: HIV/AIDS and the Struggle for the Humanization of the African." Paper circulated to affiliates, March 2002.

Ahmed, Akbar S., and Hastings Donnan, eds. *Islam, Globalization, and Postmodernity*. London: Routledge, 1994.

Ainger, Katharine. "To Open a Crack in History." *New Internationalist* 338 (2001).

Allen, James, ed. *Without Sanctuary: Lynching Photography in America*. Santa Fe: Twin Palms Publishers, 2000.

Alpers, Svetlana. "The Museum as a Way of Seeing." In Karp and Lavine, *Exhibiting Cultures*.

Altick, Richard D. *The Shows of London*. Cambridge: Belknap, 1978.

Ames, Michael. *Cannibal Tours and Glass Boxes: The Anthropology of Museums*. Vancouver: University of British Columbia Press, 1992.

André-Pallois, Nadine. *L'Indochine: Un lieu d'échange culturel?* Paris: Ecole Française d'Extrême-Orient, 1997.

Ansaldi, Waldo. "La memoria, el olvido y el poder." Seminário das Mercocidades: cidade e memória na globalização, Porto Alegre, Brasil, 2000.

Appadurai, Arjun. "Commodities and the Politics of Value." In *The Social Life of Things.*

———. "Disjuncture and Difference in the Global Cultural Economy." In Robbins, *The Phantom Public Sphere.*

———. "Disjuncture and Difference in the Global Cultural Economy." In *Modernity at Large.*

———. "Grassroots Globalisation and the Research Imagination." In *Globalization*, edited by Arjun Appadurai. Durham: Duke University Press, 2001.

———. "Introduction." In *The Social Life of Things.*

———. *Modernity at Large: Cultural Dimensions of Globalization.* Minneapolis: University of Minnesota Press, 1996.

———, ed. *The Social Life of Things: Commodities in Cultural Perspective.* Cambridge: Cambridge University Press, 1986.

Appadurai, Arjun, and Carol Breckenridge. "Why Public Culture?" *Public Culture* 1, 1 (1988): 5–9.

APSARA. *Guide to Angkor Thom.* Phnom Penh: APSARA, 2001.

Arens, W., and Ivan Karp. "Introduction." In *Creativity of Power*, edited by W. Arens and Ivan Karp, xi–xxix. Washington, D.C.: Smithsonian Institution Press, 1989.

Arizpe, Lourdes. "Cultural Heritage and Globalization." In Avrami, Mason, and de la Torre, *Values and Heritage Conservation.*

———, ed. *World Culture Report 2000: Cultural Diversity, Conflict and Pluralism.* Paris: UNESCO, 2000.

Armelagos, Adina, and Mary Sirridge. "The Identity Crisis in Dance." *Journal of Aesthetics and Art Criticism* 37, 2 (1978): 129–39.

———. "The Role of 'Natural Expressiveness' in Explaining Dance." *Journal of Aesthetics and Art Criticism* 41, 3 (1983): 301–7.

Armstrong, Robert Plant. *The Affecting Presence: An Essay in Humanistic Anthropology.* Urbana: University of Illinois Press, 1971.

———. *The Powers of Presence: Consciousness, Myth, and Affecting Presence.* Philadelphia: University of Pennsylvania Press, 1981.

Artaud, Antonin. "No More Masterpieces." In *The Theater and Its Double.* New York: Grove Press, 1958.

Arts and Culture Task Group. *Report of the Arts and Culture Task Group, presented to the Minister of Arts, Culture, Science and Technology.* Pretoria: DACST, 1995.

Asia Society. "An Implementation Grant Proposal to the NEH for the Exhibition 'Dreamings: The Art of Aboriginal Australia.'" Asia Society, New York, 1987.

Associated Press. "King Day Honors the Man, His Message: 50,000 March for Removal of Confederate Flag — Statehouse Banner 'Is Coming Down Today,' Marchers Sing." *St. Louis Post-Dispatch*, January 18, 2000.

Attwood, Bain, and S. G. Foster. *Frontier Conflict: The Australian Experience.* Canberra: National Museum of Australia, 2003.

Auslander, Philip. *Liveness: Performance in a Mediatized Culture.* London: Routledge, 1999.

Automobile Association of South Africa. *Road Atlas and Touring Guide of Southern Africa,* 3rd edition. Johannesburg: AASA, 1968.

Avrami, Erica, Randall Mason, and Marta de la Torre, eds. *Values and Heritage Conservation: Research Report.* Los Angeles: Getty Conservation Institute, 2000.

Bachelard, Gaston. *The Poetics of Space.* Translated by Maria Jolas. New York: Orion Press, 1964.

Baer, Ulrich. "To Give Memory a Place: Holocaust Photography and the Landscape Tradition." *Representations* 69 (2000): 32–62.

Bakhtin, Mikhail. *The Dialogic Imagination.* Austin: University of Texas Press, 1981.

Bal, Mieke. *Double Exposure: The Subject of Cultural Analysis.* London: Routledge, 1996.

Baniotopoulou, Evdoxia. "Art for Whose Sake? Modern Art Museums and Their Role in Transforming Societies: The Case of the Guggenheim Bilbao." *Journal of Conservation and Museum Studies* 7 (2001).

Bank, Andrew. "Evolution and Racial Theory: The Hidden Side of Wilhelm Bleek." *South African Historical Journal* 43 (2000): 163–79.

Bann, Stephen. *The Clothing of Clio: A Study of the Representation of History in Nineteenth-Century Britain and France.* Cambridge: Cambridge University Press, 1984.

Barabas, Alicia M., and Miguel A. Bartolomé, coords. *Configuraciones étnicas en Oaxaca,* Vol. I. México, D.F.: INAH-INI, 1999.

Barringer, Tim, and Tom Flynn, eds. *Colonialism and the Object: Material Culture and the Museum.* London: Routledge, 1998.

Baudrillard, Jean. "Simulacra and Simulations." In *Selected Writings.* Stanford: Stanford University Press, 2001.

Bauman, Zygmunt. *Globalization: The Human Consequence.* New York: Columbia University Press, 1998.

Becker, Howard. *Art Worlds.* Berkeley: University of California Press, 1982.

Bedford, Emma and Tracy Murinik. "Re-membering that place: public projects in District Six." In Soudien and Meyer, *The District Six Public Sculpture Project.*

Beidelman, Thomas O. "Promoting African Art: The Catalogue of the Exhibit of African Art at the Royal Academy of Arts, London." *Anthropos* 92 (1997): 3–20.

Beinart, William. "Soil Erosion, Animals and Pasture over the Longer Term." In Leach and Mearns, *The Lie of the Land,* 54–72.

———. "Soil Erosion, Conservationism and Ideas About Development: A Southern African Exploration, 1900–1960." *Journal of Southern African Studies* 11, 1 (1984): 52–83.

Beinart, William, and Peter Coates. *Environment and History: The Taming of Nature in the USA and South Africa.* London: Routledge, 1995.

Beinart, William, and Joanne McGregor, eds. *Social History and African Environments.* Oxford: James Currey, 2003.

Benjamin, Walter. *Illuminations.* London: Pimlico, 1999 [1958].

———. "The Work of Art in the Age of Mechanical Reproduction." In *Illuminations.*

Bennett, Tony. *The Birth of the Museum: History, Theory, Politics.* New York: Routledge, 1995.

———. "The Exhibitionary Complex." *New Formations* 1 (1988): 73–102.

———. "Intellectuals, Culture, Policy: The Technical, the Practical and the Critical." *Pavis Papers in Social and Cultural Research* 2 (1999): 26.

———. "Out of Which Past?" In *The Birth of the Museum.*

———. *Pasts Beyond Memory: Evolution, Museums, Colonialism.* London: Routledge, 2004.

———. "Pedagogic Objects, Clean Eyes and Popular Instruction: On Sensory Regimes and Museum Didactics." *Configurations: A Journal of Literature, Science and Technology* 6, 3 (1998): 345–71.

Berndt, Ronald Murray. "The Wuradilagu Song Cycle of North East Arnhem Land." In *The Anthropologist Looks at Myth*, edited by John Greenaway. Austin: University of Texas Press, 1966.

Bernstein, David. "A Museum in Chicago Is Closing Its Doors." *New York Times*, Oct. 30, 2004.

Beverley, John. *Subalternity and Representation: Arguments in Cultural Theory.* Durham: Duke University Press, 1999.

Bhabha, Homi. "Conversational Art." In *Conversations at the Castle: Changing Audiences and Contemporary Art*, edited by Mary Jane Jacob with Michael Brenson. Cambridge, Mass.: MIT Press, 1998.

Bickford-Smith, Vivian. "The Origins and Early History of District Six to 1910." In Jeppie and Soudien, *The Struggle for District Six.*

Bickford-Smith, Vivian, Sean Field, and Clive Glaser. "The Western Cape Oral History Project: The 1990s." *African Studies* 60, 1 (2001): 5–23.

Bilbao Metropoli-30. "Revitalization Plan for Metropolitan Bilbao." Bilbao Metropoli-30, Bilbao, 1998a. Available at http://www.bm30.es/plan/pri_uk.htm (accessed July 30, 2003).

Blight, David. *Race and Reunion: The Civil War in American Memory.* Cambridge, Mass.: Harvard University Press, 2002.

Blunt, Wilfred. *The Ark in the Park: The Zoo in the Nineteenth Century.* London: Hamish Hamilton, 1976.

Boas, Franz. "Ethnology at the Exposition." *The Cosmopolitan* 15 (1893).

Borden, Carla, ed. *Program Book for the 36th Annual Smithsonian Folklife Festival.* Washington, D.C.: Smithsonian Institution, 2002.

Bormann, Tammy, and Nelson Hewitt. "Report of Racial Reconciliation Research to the National Underground Railroad Freedom Center." Report to the National Underground Railroad Freedom Center, Cincinnati, Ohio, January 2000.

Bourdieu, Pierre. *Distinction: A Social Critique of the Judgement of Taste.* Translated by Richard Nice. Cambridge, Mass.: Harvard University Press, 1984.

———. *The Field of Cultural Production: Essays on Art and Literature.* Edited by Randall Johnson. New York: Columbia University Press, 1993.

———. *Pascalian Meditations.* Cambridge: Polity Press, 2000.

———. "Uniting Better to Dominate." *Items and Issues* (Social Science Research Council, New York) 2, 3–4 (2001): 1–6.

———. "Utopia of Endless Exploitation." *Le Monde Diplomatique*, March 1998, 3.

Bourdieu, Pierre, and Alaine Darbel with Dominique Schnapper. *The Love of Art: European Art Museums and Their Public.* Translated by Caroline Beatty and Nick Merriman. Stanford: Stanford University Press, 1990.

Bourdieu, Pierre, and Loïc Wacquant. "NewLiberalSpeak: Notes on the New Planetary Vulgate." *Radical Philosophy* 105 (2001): 2–5.

Bozzoli, Belinda, ed. *Class, Community and Conflict: South African Perspectives.* Johannesburg: Ravan Press, 1987.

Bradford, Helen. "Getting Away with Murder: 'Mealie Kings,' the State and Foreigners in the Eastern Transvaal, c. 1918–1950." In *Apartheid's Genesis, 1935–1962*, edited by Philip Bonner, Peter Delius, and Deborah Posel. Johannesburg: Ravan Press/ Witwatersrand University Press, 1993.

———. "The Industrial and Commercial Workers' Union of Africa in the South African Countryside, 1924–1930." Ph.D. dissertation, University of the Witwatersrand, 1985.

Bradley, Kim. "The Deal of the Century." *Art in America*, July 1997, 48–55, 105–6.

Breckenridge, Carol A. "The Aesthetics and Politics of Colonial Collecting: India at World Fairs." *Comparative Studies in Society and History* 31, 2 (1989): 195–216.

Bredekamp, Horst. *The Lure of Antiquity and the Cult of the Machine: The Kunstkammer and the Evolution of Nature, Art and Technology.* Princeton: Markus Wiener Publishers, 1995.

Brenner, Neil, and Nik Theodore. "Cities and the Geographies of 'Actually Existing Neoliberalism.'" In *Spaces of Neoliberalism: Urban Restructuring in North America and Western Europe*, edited by Neil Brenner and Nik Theodore. Oxford: Blackwell Publishing, 2002.

Brenson, Michael. *The Guggenheim, Corporate Populism, and the Future of the Corporate Museum.* New York: The New School/Vera List Center for Art and Politics, 2002.

Brigham, David. *Public Culture in the Early Republic: Peale's Museum and Its Audience.* Washington, D.C.: Smithsonian Institution Press, 1995.

British Trade International. *Heritage, Tourism and Museums: British Expertise.* London: British Trade International, 2000.

Bruner, Edward. "Tourism in Ghana: The Representation of Slavery and the Return of the Black Diaspora." *American Anthropologist* 98, 2 (1996): 290–304.

Bruner, Edward M., and Barbara Kirshenblatt-Gimblett. "Maasai on the Lawn: Tourist Realism in East Africa." *Cultural Anthropology* 9, 4 (1994): 435–70.

Buckley, Stephen. "Heritage Battle Rages at Slavery's Sacred Sites." *The Guardian*, May 1, 1995.

———. "U.S., African Blacks Differ on Turning Slave Dungeons into Tourist Attractions." *Washington Post*, April 17, 1995.

Buku Larrnggay Mulka Centre. *Saltwater: Yirrkala Barks of the Sea Country*. Yirrkala: Buku Larrnggay Mulka Centre, 1999.

Bunn, David. "An Unnatural State: Tourism, Water, and Wildlife Photography in the Early Kruger National Park." In Beinart and McGregor, *Social History and African Environments*.

———. "Whited Sepulchres: On the Reluctance of Monuments." In *Blank: Architecture, Apartheid and After*, edited by Hilton Judin. Rotterdam: NAI Publishers, 1999.

Bunn, David, and Roger Field. *Trauma and Topography*. Johannesburg: Landscape and Memory Project, 2000.

Buntinx, Gustavo. *Emergencia artística. Arte crítico 1998–1999*. Lima: Micromuseo Productions, 1999.

———. " 'Estética de proyección social': E. P. S. Huayco y la utopia socialista en el arte peruano." In *E. P. S. Huayco: Documentos*, edited by Gustavo Buntinx. Lima: Centro Cultural de España, Instituto Francés de Estudios Andinos y Museo de Arte de Lima, 2005.

———. "La identidad como discurso: El caso de los frescos de Mar del Plata." In *Rasgos de identidad en la plástica argentina: Premio a la Crítica de Arte Jorge Feinsilber, 1993*. Buenos Aires: Grupo Editor Latinoamericano, 1994.

———. "El 'Indio alfarero' como construcción ideológica. Variaciones sobre un tema de Francisco Laso," In *Arte, historia e identidad en América: Visiones comparativas*, vol. I. México, D.F.: Instituto de Investigaciones Estéticas, Universidad Nacional Autónoma de México, 1994.

———. "Modernidades cosmopolita y andina en la vanguardia peruana." In *Cultura y política en los años 60*, edited by Enrique Oteiza. Buenos Aires: Instituto de Investigaciones Gino Germani, Facultad de Ciencias Sociales, Universidad de Buenos Aires, 1997.

———. "Museo moderno/Museo alternativo." Paper presented at the First Conference on Peruvian Museums, organized by ICOM-Peru at the Museum of Art of Lima, May 1986. Published, with errors and omissions, in *Cuadernos de Museología*, 1. Lima: Museo de Arte Popular, Instituto Riva-Agüero, 1989. For a corrected version, see *Micromuseo 0*. Lima: Micromuseo Productions, April 2001.

———. "Pintando el horror: Sobre *Memorias de la ira* y otros momentos en la obra de Jesús Ruiz Durand." In *Batallas por la memoria: Antagonismos de la promesa peruana*, edited by Marita Hamann, Santiago López Maguiña, Gonzalo Portocarrero and Víctor Vich. Lima: Red Para el Desarrollo de las Ciencias Sociales en el Perú, 2003.

———. "El poder y la ilusión: Pérdida y restauración del aura en la 'República Weimar peruana' (1980–1992)." In *Arte latinoamericano actual*, edited by Gabriel Peluffo.

Montevideo: Museo Municipal de Bellas Artes Juan Manuel Blanes, 1995. Reprinted in English as "The Power and the Illusion: Aura, Lost and Restored in the 'Peruvian Weimar Republic' (1980–1992)," in *Beyond the Fantastic: New Art Criticism from Latin America*, edited by Gerardo Mosquera. MIT Press, Cambridge, Mass., 1996.

———. "El retorno de las luciérnagas. Deseo aurático y voluntad chamántica en las tecnoesculturas de Francisco Mariotti." *Márgenes* 17 (2000): 55–93.

———. *Sarita iluminada: De ícono religioso a héroe cultural (la revelación)*. Lima: Micromuseo Productions, 2005.

———. "La utopía perdida: Imágenes de la revolución bajo el segundo belaundismo." *Márgenes* 1 (1987): 52–98.

Bürger, Peter. *Theory of the Avant-Garde*. Translated by Michael Shaw. Minneapolis: University of Minnesota Press, 1984.

Burnside, Madeleine H., ed. *A Slave Ship Speaks: The Wreck of the Henrietta Marie*. Key West, Fla.: Mel Fisher Maritime Heritage Society, 1995.

Bustillo, Alejandro. *La belleza primero: Hipótesis metafísica*. Buenos Aires: Alejandro Bustillo, 1957.

Butler, Shelley Ruth. *Contested Representations: Revisiting "Into the Heart of Africa."* Amsterdam: Gordon and Breach Publishers, 1999.

Cahn, Walter. *Masterpieces: Chapters on the History of an Idea*. Princeton: Princeton University Press, 1979.

Calhoun, Craig. "Imagining Solidarity: Cosmopolitanism, Constitutional Patriotism, and the Public Sphere." *Public Culture* 14, 1 (2000): 147–71.

Camarena, Cuauhtémoc et al. *Pasos para crear un museo comunitario*. México, D.F.: CONACULTA, 1994.

Camarena, Cuauhtémoc and Teresa Morales. *Communities Creating Exhibitions/ Comunidades Creando Exposiciones*. Oaxaca: Fideicomiso para la Cultura México/ USA, INAH, Anacostia Museum, 1999.

———. "Community Museums and the Conservation of Heritage: The Case of Oaxaca." Paper presented at the Conference on Bilateral Protection of Cultural Heritage Along the Borderlands, National Park Service–Instituto Nacional de Antropología e Historia, San Antonio, Texas, October 23–25, 1997.

———. "The Community Museums of Oaxaca as Economic Catalysts." Paper presented at the annual meeting of the American Association of Museums, Baltimore, 2000.

———. *Fortaleciendo lo propio: ideas para la creación de un museo comunitario*. Oaxaca: CONACULTA, 1995.

———. "Los museos comunitarios de Oaxaca: un caso de apropiación cultural a través del sistema de cargos." In *Patrimonio Histórico y Cultural de México, IV Semana Cultural de la Dirección de Etnología y Antropología Socia*, edited by Ma. Elena Morales Anduaga et al. México, D.F.: INAH, 2001.

———. "The Power of Self-Interpretation: Ideas on Starting a Community Museum."

In *Living Homes for Cultural Expression: North American Native Perspectives on Creating Community Museums*, edited by Nicolasa Sandoval. Washington, D.C.: National Museum of the American Indian, 2006.

Cameron, Duncan. "The Museum: A Temple or the Forum." *Journal of World History* 14, 1 (1972): 189–201.

Campbell, Edward D. C., Jr., and Kym S. Rice, eds. *Before Freedom Came: African American Life in the Antebellum South*. Charlottesville: University Press of Virginia, 1991.

Cape Rainbow Tours. *See the Cape with Colour*. Cape Town: Cape Rainbow Tours, 2000.

Carroll, Noel. "Performance." *Formations* 3, 1 (1986): 63–81.

Carruthers, E. J. "Game Protection in the Transvaal, 1846–1926." Ph.D. dissertation, University of Cape Town, 1988.

———. *The Kruger National Park: A Social and Political History*. Pietermaritzburg: University of Natal Press, 1995.

———. " 'Police Boys' and Poachers: Africans, Wildlife Protection and National Parks, The Transvaal 1902–1950." *Koedoe* 36, 2 (1993): 11–22.

Carter, Paul. *The Road to Botany Bay*. New York: Knopf, 1988.

Castañeda, Quetzil. *In the Museum of Maya Culture: Touring Chichén Itzá*. Minneapolis: University of Minnesota Press, 1996.

Castells, Manuel. *The Information Age: Economy, Society and Culture*. 3 vols. Oxford: Blackwell, 1996–1998.

Castrillón Vizcarra, Alfonso. *El museo peruano: Utopía y realidad*. Lima: Alfonso Castrillón Vizcarra, 1986.

Centre for Popular Memory. *Annual Report*. Cape Town: Centre for Popular Memory, University of Cape Town, 2001.

Centro de Apoyo al Movimiento Popular Oaxaqueño. *Oaxaca, Land of Contrasts*. Oaxaca: CAMPO, A.C., 2000.

Cernea, Michael M. *Cultural Heritage and Development: A Framework for Action in the Middle East and North Africa*. Washington, D.C.: World Bank, 2001.

Chandler, David. "Reflections on Cambodian History." *Cultural Survival Quarterly* 14, 3 (1990): 16–19.

Chapman, Kathleen. "Township Tours—Exploitation or Opportunity." *Cape Times*, July 8, 1999.

Chard, John. "On Circulating Museum Cabinets for Schools and Other Educational Purposes." *Journal of the Museums Association*, 1890.

Clark, Ian. *Globalization and Fragmentation: International Relations in the Twentieth Century*. Oxford: Oxford University Press, 1997.

Clay, Jason. "Radios in the Rain Forest." *Technology Review* 92, 7 (1989): 52–57.

Clemetson, Lynette. "Long Quest, Unlikely Allies: Black Museum Nears Reality." *New York Times*, June 29, 2003.

Clifford, James. "Four Northwest Coast Museums: Travel Reflections." In Karp and Lavine, *Exhibiting Cultures*.

———. "On Collecting Art and Culture." In *The Predicament of Culture*.

———. "Palenque Log." In *Routes*.

———. *The Predicament of Culture*. Cambridge, Mass.: Harvard University Press, 1988.

———. *Routes: Travel and Translation in the Late Twentieth Century*. Cambridge, Mass.: Harvard University Press, 1997.

Clifford, James, and George Marcus, eds. *Writing Culture*. Berkeley: University of California Press, 1986.

Cluver, Michael, and Patricia Davison. "The South African Museum and the Challenges of Change." *Archiv für Völkerkunde* 50 (1999): 275–86.

Coburn, M. "Township Tours." *Cape Review*, September 2001, 32–36.

Coetzee, J. M. "The African Experience." *Preservation*, March/April 2002, 20–24.

———. *White Writing: On the Culture of Letters in South Africa*. New Haven: Yale University Press, 1988.

Cohen, Marilyn S. "American Civilization in Three Dimensions: The Evolution of the Museum of History and Technology of the Smithsonian Institution." Ph.D. dissertation, George Washington University, 1980.

Coles, Alex, ed. "Interview with James Clifford." In *Site-Specificity: The Ethnographic Turn*, edited by Alex Coles, vol. 4 of *de-,dis-,ex-*. London: Black Dog Publishing, 2000.

Collier, Peter, and David Horowitz, eds. *The Race Card: White Guilt, Black Resentment and the Assault on Truth and Justice*. Rocklin, Calif.: Prima Publishers, 1997.

———. *Second Thoughts About Race in America*. Lanham, Wis.: Madison Books, 1991.

Comaroff, Jean, and John Comaroff, eds. *Modernity and Its Malcontents*. Chicago: University of Chicago Press, 1993.

———. "Naturing the Nation: Aliens, Apocalypse, and the Postcolonial State." *HAGAR International Social Sciences Review* 1, 1 (2000): 7–40.

Committee of Inquiry on Museums and National Collections. *Museums in Australia 1975: Report of the Committee of Inquiry on Museums and National Collections Including the Report of the Planning Committee on the Gallery of Aboriginal Australia*. Canberra: Australian Government Publishing Service, 1975.

Commonwealth of Australia. *Review of the National Museum of Australia, Its Exhibition and Public Programs: A Report to the Council of the National Museum of Australia*. Canberra: National Museum of Australia, 2003.

Congreso General de Cultura Kuna. "Proyecto de Isla Museo Uer-Uerdup de la Comarca Kuna Yala." Paper presented at the conference Estrechando Lazos: Encuentro de Museos Comunitarios de las Américas, September 29–October 5, 2000.

Connerly, Ward. *Creating Equal: My Fight Against Race Profiles*. San Francisco: Encounter Books, 2000.

Connex Travel. *South Africa: Discover Our New World in One Country*. Johannesburg: Connex, 1994.

Conolly, D. *The Tourist in South Africa*. 4th edition. Johannesburg: Spectrum Publishing, 1967–68.

Coombe, Rosemary. "The Properties of Culture and the Possession of Identity: Post-colonial Struggle and the Legal Imagination." In *Borrowed Power: Essays in Cultural Appropriation*, edited by Bruce Ziff and Pratima Rao. New Brunswick, N.J.: Rutgers University Press, 1997.

Coombes, Anne. *Reinventing Africa: Museums, Material Culture and Popular Imagination in Late Victorian and Edwardian England*. Cambridge, Mass.: Harvard University Press, 1994.

Copeland, Larry. "From a Whisper to a Shout: Museums Teach Black History." *USA Today*, May 15, 2002.

Corrin, Lisa, ed., *Mining the Museum: An Installation by Fred Wilson*. New York: New Press, 1994.

Crais, Clifton. *The Making of the Colonial Order*. Johannesburg: Witwatersrand University Press, 1992.

Crane, Susan, ed. *Museums and Memory*. Stanford, Calif.: Stanford University Press, 2000.

Crary, Jonathan. *Suspensions of Perception: Attention, Perception, and Modern Culture*. Cambridge, Mass.: MIT Press, 2001.

————. *Techniques of the Observer: On Vision and Modernity in the Nineteenth Century*. Cambridge, Mass.: MIT Press, 1996.

Crimp, Douglas. "On the Museum's Ruins (1980)." In *The Anti-Aesthetic*, edited by Hal Foster. Seattle: Bay Press, 1983.

Cubé, Christine. "Site Search Narrows for African American History Museum." *Washington Business Journal*, September 27, 2002.

CVR Tourist Guide. *The CVR Tourist Guide to South Africa 1966-7*. Johannesburg: C. van Rensburg Publications, 1966.

Cypher, Jennifer, and Eric Higgs. "Colonizing the Imagination: Disney's Wilderness Lodge." *Capitalism, Nature, Socialism* 8, 4 (1997): 107-30.

da Cunha, Manuela Carneiro. "The Role of UNESCO in the Defense of Traditional Knowledge." In Seitel, *Safeguarding Traditional Cultures*.

Dagens, Bruno. *Angkor: Heart of an Asian Empire*. London: Thames and Hudson, 1995.

Dann, Graham M. S., and Robert B. Potter. "Supplanting the Planters: Hawking Heritage in Barbados." In Dann and Seaton, *Slavery, Contested Heritage and Thanatourism*.

Dann, Graham M. S., and A.V. Seaton, eds. *Slavery, Contested Heritage and Thanatourism*. New York: Haworth Press, 2001.

Daston, Lorraine, and Katharine Park, eds. *Wonders and the Orders of Nature, 1150-1750*. New York: Zone Books, 1998.

Davaruth, Ly, and Ingrid Muan, eds. *The Legacy of Absence: A Cambodian Story*. Phnom Penh: Reyum, 2000.

Dávila, Arlene. "Latinizing Culture: Art Museums and the Politics of Multicultural Encompassment." *Cultural Anthropology* 14, 2 (1999): 180-202.

Davis, Kathy. "A Question of Ownership: Local Artists Wage Three-Year Battle over San Diego Centro Cultural de la Raza." *San Diego City Beat*, January 14, 2003.

Davis, Susan. *Spectacular Nature: Corporate Culture and the Sea World Experience.* Berkeley: University of California Press, 1997.

Davison, Patricia. "Museums and the Reshaping of Memory." In Nuttall and Coetzee, *Negotiating the Past.*

———. "Typecast: Representation of the Bushmen at the South African Museum." *Public Archaeology* 2, 1 (2001): 3–20.

Deacon, Harriet. "Remembering Tragedy, Constructing Modernity: Robben Island as a National Monument." In Nuttall and Coetzee, *Negotiating the Past.*

Dean, David. *Museum Exhibition: Theory and Practice.* London: Routledge, 1994.

de Kok, Ingrid. "Cracked Heirlooms: Memory on Exhibition." In Nuttall and Coetzee, *Negotiating the Past.*

Delius, Peter. *A Lion Among the Cattle.* Johannesburg: Witwatersrand University Press, 1997.

Dellios, Paulette. "The Museumification of the Village: Cultural Subversion in the 21st Century." *The Culture Mandala: Bulletin of the Centre for East-West Cultural and Economic Studies* 5, 1 (2002).

Delport, Peggy. "Digging Deeper in District Six: Features and Interfaces in a Curatorial Landscape." In Rassool and Prosalendis, *Recalling Community in Cape Town.*

———. "Signposts for Retrieval: A Visual Framework for Enabling Memory of Place and Time." In Rassool and Prosalendis, *Recalling Community in Cape Town.*

Denbow, James. "A New Look at the Later Prehistory of the Kalahari." *Journal of African History* 27, 1 (1986): 3–28.

Department of Arts, Culture, Science and Technology (DACST). *Annual Report 2001/ 2002.* Pretoria: Department of Arts, Culture, Science and Technology, 2002.

———. "The Portfolio of Legacy Projects: A Portfolio of Commemorations Acknowledging Neglected or Marginalised Heritage." Internal discussion document, January 1998.

———. *White Paper on Arts, Culture and Heritage: All Our Legacies, Our Common Future.* Pretoria: Department of Arts, Culture, Science and Technology, 1996.

Derrida, Jacques. "Remarks on Deconstruction and Pragmatism." In *Deconstruction and Pragmatism*, edited by Chantal Mouffe. London: Routledge, 1996.

———. *Specters of Marx.* Translated by Peggy Kamuf. London: Routledge, 1994.

Dhupelia-Mesthrie, Uma, ed. *From Cane Fields to Freedom: A Chronicle of Indian South African Life.* Cape Town: Kwela Books, 2000.

Dias, Nélia. "Looking at Objects: Memory, Knowledge in Nineteenth-Century Ethnographic Displays." In *Travellers' Tales: Narratives of Home and Displacement*, edited by George Robertson, Melinda Mash, Lisa Tickner, Jon Bird, Barry Curtis, and Tim Putnam. London and New York: Routledge, 1994.

Dinan, Stephen. "Gilmore Surrenders Virginia's Heritage." *Washington Times*, March 21, 2001.

Dirección General de Población del Gobierno del Estado de Oaxaca—Instituto Nacional de Estadística, Geografía e Informática. *Marginación Municipal Oaxaca 2000.* Oaxaca: DIGEPO-INEGI, 2002.

District Six Museum. "District Six Museum Curatorial and Research Committee: Terms of Reference." Internal discussion document. Cape Town: District Six Museum, 2002.

――. *A Guide to the District Six Museum and the "Digging Deeper" Exhibition.* Cape Town: District Six Museum, 2000.

――. Information leaflet. Cape Town: District Six Museum, 2001.

――. "Mission Statement." Cape Town: District Six Museum, 2001.

――. "The Objectives of the District Six Museum." Internal discussion document. Cape Town: District Six Museum, 2002.

Dodson, Howard. *Jubilee: The History of African Americans from Slavery to Emancipation.* New York: New York Public Library, 2002.

Dondolo, Luvuyo. "The Construction of Public History and Tourist Destinations in Cape Town's Townships: A Study of Routes, Sites and Heritage." M.A. mini-thesis, University of the Western Cape, 2002.

Duah, Francis Boakye. "Ghana Museums and History: The Cape Coast Castle Museum." In *Museums and History in West Africa*, edited by Claude Daniel Ardouin and Emmanuel Arinze. Washington, D.C.: Smithsonian Institution Press, 2000.

Dubin, Steven. *Displays of Power: Memory and Amnesia in the American Museum.* New York: New York University Press, 1999.

Dubow, Saul. *Racial Segregation and the Origins of Apartheid in South Africa, 1919–1936.* London: Macmillan, 1989.

Duncan, Carol. *Civilizing Rituals: Inside Public Art Museums.* London: Routledge, 1995.

Duncan, Carol and Alan Wallach. "The Universal Survey Museum." *Art History* 3, 4 (1980): 448–69.

Dunlop, Ian. *One Man's Response.* Sydney: Film Australia, 1987.

During, Simon. "Popular Culture on a Global Scale: A Challenge for Cultural Studies?" *Critical Inquiry* 23 (1997): 808–33.

Durrans, Brian. "Talking in Museums." *Folk* 43 (2001): 151–64.

Dussart, Françoise. "A Body Painting in Translation." In *Rethinking Visual Anthropology*, edited by Howard Morphy and Marcus Banks. New Haven: Yale University Press, 1997.

Early, James and Peter Seitel. "UNESCO Meeting in Rio: Steps Toward a Convention." *Smithsonian Talk Story* 21 (2002): 3.

Ebron, Paulla A. "Tourists as Pilgrims: Commercial Fashioning of Transatlantic Politics." *American Ethnologist* 26, 4 (2000): 910–32.

Eco, Umberto. *The Island of the Day Before.* London: Secker and Warburg, 1995.

――. *Travels in Hyperreality.* New York: Harcourt Brace Jovanovich, 1986.

Edwards, Elizabeth. "Photography and the Performance of History." *Kronos* 27 (2001): 15–29.

Edwards, Penny. *Cambodge: The Cultivation of a Nation 1860–1945.* Ph.D. dissertation, Monash University, 1999.

Eggen, Dan. "In Williamsburg, the Painful Reality of Slavery." *Washington Post*, July 7, 1999.

Eichstedt, Jennifer L., and Stephen Small. *Representations of Slavery: Race and Ideology in Southern Plantation Museums*. Washington, D.C.: Smithsonian Institution Press, 2002.

Ekarv, Margareta. *Cultural Adventures:* SAMP — *Ten Years of Swedish-African Museum Exchanges/Une aventure culturelle:* SAMP — *dix ans de rencontres des musées africains et suédois*. Stockholm: SAMP, 2000.

El Comercio. "Hacia el museo" [interview with Frederick Cooper Llosa]. *El Comercio*, Lima, June 20, 1999.

Els, H. and J. B. Hartman. "Life History of Nkayinkayi Samuel Mavundla." Stevenson-Hamilton Library, Skukuza, n.d.

Eriksen, Erik Oddvar. "Globalization and Democracy." ARENA [Advanced Research on the Europeanisation of the Nation-State] working paper no. 23, August 15, 1999. Available at http://www.arena.uio.no/publications/wp99_23.htm (accessed September 28, 2004).

Essah, Patience. "Slavery, Heritage and Tourism in Ghana." In Dann and Seaton, *Slavery, Contested Heritage and Thanatourism*.

Evers, T. M. "Sotho-Tswana and Moloko Settlement Patterns and the Bantu Cattle Pattern." In M. Hall, G. Avery, D. M. Avery, M. L. Wilson, and A. J. B. Humphreys, eds., *Frontiers: Southern African Archaeology Today*. British Archaeological Reports International Series 207. Oxford: British Archaeological Reports, 1984.

"Exhibit Maps the History of Lwandle." *Helderberg District Mail*, August 31, 2001.

Exposition Coloniale Internationale. *Trois Ecoles d'Art de L'Indochine*. Hanoi: Imp. d'Extrême Orient, 1931.

Fabian, Johannes. *Power and Performance*. Madison: University of Wisconsin Press, 1990.

——. *Time and the Other: How Anthropology Makes Its Object*. New York: Columbia University Press, 1983.

Falk, John, and Lynn Dierking. *The Museum Experience*. Washington, D.C.: Whalesback Books, 1992.

Featherstone, Mike. *Undoing Culture: Globalization, Postmodernism and Identity*. London: Sage, 1995.

Featherstone, Mike, ed. *Global Culture: Nationalism, Globalization and Modernity*. London: Sage, 1990.

Feld, Steven. "From Schizophonia to Schismogenesis: The Discourses and Practices of World Music and World Beat." In Marcus and Myers, *The Traffic in Culture*.

Felski, R. "The Invention of Everyday Life." *New Formations* 39 (1999–2000): 13–31.

Fénéon, Félix et al. *Iront-ils au Louvre? Enquête sur des arts lointains*. Toulouse: Editions Toguna, 2000 [1920].

Field, Sean. *Lost Communities, Living Memories: Remembering Forced Removals in Cape Town*. Cape Town: David Philip, 2001.

Figal, Gerald. *Civilisation and Monsters: Spirits of Modernity in Meiji Japan*. Durham: Duke University Press, 1999.

Filler, Martin. "The Museum Game." *The New Yorker*, April 2000, 97–105.

Findlay, John M. *Magic Lands: Western Cityscapes and American Culture After 1940*. Berkeley: University of California Press, 1992.

Findlen, Paula. *Possessing Nature: Museums, Collecting and Scientific Culture in Early Modern Italy*. Berkeley: University of California Press, 1994.

Fjellman, Stephen. *Vinyl Leaves: Walt Disney World and America*. Boulder, CO: Westview Press, 1992.

Flood, Finbarr Barry. "Between Cult and Culture: Bamiyan, Islamic Iconoclasm, and the Museum." *Art Bulletin* 84, 4 (2002): 641–58.

Foglesong, Richard E. *Married to the Mouse: Walt Disney World and Orlando*. New Haven: Yale University Press, 2001.

Foner, Eric, and Olivia Mahoney. *A House Divided: America in the Age of Lincoln*. New York: Norton for the Chicago Historical Society, 1990.

"Foot and Mouth Disease Danger in Park." *Star*, February 1939.

Foster, Hal. "Master Builder." In *Design and Crime (and Other Diatribes)*. London: Verso Press, 2002.

———. "The 'Primitive' Unconscious of Modern Art, or White Skin Black Masks." In *Recodings: Art, Spectacle, Cultural Politics*. Seattle: Bay Press, 1985.

Foster, Hal, et al. "The MOMA Expansion: A Conversation with Terence Riley." *October* 84 (1998): 3–30.

Foucault, Michel. *Discipline and Punish: The Birth of the Prison*. Translated by Alan Sheridan. New York: Vintage, 1979.

———. "Governmentality." In *The Foucault Effect: Studies in Governmentality*, edited by Graham Burchell, Colin Gordan, and Peter Miller. Hemel Hampstead: Harvester Wheatsheaf, 1991.

———. *The Archaeology of Knowledge and the Discourse on Language*. Translated by A. M. Sheridan Smith. New York: Pantheon, 1982.

Fransen, H., comp. *Guide to the Museums of Southern Africa*. Cape Town: South African Museums Association, 1969.

Fraser, Andrea. "Museum Highlights: A Gallery Talk." Written and performed by Andrea Fraser. Videotape. New York: American Fine Arts, 1989.

———. "Museum Highlights: A Gallery Talk." *October* 57 (1991): 104–22.

———. "'A Museum Is Not a Business. It Is Run in a Business-Like Fashion.'" In *Beyond the Box: Diverging Curatorial Practices*, edited by Melanie Townsend. Banff: Banff Centre Press, 2003.

———. "A 'Sensation' Chronicle." *Social Text* 67 (2001): 127–56.

Fraser, Nancy. "Rethinking the Public Sphere: A Contribution to the Critique of Actually Existing Democracy." *Social Text* 25–26 (1990): 56–81.

———. *Unruly Practices: Power, Discourse and Gender in Contemporary Social Theory*. University of Minnesota Press and Polity Press, 1989.

Freedberg, David. *The Power of Images: Studies in the History and Theory of Response*. Chicago: University of Chicago Press, 1989.

Freiman, Ziva. "Memory Too Politic." *P/A*, October 1995, 63.

Freire, Luis, and Fietta Jarque. "¿A quién servirá el Museo de Arte Contemporáneo?" *El Observador* (Lima), November 5, 1981.

French, Howard W. "On Slavery, Africans Say the Guilt Is Theirs, Too." *New York Times*, December 27, 1994.

Freud, Sigmund. "Formulations Regarding the Two Principles in Mental Functioning (1911)." In *General Psychological Theory*, edited by Philip Rieff. New York: Collier Books, 1963.

Frey, Bruno S., and Werner W. Pommerehne. *Muses and Markets: Explorations in the Economics of the Arts*. Oxford: Blackwell, 1989.

Frishberg, Manny. "Local Access: It Takes a Village." *Wired News*, May 27, 2002.

Frow, John. "Tourism and the Semiotics of Nostalgia." In *Time and Commodity Culture*. Oxford: Clarendon Press, 1997.

Fry, Tony, and Anne-Marie Willis. "Aboriginal Art: Symptom or Success?" *Art in America*, July 1989, 108–17.

Fukuoka Asian Art Museum. *The 1st Fukuoka Asian Art Triennale 1999*. Fukuoka: Fukuoka Asian Art Museum, 1999.

Fuller, Nancy J. "The Museum as a Vehicle for Community Empowerment: The Ak-Chin Indian Community Ecomuseum Project." In Karp, Kreamer, and Lavine, *Museums and Communities*.

García Canclini, Néstor. *Hybrid Cultures: Strategies for Entering and Leaving Modernity*. Minneapolis: University of Minnesota Press, 1995.

———. *La globalización imaginada*. Buenos Aires: Editorial Piados, SAJCF, 1999.

———. *Transforming Modernity: Popular Culture in Mexico*. Austin: University of Texas Press, 1993.

Gaspar de Alba, Alicia. *Chicano Art Inside/Outside the Master's House: Cultural Politics and the CARA Exhibition*. Austin: University of Texas Press, 1998.

Geertz, Clifford. "Epilogue." In *The Anthropology of Experience*, edited by Victor W. Turner and Edward M. Bruner. Urbana: University of Illinois Press, 1986.

———. "From the Native's Point of View: On the Nature of Anthropological Understanding." In *Meaning in Anthropology*, edited by Keith Basso and Henry Selby. Albuquerque: University of New Mexico Press, 1975.

Gell, Alfred. *Art and Agency: An Anthropological Theory*. Oxford: Oxford University Press, 1998.

George, Alice Rose, et al. *Here Is New York: A Democracy of Photographs*. New York and Zurich: Scalo Verlag, 2002.

George, Kenneth. "Objects on the Loose: Ethnographic Encounters with Unruly Objects—A Forward." *Ethnos* 64, 2 (1999): 149–50.

Ginsburg, Faye. "Aboriginal Media and the Australian Imaginary." *Public Culture* 5, 3 (1993): 557–78.

———. "The Parallax Effect: The Impact of Indigenous Media on Ethnographic Film." In *Collecting Visible Evidence*, edited by Jane Gaines and Michael Renov. Minneapolis: University of Minnesota Press, 1999.

Gobierno del Estado de Oaxaca-INEGI. *Anuario Estadístico del Estado de Oaxaca.* 2 vols. Oaxaca: Gobierno del Estado de Oaxaca-INEGI, 1999.

Golinski, Jan. *Science as Public Culture: Chemistry and Enlightenment in Britain, 1760–1820.* Cambridge: Cambridge University Press, 1992.

Goodin, Robert. "Utility and the Good." In *A Companion to Ethics*, edited by Peter Singer. Oxford: Blackwell Reference, 1991.

Goodman, Nelson. *Languages of Art: An Approach to a Theory of Symbols.* Indianapolis: Bobbs-Merrill, 1968.

Gosden, Chris. "On his Todd: Material Culture and Colonialism." In *Hunting the Gatherers: Ethnographic Collectors, Agents and Agency in Melanesia, 1870s-1930s*, edited by Michael O'Hanlon and Robert L. Welsch. Oxford: Berghahn Books, 2000.

Grassroute Tours. *Grassroute Tours Invites You to Have a Look Beyond the Rainbow Curtain.* Cape Town: Grassroute, 1999.

Grau, Oliver. "The History of Telepresence: Automata, Illusion, and the Rejection of the Body." In *The Robot in the Garden: Telerobotics and Telepistemology in the Age of the Internet*, edited by Ken Goldberg. Cambridge: MIT Press, 2000.

Greenberg, Reesa, Bruce Ferguson, and Sandy Nairne, eds. *Thinking About Exhibitions.* London: Routledge, 1996.

Greenblatt, Stephen. "Resonance and Wonder." In Karp and Lavine, *Exhibiting Cultures.*

Greenhalgh, Paul. *Ephemeral Vistas: The Expositions Universelles, Great Exhibitions and World's Fairs, 1851–1939.* Manchester: Manchester University Press, 1988.

Griffin, Tim. "Global Tendencies: Globalism and the Large-scale Exhibition." *Artforum* 42, 3 (2003): 152–63, 206, 212.

Griffith, Alison. " 'Animated Geography': Early Cinema at the AMNH in Fullerton." In *Celebrating 1895: The Centenary of Cinema*, edited by John Fullerton. London: John Libby, 1998.

Groslier, Georges. "L'Agonie des arts cambodgiens." *Revue Indochinoise* 6 (1918): 547–60.

———. "La Convalescence des arts cambodigens." *Revue Indochinoise* 5 (1919): 871–924.

———. "L'Enseignement et la mise en pratique des arts indigenes 1918–1930." *Bulletin de l'Académie des Sciences Coloniales* XVI (1931).

———. "Etude sur la psychologie de l'artisan cambodgien." *Arts et Archéologies khmers* I (1926): 125–37, 205–20.

———. "La Fin d'un art." *Revue des Arts Asiatiques* VI (1929–30): 176–86.

———. "Inauguration du Musée Albert Sarraut et de l'Ecole des Arts Cambodgiens." Speech. Phnom Penh: Imprimerie du Protectorat, 1920.

———. "La Prise en charge des arts cambodgiens." *Revue Indochinoise* 9 (1918): 251–64.

———. "La Tradition cambodgienne." *Revue Indochinoise* 5 (1918): 459–69.

Guerny, Jacques du, and Lee-Nah Hsu. "Early Warning Rapid Response System: HIV Vulnerability Caused by Mobility Related to Development." South East Asia HIV and Development Project, United Nations Development Programme, July 2000.

Guggenheim Bilbao. *Manual de estilo de atencion al visitante Guggenheim Bilbao Museoa.* Bilbao: Guggenheim Bilbao, 1999.

Habermas, Jürgen. *The Structural Transformation of the Public Sphere: An Inquiry into a Category of Bourgeois Society.* Translated by Thomas Burger with Frederick Lawrence. Cambridge, Mass.: MIT Press, 1991.

———. *The Theory of Communicative Action.* Translated by Thomas McCarthy. Boston: Beacon Press, 1987.

Hafstein, Valdimar Tr. "The Making of Intangible Cultural Heritage: Tradition and Authenticity, Community and Humanity." Ph.D. dissertation, University of California, Berkeley, 2004.

Hage, Ghassan. *White Nation: Fantasies of White Supremacy in a Multicultural Society.* Annandale, NSW: Pluto Press, 1998.

Haley, Alex. *Roots.* Garden City, N.Y.: Doubleday, 1976.

Hall, Martin. "Earth and Stone: Archaeology as Memory." In Nuttall and Coetzee, *Negotiating the Past.*

———. "Social Archaeology and the Theatres of Memory." *Journal of Social Archaeology*, 1, 1 (2000): 50–61.

Hamilton, Carolyn. "Against the Museum as Chameleon." *South African Historical Journal* 31 (1994): 184–90.

Handler, Richard. "Who Owns the Past? History, Cultural Property and the Logic of Possessive Individualism." In *The Politics of Culture*, edited by Brett Williams, 63–74. Washington, D.C.: Smithsonian Institution Press, 1991.

Handler, Richard, and Eric Gable. *The New History in an Old Museum: Creating the Past at Colonial Williamsburg.* Durham: Duke University Press, 1997.

Hannigan, John. *Fantasy City: Pleasure and Profit in the Postmodern Metropolis.* London: Routledge, 1998.

Hardt, Michael, and Antonio Negri. *Empire.* Cambridge, Mass.: Harvard University Press, 2000.

Harries, Patrick. "Aspects of Poverty in Gazankulu: Three Case Studies." Paper presented at the Second Carnegie Inquiry into Poverty and Development in Southern Africa, April 13, 1984.

———. "'A Forgotten Corner of the Transvaal': Reconstructing the History of a Relocated Community Through Oral Testimony and Song." Paper presented at the University of the Witwatersrand History Workshop, January 1984.

———. "The Roots of Ethnicity: Discourse and the Politics of Language Construction in South-East Africa." Paper presented at the University of the Witwatersrand History Workshop, February 9, 1987.

———. *Work, Culture, and Identity: Migrant Laborers in Mozambique and South Africa, c. 1860–1910.* Johannesburg: Witwatersrand University Press, 1996.

Harris, Neil. *Cultural Excursions: Marketing Appetites and Cultural Tastes in Modern America*. Chicago: University of Chicago Press, 1990.

———. "Museums, Merchandising, and Public Taste." In *Cultural Excursions: Marketing Appetites and Cultural Tastes in Modern America*. Chicago: University of Chicago Press, 1990 [1978].

———. "Polling for Opinions." *Museum News* 69, 5 (1990): 46–53.

Hart, Deborah M. "Political Manipulation of Urban Space: The Razing of District Six, Cape Town." In Jeppie and Soudien, *The Struggle for District Six*.

Harvey, Penelope. *Hybrids of Modernity: Anthropology, the Nation State and the Universal Exhibition*. London: Routledge, 1996.

Harwit, Martin. *An Exhibit Denied: Lobbying the History of the Enola Gay*. New York: Copernicus, 1997.

Hauenschild, Andrea. "Claims and Reality of the New Museology." Ph.D. dissertation, University of Hamburg, 1988.

Healy, Kevin. *Llamas, Weavings, and Organic Chocolate*. Notre Dame: University of Notre Dame Press, 2001.

Hein, George. *Learning in the Museum*. London: Routledge, 1998.

Held, David, Anthony McGrew, David Goldblatt, and Jonathan Perraton. *Global Transformations: Politics, Economics and Culture*. Cambridge: Polity Press, 1999.

Henderson, Amy, and Adrienne Kaeppler, eds. *Exhibiting Dilemmas*. Washington, D.C.: Smithsonian Institution Press, 1997.

Hevia, James Louis. "World Heritage, National Culture, and the Restoration of Chengde." *Positions: East Asia Cultures Critique* 9, 1 (2001): 219–44.

Hinsley, Curtis M., Jr., and Bill Holm. "A Cannibal in the National Museum: The Early Career of Franz Boas in America." *American Anthropologist* 78 (1976): 306–16.

Hirst, Paul, and Grahame Thompson. *Globalisation in Question: The International Economy and the Possibilities of Governance*. Cambridge: Polity Press, 1996.

Hoffenberg, Peter. *An Empire on Display: English, Indian, and Australian Exhibitions from the Crystal Palace to the Great War*. Berkeley: University of California Press, 2001.

Hofmeyr, Isabel. "Popularising History: The Case of Gustav Preller." *Journal of African History* 29, 3 (1988): 521–35.

———. *"We Spend Our Years as a Tale That Is Told": Oral Historical Narrative in a South African Chiefdom*. Johannesburg: Witwatersrand University Press, 1994.

Holo, Selma Reuben. *Museums and Identity in Democratic Spain*. Washington, D.C.: Smithsonian Institution Press, 1999.

Honigsbaum, Mark. "McGuggenheim?" *The Guardian*, January 27, 2001.

Hooper, John. *The New Spaniards*. New York: Penguin Books, 1995.

Horowitz, David. *Hating Whitey and Other Progressive Causes*. Dallas, Tex.: Spence Books, 1999.

Horton, James Oliver and Spencer Crew. "Afro-American Museums: Toward a Policy of Inclusion." In *History Museums in the United States: A Critical Assessment*, edited by Warren Leon and Roy Rosenzweig. Urbana: University of Illinois Press, 1989.

Horwitz, Tony. *Confederates in the Attic: Dispatches from the Unfinished Civil War*. New York: Vintage Books, 1999.

Houston, Charlene. "Consultative Workshops Report—January 2002." Cape Town: District Six Museum, 2002.

Hudson, Kenneth, and A. Nicholls. *The Directory of Museums*. London: Macmillan, 1975.

Huffman, Thomas N. *Snakes and Crocodiles: Power and Symbolism in Ancient Zimbabwe*. Johannesburg: Witwatersrand University Press, 1996.

Hufford, Mary. "Tending the Commons—Stalking the Mother Forest: Voices Beneath the Canopy." *Folklife Center News* (Library of Congress) 17, 3 (1995).

Huhtamo, Erikki. "On the Origins of the Virtual Museum." Paper presented at the Nobel Symposium (NS 1 20), Virtual Museums and Public Understanding of Science and Culture, Stockholm, May 26–29, 2002.

Hunter, James Davison. *Culture Wars: The Struggle to Define America*. New York: Basic Books, 1991.

Hutchinson, Louise Daniel. *Out of Africa: From West African Kingdoms to Colonization*. Washington: Smithsonian Institution Press, 1979.

Hyatt, Vera. *Ghana: The Chronicles of a Museum Development Project in the Central Region*. Washington, D.C.: Smithsonian Institution, 1997.

Hyland, Anthony. "Monuments Conservation Practice in Ghana: Issues of Policy Management." *Journal of Architectural Conservation* 2 (July 1995): 45–62.

Ice, Joyce. "Invoking Community: Contested Values in a Museum Exhibition." Paper presented at the workshop Cultural Battlefields: The Changing Shape of Controversy in Exhibition and Performance, Center for the Study of Public Scholarship, Emory University, Atlanta, March 22–23, 2002.

Informe Anual de la Red Oaxaqueña de Derechos Humanos. *Los derechos de los pueblos indígenas en el estado de Oaxaca*. Oaxaca: RODH, 2000.

Instituto de Arte Contemporáneo. *El Museo de Arte Contemporáneo*. Lima: Instituto de Arte Contemporáneo, 1986.

Instituto Nacional de Estadística, Geografía e Informática. *Tabulados básicos, Estados Unidos Mexicanos, XII Censo General de Población y Vivienda, 2000*. México, D.F.: INEGI, 2001.

International Coalition of Historic Site Museums of Conscience. "Founding Declaration." In Rassool and Prosalendis, *Recalling Community in Cape Town*.

International Council of Museums (ICOM). "Development of the Museum Definition According to ICOM Statutes (1946–2001)." Paris: ICOM, 2001.

Jackson, Carey-Ann, and Laurens Cloete. "Lessons from WWW Tourism Initiatives in South Africa." Paper presented at INET 2000, Yokohama, Japan, July 18–21, 2000. Available at http://www.isoc.org/isoc/conferences/inet/oo/cdproceedings/7a/7a _3.htm (accessed May 7, 2002).

Jameson, Fredric. *Postmodernism or, the Cultural Logic of Late Capitalism*. London: Verso, 1991.

Jameson, Fredric, and Masao Miyoshi, eds. *The Cultures of Globalization*. Durham: Duke University Press, 1998.

Jenkins, Simon. "Hysteria Calls the Shots." *The Times* (London), November 19, 1997.

Jeppie, Shamil. "Popular Culture and Carnival in Cape Town: The 1940s and 1950s." In Jeppie and Soudien, *The Struggle for District Six*.

Jeppie, Shamil, and Crain Soudien, eds. *The Struggle for District Six: Past and Present*. Cape Town: Buchu Books, 1990.

Jessup, Helen, and Thierry Zephir, eds. *Sculpture of Angkor and Ancient Cambodia: Millennium of Glory*. Washington, D.C.: National Gallery of Art, 1997.

Johannes, Calvin. *The History of the Black Townships and Squatter Camps of Cape Town*. Cape Town: Southern Tip Tours, 2000.

Johnson, Charles. *Middle Passage*. New York: Atheneum, 1990.

Johnson, Charles, Patricia Smith, and the WGBH Series Research Team. *Africans in America: America's Journey through Slavery*. New York: Harcourt Brace, 1998.

Johnson, Vivien. "Art and Aboriginality." In *Art and Aboriginality 1987*. Portsmouth, UK: Aspex Gallery, 1987.

Jones, Edward P. *The Known World: A Novel*. New York: Amistad, 2003.

Judin, Hilton, ed. *Blank: Architecture, Apartheid and After*. Rotterdam: NAI, 1999.

ka Mpumlwana, Khwezi, Gerard Corsane, Juanita Pastor-Makhurane, and Ciraj Rassool. "Inclusion and the Power of Representation: South African Museums and the Cultural Politics of Social Transformation." In Sandell, *Museums, Society, Inequality*.

Kant, Immanuel. *Perpetual Peace, and Other Essays on Politics, History, and Morals*. Translated by Ted Humphrey. Indianapolis: Hackett, 1983.

Kantor, Shira. "Time Running Out for Black Museum." *Chicago Tribune*, November 9, 2002.

Kanuma, Shyaka. "Songs of Hate." *Mail and Guardian* (Johannesburg), June 28, 2002.

Karp, Ivan. "Culture and Representation." In Karp and Lavine, *Exhibiting Cultures*.

———. "Introduction, Museums and Communities: The Politics of Public Culture." In Karp, Kreamer, and Lavine, *Museums and Communities*.

———. "On Civil Society and Social Identity." In Karp, Kreamer, and Lavine, *Museums and Communities*.

Karp, Ivan, Christine Mullen Kreamer, and Steven D. Lavine, eds. *Museums and Communities: The Politics of Public Culture*. Washington, D.C.: Smithsonian Institution Press, 1992.

Karp, Ivan, and Steven D. Lavine, eds. *Exhibiting Cultures: The Poetics and Politics of Museum Display*. Washington, D.C.: Smithsonian Institution Press, 1991.

———. "Museums and Multiculturalism." In *Exhibiting Cultures*.

Karp, Ivan, and Fred Wilson. "Constructing the Spectacle of Culture in Museums." In Greenberg, Ferguson, and Nairne, *Thinking About Exhibitions*.

Kavanagh, Gaynor. *Museums and the First World War: A Social History*. London and New York: Leicester University Press, 1994.

Keneally, Thomas. *Schindler's Ark*. London: Hodder and Stoughton, 1982.

Kennedy, Randy. "With Irreverence and an iPod, Recreating the Museum Tour." *New York Times*, May 28, 2005.

Kennedy, Richard. "The Silk Road: Connecting Cultures, Creating Trust." *Smithsonian Talk Story* 21 (2002): 1.

Kenny, Leo, and Beate Kasale. "Swedish African Museum Programme (SAMP): An Evaluation. Department for Democracy and Social Development: Section for Culture and Media, March–July." Sida Evaluation 95/3, 1995.

Keyes, Charles. "The Legacy of Angkor." *Cultural Survival Quarterly* 14, 3 (1990): 56–59.

Kimmelman, Michael. "An Era Ends for the Guggenheim." *New York Times*, December 6, 2002.

———. "The Globe Straddler of the Art World." *New York Times*, April 19, 1998.

King, Margaret J. "The Audience in the Wilderness: The Disney Nature Films." *Journal of Popular Film and Television* 24, 2 (1996): 60–68.

Kirshenblatt-Gimblett, Barbara. "Confusing Pleasures." In Marcus and Myers, *The Traffic in Culture*.

———. *Destination Culture: Tourism, Museums and Heritage*. Berkeley, Los Angeles and London: University of California Press, 1998.

———. "Destination Museum." In *Destination Culture*.

———. "Folklore's Crisis." *Journal of American Folklore* 111, 441 (1998): 281–327.

———. "Folklorists in Public: Reflections on Cultural Brokerage in the United States and Germany." *Journal of Folklore Research* 37, 1 (2000): 1–21.

———. "Mistaken Dichotomies." In *Public Folklore*, edited by Nicholas R. Spitzer and Robert Baron. Washington, D.C.: Smithsonian Institution Press, 1992.

———. "The Museum as Catalyst." In *Museum 2000: Confirmation or Challenge?* edited by Per-Uno Ågren. Stockholm: Svenska Museiföreningen, 2002.

———. "Museums, World Heritage and Cultural Economics." Paper presented at the Museums and Global Public Spheres conference, July 22–26, 2002, Bellagio, Italy.

———. "Objects of Ethnography." In Karp and Lavine, *Exhibiting Cultures*.

———. "Plimoth Plantation." In *Destination Culture*.

Klamer, Arjo, and Peter-Wim Zuidhof. "The Values of Cultural Heritage: Merging Economic and Cultural Appraisals." In *Economics and Heritage Conservation: A Meeting Organized by the Getty Conservation Institute, December 1998*, edited by Marta de la Torre and Randy Mason. Los Angeles: Getty Conservation Institute, 1999.

Klein, Kerwin Lee. "On the Emergence of *Memory* in Historical Discourse." *Representations* 69 (2000): 127–50.

Kozain, Rustum. "Miscast." *South African Review of Books* 44 (1996): 14–15.

Kramer, Carol. "Inside Disney's Animal Kingdom: Animals and Nature Are the Stars at This Theme Park." 2001. Available at http://familyfun.go.com/family-travel/disney/feature/dony48kingdom/dony48kingdom.html (accessed August 15, 2006).

Kratz, Corinne. "Circumcision Debates and Asylum Cases: Intersecting Arenas, Contested Values, and Tangled Webs." In *Engaging Cultural Differences: The Multi-*

cultural Challenge in Liberal Democracies, edited by Richard A. Shweder, Martha Minow, and Hazel Markus. New York: Russell Sage Foundation, 2002.

————. *The Ones That Are Wanted: Communication and the Politics of Representation in a Photographic Exhibition.* Berkeley: University of California Press, 2002.

————. "Rhetorics of Value: Constituting Worth and Meaning through Cultural Display." Paper presented at the session "Beyond Binaries: Globalizing Objects, Identities and Aesthetics" at the annual meetings of the American Anthropological Association, November 20, 2002.

Kratz, Corinne A., and Ivan Karp. "Islands of 'Authenticity': Museums in Disney's World." Emory University, Atlanta, 1992.

————. "Wonder and Worth: Disney Museums in World Showcase." *Museum Anthropology* 17, 3 (1993): 32–42.

Krauss, Rosalind. "The Cultural Logic of the Late Capitalist Museum." *October* 54 (1990): 3–17.

————. *The Originality of the Avant-Garde and Other Modernist Myths.* Cambridge: MIT Press, 1985.

Kreamer, Christine Mullen, and Sarah Fee, eds. *Objects as Envoys: Cloth, Imagery and Diplomacy in Madagascar.* Washington, D.C.: Smithsonian Institution Press, 2002.

Kreps, Christina. *Liberating Culture: Cross-cultural Perspectives on Museums, Curation and Heritage Preservation.* London: Routledge, 2003.

Kubin, Jacquie. "Disney, Dinos and Company-Animal Kingdom, at Walt Disney World." *Insight on the News,* December 21, 1998.

Kugelmass, Jack. "The Rites of the Tribe: American Jewish Tourism in Poland." In Karp, Kreamer, and Lavine, *Museums and Communities.*

Kurin, Richard. *Reflections of a Culture Broker: A View from the Smithsonian.* Washington, D.C.: Smithsonian Institution Press, 1997.

Kurlansky, Mark. *The Basque History of the World.* New York: Walker, 1999.

Kymlicka, Will. *Politics in the Vernacular: Nationalism, Multiculturalism, and Citizenship.* Oxford: Oxford University Press, 2001.

Labuschagne, R. J. *60 Jaar Krugerwildtuin.* Pretoria: National Parks Board of Trustees, 1958.

Laquer, Thomas W. "Introduction." *Representations* 69 (2000): 1–8.

Larson, Pier M. *History and Memory in the Age of Enslavement: Becoming Merina in Highland Madagascar, 1770–1882.* Portsmouth, N.H.: Heinemann, 2000.

Lavalle y Arias, José Antonio de. "Crónica." *La Revista de Lima,* 1860, 757–65.

Layne, Valmont. "Public Knowledge and Music History in Cape Town: Challenges for a Local Archive." Paper presented at the Institutions of Public Culture Seminar, Emory University, April 11, 2002.

Layne, Valmont, and Ciraj Rassool. "Memory Rooms: Oral History in the District Six Museum." In Rassool and Prosalendis, *Recalling Community in Cape Town.*

Leach, Melissa, and Robin Mearns, eds. *The Lie of the Land: Challenging Received Wisdom on the African Environment.* Portsmouth, N.H.: Heinemann, 1996.

Leclère, Adhémard. "Cambodge: Le Tang-tok." *Revue Indochinoise* 5, 2 (1904): 335–41.

———. "Tang Tok." *Revue Indochinoise* 1, 2 (1904–5).

Legassick, Martin, and Ciraj Rassool. *Skeletons in the Cupboard: South African Museums and the Trade in Human Remains.* Cape Town: South African Museum, 2000.

Lennon, John, and Malcolm Foley. *Dark Tourism: The Attraction of Death and Disaster.* London: Continuum, 2000.

Lewis, Geoffrey. *For Instruction and Recreation—A Century History of the Museums Association.* Quiller Press: London, 1989.

Ley, Graham. *From Mimesis to Interculturalism: Readings of Theatrical Theory Before and After "Modernism."* Exeter: University of Exeter Press, 1999.

Life Interactive World. *Take a Look at Life: Guide to Life Interactive World.* Newcastle: International Centre for Life, 2000.

"Life in Transit in Makeshift Housing: Khayelitsha," *Event: The Exclusive Guide to Cape Town,* February 1998, 7.

"Lightning Law to Privatise 'la Bella Italia,'" *The Art Newspaper,* July 5, 2002.

Lippard, Lucy. *On the Beaten Track.* New York: The New Press, 1999.

Lovrenovic, Ivan. "The Hatred of Memory: In Sarajevo, Burned Books and Murdered Pictures." *New York Times,* May 28, 1994.

Lowenthal, David. *The Heritage Crusade and the Spoils of History.* London: Penguin Books, 1997.

———. "National Museums and Historical Truth." In McIntyre and Wehner, *Negotiating Histories.*

Lowndes, Esmé, and L.E.O. "Tess of the Bushveld." Stevenson-Hamilton Library, Skukuza.

Luke, Timothy. *Museum Politics: Power Plays at the Exhibition.* Minneapolis: University of Minnesota Press, 2002.

Lumbreras, Luis Guillermo. "Tres fundaciones de un museo para el Perú." *Copé* 20 (1977): 4–7.

Lwandle Migrant Labour Museum. *Lwandle Migrant Labour Museum and Arts and Crafts Centre.* Cape Town: Lwandle Museum, 2000.

MacCannell, Dean. *The Tourist: A New Theory of the Leisure Class.* Berkeley: University of California Press, 1999.

MacDonald, Sharon. *Behind the Scenes at the Science Museum.* London: Routledge, 2002.

———, ed. *A Companion to Museum Studies.* Oxford: Blackwell, 2006.

———. *The Politics of Display: Museums, Science, Culture.* London: Routledge, 1998.

MacDonald, Sharon, and Gordon Fyfe, eds. *Theorizing Museums.* Oxford: Blackwell/ Sociological Review, 1996.

MacKnight, Charles Campbell. *The Voyage to Marege: Macassan Trepangers in Northern Australia.* Melbourne: Melbourne University Press, 1976.

Mahon, Maureen. "The Visible Evidence of Cultural Producers." *Annual Review of Anthropology* 29 (2000): 467–92.

Majluf, Natalia, Cristóbal Makowski, and Francisco Stastny. *Art in Perú: Works from the Collection of the Museo de Arte de Lima.* Lima: Museo de Arte de Lima and PromPerú, 2001.

Maldonado Alvarado, Benjamín. *Autonomía y comunalidad india.* Oaxaca: INAH-CMPIO-CEDI-SAI, 2002.

———. *Organización social y política.* Oaxaca: n.p., 1999.

Maleuvre, Didier. *Museum Memories: History, Technology, Art.* Stanford, Calif.: Stanford University Press, 1999.

Malinowski, Bronislaw. *The Argonauts of the Western Pacific.* Prospect Heights, IL: Waveland Press, 1984 [1922].

Malraux, André. *Le Musée imaginaire.* Paris: Gallimard, 1947.

Mamdani, Mahmood. *Citizen and Subject: Contemporary Africa and the Legacy of Late Colonialism.* Cape Town: David Philip, 1996.

Manne, Robert, ed. *Whitewash: On Keith Windschuttle's Fabrication of Aboriginal History.* Melbourne: Black Inc., 2003.

Marais, C. "Flavours of Soweto," *Sawubona*, March 2002, 71–73.

Marchal, Henri. "L'art cambodgien moderne." *Bulletin de la Société des Etudes Indochinoises de Saigon* 65 (1913): 69–75.

———. "Reflexions sur l'art moderne Cambodgien." *France-Asie* 37–38 (1949): 819–25.

Marcus, George E. *Ethnography Through Thick and Thin.* Princeton: Princeton University Press, 1998.

Marcus, George E., and Fred R. Myers. *The Traffic in Culture: Refiguring Art and Anthropology.* Berkeley: University of California Press, 1995.

Margolis, Joseph. "The Autographic Nature of the Dance." *Journal of Aesthetics and Art Criticism* 39, 4 (1981): 419–27.

Marika, Wandjuk, as told to Jennifer Isaacs. *Wandjuk Marika: A Life Story.* Brisbane: University of Queensland Press, 1995.

Mariners' Museum. *Captive Passage: The Transatlantic Slave Trade and the Making of the Americas.* Washington, D.C.: Smithsonian Institution Press, 2002.

Martin, Marilyn. "Bringing the Past into the Present—Facing and Negotiating History, Memory, Redress and Reconciliation at the South African National Gallery." Paper presented at the Fault Lines conference, Cape Town, July 5, 1996.

McClellan, Andrew. *Inventing the Louvre: Art, Politics, and the Origins of the Modern Museum in Eighteenth-Century Paris.* Cambridge: Cambridge University Press, 1994.

McEachern, Charmaine. *Narratives of Nation: Media, Memory and Representation in the Making of the New South Africa.* New York: Nova Science, 2002.

McIntosh, Ian. "The Birrinydji Legacy: Aborigines Macassans and Mining in North-East Arnhem Land." *Aboriginal History* 21 (1997): 70–89.

McIntyre, Darryl, and Kirsten Wehner. "Introduction." In *Negotiating Histories.*

———, eds. *Negotiating Histories: National Museums.* Canberra: National Museum of Australia, 2001.

McLean, Ian. *White Aborigines: Identity Politics in Australian Art.* Cambridge: Cambridge University Press, 1998.

McWhorter, John. *Authentically Black: Essays for the Black Silent Majority.* New York: Gotham Press, 2003.

————. *Losing the Race: Self-Sabotage in Black America.* New York: Free Press, 2000.

Meekison, Lisa. "Indigenous Presence in the Olympic Games." In Smith and Ward, *Indigenous Cultures.*

Mellado, Justo Pastor. "El curador como productor de infraestructura." Paper presented at the I Foro Internacional para Especialistas en el Campo del Arte, Museo Antropológico y de Arte Contemporáneo, Guayaquil. July 4–7, 2001.

Mellor, Doreen, and Anna Haebich. *Many Voices: Reflections on Experiences of Indigenous Child Separation.* Canberra: National Library of Australia, 2002.

Ménétrier, E. "Les Fêtes du Tang-tok à Pnom Penh." *Revue Indochinoise* 10 (1912): 334–45.

Merrington, Peter. "Pageantry and Primitivism: Dorothy Fairbridge and the 'Aesthetics of Union.'" *Journal of Southern African Studies* 21, 4 (1995): 643–56.

Meskell, Lynn. "Sites of Violence: Terrorism, Tourism, and Heritage in the Archeological Present." Paper presented at the Wenner-Gren Foundation conference Beyond Ethics: Anthropological Moralities at the Boundaries of the Public and the Professional, March 1–7, 2002, Baja California Sur.

Mesthrie, Uma Shashikant. "The Tramway Road Removals, 1959–61." *Kronos* 21 (1994): 61–78.

Meyer, Birgit, and Peter Geschiere, eds. *Globalization and Identity: Dialectics of Flow and Closure.* Malden, Mass.: Blackwell Publishers, 1999.

Meyer, John W. "Globalization: Sources and Effects on National States and Societies." *International Sociology* 15 (2000): 233–48.

Mgijima, Bongani, and Vusi Buthelezi. "Mapping Museum-Community Relations in Lwandle." Paper presented to the Mapping Alternatives: Debating New Heritage Practices in South Africa Conference, hosted by the Project on Public Pasts (UWC) and the Research Unit for the Archaeology of Cape Town (UCT), September 22–23, 2001.

Miller, Daniel. *Worlds Apart: Modernity through the Prism of the Local.* ASA Decennial Conference Series. London: Routledge, 1995.

Miller, Toby, and George Yúdice. *Cultural Policy.* Thousand Oaks: Sage Publication, 2002.

Miner, Horace. "Body Ritual Among the Nacirema." *American Anthropologist* 58, 3 (1956): 503–7.

Ministère de L'éducation Nationale, de la Recherche et de la Technologie. "Inauguration du pavillon des Sessions, Palais du Louvre," press kit, April 2000. Available at http://www.quaibranly.fr/IMG/pdf/doc-387.pdf (accessed September 28, 2004).

Minkley, Gary, and Ciraj Rassool. "Orality, Memory and Social History in South Africa." In Nuttall and Coetzee, *Negotiating the Past.*

Minkley, Gary, Ciraj Rassool, and Leslie Witz. "Thresholds, Gateways and Spectacles: Journeying Through South African Hidden Pasts and Histories in the Last Decade of the Twentieth Century." Paper presented at the conference The Future of the Past: The Production of History in a Changing South Africa, University of the Western Cape, July 10–12, 1996.

Mitchell, Timothy. "Making the Nation: The Politics of Heritage in Egypt." In *Consuming Tradition, Manufacturing Heritage: Global Norms and Urban Forms in the Age of Tourism*, edited by Nezar AlSayyad. London: Routledge, 2001.

———. "The World as Exhibition." *Comparative Studies in Society and History* 31, 2 (1989): 217–36.

———. "Worlds Apart: An Egyptian Village and the International Tourism Industry." *Middle East Report* 25 (1995): 8–11, 23.

Mokaba, Peter. *Tourism: A Development and Reconstruction Perspective*. Johannesburg: ANC, 1994.

Monaghan, John. *The Covenants with Earth and Rain: Exchange, Sacrifice, and Revelation in Mixtec Sociality*. Norman: University of Oklahoma Press, 1995.

Morales, Ed. "Spanish Harlem on His Mind." *New York Times*, February 23, 2003.

Moresi, Michele Gates. "Exhibiting Race, Creating Nation: Representations of Black History and Culture at the Smithsonian Institution, 1895–1976." Ph.D. dissertation, George Washington University, 2003.

Morphet, Tony. "An Archaeology of Memory." *Mail and Guardian*, February 3, 1995.

Morphy, Howard. "Aboriginal Art in a Global Context." In Miller, *Worlds Apart*.

———. *Ancestral Connections: Art and an Aboriginal System of Knowledge*. Chicago: University of Chicago Press, 1991.

———. "Beginnings Without End: Aboriginal Art and First Contact." Federation Lecture, Art Gallery of New South Wales, Sydney, February 2001.

———. "Elite Art for Cultural Elites: Adding Value to Indigenous Arts." In Smith and Ward, *Indigenous Cultures*.

———. "Manggalili Art and the Promised Land." In *Painting the Land Story*, edited by Luke Taylor. Canberra: National Museum of Australia, 1999.

———. " 'Now You Understand' — An Analysis of the Way Yolngu Have Used Sacred Knowledge to Retain their Autonomy." In *Aborigines, Land and Land Rights*, edited by Nicolas Peterson and Marcia Langton. Canberra: Australian Institute of Aboriginal Studies, 1983.

Moubray, J. M. *In South Central Africa*. London: Constable, 1912.

Mouffe, Chantal. "Every Form of Art Has a Political Dimension." Interview with Chantal Mouffe by Rosalyn Deutsche, Branden W. Joseph, and Thomas Keenan. *Grey Room* 1, 2 (2001): 99–125.

Moulaert, Frank, Arantxa Rodriguez, and Erik Swyngedouw. "Neoliberal Urbanization in Europe: Large-Scale Urban Development Projects and the New Urban Policy." In Brenner and Theodore, *Spaces of Neoliberalism*.

Muan, Ingrid. "Citing Angkor: The 'Cambodian Arts' in the Age of Restoration 1918–2000." Ph.D. dissertation, Columbia University, 2001.

Muller, Gregor. "Visions of Grandeur, Tales of Failure: The Life Story of Thomas Caraman." Ph.D. dissertation, University of Zurich, 2002.

Munn, Nancy. *The Fame of Gawa.* Cambridge: Cambridge University Press, 1986.

———. *Walbiri Iconography.* Ithaca: Cornell University Press, 1973.

Murphy, Cullen. "Immaterial Civilization." *Atlantic Monthly,* September 2001: 20–22.

Muschamp, Herbert. "Culture's Power Houses: The Museum Becomes an Engine of Urban Redesign." *New York Times,* April 21, 1999.

———. "The Miracle in Bilbao." *New York Times Magazine,* September 7, 1997.

Museo Comunitario de Perquín. "Museo Comunitario de Perquín." Paper presented at the conference Estrechando Lazos: Encuentro de Museos Comunitarios de las Américas, Oaxaca, September 29–October 5, 2000.

Museo Comunitario Uwaupakira Tikitbita "Winakirika." "Lo de Nuestro Pueblo." Kakawira, Morazán, El Salvador, 2000.

Museo del Barro. *Centro de Artes Visuales/Museo del Barro.* Asunción: Museo del Barro, n.d.

Myers, Fred. "Culture-Making: Performing Aboriginality at the Asia Society Gallery." *American Ethnologist* 21, 4 (1994): 679–99.

———, ed. *The Empire of Things: Regimes of Value and Material Culture.* School of American Research Advanced Seminar Series. Santa Fe: School of American Research, 2001.

———. "Locating Ethnographic Practice: Romance, Reality and Politics in the Outback." *American Ethnologist* 5, 4 (1988) 609–24.

———. *Painting Culture: The Making of an Aboriginal High Art.* Durham: Duke University Press, 2002.

———. *Pintupi Country, Pintupi Self: Sentiment, Place and Politics Among Western Desert Aborigines.* Washington, D.C.: Smithsonian Institution Press and the Australian Institute of Aboriginal Studies Press, 1986.

———. "The Politics of Representation: Anthropological Discourse and Australian Aborigines." *American Ethnologist* 13, 1 (1986): 138–53.

———. "Representing Culture: The Production of Discourse(s) for Aboriginal Acrylic Paintings." *Cultural Anthropology* 6, 1 (1991): 26–62.

———. "The Wizards of Oz: Nation, State and the Production of Aboriginal Fine Art." In *The Empire of Things.*

Nagatani, Patrick. *Nuclear Enchantment.* Albuquerque: University of New Mexico Press, 1991.

Naidu, Edwin. "Moosa Ecstatic over Torrent of Tourists." *Sunday Independent,* March 9, 2003.

Nas, Peter J. M., H.R.H. Princess Basma Bint Talal, Henri J. M. Claessen, Richard Handler, Richard Kurin, Karen Olwig, and Laurie Sears. "Masterpieces of Oral and Intangible Culture: Reflections on the UNESCO World Heritage List." *Current Anthropology* 43, 1 (2002): 139–48.

Nasson, Bill. "Oral History and the Reconstruction of District Six." In Jeppie and Soudien, *The Struggle for District Six.*

National Endowment for the Arts. *Multidisciplinary Arts: A Report from the Director.* Available at http://www.nea.gov/artforms/Multi/Multi2.html (accessed October 23, 2003).

National Library of Australia. *Cook and Omai: The Cult of the South Seas.* Canberra: National Library of Australia, 2001.

National Monuments Council. "Cross-cultural Heritage Management Workshops: Dr. Amareswar Galla." National Monuments Council, South Africa, December 19, 1995.

National Park Service. "Underground Railroad Special Resources Study." Washington, D.C.: U.S. Department of Interior, 1995.

National Union of Community Museums and Ecomuseums. "Acta Constitutiva, UNMCE." 1995.

————."Memoria del primer encuentro nacional de museos comunitarios y ecomuseos." *Boletín de la Unión Nacional de Museos Comunitarios y Ecomuseos* (1995).

Necoli, S. G. (Groslier). "Ce qui a été fait au Cambodge pour la pratique et la protection des arts indigènes; Historique du Musée Khmer jusqu'a l'organisation du Musée du Cambodge (1905–1920)." *Arts et Archéologies Khmèrs* I–II (1926): 83–106.

Nederveen Pieterse, Jan. "Multiculturalism and Museums: Discourse About Others in the Age of Globalization." *Theory, Culture and Society* 14, 4 (1997): 123–46.

————. "Globalization North and South: Representations of Uneven Development and the Interaction of Modernities." *Theory, Culture and Society* 17, 1 (2000): 129–37.

Nemaheni, Israel. "An Interview with Mr. Nkayinkayi Samuel Mavundla." Department of Social Ecology, Kruger National Park, September 4, 1998.

Ngcelwane, Nomvuyo. *Sala Kahle, District Six,* Cape Town: Kwela Books, 1998.

Nora, Pierre. "Between Memory and History: Les Lieux de Mémoires." *Representations* 26 (1989): 7–24.

Nora, Pierre, and Lawrence D. Kritzman, eds. *Realms of Memory: Rethinking the French Past.* New York: Columbia University Press, 1996–1998.

Norval, A. J. *The Tourist Industry: A National and International Survey.* London: Isaac Pitman and Sons, 1936.

Novick, Peter. *The Holocaust in American Life.* Boston: Houghton Mifflin, 1999.

Nunn, Tom, and Philip Jalsevac. "Museum Closed, Converted into Cineplex." *Archives Society of Alberta Newsletter* 16, 4 (1997).

Nuttall, Sarah, and Carli Coetzee. *Negotiating the Past: The Making of Memory in South Africa.* Cape Town: Oxford University Press, 1999.

Ockman, Joan. "Applause and Effect." *Artforum,* summer 2001, 140–49.

Ogletree, Charles Jr. *All Deliberate Speed: Reflections on the First Half-Century of Brown v. Board of Education.* New York: W. W. Norton and Co., 2004.

O'Hanlon, Michael. *Paradise: Portraying the New Guinea Highlands.* London: British Museum Press, 1993.

O'Hanlon, Michael, and Robert L. Welsch, eds. *Hunting the Gatherers: Ethnographic*

Collectors, Agents and Agency in Melanesia, 1870s–1930s. Oxford: Berghahn Books, 2000.

Oldham, Jennifer. "Art Work Spurs Flap." *Los Angeles Times*, February 11, 2004.

Olofsson, Elisabet. "Growing from Challenge." *Nordisk Museologi* 1 (1999): 125–34.

Oostindie, Gert, ed. *Facing Up to the Past: Perspectives on the Commemoration of Slavery from Africa, the Americas and Europe*. Kingston: Ian Randle; The Hague: Prince Claus Fund, 2001.

Opoku-Agyemang, Kwadwo. "A Crisis of Balance: The (Mis)Representation of Colonial History and the Slave Experience as Themes in Modern African Literature." *Okike* 32 (1996): 49–67.

Overing, Johanna. "The Shaman as a Maker of Worlds: Nelson Goodman in the Amazon." *Man* n.s. 25, 4 (1990): 602–19.

"Pabene se Gryskop Begrawe." *Custos*, May 1975, 13–19.

Pagani, Catherine. "Chinese Material Culture and British Perceptions of China in the Mid-Nineteenth Century." In Barringer and Flynn, *Colonialism and the Object*.

Pagiola, Stefano. *Economic Analysis of Investments in Cultural Heritage: Insights from Environmental Economics*. Washington, D.C.: Environment Department, World Bank, 1996.

Palmer, Colin. "The Middle Passage." In Burnside, *A Slave Ship Speaks*.

———. "The Middle Passage." In Mariner's Museum, *Captive Passage*.

Panofsky, Erwin. *Meaning in the Visual Arts*. Garden City, N.Y.: Doubleday Anchor, 1955.

Parkington, John. "Clanwilliam Living Landscape Project." *Nordisk Museologi*, 1 (1999): 147–54.

Paulse, Michelle. "Everyone Had Their Differences but There Was Always Comradeship: Tramway Road, Sea Point, 1920s–1961." In Field, *Lost Communities, Living Memories*.

Pavis, Patrice, ed. *The Intercultural Performance Reader*. London: Routledge, 1996.

Pearce, Susan, ed. *Interpreting Objects and Collections*. London: Routledge, 1994.

Pearson, Mike, and Michael Shanks. *Theatre/Archaeology: Disciplinary Dialogues*. London: Routledge, 2001.

Peirce, C. S. "Logic as Semiotic: The Theory of Signs." In *Semiotics: An Introductory Reader*, edited by Robert Innis. Bloomington: Indiana University Press, 1985.

Peires, J. B. *The Dead Will Arise: Nongqawuse and the Great Xhosa Cattle-Killing Movement of 1856–7*. Bloomington: Indiana University Press, 1989.

Pekarik, Andrew J., Zahava D. Doering, and David A. Karns. "Exploring Satisfying Experiences in Museums." *Curator* 42, 2 (1999): 152–73.

Pels, Peter. "Professions of Duplexity: A Prehistory of Ethical Codes in Anthropology." *Current Anthropology* 40, 2 (1999): 101–36.

People, Places and Design Research. "Reassessing the Public's Interest in the Freedom Center." Report to the National Underground Railroad Freedom Center, Cincinnati, Ohio, August 2000.

Petropoulos, Jonathan. *The Faustian Bargain: The Art World in Nazi Germany.* London: Penguin Books, 2000.

Phelan, Peggy. "The Ontology of Performance: Representation Without Reproduction." In *Unmarked: The Politics of Performance.* New York: Routledge, 1993.

Philips, Ruth B. "Show Times: De-celebrating the Canadian Nation, De-Colonising the Canadian Museum 1967–92." In McIntyre and Wehner, *Negotiating Histories.*

Phillips, Caryl. *The Atlantic Sound.* New York: Knopf, 2000.

Pickrell, John. "Science Centers Blossom, But How Many Will Survive?" *Science,* April 6, 2001, 37–38.

Pienaar, U. de V. "Indications of Progressive Dessication of the Transvaal Lowveld Over the Past 100 Years, and Implications for the Water Stabilization Programme in the Kruger National Park." *Koedoe* 28 (1985): 93–165.

———. *Neem uit die verlede.* Pretoria: National Parks Board, 1990.

Pine, Joseph B., and James H. Gilmore. *The Experience Economy: Work Is Theatre and Every Business a Stage.* Boston: Harvard Business School Press, 1999.

Pinna, Giovanni. "Heritage and 'Cultural Assets.'" *Museum International* 53, 2 (2001): 62–64.

Pinney, Christopher. *Camera Indica: The Social Life of Indian Photographs.* Chicago: University of Chicago Press, 1997.

Pinnock, Don. "Ideology and Urban Planning: Blueprints of a Garrison City." In *The Angry Divide: Social and Economic History of the Western Cape,* edited by Wilmot G. James and Mary Simons. Cape Town: David Philip, 1989.

Plaatje, Sol. *Native Life in South Africa.* Johannesburg: Ravan Press, 1995 [1916].

Pointon, Marcia. *Art Apart: Art Institutions and Ideology Across England and North America.* Manchester: Manchester University Press, 1994.

Pollock, Griselda. *Differencing the Canon: Feminist Desire and the Writing of Art's Histories.* London: Routledge, 1999.

Polzer, Tara. "'We Are All South Africans Now': The Integration of Mozambican Refugees in Rural South Africa." University of the Witwatersrand, Forced Migration Studies Programme, Working Paper Series no. 8, May 2004.

Pomian, Krysztof. *Collectors and Curiosities: Paris and Venice, 1500–1800.* Cambridge: Polity Press, 1990.

Potgieter, F. S. "Natives in the Kruger National Park: An Authoritative Statement." *Star,* September 3, 1931.

Pradhan, Suman. "South Asia — AIDS: HIV Sneaks Across Open Borders." Interpress News Service, July 7, 1997.

Prakash, Gyan. *Another Reason: Science and the Imagination of Modern India.* Princeton: Princeton University Press, 1999.

———. "The Colonial Genealogy of Society: Community and Political Modernity in India." In *The Social in Question: New Bearings in History and the Social Sciences,* edited by Patrick Joyce. London: Routledge, 2002.

Prance, Edith. *Three Weeks in Wonderland: The Kruger National Park.* Cape Town: Juta, n.d.

Pratt, Mary Louise. *Imperial Eyes: Travel Writing and Transculturation.* New York: Routledge, 1992.

Preziosi, Donald, and Claire Farago, eds. *Grasping the World: The Idea of the Museum.* Hants, UK: Ashgate, 2004.

Prince, Sabiyha Robin. "Manhattan Africans: Contradiction, Continuity, and Authenticity in a Colonial Heritage." In *Afro-Atlantic Dialogues: Anthropology in the Diaspora,* edited by Kevin A. Yelvington. Santa Fe: School of American Research, 2005.

Prosalendis, Sandra, et al. "Punctuations: Periodic Impressions of a Museum." In Rassool and Prosalendis, *Recalling Community in Cape Town.*

Prosler, Martin. "Museums and Globalization." In MacDonald and Fyfe, *Theorizing Museums.*

Quainoo, Janet. "Elmina Mourns Slaves." *Daily Graphic* (Accra), August 30, 1997.

Rankin, Elizabeth, and Carolyn Hamilton. "Revision; Reaction; Re-vision: The Role of Museums in (a) Transforming South Africa." *Museum Anthropology* 22, 3 (1999): 3–13.

Ransdell, Eric. "Africa's Cleaned-Up Slave Castle." *U.S. News and World Report,* September 18, 1995, 33.

Rantao, Jovial. "Museums Must Rewrite History, Says Mandela." *Cape Argus,* September 25, 1997.

Rassool, Ciraj. "Ethnographic Elaborations and Indigenous Contestations." Paper presented at the Institutions of Public Culture Workshop on Museums, Local Knowledge and Performance in an Age of Globalisation, Cape Town, August 3–4, 2001.

———. "The Rise of Heritage and the Reconstitution of History in South Africa." *Kronos* 26 (2000): 1–23.

Rassool, Ciraj, and Sandra Prosalendis, eds. *Recalling Community in Cape Town: Creating and Curating the District Six Museum.* Cape Town: District Six Museum, 2001.

Rassool, Ciraj, and Leslie Witz. "The 1952 Jan van Riebeeck Tercentenary Festival: Constructing and Contesting Public National History in South Africa." *Journal of African History* 34, 3 (1993): 447–68.

———. "'South Africa: A World in One Country': Moments in International Tourist Encounters with Wildlife, the Primitive and the Modern." *Cahiers d'Etudes Africaines* 143 (1996): 335–71.

Ray, William. *The Logic of Culture: Authority and Identity in the Modern Era.* Oxford: Blackwell, 2001.

Rectanus, Mark W. *Culture Incorporated: Museums, Artists, and Corporate Sponsorships.* Minneapolis: University of Minnesota Press, 2002.

Reilly, Bernard. "Merging or Diverging? Emerging International Business Models for Museums on the Web." *Museum News,* January-February 2001.

Reuben Holo, Selma. *Beyond the Prado: Museums and Identity in Democratic Spain.* Washington, D.C.: Smithsonian Institution Press, 1999.

Reynolds, Christopher. "Armenians Seek Place in Museum." *Los Angeles Times,* February 3, 2003.

Ridgeway, James. "Bush-League Censorship." *Village Voice,* December 24–30, 2003.

Rivard, René. *Opening Up the Museum*. Quebec City: n.p., 1984.

Rive, Richard. *Buckingham Palace, District Six*. Cape Town: David Philip, 1986.

Robbins, Bruce. "Introduction: The Public as Phantom." In *The Phantom Public Sphere*.

———, ed. *The Phantom Public Sphere*. Minneapolis: University of Minnesota Press, 1993.

Roberts, H. R. *Betterment for the Bantu*. Pretoria: Department of Native Affairs, 1948.

Roberts, Lisa. *From Knowledge to Narrative: Educators and the Changing Museum*. Washington, D.C.: Smithsonian Institution Press, 1997.

Roberts, Mary Nooter, with contributions by 'Wande Abimbola. *Secrecy: African Art That Conceals and Reveals*. New York: Museum for African Art, 1993.

Robertson, Roland. *Globalization: Social Theory and Global Culture*. London: Sage, 1992.

Robins, Steven. "Silence in My Father's House: Memory, Nationalism, and Narratives of the Body." In Nuttall and Coetzee, *Negotiating the Past*.

Robinson, Imahkus Vienna. "Is the Black Man's History Being Whitewashed?" *Uhuru* 9 (1994): 48–50.

Robinson, Randall. *The Debt: What America Owes to Blacks*. New York: Dutton, 2000.

Rodriguez, Arantxa, Galder Guenaga, and Elena Martinez. "Bilbao: Case Study 2." *Urban Redevelopment and Social Polarisation in the City (URSPIC)*. European Union in collaboration with the Department of Applied Economics of the Universidad del País Vasco-Euskal Herriko Unibertsitatea, Bilbao, Spain, 2005.

Rosaldo, Renato. "Imperialist Nostalgia." In *Culture and Truth: The Remaking of Social Analysis*. Boston: Beacon Press, 1989.

Rose, Walter. *Bushman, Whale and Dinosaur: James Drury's Forty Years at the South African Museum*. Cape Town: Howard Timmins, 1961.

Rosenzweig, Roy, and Elizabeth Blackmar. *The Park and the People: A History of Central Park*. New York: Henry Holt, 1992.

Ross, Andrew. "Cultural Preservation in the Polynesia of the Latter Day Saints." In *The Chicago Gangster Theory of Life: Nature's Debt to Society*. London: Verso, 1994.

Rothfield, Lawrence, ed. *Unsettling "Sensation."* New Brunswick: Rutgers University Press, 2001.

Rousseau, Nicolene. "Popular History in South Africa in the 1980s: The Politics of Production." M.A. thesis, University of the Western Cape, 1994.

Rubin, William. "Modernist Primitivism: An Introduction." In *"Primitivism" in 20th Century Art: Affinity of the Tribal and the Modern*, edited by William Rubin. New York: Museum of Modern Art, 1984.

Ruffins, Fath Davis. "Culture Wars Won and Lost, Part II: The National African-American Museum Project." *Radical History Review*, winter 1998.

———. "Mythos, Memory, and History: African American Preservation Efforts 1820–1990." In Karp, Kreamer, and Lavine, *Museums and Communities*.

Ruffins, Paul. "The Peculiar Institution: New Trends and Controversies in Researching and Teaching Slavery." *Black Issues in Higher Education*, May 24, 2001.

Sahlins, Marshall. *Historical Metaphors and Mythical Realities: Structure in the Early History of the Sandwich Islands Kingdom.* Ann Arbor: University of Michigan Press, 1981.

Salazar Bondy, Sebastián. "El sentido social y popular de los museos." *Dominical*, supplement to *El Comercio* (Lima), October 18, 1959, 3.

Saltz, Jerry. "Downward Spiral: The Guggenheim Museum Touches Bottom." *Village Voice*, February 19, 2002, 65.

Sandberg, Mark B. "Material Mobility and the Primitive in the Scandinavian Metropolis." Paper presented at the conference Die Grosstadt und das "Primitive": Text, Politik und Repräsentation at the Internationales Forschungszentrum, Vienna, 2001.

Sandeen, Eric J. *Picturing an Exhibition: The Family of Man and 1950's America.* Albuquerque: University of New Mexico Press, 1995.

Sandell, Richard. "Museums and the Combating of Social Inequality: Roles, Responsibilities, Resistance." In *Museums, Society, Inequality.*

———, ed. *Museums, Society, Inequality.* London: Routledge, 2002.

Sanguinetti, Julio María. "Seis maestros. Una pintura. Una nación." In *Seis maestros de la pintura uruguaya*, edited by Ángel Kálenberg. Buenos Aires and Montevideo: Embajada de la República Oriental del Uruguay en la República Argentina, Museo Nacional de Artes Visuales de Montevideo, Museo Nacional de Bellas Artes de Argentina, 1987.

Sassen, Saskia. *Cities in a World Economy.* Second edition. Thousand Oaks, Calif.: Pine Forge Press, 2000.

———. *Globalization and Its Discontents: Essays on the New Mobility of People and Money.* New York: The New Press, 1998.

———. *Losing Control? Sovereignty in an Age of Globalization.* New York: Columbia University Press, 1996.

———. "Spatialities and Temporalities of the Global: Elements for a Theorization." *Public Culture* 12, 1 (2000): 215–32.

Sax, Joseph. *Playing Darts with a Rembrandt: Public and Private Rights in Cultural Treasures.* Ann Arbor: University of Michigan Press, 1999.

Sayre, Henry M. *The Object of Performance: The American Avant-Garde Since 1970.* Chicago: University of Chicago Press.

Schafer, R. Murray. *The Tuning of the World.* New York: Knopf, 1977.

Schapera, Isaac. "Economic Conditions in a Bechuanaland Native Reserve." *South African Journal of Science* 30 (1933): 633–55.

Schildkrout, Enid. "Kingdom of Gold." *Natural History*, October 1996, 36–47.

Schimmel, Paul, Kristine Stiles, and Museum of Contemporary Art, eds. *Out of Actions: Between Performance and the Object, 1949–1979.* Los Angeles: Museum of Contemporary Art/Thames and Hudson, 1998.

Schouten, Frans. "Heritage as Historical Reality." In *Heritage, Tourism and Society*, edited by David T. Herbert. London: Mansell, 1995.

Schramm, Katherine. " 'Coming Home to the Motherland': Pilgrimage Tourism in Ghana." In *Reframing Pilgrimage: Culture in Motion*, edited by S. Coleman and J. Eade. London: Routledge, 2004.

Schuster, Mark J. "Making a List and Checking It Twice: The List as a Tool of Historic Preservation." Working paper no. 14, Cultural Policy Center, University of Chicago, 2002.

Secretariat of the Pacific Community in Noumea, New Caledonia. *Regional Framework for the Protection of Traditional Knowledge and Expressions of Culture.* Noumea, New Caledonia: Secretariat of the Pacific Community in Noumea, 2002.

Seitel, Peter, ed. *Safeguarding Traditional Cultures: A Global Assessment of the 1989 UNESCO Recommendation on the Safeguarding of Traditional Culture and Folklore.* Washington, D.C.: Center for Folklife and Cultural Heritage, Smithsonian Institution, 2001.

Shaw, Rosalind. *Memories of the Slave Trade: Ritual and the Historical Imagination in Sierra Leone.* Chicago: University of Chicago Press, 2002.

Shelton, Anthony. "Museums in an Age of Cultural Hybridity." *Folk* 43 (2001): 221–50.

Sherkin, Samantha. "A Historical Study on the Preparation of the 1989 Recommendation." In Seitel, *Safeguarding Traditional Cultures.*

Sherman, Daniel, and Irit Rogoff, eds. *Museum Culture: Histories, Discourses, Spectacles.* Minneapolis: University of Minnesota Press, 1994.

Shin, Annys. "Mall and Chains." *Washington City Paper*, January 11–17, 2002.

Simpson, Moira. *Making Representations: Museums in the Post-Colonial Era.* London: Routledge, 1996.

Singleton, Theresa A. "The Slave Trade Remembered on the Former Gold and Slave Coasts." *Slavery and Abolition* 20, 1 (1999): 150–58.

Sinha, Prakash. "Human Rights: A Non-Western View Point." *Archiv für Rechts- und Sozialphilosophie* 67 (1981): 77.

Skinner, Elliott P. "The Dialectic Between Diasporas and Homelands." In *Global Dimensions of the African Diaspora*, edited by Joseph E. Harris. Washington, D.C.: Howard University Press, 1982.

Skotnes, Pippa. "Introduction." In *Miscast: Negotiating the Presence of the Bushmen*, edited by Pippa Skotnes. Cape Town: University of Cape Town Press, 1996.

———. "The Politics of Bushman Representations." In *Images and Empires: Visuality in Colonial and Postcolonial Africa*, edited by Paul S. Landau and Deborah D. Kaspin. Berkeley: University of California Press, 2002.

Sly, Liz. "Ghana Still Hears Rattle of Slaves' Chains." *Chicago Tribune*, April 2, 1995.

Small, Lawrence M. "On the Road from the Secretary." *Smithsonian* 33, 3 (2002): 20.

Smith, Claire, and Graeme Ward. *Indigenous Cultures in an Interconnected World.* St. Leonards: Allen and Unwin, 2000.

Smith, Jeff. "Cambodian Art Seeks a Market." *Cambodia Daily*, December 12, 1998.

Smith, Tina, and Ciraj Rassool. "History in Photographs at the District Six Museum." In Rassool and Prosalendis, *Recalling Community in Cape Town.*

Sollors, Werner. *Beyond Ethnicity: Consent and Descent in American Culture*. New York: Oxford University Press, 1988.

Sorkin, Michael. "See You in Disneyland." In *Variations on a Theme Park: The New American City and the End of Public Space*. New York: Noonday Press, 1992.

Soudien, Crain, and Renata Meyer, eds. *The District Six Public Sculpture Project*. Cape Town: District Six Museum, 1997.

South African Development Community. "Trade, Industry and Investment and Review 2001." Available at http://www.sadcreview.com/country%20profiles%202001 /southafrica/southafricaTourism.htm (accessed May 7, 2002).

South African Museum. "Mission Statement." Available at http://www.museums.org .2a/sam/gen/mission.htm (accessed May 11, 2002).

South African Press Association, "Tourists Flock to SA After Sept. 11," *Mail and Guardian Online*, May 13, 2002 (accessed May 13, 2002).

South African Railways and Harbours. *Travel in South Africa*. Second edition. Pretoria: SAR&H, 1924.

South African Tourism Board (SATOUR). *The Role and Function of SATOUR*. Cape Town: SATOUR 1994.

Spencer, C. C. *Beautiful South Africa*. Johannesburg: APB Publishers, 1951.

Spiegel, Andrew. "Moving Memories." In Bunn and Field, *Trauma and Topography*.

Stafford, Barbara. *Artful Science: Enlightenment Entertainment and the Eclipse of Visual Education*. Cambridge, Mass.: MIT Press, 1994.

Stanley, Nick. *Being Ourselves for You: The Global Display of Cultures*. London: Middlesex University Press, 1998.

Stannard, David E. *American Holocaust: Columbus and the Conquest of the New World*. New York: Oxford University Press, 1992.

Stanner, W. E. H. "The Dreaming." In *Australian Signpost*, edited by T. A. G. Hungerford. Melbourne: F. W. Cheshire, 1956.

———. *White Man Got No Dreaming*. Canberra: Australian National University Press, 1979.

Steele, Shelby. *The Content of Our Character: A New Vision of Race in American*. New York: St. Martin Press, 1990.

———. *A Dream Deferred: The Second Betrayal of Black Freedom in America*. New York: HarperCollins, 1998.

Steichen, Edward. *The Family of Man: The Greatest Photographic Exhibition*. New York: Museum of Modern Art, 1955.

Stephen, Lynn. *Zapotec Women*. Austin: University of Texas Press, 1991.

Stephens, Sarah. "The Art of Saving a Nation's Soul." *Phnom Penh Post*, January 22–February 4, 1999.

Stevenson-Hamilton, James. *The Kruger National Park*. Pretoria: Publicity Department South African Railways and Harbours, 1932.

———. *The Low-Veld: Its Wild Life and Its People*. London: Cassell, 1934.

———. *South African Eden, the Kruger National Park*. Cape Town: Struik, 1993 [1937].

Stewart, Laura, and Cindi Brownfield. "DBCC Museum Director Claims Censorship." *Daytona Beach News-Journal*, December 13, 2001.

Stocking, George W., Jr. "The Space of Cultural Representation, Circa 1887 and 1969: Reflections on Museum Arrangement and Anthropological Theory in the Boasian and Evolutionary Traditions." In *The Architecture of Science*, edited by Peter Galison and Emily Thompson. Cambridge, Mass.: MIT Press, 1999.

Strathern, Marilyn. "What Is Intellectual Property After?" In *Property, Substance, and Effect: Anthropological Essays on Persons and Things*. London and New Brunswick: Athlone, 1999.

Sutherland, Peter. "In Memory of the Slaves: An African View of the Diaspora in the Americas." In *Representations of Blackness and the Performance of Identities*, edited by Jean Muteba Rahier. Westport, Conn.: Bergin and Garvey, 1999.

Sutton, Peter. "The Morphology of Feeling." In *Dreamings: The Art of Aboriginal Australia*.

―――. "Dreamings: The Story Thus Far." *Bulletin of the Conference of Museum Anthropologists* 23 (1990): 176–78.

―――. "Reading 'Aboriginal Art.'" *Australian Cultural History* 11 (1992): 28–38.

―――. "Reply to von Sturmer." Manuscript.

―――, ed. *Dreamings: The Art of Aboriginal Australia*. New York: George Braziller/ Asia Society Galleries, 1988.

Swade, Doron. "Virtual Objects: Threat or Salvation?" In *Museums of Modern Science*, edited by Svante Lindqvist, Marika Hedin, and Ulf Larsson. Nobel Symposium 112. Canton, Ohio: Science History Publications/USA, 2000.

Tadao, Umesao, Josef Kreiner, Kasuya Kazuki, and Ogi Shinzo. "Edo-Tokyo as an Instrument of Civilisation." In *Guide to Edo-Tokyo Museum*. Tokyo: Foundation Edo-Tokyo Historical Society, 1995.

Tanaka, Stefan. *Japan's Orient*. Berkeley: University of California Press, 1993.

Taylor, Diana. "Acts of Transfer." In *The Archive and the Repertoire: Performing Cultural Memory in the Americas*. Durham: Duke University Press, 2003.

Tejera Gaona, Héctor. "La comunidad indígena en México: la utopía irrealizada." In *Diversidad Étnica y Conflicto en América Latina*, Vol. II, edited by Raquel Barceló et al. Plaza y Valdés: Universidad Nacional Autónoma de México, 1995.

Thomas Cook and Son. *Cook's Tour of South Africa*. London: Thomas Cook, 1935.

Thomas, Nicholas. *Colonialism's Culture: Anthropology, Travel and Government*. Princeton: Princeton University Press, 1994.

―――. *Entangled Objects: Exchange, Material Culture and Colonialism in the Pacific*. Cambridge, Mass.: Harvard University Press, 1991.

Thomas, Velma Maia. *Lest We Forget: The Passage from Africa to Slavery and Emancipation*. New York: Crown, 1997.

Thompson, Edward P. *The Making of the English Working Class*. New York: Vintage Books, 1963.

Thompson, Robert Farris. *African Art in Motion: Icon and Act in the Collection of Katherine Coryton White*. Los Angeles: University of California Press, 1974.

Thomson, Donald. *Economic Structure and the Ceremonial Exchange Cycle in Arnhem Land*. Melbourne: Macmillan, 1939.

Thornton, John. "Africa: The Source." In Mariners' Museum, *Captive Passage*.

Throsby, David. "Economic and Cultural Value in the Work of Creative Artists." In Avrami, Mason, and de la Torre, *Values and Heritage Conservation*.

Tomlinson, John. *Cultural Imperialism: A Critical Introduction*. Baltimore: Johns Hopkins University Press, 1991.

————. *Globalization and Culture*. Chicago: University of Chicago Press, 1999.

Torre, Marta de la, and Randy Mason, eds. *Economics and Heritage Conservation: A Meeting Organized by the Getty Conservation Institute, December 1998*. Los Angeles: Getty Conservation Institute, 1999.

Transvaal Province. *Report of the Game Reserves Commission*. Pretoria: Government Printers, 1918.

Trescott, Jacqueline. "Capitol Site Favored for Black History Museum." *Washington Post*, April 3, 2003.

————. " 'Silk Road' Traffic Jam: Smithsonian Predicts Record Turnout for Folk Festival." *Washington Post*, April 23, 2002, C1.

Tsing, Anna Lowenhaupt. *Friction: An Ethnography of Global Connection*. Princeton: Princeton University Press, 2004.

Turner, Terence. "Anthropology and Multiculturalism: What Is Anthropology That Multiculturalists Should Be Mindful of It?" *Cultural Anthropology* 8, 4 (1993): 411–29.

————. "Indigenous and Culturalist Movements in the Contemporary Global Conjuncture." Manuscript, n.d.

Turner, Victor. *Dramas, Fields and Metaphors*. Ithaca: Cornell University Press, 1974.

Turtinen, Jan. "Globalising Heritage: On UNESCO and the Transnational Construction of a World Heritage." *SCORE Rapportserie* 12 (2000), [Stockholm Center for Organizational Research, Stockholm.

UNESCO (United Nations Educational, Scientific and Cultural Organization). "Consolidated Preliminary Draft Convention for the Safeguarding of Intangible Heritage, Third Session of the Intergovernmental Meeting of Experts on the Preliminary Draft." Convention for the Safeguarding of Intangible Cultural Heritage, Paris, UNESCO Headquarters, June 2–14, 2003.

————. "Intercultural Dialogue in Central Asia." Paris: UNESCO, 2003. Available at http://www.unesco.org/culture/dialogue/eastwest/index.shtml (accessed September 28, 2004).

————. "Report on the Preliminary Study on the Advisability of Regulating Internationally, Through a New Standard-Setting Instrument, the Protection of Traditional Culture and Folklore." UNESCO Executive Board, Paris, May 16, 2001, doc. no. 161 EX/15. Available at http://unesdoc.unesco.org/images/0012/001225/12285e.pdf (accessed September 28, 2004).

————. "UNESCO Issues Proclamation of Masterpieces of the Oral and Intangible

Heritage of Humanity." Press release, May 18, 2001. Available at http://www.unesco .org/bpi/eng/unescopress/2001/01-71e.shtml (accessed September 28, 2004).

Union of Community Museums of Oaxaca. "Compartiendo Experiencias: Segundo Encuentro de Museos Comunitarios de las Américas, Oaxaca." 2002.

————. "Final Report: Community Workshops, Training Center of the Union of Community Museums of Oaxaca, January 1, 2001–March 31, 2002." 2002.

————. "Mission of the Union of Community Museums of Oaxaca." Working document, 2001.

————. "Pilot Project: Workshops for the Creation of Community Museums of the Americas, Oaxaca." 2001.

Union of South Africa. *Report of the Native Economic Commission, 1930–1932*. U. G. 22, 1932.

University of Cape Town. *Impact: A Report on Research and Outreach at the University of Cape Town*. Cape Town: University of Cape Town, n.d.

Urry, John. "Gazing on History." In *Representing the Nation: A Reader, Histories, Heritage and Museums*, edited by David Boswell and Jessica Evans. London: Routledge, 1999.

————. *The Tourist Gaze*. London: Sage, 2002.

van Dantzig, Albert. *Forts and Castles of Ghana*. Accra: Sedco Publishing Limited, 1980.

Van Graan, Mike, and Tammy Ballantyne, comps. *The South African Handbook on Arts and Culture, 2002–2003*. Cape Town: David Philip, 2003.

Velho, Gilberto. "Cambios Globales y Diversidad Cultural: una Visión Antropológica." In *Pueblos Indígenas, Derechos Humanos e Interdependencia Global*, edited by Patricia Morales. México: Siglo XXI Editores, S.A. de C.V., 2001.

Vidler, Anthony. "Aformal Affinities." *Artforum*, summer 2001, 140–49.

Vlach, John. *Back of the Big House: The Architecture of Plantation Slavery*. Chapel Hill: University of North Carolina Press, 1993.

Vogel, Carol. "Despite Criticisms, Thomas Krens Plans Still Other Guggenheims." *New York Times*, April 27, 2005.

————. "Guggenheim Grows: The Next Stop Is Rio." *New York Times*, May 1, 2003.

Volkman, Toby Alice. "Visions and Revisions: Toraja Culture and the Tourist Gaze." *American Ethnologist* 17, 1 (1990): 91–110.

von Sturmer, John. "Aborigines, Representation, Necrophilia." *Art and Text* 32 (1989): 127–39.

Wager, J., ed. *Zoning and Environmental Management Plan for the Siem Reap/Angkor Region*. Phnom Penh: UNDP/UNESCO, 1994.

Walsh, Kevin. *The Representation of the Past: Museums and Heritage in the Post-Modern World*. London: Routledge, 1992.

Ward, Martha. "What's Important About the History of Exhibition." In Greenberg, Ferguson, and Nairne, *Thinking About Exhibitions*.

Warner, W. Lloyd. *A Black Civilization*. Chicago: Harper Row, 1958.

Weiner, Annette. *Inalienable Possessions: The Paradox of Keeping-While-Giving*. Berkeley: University of California Press, 1992.

West, Margaret, ed. *The Inspired Dream: Life as Art in Aboriginal Australia*. Brisbane: Queensland Art Gallery, 1988.

Westbrook, David A. *City of Gold: An Apology for Global Capitalism in a Time of Discontent*. New York: Routledge, 2004.

Williams, Nancy. "On Aboriginal Decision Making." In *Metaphors of Interpretation: Essays in Honour of W. E. H. Stanner*, edited by Dianne Barwick, Jeremy Beckett and Mary Reay. Canberra: Australian National University Press, 1985.

Windschuttle, Keith. *The Fabrication of Aboriginal History*, Vol. 1: *Van Dieman's Land 1803–1847*. Sydney: Macleay, 2002.

Witz, Leslie. *Apartheid's Festival*. Bloomington: Indiana University Press, 2003.

———. "Museums on Cape Town's Township Tours." Paper presented at the Institutions of Public Culture Workshop on Museums, Local Knowledge and Performance in an Age of Globalisation, Cape Town, August 3–4, 2001.

Witz, Leslie, Ciraj Rassool, and Gary Minkley. "The Boer War, Museums and Ratanga Junction, the Wildest Place in Africa: Public History in South Africa in the 1990s." Working paper no. 2. Basel, Switzerland: Basler Afrika Bibliographien, 2000.

———. "Repackaging the Past for South African Tourism." *Daedalus* 130, 1 (2001): 277–96.

Wolhuter, Harry. *Memories of a Game-Ranger*. Johannesburg: Wild Life Protection Society, 1948.

X, Malcolm, with Alex Haley. *The Autobiography of Malcolm X*. New York: Grove Press, 1965.

Xinhua News Agency, "First Shanghai Private Art Museum Closed," July 14, 2003. Available at www.china.org.cn/english/culture/69823.htm (accessed August 1, 2004).

Young, James E., ed. *The Art of Memory: Holocaust Memorials in History*. New York: Jewish Museum, 1994.

Yúdice, George. *The Expediency of Culture: Uses of Culture in the Global Era*. Durham: Duke University Press, 2003.

Zinn, Howard. "Respecting the Holocaust." *The Progressive*, November 1999.

Zirakzadeh, Cyrus Ernesto. *A Rebellious People: Basques, Protest, and Politics*. Reno: University of Nevada Press, 1991.

Zulaika, Joseba. *Crónica de una seducción: El museum Guggenheim Bilbao*. Madrid: Editorial NEREA, 1997.

———. " 'Miracle in Bilbao': Basques in the Casino of Globalism." In *Basque Cultural Studies*, edited by William A. Douglass, Carmelo Urza, Linda White, and Joseba Zulaika. Basque Studies Program Occasional Papers Series, no. 5. Reno: University of Nevada, Center for Basque Studies, 2000.

———. "Postindustrial Bilbao: The Reinvention of a New City." *Basque Studies Program Newsletter* 57 (1998).

CONTRIBUTORS

TONY BENNETT is a professor of sociology at the Open University in the United Kingdom. His current interests focus on the sociology of culture and media, with special reference to questions of culture and governance, the history and theory of museums, cultural and media policy, and relations of class, culture, and social exclusion. His publications include *Formalism and Marxism*; *Outside Literature*; *Bond and Beyond: The Political Career of a Popular Hero* (with Janet Woollacott); *The Birth of the Museum: History, Theory, Politics*; *Culture: A Reformer's Science*; *Accounting for Tastes: Australian Everyday Cultures* (with Michael Emmison and John Frow); and *Pasts Beyond Memory: Evolution, Museums, Colonialism*. He is also (with Larry Grossberg and Meaghan Morris) the editor of *New Keywords*.

DAVID BUNN is head of the new Wits School of Arts and professor and chair of history of art at the University of the Witwatersrand, in Johannesburg. He is a cultural theorist who works on contemporary South African culture and in interdisciplinary landscape studies and visual theory, having published widely in all these areas.

GUSTAVO BUNTINX is a curator and art historian best known for his reflections on art and violence, art and politics, and art and religion. After graduating from Harvard, he taught at several Latin American universities. Currently he is involved in alternative curatorial and museological initiatives on constructing viable institutional supports for critical art.

CUAUHTÉMOC CAMARENA and TERESA MORALES are both anthropologists working for the National Institute of Anthropology and History of Mexico. They have coordinated the Program for Community Museums of Oaxaca since 1987, and helped found

the Union of Community Museums of Oaxaca in 1991. They also established the National Program of Community Museums and Ecomuseums and coordinated it from 1993 to 1996, helped create the National Union of Community Museums and Ecomuseums of Mexico in 1994, and supported the development of a network of community museums in Canada, Mexico, Guatemala, El Salvador, Nicaragua, Costa Rica, Panama, Venezuela, Bolivia, Chile, and Brazil.

ANDREA FRASER is a New York–based artist whose work has been identified with performance, context art, and institutional critique. *Andrea Fraser: Works 1984 to 2003* was published by the Kunstverein Hamburg and DuMont Buchverlag in 2003. In 2005, MIT Press released *Museum Highlights: The Writings of Andrea Fraser*, a collection of essays and performance scripts edited by Alexander Alberro and with a foreword by Pierre Bourdieu. She is on the faculty of the Whitney Independent Study Program in New York.

MARTIN HALL is a historical archaeologist who has researched the origins of farming settlement in southern Africa, the archaeology of colonial settlement, and more recently material expressions of identity in the contemporary world. He has been attached to the Centre for African Studies at the University of Cape Town and is currently deputy vice chancellor at the university.

IVAN KARP is National Endowment for the Humanities Professor at Emory University and co-director of the Center for the Study of Public Scholarship. A social anthropologist, Karp was formerly curator of African cultures at the Smithsonian Institution's National Museum of Natural History and is author of numerous books and articles on African social organization and African systems of thought. He is also editor of two books on museums, *Exhibiting Cultures: The Poetics and Politics of Museum Display* and *Museums and Communities: The Politics of Public Culture*.

BARBARA KIRSHENBLATT-GIMBLETT is University Professor and professor of performance studies at the Tisch School of the Arts, New York University, where she chaired the department of performance studies for more than a decade. She teaches courses on museums, tourism, and heritage and serves on the advisory committee for the Museum Studies Program. She has curated exhibitions and consulted for many museums, including the United States Holocaust Memorial Museum (Washington, D.C.), the Museum of the History of Polish Jews (Warsaw), Te Papa Tongarewa/Museum of New Zealand, and the Karl Ernst Osthaus Museum (Hagen, Germany). She is the author of *Destination Culture: Tourism, Museums, and Heritage.*

CORINNE A. KRATZ co-directs the Center for the Study of Public Scholarship at Emory University, where she is also professor of anthropology and African studies. She writes and teaches about culture and communication, museums and exhibitions, ritual, performance, photography, and other forms of cultural display and representation. She has been doing research in Kenya since 1974, has curated exhibitions, and is the author of *The Ones That Are Wanted: Communication and the Politics of Representation in a*

Photographic Exhibition and *Affecting Performance: Meaning, Movement, and Experience in Okiek Women's Initiation.*

CHRISTINE MULLEN KREAMER, a curator since 2000 at the National Museum of African Art, Smithsonian Institution, has extensive museum experience in the United States, Ghana, and Vietnam. From 1993 to 1999 she served as content coordinator and exhibit developer for "African Voices," an innovative, audience-centered permanent exhibition of African history and culture at the Smithsonian's National Museum of Natural History. She is co-author of *Inscribing Meaning: Writing and Graphic Systems in African Art*; *Crowning Achievements: African Arts of Dressing the Head*; and *Wild Spirits, Strong Medicine: African Art and the Wilderness.* She co-edited and contributed essays in *Objects as Envoys: Cloth, Imagery and Diplomacy in Madagascar* and *Museums and Communities.* Her writings on African art and museum practice also have been published in several journals and edited publications. She received her Ph.D. in African art history from Indiana University and has conducted research on art, ritual, and the creativity of work in Togo, Ghana, and Indonesia.

JOSEPH MASCO is assistant professor of anthropology at the University of Chicago. He is the author of *The Nuclear Borderlands: The Manhattan Project in Post–Cold War New Mexico.*

HOWARD MORPHY is an anthropologist and curator, and is presently director of the Centre for Cross-Cultural Research at Australian National University. He has published widely in the anthropology of art, aesthetics, performance, museum anthropology, visual anthropology, and religion, and his books include *Ancestral Connections* and *Aboriginal Art.* His current focus is on the use of digital media in cross-cultural research and the humanities, and he recently published a multimedia biography of the Australian Yolngu artist Narritjin Maymuru.

INGRID MUAN received her Ph.D. in art history from Columbia University. She taught twentieth-century art history at the Department of Fine Arts, Royal University of Fine Arts (Phnom Penh), and was co-founder and co-director (with Ly Daravuth) of the Reyum Institute of Arts and Culture, an exhibition space and publishing house in downtown Phnom Penh. Her sudden death in January 2005 is widely mourned.

FRED MYERS is professor and chair of the Department of Anthropology at New York University. He is interested in exchange theory, material culture, cultural politics, and the circulation of culture in contemporary art worlds. Myers is the author of *Pintupi Country, Pintupi Self: Sentiment, Place and Politics Among Western Desert Aborigines*; *Painting Culture: The Making of an Aboriginal High Art*; co-editor of *The Traffic in Culture: Refiguring Art and Anthropology*; and editor of *The Empire of Things.* He has also published numerous articles on the development and significance of Western Desert Aboriginal acrylic painting.

Born and raised in Cape Town, CIRAJ RASSOOL is associate professor of history at the University of the Western Cape, where he also directs the African Programme in Mu-

seum and Heritage Studies. He has written widely on South African public history, visual history, and resistance historiography. His publications include a co-authored book, *Skeletons in the Cupboard: South African Museums and the Trade in Human Remains 1907–1917*, and a co-edited volume, *Recalling Community in Cape Town: Creating and Curating the District Six Museum*. He is a trustee of the District Six Museum in Cape Town.

VICENTE RAZO is an artist. After studying art at the Universidad Nacional Autónoma de México, he received a Fulbright scholarship to pursue a master's degree at New York University. In 1996 he founded the Museo Salinas and in 2002 published *The Official Museo Salinas Guide* with Smart Art Press.

FATH DAVIS RUFFINS has been a historian at the Smithsonian's National Museum of American History since 1981. She has curated a number of exhibitions around the United States and published a number of articles on African American history. Most recently, she served as guest curator for an inaugural exhibition at the National Underground Railroad Freedom Center in Cincinnati, Ohio, titled "From Slavery to Freedom."

LYNN SZWAJA is program director for theology at the Henry Luce Foundation, where she focuses on theological education in Asia and North America, interfaith understanding, and religion and the arts. From 1982 to 2004 she was a program officer in the Arts and Humanities Program of the Rockefeller Foundation, serving twice as acting director and as deputy director for the Creativity and Culture Program from 2001 to 2004. Szwaja served as chair of the Fund for U.S. Artists at International Festivals and Exhibitions from 1999 to 2003. She received the John Evans Medal for Outstanding Contribution to the Wellbeing of Humankind in 2002 and the Femmy Award for promoting women's studies and women's voices in 2003. She is a trustee of the Connecticut Historical Society Museum and of the Feminist Press.

KRISTA A. THOMPSON is assistant professor of African diaspora art in the Department of Art History at Northwestern University. Her teaching, research, and curatorial projects examine the role of photography in African diasporic communities. She is the author of *An Eye for the Tropics: Tourism, Photography, and the Caribbean Picturesque*.

LESLIE WITZ is associate professor in the History Department, University of the Western Cape, Cape Town. His major research interest is in the field of public history, and he has published extensively about the different ways that histories are represented to various public audiences through festivals, tourism, memorials, and museums. He is the author of *Apartheid's Festival: Contesting South African National Pasts* and *Write Your Own History*, and a co-author of *How to Write Essays*.

TOMÁS YBARRA-FRAUSTO recently retired as associate director for the Creativity and Culture Program at the Rockefeller Foundation. His work included the Humanities Residency Fellowship Program, the North American Transnational Communities program, and Partnerships Affirming Community Transformation. Prior to joining the

Rockefeller Foundation, Dr. Ybarra-Frausto was a tenured professor at Stanford University in the Department of Spanish and Portuguese. He has served as the chair of the Mexican Museum in San Francisco and the Smithsonian Council, and has written and published extensively, focusing, for the most part, on Latin American and U.S./Latino cultural issues. In 1998, Dr. Ybarra-Frausto was awarded the Henry Medal by the Smithsonian Institution.

INDEX

Aboriginal artists, 517–21, 528–9
Aboriginal culture, 493–4; art and,
 350–2; in context of Australia, 523–
 7; "experts" on, 527–8; image making
 of, 508–10; performance and, 355–
 6; "possession" of, 527–30. *See also*
 Australia; "Dreamings: The Art of
 Aboriginal Culture"; First Australians
 Gallery; Indigenous cultures; National
 Museum of Australia; *Yingapungapu*
 sand sculptures and ceremonies
Aboriginal paintings, 518–23
ACTAG (Arts and Culture Task Group),
 293
Activists, scholars as, 21
Aesthetic disciplines: art museums and,
 55, 142–5; of Guggenheim Bilbao, 38;
 museums shaping, 37, 65–6. *See also*
 Senses, the
Afghanistan, Bamiyan Valley, Buddhas
 in, 162, 177–8
Africa. *See* Ghana; South Africa
African American Museum, Detroit, 402

African American museum, plans for,
 424–5
African Americans: on exhibitions
 about slavery, 408–9; history of, 400–
 1; on Holocaust Memorial Museum,
 399–400; lack of national museum on,
 221; "race memory" and, 414–15; slave
 trade sites in Ghana and, 457–8, 460,
 463. *See also* Slavery, history of
African Burial Ground, New York City,
 413–14
"After the Revolution: Everyday Life in
 America 1780–1800" (exhibition),
 402–3
Akeley, Carl, 358
Albasini region, South Africa, 364–
 6, 369–73, 377–83. *See also* Kruger
 National Park; South Africa
Albert Sarraut Museum. *See* National
 Museum of Cambodia
Albuquerque, New Mexico, National
 Atomic Museum in, 104
Allen, Debbie, 403, 417

504–32; impact of current affairs on, 9–17; international connections as trend in, 5; managing the past and, 107–9; modeled after global corporations, 8–9; performance and, 504–32; processes impacting, 6; shifts in, 9–17; training programs and, 334–6, 447–50. *See also* Exhibitions; Symposia, on Aboriginal art

Museum spaces, 214, 352, 363–4

Museum void, 210, 219–41

"Museumization," 301–14, 350, 394–426

Museums: building vs. constructing, 239–41; as businesses, 301–14; as contact zones, 2, 64, 71, 208; definitions of, 24–5, 42; descriptions of, 1–2; as "differencing machines," 46, 76; events at, 511–12; as forums, 292; goals of, 1; as hybrid space of scholarship and community, 215–16; idea of, 207–8; impact of contexts on, 25–6; impact of international debates on, 347, 350–1; implications of technology for, 43; other forms of entertainment and, 23, 474–5; as part of public spheres, 49–50; as "people movers," 51–7, 59–61, 67; as products for international tourist markets, 115; for radical purposes, 213–14; relationship to actors, 24; relationship to field sites, 358–9, 363–4, 383–4; remapping, 347–56; as sites of cultural production, 439, 504–5, 507; as sites to visually manage the past, 107–8; specialized, 14; as technology of space, time, and representation, 24; as term, 255, 358–9; as tool of civil society, 342; "value creation processes" at, 471–2. *See also* Community museums; *and names of specific museums*

Museums and Communities (Karp, Kreamer, Lavine), 13, 19, 461

Museum of Pictorial Reproductions (Museo de Reproducciones Pictóricas), Lima, 43

Myers, Fred, 19, 21, 26, 348–9, 352, 355

Myles, Kwesi, 449

Nagatani, Patrick, 41, 105–6

Nair, Surendran, 13

Nampitjinpa, Dolly Granites, 517, 518

Napanangka, June Walker, 517

Narritjin at Djarrakpi (Dunlop), 515

Nation: construction of, 223; defining through new museums, 11; identity and, 22–23, 357; memory and, 357

Nation of Islam, 454–5

National Atomic Museum, Albuquerque, 104

National Conference of Community and Justice (NCCJ), 422

National Gallery, South Africa, 119–20

National Gallery of Modern Art, New Delhi, 13

National Institute of Anthropology and History of Mexico (INAH), 330

National Living Treasure, 182–3

National Museum of African American History and Culture, Smithsonian, 424–5

National Museum of American History, Smithsonian, 402–3

National Museum of Anthropology, Mexico, 331

National Museum of Australia, 10–11, 59–61, 351–2, 470–3. *See also* Aboriginal culture; *Yingapungapu* sand sculptures and ceremonies

National Museum of Cambodia, 210, 261–8

National Museum of China, plans for, 10

National Museum of the American Indian, Washington, D.C., 10

National Museums of Kenya, 12

IVAN KARP is National Endowment for the Humanities Professor and Co-Director of the Center for the Study of Public Scholarship at Emory University. He has coedited numerous books, including *Museums and Communities: The Politics of Public Culture* and *Exhibiting Cultures: The Poetics and Politics of Museum Display*.

CORINNE A. KRATZ is Professor of Anthropology and African Studies and Co-Director of the Center for the Study of Public Scholarship at Emory University. She is the author of *The Ones That Are Wanted: Communication and the Politics of Representation in a Photographic Exhibition*.

LYNN SZWAJA is Program Director for Theology at the Henry Luce Foundation.

TOMÁS YBARRA-FRAUSTO was, until retirement in 2005, Associate Director for Creativity and Culture at the Rockefeller Foundation. In 1998, he was awarded the Joseph Henry Medal for "exemplary contributions to the Smithsonian Institution."

LIBRARY OF CONGRESS
CATALOGING-IN-PUBLICATION DATA

Museum frictions : public cultures/global transformations / edited by Ivan Karp . . . [et. al.]; with Gustavo Buntinx, Barbara Kirshenblatt-Gimblett, and Ciraj Rassool.
p. cm.
Papers from a series of meetings on museums and globalizing processes convened over the last six years by the Rockefeller Foundation in New York, Buenos Aires, Cape Town, and Bellagio, Italy.
Includes bibliographical references and index.
ISBN-13: 978-0-8223-3878-9 (cloth : alk. paper)
ISBN-10: 0-8223-3878-5 (cloth : alk. paper)
ISBN-13: 978-0-8223-3894-9 (pbk. : alk. paper)
ISBN-10: 0-8223-3894-7 (pbk. : alk. paper)
1. Museums—Social aspects—Congresses.
2. Museums—Economic aspects—Congresses.
3. Museums—Political aspects—Congresses.
4. Globalization—Social aspects—Congresses.
5. Museum techniques—Congresses. 6. Museum exhibits—Congresses. 7. Popular culture—Congresses. 8. Culture diffusion—Congresses.
9. Pluralism (Social sciences)—Congresses.
I. Karp, Ivan. II. Kratz, Corinne Ann, 1953–
III. Szwaja, Lynn. IV. Ybarra-Frausto, Tomás.
V. Buntinx, Gustavo. VI. Kirshenblatt-Gimblett, Barbara. VII. Rassool, Ciraj. VIII. Rockefeller Foundation.
AM7.M8729 2006
069—dc22 2006016164